Life, Liberty,

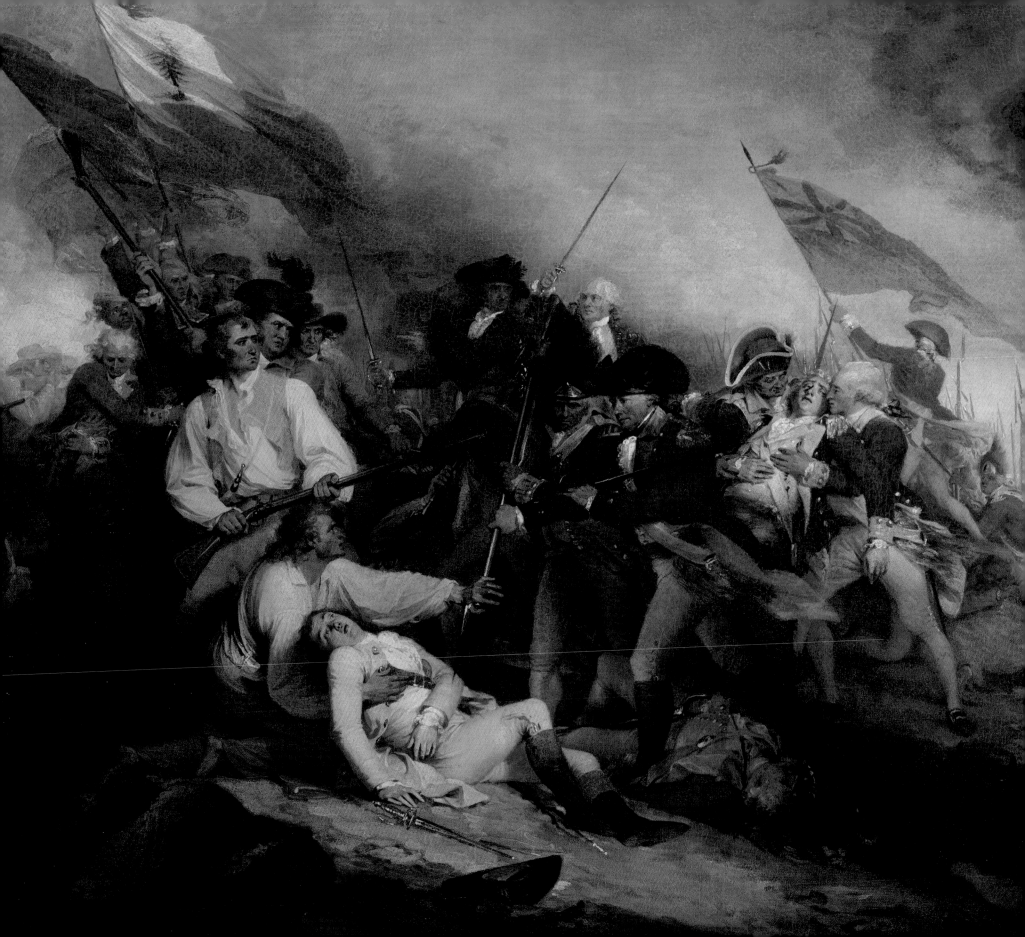

Exhibition and catalogue ———————————
organized by Helen A. Cooper with Robin Jaffee Frank,
and Elisabeth Hodermarsky and Patricia E. Kane,
with the assistance of Amy Kurtz Lansing

Introduction ————————
David McCullough

Essays ————————
Jon Butler
Joanne B. Freeman
Howard R. Lamar
Jules David Prown

Life, Liberty, and the Pursuit of Happiness

American Art from the Yale University Art Gallery

Yale University Art Gallery, New Haven,
in association with Yale University Press, New Haven and London

Contents

The Yale University Art Gallery, the oldest university art museum in America, has long been famous for its extraordinary holdings in American paintings and decorative arts. The major multiyear renovation that the Gallery's buildings are currently undergoing meant that these celebrated collections would be removed from public view for several years. We realized that this was a rare opportunity to share these works, such as John Trumbull's original paintings of the Revolutionary War—which had never before left the Yale campus—with a wider audience in a traveling exhibition.

Life, Liberty, and the Pursuit of Happiness: American Art from the Yale University Art Gallery is organized to reflect the way the American arts have been taught at Yale. In the belief that works of art are the signposts of our history and culture, revealing in nonverbal ways the ideas, attitudes, and traditions of a nation and its people, this exhibition presents the greatest treasures from these collections in their larger aesthetic, historical, and cultural contexts. They tell the story of America from its pre-Revolutionary beginnings as a people of diverse ethnic and cultural heritages faced with the challenge of establishing a home in the New World, through more than two centuries of economic growth and political expansion, to its becoming a powerful continental nation. Freed from the traditional artistic establishments of their original cultures, these immigrants brought fresh energies to the objects they created on these shores, establishing a visual heritage in paint, wood, ceramic, metal, glass, textile, print, and photography. The story of this exhibition is the story of the American experience as seen through its material culture from the time of the early colonies to the World's Columbian Exposition in 1893, creating a vivid portrait of a people defining itself culturally, politically, and geographically.

Long before the Gallery was established in 1832 with John Trumbull's gift of his Revolutionary War paintings and the picture gallery erected to house them, Yale was collecting American art. The growth of these American collections mirrors the art history of our nation. In a sense, Yale has always collected contemporary art: in the early Republic, portraiture was the preferred art form, so it is not surprising that our early acquisitions were largely portraits, many of whose sitters had ties to Yale while others depicted important public figures of the day. Later, when landscape, still life, and genre subjects became popular, the growing collections reflected this change in collecting taste. In the twentieth century, works by America's greatest modernist artists found their way to Yale, as did the magnificent Mabel Brady Garvan Collection of American decorative arts. Assembled by Francis P. Garvan, this pioneering collection reflected the emerging aesthetic appreciation of American furniture, silver, and other domestic objects, setting the standard and the foundation for what is now one of the country's greatest collections of decorative arts. Now, in the twenty-first century, extraordinary gifts continue to have a transformative effect on the permanent collection.

Throughout its history, the Gallery has benefited from the generosity of alumni and friends. By far, the largest parts of our American collections are the result of gift or bequest. As such, they reflect the interests

and backgrounds of their donors. While these magnificent collections have made the Yale University Art Gallery the important museum it is today, they have also been circumscribed by the particularities of their donors' enthusiasms. We are not as fully representative as we all might wish; for example, our holdings in African American art are thin. Like the history of the American collections in many of our greatest museums, the Yale collections were largely formed through the prism of English- and European-influenced art, with artists from some regions of the country such as the Southwest, Far West, and South barely represented, and with almost no pieces by or about African Americans, Hispanics, or Native Americans working in the eighteenth and nineteenth centuries, the period covered by this exhibition. Until relatively recently, their work was not considered important enough to attract the attention of serious collectors. Happily this attitude has changed, and today their work is prized by museums and collectors. At Yale we are endeavoring to build these areas so that our American collections more accurately reflect the great diversity of our nation and the many peoples who helped create it.

This interdisciplinary exhibition, the largest traveling show ever organized by the Yale University Art Gallery, is the result of an extraordinary scholarly collaboration between the departments of American Paintings and Sculpture, American Decorative Arts, and Prints, Drawings, and Photographs. Under the inspired leadership of Helen A. Cooper, the Holcombe T. Green Curator of American Paintings and Sculpture, an outstanding team of curators, professors of American art, history, and American studies, cultural historians, and graduate students worked together to build the exhibition's intellectual framework. Professors Jules David Prown, Edward S. Cooke, Jr., Jon Butler, Joanne B. Freeman, and Howard R. Lamar were enthusiastic supporters from the beginning and helped shape the story we wanted to tell. These eminent scholars, joined by Pulitzer Prize–winning author David McCullough, have further illuminated the project with superb essays for this book. The enthusiasm and tireless efforts of Robin Jaffee Frank, the Alice and Allan Kaplan Senior Associate Curator of American Paintings and Sculpture, played a crucial role in every phase of the project. Amy Kurtz Lansing, the former Marcia Brady Tucker Graduate Curatorial Research Assistant, and Janet Miller, Museum Assistant, meticulously coordinated the complex, myriad tasks of compiling the manuscript. Critical throughout the project was the scholarship and guidance of Patricia E. Kane, Friends of American Arts

Curator of American Decorative Arts; David L. Barquist, then Associate Curator of American Decorative Arts; Elisabeth Hodermarsky, the Sutphin Family Associate Curator of Prints, Drawings, and Photographs; and Erin Eisenbarth, the former Marcia Brady Tucker Assistant Curator of American Decorative Arts. A significant number of established scholars as well as graduate students and interns wrote entries for the catalogue, and their names appear in Helen Cooper's acknowledgments. I join her in thanking them for their contributions.

This exhibition and publication received crucial and generous funding from Happy and Bob Doran, B.A. 1955, Carolyn and Gerald Grinstein, B.A. 1954, Mrs. William S. Kilroy, Sr., Mrs. Frederick R. Mayer, Nancy and Clive Runnells, B.A. 1948, Ellen and Stephen D. Susman, B.A. 1962, for their special support of the audio tour, the Eugénie Prendergast Fund for American Art, given by Jan and Warren Adelson, and the Friends of American Arts at Yale. We are honored that the Yale collections will be shown in three distinguished museums — the Speed Art Museum, Louisville, Kentucky; the Seattle Art Museum; and the Birmingham Museum of Art, Alabama—and I warmly thank their respective directors, Charles L. Venable, Mimi Gardner Gates, and Gail Andrews. We are indebted to them and their staffs for their generous and enthusiastic support.

As America enters the twenty-first century, its rich artistic past has much to teach us about the many roads that creative expression may take. It is our hope that the people who visit this exhibition—whether the descendants of our early colonists or those more recently arrived—will share with us the pride of these earlier American accomplishments and be inspired by them.

Jock Reynolds
The Henry J. Heinz II Director
Yale University Art Gallery

Acknowledgments

If ever an exhibition can be said to be the work of many hands, it is *Life, Liberty, and the Pursuit of Happiness: American Art from the Yale University Art Gallery*, the largest and most complicated show ever mounted by the Yale University Art Gallery. When the idea of organizing a traveling exhibition of the Gallery's greatest treasures of American art was still only a casual thought, Jock Reynolds, the Henry J. Heinz II Director, immediately encouraged us to think ambitiously, then offered generous support and encouragement throughout the process to help us realize our goal. This exhibition and catalogue are the outcome of an extraordinary collaboration between three departments—American Paintings and Sculpture, American Decorative Arts, and Prints, Drawings, and Photographs. Although I nominally headed the project, every aspect of its execution was collegial, with the complete involvement of the curators, interns, and graduate students in the three departments. Together we were creating a special exhibition, but we were also learning a great deal from one another as we traveled along curatorial paths that took us into unfamiliar territory. It was an immensely rewarding experience for all. I take this opportunity to express my profound gratitude to the many people who have helped in the research and organization of this exhibition and catalogue.

At the Gallery, I would like to thank Robin Jaffee Frank, the Alice and Allan Kaplan Senior Associate Curator of American Paintings and Sculpture, who was critical to the success of the project, bringing outstanding scholarship, enthusiasm, and energy to every task. Patricia E. Kane, Friends of American Arts Curator of American Decorative Arts, opened our eyes to the expressive power and cultural resonance of the decorative arts and made us more aware than ever of exactness in language. Elisabeth Hodermarsky, the Sutphin Family Associate Curator of Prints, Drawings, and Photographs, brought a breadth of knowledge that illuminated the important role of American prints in our culture. David L. Barquist, then Associate Curator of American Decorative Arts, played a seminal role in formulating the overall concept of the exhibition. Caroline Hannah, former Acting Assistant Curator of American Decorative Arts, supported the project at an important early stage. Erin Eisenbarth, then the Marcia Brady Tucker Assistant Curator of American Decorative Arts, was a most generous and knowledgeable colleague of the team, always willing to go the extra step to ensure that the information was correct. Amy Kurtz Lansing, then the Marcia Brady Tucker Graduate Curatorial Research Assistant in the Department of Paintings and Sculpture, was the kind of young scholar a curator dreams of finding; she oversaw myriad tasks, among them the gathering and organization of the photographs, the object entries, and the various manuscript edits. Our department has a magician in its midst, Janet Miller, Museum Assistant: no matter how frazzled the rest of us were, she was unfailingly helpful and good humored, knew exactly where everything was and at what stage, and somehow managed to keep all other office

tasks on target. Amy Torbert and Mary Dailey Pattee, the Marcia Brady Tucker Curatorial Intern and the Rose Herrick Jackson Graduate Curatorial Intern, respectively, joined us late in the project, and both young scholars immediately became critical members of the team. Special thanks are also due to Nancy Yates, Museum Assistant for American Decorative Arts, who was a tremendous help on all aspects of the project, particularly those dealing with the decorative arts. Of particular assistance was Graham C. Boettcher, former Marcia Brady Tucker Curatorial Intern, who spent time in all three departments, and whose breadth of knowledge continually amazed us. In the project's final phase, John Stuart Gordon, the Benjamin Attmore Hewitt Assistant Curator of American Decorative Arts, offered his insights and fresh perspective. We are also grateful to Elise K. Kenney, Gallery Archivist, for her painstaking research on the endnotes.

It is impossible to overstate the generous support we received from other colleagues at the Yale University Art Gallery. We are especially indebted to our Paintings Conservation Department: Mark Aronson and Patricia Garland, and to paper conservator Theresa Fairbanks-Harris, whose talents have made the paintings and works on paper look their best. The beautiful photographs that illuminate the book are the work of the Gallery's Digital Media Department: Susan Cole, Alex Contreras, Anthony De Camillo, John ffrench, Chris Mir, and Janet Sullivan. Thanks are also due to Louisa Cunningham and her Business Office staff, including Kevin Johnson and Charlene Senical, and in Development, Jill Westgard and Carol Clay Wiske. Director of Collections and Technology Carol DeNatale and Registrar L. Lynne Addison made all the difficulties of shipping such a complicated exhibition seem effortless. Burrus Harlow and his installation team prepared the works for shipment and display. In the Departments of Programs and Public Affairs and Education, Anna Hammond, Pamela Franks, Amy Jean Porter, and Jessica Sack provided important advice and guidance. Chief Curator Susan B. Matheson was a wise and supportive colleague. We also thank Suzanne Boorsch, the Robert L. Solley Curator of Prints, Drawings, and Photographs; Diana Brownell, Museum Technician; Katherine Chabla, Museum Assistant; Elizabeth DeRose, then the Florence B. Selden Assistant Curator; Amy Freedberg, Yale undergraduate; Suzanne Greenawalt, Museum Assistant; Frederick Lamp, the Frances and Benjamin Benenson Foundation Curator of African Art; Russell Lord, former Museum Assistant; and William E. Metcalf, the Ben Lee Damsky Curator of Coins and Medals.

At Yale University, we wish to thank the faculty for their special assistance and advice, in particular Tim Barringer, the Paul Mellon Professor, History of Art; Jon Butler, Dean of the Graduate School and the Howard R. Lamar Professor of American Studies and Religious Studies; Edward S. Cooke, Jr., the Charles F. Montgomery Professor, History of Art; John Mack Faragher, the Arthur Unobskey Professor of American History; Joanne B. Freeman, Professor of History; Jay L. Gitlin, Lecturer in History and Associate Director, Howard R. Lamar Center for the Study of Frontiers and Borders; Howard R. Lamar, Sterling Professor of History Emeritus; Alyssa Mt. Pleasant, Assistant Professor of American Studies and History; Alexander Nemerov, Professor, History of Art; Jules David Prown, the Paul Mellon Professor Emeritus of the History of Art; and Kariann Yokota, Assistant Professor of American Studies and History. We also express our gratitude to our colleagues in the Yale University Libraries: Susan E. Burdick, Stephen C. Jones, Laurie Klein, Becca Findley Lloyd, Anne Marie Menta, George A. Miles, Reverend Paul F. Stuehrenberg, Frank Turner, and Timothy G. Young. We owe special thanks to David McCullough, a devoted Yale alumnus, whose enthusiasm for this project was an inspiration to all of us.

We extend special appreciation to content editor Diana Murphy and her assistant Claudia De Palma, and to the Gallery's associate director of publications and editorial services, Tiffany Sprague, who transformed innumerable pages of manuscript into a coherent text, and to designer Jenny Chan, who turned it into this beautiful book. At Yale University Press, publisher Patricia Fidler and editor Michelle Komie encouraged the book from the first, and Kate Zanzucchi, Senior Production Editor; Mary Mayer, Art Book Production Manager; and John Long, Photo Editor and Assistant Production Coordinator, oversaw its production. We also thank freelance copyeditor Janet Wilson, proofreader June Cuffner, and indexer Cathy Dorsey.

Life, Liberty, and the Pursuit of Happiness relied upon the research and expertise of a wide community of scholars, collectors, dealers, and other individuals scattered across the country. More than thirty individuals, whose names are listed elsewhere in this volume, contributed to the catalogue, and on behalf of these authors I would like to thank: Francis D. Campbell, American Numismatic Society, New York; Martha A. Sandweiss, Amherst College, Massachusetts;

Peter McGivney, Beacon Library, New York; Emily G. Hanna, Birmingham Museum of Art, Alabama; David R. Moore, Bridgewater Historical Commission, Massachusetts; Barry Harwood, Brooklyn Museum, New York; Brenda Baldwin, California Historical Society, North Baker Research Library, San Francisco; Anita J. Ellis, Cincinnati Art Museum; Sarah Tapper, Stephen Decatur House Museum, Washington, D.C.; William C. Gates, Jr., East Liverpool Historical Society, Ohio; German Historical Society, Philadelphia; Ramona M. Austin, Hampton University Museum, Virginia; Edith Rotkopf, Howard R. Lamar Center for the Study of Frontiers and Borders, Yale University, New Haven; Shirley Lamar; Allen Weathers, Meriden Historical Society, Connecticut; Barbara Veith, Metropolitan Museum of Art, New York; Barbara McLean Ward, Moffatt-Ladd House, Portsmouth, New Hampshire; Ulysses G. Dietz, Newark Museum, New Jersey; Margaret K. Hofer, New-York Historical Society; Susan K. Anderson, Kathleen A. Foster, Beatrice Garvan, Alexandra Alevizatos Kirtley, and Audrey Lewis, Philadelphia Museum of Art; Frank Futral, Roosevelt-Vanderbilt National Historic Sites, Hyde Park, New York; Bonnie Lilienfeld, Smithsonian Institution, National Museum of American History, Washington, D.C.; and Wendy Cooper, Linda Eaton, and Jeanne Solensky, Winterthur Museum, Garden, and Library, Delaware.

For their research assistance we also acknowledge James R. Beachley; John Bieber; Robin Cowie; Ellen Paul Denker; Nancy Goyne Evans; the late William H. Guthman, Guthman Americana; Susan Hobbs; Hugh Howard; Sean Keith; Ralph and Terry Kovel, Antiques, Inc.; Catherine Lanford; Jay and Emma Lewis; Crawford Alexander Mann III; Diana and J. Garrison Stradling; Peter Tuite; and Philip D. Zimmerman.

For providing images from their collections we are grateful to Elena Stolyarik, American Numismatic Society, New York; Barbara Wolanin, Curator, Architect of the Capitol, Washington, D.C.; Jennifer Belt, Art Resource, New York; Nadège Danet, Bibliothèque Nationale de France, Paris; Graham C. Boettcher; Jenni Lankford, City of Charleston, South Carolina; Aimee Marshall, Chicago History Museum; Nancy Sazama, Chipstone Foundation, Milwaukee; Kathleen Cornell and Mary Suzor, Cleveland Museum of Art; Charlene Peacock, Library Company of Philadelphia; Library of Congress, Washington, D.C.; Christopher Huntoon, Secretary, Lodge of St. Andrew, A.F. & A.M., Boston; Christa Zaros, Long Island Museum of American Art, History & Carriages, Stony Brook, New York; Cheryle T. Robertson, Los Angeles County Museum of Art; Eileen Sullivan, Metropolitan Museum of Art, New York; Jennifer Riley, Museum of Fine Arts, Boston; Marguerite Lavin, Museum of the City of New York; Maureen K. Harper, National Heritage Museum, Lexington, Massachusetts; Amy Trout, New Haven Museum and Historical Society; Nicole Wells, New-York Historical Society; Bill McMorris, Oakland Museum of California; Barbara Katus and Kevin Martin, Pennsylvania Academy of the Fine Arts, Philadelphia; Holly Frisbee, Philadelphia Museum of Art; David Oakey, Royal Collection, London; Martha Knapp, Saint-Gaudens National Historic Site, Cornish, New Hampshire; David Conradsen and Patricia Woods, Saint Louis Art Museum; Katherine Martin, Scholten Japanese Art, New York; Maria Mahon, Sotheby's American Art, New York; Louise Bann and Annamarie Sandecki, Tiffany Archives, Parsippany, New Jersey; Laura Pedrick, Touro Synagogue, Congregation Jeshuat Israel, Newport, Rhode Island; Kim Robinson, U.S. Department of the Interior Museum, Washington, D.C.; Jeff Trandahl, Clerk of the House, U.S. House of Representatives, Washington, D.C.; Andrew Fotta, Wadsworth Atheneum Museum of Art, Hartford, Connecticut; Ann Verplanck and Susan Newton, Winterthur Museum, Library, and Garden, Delaware; and Melissa Gold Fournier, Yale Center for British Art, New Haven.

Helen A. Cooper
The Holcombe T. Green Curator of
American Paintings and Sculpture

CONTRIBUTORS

D.L.B. David L. Barquist
T.B. Tim Barringer
G.C.B. Graham C. Boettcher
TH.B. Thomas Bruhn
D.A.C. Dennis A. Carr
S.L.C. Sally Lorensen Conant
E.S.C. Edward S. Cooke, Jr.
H.A.C. Helen A. Cooper
E.E. Erin Eisenbarth
R.S.F. Richard S. Field
R.J.F. Robin Jaffee Frank
G.G. Gabrielle Gopinath
J.A.G. Jennifer A. Greenhill
C.M.H. Caroline M. Hannah
E.H. Elisabeth Hodermarsky
P.E.K. Patricia E. Kane
E.K.K. Elise K. Kenney
A.K.L. Amy Kurtz Lansing
E.L. Ethan Lasser
A.M. Alyssa Mt. Pleasant
A.N. Alexander Nemerov
J.D.P. Jules David Prown
J.C.R. Jennifer C. Raab
R.S. Robert Slifkin
K.W. Katherine Wahlberg
K.Y. Kariann Yokota

NOTE TO THE READER

For all objects, the principal medium is given first, followed by other media in order of importance.

Dimensions are given in both inches and centimeters. For paintings and prints, height precedes width; sheet dimensions are given for prints. For most three-dimensional decorative objects such as furniture, height precedes width precedes depth. For decorative objects such as cups and bowls, height precedes diameter precedes weight. For medals, weight is given in grams, axis in clock hours, and diameter in millimeters. If an object is shaped irregularly, maximum measurements are given.

The abbreviation "YUAG Object Files" indicates the collection research files at the Yale University Art Gallery.

An Introduction

On a day in early March 1786, during a visit with her husband to the London studio of the American artist Benjamin West, Abigail Adams stood before a painting of the Battle of Bunker Hill by a young American then studying with West, John Trumbull. The painting, later to be titled *The Battle of Bunker's Hill, June 17, 1775* (cat. no. 31), had only just been completed.

For both John and Abigail Adams—as for virtually every American of the time—the first encounter with the culture of Europe and Britain was overwhelming. Until crossing the Atlantic to join her husband after the end of the Revolutionary War, Abigail Adams had never been more than a hundred miles from her home in Massachusetts. She had never seen a play performed on stage. She had never attended an opera, never beheld such art and architecture as she had seen in Paris and London, and she was transported by much of it. But now, viewing this comparatively small (25-by-37-inch) canvas by one of her own countrymen was an experience such as she had never known, as she duly recorded. "To speak of its merit," she wrote to her sister, "I can only say that in looking at it, my whole frame contracted, my blood shivered, and I felt a faintness at my heart."[1]

General Warren—Dr. Joseph Warren, the fallen hero of Bunker Hill—had been the Adams family physician and a close friend. Abigail on the day of the battle had seen with her own eyes the smoke rising over Bunker Hill, miles distant from her vantage point on a rock outcropping at Braintree. She had since read and heard many firsthand accounts. But never had she seen or imagined anything so arresting as this "history painting" by young Trumbull. "He is the first painter who has undertaken to immortalize by his pencil [brush] those great actions that gave birth to our nation," she continued in her letter. "By this means he will not only secure his own fame, but transmit to posterity characters and actions which will command the admiration of future ages, and prevent the period which gave birth to them from ever passing away into the dark abyss of time."[2]

Trumbull was not quite thirty years old, yet he knew nearly all the leading figures of the American cause, those we call the Founders. In the first year of the Revolutionary War, he had served briefly on George Washington's staff. (Once during the Siege of Boston, when the general had asked for maps and drawings of the British defenses, Trumbull had crawled through high grass almost to the enemy lines.) Benjamin Franklin had written his letter of introduction to West. John Adams, the new American minister to the Court of St. James, had gone out of his way to befriend him. And it was soon after that March of 1786, when Thomas Jefferson came over to London from Paris to work with Adams, that Jefferson, too, saw Trumbull's work for the first time and heard of his great ambitions. As Trumbull later wrote: "He [Jefferson] had a taste for the fine arts, and highly approved my intention of preparing myself for the accomplishment of a national work. He encouraged me to persevere in this pursuit, and kindly invited me to come to Paris, to see and study the fine works there, and to make his house my home . . . and during my stay I began the composition of the *Declaration of Independence*, with the assistance of his information and advice."[3]

The human drama of the nation's birth must be made immortal through art. This was Trumbull's grand plan: to record, to teach, to inspire, to make the noble deeds of his time everlasting, perhaps even move future generations, as Abigail Adams had been moved. Facts alone could never suffice. Mighty events must be felt to be understood and remembered. Further, it was the character of those at the center of the drama that had to be delineated. As Abigail wrote of Trumbull, in explanation of his mission, "At the same time, he teaches mankind that it is not rank, not titles, but character alone, which interests posterity."[4]

Following *Bunker's Hill*, Trumbull was to do seven more scenes commemorating historic events of the American Revolution, all of which are included in *Life, Liberty, and the Pursuit of Happiness*, and of these, *The Declaration of Independence, July 4, 1776* (cat. no. 33) is by far the best known and most important. It is as familiar as any rendering we have from the American past, though chiefly because of the larger, later—and considerably less successful—version by Trumbull that hangs in the Rotunda of the Capitol in Washington. The scene is commonly understood to portray the signing of the Declaration on 4 July. In fact, no such formal ceremony ever took place on that or any other day. The signing began at the Continental Congress on 2 August, in secrecy and with only part of the Congress present, and it continued for months afterward as absent delegates returned from their distant states.

Jefferson did indeed offer advice to Trumbull on the setting, even sketching a rough floor plan of the Pennsylvania Assembly Room in what is now Independence Hall, Philadelphia (cat. no. 33 fig. a). But almost nothing about the room or its furnishings is accurate. The chairs are the wrong style, doors are in the wrong place. No heavy draperies hung at the windows. The military banners and trophies decorating the back wall are strictly a product of Trumbull's imagination, a reminder that while the politicians deliberated, a war was being fought.

The accuracy of the painting—the phenomenal, all-important accuracy—is in the faces. Each and every one of the forty-eight men in the room is presented as an identifiable and thus accountable individual. Trumbull was adamant about this. By the time he finished, he had painted or sketched thirty-six of the faces from life. The task took years, during which he traveled much of the country at considerable expense and inconvenience.

He wanted to get it right. He wanted us to know who they were, these valorous patriots who by the very act of declaring American independence were declaring themselves traitors to the Crown and thus could expect to be hanged if captured by the British. Nor should it be forgotten that by the time the signing began that August, the British had arrived in New York with 32,000 troops, an army greater than the entire population of Philadelphia, then the largest city in America.

Trumbull leaves no doubt about who counted most at Philadelphia. Adams, Jefferson, and Franklin stand front and center, and theirs are three magnificent portraits, each a perfect likeness but also deftly delineating character.

But then the faces of nearly all the protagonists in his historic tableaux are "very like" their subjects and done with exceptional clarity, and the fifty Trumbull miniatures included in the exhibition are nearly all perfect gems. (Trumbull, who had vision in only one eye as the result of a childhood accident, worked on his miniatures almost as a jeweler with his glass.) Small as they are, they have remarkable scale and vitality. Those of Revolutionary War officers—General Nathanael Greene and Colonel Ebenezer Stevens (cat. no. 40), for example—are as fine as any we have.

By including the hilt of his sword with his brushes and palette in his own stunning self-portrait, the artist made it clear that he, too, wished to be remembered as a soldier as well as an artist (cat. no. 119).

Trumbull, to be sure, was not the first master of American portraiture, or the only artist of his generation to embrace the history of that founding time. Ralph Earl's circa 1775 painting of stalwart Roger Sherman of Connecticut, a genuine, unadorned man of the people and signer of the Declaration of Independence, speaks volumes (cat. no. 49). John Singleton Copley's 1769 portrait of Isaac Smith (cat. no. 105) is outstanding. (Smith had the distinction of being both a leading Boston merchant and the brother of Abigail Adams.) The deceptively plain rendering of the Reverend Ezra Stiles by Samuel King, done in 1771 (cat. no. 114), is one of the strongest works in the exhibition, not to say one of the emblematic portraits of the era.

The irrepressible Charles Willson Peale of Philadelphia, as American in spirit as any artist who ever lived, served in the war as Trumbull had, and like Trumbull he knew and painted nearly every principal public figure. Peale, handsomely represented in the exhibition by his portrait of the celebrated architect William Buckland (cat. no. 107), was the ultimate eighteenth-century polymath and, over a long life, was as productive as few men in history have been. He lived eighty-six years and painted more than a thousand portraits, including seventy of Washington, a record. Self-educated, he was an artist, soldier, politician,

inventor, naturalist, museum proprietor, essayist, farmer, gardener, and tireless correspondent. Moreover, he had three wives and fathered seventeen children, several of whom (Raphaelle, Rembrandt, Rubens, and Angelica Kauffman) became artists.

Others who followed in the nineteenth century turned their attention to the unfolding history of their time, and it is such works as George Caleb Bingham's *The County Election* (cat. no. 78), Winslow Homer's Civil War painting *In Front of Yorktown* (cat. no. 94), and Thomas Eakins's haunting portrait *The Veteran* (cat. no. 95), together with the Trumbull ensemble, that give the Yale collection its exceptional strength—not as an illustration of history only, but integral to what happened.

Writing in 1871, Bingham called art "the most efficient hand-maid of history . . . its power to perpetuate a record of events with a clearness second only to that which springs from actual observation."[5] Like Trumbull and Peale, Bingham played a part in the history he portrayed. This robust genre painter of American grassroots politics ran for office and served as state treasurer and later adjutant-general of Missouri.

Some of the works portraying historic events also demonstrably affected the course of the events they portray. Public outrage over the Boston Massacre was compounded many times over when Paul Revere's incendiary illustration (cat. no. 27) appeared in print, which was exactly as Revere intended. Thomas Nast's cartoons (cat. nos. 221–24) had much to do with bringing down the corrupt politicians of the Gilded Age. ("I don't care a straw for your newspaper articles," Boss Tweed exclaimed when under attack from the press. "My constituents don't know how to read, but they can't help seeing them damned pictures.")[6]

The historic value of the pencil sketches of the individual *Amistad* captives—the African slaves taken prisoner after their mutiny on that ship in 1839—is beyond measure (cat. no. 82). These portraits are the only record of what the men and children looked like. Nor is anything known of the artist, William Townsend, except that the New Haven native was seventeen when he made the drawings.

For all that has been written about the Civil War, it is in the paintings and drawings of Homer, who covered the conflict as an artist-correspondent, and in the eerily sharp, black-and-white photographs by Mathew Brady, Timothy O'Sullivan (cat. no. 92), Alexander Gardner (cat. no. 90), and George Barnard (cat. nos. 91, 93) that we sense and feel, as in no other way, the magnitude and human reality of what transpired then. Asked by his wife and friends why he would abandon

his commercial work and the comforts of home to go off and photograph the war, Brady replied, "I can only describe the destiny that overruled me . . . I felt I had to go. A spirit in me said 'go' and I went."[7]

And so it must have been, one senses, with John Mix Stanley, who, as a documentary artist and photographer, accompanied numerous exploring and surveying expeditions to the far reaches of the Dakota Territory, Texas, New Mexico, Oregon, and California. Stanley's watercolors and lithographs, eight of which are on display (cat. nos. 183–90), have great charm, as well as historic value, and are too little known to most Americans.

Near the close of his life, when Eakins was all but blind and could no longer paint, he urged young artists "to peer into the heart of American life."[8] It is something I have thought of often while looking at the American panorama of this exhibition. The title of the show, *Life, Liberty, and the Pursuit of Happiness*, borrows the indelible words from the Declaration of Independence. The definitions of life and liberty are largely self-evident. But what of that third inalienable right? What did the Founders mean by "the pursuit of happiness"? This, I believe, is a matter of considerable concern to our own time, and to our appreciation of the exhibition.

To Jefferson, who wrote the Declaration of Independence, to Adams, who fought for its approval by the Continental Congress, to Franklin, who, with Adams, helped with the editing of Jefferson's initial draft, and to Washington, who led the Continental army to ultimate victory— and thus saved Jefferson's noble expressions from being no more than words on paper—personal and public happiness, assuredly, was not taken to mean long vacations or an overabundance of marble kitchen countertops and garage space. Or ease. Or idleness. As much as anything, it meant the enlargement of individual human experience through the life of the mind and the spirit. It meant, above all, education and the love and spread of learning, as they all said again and again in a variety of different ways over many years.

Jefferson defined happiness as "tranquility and occupation,"[9] and for Jefferson, as we know, "occupation" mainly meant his intellectual pursuits—his books, his scientific experiments, his passion for architecture and gardening. ("But though an old man, I am but a young gardener,"[10] he once wrote to Charles Willson Peale.) Jefferson devoted most of his last years to the creation of the University of Virginia. But then, like Goethe, Jefferson could be fairly described as a university unto himself.

Franklin affirmed as early as 1749, a generation before the Declaration of Independence, that education was "the surest foundation of the happiness both of private families and of commonwealths."[11]

Washington, who, like Franklin, had little formal schooling, contributed some $25,000—a fortune at the time—to help establish what became Washington and Lee University. When a friend asked for financial help to send his son to Princeton, Washington readily consented, saying the boy's education would "not only promote his happiness, but the future welfare of others."[12] "Knowledge," Washington said on another occasion, "is in every country the surest basis of public happiness."[13]

John Adams was still more emphatic and in private correspondence especially expressed themes to be found throughout this exhibition. His great, enduring statement on education is contained in the Constitution of the Commonwealth of Massachusetts, which he drafted in 1779, a full decade before our national Constitution. It was the "duty" of the government to educate everyone,[14] Adams stated. To achieve the good society, the people and their representatives in the government must "cherish" learning across the broad range of science, literature, and the arts. One must learn to think for oneself, Adams had confided to his diary as a young man, "but how can I judge, how can any man judge, unless his mind has been opened and enlarged by reading."[15]

In a wonderful letter to his oldest son, John Quincy, written in May 1781, when Adams was in the Netherlands laboring to raise desperately needed funds for the American cause and had enrolled the boy at the University of Leiden, Adams went out of his way to stress the connection between poetry and happiness. He must read poetry, he must carry a book with him always, for his happiness, he told the boy. "In all the disquisitions you have heard [at the university] concerning the happiness of life, has it ever been recommended to you to read poetry?" Then in a memorable line, he added affectionately, "You will never be alone with a poet in your pocket."[16]

Adams knew from experience the transporting miracle of education. His father was a farmer with little or no education, his mother almost certainly illiterate. But with a scholarship to Harvard, Adams discovered books and "read forever,"[17] as he said.

It was Franklin who founded the first public library in the country. Adams, as president, signed into law the creation of the Library of Congress. Jefferson brought home from Paris crateloads of volumes, personally selected from the bookstalls by the Seine, and later told Adams, "I cannot live without books."[18]

People who sit for their portraits usually want some representation included—a prop or two, some bit of staging—to show what they most value in life and wish to be remembered for. So it is particularly interesting to note how often books figure in the portraits in the exhibition, such as Reuben Moulthrop's forceful portrait of the Reverend Ammi Ruhamah Robbins (cat. no. 4). Look also at the Beardsley Limner's rendering of Dr. and Mrs. Hezekiah Beardsley (cat. no. 8) and the John Greenwood portrait of Elizabeth Moffatt Sherburne (cat. no. 103).

In Jonathan Budington's 1798 painting of George Eliot and his family (cat. no. 124), all three—father, mother, and son—are either holding or touching books. A generous supply of heavy tomes lines the shelves directly behind them, including a three-volume set of Adam Smith's *Wealth of Nations*, another landmark of the year 1776. (Eliot, a gentleman farmer, was a descendant of Jared Eliot, clergyman and physician, who in 1763 made the earliest bequest to the Yale Library.)

Nor is there the least ambiguity about Samuel King's portrayal of Ezra Stiles. The message is plain: the man and his books (his intellectual pursuits) are one and the same. Stiles was born in New Haven in 1727, which made him five years senior to Washington. As an undergraduate at Yale, he excelled in all branches of learning, and as an ordained clergyman, he never ceased his broad-ranging studies in astronomy and electricity, in addition to ecclesiastical history. Stiles studied law, learned Hebrew, and ardently supported American independence and all that was promised by the Declaration of Independence. In 1778, he was elected president of Yale.

Time with this portrait is well spent. High intelligence and ambition are unmistakable in the clear-eyed face that looks out at us. His right hand on his heart, his left hand holding a preaching Bible, a starched, old-style clerical collar at his throat, he sits in what he called a "Teaching Attitude" among his books and astronomical diagrams. How much, we wonder, had he come to know and understand that we don't? What would we give to spend an hour with such a man?

Lest future generations have any doubt or resort to false conjecture about the meaning of the items that he had the artist include in the picture, Stiles provided an extended explanation in his diary entry for 1 August 1771. "This day Mr. King finished my picture," he began, then procceded for pages, naming every book on the shelves.[19] There

David McCullough

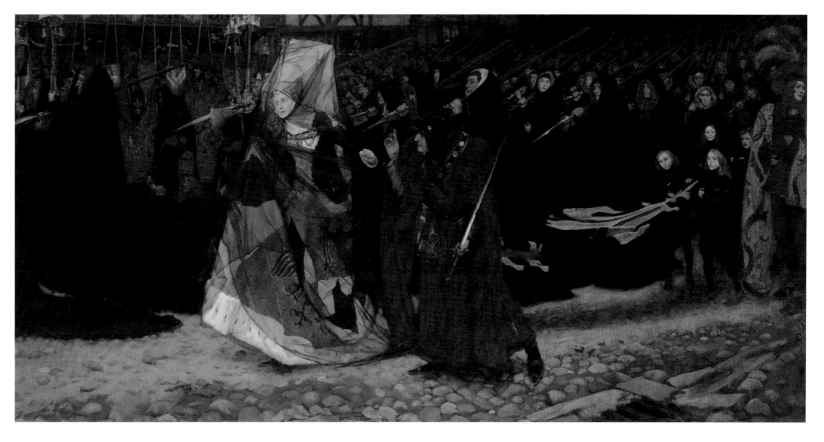

fig. 1 Edwin Austin Abbey, *Richard, Duke of Gloucester, and the Lady Anne*, 1896. Oil on canvas, 52 ⅝ in. x 8 ft. 8 ¾ in. (133.7 cm x 2.7 m). Yale University Art Gallery, Edwin Austin Abbey Memorial Collection, 1937.2224

are folio editions of Roman and Chinese history and the Talmud ("By these I denote my taste in history"), as well as "Newton's *Principia*, Plato, Watts, Dodridge, Cudworth's Intellectual System, and also the New England divines, Hooker, Chauncey, Mather, Cotton."[20] In still greater detail, he explained, "the Newtonian and Pythagorean system of the sun and planet and comets," as diagrammed just to the left of his shoulder, are "Emblems . . . more descriptive of my Mind than the Effigies of my Face." His books and studies, he wrote in conclusion, were an everlasting source of enjoyment. "I possess and read all Newton's works and his *Principia* often, and am highly delighted with his optics and astronomy. Plato I have read with pleasure."[21]

The portrait of Stiles is truly a portrait of the pursuit of happiness, as is, in a very different way, a much later work, *The Microscope* by Robert Walter Weir, painted in 1849 (cat. no. 130). Here warm light seems to glow from within the scene itself, like the light in a Caravaggio painting, except that here it is the light of nineteenth-century science. The look of pleasure in the faces of the family gathered about an experiment is as warm as the light.

In a letter to his daughter Abigail about the importance of attending to the education of her children, John Adams wrote, "You will find it more for your happiness, to spend your time with them in this manner than to be engaged in fashionable amusements and social entertainments, even in the best company."[22]

I try to imagine how those who set the course with the Declaration of Independence would feel if they could see works such as *The Microscope*, the amazing photograph of the surface of the moon, dating from 1864 (cat. no. 131), or Edwin Austin Abbey's extraordinary scene from Shakespeare's *Richard III* (fig. 1). Taken together, they go far to exemplify the old Enlightenment tenet that with a close study of man and nature there is virtually no limit to what can be known and understood.

In their quest to fathom humankind, it was to Shakespeare that the likes of Adams and Jefferson turned especially, repeatedly. "Let me search for the clue which led great Shakespeare into the labyrinth of human nature,"[23] Adams wrote, while for Abigail one of the high points of her life was seeing the celebrated English tragedian Sarah Siddons in *Othello* and *Macbeth*.

John Adams and Jefferson were inordinately fond of *King Lear*. Jefferson insisted that Shakespeare must be part of a full education, and Adams called him "the great master of every affection of the heart and every sentiment of the mind as well as all the powers of expression."[24] How much Adams or Jefferson might read into the expression and body language of King Richard III, as rendered by Edwin Austin Abbey, we will, alas, never know.

If the reaches of the mind were to the Founders limitless, so, too, was the nation they envisioned. In one of the many remarkable letters to his wife, this one written from Philadelphia in the fateful summer of 1776 and dated 2 July, the day the Continental Congress voted for the Declaration of Independence, John Adams pictured that "Day of Deliverance" being commemorated in times to come with prayers, parades, and fireworks "from one end of the continent to the other."[25] This continental vision was an astonishing leap of faith and foresight, given the reality of the United States of America then aborning. Two-thirds of Massachusetts and Pennsylvania were still forest. The westernmost settlement of any consequence was Pittsburgh, still a rough little river town of only a few thousand people. The entire population of the thirteen states was all of 2.5 million.

Imagine Adams or Jefferson—Jefferson of the Louisiana Purchase and the Lewis and Clark Expedition—or Franklin or Washington, with their interest in the West, pondering the long horizons as recorded by John Mix Stanley, or the Yosemite views by photographer Carleton Watkins (cat. nos. 195–97)! Or, for that matter, the 1892 Currier & Ives bird's-eye panorama of Chicago (cat. no. 227)! The railroad in Frances Palmer's *Across the Continent* (cat. no. 191) would require some explaining, of course, but the public school featured large in the foreground of the scene would assuredly evoke full approval.

There is no filth or struggle or inequity or tragedy portrayed in these western images. Except for the column of black smoke from the locomotive about to envelop and choke the two Indians on horseback who watch from the side in Frances Palmer's print, one might think the

settlement of the West was entirely effortless and benign, just as one might conclude from John Trumbull's history paintings that the Revolution was largely fought by stagy patriots in beautiful, spotless uniforms. But the dreams, the noble ideas, the reverence for heroic sacrifice, the glorification of great men and deeds were all part of what stirred the heart and moved the nation and were often as important as gritty truth, or more so.

Perhaps, making their way toward the end of the exhibition, those who were present at the creation in 1776, at Philadelphia or on the battlefield, might stop to consider the Thomas Eakins painting *Rail Shooting*, done exactly a century later, in 1876 (cat. no. 208). And perhaps they would see in it a statement of the equality they promised in their Declaration, but never saw fulfilled in their time. Two hunters, one white, one black, equal in their respective skills and in their focus on a shared objective, are seen in the same boat. Neither man is idealized nor belittled by the artist. They are given equal weight in the composition. Upon their balance in the boat, their understanding of what each of them expects of the other, the importance of their ability to work in harmony, depends their success.

And then comes the final picture, *At the Sculpture Exhibition* by Charles Courtney Curran (cat. no. 229), a curious choice to end on, one might think. Painted at the close of the nineteenth century, it is, to say the least, worlds apart from *The Battle of Bunker's Hill*. Yet it represents perfectly so much that those of Trumbull's time dreamed of for their posterity. Few ever expressed the dream so succinctly as did John Adams in a letter to Abigail from France in 1780, as war raged at home. In an effort to explain to her and the family why he would give so much of his life to serving his country so far from home, why he felt the struggle to bring France into the war on the American side was of such importance, and why he could not take time away from his efforts to study and enjoy the "enticing" manifestations of science and the arts all around him in Paris, he wrote this memorable, prophetic passage:

I must study politics and war that my sons may have the liberty to study mathematics and philosophy. My sons ought to study mathematics and philosophy, geography, natural history, naval architecture, navigation, commerce and agriculture, in order to give their children a right to study painting, poetry, music, architecture, statuary, tapestry and porcelaine.[26]

By use of the word children, instead of sons, in referring to the generation of his grandchildren, Adams appears to include women in his dream of the good society of the future. This is quite in keeping, as he thought women not only equal to men but in many ways superior.

The setting of *At the Sculpture Exhibition* was the first-floor gallery of the American Fine Arts Society in New York in 1895, and it would seem to exemplify almost perfectly progress of the kind Adams envisioned. The men and women seen enjoying the display could very well be the descendants of Adams—or of the other Founders—but then, in so many ways, we are all their descendants.

Notes

1. Charles Francis Adams, ed., *The Letters of Mrs. Adams, the Wife of John Adams* (Boston: Wilkins, Carter, and Co., 1848), 277.

2. Ibid.

3. Theodore Sizer, ed., *The Autobiography of John Trumbull* (New Haven: Yale University Press, 1943), 92–93.

4. Adams, 1848, 277.

5. E. Maurice Bloch, *George Caleb Bingham: The Evolution of an Artist* (Berkeley: University of California-Berkeley Press, 1967), 222.

6. David McCullough, *The Great Bridge* (New York: Simon & Schuster, 1972), 126.

7. Mathew Brady, interview with George Alfred Townsend, *New York World*, 12 Aug. 1891.

8. Quoted in *Philadelphia Press*, 22 Feb. 1914.

9. Thomas Jefferson to Anna Jefferson Marks, 12 July 1788, in Julian Boyd, ed., *Papers of Thomas Jefferson*, vol. 13 (Princeton: Princeton University Press, 1956), 350.

10. Andrew Lipscomb, ed., *Writings of Thomas Jefferson*, vol. 13 (Washington, D.C.: Thomas Jefferson Memorial Foundation, 1904), 79.

11. Benjamin Franklin, "Proposals Relating to the Education of Youth in Pennsylvania" (Philadelphia, 1749).

12. George Washington to William Ramsey, 29 Jan. 1769, in John C. Fitzpatrick, ed., *Writings of George Washington*, vol. 2 (Washington, D.C.: Government Printing Office, 1931), 499.

13. George Washington to William Ramsey, 29 Jan. 1796, in ibid., 30 (1939), 493.

14. Charles Francis Adams, ed., *The Works of John Adams*, vol. 4 (Boston: Charles C. Little and James Brown, 1851), 259.

15. Lyman Henry Butterfield, ed., *The Diary and Autobiography of John Adams*, vol. 1 (Cambridge, Mass.: Belknap Press of Harvard University Press, 1961), 220.

16. John Adams to John Quincy Adams, 14 May 1791, in Lyman Henry Butterfield, ed., *Adams Family Correspondence*, vol. 4 (Cambridge, Mass.: Belknap Press of Harvard University Press, 1963), 114.

17. Butterfield, 1961, 3:262.

18. Lester J. Cappon, ed., *Adams-Jefferson Letters*, vol. 2 (Chapel Hill: University of North Carolina Press, 1959), 443.

19. Franklin Bowditch Dexter, ed., *The Literary Diary of Ezra Stiles*, vol. 1 (New York: Charles Scribner's Sons, 1901), 131.

20. Ibid.

21. Ibid., 132.

22. John Adams to Abigail ("Nabby") Adams, 21 Feb. 1797, in *Adams Papers* (Collections of the Massachusetts Historical Society).

23. Butterfield, 1961, 2:30.

24. Ibid., 2:53.

25. Ibid., 2:30.

26. Ibid., 3:342.

American Art History:
The Development of a Discipline

If one had to choose a single word to describe the change that has taken place in the study of American art over the past half century, the word would be "contextualization." The focus has increasingly shifted from works of art and the artists who made them to the social and cultural context in which the objects were produced. The move toward context uncovered large areas for further investigation and opened up new understandings of such subjects as gender, class, and race. The artistic production of women and of African American, Hispanic, and American Indian artists has become increasingly visible. Area studies of the Far West, the Southwest, and the South have uncovered both previously overlooked artists and larger, sometimes vexing issues (as in the case of *The West as America*, a controversial exhibition held in 1991 at the National Museum of American Art, now the Smithsonian American Art Museum).[1] Approaches have been expanded to include such considerations as sexual orientation and power. Art is used more as the means rather than as the object of study. Art is examined, to borrow a metaphor from M. H. Abrams, not so much as a mirror reflecting its age as a lamp illuminating it. Although these are certainly positive developments, there has been to some extent a regrettable concomitant fragmentation of Americanists into specialists. Ideally, all scholars of American art should embrace the entire spectrum of the subject while energetically pursuing their own particular areas of interest.[2]

This book, *Life, Liberty, and the Pursuit of Happiness*, like the exhibition to which it relates, reflects the change I have described. It is about the relationship between American art and American culture. In the essays that accompany the three main sections, eminent historians discuss the ways in which objects illuminate and are illuminated by their historical context. This essay presents some informal observations about the growth of the field from the perspective of an art historian.[3]

Graduate study in the history of American art is a relatively recent development. As late as the mid-twentieth century, American art was not accepted as a serious subject of academic interest. The major scholars in the field of American painting, few in number, were connected with museums—Lloyd Goodrich at the Whitney Museum of American Art; John I. H. Baur at the Brooklyn Museum, later at the Whitney; Edgar P. Richardson at the Detroit Institute of Arts; Louisa Dresser at the Worcester Art Museum. Not a single university in the country offered a PH.D. program in or had a professor of American art history.[4] The literature on American art was largely anecdotal or taxonomic—biographies, exhibition records, and studies establishing authorship, provenance, and chronology.

American art was considered aesthetically inferior to European art; scholarship in American art, by what might be termed the aesthetic fallacy, was therefore deemed inferior to other art historical scholarship; and, by extension, Americanists were viewed as inferior art historians. This pervasive attitude discouraged young art historians from entering the American field. American decorative arts scholars were doubly suspect because not only was their subject of study *American* but it represented a lower order of artistic production— merely *decorative*. The elimination of these prejudices has been a

noteworthy accomplishment effected by academic scholars, curators, and collectors of American art over the past fifty years.

In terms of subject matter, the primary focus in the study of historic American art had long been on portraiture. During the 1960s and 1970s, it shifted to landscape (and its corollary, seascape). Subsequently, attention also embraced figure painting. As the investigation of American art moved through various genres in the past half century (these changes were, of course, general trends, not abrupt shifts), so, too, it progressed chronologically. In the 1950s, the main emphasis was on the seventeenth and eighteenth centuries. But quite rapidly, with the new interest in landscape and then figure painting, attention progressed to the nineteenth century and then, more recently, to the early decades of the twentieth and beyond. In the decorative arts, the same chronological advance occurred in both scholarship and collecting. The topics of doctoral dissertations over the years reflect an inexorable forward progression in time. Currently there is a revival of interest in the eighteenth century by some leading scholars, which may presage renewed interest in earlier art among the next generation.

The central issue in the mid-twentieth century, addressed directly and indirectly, was, What is American about American art? As a defensive reaction to general disdain, American art was celebrated not for its aesthetic quality but for its Americanness, usually defined in painting as honest realism and directness, embodied in the work of artists such as John Singleton Copley, Thomas Eakins, and Winslow Homer, not dandified or flashy expatriates like John Singer Sargent or James McNeill Whistler. In the decorative arts, simplicity, emphasis on form and structure, and restraint in the application of decorative detail were positive American virtues.

At Harvard in the early 1950s, for example, graduate students like me were trained methodologically as formalists by German expatriate scholars such as Wilhelm Koehler and Jakob Rosenberg. Few of us were aware that American art existed. I discovered it a year later when I began to work as an apprentice to an art dealer, Norman Hirschl, in New York City. In 1954, I entered the Winterthur Program in Early American Culture, which offered a master's degree through the University of Delaware. There the emphasis was on the decorative arts and architecture as well as painting, and students were introduced to the concept of objects as cultural evidence. At most universities offering doctoral degrees in art history, students who chose to write dissertations on American art worked under the supervision of faculty who specialized in other areas. At Harvard, William Gerdts, Barbara Novak,

Theodore Stebbins, John Wilmerding, and a number of other budding Americanists, including me, were advised by a specialist in Oriental art, Benjamin Rowland. At Yale, David Huntington worked on Frederic Church under the direction of a scholar of French modernism, George Heard Hamilton. Although curators John Marshall Phillips and Theodore Sizer had taught courses in American art, the History of Art Department at Yale did not include an Americanist. I was hired to teach art history and American studies in 1961. A few years later, I assumed the added responsibility of curating the American collections at the Yale University Art Gallery.

During the ensuing years, vigorous PH.D. programs in American art emerged at a number of universities, including Boston University, Columbia, Princeton, Stanford, the University of California at Berkeley, the University of Delaware, the University of Pennsylvania, and Yale, and major scholars of American art now teach at colleges and universities throughout the country. Fifty years ago, scholars of American art were virtually absent from meetings of the College Art Association of America, nor was the subject manifested in its programs. Three decades later, there was a small but vigorous presence of young scholars, exchanging ideas and beginning to present papers, not only at these gatherings but also at the annual meetings of the American Studies Association. Now there are hundreds of Americanists of all ages at CAA with their own active affiliated organization, the Association of Historians of American Art.

A half-century ago, the literature on American art was thin and quite quickly mastered. The passing years have seen an ever increasing flow of new books, many of which move away from a monographic focus to examine sweeping contextual themes. Articles on American art tended early on to be popular rather than scholarly, and they saw the light of day only in larger-circulation journals such as *The Magazine Antiques* and *Art in America*. Scholarly writing on American art was not to be found at all in the prestigious *Art Bulletin* and only on occasion in the now defunct *Art Quarterly*. This has all changed, and major articles have appeared in *Art Bulletin*; in periodicals devoted to the field such as *American Art*, *American Art Journal*, *American Furniture*, and *Winterthur Portfolio*; and in a number of American studies journals. In recent decades, a number of major books were published, both monographs and broader thematic investigations. Some of the best scholarship of the second half of the twentieth century appeared in the form of articles and museum exhibition catalogues, and in the absence of a single fully satisfactory, affordable survey text, this has been especially useful in

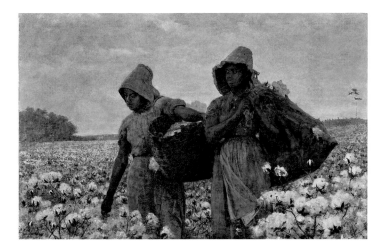

creating customized course packets for teaching. Digital technology has, in recent years, impacted teaching methods, especially in making good color images accessible online for study purposes, providing powerful new research tools and making primary source materials available.

Finally, it should be noted that whereas American art, other than that of the post–World War II era, was rarely noticed outside of the continental United States, there is now a major collection in Europe, Spain's Museo Thyssen-Bornemisza, with a significant catalogue. And an increasing number of European exhibitions of American art have been presented, including *American Sublime: Landscape Painting in the United States 1820–1880*, shown in both the United States and England in 2002, with an excellent catalogue by the English organizers; and *American Artists and the Louvre*, a 2006 collaboration between the Terra Foundation and the Louvre that produced the first exhibition at the Louvre dedicated to American artists.

What explains the explosion of scholarly as well as collecting interest in American art during the second half of the twentieth century? The subject may have had nationalistic appeal in the cold-war context. Change in taste may have been another factor, as collectors were often the first to move into new fields. In the late nineteenth and early twentieth centuries, both nationalism and aesthetic preferences influenced the formation of great private collections of American decorative arts and, concomitantly, architecture, especially interiors, which are now at the Museum of Fine Arts, Boston, Colonial Williamsburg, Historic Deerfield, the American wing of the Metropolitan Museum of Art, the Wadsworth Atheneum, Winterthur, Yale, and elsewhere. At mid-century, the same criteria guided Maxim Karolik's pioneer collect-

ing of the work of neglected landscape painters of the nineteenth century, as they did collectors of folk art and American impressionism. The sudden burgeoning of interest in American landscape painting in the 1960s coincided with increased concern for the natural environment. New resources became available, notably the Archives of American Art, begun in Detroit and now based at the Smithsonian Institution in Washington, D.C. Academic programs started up at Winterthur and at Cooperstown in affiliation with the State University of New York. Certainly the field of American art appealed to students as an area of opportunity because language was not a problem, relatively little modern scholarship existed, and there was much scholarly work to be done. Moreover, teaching prospects brightened as colleges and universities enlarged their art history curricula to include American art, and curatorial positions opened in museums and historical societies as American collections grew. And, very important, strong financial support of graduate study became available, especially through the American Art Program of the Henry Luce Foundation.

The centrality of original works of art has long been a defining characteristic of the teaching of art history at Yale. Typically, one meeting each week of my undergraduate course (which included painting, architecture, and the decorative arts) and many graduate seminars were held in the Yale University Art Gallery, focusing on close analysis of a single work—a painting, a high chest of drawers, a silver cup. The collections of American art at the Gallery, as well as other universities and colleges with access to great collections, are a rich resource used and interpreted differently by teachers and scholars across time and from multiple disciplines. My teaching was shaped by the convergence of the two different aspects of my training: the formalist interest and methodology nurtured at Harvard and a concern for cultural context initiated at Winterthur.[5]

My realization of the potential of systematic formal analysis for unpacking contextual issues evolved over time, but one specific moment sticks in my mind. In the spring of 1969, I taught a graduate seminar on Homer and Eakins. One of my students from American Studies was a quiet African American, Charles Heglar, who had come to Yale from a small southern Catholic college. Having had no background in art history, he rarely spoke up in class. One day we were analyzing slides, including Homer's *Cotton Pickers* (fig. 1). Following extended formal description of the picture, I asked Charles to discuss it. After a long, somewhat awkward silence, he said simply, "All that cotton!" I was taken aback by his brevity but intrigued by the novel response, and

asked him to expand on his comment. He then spoke of the human effort required to gather that immense field of cotton. Soon we were considering questions about the production, gathering, and distribution of cotton and analogous issues of labor, management, agricultural practices, and technology—all provoked by Charles's observation but also informed and enriched by our previous formal analysis of the image. That enlargement in focus from consideration of the formal elements of the picture or such art historical issues as its compositional precedents or mythological overtones to the quotidian reality of the scene—what it meant as an experience of the real world in a particular time and place—struck me forcefully. From that time onward, systematic empathetic engagement with the image as an initial step toward fuller understanding of its context, pictured and historical, became increasingly important for me, as it did for many colleagues in the field of American art.

This approach related to a broad wave of scholarly innovation and theorizing known as the New History, which began with French historians at mid-century. It was motivated by a concern with the investigation of social classes that had been neglected by the traditional historical interest in great men and great events. This new social history found its way into art history, notably in the work of T. J. Clark on Gustave Courbet and mid-nineteenth-century France and of Michael Baxandall on the Italian Renaissance. The scholarly achievements of the social-history-of-art approach have played a prominent role in the change in art historical scholarship, eclipsing the dominant formalist, taxonomic, and iconographic modes of art history that prevailed a half-century ago. Although my own work has not pursued the historically grounded, even determined, approach of the social history of art, I admire its achievements in widening the lens of investigation to explore context, as in the work of such Americanists as Patricia Hills and Alan Wallach. In my own early study of Copley, done in the early and mid-1960s, I had started in that direction, making what was then innovative use of the computer to analyze Copley's American clientele in terms of such factors as religion, politics, occupation, place of residence, age, marital status, wealth, education, size of painting, and medium.[6] But my approach fundamentally insists upon analysis of the object itself as the primary text, the starting point and home base, although it departs from strict art historical formalism or its literary counterpart, the New Criticism, in not believing that close reading of a text alone provides the entire story. I favor incorporating any relevant biographical or historical information. But for me the most perti-

nent context, while incorporating external factual evidence, is not so much social history, what people did and what happened, as the ambient climate of belief, the culture in which the work was created and of which it speaks, sometimes openly but more often indirectly and inadvertently. I think of this as cultural art history.[7] In recent years, attention to cultural context has been the goal of a variety of cultural studies—popular culture, visual culture, folklore, and folklife; my particular involvement, teaching and writing, has been in the area of material culture.

Scholarship in cultural studies again derives from French models, a body of theoretical writings on structuralism, semiotics, and their intellectual offspring, deconstruction and poststructuralism, which have been especially influential in the fields of literature and the social sciences, above all in anthropology. Recent innovative scholarship in American art assumes that art, including photography and film, in which there has been a great expansion of interest, embodies *cultural* evidence—the values and beliefs of its makers and users—and that the interpretive study of objects can enlarge our understanding of culture, past and present. Many Americanist scholars, not just art historians, have come to see American art as material evidence of our national culture. And a number of influential historians of American art whose scholarship enriches the field have come from other disciplines, especially literature. Elizabeth Johns and Roger Stein are notable scholars who moved from literature to art, probing deeply in their explication of works of art. David Lubin and Bryan Wolf are among a number of my former students who also have a literary background. The academic track of many younger scholars now teaching in art history departments throughout the country has often been through American studies, where American art is only one of many areas explored, a factor that has contributed to the breadth of recent scholarship.

Material culture has been enriched by the fusion of the decorative and vernacular (folk) arts as fields of study with cultural anthropology. In my case, Harvard training in formalism and work with the decorative arts at Winterthur merged into a material culture methodology.[8] Since I view fine art as a subset, albeit a particularly significant subset, of the larger universe of artifacts that constitute the material of material culture study, I apply a common analytical process to the interpretation of all objects, high or low, fine or rude.

Yale has played a prominent role in the resurgence of interest in American art, the development of innovative modes of object study, and the training of a new and impressive generation of American art scholars.

My primary goal as a teacher, above and beyond conveying information, which was largely available in books, has always been to get students to see and to think *creatively* on the basis of the visual evidence provided by original works of art. I have consistently worked with the collections of American art at the Yale University Art Gallery, teaching students to analyze and interpret works of art as evidence of the culture that produced them. My methodological grounding in formalism and my interest in context, especially the cultural context, are the twin pillars on which my teaching and scholarship rest.[9] What may be my original contribution is in bringing these two elements together. Put succinctly, I believe that artifacts—art and all other human fabricated objects—are historical events, things that happened in the past; that they are the products of the beliefs of their makers and their times; and that close formal analysis, rigorously applied, is an appropriate and especially fruitful method for arriving at a fuller understanding of the culture that produced them. They provide a mode of understanding that is different from what we learn from verbal and statistical sources. Objects are poor conveyers of information but as embodiments of belief they can communicate feelings, attitudes, assumptions, and values. And when these mute objects are made to speak, they yield affective insight into their time and their place.

To achieve this insight, the first step is to harvest all of the information we can from the object without any imposition of our own beliefs. It is simply to describe the object as thoroughly as possible—its material, dimensions, and construction; any inscribed information and imaged representations, which in the case of a picture is its entire subject; and its formal arrangement of two- and three-dimensional geometries, color, value (light and dark), texture, and so on. Then the object is interrogated and deductions are drawn, scrupulously based on, and only on, the visual and material evidence—no jumping to conclusions. Finally, on the basis of the information gathered, which is substantial, and self-examination of the emotional responses triggered by the object, speculative questions and hypotheses are formulated.

This rigorous interrogation is a time-consuming process, one that requires patience and faith in the object. The disciplined encounter between an object that is authentic historical evidence of a particular time and place (subject to whatever alterations or damage it has sustained over time, which is also in itself evidence) and an investigator who is the product of and embodies a different culture with all its beliefs and biases can lead to original speculative insights, which then must be tested. That testing is scholarship, investigation of relevant sources, whether archival or literary or a body of related objects—whatever is dictated by the questions raised and the hypotheses proposed.

Over the course of the past half century, the field of American art has moved from being considered a provincial backwater to an arena of bold, innovative scholarship. This has been marked by, indeed in part generated by, the broader interests of American studies scholarship, bringing the perspectives of literary, historical, and social science studies to bear along with art history in the investigation of American art as the material embodiment and evidence of American culture.

Notes

A number of articles related to this essay are reprinted in my *Art as Evidence: Writings on Art and Material Culture* (New Haven and London: Yale University Press, 2002), hereafter Prown, 2002.

1. William H. Truettner, ed., *The West as America: Reinterpreting Images of the Frontier, 1820–1920*, exh. cat. (Washington, D.C., and London: Smithsonian Institution Press for the National Museum of American Art, 1991).

2. "The Promise and Perils of Context," in Prown, 2002, 243–53; see my "Art History vs. the History of Art," *Art Journal* 44 (winter 1984), 313–14; and M. H. Abrams, *The Mirror and the Lamp: Romantic Theory and the Critical Tradition* (New York: Oxford University Press, 1953).

3. For a fuller consideration of the state of scholarship in the field, packed with detailed bibliographic information about significant articles, exhibitions, catalogues, and books, see John Davis, "The End of the American Century: Current Scholarship on the Art of the United States," *Art Bulletin* 85 (Sept. 2003), 544–80. Some of the material in this introduction echoes my "A Retrospective View," in "Passing the Torch: American Art at the Millennium," *American Art* 14 (fall 2000), 6–9.

4. A few authors of books on American art such as Milton Brown at the City University of New York and Oliver Larkin at Smith College taught American art, but not at the graduate level.

5. For more on my approach, see my "The Work of Art and Historical Scholarship," *Ventures* 8 (fall 1968), 56–61; "Style in American Art: 1750–1800," *American Art, 1750–1800: Towards Independence*, exh. cat. (New Haven: Yale University Art Gallery, 1976), 32–39; "Style as Evidence" and "Promise and Perils," in Prown, 2002, 52–68 and 243–53, respectively; and "Comments from the Symposium Dinner, October 20, 1995," *Yale Journal of Criticism* 11 (spring 1998), 9–10.

6. Jules David Prown, *John Singleton Copley*, 2 vols. (Cambridge, Mass.: Harvard University Press, 1966), 1:101–99.

7. See my "In Pursuit of Culture: The Formal Language of Objects," *American Art* 9 (summer 1995), 2–3.

8. See my "Mind in Matter: An Introduction to Material Culture Theory and Method," in Prown, 2002, 69–95.

9. For a fuller account of the methods that I teach and use, and of the results, see Prown, 2002, passim, and Jules David Prown and Kenneth Haltman, eds., *American Artifacts: Essays in Material Culture* (East Lansing: Michigan State University Press, 2000).

Expressions of Heritage

The Artistic Creation of American Heritage

What can *Life, Liberty, and the Pursuit of Happiness* tell us about art and America before 1900? Historical exhibitions of art, including this one, face vexing questions about representing the past. Perhaps the art displayed epitomizes only a special segment of a nation's past. Perhaps the objects tell us most about the collectors who acquire them or the museums that house them, in this case, the Yale University Art Gallery. Perhaps the objects are shown in ways that convey meanings never intended by their makers.

Pleasure in the objects themselves usually dwarfs these questions. The artworks—John Trumbull's paintings of the American Revolution (cat. nos. 31–38), the exquisite silver bowl by the Huguenot refugee silversmith Simeon Soumaine (cat. no. 6), or the low-seated child's chair made by an unknown Louisiana artisan (cat. no. 24)—captivate viewers through their beauty, subject matter, and craft. They create worlds that viewers consume in the exhibitions themselves. They smother the cautions of essayists and commentators.

The objects in *Life, Liberty, and the Pursuit of Happiness* shape heritage because viewers take them as representing "heritage" and exhibitors sometimes present them as such. The beauty and fascination of the Trumbull paintings, the Soumaine bowl, and the Louisiana chair will very likely overwhelm concerns about their representation of America before 1900. They also may ease concerns about objects that are absent from this and other exhibitions because in the past their creators were deemed unimportant (usually Africans, Indians, and poor Europeans)

and their art prosaic. Or the objects might obscure an exhibition's regional limitations, in this case the limitations of the collections at the Yale University Art Gallery, which has assembled this show from its own holdings.

Of course, all the objects in *Life, Liberty, and the Pursuit of Happiness* both express and create heritage, meaning the past itself and the sense of the past that comes down to us or is generated for us and by us. These forms of heritage are complex, and the objects displayed express them with considerable force.

The exhibition illuminates an America undergoing rapid, sometimes bewildering change. Contrary to many myths about early America, this change occurred as dazzlingly in the colonial period, and especially in the eighteenth century, as it did between 1776 and 1900. In the full century before 1776, and long before colonists were thinking of independence, Britain's mainland colonies emerged as remarkably modern places. If their population, in addition to declining numbers of Indians, was largely English in 1676, by 1776 Britain's mainland colonies contained a great many Scots, Germans, Dutch, Swiss, and French as well, and, of course, massive numbers of captive Africans, especially in the Southern colonies. Between 1676 and 1776, the economies of the mainland colonies became exceedingly complex and far more deeply integrated into international trade than the British themselves, or at least British planners, would have liked. The colonies began to produce more of their own goods, particularly consumer goods such as furniture

and art, which might be thought the monopoly of the mother country. A vigorous and assertive local politics increasingly outdistanced patterns of politics in the British provinces back home. And cities, still minuscule by current standards, assumed an importance out of all proportion to their actual size in an overwhelmingly rural farming society.[1]

After the Revolution, Americans both imagined and wanted to imagine that the changes that occurred in the colonial era had been managed with beneficence. These desires shaped their own sense of the past and the past they were making as they drew, painted, sculpted, and wrote. And the Americans' aggressive movement into the original "west" of the Appalachians—the territory that would become Ohio, Indiana, Illinois, and Missouri—would only further enrich the human and cultural heritage that would distinguish America in the nineteenth century and later.

For example, the Quaker artist Edward Hicks shaped and reshaped the Pennsylvanian and American heritage in the many landscapes he painted throughout his prolific career. Hicks's *Peaceable Kingdom* series, executed in the first half of the nineteenth century (cat. nos. 9–10), imagines serenely peaceful intentions for Pennsylvania's Quaker founder, William Penn, and his famous treaty with Delaware Indians negotiated and signed in 1682 (fig. 1). Hicks's landscape depicts not only Penn's effort with the Indians but also a timeless America where lions lay down with lambs, children, and cattle in wondrous biblical harmony.[2]

Hicks's paintings convey the tensions implicit in artistic efforts to capture and express the heritage of the past. Historians dispute Hicks's portrayal of Penn's seemingly irenic relations with Indians. Penn proved far sharper in his dealings with Indians than Hicks suggested: the famous 1737 "walking purchase" generated two decades of controversy between Indians and Pennsylvanian authorities, and the colony's increasing animosity toward the native peoples resulted in deadly attacks on western Indians in the 1760s. Indeed, even as Hicks was painting in the 1830s, President Andrew Jackson was forcibly moving Cherokees from the Appalachians to the territory of modern Oklahoma in the infamous "Trail of Tears," the uprooting of an entire Indian people that resulted in the deaths of more than four thousand Cherokees.[3]

Objects often reveal tensions about heritage emerging in the societies where they are produced, although they are not easy to discern and can be hidden for generations after they have been created. The paired portraits of Dr. and Mrs. Hezekiah Beardsley by the so-called Beardsley Limner, which date from between 1788 and 1790 (cat. no. 8), can be

fig. 1 Edward Hicks, *The Peaceable Kingdom and Penn's Treaty*, 1845 (detail of cat. no. 10)

fig. 2 The Beardsley Limner, *Mrs. Hezekiah Beardsley (Elizabeth Davis)*, between 1788 and 1790 (detail of cat. no. 8)

fig. 3 Attributed to Peter Blin,
Cupboard. Wethersfield, Conn.,
1675–90 (detail of cat. no. 97)

taken as quaint New England pastorals: Dr. Beardsley is engaged with his copies of Edward Gibbon's *Decline and Fall of the Roman Empire*, his window opening on a broad New England horizon, and Mrs. Beardsley sits content with a slim book (fig. 2), the window behind her revealing an orderly garden, probably of her own creation. The recent discovery that Mrs. Beardsley holds *Meditations and Contemplations* by the British minister James Hervey, which describes nature's place in God's world, might seem to confirm the peaceful setting of the portraits.[4] But Hervey also was a deeply conservative evangelical Calvinist frequently cited by eighteenth-century New England revivalists for his repudiation of works as a means of salvation and his stress on sinfulness in humans and decay in nature. It is possible that the Beardsley portraits, painted in the era of the *Federalist Papers* and the ratification of the U.S. Constitution, reflect not satisfaction with the new nation but the enduring New England fixation on human depravity. A new wave of Calvinist revivalists saw the flaws of their own society mirrored in the decadence of the Roman empire.[5]

Peter Blin's cupboard (cat. no. 97), made between 1675 and 1690, says much about the breadth of late-seventeenth-century colonial trade and aspiring New England taste in a cautiously post-Puritan society. Its straight legs, which merely lift the chest's two storage boxes off the floor, confirm an aesthetic severity that might have looked back to the earliest decades of English settlement in New England. But the woods Blin utilized—white oak, southern yellow pine, yellow poplar, maple, and eastern red cedar—and the broad array of floral and geometric patterns (fig. 3) gave variety as well as ostentation to the cupboard, highlighted by spindles and half-egg decorations attached to the front of the cupboard in a linear fashion. Blin's enthusiastic if confused eclecticism finds its match in Peter Pelham's 1728 mezzotint of the Puritan theologian Cotton Mather (cat. no. 3). Issued the year Mather died, Pelham's print portrays a clergyman whose ostentatious gown and substantial wig contrast awkwardly with his simple clerical collar and his effort to radiate personal sobriety. Like Blin's cupboard, Pelham's Mather may have looked back to a more secure, straightforward past, even as it looked ahead to a more abundant, profitable future.[6]

This profitability of colonial America's artistic and cultural heritage emerges with particular force in the work of New York City's eighteenth-century silversmiths. There elegance emerges in the joyous craftsmanship of silversmiths drawn from the expanding population so common to Britain's dynamic eighteenth-century colonies.

Soumaine's extraordinary silver bowl (cat. no. 6), created about 1740, illustrates the growing internationalism of Britain's colonies, the healthy economy that rewarded many Europeans, if not others, and the refinement increasingly typical of the mainland colonies' wealthiest European residents. Soumaine was a Huguenot, the son of a refugee from France who fled Louis XIV's persecution of Protestants in the 1680s. Arriving in New York City in the 1690s, Soumaine steadily rose in wealth from the city's bottom tax bracket between 1695 and 1703 to its highest two brackets between 1709 and 1735. And little wonder at his success. As his exquisite bowl suggests, Soumaine's truly exceptional craftsmanship allowed him to create this most subtle vessel, which in

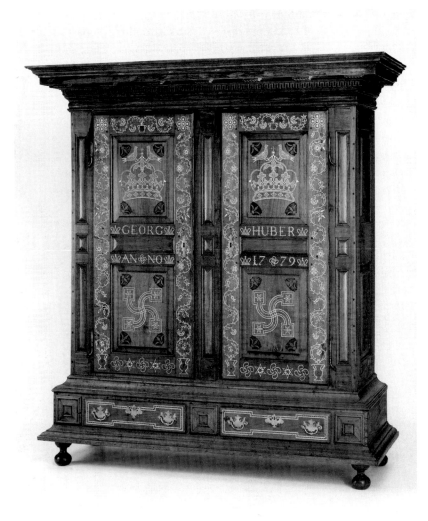

turn was meant for the most exotic of commodities: sugar. Working at his shop in New York City, Soumaine modeled his silver bowl on a Chinese porcelain dish that itself expressed the rapid expansion of international influences in Britain's American colonies.[7]

In fact, New York teemed with superb silversmiths who exemplified the increasingly multinational heritage being created in eighteenth-century America. The silver cann (cat. no. 5) was the product of two Huguenot immigrants to New York City, silversmith Bartholomew Le Roux II and engraver Joseph Leddel, Sr., working in a city already famous for its ethnic diversity. Cornelius Vander Burgh's beaker (cat. no. 11), made in the 1680s, and Cornelius Kierstede's much more elaborate if staid bowl (cat. no. 116), made in the 1740s, reveal the abiding presence of Dutch craftsmen in New York and its environs from just after English conquest into the mid-eighteenth century. Added to the distinctive type of chest or *Schrank* (fig. 4) and the fraktur painting common in German-dominated areas of Pennsylvania (though not in the Yale collections), the arts of the colonial era clearly reflected the multiplicity of cultures, nations, and peoples to be found in Britain's mainland colonies prior to the American Revolution.[8]

The purchase of Louisiana by the United States during the presidency of Thomas Jefferson broadened America's artistic heritage, perhaps ironically exemplified in Antoine Oneille's silver pitcher made in Sainte Genevieve, Missouri, between 1810 and 1815 (cat. no. 15). Oneille, like Soumaine, was a French silversmith whose trade depended on relations with well-off local clients. But the frontier where he worked in 1810 was far less sophisticated than the New York where Soumaine labored in the early 1700s. Perhaps the skills of each suited his circumstances. Oneille's pitcher is unevenly made—the soldering techniques seem elemental and the handle is solid rather than hollow. But his attempt at neoclassical style reveals the continuing American quest for achievement and distinction that Hector St. John de Crèvecoeur had described thirty years earlier in his famous 1782 *Letters from an American Farmer*.

The Native American heritage is present in this exhibition solely through non-Native eyes, though often with considerable dignity and beauty (cat. nos. 17, 21). Hicks's paintings suggest the great fascination that Indians held for so many American artists. If Indians appear only rarely in Trumbull's epic paintings of the American Revolution— for example, the Mohawk Indian chief "Colonel Louis" in *The Death of General Montgomery*, at center (cat. no. 32)—they are nonetheless well

fig. 4 Attributed to Peter Holl III and Christian Huber, *Schrank*. Manheim or Warwick Townships, Penn., 1779. Black walnut with sulfur inlay decoration, yellow pine, yellow poplar, oak, brass, and iron, 83⅛ x 78 x 27½ in. (211.1 x 198.1 x 69.9 cm). Philadelphia Museum of Art, Purchased with Museum funds, 1957

represented in Trumbull's miniatures. *"The Infant," Chief of the Seneca Indians* (fig. 5; cat. no. 41), *"The Young Sachem," A Chief of the Six Nations* (cat. no. 42), and *"Good Peter," Chief of the Oneida Indians* (cat. no. 47) take center place in three of Trumbull's assemblages of miniatures of American Revolutionary heroes, and Trumbull imbued them with a dignity that matches the poses of the English heroes. Interestingly, William John Wilgus's portrait, *Captain Cold* or *Ut-ha-wah* (cat. no. 16), one of many the artist painted of New York Indians in the 1840s, appeared at a time when a number of American writers were increasingly publishing popular biographies of prominent Indians, such as William Leete Stone's *Life of Joseph Brant—Thayendanegea* (1838) and *Life and Times of Red-Jacket, or Sa-go-ye-wat-ha* (1841). These books often portrayed the chiefs as great leaders, and Wilgus similarly cast his subject with exceptional strength and beauty. In Wilgus's portrait, Ut-ha-wah literally rises above the land behind him.[9]

Far more scarce are both the presence and portrayal of African Americans in American culture. In this respect, *Life, Liberty, and the Pursuit of Happiness* regrettably typifies the holdings of most American museums, large and small alike. Here the African American creative heritage is represented by only two objects from the mid- and late nineteenth century: a cane or walkingstick made in the late 1860s by a Missouri carver, Henry Gudgell (cat. no. 25), and a painting executed in 1894 by Henry Ossawa Tanner, *Spinning by Firelight—The Boyhood of George Washington Gray* (cat. no. 86). Gudgell's serpent, turtle, and lizard parallel figures found on Central African staffs. They most likely represent the survival of African healing practices in America, conveyed in the notion of "conjure," as well as the adaptation and spread of those practices in North America's bountiful natural environment even in the face of slavery's oppression.[10]

Tanner's *Spinning by Firelight*, which portrays Chicago social reformer George Washington Gray, shows how the traditional family painting, represented by such works as John Singleton Copley's pendant portraits of Mr. and Mrs. Isaac Smith (cat. no. 105) or even John Smibert's *The Bermuda Group* (cat. no. 1), had been democratized since the eighteenth century. Tanner, a deeply spiritual painter, inverted the traditional emphasis on aristocratic status to emphasize log-cabin modesty and homespun values, epitomized by Gray's mother at a spinning wheel and a youthful Gray before a fire, as the foundation of Gray's commitment to social reform. Here, then, was a household of safety and

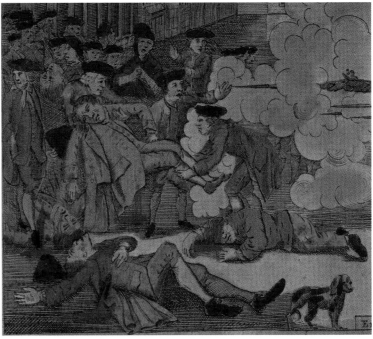

comfort, whose essential security and peacefulness may or may not have been assured by a husband in a chair and the gun on the cabin's rear wall (fig. 6).[11]

Elsewhere, non-African artists largely ignored or marginalized the African American presence. William H. Townsend's sensitive pencil sketches of the *Amistad* captives (cat. no. 82) are among the few exceptions. Paul Revere's powerful and famous engraving, *The Bloody Massacre Perpetrated in King-Street Boston on March 5th 1770* (cat. no. 27), transformed the former slave Crispus Attucks and the other Boston protesters into wigged and coated white gentlemen (fig. 7), five of whom died in the protest. Revere simultaneously masked Attucks's African heritage and the mixed social background of the other Boston protesters; in so doing he stressed the propriety of the protest.[12]

Alphonse-Léon Noël's two 1840s prints on music, *The Power of Music!* and *Music is Contagious!* (cat. nos. 79–80), based on paintings by William Sidney Mount (fig. 8), perhaps unwittingly or perhaps consciously exhibit the position of Africans in the United States both as fact and as presented heritage. Here Mount devastatingly depicted the separation of the races in America. The African figures must wait outside: a man hovers, hat in hand, in the latter painting, while in the

former, a boy beats drumsticks against the barn wall. The ax and the diverted gaze of the African American man speak more ominously in *The Power of Music!* than does the rifle on the rear wall of Tanner's *Spinning by Firelight* because they suggest a progression toward violence: the innocent African American boy of *Music is Contagious!* becomes the wary, frustrated, still marginalized man in *The Power of Music!* Mount completed his compositions as the bitter American argument over slavery moved toward the great Southern victory in the contentious 1850 Fugitive Slave Act.[13]

Overwhelmingly, of course, the paintings, prints, silver, and furniture exhibited in *Life, Liberty, and the Pursuit of Happiness* reflect the European economic success in colonial America. This prosperity contrasts sharply with the enforced poverty and personal and legal degradation of slavery (cat. nos. 83–84), and it allowed Europeans in America to experience both increasing and persistent consumption and to expect it as the heritage of the American colonial experience. Much of that material consumption focused on European imports, and indeed the free residents of America imported large quantities of Old World goods to replicate in the New World patterns that typified public and private display of wealth and attainment in Britain and the European continent.

fig. 8 William Sidney Mount,
The Power of Music, 1847.
Oil on canvas, 17 1⁄16 x 21 1⁄16 in.
(43.4 x 53.5 cm). The Cleveland
Museum of Art, Leonard C.
Hanna, Jr., Fund, 1991.110

When the Charleston merchant Richard Baker eagerly informed patrons in 1735 that he featured imports such as "mahaggany tables, chests of drawers, burros, desks, cloath chests, cupboards, [and] back-gamon tables," he well represented the strategy of many colonial merchants to profit by satisfying their clients' New World aspirations with Old World goods.[14]

But the success of the colonial economy for free European colonists also stimulated a tremendous proliferation of craftsmen and artisans throughout Britain's mainland colonies. Soumaine knew and worked with not only other refugee Huguenot silversmiths in New York City but also with almost a dozen other silversmiths, both Dutch and English, in what was still a small town from the 1690s into the 1730s. One Charleston silver- and goldsmith, Nicholas De Longemare, found it advisable also to trade in rum, olive oil, and hoes and to manage cattle and swine on a farm along the Santee River in the 1690s to supplement earnings from making silver and brass seals, mourning and wedding rings, and eyeglasses. But within a decade his Charleston successors could specialize in their finer crafts alone. For many European

fig. 9 Myer Myers, *Pair of Torah Finials*. New York City, 1784–95. Silver and gilded brass, A. h. 14 3/8, diam. base 1 1/4 in. (36.5 x 3.2 cm), gross wt. 24 oz., 12 dwt. (756 g), B. h. 13 7/8, diam. base 1 1/4 in. (35.2 x 3.2 cm), gross wt. 23 oz., 9 dwt. (730 g). Touro Synagogue, Congregation Jeshuat Israel, Newport, Rhode Island

colonists in America, neither ethnicity nor religion seemed a bar to broader success. New York City's Jewish silversmith Myer Myers (cat. nos. 108–9), who would have been denied membership in craft guilds in his native England, developed a Gentile as well as a Jewish clientele. Myers produced Torah finials or *rimonim*, which are placed at the upper end of Torah scrolls, for Jewish congregations in Philadelphia, New York, and Newport (fig. 9); he also made Communion silver for New York City's Presbyterian Church.[15]

Rural areas also saw crafts proliferate at an astonishing pace. In rural Talbot County, Maryland, more than eight hundred skilled craftsmen defined the expression of fine taste in art, architecture, and material possession between the 1690s and the 1760s. These included cloth workers such as tailors, weavers, and hatters; carpenters; barrelmakers; leatherworkers; and metalworkers, including silversmiths, blacksmiths, and brassworkers. This range of crafts and craftsmanship at least equaled and probably exceeded any similar array of crafts available in Britain's eighteenth-century home territories.[16]

This heritage of robust local New World craftsmanship took particularly aggressive form among furnituremakers, especially the makers of chairs. The side chair by an unknown maker, probably produced between 1750 and 1770, represents the finer examples of colonial craftsmanship available in the mid-eighteenth century (cat. no. 101). But the low-seated chair, also by an unknown maker of the later eighteenth

or early nineteenth century, likely represents more typically modest chair production among eighteenth-century colonial furnituremakers (cat. no. 24). In fact, this chair and its taller counterparts were available in an astonishing variety of forms throughout the colonies. A recent study of joiners and woodworkers in rural western Connecticut reveals that these makers of chests and desks also created an extraordinary range of chairs that belied their rural provenance: round-top chairs, fiddleback chairs, fiddleback rocking chairs, crookedback chairs, and crookedback armchairs. In New York, Pennsylvania, Virginia, the Carolinas, and New England, the proliferating colonial chairmakers experimented with woods and imported cane and developed sometimes peculiar local types even as they incorporated the styles of others into their own. If some of this work exhibited the common plainness of the low-seated chair, the handsome mid-eighteenth-century side chair suggests a growing level of sophistication and craftsmanship among many of the same colonial chairmakers.[17]

Three of the important furniture pieces included in *Life, Liberty, and the Pursuit of Happiness* demonstrate the expanding production that typified later-eighteenth-century American furniture, namely, the high chest made in Montgomery County, Pennsylvania, between 1765 and 1770 (cat. no. 12); the desk and bookcase constructed in Newport, Rhode Island, between 1760 and 1790 (cat. no. 106); and the pine chest constructed in New Mexico between 1775 and 1825 by an unknown maker (cat. no. 23).

The exceptional quality of design, proportion, construction, and finish of the Pennsylvania high chest and the enormous Newport desk and drawers represents colonial furniture craftsmanship at its finest in the era of the American Revolution. The quality of the Newport desk and bookcase might be expected, since by the 1760s both Newport and Philadelphia had become home to colonial craftsmen of truly extraordinary skill and sophistication. Perhaps more surprising is the quality of the Pennsylvania high chest, a testament to the distribution of substantial craftsmanship well into the colonial countryside. Both display a craftsmanship on a par with that of London furnituremakers. They bespeak the achievement, and the sense of achievement, that American colonists had come to expect as the eighteenth century raced toward an unexpected fissure between America and Britain.

But the New Mexico pine chest, produced a few decades later, might be considered even more remarkable, not only in and of itself but also for the heritage of popular artistic expression it represents (fig. 10).

Here we may have an example of the rarest kind, a furniture piece whose lack of sophistication might not appeal to all serious collectors but which is in fact more emblematic of both vernacular furniture and the strength of vernacular artistic expression than the more elegant pieces. In this case it is linked to the old Spanish Southwest, which would be forcibly brought within the United States two generations later. The New Mexico chest is crudely constructed in a simple rectangular shape using readily available pine, but the craftsman clearly valued adornment. The maker framed the chest's front in seven rectangles, then added lions and flowers to the bottom rectangles and pomegranates to those on top (lions and pomegranates are drawn from Hispanic traditions and are often symbols in heraldry). The result is a chest of exceptional and simple charm that surely brought satisfaction and pride to its creator. The artistic flowering of nineteenth-century America, so evident throughout *Life, Liberty, and the Pursuit of Happiness*, is strongly foreshadowed in this elegantly homely chest.

As colonial unrest gathered strength, the lively heritage of popular artistic expression found its voice in protest and emerged as a force in the Americans' increasingly anti-British politics. Two politically ambivalent cartoons of 1774—*The Bostonians Paying the Excise-Man,* or *Tarring & Feathering* (cat. no. 28) and *The Bostonians in Distress* (cat. no. 29), attributed to Philip Dawe—deliberately invoked the heritage of popular cartooning common on both sides of the Atlantic to express British reactions to American excesses. The cartoons' exaggerations probed the emotional divide between Loyalists and budding patriots in the colonies.[18]

Paradoxically, colonial protest also tended to flatten the American colonies' increasing cultural heterogeneity, with important consequences for art and material culture. The protests and the Revolution itself accentuated the traditional leadership of the colonies' British-descended elites, because they still dominated officeholding in the legislatures and in the governments of towns and counties whose members also were increasingly angry with the British ministries and, finally, with the king. As a consequence, this reversal shifted expressions of the Revolutionary heritage back to older and somewhat more traditional British models.

No works better represent this renewal of British heritage in American culture than Trumbull's Revolutionary War paintings (cat. nos. 31–38). The Connecticut-born Trumbull briefly served as an aide to Virginia's George Washington in the Revolution and, after studying art following the war, made documenting the American Revolution his own vivid and most patriotic act.

Trumbull crafted an almost wholly English-American panorama of Revolutionary drama. Germans, French, Dutch, and, except in *The Battle of Bunker's Hill, June 17, 1775* (cat. no. 31), Africans are largely absent from the panorama of colonial population; similarly absent are the mutilations and daily humiliations of slavery, or concerns about the widening social and economic gaps among the wealthy, "middling sorts," and the poor in the colonial cities. Neither do we see the angry contests over ratification in 1788 of the federal Constitution or the tensions among Jefferson, Madison, Hamilton, and Adams within the Washington administration over the control and direction of the nation's new government.

Instead, Trumbull fashioned a singular heritage of Revolutionary triumph, even when portraying an American defeat as in *Bunker's Hill*, one that might transcend the post-Revolutionary bickering that marred the Adams administration and propelled Jefferson to a narrow victory over Adams in the closely contested election of 1800. Even Trumbull's battle canvases, such as *Bunker's Hill* or *The Death of General Montgomery in the Attack on Quebec, December 31, 1775* (cat. no. 32), emphasize the nobility of commanders facing death amid the spectacle of formal uniformed warfare, participants everywhere awed by unfurled flags, darkened skies, and aristocratic sacrifice. Trumbull's most celebrated painting, *The Declaration of Independence, July 4, 1776* (cat. no. 33), created a heritage of assent and common purpose in a different fashion by drastically restaging this seemingly singular moment in American history. In reality, only John Hancock and perhaps a few others signed the

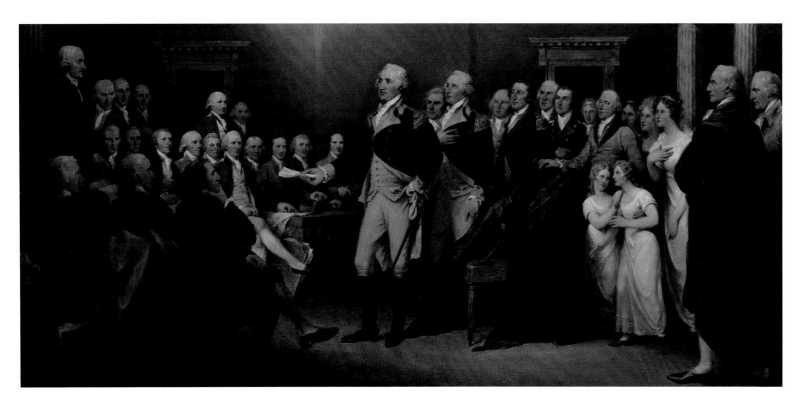

fig. 11 John Trumbull,
*The Resignation of General
Washington, December 23, 1783,*
1824–28 (detail of cat. no. 38)

Declaration, and then with little ceremony, when it was accepted by the Continental Congress on 2 July. Although no formal ceremony took place on 4 July or any other day, Trumbull created an event attended by all members of the Congress on what became Independence Day, grouping the most prominent Founding Fathers around the Declaration that several signed only later.[19]

Little matter. Trumbull's imagination, technical skill, and productivity created not only the "signing of the Declaration of Independence" but the entire understanding of the American Revolutionary experience. Trumbull's brilliantly colored, spaciously arranged depictions of the surrenders of General Burgoyne (cat. no. 36) and Lord Cornwallis (cat. no. 37) and the capture of the Hessians at Trenton (cat. no. 34) bring a decorous propriety and moral weight to uncertain events. His portrayal of Washington's surrender of his commission as commander in chief parallels his achievement in *The Declaration of Independence*, and Trumbull augmented the grandeur of Washington's significant act, eschewing a military structure for the infant nation by retiring to Mount Vernon without title and power (fig. 11). Perhaps like *The Declaration*

of Independence, The Resignation of General Washington, December 23, 1783 (cat. no. 38) includes men, and now women, who were not there. But the event, held in the Senate chamber of the Maryland Statehouse in Annapolis, was indeed recognized as momentous at the time, and Trumbull's display of the participants' gratitude for Washington's sound judgment was meant to be a somber lesson for a nation still coming into being.[20]

Trumbull, then, moved beyond the many artists and craftsmen who elevated family heritage and satisfied personal aspirations in the colonial and Revolutionary eras, from Soumaine to the Beardsley Limner, or from Blin to the proud maker of the post-Revolutionary pine chest. He understood, indeed fervently believed, that posterity's image of the American Revolution might rest in his skilled hands. His achievement stands as a reminder of the ways in which art and artisans shaped heritage before and after the American Revolution with materials and subjects they, too, understood as partial and uneven, yet which might also please, uplift, and inspire in a New World and, ultimately, in a new Republic.

Notes

1. Jon Butler, *Becoming America: The Revolution Before 1776* (Cambridge, Mass.: Harvard University Press, 2000); Alan Taylor, *American Colonies* (New York: Viking Press, 2001); Jack P. Greene, *Pursuits of Happiness: The Social Development of Early Modern British Colonies and the Formation of American Culture* (Chapel Hill: University of North Carolina Press, 1988).

2. Carolyn J. Weekley and Laura Pass Barry, *The Kingdoms of Edward Hicks* (Williamsburg, Va.: Colonial Williamsburg Foundation, 1999).

3. James H. Merrell, *Into the American Woods: Negotiators on the Pennsylvania Frontier* (New York: W. W. Norton, 1999); T. J. Sugrue, "The Peopling and Depeopling of Early Pennsylvania: Indians and Colonists, 1680–1720," *Pennsylvania Magazine of History and Biography* 116 (1992), 3–32; Frederick E. Hoxie, Ronald Hoffman, and Peter J. Albert, eds., *Native Americans and the Early Republic* (Charlottesville: University Press of Virginia, 1999); Anthony F. C. Wallace, *Jefferson and the Indians: The Tragic Fate of the First Americans* (Cambridge, Mass.: Belknap Press of Harvard University Press, 1999); James P. Ronda, "'We Have a Country': Race, Geography, and the Invention of Indian Territory," *Journal of the Early Republic* 19 (1999), 739–55.

4. For a discussion of Hervey's *Meditations and Contemplations,* see catalogue entry 8.

5. William Breitenbach, "Unregenerate Doings: Selflessness and Selfishness in New Divinity Theology," *American Quarterly* 34 (1982), 481; Leigh Eric Schmidt, "'A Second and Glorious Reformation': The New Light Extremism of Andrew Croswell," *William and Mary Quarterly*, 3rd ser., 43, 2 (Apr. 1986), 242; Stephen A. Marini, *Radical Sects of Revolutionary New England* (Cambridge, Mass.: Harvard University Press, 1982).

6. Kenneth Silverman, *The Life and Times of Cotton Mather* (New York: Harper & Row, 1984), 410.

7. Jon Butler, *The Huguenots in America: A Refugee People in New World Society* (Cambridge, Mass.: Harvard University Press, 1983), 178–79, 182–83.

8. For a discussion of the influence of Germanic culture on Pennsylvania furniture, see catalogue entry 12.

9. Scott E. Casper, *Constructing American Lives: Biography and Culture in Nineteenth-Century America* (Chapel Hill: University of North Carolina Press, 1999), 153–55; William L. Stone, *Life and Times of Red-Jacket, or Sa-go-ye-wat-ha* (New York: Wiley and Putnam, 1841), and Stone, *Life of Joseph Brant—Thayendanegea* (New York: A. V. Blake, 1838).

10. Philip D. Morgan, *Slave Counterpoint: Black Culture in the Eighteenth-Century Chesapeake and Lowcountry* (Chapel Hill: University of North Carolina Press, and Williamsburg, Va.: Omohundro Institute of Early American History and Culture, 1998), 616–17; Albert J. Raboteau, *Slave Religion: The "Invisible Institution" in the Antebellum South* (New York: Oxford University Press, 1978), 80–86, 275–88.

11. Marcus Bruce, *Henry Ossawa Tanner: A Spiritual Biography* (New York: Crossroad Publishing Company, 2002); for a somewhat different analysis of this painting, see Amy Kurtz, "'Look Well to the Ways of the Household, and Eat Not the Bread of Idleness': Individual, Family, and Community in Henry Ossawa Tanner's *Spinning by Firelight—The Boyhood of George Washington Gray*," *Yale University Art Gallery Bulletin* (1997–98), 52–67.

12. Hiller B. Zobel, *The Boston Massacre* (New York: W. W. Norton, 1970).

13. Don Edward Fehrenbacher and Ward McAfee, *The Slaveholding Republic: An Account of the United States Government's Relations to Slavery* (New York: Oxford University Press, 2001).

14. Richard Baker, quoted in Butler, 2000, 155.

15. Butler, 1983, 100; David L. Barquist, Jon Butler, and Jonathan D. Sarna, *Myer Myers: Jewish Silversmith in Colonial New York*, exh. cat. (New Haven: Yale University Art Gallery, and New Haven and London: Yale University Press, 2001), 154–60.

16. Jean B. Russo, "Self-Sufficiency and Local Exchange: Free Craftsmen in the Rural Chesapeake Economy," in Lois Green Carr, Philip D. Morgan, and Jean B. Russo, eds., *Colonial Chesapeake Society* (Chapel Hill: University of North Carolina Press, and Williamsburg, Va.: Institute of Early American History and Culture, 1988), 389–432.

17. Edward S. Cooke, Jr., *Making Furniture in Preindustrial America: The Social Economy of Newtown and Woodbury, Connecticut* (Baltimore: Johns Hopkins University Press, 1996), ch. 5, "Consumer Behavior in Newtown and Woodbury," 91–117.

18. Michael A. McDonnell, "Popular Mobilization and Political Culture in Revolutionary Virginia: The Failure of the Minutemen and the Revolution from Below," *Journal of American History* 85 (1998), 946–81.

19. Pauline Maier, *American Scripture: Making the Declaration of Independence* (New York: Alfred A. Knopf, 1997), 150–51, 175, 181–83.

20. James Thomas Flexner, *Washington, the Indispensable Man* (Boston: Little, Brown, 1974), 178.

Religious Diversity

1

John Smibert (b. Scotland, 1688–1751)
The Bermuda Group (Dean Berkeley and His Entourage), begun 1728, completed 1739

Oil on canvas, 69½ x 93 in. (176.5 x 236.2 cm)
Gift of Isaac Lothrop, 1808.1

The Bermuda Group commemorates Dean George Berkeley's ill-fated attempt to found a seminary in Bermuda "for the better supplying of churches in our foreign plantations and for converting the savage Americans to Christianity."[1] Although the Anglican cleric's project ultimately failed for lack of funds, the Scottish-born artist John Smibert succeeded in establishing himself as the first professional portrait painter in America.[2] His group portrait of Berkeley (1685–1753) and his entourage is the largest, most ambitious canvas painted in America before 1750. The compendium of gestures, poses, and props used in this and other compositions in Smibert's studio—the first American atelier—inspired American artists throughout the eighteenth century, among them John Singleton Copley and John Trumbull.

Smibert's notebook entry for July 1728 records: "A Large picture begun for Mr. Wainwright," a reference to Berkeley's friend John Wainwright, a barrister and supporter of the seminary venture.[3] Wainwright commissioned the painter, whom Berkeley had hired to teach art at the new college, to create this portrait of the expeditionary party. Smibert himself stands at the far left, addressing the viewer with a fixed outward stare, while Berkeley, attired in an austere cassock, stands at the far right, conveying a powerful presence. Posed between them are Richard Dalton and John James, who were described as "Men of Fortune" and "gentlemen of substance";[4] and behind a rug-decked table in the foreground sit Miss Handcock, a companion to Berkeley's wife, Anne Forster Berkeley, who holds the couple's firstborn son, Henry. Even though Wainwright did not make the voyage to the New World, Smibert included him in the portrait; he is seated in the foreground, where he serves as Berkeley's scribe.

Berkeley's party set sail from England on 5 September 1728, arriving in Newport, Rhode Island, on 23 January 1729, where they awaited additional funds from Parliament for the Bermuda endeavor. When funds were not forthcoming, Smibert left the group in Newport and went to Boston, where he established a studio and continued to work on the *Bermuda Group* for the next decade.

Berkeley's imposing stance, closely aligned with the column behind him, underscores his status as a "pillar" of the educational and ecclesiastical communities. *The Bermuda Group* has been interpreted as the "visual equivalent" of a contemporary sermon on "governments and rulers as earthly pillars."[5] On 13 August 1730, the Reverend Benjamin Colman, a prominent Boston clergyman, preached a sermon before Jonathan Belcher, the newly inaugurated governor of Massachusetts, in which he proclaimed, "Integrity, uprightness, faithfulness added to knowledge and wisdom, makes men strong and beautiful pillars, whether in church or state."[6] Dalton and James, "faithful" and "upright" supporters of Berkeley, are positioned in front of the actual pillars, and their placement between Smibert and Berkeley completes both a literal and figurative colonnade. Smibert's use of Colman's metaphor can hardly be coincidental. Smibert was living in Boston at the time of the clergyman's sermon and only three months later, in November 1730, recorded in his notebook the completion of a full-length standing portrait of Governor Belcher,[7] whose inauguration in Boston inspired Colman's sermon.

The Bermuda Group can also be read in relation to Berkeley's poem "Verses on the Prospect of Planting Arts and Learning in America" of 1726, in which he predicts that his college will bring about a new "golden age" of arts and learning:

> There shall be sung another golden age,
> The rise of empire and arts,
> The good and great inspiring epic rage,
> The wisest heads and noblest hearts . . .
>
> Westward the course of empire takes
> its way;
> The four first acts already past,
> A fifth shall close the drama with
> the day;
> Time's noblest offspring is the last.[8]

It has been argued that the painting "proposes the alchemical power of the arts and letters to transform America's 'virgin earth' into Berkeley's 'golden age.'" Anne Berkeley's golden dress and her child's golden hair connect them with the auriferous horizon, symbolizing a prosperous future. Henry, who was born after his parents' arrival in Newport, seems to offer us a piece of golden fruit. As the only sitter born on American soil, he "personifies the western fruition of human destiny or 'Time's noblest offspring' in the New World."[9]

Once it became clear that Berkeley's plans for establishing a college in Bermuda would never be realized, he and his family returned to England late in 1731. Ironically, although Berkeley never witnessed the dawn of his "golden age," *The Bermuda Group* was displayed prominently at the World's Columbian Exposition, held in Chicago in 1893, a lavish fair that celebrated "the rise of empire and arts." G.C.B.

Notes

1. George Berkeley, *A Proposal for the Better Supplying of Churches in our Foreign Plantations and for Converting the Savage Americans to Christianity* (London: printed by H. Woodfall, 1724).
2. Smibert had studied in London with the celebrated English portraitist Sir Godfrey Kneller.
3. *The Notebook of John Smibert* (Boston: Massachusetts Historical Society, 1969), 17 [facsimile], 85 [transcription].
4. *Maryland Gazette* (Annapolis), 22 April 1729, quoted in Richard Saunders, *John Smibert: Colonial America's First Portrait Painter* (New Haven: Yale University Press, 1995), 172.
5. David Bjelajac, *American Art: A Cultural History* (London: Laurence King, 2000), 104.
6. Rev. Benjamin Colman, "Government, the Pillar of the Earth" (orig. Boston: T. Hancock, 1730), 16, reprinted in Ellis Sandoz, ed., *Political Sermons of the American Founding Era, 1730–1805,* 2 vols. (Indianapolis: Liberty Fund, 1998), 1:8–24.
7. Smibert's portrait of Governor Belcher is thought to have been destroyed during the American Revolution (Saunders, 1995, 216, no. 185). In 1734, Smibert portrayed the Reverend Colman himself. Although the work has never been located, it is known from a 1735 mezzotint by Peter Pelham (Saunders, 1995, 220, no. 236).
8. The revised version of this poem was first published in *A Miscellany, Containing Several Tracts on Various Subjects* (Dublin: for G. Faulkner, 1752).
9. Bjelajac, 2000, 103–4.

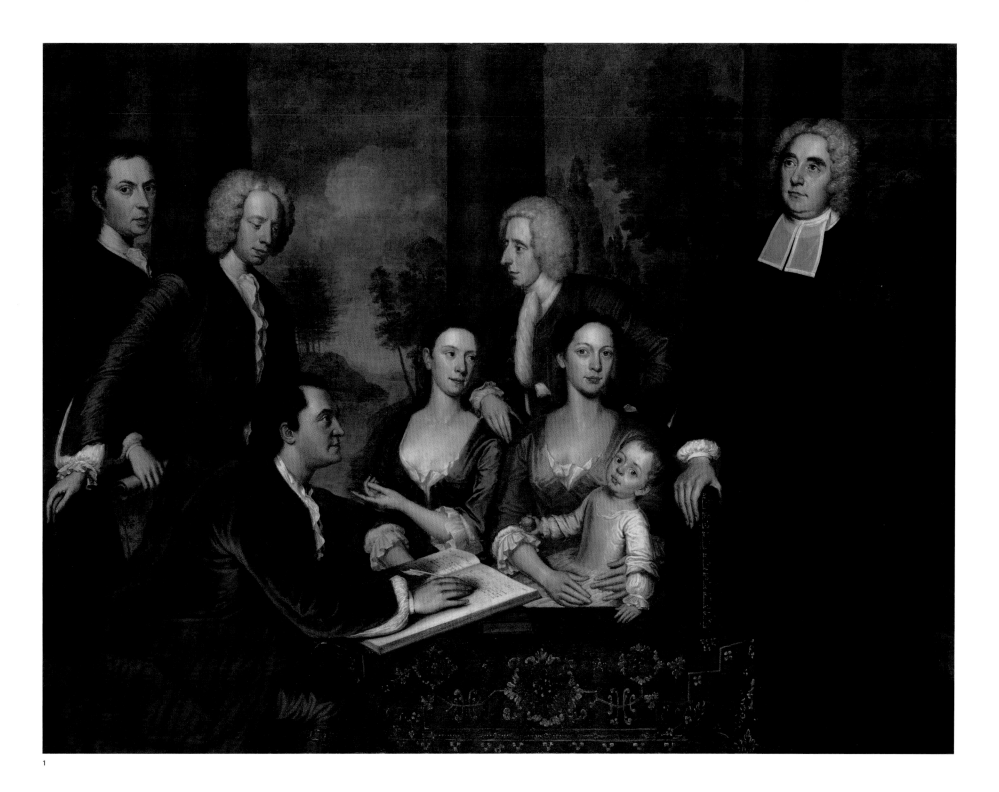

1

2

2

John Hull (b. England, 1624–1683)
and **Robert Sanderson** (b. England,
1608–1693)
Communion Cup
Boston, 1664–70

Silver, h. 7 5/16, diam. rim 4 1/4, diam. base 4 1/16 in.
(18.6 x 10.8 x 10.3 cm), wt. 12 oz., 17 dwt. (398 gm)
Mabel Brady Garvan Collection, 1936.137

Thomas Willet, the son of an English clergy-
man, was part of the Great Migration of
Protestants who fled repression in England
after breaking with the Church of England
and its rituals, which retained overtones of
Roman Catholicism. He joined the exodus to
Leiden and then came to Plymouth Planta-
tion about 1630. In his will, made in 1671, he
stipulated bequests to three Massachusetts
churches—the Congregational churches at
Plymouth and Rehoboth and the Baptist
church at Swansea. With its bequest, the
church at Rehoboth may have acquired this
Communion cup by John Hull and Robert
Sanderson, the earliest silversmiths to work
in New England.[1] Based on a simple domes-
tic cup for drinking wine or beer and
engraved with a diminutive inscription com-
memorating Willet's bequest, the cup suited
the plainness espoused by New England
Protestants for their Communion services.

Willet's bequest illuminates the divisive-
ness that emerged over differences in the
practice of faith among communities in New
England. Congregationalists believed in the
bonding of government and religion. Mem-
bership in the church signified that one was
among God's elect. For males, church mem-
bership provided the franchise and access to a
role in government. The government in turn
supported the ministry by imposing rates
on the whole population. Baptists, by con-
trast, believed that religion and government
should be separate spheres.

Throughout his life Willet gained a repu-
tation for resolving disputes. He learned the
Dutch language, which facilitated his career
as a shipowner trading with New Amsterdam
and led to his roles as a mediator between
the English and the Dutch and as mayor of
New York City in 1665. His marriage to Mary
Brown, a daughter of John Brown, a Baptist
and a magistrate of the Plymouth Colony,
affirms his Baptist leanings. As an early settler
of Rehoboth and founder of Swansea, he
was prominent in these communities. When
the Rehoboth Congregational Church asked
Willet to procure a minister to assist the
Reverend Zachariah Symmes, Willet brought
the Baptist minister John Myles to Rehoboth.
The ensuing tension within the church led to
the withdrawal of the Baptists to Swansea in
1667, where they established the first Baptist
church in New England outside of Rhode
Island. In Rehoboth, town offices and church
control reverted to the Congregationalists.
Willet's bequest to the Rehoboth church may
be seen as his attempt to mollify the conten-
tiousness that existed among the religious
factions that settled New England.[2] P.E.K.

Notes
1. E. Alfred Jones, *Old Silver of American Churches*
(Letchworth, England: National Society of Colonial
Dames of America, 1913), 162.
2. Thomas W. Bicknell, "The First Baptist Church in
Massachusetts," *Bay State Monthly* 1 (Feb. 1884),
90–95; Richard Le Baron Bowen, *Early Rehoboth:
Documented Historical Studies of Families and
Events in This Plymouth Colony Township*, 4 vols.
(Rehoboth, Mass.: privately printed, 1945); Henry
L. Shumway, "John Myles, Baptist," *New England
Magazine*, n.s. 33 (1905–6), 29–32.

3

Peter Pelham (b. England, 1697–1751)
Cottonus Matherus (Cotton Mather), 1728

Mezzotint, 13⅞ x 10 1/16 in. (35.2 x 25.5 cm)
Mabel Brady Garvan Collection, 1946.9.200

Peter Pelham arrived in Boston in 1727 at the age of thirty with a reputation already established as a mezzotint engraver in London. Under the tutelage of John Simon, one of England's leading engravers, young Pelham had the opportunity to work directly from oil portraits painted by Simon's associate, Sir Godfrey Kneller, one of the most revered portrait painters of the day. Between 1720 and 1726, Pelham is known to have produced at least twenty-five mezzotint portraits of prominent Englishmen.[1]

Newly arrived in the colonies, Pelham asked the venerable Cotton Mather (1663–1728) to sit for the engraver's first mezzotint portrait to be made on American soil—evidence of Pelham's business acumen and his eagerness to establish a reputation in this country. Mather, a prolific writer, scholar, and minister of Second Church in Boston, was perhaps the most celebrated of all New England Puritans. By the winter of 1727–28, when the sitting took place, Mather had published hundreds of books and treatises, including his magnum opus, *Magnalia Christi Americana* (1702), an ecclesiastical history of America from the founding of New England to his own time. Curiously, Mather combined a belief in mystical phenomena (including witchcraft) with an interest in modern scientific inquiry; for example, he supported smallpox inoculation despite much opposition.

Given Mather's considerable renown, it was essential that Pelham's likeness of the minister be a good one. Yet in America Pelham found himself without a Kneller to produce a suitable portrait from which to compose his mezzotint, and he was forced to

paint his own.[2] Though Mather posed for Pelham's painted study, the minister would not live to see the final mezzotint; he died in Boston on 13 February 1728, four months before the print's publication. To encourage a large subscription, Pelham took out an advertisement for his print in late February, inviting potential buyers to his house on Summer Street to look at "specimens" of some of the engraver's other "prints in Metzotinto." The print sold by subscription for three shillings down and two shillings at the time of delivery. Those who purchased twelve would receive a thirteenth gratis, evidence that Pelham hoped wealthier citizens would purchase multiple impressions to give as gifts.[3]

At the time of this print's creation, its esteemed subject was what made Pelham's portrait so popular; Mather's death, just at the commencement of Pelham's work on the print, helped sales as well. In a curious twist of fate, today original impressions of Pelham's portrait are sought after not so much because of the print's sitter but because of its author[4] and its distinction as the first fine mezzotint engraving made in America. E.H.

Notes
1. See Andrew Oliver, "Peter Pelham (c. 1697–1751), Sometime Printmaker of Boston," in *Boston Prints and Printmakers 1670–1775, A Conference Held by the Colonial Society of Massachusetts 1 and 2 April 1971* (Boston: Colonial Society of Massachusetts, 1973), 134.
2. Competent but somewhat awkward, Pelham's portrait of Cotton Mather survives today in the collection of the American Antiquarian Society in Worcester, Mass.
3. Oliver, in *Boston Prints*, 1973, 135–36, reprints the full text of Pelham's advertisement.
4. A celebrated artist in his own right, Pelham was also the stepfather of the famed portraitist John Singleton Copley (cat. no. 105).

3

4

4

Reuben Moulthrop (1763–1814)
Reverend Ammi Ruhamah Robbins, 1812

Oil on canvas, 59⅝ x 59¾ in.
(151.4 x 151.8 cm)
Gift of Trustees of the Ellen Battell Stoeckel
Foundation, 1943.104

Reuben Moulthrop, a self-taught itinerant artist, was best known for his traveling wax-works museum. A gifted self-promoter, he was equally effective in selling theatrical spectacle to the newly emerging middle class and in soliciting traditional patrons from among the Connecticut elite. Both his back-ground in wax modeling and his experience in conventional portraiture are reflected in his likeness of the Reverend Ammi Ruhamah Robbins (1740–1813).

Moulthrop's imperfect grasp of per-spective, especially evident in the patterned floor, contrasts with the unflinching sculp-tural accuracy of Robbins's head, which is much like that of a waxwork figure. He care-fully delineates the sitter's wrinkled counte-nance, including three prominent warts—possibly signs of Robbins's terminal skin cancer. Such verisimilitude at flattery's expense typifies the candor of much early New England portraiture.

In 1761, the Reverend Mr. Robbins became the minister of the Congregational Church in Norfolk, Connecticut. He shepherded his flock with such an authorita-tive hand that other religious denomina-tions could not establish a foothold in Norfolk until after his death. Robbins had been brought up in the conservative and legally established Congregationalism of the colonial period, but by the end of his long life the country had entered a period of religious upheaval.

In the face of Enlightenment ideals pro-mulgated by the French and American Revolutions, traditional Congregational tenets, which emphasized hellfire and dam-nation, the literal interpretation of the Bible, and rejection of "luxury," seemed less rel-evant. Newer belief systems celebrated reason and free will and understood the creator and cosmos to be benign. Mass conversion to Unitarianism and the rapid growth of other sects meant that Congregationalism, which once enjoyed hegemony in colonial New England, was in crisis by the time Robbins sat for this portrait.[1]

Moulthrop's frank representation of the minister's aged visage suggests a deprecation of worldly vanity that is at odds with the detailed depiction of his material goods. The appurtenances of this provincial minister's study, while sober and restrained, hint at an appreciation for the finer things in life. Robbins's books are rendered meticulously: as a minister of a religion based on the literal interpretation of the Bible, he is emphati-cally a man of the Word. But while the bind-ings are depicted crisply, and every line in the open book is represented, the words are, in fact, undecipherable. Meanwhile, objects of similar size, such as the quill's nib, are limned with exactitude. The literal reading of religious texts that the painting seems to invite proves impossible.

In Moulthrop's and Robbins's lifetimes, old systems of belief had broken down; religious certainties were questioned. Perhaps both the portraitist and his sitter, poised between the logocentric austerity of the Puritan past and the materialism of the nine-teenth century, found that the flesh could still be rendered precisely but the Word could not. G.G.

Note
1. See Jon Butler, "Coercion, Miracle, Reason: Rethinking the American Religious Experience in the Revolutionary Age," in Ronald Hoffman and Peter J. Albert, eds., *Religion in a Revolutionary Age* (Charlottesville: University Press of Virginia, 1994), 193.

5

Bartholomew Le Roux II
(1717–1763), silversmith
Joseph Leddel, Sr. (b. England,
ca. 1690–1754), engraver
Cann
New York City, 1750

Silver, h. 4½, diam. 3¼ in. (11.4 x 8.3 cm),
wt. 9 oz. (280 gm)
Gift of Mr. and Mrs. Eddy G. Nicholson and
purchased with the Josephine Setze Fund for
the John Marshall Phillips Collection, 1995.18.1

This cann, made by Bartholomew LeRoux II
and engraved by Joseph Leddel, Sr., is a
rare example of a colonial artisan overtly stat-
ing his religious beliefs.[1] It speaks to the
challenges felt by one group of early immi-
grants to the American colonies: the Hugue-
nots. After the revocation of the Edict of
Nantes in 1685 made Catholicism the state
religion of France, French Protestants, or

Huguenots, faced religious persecution.
Many chose to leave France, and New York
City's practice of religious toleration made
it an especially attractive destination for
these refugees.

Artisans constituted a large percentage of
the new arrivals, among them many of
the colonies' great silversmithing families,
including LeRoux's. Although Bartholomew
LeRoux II was a third-generation silver-
smith of French descent, he was working at
a time when artisans and patrons interacted
across ethnic lines, creating a multiethnic
style in New York City silver.[2] The cylindri-
cal cann with a molded foot and scroll han-
dle is similar to many other New York canns
from the same period.

Leddel, a pewterer by trade, had consid-
erable engraving skill. This cann is one of
three pieces he decorated for his personal use
in 1750. In each case, when buying the silver
pieces, Leddel chose to patronize a silver-
smith of French or French Huguenot descent.

(The other pieces are a tankard by silver-
smith William Vilant of Philadelphia,
engraved with scenes from Ovid, and a bea-
ker by French silversmith Hugues Lossieux,
engraved with anti-Jacobite propaganda.)[3]
The cann is engraved with six panels that
portray the major episodes in the biblical
story of Joseph, including his brothers'
betrayal, his temptation by Potiphar's wife,
his interpretation of the pharaoh's dream,
and his triumphal reunion with his family.
The panels are separated by vertical bands of
stylized foliage and by horizontal bands
containing the captions for each scene.
Leddel probably used illustrations in English
and European Bibles as sources for the
cann's elaborate images.

In choosing the life of Joseph as the sub-
ject for this engraving, Leddel was not sim-
ply playing on his Christian name. A tale of
triumph over adversity, Joseph's story is one
that would have resonated deeply with the
Huguenot Leddel. As a refugee from religious

persecution, separated from the English
branch of his family, he may have seen the
trials in his life as divinely ordained. The
engravings on the cann express Leddel's faith
in God's benevolence and his hope that he,
like his biblical counterpart, would eventu-
ally find success and security in exile.[4] E.E.

Notes
1. Janine E. Skerry and Jeanne Sloane, "Images of
Politics and Religion on Silver Engraved by Joseph
Leddel," *Antiques* 141 (Mar. 1992), 490.
2. *The French in America, 1520–1880*, exh. cat.
(Detroit: Detroit Institute of Arts, 1951), 137; Kristan
Helen McKinsey, "New York City Silversmiths and
Their Patrons, 1687–1750" (master's thesis,
University of Delaware, 1984), 46.
3. The tankard is in the Historic Deerfield collec-
tion, and the beaker is owned by the Museum of
the City of New York. Skerry and Sloane, 1992, 497.
4. Skerry and Sloane, 1992, 498.

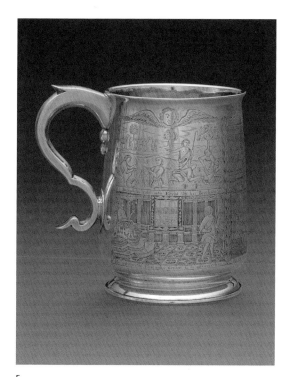

5

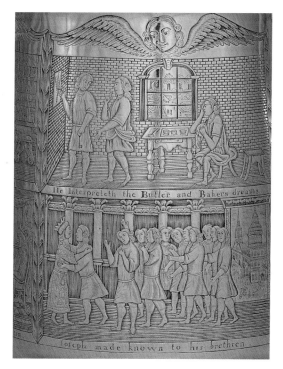

Joseph's interpretation of the pharaoh's dream
and his triumphal reunion with his family

Joseph's brothers' betrayal

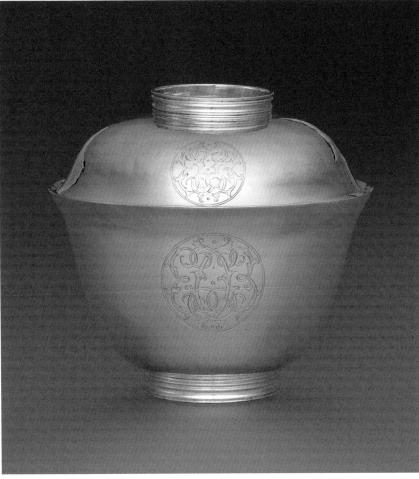

6

6

Simeon Soumaine (b. England,
ca. 1660 or ca. 1685–ca. 1750)
Sugar Bowl
New York City, 1738–45

Silver, h. 4³/₁₆, diam. lip 4¹¹/₁₆ in.
(10.6 x 11.9 cm), wt. 9 oz., 6 dwt. (288 gm)
Mabel Brady Garvan Collection, 1930.1056

This beautifully proportioned sugar bowl has
been called "[one] of the most distinguished
objects in the whole range of American
silver."[1] It was made by Simeon Soumaine, a
silversmith of French Huguenot descent.
He (or possibly a son with the same name)
was baptized in London in 1685 and moved
to New York City by 1689. Soumaine had
his own silversmithing shop there by 1719,
when he registered William Anderson, Jr., as
an apprentice. Like many of his fellow
Huguenot immigrants, Soumaine quickly
assimilated into New York's multiethnic
culture, which was quickly becoming domi-
nated by the English. Instead of joining one
of the city's Huguenot churches, Soumaine
joined and served as a vestryman at Trinity
Church, an Anglican parish. It may have
been there that he met the Cruger family, fel-
low parishioners for whom he made this
bowl. A versatile craftsman, he could work
in English, Dutch, and French styles, a skill
that allowed him to cater to almost every
sector of the population. Soumaine's move
to America and his ability to adapt to New
York's changing culture proved felicitous,
enabling him to rise to the top 10 to 20 per-
cent of the city's taxpayers by the 1730s.

Elizabeth Harris married Henry Cruger in
Kingston, Jamaica, in 1736. The family left
Jamaica in 1738 and returned to New York
City, Cruger's birthplace and a center in the
Atlantic trade economy.[2] As a merchant,
Henry Cruger made his fortune through the
lucrative shipping trade among England,
the West Indies, and the American colonies.

He used some of the massive wealth this
generated to commission a bowl, a salver,
salts, and spoons from Soumaine.

Trade with Asia was also an important
part of the mid-eighteenth-century economy,
and this bowl reflects the West's fascination
with Asian art and culture. Shaped like a
Chinese porcelain rice bowl, the sugar bowl
would have been the perfect prop for the
increasingly popular tea ceremony. Although
its form is based on a Chinese example, the
bowl relies on classical European proportions
for its organization. The shape of the slightly
flaring bowl and its molded foot ring echoes
that of the cover and its handle. The cover
can be inverted to serve as a shallow dish,
possibly for use as a spoon tray. The bowl and
cover are adorned only with the engraved
ciphers "EC," for Elizabeth Cruger.[3] E.E.

Notes
1. Kathryn C. Buhler and Graham Hood, *American
Silver: Garvan and Other Collections in the Yale
University Art Gallery*, 2 vols. (New Haven and
London: Yale University Press, 1970), 2:57, no. 603;
biographical information derives from this source,
in addition to Jon Butler, *The Huguenots in
America: A Refugee People in New York Society*
(Cambridge, Mass.: Harvard University Press,
1983), 178–83; and Deborah Dependahl Waters,
ed., *Elegant Plate: Three Centuries of Precious
Metals in New York City*, 2 vols. (New York:
Museum of the City of New York, 2000), 1:188.
Butler's chronology for Soumaine is slightly differ-
ent from Waters's. See *100 Years of American
Silver, 1690–1790* (New York: Sotheby's, 18 Jan.
2002), 58, lot 464.
2. YUAG Object Files and *100 Years of American
Silver*, lot 464.
3. The cipher design is taken directly from pl. 100
of Colonel Parson's *A New Book of Cyphers* (1704).
Charles F. Montgomery and Patricia E. Kane, eds.,
American Art 1750–1800: Towards Independence,
exh. cat. (New Haven: Yale University Art Gallery,
1976), 186; Buhler and Hood, 1970, 2:57.

7

Johann Christoph Heyne
(b. Germany, 1715–1781)
Flagon
Lancaster, Pennsylvania, 1771

Pewter, 11¼ x 7 5/16 x 6 5/16 in. (28.6 x 18.5 x 16 cm)
Mabel Brady Garvan Collection, 1930.725

Commissioned by a member of the German-speaking Moravian community and made by a German-born pewterer, this flagon reflects a variety of influences and illustrates the adaptation of traditional European forms in their transfer to America. The religious function of the flagon—holding unconsecrated wine during the Communion service—is made clear through its inscription: "for / The Peters Kirche / in Mount Joy Town Ship / von John Dirr / 1771."[1] Half in English, half in German, the engraved words proclaim the acculturation of its maker, Johann Christoph Heyne of Lancaster, and its patron, John or Johannes Dirr, presumably of Mount Joy Township.

The flagon illustrates the aspirations of an immigrant craftsman to practice both his religion and his trade free from Old World strictures. In many areas of Europe, permission to work under a master, to set up one's business, and sometimes even to marry were aspects of life governed by centuries-old artisans' guilds. Because guild membership was often determined by religion, practicing a faith outside the established church could become a career liability. Such circumstances may have influenced Heyne's decision to leave his native Saxony before completing his training. After an interlude in the German port of Stettin (today Szczecin, Poland), Heyne worked for the widow of a pewterer named Jakob Sauer from 1735 to 1737 in Stockholm, according to guild rolls. He also joined the Moravian Church, as his name appears on the manifest of the ship *Catherine*, which, after being denied port in Denmark,

arrived in Philadelphia on 7 June 1742, bearing the Moravians' "First Sea Congregation." Grateful to be in William Penn's more tolerant colony, all non-English passengers, Heyne included, swore their allegiance. Over the next decade, Heyne's path led him to Bethlehem, Pennsylvania, where he worked in an unusual communal metalshop; to Ireland as a missionary; and to Tulpehocken, Pennsylvania, his wife's hometown. By 1757, he had set up shop as an independent pewterer in Lancaster, the largest inland town in colonial America.[2]

Stylistically, this flagon retraces parts of this remarkable journey. Heyne often used expensive brass-casting molds for a variety of purposes. The base relates to Heyne's small patens, or dishes, and the curved handle, shorter than those found on most flagons, may have originally been intended for a tankard. Hollow, it is similar to other Heyne handles, which are in the English style favored in Philadelphia. The cherub-head feet are Germanic; similar feet are found on a Bavarian, strap-handled flagon in Lancaster's Trinity Lutheran Church.[3] Furthermore, the distinctive banding concealing the junction between the lower and upper parts of the body is a regional trait of eighteenth-century Alsatian *Stitzen*, or flagons. Most telling, however, is the spout, a wonderfully abstract sculptural device, which directly links the flagon to eighteenth-century Swedish pewter. Heyne's exceptional flagon expresses a complex cultural identity. c.m.h.

Notes
1. Now Trinity Lutheran Church; see Rev. Frederick S. Weiser, *A Church of Many Names: The Story of Trinity Lutheran Church, Colebrook, Pennsylvania* (Colebrook: published by the Congregation, Mar. 1971).
2. Eric de Jonge, "Johann Christoph Heyne, Pewterer, Minister, Teacher," *Winterthur Portfolio* 4 (1968), 174.

3. "Editor's Attic: 'A Footnote Ahead,'" *Antiques* 20 (Sept. 1931), 145. See also Donald Herr, *Pewter in Pennsylvania German Churches* (Birdsboro: Pennsylvania German Society, 1995), 44.

7

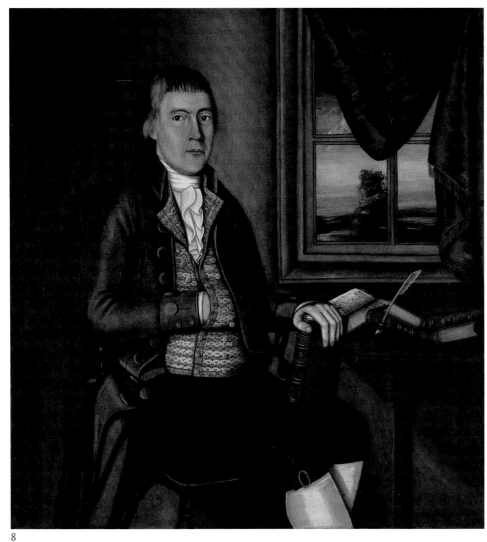

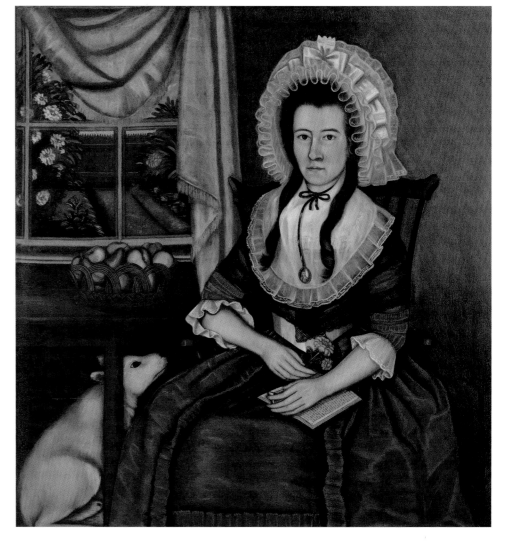

8

The Beardsley Limner
(active ca. 1785–ca. 1800)

Dr. Hezekiah Beardsley and *Mrs. Hezekiah Beardsley (Elizabeth Davis)*, between 1788 and 1790

Oil on canvas, each 45 x 43 in. (114.3 x 109.2 cm)
Gift of Gwendolen Jones Giddings, 1952.46.1 and 1952.46.2

The unidentified artist who painted paired portraits of New Haven, Connecticut, pediatrician Hezekiah Beardsley and his wife, Elizabeth, imbued the exquisitely balanced compositions with details personal to the couple, revealing their love for each other, their religious beliefs, and their reason for commissioning the portraits.[1] Admired by his contemporaries for his avid "reading and reflection" and his "strength of mind which rendered him one of the most independent of men," Dr. Beardsley (1748–1790) pursued pediatrics before the field's importance was widely recognized.[2]

His open-minded spirit is reflected in this portrait. Seated in a Windsor chair that matches his wife's, Dr. Beardsley holds the third volume of Edward Gibbon's recently published *Decline and Fall of the Roman Empire*; the table beside him supports volumes four and five, a quill pen, and a notebook in which he is jotting down "Extracts." In early America, *Decline and Fall* was perceived by some as a warning against the dangers of empire—a check on a growing nation's ambitions. One contemporary critic of Gibbon advised readers to pay "painful attention," as "most men, who have read this history perceive a difficulty in understanding it"; another cautioned that Gibbon "may be read with profit," but only by "one whose religious principles are established."[3] At a time when the historian's opus was exciting controversy, Dr. Beardsley's mining of the

text indicated his engagement with the intellectual issues debated by his community.

The doctor's pen and history tomes mark his public engagement with the secular world; in his wife's portrait, her flowers and book—now identified as the Reverend James Hervey's *Meditations and Contemplations*, open to the chapter "Reflections on a Flower-Garden"—honor her private engagement with a sacred text.[4] Mrs. Beardsley (1748 or 1749–1790) is posed before an enclosed garden, as if interrupted in her devotional reading. The artist's decision to paint her in this way takes on a spiritual and political gloss, because such gardens are associated in art and literature with the Virgin (the *hortus conclusus*), and through her with republican womanhood. In Protestant New England, subtle references to images of Mary at home accorded with the elevation of women as icons of domestic virtue. Following the Revolution, there was widespread concern about how a republic on the unprecedented scale of the United States would socialize its citizens; as a result, women, as wives and mothers, were endowed with a sacred political function. As John Adams declared: "National Morality never was and never can be preserved without the utmost purity and chastity in women; and without national Morality, a Republican Government cannot be maintained."[5] The Reverend Jedidiah Morse, who wrote popular geography books for ladies, considered New England the best "garden" for the growth of republican government, and he compared the state of Connecticut to "a well cultivated garden, which, with that degree of industry that is necessary to happiness, produces the necessities and conveniences of life in great plenty."[6] In adherence to this cultural ideal, gardening was primarily a woman's purview.[7] The neatly planted herbaceous borders and flowering shrubs pictured outside the window in Elizabeth Beardsley's portrait announced

that she had the leisure, resources, and skill to nurture them. The fence behind the parlor or kitchen garden both delineates the limits of the domestic sphere and celebrates her creativity within it.

Mrs. Beardsley's decision to be portrayed contemplating the words of the late unorthodox Calvinist minister Hervey, a leading figure among London-based evangelicals, defined her as deeply involved in New Light religious revivalism, a transatlantic movement.[8] Incendiary New England minister Andrew Croswell wrote to Hervey: "My *Soul cleaves* to yours, from the Acquaintance I have had with your writings."[9] Hervey's books led people like the Beardsleys to join the battle against New England's clerical establishment. In simple terms, Old Light adherents, who believed salvation came through faith *and* good works, labeled Hervey "antinomian" for believing largely in faith alone. A weary Croswell lamented in 1784, "Religion never was at so low an ebb since *America was America*."[10] But a new Awakening was stirring in the late 1780s, when the Beardsleys commissioned these portraits.

Hervey wrote his "Reflections on a Flower-Garden" in the form of a letter to a lady, a kind of informality that made established clergy uneasy. They feared that such spiritual accessibility posed a frightening egalitarianism. Extreme evangelicalism gave rise to the public spectacle of the sexes, races, and classes praying together, dissolving distinctions not only between minister and congregation but also between worshipers of different social rank. Indeed, with prophetic zeal, evangelical Calvinists in New England took up the cause of prison reform and condemned the slave trade.

As if in response to Gibbon's *Decline and Fall*, Hervey repeatedly proclaimed that like the flowers that flourish and fade, "*YES; Ye flowery Nations, Ye must all decay*."[11] Taken

together, the books that the Beardsleys read raise profound questions about the place of religion in the life of the individual and society. Gibbon's arguments against a corrupt Christianity in Rome overlap contemporary ones against the Christian establishment.[12] He implied that what Rome had needed were those who could save it from decay; ministers like Hervey and Croswell—and presumably followers like the Beardsleys—were willing to disrupt the established order to reverse what they perceived as religious and social decline. By including both Gibbon's *Decline and Fall of the Roman Empire* and Hervey's *Meditations and Contemplations* in this marital portrait pair, the Beardsleys declared their urgent concern, driven by a Calvinist evangelicalism, about the state of the world.

Accompanying Hervey on his "delightful Excursion" in "Reflections" uncovers hidden meanings in both portraits, revealing the couple's anxiety about their own fate. In Hervey's survey of "the neighbouring *Country*," his words call forth the view through Dr. Beardsley's window. The vast landscape suggests the breadth of his accomplishments as a physician, as well as his own need for healing, because the wilderness is the source through "Divine Beneficence" of "an abundance of those *Herbs*, which assuage the Smart of our Wounds, and allay the fiery Tumults of the Fever . . . and, thereby, repair the Decays of our enfeebled Constitutions." Furthermore, "like well-disposed Shades in Painting," this "uncultivated" scene serves as a "Foil" for the "ornamented Parts of the Landscape," described in "Reflections" and mirrored in the enclosed garden in his wife's portrait. Hervey elevated the "small *Inclosures*" found in a "plain and frugal Republic," dotted with the "friendly Warmth" of "*Kitchen-Gardens*," above the "Pomp of Courts" that "affect finery." The domestic plantings, the "very Perfection of

Decency," pay tribute to a woman's household management: "Here, those celebrated Qualities are eminently united, the utmost Simplicity with the exactest Neatness.—A skilful Hand has parceled out the whole Ground, into narrow Beds, and intervening Alleys. . . . If it be pleasing to behold their orderly Situation, and their modest Beauties; how much more delightful, to consider the Advantages, they yield! . . . Why then should the *Possessor* of so valuable a Spot, envy the Condition of Kings?"[13] Hervey's preference for the humble over the royal accorded with his evangelical appeal across class lines and found an echoing spirit in Gibbon's denunciation of Rome's excesses.

The pears and apples depicted in the basket beside Mrs. Beardsley answer Hervey's prayer: "Let the *Pear-tree* suckle her juicy Progeny; till they drop into our Hands, and dissolve in our Mouths. . . . And as for the *Apples*, that staple Commodity of our *Orchards*, let no injurious Shocks precipitate them immaturely to the Ground; till revolving Suns, have tinged them with a ruddy Complexion, and concocted them into an exquisite Flavour." A common emblem of fertility, the fruit strikes a poignant chord in the portrait of Elizabeth Beardsley, who never bore children. She holds Hervey's *Meditations* forever open to this passage: "If His sacred Will, ordains *Sickness* for thy Portion; never dare to imagine, That uninterrupted Health would be more advantageous. If He pleases to with-hold, or take away, *Children*; never presume to conclude, That thy Happiness is blasted, because thy Hopes of an increasing Family are disappointed. . . . HE orders all the *Peculiarities*, all the *Changes* of thy State, with a . . . Goodness, that endureth for ever. . . . Rest satisfied, That *whatever is*, by the Appointment of Heaven, *is right*, is best."[14] Facing childlessness and her own and her husband's declining health, she finds in "Reflections" a personal

Redeemer to lead her down the garden path to salvation, if she accepts His will. Mrs. Beardsley holds flowers picked from her simultaneously real and symbolic garden; at various stages of growth, from a bud of hope to an open flower of maturity, they evoke the cycle of life, its beauty and brevity.

Hezekiah's portrait is diminutively mirrored in hers, for Elizabeth wears a miniature of him over her heart as a token of lasting affection. A symbol of fidelity, the dog seated at her knees gazes at the miniature of Dr. Beardsley, to whom Mrs. Beardsley has vowed her loyalty. In contemporary allegories of both romance and mourning, the miniature and the dog are emblems of undying devotion. As the passage Mrs. Beardsley contemplates reveals, the couple likely chose to memorialize their love in these companion portraits because both of them were suffering from ill health in the late 1780s. The painted allusions to "Reflections on a Flower-Garden" attest to their finding consolation in prayer. But they also sought medical help for their illnesses. In 1789, the doctor accompanied his wife to Savannah in the hope that warm weather would cure her. He was afflicted with consumption and returned home, probably to seek treatment from colleagues in New Haven. Not long after these portraits were painted, Hezekiah and Elizabeth Beardsley died, each without the other knowing, many miles apart, within three weeks of each other.[15] R.J.F.

Notes

1. This discussion builds on Christine Skeeles Schloss, *The Beardsley Limner and Some Contemporaries: Postrevolutionary Portraiture in New England, 1785–1805* (Williamsburg, Va.: Colonial Williamsburg Foundation, 1972), esp. 19–23; and Robin Jaffee Frank, *Love and Loss: American Portrait and Mourning Miniatures*, exh. cat. (New Haven: Yale University Art Gallery, and New Haven and London: Yale University Press, 2000), 22–31.
2. Obituary in the *Connecticut Journal*, 10 May

1790, quoted in Frederick G. Kilgour, "Portraits of Doctor Hezekiah Beardsley and His Wife, Elizabeth," *Connecticut State Medical Journal* 17 (Apr. 1953), 299.
3. "Webster's Criticisms upon Gibbon's History," *Massachusetts Magazine* 1 (Aug. 1789), 475. Anonymous letter to the editor, dated 17 Dec. 1787, *American Museum* 3 (Feb. 1788), 183.
4. Among the books listed in the "Inventory of Hezekiah Beardsley, 1790," Connecticut State Library, is "*2 Vol Herveys Meditations*"; "REFLECTIONS," which appears as a page heading in the portrait of Elizabeth Beardsley, matches the headings on the left side throughout the chapter "Reflections on a Flower-Garden" in Reverend James Hervey, *Meditations and Contemplations*, originally published in 1746. While it is difficult to determine with certainty which of the numerous editions the sitter holds, it probably is the twentieth, published in London by John and Frances Rivington et al. in 1774; it appeared in two volumes, in accord with Dr. Beardsley's "Inventory," and the "Reflections" chapter includes page 191, visible in the painting.
5. John A. Schutz and Douglas Adair, eds., *The Spur of Fame: Dialogues of John Adams and Benjamin Rush, 1805–1813* (San Marino, Calif.: Huntington Library, 1966), 76.
6. Jedidiah Morse, *American Geography, or, A View of the Present Situation of the United States of America* (Elizabeth, N.J., 1789), 218–19.
7. Rudy F. Favretti, *Early New England Gardens, 1620–1840*, 2nd ed. (Sturbridge, Mass.: Old Sturbridge Village, 1966), 3, 9–11.
8. In addition to Hervey's *Meditations*, the Beardsley inventory includes "Watts *Sermons*" and "*Lyricks*," a reference to Isaac Watts (1674–1748), a nonconformist hymn writer.
9. On Croswell and Hervey, I am indebted to Leigh Eric Schmidt, "'A Second and Glorious Reformation': The New Light Extremism of Andrew Croswell," *William and Mary Quarterly*, 3rd. ser., 43, 2 (Apr. 1986), 244. I thank Jon Butler for calling this article to my attention and for his insights.
10. Ibid., 244.
11. Hervey, 1774, 1:225, 227, and 228.
12. Controversy persists regarding Gibbon's views of Christianity. See Paul Turnbull, "The 'Supposed Infidelity' of Edward Gibbon," *Historical Journal* 25 (Mar. 1982), 23–41; Keith Windschuttle, "Edward

Gibbon and the Enlightenment," *New Criterion* 15 (June 1997), 20–26; David Wootton, "Narrative, Irony, and Faith in Gibbon's *Decline and Fall*," *History and Theory* 33 (1994), 77–106.
13. Hervey, 1774, 1:135–41.
14. Ibid., 138, 189–91; also see n. 5 above.
15. Schloss, 1972, 20, 23.

Edward Hicks (1780–1849)

9

The Peaceable Kingdom, 1829–30

Oil on canvas, 17½ x 23½ in. (44.5 x 59.7 cm)
Bequest of Robert W. Carle, B.A. 1897, 1965.46.2

10

*The Peaceable Kingdom and
Penn's Treaty*, 1845

Oil on canvas, 24¼ x 31 in. (61.6 x 78.7 cm)
Bequest of Robert W. Carle, B.A. 1897, 1965.46.3

*The wolf also shall dwell with the lamb,
and the leopard shall lie down with the kid;
and the calf and the young lion and the
fatling together; and a little child shall
lead them.*

—Isaiah 11:6–7

Deriving his subject matter from the Old
Testament, the Quaker minister and painter
Edward Hicks is best known for his so-called
Peaceable Kingdom pictures, of which sixty-
two are known to exist.[1] Born in Bucks
County, Pennsylvania, Hicks was appriced
to a coachmaker at the age of thirteen. In his
Memoirs, Hicks recalls that during his
apprenticeship, he was "unfortunately
introduced to those places of diversion called
apple frolics, spinning frolics, raffling
matches, and indeed all kind of low convivial
parties, so peculiarly calculated to nourish
the seeds of vanity and lies."[2] Following a
time of "licentious lewdness" and influenced
by the acquaintance of prominent Quakers,
Hicks became deeply introspective and in
1803 joined the Society of Friends. By 1811,
Hicks was acknowledged as a "Friend that
had a gift in the ministry" and became a
preacher of the Quaker sect.[3]

Quakerism began to affect every aspect
of Hicks's life, including his trade as a
painter. As a devout adherent of a tradition-
ally iconophobic denomination, Hicks was

10

burdened by feelings of hypocrisy that caused him, around 1815, to give up painting for a year or two. He tried farming, at which he failed miserably. By mid-1816, Hicks had returned to ornamental painting and also begun to make easel paintings, which he primarily gave, sold, or traded to his family, acquaintances, and fellow Friends. Chief among these were his *Peaceable Kingdom* paintings.

During the 1820s, a severe rift formed within the Society of Friends, which ultimately led to the Separation of 1827, dividing Quakers into two antagonistic sects: the Orthodox and the Hicksites. The former group was so named by its opponents because of its purported ties to the Episcopal Church and the Church of England. The latter group was named for Elias Hicks, the artist's second cousin, who was a leading minister and a proponent of "extreme quietism," the belief that only by quieting worldly concerns in one's consciousness could the individual "spontaneously receive from God the divine revelation of the 'inner light.'" Elias charged the Orthodox Quakers with placing undue importance on Scripture, which he held to be the work of man, a "collection of divinely inspired allegories" that were "symbolic rather than literal in meaning."[4]

Although *The Peaceable Kingdom* paintings were inspired by Scripture, the curious mixture of secular and religious imagery yields a symbolic allegory of Hicks's own invention (cat. no. 9). In the foreground, Hicks depicted Isaiah's prophecy of God's kingdom on earth, but in the background he painted a host of Quaker worthies—including William Penn and Elias Hicks—bathed in light and enveloped by a flowing banner with inscriptions paraphrased from the Book of Luke (2:10–11, 14).[5] Orthodox Quakers would have been affronted by this portrayal of Elias Hicks and its effusion of light, an

allusion to the "inner light" of Hicks's sermons.[6] The *Kingdom* pictures clearly serve as calculated Hicksite propaganda, but they also represent the painter's earnest desire for peace between the two Quaker factions: their split is represented by the shattered tree trunk before which a menagerie of typically discordant beasts lie down in perfect harmony.

The Peaceable Kingdom and Penn's Treaty of 1845 (cat. no. 10), a late work, reiterates Hicks's plea for peace, while epitomizing his penchant for combining the American with the biblical. Here, Virginia's Natural Bridge provides a dramatic backdrop for the unusual menagerie.[7] Thomas Jefferson called this 215-foot-tall limestone arch "the most sublime of nature's works . . . springing as it were up to heaven!"[8] Hicks would have undoubtedly seen the Natural Bridge as a divine creation, and his use of it in the *Kingdom* canvases conveys his belief in God's presence in nature, while marking the scene as uniquely American.

In the background, a vignette depicts William Penn's 1682 treaty with the Lenni Lenape. The motif appears frequently in Hicks's *Kingdom* paintings of the 1820s and was derived from Benjamin West's celebrated 1771–72 painting *Penn's Treaty with the Indians* (fig. a), in which the artist depicted Penn as an exemplar of peacemaking who desired to win "the love and friendship" of the Lenape Nation "by a kind, just, and peaceable life."[9] By including Penn, a figure venerated by Hicksite and Orthodox Quakers alike, Hicks reminded his quarreling brethren of the ideals of friendship and peace for which the famous Quaker was remembered.

G.C.B.

Notes

1. The examples in Yale's collection were bequeathed by Hicks's great-grandson. For a discussion of these paintings, see Carolyn J. Weekley, *The Kingdoms of Edward Hicks* (Williamsburg, Va.: Colonial Williamsburg Foundation, 1999).

2. Edward Hicks, *Memoirs of the Life and Religious Labors of Edward Hicks* (Philadelphia: Merrihew & Thompson Printers, 1851), 35.

3. Ibid., 36, 58.

4. David Tatham, "Edward Hicks, Elias Hicks and John Comly: Perspectives on the Peaceable Kingdom Theme," *American Art Journal* 8 (spring 1981), 41, 43.

5. The figure shown in profile, handkerchief in hand, has been definitively identified as Elias Hicks; it was derived from a silhouette portrait. See Alice Ford, *Edward Hicks: His Life and Art* (New York: Abbeville Press, 1985), 78–79.

6. Tatham, 1981, 44.

7. Hicks employed this geological wonder in his early *Kingdoms* and probably derived the motif from a vignette on a map of North America published in 1822. See Weekley, 1999, 95, figs. 84 and 85.

8. Thomas Jefferson, Query 5: "Cascades: Its Cascades and Caverns?" (1781–82), *Notes on the State of Virginia* (1785; Boston: Wells and Lilly, 1829), 21–22.

9. William Penn, letter "To the King of the Indians," London, 18 Oct. 1681, in Richard S. Dunn and Mary Maples Dunn, eds., *The Papers of William Penn*, 5 vols., 1680–84 (Philadelphia: University of Pennsylvania Press, 1982), 2:128.

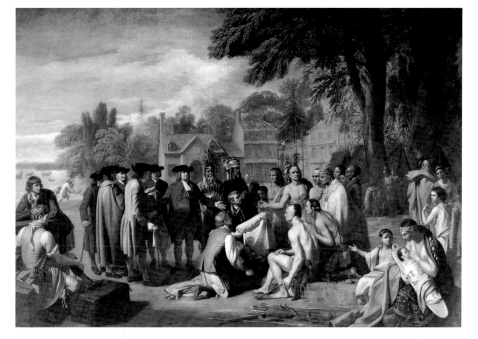

fig. a Benjamin West, *Penn's Treaty with the Indians*, 1771–72. Oil on canvas, 75 1/2 x 107 3/4 in. (191.8 x 273.7 cm). Courtesy of the Pennsylvania Academy of the Fine Arts, Philadelphia, Gift of Mrs. Sarah Harrison (The Joseph Harrison, Jr., Collection), 1878.1.10

11

along their rims. They have heavy base moldings with applied ornament and are sometimes engraved with medallions containing figures representing Faith, Hope, and Charity.[2] Although the form and organization of this beaker reflect Dutch precedents, the subject matter of its engraving is radically different from other Dutch examples.

The engravings are taken from illustrations by Adriaen van de Venne for the emblem book of Jacob Cats (fig. a). Highly popular in post-Gutenberg Europe, emblem books were collections of illustrated allegorical poems and mottoes. Through both verbal and visual symbols, they helped communicate religious, philosophical, and social values. The moral lessons and standards of behavior promoted by emblem books made them especially important didactic tools for the Dutch, whose mercantile economy depended on the successful maintenance of interpersonal relationships. Vander Burgh could easily have had access to Cats's work, since the fables were popular reading among Dutch New Yorkers.[3]

The allegories on the beaker depict qualities that Livingston might have valued in a business associate like Sandersen. Two of the medallions feature recognized allegories for integrity (an ermine surrounded by mud, starving itself rather than soiling its coat) and hard work (geese braving the marsh to find food). Three more allegorical scenes with a sardonic twist are engraved around the base of the beaker. They symbolize humility (an eagle lifting a tortoise only to drop him on rocks), faithful love (a crocodile that continues to grow even as death draws near), and magnanimity (shown here), a brutal depiction of the Golden Rule, in which each animal is devoured by a larger beast, reminding the viewer that "whatsoever you do to the weak will be visited upon you by those stronger than yourself."[4] E.E.

Converging Cultures

11

Cornelius Vander Burgh
(ca. 1653–1699)
Beaker
New York City, 1685

Silver, h. 8, diam. lip 4 15/16 in. (20.3 x 12.2 cm),
wt. 15 oz., 14 dwt. (487 gm)
Mabel Brady Garvan Collection, 1932.100

Although it was made for an English patron, this large beaker reflects the Dutch culture that dominated in New York in the late seventeenth century. Made by Cornelius Vander Burgh, it was presented to Robert Sandersen (1641–ca. 1691) of Schenectady in 1685. The Protestant Sandersens fled England for Holland during the reign of Mary II, eventually settling in Dutch-controlled New York. Sandersen probably received the beaker as a token of gratitude from Robert Livingston, a Scottish merchant and patron, after he served as an interpreter to help Livingston acquire a large tract of land from local Indians.[1]

This beaker is a secular example of a form often seen in seventeenth-century Dutch ecclesiastical silver. As the New York–born child of Dutch and German parents, Vander Burgh would probably have been familiar with this form. Such beakers generally feature engraved strapwork and floral sprays

Notes

1. The beaker is engraved "To Robbert Sandersen," but the family later changed their name to Sanders. Kathryn C. Buhler and Graham Hood, *American Silver: Garvan and Other Collections in the Yale University Art Gallery*, 2 vols. (New Haven and London: Yale University Press, 1970), 2:8, no. 553.

2. Mrs. Russel Hastings, "Cornelius Vanderburgh–Silversmith of New York, Part First," *Antiques* 29 (Jan. 1936), 10–11; C. Louise Avery, *Early American Silver* (1930; repr. New York: Russell & Russell, 1968), 129–35.

3. Allison B. Leader, "Historical Emblems: A Provisional Definition of the Genre," in *Reinventing the Emblem: Contemporary Artists Recreate a Renaissance Idea*, exh. cat. (New Haven: Yale University Art Gallery, 1995); Roderic H. Blackburn and Ruth Piwonka, *Remembrance of Patria: Dutch Arts and Culture in Colonial America, 1609–1776*, exh. cat. (Albany, N.Y.: Albany Institute of History and Art, 1988), no. 299.

4. Mrs. Russel Hastings, "The Sanders-Garvan Beaker by Cornelis VanderBurch," *Antiques* 27 (Feb. 1935), 54.

fig. a Adriaen van de Venne, "L'araigne mange la mouche, & le lizard l'araigne, &c.," from Jacob Cats, *Alle de Wercken, So ouden als nieuwen* (Amsterdam: Jan Jacobsz Schipper, 1658). Yale Center for British Art, Paul Mellon Collection

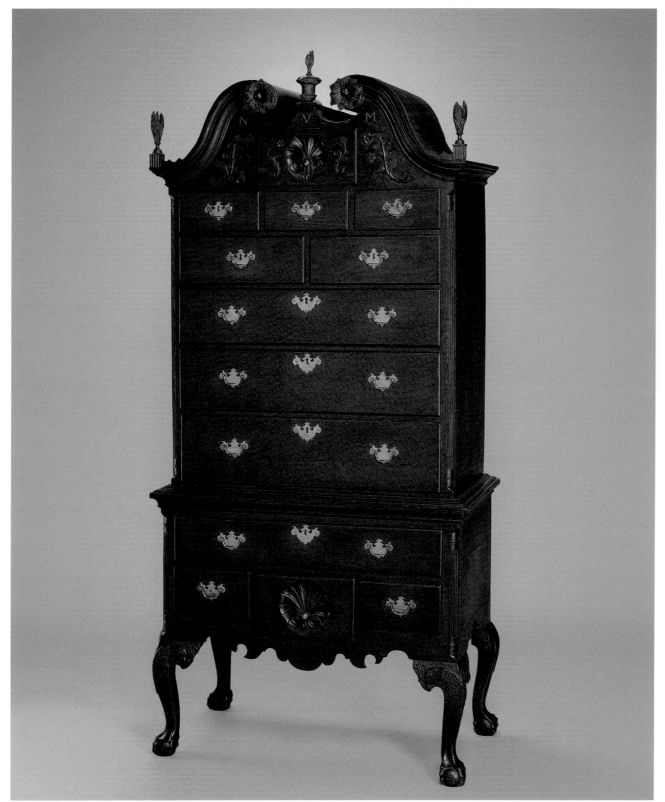

12

Possibly by Samuel Henszey
(worked 1767)
High Chest of Drawers
Pennsylvania, 1765–70

American black cherry, southern yellow pine, and Atlantic white cedar, 94½ x 44 x 23 1/16 in. (240.1 x 111.8 x 58.5 cm)
Mabel Brady Garvan Collection, 1930.2632

This high chest of drawers shows the influence of Germanic culture in the design of late-colonial furniture in southeastern Pennsylvania. The choice of a high chest for storing clothing and textiles rather than a traditional Germanic form such as a two-door cupboard, or *Schrank*, indicates the dominance of the English cabinetmaking style of Philadelphia. The carved rosettes and finials on the scrolled pediment and the shell motifs in the upper and lower drawers show the influence of English furniture designs; however, the Germanic flavor of the piece is evident in other aspects of the construction and decoration.

The figures of birds with flowers in their beaks relate to motifs found on Pennsylvania German legal documents, called taufscheine, used by German settlers to commemorate births, deaths, and, less often, marriages.[1] The birds, carved into the knees, are similar to hand-painted birds that adorn a taufschein made by the artist Friedrich Krebs for a patron in Northampton County (fig. a).[2] Also similar to those in such documents are the scrolled vine-and-leaf motifs on either side of the upper drawer. The initials "NVM" inlaid at the top of the pediment, probably those of the original owner, function in the same way as the written text on the taufschein. Only rarely are the names or initials of the owners recorded on high chests, but it is more common to find such inscriptions, particularly inlaid ones, on Germanic forms of furniture.[3] High chests, large and expensive

furniture typically used in a bedchamber, were sometimes given as wedding gifts or a dowry.

A second closely related high chest displays the initials "SG" and the date October 15, 1767 painted on the back of the pediment. The lower case bears the inscription "Made by S. Henszey." The inscription "by Samuel . . . " appears faintly on the top of the lower case of the Yale example.[4] These inscriptions suggest that Samuel Henszey, an as yet unidentified craftsman working about 1767, may have made the two high chests.

D.A.C.

Notes

1. Frederick S. Weiser, "Fraktur," in Scott T. Swank et al., *Arts of the Pennsylvania Germans* (New York and London: W. W. Norton & Co. for the Henry Francis du Pont Winterthur Museum, 1983), 231.
2. The author thanks James Beachley for suggesting this comparison.
3. For examples of *Schränke* and painted chests, see Benno M. Forman, "German Influences in Pennsylvania Furniture," in Swank et al., 1983, 102–70.
4. Gerald W. R. Ward, *American Case Furniture in the Mabel Brady Garvan and Other Collections at Yale University* (New Haven: Yale University Art Gallery, 1988), 286.

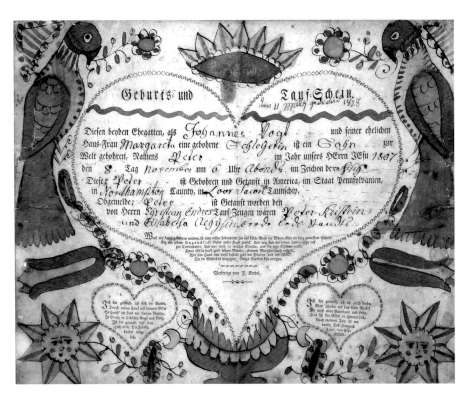

fig. a Friedrich Krebs, *Taufschein*, ca. 1807. Watercolor and ink on paper, 13 x 16 1/8 in. (33 x 41 cm). Private collection

13

New Bremen Glassmanufactory
(1784–95)
Tumbler
New Bremen, Maryland, 1789

Blown colorless, nonlead glass, h. 5 11/16, diam.
rim 4 11/16, diam. base 3 3/4 in. (14.4 x 11.9 x 9.5 cm)
Mabel Brady Garvan Collection, 1935.258

As one of the most specialized of early
American crafts, glassmaking depended on
foreigners, many of whom were of German
heritage. Since the establishment of the first
glasshouse at Jamestown, Virginia, in 1608,
entrepreneurs had solicited skilled artisans
overseas, often paying ship's passage.[1]
John Frederick Amelung (1741–1798) left
Hannover in the spring of 1784, sailing
with sixty-eight others—including glass-
blowers from Bohemia, Thuringia, and vari-
ous parts of Germany—"three different
Glass Ovens," initial backing from Bremen
merchants for a company run by Amelung,
and letters of introduction from Benjamin
Franklin and John Adams.[2]

Of the eighteen major glassmakers who
worked in the years immediately following
the Revolution, Amelung alone had prior
experience. He brought with him a knowl-
edge of the medium and management skills
honed during eleven years at his brother's
looking-glass factory. He also brought the
sense of civic responsibility that comes from
running a factory town, and he endeavored
to build houses and schools in New Bremen
to attract more workers from Europe. By all
accounts, production was varied, from "bot-
tles, window to flint glass," but it was the
elaborate engraving that won him fame and
attracted support for his new enterprise.[3]

Between 1788 and 1792, several specially
engraved pieces like this tumbler were pre-
sented to politicians, merchants, and finan-
cial backers—including a pair of engraved
goblets delivered to George Washington
at Mount Vernon. With straightforward
simplicity in its largish form, this tumbler,
called the "Boston tumbler," was probably
presented to Thomas Walley, a partner in
the Boston Crown Glass Company. The
inscription expresses the camaraderie
among young industries in the new republic.
The real threat remained the flood of inex-
pensive and reasonably well-made imported
glass, against which Amelung petitioned
Congress on more than one occasion to
raise tariffs. Mounting costs coupled with
competition and a devastating fire on
7 May 1790 led the New Bremen venture to
close in 1795. C.M.H.

Notes

1. Arlene Palmer Schwind, "The Glassmakers of
Early America," in Ian M. G. Quimby, ed., *The
Craftsman in Early America* (Winterthur, Del.:
Henry Francis Du Pont Winterthur Museum, and
New York and London: W. W. Norton & Co., 1984),
158–60.
2. The most complete history of the firm is
Dwight P. Lanmon, Arlene Palmer Schwind, et al.,
*John Frederick Amelung: Early American
Glassmaker* (Corning, London, and Toronto:
Corning Museum of Glass Press and Associated
University Presses, 1990).
3. Ibid., 136–37.

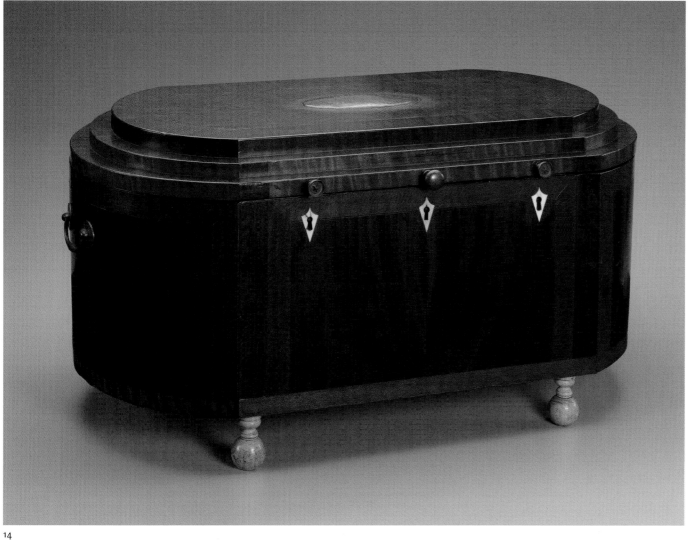

14

14

John Bower (active 1809–19), engraver
Coffer
Philadelphia, 1816

Mahogany, maple and maple veneer,
yellow poplar, cherry, ivory, and brass,
16¼ x 30⅜ x 16¼ in. (41.3 x 77.2 x 41.3 cm)
Mabel Brady Garvan Collection, 1936.312

This coffer or strongbox, built to store
money and other valuables, documents the
changing identity of early-nineteenth-
century Philadelphia's German population.
From 1683 to 1820, some seventy-five thou-
sand Germans fleeing economic instability
and political unrest settled in and around
Philadelphia and southeastern Pennsylvania.
Historians have long argued that these immi-
grants and their children took deliberate
steps to retain elements of their heritage.[1]
These steps are evident on the lid of the
coffer, where a brass plaque decorated with
an elaborate German inscription reads:
"Die Hermann Unterstützungs / PHILAD[A] /
Incorporit den 1sten May IM JAHR 1816 /
Brüderschafft" (The Hermann Relief Brother-
hood, Incorporated in Philadelphia, May
1st 1816). The name "Hermann" probably
derives from the German national folk hero
Arminius, who defeated the Roman army
in A.D. 9 and was championed in the early
nineteenth century as a symbol of the
German resistance to Napoleon's armies.[2]
"Relief Brotherhood" suggests that the
coffer was made for one of the numerous aid
societies established by second-generation
Philadelphia Germans to provide clothing,
housing, food, medicine, and money
to needy German immigrants who had
recently arrived in the city.[3] The society
may have been one of the organizations
with similar English names, including
the Relief Beneficial Society and the True
Beneficial Society, which were listed as
"incorporated in 1816."[4]

The ethnic heritage of the piece is emphasized by the inscription's language and its reference to a prominent folk hero, as well as by its tie to an organization that was meant to serve Philadelphia's German population. Nevertheless, little about the design of the coffer is particularly German. Both the oval shape and the placement of the four feet bear a clear relationship to Philadelphia's astragal-shaped sewing tables, which were derived from English precedents. Turned ivory feet were also widely produced by Philadelphia's Anglo-American craftsmen, as early-nineteenth-century advertisements attest.[5] These English attributes tie the coffer to other assimilatory aspects of the early-nineteenth-century Philadelphia German population, such as their integration into the mainstream economy and their adoption of English names. This assimilation would eventually require the Germans' "abandonment of old allegiances and German identity."[6] The coffer's balance of ethnic heritage and integration represents a point on the trajectory of this change. E.L.

Notes

I thank Michael Heindorff of the German Society of Pennsylvania for his assistance in my research for this text.

1. Swank, "The Germanic Fragment," in Scott T. Swank et al., *Arts of the Pennsylvania Germans* (New York and London: W. W. Norton & Co. for the Henry Francis du Pont Winterthur Museum, 1983), 3–18.

2. Gerald W. R. Ward, *American Case Furniture in the Mabel Brady Garvan and Other Collections at Yale University* (New Haven: Yale University Art Gallery, 1988), 78. It has been suggested that a connection exists between the "Hermann" on the inscription and Philadelphia's Hermann Masonic lodge; however, little evidence supports this contention: no Masonic symbolism decorates the coffer, and the Hermann lodge was established in 1810 rather than 1816.

3. Erna Risch, "Immigrant Aid Societies Before 1820," *Pennsylvania Magazine of History and Biography* 60 (Jan. 1936), 15–33.

4. John Paxton, *Philadelphia Directory and Register* (Philadelphia: B. and T. Kite, 1817 and 1818), cxvii, cxx. A later Philadelphia organization with a similar name, Deutschen Philadelps Unterstützungs Brüderschafft, was incorporated in May 1828 to provide aid. See *Constitution of the German Philadelphia Benevolent Brotherhood* (Philadelphia: F. W. Thomas, 1847).

5. John Paxton, *Philadelphia Directory and Register* (Philadelphia: B. and T. Kite, 1819), n.p. The author thanks Alexandra Kirtley for this reference.

6. Swank, "The Germanic Fragment," in Swank et al., 1983, 5.

15

Antoine Oneille (b. Canada, ca. 1764–1820)
Pitcher
Sainte Genevieve, Missouri, 1810–15

Silver, h. 4½, diam. 6¼ in. (29.2 x 15.9 cm), wt. 34 oz. (1058 gm)
Josephine Setze Fund for the John Marshall Phillips Collection, 1999.84.1

This silver pitcher was made between 1810 and 1815 in Sainte Genevieve, Missouri, an area that was then called the Illinois Country. In the eighteenth century, immigrants from France and French Canada settled the Illinois Country, which corresponds to present-day Missouri and Illinois. The region was ceded to Spain in 1762, returned to France in 1800, and sold to the United States as part of the Louisiana Purchase in 1803. French-Canadian and Creole culture dominated in the area until the early nineteenth century, when American influences gradually began to take over. This pitcher's maker and owner were both of French descent, and the object looks to high-style French silver of this era for its form and decoration.

Antoine Oneille, the Quebec-born silversmith who made the pitcher, worked in Canada; Detroit; Vincennes, Indiana; and Sainte Genevieve. His peripatetic career took him to towns that were centers of the fur trade, where the constant need for Indian trade silver would have guaranteed him work. Trade-silver pieces, with the occasional piece of hollow ware, probably made up the bulk of his output. Although spoonmakers were active in many rural locations, larger pieces

15

of silver were often made in urban centers, shipped out to smaller markets, and stamped for retail with a local silversmith's mark. However, construction evidence suggests that Oneille made this pitcher himself. Details such as uneven thickness of the body wall, unusual soldering techniques showing poor temperature control, a solid rather than hollow-cast handle, and molding that was cut rather than drawn are all signs that this piece was made in a frontier workshop without access to the specialized tools and equipment that an urban silversmith would possess. Nevertheless, in form and decoration, the piece mimics the neoclassical style of urban work of the period.[1]

The engraved initials "CR" inside a bright-cut medallion with a bowknot stand for Constance Roy and may have been part of her wedding silver when she married Ferdinand Rozier in Sainte Genevieve in 1812 or 1813. Rozier immigrated to the United States from France in 1806 with his business partner, John James Audubon. They initially went to Pennsylvania to supervise Audubon's father's mining interests, but soon decided to move west and try their luck as merchants. They eventually chose to settle in Sainte Genevieve, the oldest white settlement in Missouri. Audubon soon left the business to pursue his artistic interests, but Rozier remained at the shop in Sainte Genevieve, becoming a leading member of the community and occasionally making trips to New Orleans and France to visit friends and relatives.[2] E.E.

Notes

1. Michael J. Weller, "A New Pitcher from the Missouri Frontier," *Silver* 30 (Nov.–Dec. 1998), 55.
2. There is some confusion as to their marriage date. Weller, 1998, lists it as 1812, while it is given as 1813 in Mary Rozier Sharp and Louis J. Sharp III, *Between the Gabouri: A History of Ferdinand Rozier and "Nearly" All His Descendants* (Sainte Genevieve, Mo.: Histoire de Rozier, 1981), 12–24, 33–35, and 46–49.

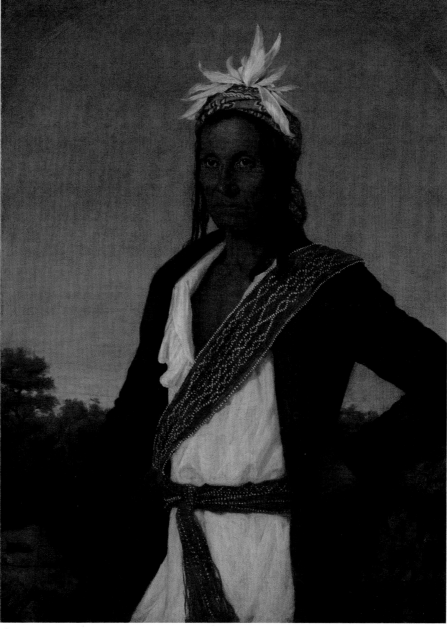

16

16

William John Wilgus (1819–1853)
Captain Cold, or *Ut-ha-wah*, 1838

Oil on canvas, 40 x 30 in. (101.6 x 76.2 cm)
Gift of de Lancey Kountze, B.A. 1899, 1939.39

Ut-ha-wah (d. 1845), chief of the Onondaga, was nicknamed Captain Cold by white colonists.[1] With the Cayuga, Mohawk, Oneida, Seneca, and Tuscarora, all Iroquois-speaking peoples who lived in contiguous regions, the Onondaga comprised a confederacy known among themselves as the Haudenosaunee and as the Six Nations or Iroquois to colonists. Their territory extended from the Hudson River to Lake Erie. Like many Six Nations people, Ut-ha-wah distinguished himself while fighting on the American side during the War of 1812, a conflict in which his people were pitted against one another by their American and British allies. He was wounded leading the Onondaga in battle against pro-British Iroquois at Fort George on 17 August 1813.[2] In addition to his role in military engagements, Ut-ha-wah held an important position within the Haudenosaunee Confederacy. He was the Thadodaho or Atorarho, responsible for keeping the council fire and wampum records of the Haudenosaunee at the central fire on the Buffalo Creek reservation.[3] Wilgus's psychologically complex portrait reveals the different roles its sitter assumed in peacetime and in war.

Ut-ha-wah is represented in a dramatic pose derived from classical sources and typically reserved for military heroes. His introspective gaze subverts the painting's celebratory tone, giving it an elegiac feeling at odds with the militaristic bravura of the pose. His dress is a combination of indigenous and European elements, typical of that worn by Iroquois in the early nineteenth century: a loose, ruffled shirt with an open

neck, a regimental jacket, and a beaded sash that crosses the chest military style and knots around the waist like a belt. He wears a printed turban ornamented with a spray of white feathers, characteristic of Indian dress in the Northeast at this time. His hybrid costume conveys the extensive exchange of material culture between American Indians and Euro-American settlers that had been ongoing for several generations by the time this portrait was painted. Buffalo Creek, situated near both American and British forts, was a site of lively intercultural trade. The portrait was painted the same year that a fraudulent treaty was concluded at Buffalo Creek, ceding all Haudenosaunee lands in western New York State. Following protests, a modified treaty restored some of the reservation communities in 1842, but Ut-ha-wah and other Buffalo Creek residents were forced to leave their homes on the reservation.

William John Wilgus is best known for his depictions of New York Indians, reflecting his era's fascination with Native Americans. Indian portraits, histories, biographies, and fiction became popular between 1830 and 1850. The significant, often contradictory roles that Native Americans had played in the War of 1812 excited public interest. During the same period, Andrew Jackson's Indian Removal Act of 1830 mandated the forced mass deportation of Indians from their ancestral lands. Ironically, popular fascination with Indians increased as they "disappeared" from the American landscape through relocation to more remote areas of the country. G.G. *and* A.M.

Notes

1. The name derived from "the severity of the weather at the time of his birth." Joshua Victor Hopkins Clark, *Onondaga: or, Reminiscences of Earlier and Later Times*, 2 vols. (Syracuse: Stoddard and Babcock, 1849), 1:109.
2. "Official," The Military Monitor and American Register, 5 Sept. 1813, 1.

3. See Daniel K. Richter, *The Ordeal of the Longhouse: The Peoples of the Iroquois League in the Era of European Colonization* (Chapel Hill: Published for the Institute of Early American History and Culture, Williamsburg, Va., by the University of North Carolina Press, 1992). Richter notes, "In recognition of the Onondaga leader's prominent role, he and [the Onondaga people] . . . act[ed] as 'firekeepers,' or hosts and moderators, for a Grand Council of fifty Sachems," which met first at Onondaga and later moved, during the Revolutionary War, to Buffalo Creek (39).

17

Daniel Christian Fueter (b. Switzerland, 1720–1785), designer
George III Indian Peace Medal, so-called *Happy While United Medal*
New York City, 1764

Silver, wt. 54 gm, 12:00, 54 mm
Mabel Brady Garvan Collection, 1932.85

As the British and the French vied for control of the resource-rich land of the Great Lakes region, both used peace medals as well as gifts of guns, gunpowder, bullets, and blankets to secure the allegiance of local Indian tribes, whose combat skills made them desired allies for the warring Europeans. In 1761, in an effort to cut expenses, Lord Jeffrey Amherst, British commander in chief for North America, had eliminated the occasional giving of gifts to the Indians and closed all British forts to them, thereby cutting tribes off from the gunpowder and bullets they relied on for hunting.[1]

Amherst's parsimonious policies enraged the Indians, particularly those accustomed to

the generosity of the French, and in the spring of 1763, Pontiac (1720?–1769), a charismatic Ottawa chief, led a confederation of Indian tribes to attack the ten British forts west of the Alleghenies, eight of which fell before reinforcements arrived to quash what came to be known as Pontiac's Rebellion.[2] Realizing the importance of appeasing the Indians, in the spring of 1764, Sir William Johnson, superintendent of Indian affairs, invited all Indians who had been allied with the French to attend a grand council at Fort Niagara that summer. In preparation for the meeting, Johnson wrote on 1 June to General Thomas Gage, Amherst's successor, requesting a supply of sixty peace medals to give to "such sachems as still carry French Meddals [*sic*]."[3]

On 26 June, Gage sent Johnson the medals, remarking, "I cannot say much for the workmanship of them nevertheless they are finished by the best hand that could be found here."[4] The "hand" was that of Daniel Christian Fueter, a Swiss-born silversmith who for political reasons fled Switzerland for London in 1749 and arrived in New York

17

Reverse

City in 1754. Fueter was a highly skilled artisan (cat. no. 102); the crude appearance of the medal that Gage noted may be attributed to the fact that the colonies lacked proper minting facilities at the time. The medals were likely cast using the lost-wax method, which does not produce much sharpness of detail.[5]

The obverse of the medal features a bust of George III, crowned with laurel, wearing a Roman-style toga and encircled by an inscription. On the reverse under the motto "Happy While United," an Indian and an Englishman sit beneath a tree smoking a peace pipe, and a house and ships are depicted in the background; "N:YORK" indicates where it was made. The medal's hanger —an Indian calumet or peace pipe conjoined with an eagle's wing, a symbol of royal authority—further emblematizes the union of the two factions. A contingent of 1,725 Indians attended the council at Fort Niagara, where the sixty Happy While United medals were distributed to chiefs. While subsequent correspondence between Gage and Johnson concerning the improvement of the medal suggests that tribal leaders were unimpressed with it, the gesture was nevertheless successful in beginning a peace process that culminated in July 1766, when Johnson brokered a final peace with Pontiac himself.[6] G.C.B.

Notes

1. John W. Adams, *The Indian Peace Medals of George III or His Majesty's Sometime Allies* (Crestline, Calif.: George Frederick Kolbe, 1999), 19, 61.
2. Ibid., 19–20, 62–63.
3. Johnson to Gage, 1 June 1764, in William Johnson, *The Papers of Sir William Johnson*, 14 vols. (Albany: University of the State of New York, 1921–65), 2:216.
4. Gage to Johnson, 26 June 1764, in Johnson, 1921–65, 4:453.
5. Adams, 1999, 70.
6. Ibid., 65–66.

18

19

20

John Trumbull (1756–1843), designer
Conrad Heinrich Küchler (1740–1810), engraver
Soho Manufactory of
Matthew Boulton (1728–1809) and
James Watt, Sr. (1736–1819)

18

"The Shepherd," one of three so-called Season Medals
Staffordshire, England, 1796–98

Silver (electrotype), wt. 20.27 gm, 12:00, 48 mm
Yale University Numismatic Collection
Transfer, 2001, Bequest of C. Wyllys Betts, 2001.87.3432

19

"The Farmer," one of three so-called Season Medals
Staffordshire, England, 1796–98

Copper, wt. 46 gm, 12:00, 48 mm
Yale University Numismatic Collection
Transfer, 2001, Bequest of C. Wyllys Betts, 2001.87.3433

20

"The Family," one of three so-called Season Medals
Staffordshire, England, 1796–98

Silver, wt. 46 gm, 12:00, 48 mm
Mabel Brady Garvan Collection, 1932.105

America's westward expansion brought increasing tensions with Native Americans and the constant need to broker peace agreements, however ineffective they proved to be. Peace medals became important emblems of these accords. In 1796, during President George Washington's second term, Secretary of War James McHenry commissioned a set of three peace medals for presentation to Indian chiefs. Because the United States had no mint capable of producing such intricate pieces, McHenry arranged for the medals to be produced in England. Designed by John Trumbull, a leading painter of the day, the medals became known as the Season Medals, though they do not represent the seasons per se. The designs refer to "different phases of civilized life, being intended to attract attention to its comforts and advantages, and to induce [Indians] to make a change in their habits of living."[1]

Trumbull's three designs are described as "The Shepherd," "The Farmer," and "The Family." The first medal (cat. no. 18), depicting a cow and a calf in the foreground and a shepherd with two sheep and a lamb in the background, was intended to promote animal husbandry. The second (cat. no. 19), featuring a farmer sowing grain in the foreground with a house and a man plowing in the background, advanced the ideals of agriculture, homesteading, and private property (a fence borders a field). The third medal, "The Family" (cat. no. 20), shows a domestic interior. In the foreground, beside an open fireplace, a woman spins at a wheel, while a child watches a baby in a cradle. In the background, a woman weaves at a loom. In addition to fostering family and domesticity—the values of hearth and home—the production of textiles served as subtle encouragement to Native Americans to forsake their "savage" dress for "civilized" garb. On the reverse of all three medals, in a wreath of oak and olive leaves—symbols of strength and peace, respectively—are the words "Second Presidency of Geo: Washington MDCCXCVI [1796]."

Using Trumbull's sketches, Conrad Heinrich Küchler, a Belgian engraver in the employ of Matthew Boulton, cut dies from which the medals were struck by the Soho Manufactory of Boulton and James Watt, Sr. Although seven hundred pieces (five hundred in silver and two hundred in copper) were ordered by the United States, the only

recorded shipment, in July 1798, contained 326 silver medals and an unknown quantity in copper.[2] By the time the medals arrived, John Adams was in office. The medals were used throughout his presidency and into Thomas Jefferson's administration, when fifty-five were distributed by Lewis and Clark on their western expedition of 1804–6. However, the medals were unpopular with Native American chiefs: not only were they out-of-date, but they did not bear a likeness of the president, or "Great Chief," to whom Indian leaders were asked to pledge their allegiance.[3] Beginning in 1801, the United States Mint began making its own Indian peace medals, a practice that continued into the 1880s. G.C.B.

Notes

1. William Spohn Baker, *Medallic Portraits of Washington* (1885; repr. Iola, Wis.: Krause Publications, 1965), 83.
2. Russell Rulau and George Fuld, *Medallic Portraits of Washington* (Iola, Wis.: Krause Publications, 1985), 70.
3. National Park Service, "Preparing for the Trip West: Peace Medals," *The Lewis and Clark Journey of Discovery*, http://www.nps.gov/jeff/LewisClark2/CorpsOfDiscovery/Preparing/PeaceMedals/PeaceMedals.htm.

21

Zebulon Smith (1786–1865)
Armband
Bangor, Maine, ca. 1812–20

Silver, 5 1/16 x 3 5/16 x 3 1/2 in. (13 x 8.4 x 8.9 cm), wt. 4 oz., 18 dwt. (151 gm)
Mabel Brady Garvan Collection, 1934.360

As a white male, Zebulon Smith, the Bangor silversmith who made this armband, was a member of New England's dominant cultural group. Yet the ornament and form of the armband suggest that Smith intended the object to appeal to one of the smallest ethnic populations in early America: the 250 members of the Penobscot Indian tribe, who resided outside of Bangor. The armband's pierced circles, stars, and arrowhead shapes and triangular rocker-engraving are borrowed from the standard motifs of the tribe's jewelry and clothing. The object's c-shaped form, which was designed to wrap around the upper arm, also resembles the bark, beadwork, and leather armbands that the Penobscot wore. These armbands were copied in silver throughout the seventeenth and eighteenth centuries and were presented to the Penobscot by European traders in exchange for furs.[1]

By the time the present armband was produced, however, the fur trade in Maine had ended. Both New England beavers and, sadly, the Penobscot were almost extinct. But the armband was still tied to exchange. Between 1810 and 1820, the Penobscot traded the last of their ancestral lands to the U.S. government. A treaty of 1818 stipulated that the tribe would be "compensated" by a program of forced assimilation—the Penobscot were placed under the control of Maine state officials, who imposed their own beliefs about religion and education—as well as a variety of goods, including fifty dollars' worth of silver objects.[2] Smith's armband

may have been among these items, as the Penobscot were too poor to afford their own silver.

Whatever the terms of its production, the fact that the armband was made around the time the Penobscot sold their land invests its traditional ornament and form with significance. During a period when the pressure of Europeanization threatened to dissolve the cultural identity of the Penobscot, the armband powerfully asserted the tribal heritage, cutting against the pressures of the dominant culture. Dents and areas of wear on the object attest to its frequent use, showing how boldly this assertion was made in practice. At the same time, as a gift from white officials, the armband resonated with the call for assimilation.[3] E.L.

Notes

1. Frank Speck, *Penobscot Man: The Life History of a Forest Tribe in Maine* (Philadelphia: University of Pennsylvania Press, 1940), 155. See also Laura Frecych Sprague, ed., *Agreeable Situations: Society, Commerce and Art in Southern Maine, 1780–1830* (Boston: Northeastern University Press, 1987), 203–5.
2. William Williamson, *A History of the State of Maine* (Hallowell, Me.: Glazier, Masters, 1832), 670.
3. Francis Paul Prucha, *Indian Peace Medals* (Madison: State Historical Society of Wisconsin, 1971), 3–11. See also Sprague, 1987, 204.

21

22

Edmund C. Coates (1816–1871)
Indians Playing Lacrosse on the Ice, 1859

Oil on canvas, 28½ x 35⅛ in. (72.4 x 89.2 cm)
Whitney Collections of Sporting Art, given in
memory of Harry Payne Whitney, B.A. 1894, and
Payne Whitney, B.A. 1898, by Francis P. Garvan,
B.A. 1897, M.A. (HON.) 1922, 1934.19

Lacrosse originated among American Indians
in northeastern North America. Variants of
stick-and-ball games are played by American
Indian nations throughout the eastern part
of the continent. Oral traditions testify to the
antiquity of the sport, which was first doc-
umented by Jesuit missionaries during the
early seventeenth century. Lacrosse has an
important place in American Indian commu-
nity life. Both men and women, sometimes
on mixed teams, participate in this popular
form of entertainment. It is played for fun,
to settle disagreements, and for spiritual or
ceremonial reasons. Games are sometimes
organized to honor guardian spirits or satisfy
dreams. Matches are also played in con-
junction with particular ceremonies. Addi-
tionally, the sport has played a role in mili-
tary contests: in June 1763, Ojibwe people
participating in Pontiac's Rebellion orches-
trated a lacrosse match to distract soldiers at
Fort Michilimackinac prior to attacking the
British outpost.

This winter lacrosse scene bears a striking
similarity to Seth Eastman's 1848 painting
*Ballplay of the Dakota on the St. Peter's River in
Winter* (Amon Carter Museum, Fort Worth,
Texas). Edmund C. Coates, who worked out
of a studio in Brooklyn, New York, was
known to draw inspiration from other artists'
work.[1] The everyday winter attire of players,
as well as the baskets, quiver of arrows,
and other items set down along the river-
bank, and the tipis in the background are
details found in both paintings. In Coates's
scene, the small number of players and few
spectators suggests that the game may be
an informal competition. Like many sports,
lacrosse games can be highly organized
events or casual pick-up games. Larger and
more formal contests are likely to take place
in the summer, when lacrosse is played most
frequently. Throughout the year, players
and spectators alike are inspired to gamble
on the outcome. It is possible that the items
arrayed along the bank were wagered on
this game.

Players in this painting carry sticks cre-
ated with a characteristic Great Lakes
design. They are produced by skilled special-
ists within American Indian communities
and are frequently made of a hardwood such
as hickory that is carefully bent to form a
pocket on one end. The small, round pocket
of the stick is the design element that dis-
tinguishes the Great Lakes–style of lacrosse
stick from Iroquois-style sticks (which
have a much larger pocket and are consid-
ered the progenitor of contemporary
lacrosse sticks). Players appreciate these
Great Lakes–style sticks because they are
highly accurate and capable of hurling the
ball great distances.[2] A.M.

Notes
1. "Edmund C. Coates," in Natalie Spassky, *American
Paintings in the Metropolitan Museum of Art,
Volume II: A Catalogue of Works by Artists Born
between 1816 and 1845* (New York: Metropolitan
Museum of Art in association with Princeton
University Press, 1985), 8–9.
2. Thomas Vennum, Jr., *American Indian Lacrosse:
Little Brother of War* (Washington, D.C., and
London: Smithsonian Institution Press, 1994), 77–82.

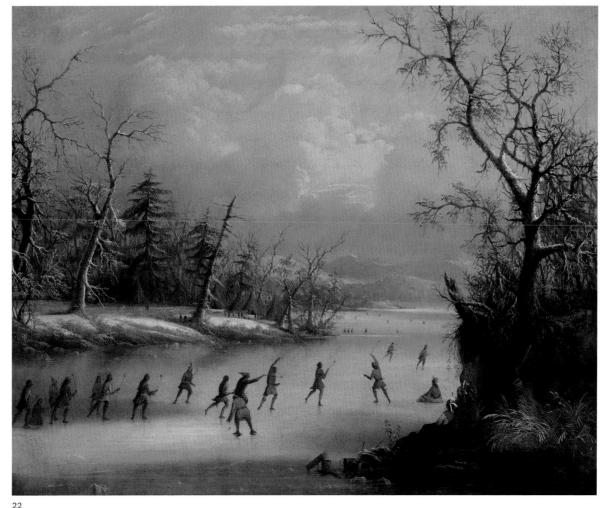

22

fig. a *Chest*. New Mexico, 1760–1800.
Pine, 30 x 55 x 19 in. (76.2 x 139.7 x 48.3 cm).
Courtesy of Sotheby's, New York

23

Chest
Rio Abajo region, New Mexico, 1775–1825

Pine and iron, 18 ½ x 52 x 18 in.
(47 x 132.1 x 45.7 cm)
Mabel Brady Garvan Collection, by exchange,
2000.83.1

When decorative arts scholarship first emerged in the late nineteenth century, studies of colonial American furniture privileged the English and Protestant traditions, a bias that paralleled the concerns of historians writing at the time. During the past quarter century, as historians have widened their scope of study to consider the various strands of American colonial identity, furniture historians have begun to explore Native American, Spanish, and French traditions.

In the Spanish Southwest, *carpinteros* introduced European forms, construction techniques, and iron-edge tools to the native Pueblo population, whose craftwork played an integral role in the region's mixed agricultural economy. Although ceramics had been an important craft for centuries, woodworking remained rudimentary until Spanish settlement. As Spanish-trained craftsmen taught natives, certain Pueblos such as Abó and Pecos became known as woodworking centers. By the eighteenth century, both Hispanic and Pueblo craftsmen supplied furniture and architectural woodwork for the region.[1]

This chest, or *caja*, illustrates the preservation of a Spanish vernacular tradition. The dovetailed carcass, the applied moldings that subdivide the facade into neatly organized visual compartments, and the low-relief heraldic carving all bespeak deep familiarity with Hispanic conventions. The carved motifs—lions, rosettes, and pomegranates—are drawn from Spanish traditions, and the quality and consistency of the carving suggest access to the best gouges and chisels.

The lack of feet and the imperial iconography on this *caja* and several other related examples suggest that they were made by Hispanic *carpinteros* as a form of mobile authority and were probably owned by the wealthy class of Spanish leaders.[2]

The Hispanic orientation of the Yale chest is made clearer through comparison with one of another group of chests from the Southwest (fig. a). While the chest form and paneled construction in the second group manifest the influence of European traditions, the details of the construction and the iconography suggest the presence of non-European traditions. The use of chopped through-mortises and the rough, exaggerated type of chip-carving contrast noticeably with the Yale chest and are related to the architectural woodwork in the churches constructed by Puebloans. The iconography of the framed chest is also distinctive. The circular center design and radiating lines depict the Puebloan cosmology, in which four cardinal points are augmented by vertical axes of ascent and descent in the center. New Mexican framed chests like this example have integral feet, which implies that the piece has a more permanent place in the home. The example illustrated in figure a was found in San Felipe Pueblo in the early twentieth century, suggesting that Puebloan woodworkers made such chests for natives or for families of mixed heritage. E.S.C.

Notes

1. The best overview of New Mexico furniture is Lonn Taylor and Dessa Bokides, *New Mexican Furniture, 1600–1940* (Santa Fe: Museum of New Mexico Press, 1987).

2. On the contrasts between the Hispanic and Creole traditions in New Mexico, see Elizabeth Fleming, "Cultural Negotiations: A Study of the New Mexican *Caja*," in Luke Beckerdite, ed., *American Furniture 2000* (Milwaukee, Wis., and Hanover, N.H.: Chipstone Foundation and University Press of New England, 2000), 185–204.

24

24

Child's Chair
Louisiana, 1775–1825

Hickory or willow and white oak, 25 x 15 x 12 in. (63.5 x 38.1 x 30.5 cm)
Mabel Brady Garvan Collection, by exchange, 2000.90.1

The decorative arts of colonial Louisiana were heavily influenced by French prototypes. The French governed the Louisiana Territory for only two relatively brief periods in its history (ca. 1682–1764 and 1800–1803), but French taste dominated the colony's culture throughout the eighteenth and nineteenth centuries. Acadians from Canada and refugees from the French colony in Santo Domingo continued to infuse the region with a French flavor even when it was under Spanish or American control.[1]

Slat-backed chairs similar to this diminutive example can be seen in French engravings and paintings from the seventeenth and eighteenth centuries. Although similar chairs were made all over Europe, stylistic qualities and details of construction tie chairs from eighteenth-century Louisiana to the French chairmaking tradition. This chair's French elements include the arched slats with peaks along the top edges and the outward bow of the lists, or understructure, for the woven rush seat. The turned and tapered shapes of the feet also have French precedents. Although the chair was intended for utilitarian purposes, the number and variety of turnings show off its maker's skill. The rear stiles of the chair have elongated finials and a series of ring- and barrel-shaped turnings, while the front legs have a prominent disc-shaped turning just below the seat and a series of shallow ring turnings along the tapered feet. The front stretcher has ring and ball turnings, but the other stretchers are left undecorated. Often classified as children's chairs because of their small size, low-seated chairs like this one have also been

used for outdoor tasks by both adults and children. The low seat allows the sitter to cradle a bowl or basket on his or her lap, making for a more comfortable work environment.[2]

The chair was probably made by a craftsman outside of New Orleans. Cabinet-makers appear in a 1726 census of New Orleans, the earliest record of the territory's inhabitants and their trades, and furnituremakers surely continued to immigrate to the area throughout the century. Additionally, other records show that some planters made their own furniture. In 1776, Dom Francisco Bouligny, a Spanish official, noted that "men of means do not disdain to pass entire days handling a plane in the carpenter shop." Alternatively, wealthier planters might have had slaves trained in furnituremaking. Although the chair's maker is unknown, three closely related chairs survive.[3] E.E.

Notes

1. Jessie J. Poesch, *Early Furniture of Louisiana*, exh. cat. (New Orleans: Louisiana State Museum, 1972), 1.

2. Ibid., 3–4.

3. Ibid., 1; Alcée Fortier, *A History of Louisiana*, 4 vols. (New York: Manzi, Joyant, & Co., 1904), 2:33; for the related chairs, see Poesch, 1972, 49, no. 32; Jack Holden and Robert E. Smith, *Early French Louisiana Furnishings, 1700–1830*, exh. cat. (Lafayette: Art Center for Southwestern Louisiana, 1974), 16; and Jessie J. Poesch, "Furniture of the River Road Plantations in Louisiana," *Antiques* 111 (June 1977), 1189, fig. 9.

25

Henry Gudgell (1826–1895)
Cane
Livingston County, Missouri, ca. 1867

Ebonized wood, 37 x 1½ in. (94 x 3.8 cm)
Director's Purchase Fund, 1968.23

Coiling up from the cane's tip, opposite a leaf on a bent branch, an enormous snake chases a fully dressed man. Clinging to the shaft, face hidden, this hapless figure trails a smooth-backed turtle and a lizard, each making its way up, their progress stalled for eternity by the banding and spiral fluting on the handle.

These enigmatic hardwood carvings connect the cane to the healing arts of Africa that survived the period of slavery in the oral traditions, beliefs, and practices of many African Americans. They reveal a rich cultural heritage with an expressive artistic tradition rooted on the African continent. The cane's iconography has been compared to staffs carried by Woyo chieftains in Central Africa, and its diamond band, resembling cowrie shells, and spiral carving have been linked to Kongo authority symbols from Central Africa. As creatures that move between land and water, snakes, lizards, and frogs were recognized by Africans and African Americans as mediators between the living and the spirit worlds. In particular, snakes, commonly seen on canes in this country, hold significance in Africa and the diaspora. For the West African Mande, poisonous snakes contained a primal energy called "nyama," and for the Kongo people, snakes signified the authority and power of the chief, derived from his ancestors. Southern blacks in this country linked snakes to "restoration, healing, sickness, and death"—associations that would probably have been familiar to the cane's maker, Henry Gudgell, a blacksmith, silversmith, wheelwright, and carver.[1]

Gudgell was born a slave of mixed parentage in Kentucky, though he and his mother later marched from Kentucky to Missouri. His mother's family likely was among those who moved to Kentucky in the late eighteenth century from coastal Virginia, an area steeped in tribal traditions. Many enslaved Mande were blacksmiths, highly valued for their skill by slave traders and within their own society for their role as conjurers. This connection can be traced to the Mande epic of the rise of Sunjata, the great leader who was disabled at birth but "regained the use of his legs through an iron cane given to him by a healer." Gudgell's collective heritage included the knowledge of Mande blacksmith/healers known as "master of the leaves." Seen in this context, the leaf device on the cane reads as a kind of signature, opposite the shod man on bended knee, who might represent John Bryan, the wounded Civil War veteran for whom Gudgell carved these power motifs.[2]

A native of Livingston County, Missouri, Bryan enlisted in the First Missouri Calvary and was injured in the knee while fighting in the Confederate army at the Battle of Wilson's Creek.[3] Gudgell, presumably a freed slave by the time he met Bryan, carved the cane for this friend of his former master, Spence Gudgell. Bryan kept both the limp and the cane, its blackened surface polished smooth and worn at the edges, until his death in 1899.[4] In the wake of the conflict that divided the nation, Gudgell's carved figures—lizard, turtle, man, leaf, and snake—invoked the power to heal. This potent sculptural object signifies the transferal of art and beliefs from mainland Africa to the American heartland. C.M.H.

Notes

1. Robert Farris Thompson, "African Influence on Art of the United States," in Armistead L. Robinson, Craig C. Foster, and Donald H. Ogilvie, eds., *Black Studies in the University* (New Haven: Yale University Press, 1969), 128–29; Ramona M. Austin, "Defining the African-American Cane," in George H. Meyer, ed., *American Folk Art Canes, Personal Sculpture* (Bloomfield Hills, Mich.: Sandringham Press, New York: Museum of American Folk Art, and Seattle: University of Washington Press, 1992), 223–24; Betty Crouther, "Iconography of a Henry Gudgell Walking Stick," *Southeastern College Art Conference Review* 12 (1993), 189.

2. Frederick Lamp, curator of African art, Yale University Art Gallery, to author, 28–29 June 2004. See Fa-Digi Sisòkò, *The Epic of Son-Jara: A West African Tradition, An Analytical Study and Translation*, trans. John William Johnson (Bloomington: Indiana University Press, 1986), 134–41, verses 1252–1517; and D. T. Niane, *Sundiata: An Epic of Old Mali*, trans. G. D. Picket (London: Longman Group, Ltd., 1965), 18–25.

3. This battle, which engaged some 5,400 Union troops and 12,000 Confederates, with 2,330 casualties roughly divided between the two, gave the South control over southwestern Missouri.

4. Yale acquired the cane in 1968 from John Albury Bryan, a St. Louis architect, and John Bryan's great-grandson.

25

Detail of snake chasing a man

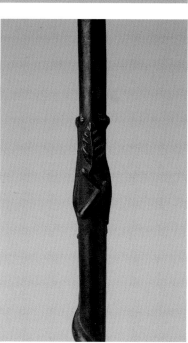

Detail of leaf on a bent branch

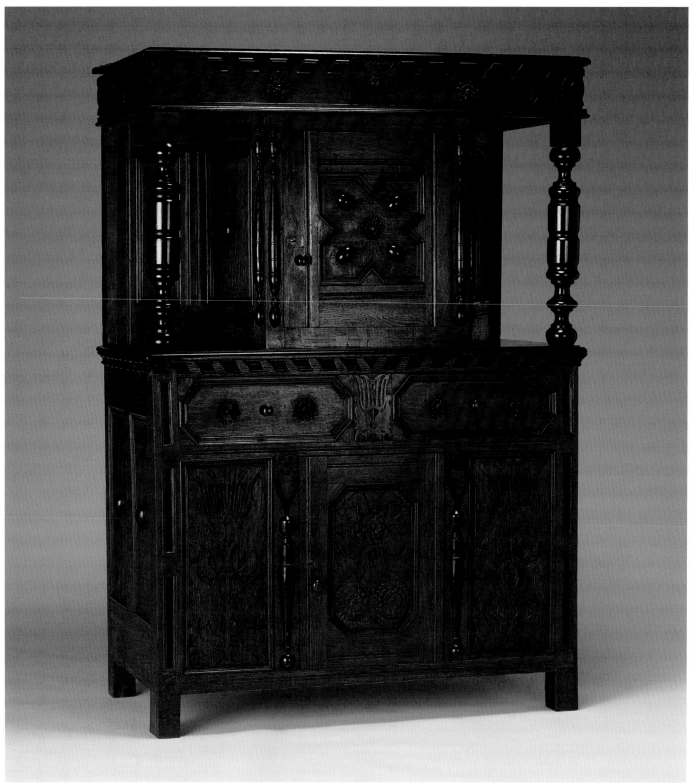

26

Cupboard
Possibly Hartford, Connecticut,
1865–1900

Oak, birch, cherry, pine, and yellow poplar,
60¾ x 43¼ x 23 in. (154.3 x 109.9 x 58.4 cm)
Gift of New Haven Colony Historical Society,
1999, in honor of Patricia E. Kane, PH.D. 1987,
1999.66.1

In the decades following the Civil War, some Americans became alarmed by urbanization and industrialization, as well as by the increasing number of immigrants that accompanied these changes. Descendants of early settlers sought refuge in organizations restricted to members of similar lineage, such as the General Society of Mayflower Descendants and the Colonial Dames. Others chose to distance themselves from the products of industrialization by collecting colonial American artifacts, which had come to symbolize the perceived agrarian simplicity and social harmony of earlier times. This cupboard was owned by the Reverend Timothy Dwight, eighth president of Yale University (1886–99), and Jane Wakeman (Skinner) Dwight, both descendants of early New Haven and Norwich families. It was published in 1921 as a seventeenth-century relic with a history in the Wheeler family of Fairfield County; this family was not related to the Dwights, suggesting that the piece was not an heirloom but had been acquired as an antique with this pedigree.[1]

The cupboard's overall form and construction are similar to cupboards made in the New Haven area during the last quarter of the seventeenth century, but this object appears to be of later-nineteenth-century manufacture. While the carved and applied ornament is atypical of coastal Connecticut furniture, it resembles that found on late-seventeenth-century cupboards and chests from Wethersfield (cat. no. 97), although the carving's high relief is without parallel among surviving seventeenth-century objects. The absence of wear or damage to exterior or interior surfaces further suggests that the object is not over three hundred years old. The maker seems to have intended that it be mistaken for an earlier object: he reused old pieces of wood, carved evenly spaced "worm holes" on selected boards, inscribed "generations" of initials on the inside, and made pseudo-repairs such as spliced feet and plugged holes from earlier knobs.[2]

The cupboard most likely was made in a cabinetmaking shop that also restored and sold old furniture. A leading firm of this type was Robbins and Winship of Hartford, which in the early 1860s repaired a genuine New Haven–area cupboard that descended in the Starr family and may have served as a model for the Dwights' cupboard. It is possible that Robbins and Winship kept templates from the Starr cupboard to make reproductions, because even in the early years of antiques-collecting the supply of genuine objects was insufficient to meet the demand. It is not known whether the elder Dwights believed their cupboard to be old, but their son and daughter-in-law apparently did.[3] D.L.B.

Notes

1. T. J. Jackson Lears, *No Place of Grace: Antimodernism and the Transformation of American Culture, 1880–1920* (New York: Pantheon Books, 1981), 188; Wallace Nutting, *Furniture of the Pilgrim Century, 1620–1720* (Boston: Marshall Jones Company, 1921), 159.
2. For New Haven–area cupboards, see Patricia E. Kane, *Furniture of the New Haven Colony: The Seventeenth Century Style*, exh. cat. (New Haven: New Haven Colony Historical Society, 1973), 50–55; Gerald W. R. Ward, *American Case Furniture in the Mabel Brady Garvan and Other Collections at Yale University* (New Haven: Yale University Art Gallery, 1988), no. 194.
3. Ward, 1988, 378–79; Mrs. Winthrop Dwight to Ralph W. Thomas, Oldwick, N.J., n.d. [Oct. 1953], New Haven Museum and Historical Society archives.

Citizenship and Democracy

America Coming of Age

Joanne B. Freeman

Between 1775 and 1865, the United States moved through an awkward adolescence. Politically, culturally, socially, and economically, the new nation gradually gained an independent sense of self. This was a period of often startling growth. The population increased exponentially; a constant stream of settlers spilled onto the frontier, pushing the nation ever westward. Technological advances abounded: steam power, mass production, the telegraph. A growing network of newspapers ferried information to a growing electorate. America was a hotbed of experimentation and innovation.

Much of this innovation took place in the world of politics. Britain's North American colonists had a fierce sense of their rights as English subjects, partly due to their direct representation in colonial legislatures and partly due to their peripheral status in the British empire; the greater the distance from the imperial center, the louder the claims of membership. Over time, these colonists developed a distinctly American understanding of their rights and liberties. The result was a revolution and more than a decade of political experimentation, capped by the drafting of a new constitution intended to create the most representative and egalitarian polity in the world. The Constitution settled many political difficulties, but Americans would discover that it was merely the starting point for an ongoing conversation about the nature of republican governance.

Culturally, too, the new republic was slowly developing a distinctive voice: direct, straightforward, and filled with New World sights and sounds. Over the course of these early decades, the United States would develop skilled artists who could begin to rival their European equivalents. American-born painters like John Trumbull honed their craft in Europe but dedicated their skills to depicting and commemorating American sensibilities and accomplishments. Writers were also developing a native style of writing, flavored by regional dialects and "calculated bluntness."[1] Even the English language was becoming Americanized, a development that Noah Webster tried to institutionalize in his *American Dictionary of the English Language* (1828). Political rhetoric likewise shaped itself to the American climate, becoming more colloquial with the rise of mass democracy. In this increasingly egalitarian nation, public figures needed to appeal to as wide an audience as possible.

As befits a young nation, this was a time of a peculiarly powerful national self-consciousness—a heightened awareness of America's youth, fragility, and New World rough edges. Some artists and writers celebrated this youthful immaturity; others satirized American efforts to mask their inadequacies beneath clumsy pomposity and pretentious display. Equally self-conscious was the ongoing attempt to create a historical narrative for the new republic, replete with national heroes and unifying symbols. Writers and painters tried to depict America's founding on paper and canvas, with mixed results.

Such growth and change were neither painless nor easy. Republican governance was an experiment that had yet to prove itself; the eventual outbreak of civil war suggested to many that the experiment had

failed. Even before the Union collapsed, it roiled with regional, racial, and social divisions, fueled by the festering wound of slavery. The American republic seemed at odds with itself, ostensibly devoted to personal liberty and equal opportunity, yet excluding entire populations from this promise. What began as an optimistic attempt to create a new type of polity matured into a rueful self-awareness that failed to stem the tide of war.

The pain and promise of this period are reflected in its artifacts. In paintings, engravings, cartoons, and crafts, Americans gave voice to the spirit of the times. Early artworks strike a lighter chord, bursting with the righteous indignation born of revolution and the pride of a new nation celebrating itself, while later ones cast shadows of ambiguity and self-doubt. Viewed as a whole, these images and objects reveal the hopes and fears of a nation gradually coming to terms with itself.

A DIFFICULT BIRTH

The United States was born of conflict. Spawned by a revolution against a major world power, the new nation came to life amid risks, challenges, and unknowns. Americans sought support in this crisis through political propaganda in broadsides, engravings, pamphlets, newspapers, and cartoons. Advertising what they perceived as the injustice of their plight and the righteousness of their cause, they struggled to rouse the support of fellow colonists and the world at large. Perhaps the most striking example of such efforts is Paul Revere's *The Bloody Massacre Perpetrated in King-Street Boston on March 5th 1770* (cat. no. 27), an image of the American Revolution that remains vivid even today. Although the actual "Boston Massacre" was more the product of confusion than cruelty, Revere showed a line of British soldiers in formation, deliberately firing on an unarmed crowd.

Of course, those who were less sympathetic to the American cause used similar methods to mock the pretensions of people they considered to be rustic colonials. In 1774 and 1775, the London firm of Sayer and Bennett published a series of cartoons ridiculing American radicals. In Philip Dawe's *The Bostonians Paying the Excise-Man,* or *Tarring & Feathering* (cat. no. 28), a group of leering Bostonians pours tea down the throat of a tarred and feathered excise man; behind him, a noose hangs threateningly from the branch of a "Liberty Tree." In *A Society of Patriotic Ladies* (fig. 1), Dawe trained his acid pen on a group of North Carolina ladies organizing a nonimportation protest. Dressed in clumsy approximations of European fashions, they flirt and guzzle alcohol

while a child sits neglected under the table in the foreground, being bitten by a dog (which, to add insult to injury, is urinating). Dawe's message is clear.

Like any number of European artists and writers, Dawe envisioned North American colonists as overreaching rubes in a cultural backwater—an image that haunted the colonists themselves, who knew all too well how far removed they were from the high culture of London and Paris. Looking to the Old World as the pinnacle of civilization, they could not help feeling inferior and insecure in comparison. In many ways, they *were* a breed apart, a collective people on the edges of empire. As their new nation took form in the 1780s and 1790s, they would convert these supposed rustic inadequacies into the banner of New World republicanism.

LEARNING TO SPEAK

During the Revolution, forgoing luxury was a political statement; boycotting British manufactured goods—fine textiles, fancy shoe buckles, and assorted delicacies—was a patriotic act of defiance against Great Britain. Yet Americans never lost their taste for European finery. Caught between their appreciation of such status symbols and their nationalistic pride in doing without them, Americans lived in a state of cultural ambivalence.

Ideologically (if not in reality), it was easy to spurn Old World excess. Americans saw themselves as everything that Europeans were not: simple, plain, direct, egalitarian. Ralph Earl's portrait of Roger Sherman precisely captures this spirit, presenting an unadorned, even stark image of a no-nonsense man (cat. no. 49). No French lace frames face and hands; no ornate furniture or lush drapery frames Sherman himself. Of course, Sherman was rather extreme in his own time, considered almost comically plain and straightforward. But the contrast between this portrait and those of the social elite—such as the 1769 John Singleton Copley portrait of Isaac Smith, complete with wig, fine linen, and gold buttons and buckles (cat. no. 105)—could not be greater. This homespun quality was an assertion of national identity through self-presentation: new, different, yet still defined in contrast with the Old World.

The creation of an American history was no less comparative or deliberate. Trumbull was a central force behind this early process of historical self-definition. As the painter himself explained, his historical paintings were intended to "diffuse the knowledge & preserve the

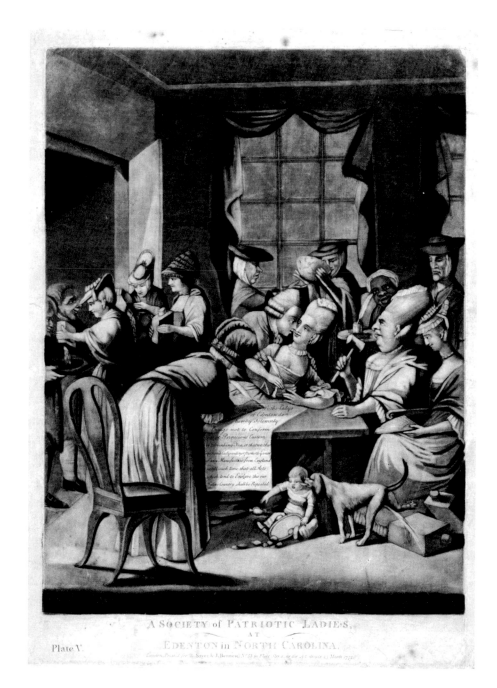

memory of the noblest series of Actions which have ever dignified the History of Man:—to give the present & the future Sons of Oppression & Misfortune, such glorious Lessons of their rights & of the Spirit with which they should assert & support them:—& even to transmit to their descendants the personal resemblance of those who have been the great actors in these illustrious scenes."[2] In documenting America's difficult birth, Trumbull would "preserve" and "diffuse" the spirit of the Revolution not only for Americans but for all "Sons of Oppression & Misfortune." His paintings would depict the Revolution as a noble sacrifice worthy of emulation the world over. To Trumbull, America's glorious revolution had earned it a place of pride on the world stage.

Beginning in the 1780s, Trumbull dedicated himself to the task of creating an American historical narrative, undertaking a series of history paintings commemorating American heroes and historical moments; as he himself put it, he began "writing, *in my language*, the History of our Country."[3] The Revolutionary War needed to be chronicled and crafted into an American creation myth that would reflect the new nation's distinctive virtues yet hold its own against European equivalents. Many of Trumbull's paintings depict battlefield scenes with vivid

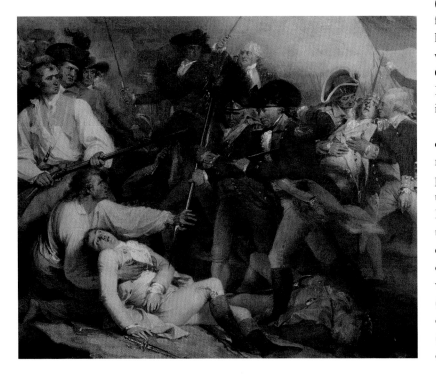

portraits of American soldiers dying noble deaths, displaying their bravery, self-sacrifice, and generosity of spirit in the process. In *The Death of General Mercer at the Battle of Princeton, January 3, 1777* (cat. no. 35), Mercer is about to receive his fatal wound in the heat of battle; his horse shot out from under him, he kneels before a British soldier, whose bayonet is thrust toward Mercer's chest. *The Battle of Bunker's Hill, June 17, 1775* (cat. no. 31) features a similar image, a British grenadier attempting to bayonet the fallen General Joseph Warren while two onlookers try to fend off the blow; the joint efforts of an American soldier and a British officer suggest a shared sense of battlefield honor that transcends national boundaries (fig. 2). Trumbull's message is clear: America has bona fide heroes and heroic sensibilities that are equal—if not superior—to those of the Old World. In a way, these images mirror the self-promotional messages of America's Revolutionary wartime propaganda; here, Americans are once again subject to British cruelty, but in the flattering light of history, instead of being victimized, they rise to new heights of nobility and purpose.

Trumbull's historical civil scenes—*The Declaration of Independence, July 4, 1776* and *The Resignation of General Washington, December 23, 1783* (cat. nos. 33, 38)—had a similarly nationalistic purpose. Both paintings feature somber assemblages of statesmen, seemingly aware of the historic significance of their actions. As Trumbull put it, these paintings would show that "those who had once wielded the arms of their Country with such effect, could also guide her Councils with equal Dignity."[4] The painter would memorialize America's superiority of spirit in peace as well as in war.

Such patriotic images came into great favor in the wake of the War of 1812. Although America's "victory" was somewhat equivocal, the nation's surviving a second war against Great Britain carried significant psychological clout. Even during the conflict, Americans enjoyed thumbing their noses at their former mother country. In 1775, Sayer and Bennett's print had depicted crude Americans pouring tea down the throat of an excise man; now, almost four decades later, Americans celebrated their ability to inflict such damage, as we see in Amos Doolittle's cartoon *Brother Jonathan Administering a Salutary Cordial to John Bull*, where an American "Brother Jonathan" jauntily pours a mug of "Perry" (representing American naval commander Oliver Hazard Perry, winner of the Battle of Lake Erie) down the throat of the British "John Bull" (cat. no. 57). Doolittle's *The Hornet and Peacock, Or, John Bull in Distress* displays a similar spirit (cat. no. 56).

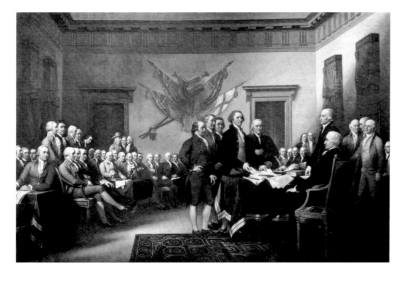

This burst of postwar patriotism led to Trumbull's commission from the U.S. government to paint four history scenes for the Rotunda of the Capitol; their subject matter was left to Trumbull's discretion. The artist ultimately painted *The Declaration of Independence*, *The Resignation of General Washington*, *The Surrender of Lord Cornwallis at Yorktown*, and *The Surrender of General Burgoyne at Saratoga*. The paintings—enlarged versions of the originals now at Yale—were installed in the Rotunda in 1826, the fiftieth anniversary of the Declaration of Independence. Iconic as the pictures are today, some early onlookers were disappointed. During a congressional debate about history paintings, Virginia Representative John Randolph noted that he hardly ever walked through the Rotunda "without feeling ashamed of the state of the Arts in this country." The rendering of *The Declaration of Independence* struck him as particularly inferior (fig. 3). It ought "to be called the Shin-piece," he declared, "for, surely, never was there, before, such a collection of legs submitted to the eyes of man."[5] To Randolph, as to many others, American artists remained an inferior breed.

In his efforts to memorialize America's founding, Trumbull took great care to record the exact likenesses of significant participants, partly for the sake of posterity and partly for future use in his history paintings. As suggested by his extreme attention to detail, he intended to document the nation's founding with historical accuracy. Beginning in 1789, he spent five years traveling around the country, making small portraits of significant military figures, statesmen, Indian chiefs, women, and family members (cat. nos. 39–48). The images present a gallery of American luminaries, portrayed so sensitively and with such detail that each portrait seems to capture the essence of the sitter.

Some Americans were profoundly moved by the idea that the infant republic had already produced such an assemblage of noteworthies. In 1791, Massachusetts Representative Theodore Sedgwick visited Charles Willson Peale's "American Museum" in Philadelphia (see Lamar, fig. 3), which contained a collection of natural specimens ("the skins of beasts & birds, minerals, fossils, coins, shells, insects, moss & dirt," Sedgwick observed) and a portrait gallery of Revolutionary War heroes. "Many of these men are now no more," Sedgwick wrote to his wife. "The various affections with which my heart was expanded . . . cannot be described. . . . [T]ill then I never so well knew the value of portraits."[6] As suggested by Sedgwick's emotional response, clusters of such portraits were particularly powerful, not only memorializing each individual but celebrating their sheer numbers as well. Like Trumbull's portrait groupings, Peale's gallery declared that the new nation had already produced a pantheon of great men and women forging a new national history.

Central to Trumbull's historical mission was the figure of George Washington. Trumbull revered Washington, considering him "one of the most distinguished and dignified men of the age."[7] The painter captured Washington's spirit in *General George Washington at Trenton* (cat. no. 58), which Trumbull considered his best portrait of Washington, and the best "in my estimation, which exists, in his heroic military character."[8] To Trumbull, Washington's resignation at the close of the Revolution was "one of the highest moral lessons ever given to the world." He explained his feelings in his 1832 autobiography:

What a dazzling temptation was here to earthly ambition! Beloved by the military, venerated by the people, who was there to oppose the victorious chief, if he had chosen to retain that power which he had so long held with universal approbation? The Caesars—the Cromwells—the Napoleons—yielded to the charm of earthly ambition, and betrayed their country; but Washington aspired to loftier, imperishable glory,—to that glory which virtue alone can give, and which no power, no effort, no time, can ever take away or diminish.[9]

In his depiction of the event, Trumbull showed Washington center stage, preparing to return his commission to Congress (cat. no. 38). Perhaps thinking back to Randolph's criticism of *The Declaration of Independence*,

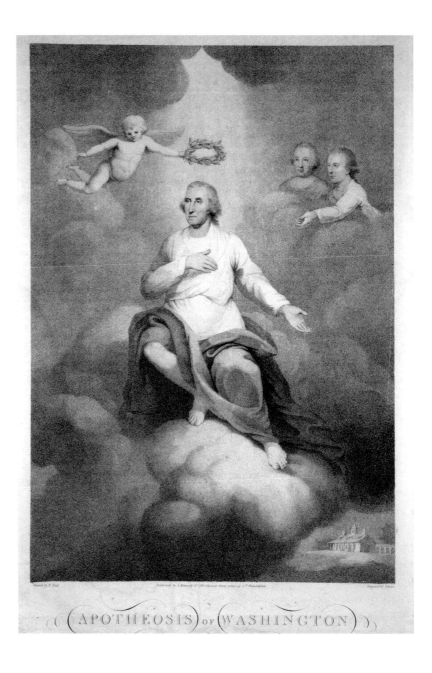

fig. 4 *George Washington*, between 1796 and 1799. Ink on paper enclosed in gold breast pin with diamonds set in silver mounts, gold and silver foliate stem set with diamonds; linked with gold chain to silver and gold stickpin with pearl head, 1 x 9/16 in. (2.5 x 1.4 cm). Yale University Art Gallery, Gift of Mr. and Mrs. Ezra P. Prentice, Jr., 1980.95

fig. 5 David Edwin after Rembrandt Peale, *Apotheosis of Washington*, 1800. Stipple engraving, 23 11/16 x 18 1/8 in. (60.1 x 46.1 cm). Yale University Art Gallery, Mabel Brady Garvan Collection, 1946.9.2134

Trumbull noted that this time "he had taken care to cover as many legs as possible from view." Even so, the version of the painting in the Rotunda received criticism. "What do you see in this picture?" asked one senator. "Why, a man looking like a little ensign, with a roll of paper in his hand, like an old newspaper, appearing as if he was saying, 'Here, take it.'"[10]

Trumbull was not alone in using Washington as a national symbol. The nineteenth century saw the rise of a "cult of Washington" celebrating the Virginian as the ultimate American hero, the nation's "first man." Washington's image appeared on jewelry, handkerchiefs, snuffboxes, china, fire pumps, and cast-iron stoves (fig. 4; cat. no. 61). In the immediate wake of his death in 1799, he was sanctified in grand style in a variety of images depicting his ascent to heaven. *Apotheosis of Washington*, by David Edwin after Rembrandt Peale (fig. 5), shows Washington being ushered into heaven by Revolutionary War generals Richard Montgomery and Joseph Warren (both killed in battle and memorialized by Trumbull) (cat. nos. 32, 31).

The period also saw the rise of an array of national symbols: the feminine figure of Liberty in flowing gown (cat. no. 54), the eagle as national bird (cat. nos. 52, 71). Adorning everything from furniture (cat. no. 53) to handkerchiefs, such icons represented a cultural assertion of nationalistic pride, as well as personal pride to the owners of such luxuries. Ironically, many of these patriotic goods were manufactured on foreign shores (cat. no. 63). Even as they reflect American patriotism and refinement, they hint at the nation's persistent pangs of cultural inferiority in comparison with England and France.

LEARNING TO WALK

Slowly, the new nation was developing a sense of identity. But—Washington's unifying symbolism notwithstanding—the nation remained far from united. The feasibility of republican governance was far from certain, the Revolution having brought not one but two experimental governments in its wake. The first one, based on the Articles of Confederation, was a logical attempt at national governance in a country recovering from a war against perceived tyranny. Drafted in 1777 and ratified in 1781, the Articles created a relatively powerless central government with no single national executive. The Confederation Congress could only make requests of the states; it had no means of enforcing its acts and desires. Although the Articles marked a vital step toward forging a unified nation from thirteen independent nation-states, they ultimately failed, brought down by their weakness and inefficiency.

The second experiment, grounded in the Constitution, was a reaction to such shortcomings, outlining a new frame of government with a stronger executive and increased power over the states. To some, it seemed to be leading the nation back toward monarchy and tyranny. But despite such misgivings, the nation rallied behind the new government as it lurched into existence. Hopes and expectations ran high in 1789. "You have, with a great expence [*sic*] of blood and treasure, rescued yourselves and your posterity from the domination of Europe," wrote David Ramsay in *The History of the American Revolution* (1789). "May the Almighty Ruler of the Universe, who has raised you to Independence . . . make the American Revolution an Era in the history of the world, remarkable for the progressive increase of human happiness."[11] Alexander Hamilton struck a similar chord in his first *Federalist* essay, capturing the tremendous sense of responsibility riding on this political experiment:

> [I]t seems to have been reserved to the people of this country, by their conduct and example, to decide the important question, whether societies of men are really capable or not of establishing good government from reflection and choice, or whether they are forever destined to depend for their political constitutions on accident and force. . . . [T]he crisis at which we are arrived may with propriety be regarded as the era in which that decision is to be made; and a wrong election of the part we shall act may . . . deserve to be considered as the general misfortune of mankind.[12]

Amos Doolittle's *A Display of the United States of America* (cat. nos. 59–60) visually captures the period's prevailing sense of nationalistic pride at the birth of the newly unified republic.

The new Constitution established a national political framework, but *only* a framework. The realities of national governance were yet to be determined. What were the rights and responsibilities of an American citizen? Precisely who qualified as a citizen? How politically active should these citizens be? Should they vote and then step aside until the next election, or should they voice their opinions on an ongoing basis? In their country's first few decades, Americans were debating the very essence of republican governance, a discussion that would continue long thereafter.

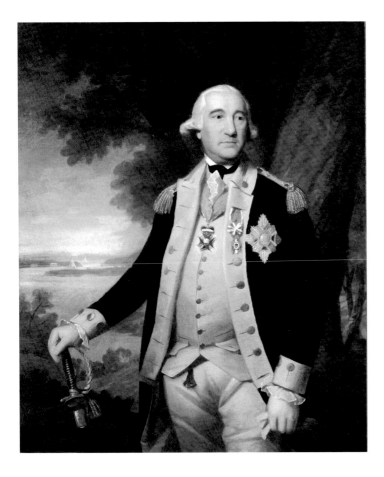

seen proudly displaying his badge; Steuben sat for the portrait shortly after being elected president of the New York State branch of the organization (fig. 6). As one of the society's foremost critics put it, the organization seemed to create a "race of Hereditary Nobles" who would soon reduce the country to "only two ranks of men; the patricians or nobles and the rabble. . . . They have laid in ruins that fine, plain, level state of civil equality . . . which our Laws and the nature of a Republican government promised us." Thomas Jefferson agreed. The organization was sure to "produce an hereditary aristocracy which will change the form of our governments from the best to the worst in the world."[13] Farfetched as such fears may appear today, they were perfectly valid in an untried republic where anything seemed possible.

fig. 6 Ralph Earl, *Major General Friedrich Wilhelm Augustus, Baron von Steuben*, ca. 1786. Oil on canvas, 49 3/4 x 41 3/8 in. (126.4 x 105.1 cm). Yale University Art Gallery, Gift of Mrs. Paul Moore in memory of her nephew Howard Melville Hanna, Jr., B.S. 1931, 1939.14

LEARNING ONE'S LIMITATIONS

This sense of endless possibilities was sometimes liberating. Americans were moving, striving, building. Cities grew at an impressive pace. In the North, technological advances led to the early stages of industrialization, though the South remained tied to a cotton economy grounded in slave labor. Adventurous and ambitious spirits left eastern urban centers for the western frontier, forming new towns and new opportunities. Independent-minded and ever watchful for the next opportunity on the horizon, Americans were a mobile population with increasingly weak community ties. During his travels in America in 1830, Alexis de Tocqueville noted the result of this independence and drive: America was a society of societies. Whether for socializing and entertainment, ethnic identity, protection (like fire societies), or political activism, Americans seemed to cohere habitually into groups (cat. nos. 69, 72). In many ways, the expanding nation was bound together by networks of small societies creating communities and connections.

Such networks were necessary in a nation that sprawled across such a great expanse of land. The Louisiana Purchase (1803), negotiated during Jefferson's presidency, more than doubled the size of the nation, adding over eight hundred thousand square miles of virtually unexplored territory; that same year, Jefferson commissioned Meriwether Lewis and William Clark to explore it. American settlers soon followed, launching a period of tremendous national growth. As people moved west, transportation networks moved with them; the first half of the nineteenth century was the era of steamboats, canals, and—within a few decades—the railroad (cat. nos. 168, 170–71). The expanding frontier

Questions about privilege and equality—about the bounds and limits of American citizenship—loomed large throughout the period, provoking intense and sometimes angry debate. Even Washington was not immune to such controversy. His membership in the Society of the Cincinnati (and, indeed, the very existence of the group) caused something of a public outcry. Composed of veteran Continental army officers, the fraternal organization initially permitted hereditary membership from father to son, raising serious concerns that its members were attempting to establish an American aristocracy. The impressive membership badges (cat. no. 50), reminiscent of the ceremonial medals and ribbons bestowed by monarchs, did nothing to ease prevailing fears. In a Ralph Earl portrait of circa 1786, Revolutionary War general Baron Friedrich Wilhelm Augustus von Steuben can be

Joanne B. Freeman

also attracted increasing numbers of immigrants, eager for jobs or land. Fueled by America's push westward, the pace of life quickened.

Artists depicted this spirit. Some painted dramatic western landscapes featuring natural vistas and views of new cities and towns. Others depicted the hustle and bustle of democratic politicking and the distinctive rhythm of frontier life. Foremost among this group is George Caleb Bingham, often noted as the first major American painter to work west of the Mississippi. A native Virginian who moved to Missouri, Bingham not only painted political scenes but also ran for political office. The mass popularity and artistic impact of his paintings ultimately inspired countless artists to engrave his images for broader audiences (cat. nos. 77–78).

Like Trumbull, Bingham wanted to document something distinctively American before it passed from sight and mind, but, unlike Trumbull, he did not want to celebrate the nobility of grand romantic gestures. Bingham's images show the everyday functioning of the democratic process, for better and worse. As he explained it, he painted so "that our social and political characteristics as daily and annually exhibited will not be lost in the lapse of time for want of an Art record rendering them full justice." To Bingham, art was "the most efficient hand-maid of history," for it had the "power to perpetuate a record of events with a clearness second only to that which springs from actual observation."[14] At heart, Bingham, like Trumbull, was a historian.

In Bingham's scenes, we see the give-and-take of the democratic process as played out on the frontier, where social distinctions were more malleable than in the East. As Tocqueville attested, "It is in the West that one can see democracy in its most extreme form."[15] Bingham showed political candidates courting potential supporters, men arguing and debating, and stump speakers attempting to sway crowds. His paintings bear witness to the rise of mass democracy in the first half of the nineteenth century and its broad social impact. By joining different levels of society in one shared debate, democratic politicking changed the social landscape. Many popular prints of the period depict this social shift, showing men of various means—merchants, musicians, laborers—mingling on streets or in taverns in scenes of everyday life. William Sidney Mount offered such an image in *After Dinner*, depicting a prosperous-looking man and a common laborer listening to a violinist, all three seated at the same table (cat. no. 75). A contemporary of Bingham's, Mount also achieved success as one of the first American

artists to portray everyday life. American art was being democratized.

Of course, women are entirely absent from Bingham's political vistas; the rough-and-tumble world of antebellum democratic politicking was overwhelmingly male. Drinking, gambling, and fisticuffs were as much a part of the political process as the exchange of opinions and ideas. Scenes such as *The County Election* (cat. no. 78) show all of this—and more—in the milling crowd assembled near a polling place on Election Day.

Also absent, or at least condemned to the sidelines, are African Americans and Native Americans, both excluded from the political process. Indeed, popular prints often expressed this exclusion visually, positioning black onlookers off to the side, away from the center of entertainment and action (cat. nos. 79–80). Such images expose the ugly underbelly of the period's massive territorial growth: the displacement of Indians and the intensification of the problem of slavery. The promise and opportunity fueling western expansion often rested on the suffering of those who were deprived of a political voice.

The growth of the frontier was a firebrand for the issue of slavery. From America's earliest years, the question of slavery had been a potential bombshell, consistently pushed aside in favor of immediate concerns about preserving the Union. Yet every state admitted to the Union raised the troubling question with increasing force. As much as the national government tried to manage matters with a series of compromises and balancing acts between "slave" and "free" states, the divisions only intensified over time. Abolitionists fueled the fire by aggressively pressing their views in print and political debate, inciting violent counterattacks from their enemies as well as praise from their friends. Such exchanges were not limited to councils of government. People of all ranks and status spoke out, including the victimized themselves (cat. nos. 81–82). One group of African Americans expressed their appreciation of an abolitionist minister by giving him a silver milk jug (cat. no. 87).

Democracy could be liberating, but it could also be exclusive, violent, and dangerous. Freedom of debate meant freedom to disagree, and by 1861, the national disagreement over slavery had come to a breaking point. The result was civil war. Unlike America's previous wars, this was one of national failures—of union, of race relations, of economic disparity between North and South. The experimental Constitution launched with such fanfare in 1789 had likewise failed. With the

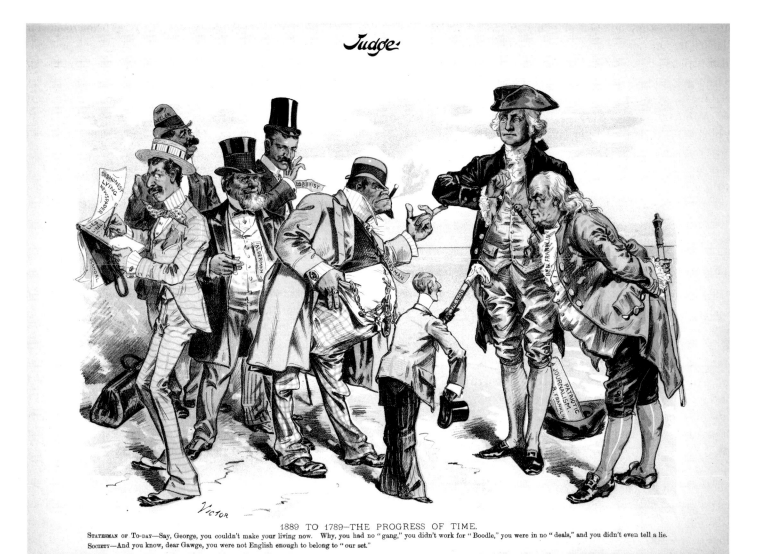

fig. 7 Victor, "1889 to 1789—
The Progress of Time," *Judge* 16
(27 Apr. 1889). Sterling Memorial
Library, Yale University

outbreak of the Civil War, Americans learned a shocking truth about their youthful republic: it could falter and fall. America's seemingly model polity had revealed its flaws and limitations—a jolt of realism that ended the nation's hopeful adolescence of endless possibilities. America no longer appeared to have a unique destiny.

Artistic images from the period reflect this sensibility. Winslow Homer's *In Front of Yorktown* (cat. no. 94) shows the monotony and hardship of military camp life in the shadows of night. Thomas Eakins's *The Veteran* (cat. no. 95) is even more haunting, depicting a lone figure draped in darkness and seemingly lost in thought; his expression appears both despondent and hardened with experience. America's recognition of its failures, and their cost, bred a world-weary self-knowledge that continued long after the war.

To many, even after the Union's victory, the nation seemed to have fallen to a new low. Complaints about corruption in government were rampant, as suggested by the pointed political cartoons of Thomas Nast (cat. nos. 221–24). Such complaints were not new to the postwar era; similar assumptions about America's political system had contributed to the breakdown of the national government in the decade before the war.[16] But in the wake of civil warfare, their implications seemed darker; the spirit of the Founders seemed to have died. An 1889 *Judge* magazine cartoon depicts this idea in graphic form (fig. 7). Titled "1889 to 1789—The Progress of Time," it shows a group of dubious-looking characters (labeled "Lobbyist," "Alderman," "Statesman," and "Dishonest Lying Newspaper") standing before Washington and Benjamin Franklin. "Say, George, you couldn't make your living now," says the "Statesman of To-day" to a shocked Washington. "Why, you had no 'gang,' you didn't work for 'Boodle' [bribes], you were in no 'deals,' and you didn't even tell a lie." The Founders seemed to have no place in postwar America.

Such cartoons stand in stark contrast with America's Revolutionary propaganda of righteous indignation; with Trumbull's bold, declarative images of battlefield heroics; with the jaunty, satirical cartoons from the War of 1812; and with the dark, haunting visions of the Civil War. Between 1775 and 1865, America had descended into warfare again and again, each time emerging with a changed sense of self. No longer a new nation rising to its feet, the United States now felt the weight of adulthood, the weight of failed promises and unfulfilled expectations. Postwar Americans had earned some self-knowledge, and they did not always like what they had learned.

Notes

1. Kenneth Cmiel, *Democratic Eloquence: The Fight over Popular Speech in Nineteenth-Century America* (Berkeley: University of California Press, 1990), 63.

2. John Trumbull to Thomas Jefferson, 11 June 1789, Thomas Jefferson Papers, Library of Congress, Washington, D.C.

3. John Trumbull to Andrew Elliott, 4 Mar. 1786, in Kenneth Silverman, *A Cultural History of the American Revolution* (New York: Columbia University Press, 1987), 465.

4. John Trumbull to Jonathan Trumbull, Jr., 27 Feb. 1787, in ibid., 469.

5. *Register of Debates*, 20th Congress, 1st Session, 9 Jan. 1828, 942.

6. Theodore Sedgwick to Pamela Sedgwick, 9 Jan. 1791, Theodore Sedgwick Papers, Massachusetts Historical Society, Boston. I thank the First Federal Congress project at George Washington University for allowing me to rummage through their files.

7. Theodore Sizer, ed., *The Autobiography of Colonel John Trumbull, Patriot-Artist, 1756–1843* (1841; repr. New Haven: Yale University Press, 1953), 22–23, 173.

8. Ibid., 166.

9. Quoted in Helen A. Cooper, *John Trumbull: The Hand and Spirit of a Painter* (New Haven: Yale University Art Gallery, 1982), 90.

10. Benjamin Silliman, "Notebook," unpublished reminiscences, 1857, Yale University Library, Silliman Family Papers, sec. II. See also n. 9 above and esp. n. 12. Senator John Holmes of Maine, in ibid., 90.

11. David Ramsay, *The History of the American Revolution*, ed. Lester H. Cohen, 2 vols. (1789; repr. Indianapolis: Liberty Classics, 1990), 2:667.

12. Alexander Hamilton, *Federalist*, no. 1, 27 Oct. 1787, in Clinton Rossiter, ed., *The Federalist Papers* (New York: New American Library, 1961), 33.

13. Cassius [Aedanus Burke], "Considerations on the Society or Order of Cincinnati; Lately Instituted by the Major-Generals, Brigadiers, and Other Officers of the American Army. Proving that it Creates a Race of Hereditary Patricians, or Nobility; and Interspersed with Remarks on its Consequences to the Freedom and Happiness of the Republic" (Hartford, Conn.: Bavil Webster, and Philadelphia: Robert Bell, 1783), 8, 10, 29; Thomas Jefferson to George Washington, 14 Nov. 1786, Thomas Jefferson Papers, Library of Congress, Washington, D.C.

14. George Caleb Bingham, in John Demos, "The Artist as Social Historian, Part I," *American Quarterly* 17 (summer 1965), 219–28, quotation at 219.

15. Alexis de Tocqueville, *Democracy in America*, ed. J. P. Mayer, 2 vols. (1850; repr. New York: Anchor Books, Doubleday, 1969), 55.

16. See Mark W. Summers, *The Plundering Generation: Corruption and the Crisis of the Union, 1849–1861* (New York: Oxford University Press, 1987).

27

Paul Revere (1735–1818)
The Bloody Massacre Perpetrated in King-Street Boston on March 5th 1770 by a Party of the 29th Regt., March 1770

Hand-colored engraving, 11½ x 9¾ in.
(29.2 x 24.2 cm)
The John Hill Morgan, B.A. 1893, LL.B. 1896,
M.A. (HON.) 1929, Collection, 1943.87

The presence of British troops in colonial Boston had long been a point of contention among the city's progressive politicians. On the night of 5 March 1770, in King Street, a mob of local men and boys taunted a British sentry standing guard at the city's customs house.[1] When other soldiers came to the sentry's aid, a skirmish ensued and shots were fired into the angry crowd. Four colonists were killed instantly, and a fifth died four days later. Six others were wounded. Businessman-turned-politician Samuel Adams recognized that this event could be used to call attention to British tyranny and to whip up anti-British sentiment among the colonists. To this end, Adams urged silversmith-patriot Paul Revere quickly to prepare an engraving of the scene. The image appeared in the 12 March 1770 issue of the *Boston Gazette*, along with Revere's "An account of a late Military Massacre at Boston, or the Consequences of Quartering Troops in a populous well regulated Town . . . ," and it was later reprinted and widely distributed as a broadside: *The Bloody Massacre Perpetrated in King-Street Boston on March 5th 1770*.[2]

The Bloody Massacre is an intriguing print for two reasons: it is one of the most informative broadsides publicizing a major event leading up to the Revolutionary War—the Boston Massacre—and it is a case study in journalistic practice and copyright issues in early America. Though published first, Revere's image is essentially an illicit copy of an engraving that was being prepared simultaneously for distribution by Revere's contemporary Henry Pelham (son of Peter Pelham and half-brother of John Singleton Copley). We know from an extant letter that Pelham wrote to Revere that he was furious about this blatant pilfering.[3] Revere's image differs from Pelham's in only a few minor details, but it is in the rather long inflammatory verse at the bottom of Revere's broadside (denouncing the British troops as "fierce Barbarians")[4] that his copy differs most dramatically from Pelham's, which quotes four far gentler lines from Psalm 94.

While Revere's broadside is long on political propaganda, it is short on historical accuracy. In the print, the British soldiers are shown standing in a straight line, shooting their rifles in an organized fashion, whereas in truth the participants on both sides were riotous and confrontational. Note too the absence of snow on the street and the blue sky in which only a wisp of a moon suggests that the riot occurred after nine o'clock on a cold winter night. Another inaccuracy is that the figure of the freed slave Crispus Attucks, lying dead in the center foreground closest to the British soldiers, is pictured as white-skinned.[5]

After the initial 12 March publication of Revere's engraving in the *Boston Gazette*, and in his subsequent rush to produce his engraving as an independent image, the silversmith likely employed the talents of Christian Remick to hand-color the print. Remick's choice of colors is simple yet effective: in particular, he used the same tone of red watercolor for both the British uniforms and the blood. Revere signed his plate (which Pelham had not) and likely pulled several hundred impressions from it, further popularizing the artist as a man of many talents beyond silversmithing—and helping to make Paul Revere, not Henry Pelham, a household name.[6] Revere's *Bloody Massacre* was so influential, in fact, that the British soldiers involved in the incident were later tried for the killings.[7]

E.H.

Notes

1. The events of 5 March 1770 took place within a few feet of the Old State House—a 1713 structure that still stands today—which is pictured at the center of the image. Six years later, the Declaration of Independence would be read aloud from the balcony of the State House to a euphoric crowd.
2. Revere's print was first advertised on 26 March 1770 and put on sale at a price of eightpence. See Clarence S. Brigham, *Paul Revere's Engravings* (Worcester, Mass.: American Antiquarian Society, 1954), 41.
3. It was common (though not always legitimate) practice in the eighteenth century for engravers to copy the work of others without citing their source. It is possible that Revere may not have known that Pelham intended to publish the print; it is also possible that Revere shared some of his profits with Pelham. For a comprehensive account of this event, as well as of the various printings and copies of the design, see Brigham, 1954, 41–57, and specifically 41–42 for a transcription of Pelham's letter of 29 March 1770 to Revere, now preserved in the Public Record Office, London. See also Gloria Gilda Deák, *Picturing America, 1497–1899*, 2 vols. (Princeton: Princeton University Press, 1988), 1:82–84, and 2: nos. 127–28. By the time Pelham advertised his own version of the engraving in the Boston newspapers of 2 April 1770—"An Original Print . . . taken on the Spot"—Revere's *Bloody Massacre* had already been in circulation for a week. No comment from Revere upon the matter has ever surfaced.
4. Revere's verse, engraved below the image, reads in part: "Unhappy BOSTON! See thy Sons deplore, / Thy hallow'd Walks besmear'd with guiltless Gore: / While faithless P---n and his savage Bands, / With murd'rous Rancour stretch their bloody Hands; / Like fierce Barbarians grinning o'er their Prey, / Approve the Carnage, and enjoy the Day . . . § The unhappy Sufferers were MESS[s] SAM[l]-GRAY, SAM[l]-MAVERICK, JAM[s] CALDWELL, CRISPUS ATTUCKS & PAT[k]-CARR Killed. Six wounded; two of them (CHRIST[r]-MONK & JOHN CLARK) Mortally."
5. Crispus Attucks—a seaman and ropemaker—would emerge as the most famous of all the black men who fought in the Revolutionary cause and would become its first martyr.
6. Revere's copperplate is preserved in the Archives Office of the State House of Boston. A third rendition of the event, by Jonathan Mulliken, a clockmaker from Newburyport, closely followed Revere's model.
7. Deák, 1988, 1:84.

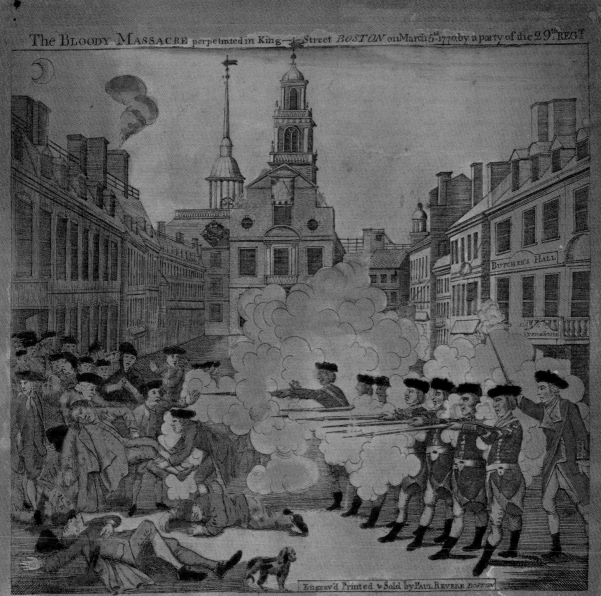

The BLOODY MASSACRE perpetrated in King——Street BOSTON on March 5th 1770 by a party of the 29th REGT.

Unhappy BOSTON! see thy Sons deplore,
Thy hallow'd Walks besmear'd with guiltless Gore.
While faithless P——n and his savage Bands,
With murd'rous Rancour stretch their bloody Hands;
Like fierce Barbarians grinning o'er their Prey,
Approve the Carnage, and enjoy the Day.

If scalding drops from Rage from Anguish Wrung,
If speechless Sorrows lab'ring for a Tongue,
Or if a weeping World can ought appease
The plaintive Ghosts of Victims such as these;
The Patriot's copious Tears for each are shed,
A glorious Tribute which embalms the Dead.

But know, Fate summons to that awful Goal,
Where JUSTICE strips the Murd'rer of his Soul:
Should venalC——ts the scandal of the Land,
Snatch the relentless Villain from her Hand,
Keen Execrations on this Plate inscrib'd,
Shall reach a JUDGE who never can be brib'd.

Engrav'd Printed & Sold by PAUL REVERE Boston

The unhappy Sufferers were Mess'rs. Sam'l Gray, Sam'l Maverick, Jam's Caldwell, Crispus Attucks & Pat'k Carr
Killed. Six wounded; two of them (Christr Monk & John Clark) Mortally

27

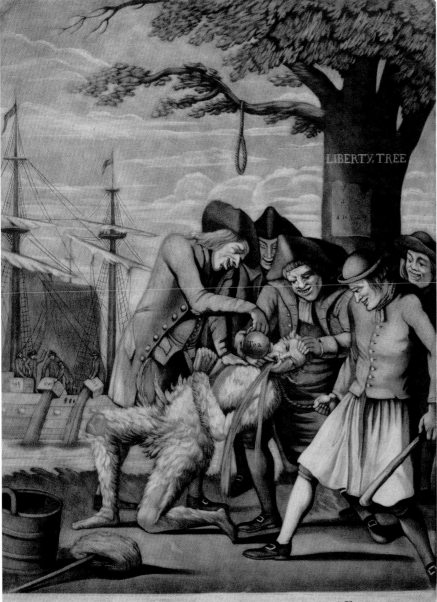

The BOSTONIAN'S Paying the EXCISE-MAN, or TARRING & FEATHERING

Plate I. London Printed for Rob.t Sayer & J.Bennett, Map & Printseller N.o 53, Fleet Street as the Act directs 31.Oct.r 1774.

28

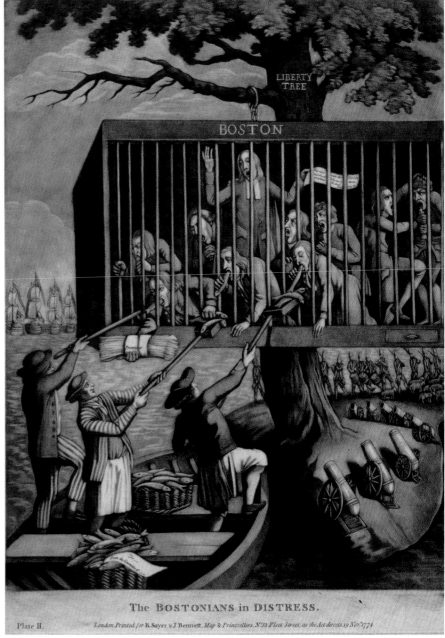

The BOSTONIANS in DISTRESS.

Plate II. London Printed for R.Sayer & J.Bennett, Map & Printsellers. N.o 53 Fleet Street, as the Act directs 19 Nov.r 1774.

29

Attributed to Philip Dawe
(active in London 1760–80)
Printed in London for R. Sayer
and J. Bennett

28

The Bostonians Paying the Excise-Man, or
Tarring & Feathering, 1774

Mezzotint with some burin work, plate 1 from a
series of 6, 18 ⅝ x 11 ⅝ in. (47.3 x 29.5 cm)
Mabel Brady Garvan Collection, 1946.9.369

29

The Bostonians in Distress, 1774

Mezzotint with some burin work, plate 2 from a
series of 6, 18 ¾ x 11 ½ in. (47.6 x 29.2 cm)
Mabel Brady Garvan Collection, 1946.9.368

Political tension had been brewing between
the American colonists and Great Britain
for several years when it finally reached the
boiling point over the Tea Act of 1773. With
this legislation, Parliament granted the
struggling English East India Company a
monopoly on all tea shipped to America,
fueling bitter discontent over the imposition
of taxes on tea.[1] At base, these disputes
emerged out of a fundamental disagreement
between colonists and Great Britain about
the legitimate limits of imperial authority
over American commerce and society.

Tea was an important commodity in colo-
nial America, whose citizens were purported
to consume over a million pounds of it each
year—more than the British themselves. To
avoid paying taxes, Americans purchased
only a quarter of their tea from the English
East India Company–approved merchants.
In an attempt to remedy this situation, the
Tea Act was instituted, lowering the price of
tea by eliminating all taxes except the mini-
mal threepence Townshend Duties and allow-
ing the East India Company to sell directly
to consumers. These two changes made the
company's tea cheaper than the Dutch tea

that Americans had been buying illegally.
Parliament assumed that Americans' economic
self-interest and fondness for tea would
prevail, but things were not that simple.

Tea was valued not only for its taste but
also for its cultural cachet. Like other
imported goods, including accoutrements for
the ritual of tea drinking, tea was consid-
ered a symbol of gentility and refinement.
Some Americans, most famously Benjamin
Franklin, warned against excessive indul-
gence in imported luxuries, and, as tensions
between America and Great Britain esca-
lated, such warnings seemed all the more
prescient. Because of its symbolic connec-
tions with British high culture, tea became
a symbol of American colonial oppression
under the British empire during the
Revolutionary crisis.

The two satirical images shown here
provide contemporary views of the heated
events of the day and the politics of con-
sumption. During this period of intense con-
flict within the British empire, American
colonists expressed their dissatisfaction with
the new forms of taxation through protests
that ascribed political significance to the
goods people chose to consume. Refraining
from selling and drinking imported British
tea during a boycott indicated a personal
sacrifice for the common good. Colonists
were encouraged (some would say coerced)
to comply.

Attributed to Englishman Philip Dawe
and originally published in London, the
two images were part of a series of six mez-
zotints.[2] At the time of their publication in
1774, they were marketed for individual
sale at a mere sixpence on the street and in
print shops. Just twenty months later, in
June 1776, the prints were being marketed
to an American audience by John Norman
of Philadelphia.

The Bostonians Paying the Excise-Man, or
Tarring & Feathering (cat. no. 28) depicts the
colonists' angry reaction to the new British

laws. In the foreground, five irate and rather
grotesque-looking Bostonians force tea down
the throat of a tarred-and-feathered man
who is purported to be John Malcomb,
commissioner of customs for the Crown.
A year after the Tea Act was passed, incensed
Bostonians had indeed subjected Malcomb
to this humiliation. In Dawe's print this
violent tableau takes place under the shade
of the "liberty tree." The tree has a noose
hanging from a branch and a ripped notice
of the Stamp Act nailed upside down onto
the trunk—both symbols of the colonists'
refusal to adhere to what they felt were
unjust laws.[3] Significantly, the liberty pole
and cap—long-standing British symbols of
freedom—lay vanquished on the ground.[4]
In the background, still more protesters
throw crates of tea into Boston Harbor—a
reference to the events of 16 December 1773,
which have since become known as the
Boston Tea Party.

The Bostonians in Distress (cat. no. 29) also
takes place under the shade of the famed
liberty tree and refers to the punishment
that the British imposed on Bostonians for
their dramatic protests against the Tea Act.
In an attempt to reassert authority,
Parliament passed a number of punitive
measures in 1774 that became known as the
Coercive Acts. The first of these closed the
port of Boston until damages from the
Boston Tea Party, as well as the requisite
taxes, were paid. In this evocative image,
ten piteous men representing the city of
Boston are imprisoned in a cage that hangs
precariously from a dead branch. The grav-
ity of Boston's plight is represented by the
ring of cannons surrounding the liberty tree
and by several frigates sent to America by
the British prime minister Lord North,
which float menacingly in the background.
In the distant right, a brigade of British
troops pillages colonial livestock. In light of
these hardships, one of the caged men recites
the following biblical passage: "They cried

unto the Lord in their Trouble & he saved
them out of their Distress" (Psalm 107:13).
These foreboding signs are counterbalanced
by the promise of intercolonial coopera-
tion—indicated by the boatload of rescuers
from neighboring regions who offer the
imprisoned Bostonians sustenance in the
form of fish, a religiously symbolic offering.
Indeed, the drastic measures taken by the
British would lead to the first meeting of the
Continental Congress in September 1774, and
eventually to America's independence. K.Y.

Notes
1. Tea was taxed as part of the Townshend Duties
of 1767. In 1770, the duties were repealed, except
for the tax on tea.
2. Descriptions of the content of the prints are based
on those found in E. McSherry Fowble, *Two Cen-
turies of Prints in America, 1680–1880: A Selective
Catalogue of the Winterthur Museum Collection*
(Winterthur, Del.: Henry Francis du Pont Winterthur
Museum, and Charlottesville: University Press of
Virginia, 1987), nos. 93–94, 150–51.
3. Wendy J. Shadwell, "Some Pre-Revolutionary
Prints and Broadsides," *Antiques* 99 (Feb. 1971), 262.
4. Amelia Rauser, "Death or Liberty: British
Political Prints and the Struggle for Symbols in the
American Revolution," *Oxford Art Journal* 21
(1998), 153–71.

30

William Hovey (1749–1834)
Powder Horn
Cambridge, Massachusetts, 1775

Horn, pine, iron, and leather, l. 17 ¾ in.
(45.1 cm), plug w. 3 in. (7.6 cm)
Bequest of Janet Smith Johnson in memory of
her husband, Frederick Morgan Johnson,
B.A. 1891, 1955.33.4

During the Revolutionary War, powder
horns were used for storing gunpowder for
flintlock muskets. Soldiers in the Continental army often supplied these horns themselves, particularly at the beginning of the
war. This example bears the inscription:
"OBADIAH : JOHNSONS : HORN : / MADE : AT :
CAMBRIDGE : 1775." It dates to the summer or
fall of that year, when, during the Siege of
Boston, American volunteers gathered to
repel the British naval occupation of Boston
Harbor. The owner of the horn, Obadiah
Johnson (1735/6–1801), was a major in the
Third Connecticut Regiment and a captain of
the fourth company, stationed at Cambridge
during the siege.[1] A pastel portrait painted
by an unknown artist about 1790 depicts
Johnson after he had returned home from the
war to resume his life as a gentleman farmer
in his native Canterbury, Connecticut (fig. a).

The carver of the horn probably was
"WILLIAM / HOVEY of / MANSFIELD [Connecticut]," whose inscription appears in smaller
letters. Hovey served as a sergeant in the
second company of the Third Connecticut
Regiment between 6 May and 16 December
1775 and was with Johnson at Cambridge.[2]
The carving on the horn displays a creative
understanding of scale, juxtaposing oversize
images of ships, soldiers, and foliate designs
with more accurate topographic depictions
of the harbor and the forts that lined it.
The cannons firing from the forts give this
scene a sense of action, but it was more likely
the monotony and boredom of camp life,

perhaps accompanied by a likely competition
among carvers of horn, that encouraged
the production of this and other elaborate
examples known to date from the siege.[3]

Another horn signed by Hovey was
unearthed from a battlefield in Pennsylvania
in the nineteenth century. Described as a
"curious relic" in the July 1841 issue of the
Germantown Telegraph, this horn, now unlocated, like Johnson's reportedly bore images
of Boston and its environs with the positions of the American forts and British fleet.
Made for Ebenezer Gray, a fellow officer
with Johnson in the Third Regiment, it was
lost at the Battle of Germantown in 1777 by
another Connecticut soldier, Elijah Lincoln.[4]
The survival of these two similar horns indicates that Hovey, probably a self-taught
carver, made horns for officers in his regiment during the siege. Hovey's work records
a rare view by a soldier of the events and
patriotic fervor at the beginning of the
Revolutionary War. D.A.C.

Notes

1. Henry P. Johnston, ed., *The Record of Connecticut
Men in the Military and Naval Service during the
War of the Revolution, 1775–1783* (Hartford: Case,
Lockwood, & Brainard Co., 1889), 53–54.
2. Ibid., 53.
3. For other horns from the so-called Siege of
Boston school, see William H. Guthman, *Drums
A'beating, Trumpets Sounding: Artistically Carved
Powder Horns in the Provincial Manner, 1746–1781*
(Hartford: Connecticut Historical Society, 1993),
51–59, 165–66.
4. John F. Watson, *Annals of Philadelphia and
Pennsylvania*, 2 vols. (Philadelphia: 1844), 2:45–46.

fig. a *Colonel Obadiah Johnson*, ca. 1790.
Pastel on paper, 18 ¼ x 14 in. (46.4 x 35.6 cm).
Yale University Art Gallery, Bequest of Janet
Smith Johnson in memory of her husband,
Frederick Morgan Johnson, B.A. 1891, 1955.33.6

Carver's inscription

JOHN TRUMBULL'S PAINTINGS OF THE AMERICAN REVOLUTION

He is the first painter who has undertaken to immortalize by his pencil those great actions that gave birth to our nation. He teaches mankind that it is not rank nor titles, but character alone, which interests posterity.

—Abigail Adams

The first artist to apply realistic innovations in history painting to American subjects, the patriot-artist John Trumbull (1756–1843) was uniquely placed to create the "official" American self-image. As a son of the governor of Connecticut, the only state governor to declare for American independence, Trumbull was a member of the new republic's political and social elite, and he knew or had access to all the leaders of the Revolution. His own life was filled with incident. He served as second aide-de-camp to George Washington; participated in a secret mission from Congress to Benjamin Franklin in Paris; was imprisoned in London as a spy; acted as courier in Thomas Jefferson's courtship of Maria Cosway, as messenger from the Marquis de Lafayette to President Washington, and as secretary to John Jay in London; and engaged in negotiations with Talleyrand. He dabbled briefly in art dealing and in the rum and tea business.[1] But above all else, his great wish was to record in pictures the principal events of the Revolution, "in which should be preserved as far as possible, faithful portraits of those who had been conspicuous actors in the various scenes, whether civil or military, as well as accurate details of the dress, manners, arms & c. of the times."[2] He believed he had been sent by divine Providence "to shew to posterity the wonderful things which it pleased God to do for our Fathers.—for it was not their own wisdom, nor the strength of their own right hand, which founded & reared the mighty fabric under which we live."[3]

The first American artist to graduate from college, Trumbull came to Washington's attention in 1773 through family influence. He became the general's second aide-de-camp and then served as deputy adjutant-general under Major General Horatio Gates, for whom he developed a plan to strengthen and defend Fort Ticonderoga. He resigned from military service in 1777, determined to pursue the "art of painting" despite his family's disapproval. In 1780, the twenty-four-year-old aspiring artist went to London, where he was welcomed into the studio of the expatriate American artist Benjamin West. His vocal anti-British sentiments led to his arrest on charges of treason; he was released after almost eight months through the efforts of West and Edmund Burke and returned to America. In 1784 Trumbull returned to London and to West, who introduced the young American into his large circle of artists, diplomats, and aristocrats and occasionally took him to Windsor Castle. Trumbull concentrated on honing his artistic skills because he saw the recent war as opening a new field in America for history painting and portraiture.

It was West who first suggested the scheme that was to become Trumbull's greatest legacy. As the beneficiary of George III's generous patronage, the older artist could not, for obvious political reasons, undertake such a series himself. But he encouraged Trumbull to pursue the project, as did John Adams in London and Jefferson in Paris. Inspired by the modern history paintings of West and John Singleton Copley, Trumbull began in 1786 "writing, *in my language*, the History of our Country."[4] Although his vision of the Revolutionary War has been enshrined in our national imagination, Trumbull originally faced criticism for portraying American defeats as well as victories. His primary aim in these paintings was didactic: to express the values of the Revolutionary generation as the common heritage of all Americans.[5] Although his instincts were aristocratic, his inclinations were democratic. The paintings convey his fundamental belief that American democracy would make the values of noble behavior—charity over victory, honor, and self restraint—the property of all citizens.

Trumbull's original plan for the series called for fourteen scenes; ultimately he completed only eight, working on some of them for decades. He had hoped to make his fortune from the sale of engravings based on the paintings, but in the end he sold few subscriptions. Discouraged, he ceased painting in 1794 and took up diplomatic and administrative posts for the new American government. In 1815, he renewed his efforts to find support for a proposed permanent exhibition of life-size versions of the paintings. He was finally rewarded in 1817, when he was chosen to decorate four of the eight niches in the Rotunda of the Capitol in Washington.

Trumbull considered the Rotunda commission to be the greatest honor of his career. He painted *The Declaration of Independence* and *The Surrender of Lord Cornwallis at Yorktown* (cat. nos. 33, 37), based on the original versions he would later give to Yale, and added *The Resignation of Washington* and *The Surrender of General Burgoyne at Saratoga* (cat. nos. 38, 36) to complement the first two works.

In 1831, Yale professor Benjamin Silliman, Trumbull's nephew-in-law, negotiated the transfer to Yale of the seventy-five-year-old artist's original history paintings and miniatures in exchange for a thousand-dollar-a-year annuity. As part of the agreement, a building to house the collection was constructed on the Yale campus after the painter's own architectural designs. To complete the Yale series of history paintings, Trumbull executed smaller versions of the Capitol's *The Resignation of Washington* and *The Surrender at Saratoga*. The neoclassical "Trumbull Gallery" opened its doors to the public in 1832, with Professor Silliman serving as its first curator. It became the first art museum connected with an educational institution in America and was an immediate success. As one local newspaper proclaimed, "Altogether this Gallery must be considered the most interesting collection of pictures in the country. They are American" (fig. a).[6]

H.A.C.

Notes

The epigraph to this text is drawn from Abigail Adams to Mrs. [John] Shaw, 4 Mar. 1786, in Charles Francis Adams, ed., *Letters to Mrs Adams, the Wife of John Adams* (Boston: C. C. Little and J. Brown, 1840), 324–25.

1. Trumbull was the first American artist to publish an autobiography. See John Trumbull, *Autobiography, Reminiscences and Letters of John Trumbull from 1756 to 1841* (New York and London: Wiley and Putnam, and New Haven: B. L. Hamlen, 1841). For further information on Trumbull's life and career as well as detailed discussion of each of the history paintings, see Helen A. Cooper, *John Trumbull: The Hand and Spirit of a Painter*, exh. cat. (New Haven: Yale University Art Gallery, 1982).

2. John Trumbull, *Catalogue of Paintings, by Colonel Trumbull; Including Eight Subjects of the American Revolution, with Near Two Hundred and Fifty Portraits, of Persons Distinguished in That Important Period. Painted by Him from the Life* (New Haven: printed by Hezekiah Howe & Co., 1832), 4.

3. Quoted in Patricia M. Burnham, "John Trumbull, Historian: The Case of the Battle of Bunker's Hill," in *Redefining American History Painting,* ed. Patricia M. Burnham and Lucretia Hoover Giese (New York: Cambridge University Press, 1995), 42.

4. John Trumbull to Andrew Elliot, 4 Mar. 1786, John Trumbull Papers, Massachusetts Historical Society, Boston.

5. Jules David Prown, "John Trumbull as History Painter," in Cooper, 1982, 41.

6. *Connecticut Journal*, 6 Nov. 1832, on the opening of the Trumbull Gallery.

TRUMBULL GALLERY OF PAINTINGS:

YALE COLLEGE.

By agreement between the College and Colonel TRUMBULL, this valuable collection of Paintings became the property of the Institution, on the death of the venerable artist,—which occurred in November, 1843. This agreement requires that the income of the Gallery, after paying his annuity, be forever applied towards the education of needy and meritorious students in Yale College.

The Gallery is contained in a stone edifice, built expressly for the object; and comprises two rooms each 30 feet square, 24 feet high, and lighted from above.

The TRUMBULL GALLERY *proper* occupies the North Room, and contains 53 Paintings from the pencil of Col. T., including all his original historical pictures of Scenes of the American Revolution. The following is a summary of the collection.

Battle of Bunker's Hill.	Declaration of Independence.
Death of Gen. Montgomery, at Quebec.	Capture of the Hessians at Trenton.
Death of Gen. Mercer, at battle of Princeton.	Surrender of General Burgoyne.
Resignation of Gen. Washington.	Surrender of Lord Cornwallis.
Our Savior with little children.	Preparing the body of our Savior for the tomb.
Our Savior bearing the cross.	Infant Savior and St. John.
Holy Family.	St. John and Lamb.
Communion of St. Jerome.	St. Jerome, (copy from Correggio.)
Madonna della Sedia.	Madonna au corset rouge.
Transfiguration, (copy from Raphael.)	Woman accused of adultery.
Earl of Angus, conferring Knighthood on De Wilton.	Peter the Great at the capture of Narva.
Lamderg and Gelchossa.	Death of Paulus Emilius.
Joshua at the battle of Ai.	Last Family which perished in the Deluge.
" I was in prison and ye visited me."	Portrait of Duke of Wellington.
Portrait of Mrs. Trumbull.	Gov. Trumbull, sen.
Timothy Dwight.	Gen. Washington.
Stephen Van Rensselaer.	Rufus King.
Christopher Gore.	Alexander Hamilton.
	12 Groups, comprising 58 portraits.

The South Room comprises a collection of portraits of the past and present officers and benefactors of the College, besides many other paintings of historic interest, the whole number being about fifty. It also includes the celebrated group in marble of *Jephthah and his Daughter* by AUGUR, several busts of distinguished persons,—ancient coins, medals, and other memorials of antiquity.

The Gallery is open for visitors generally throughout the day, except the hour from 1 to 2 P. M. *Price of admission,* 25 cts. Access to the *Cabinet of Minerals,* the *Library,* and the other public Rooms of the College, is *without charge.* Directions for finding these rooms may be obtained by visitors, on inquiry at the Treasurer's Office under the Trumbull Gallery.

N. B. *Visitors are earnestly requested not to touch the paintings or the statuary. Canes, whips, umbrellas, fruit, tobacco and dogs are excluded.*

B. SILLIMAN, *Curator.*

PRINTED BY B. L. HAMLEN.

fig. a B. L. Hamlen, printer, with text by Benjamin Silliman, curator, *Trumbull Gallery Broadside*, ca. 1850. Lithograph, 15½ x 10⅜ in. (39.4 x 26.4 cm). Yale University Art Gallery, 1932.1198

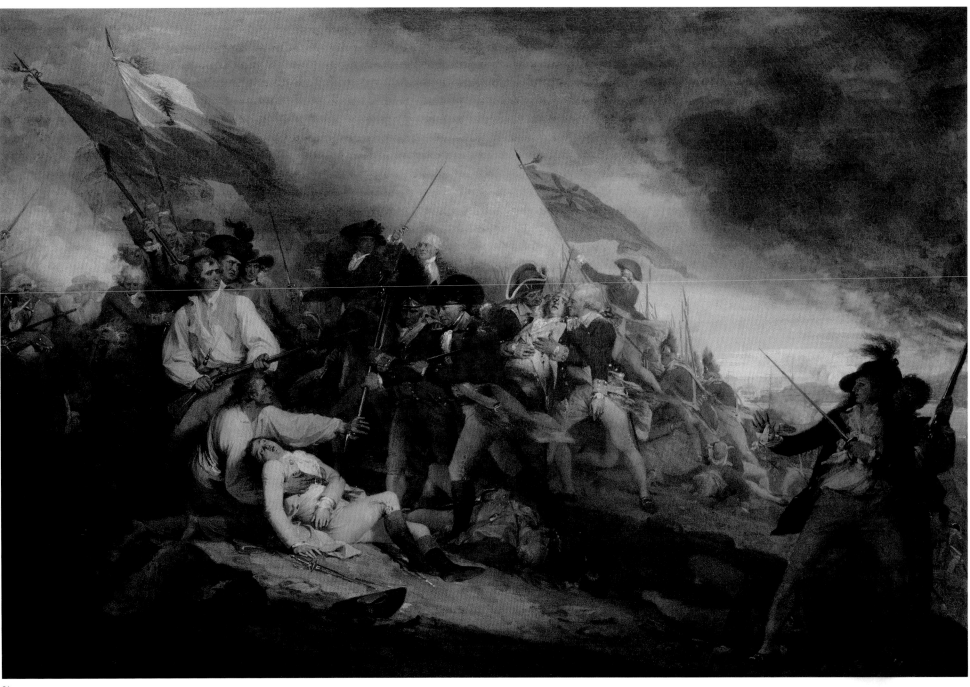

31

The Battle of Bunker's Hill, June 17, 1775,
1786

Oil on canvas, 25 ⅝ x 37 ⅝ in. (65.1 x 95.6 cm)
Trumbull Collection, 1832.1

Trumbull wrote: "This painting represents the moment where (the Americans having expended their ammunition) the British troops became completely successful and masters of the field."[1] The artist began the American Revolution series with *Bunker's Hill* because he considered this battle the earliest important event in the war.[2] It was also the only battle he actually witnessed, seeing the smoke and fire of the confrontation through field glasses while stationed across Boston Harbor at Roxbury on 17 June 1775. That day the British mounted three attacks on American fortifications guarding Bunker and Breed's Hills. The third assault ended in hand-to-hand combat, and the Americans slowly yielded their strongholds, but only after very heavy losses.

Trumbull portrayed the thirty-four-year-old American general Joseph Warren mortally wounded by a musket ball just as the British successfully press beyond the American defensive works. Despite public criticism that Trumbull should have painted a battle in which American forces proved triumphant, *Bunker's Hill* can be read as an affirmation of the bonds of chivalry and gentlemanly conduct among military officers, which transcend national boundaries. Trumbull was less concerned with the outcome of the encounter than he was in depicting the noble behavior of the participants. Such balanced treatment of conflicting armies—giving each side its due—is not commonly seen in history paintings, which only reinforces the uniqueness of his artistic decision.[3] In his notes, Trumbull described the incident: "Colonel Small (whose con-

duct in America was always equally distinguished by acts of humanity and kindness to his enemies, as by bravery and fidelity to the cause he served) . . . saw [Warren] fall, and flew to save him. He is represented seizing the musket of the grenadier, to prevent the fatal blow, and speaking to his friend; it was too late; the general had barely life remaining to recognize the voice of friendship . . . and expired."[4] Directly behind Small, Major John Pitcairn of the British marines falls dying into the arms of his son; at the far left, General Israel Putnam of Connecticut, with an upraised sword, orders the Americans to retreat. General William Howe, commander of the British forces, wearing a black hat, is seen next to the flag in the center left background, together with the white-haired General Henry Clinton. In the right foreground, Lieutenant Thomas Grosvenor of Connecticut, wounded in his breast and sword hand, is shown moving to obey Putnam's order to retreat, yet transfixed by the sight of the dying Warren. Behind him stands an unidentified black man carrying a rifle.

Many African Americans fought in the Revolution, and Trumbull would certainly have known of the valor of men such as Peter Salem, one of the recognized heroes of the Battle of Bunker Hill. Immediately after this conflict, however, Congress began to exclude African Americans, Native Americans, and others from the Continental army. General Washington originally opposed this move but quickly realized that many whites would refuse to fight alongside armed blacks when so many still lived as slaves. Trumbull's inclusion of a black man holding a rifle acknowledges the bravery and patriotism of African Americans during the early days of the Revolution.

By depicting the action on the compressed space of a hilltop, positioning the figures on the sloping ground, and placing the viewer

at the bottom of the dynamic incline, Trumbull gave the scene a dramatic sense of movement. The diagonals of banners and smoke and the alternating areas of light and shadow further heighten the immediacy and impact of the death scene. When Trumbull completed *Bunker's Hill* in March 1786, the artist Benjamin West hailed it as "the *best picture* of a modern battle that has been painted: *no Man* living can paint such another picture of the Scene."[5] H.A.C.

Notes

1. John Trumbull, *Catalogue of Paintings, by Colonel Trumbull; Including Eight Subjects of the American Revolution, with Near Two Hundred and Fifty Portraits, of Persons Distinguished in That Important Period. Painted by Him from the Life* (New Haven: printed by Hezekiah Howe & Co., 1832), 10.
2. John Trumbull, *Autobiography, Reminiscences and Letters of John Trumbull from 1756 to 1841* (New York and London: Wiley and Putnam, and New Haven: B. L. Hamlen, 1841), 93. Trumbull followed the British usage, "Bunker's Hill."
3. David Bindman, "Americans in London: Contemporary History Painting Revisited," in *English Accents, Interactions with British Art c. 1776–1855,* ed. Christina Payne and William Vaughan (Burlington, Vt.: Ashgate Publishing Ltd., 2004), 15. For an insightful discussion of the painting, see Patricia M. Burnham, "John Trumbull, Historian: The Case of the Battle of Bunker's Hill," in *Redefining American History Painting,* ed. Patricia M. Burnham and Lucretia Hoover Giese (Cambridge: Cambridge University Press, 1995), 37–53.
4. Trumbull, 1832, 10.
5. John Trumbull quoting West, to David Trumbull, 31 Jan. 1786, John Trumbull Papers, Connecticut Historical Society, Hartford. Emphasis in original.

32

The Death of General Montgomery in the Attack on Quebec, December 31, 1775, 1786
Oil on canvas, 24 5/8 x 37 in. (62.5 x 94 cm)
Trumbull Collection, 1832.2

The second of Trumbull's Revolutionary War paintings, *The Death of General Montgomery*, pictures the tragic end of a brilliant and, up to that point, successful campaign that ultimately deprived the Americans of Canada. On the night of 31 December 1775, Major General Richard Montgomery, the hero of the Battles of Ticonderoga, St. John's, Chambly, and Montreal, tried to enter Quebec during a heavy blizzard, hoping that the snow would veil the sight and sound of the marching Continentals. He planned to stage a simultaneous attack on the upper and lower sections of the town, but one part of the army deserted. Montgomery then decided to invade the lower part from two directions with his remaining troops, after which the two parties would join and march together through the upper town. One battalion, led by Colonel Benedict Arnold, managed to overcome the first British artillery unit and move on to the rendezvous point. They waited in vain for Montgomery's battalion. The general, leading about three hundred New York militiamen, was ambushed by British and Canadian troops who had waited in silence for the American forces to approach and then fired a blast from a naval cannon, killing Montgomery and several others. Despite the fact that the assault on Quebec resulted in a British triumph, Trumbull and many of his contemporaries considered Montgomery's effort to take the city in midwinter—"to attack the enemy at the heart"—distinguished for its "brilliancy of conception and hardihood of attempt."[1]

Trumbull represented the moment when General Montgomery expires in the arms of Major Matthias Ogden. Before him on the snow-covered ground lie the bodies of his two aides-de-camp, Captains Jacob Cheeseman and John MacPherson. Lieutenants John Humphries and Samuel Cooper and Lieutenant Colonel Donald Campbell surround the two central figures in a protective semicircle, while a Mohawk Indian chief, Louis Cook, or "Colonel Louis," defiantly raises his tomahawk in the direction of the shots.[2] Three figures in the left foreground, Major Return Jonathan Meigs and Captains Samuel Ward and William Hendricks, gesture in shock at the sight of their dying general. In his depiction of Montgomery's death, Trumbull made no attempt, as he did in *Bunker's Hill* (cat. no. 31), to emphasize the chivalrous relationship between adversaries. Here the British army is the invisible source of the cannon shot that mortally wounds the general.[3] The powerful diagonal composition echoed in smaller intersecting diagonals of lights and darks, the spontaneous, fluid brushwork and palette of rich, glowing colors, and the action close to the picture surface all serve to heighten the intense drama centered on the figure of the dying Montgomery. Trumbull wrote: "Grief and surprise mark the countenances of the various characters. The earth covered with snow—trees stripped of their foliage—the desolation of winter, and the gloom of night, heighten the melancholy character of the scene."[4] H.A.C.

Notes
1. John Trumbull, *Autobiography, Reminiscences and Letters of John Trumbull from 1756 to 1841* (New York and London: Wiley and Putnam, and New Haven: B. L. Hamlen, 1841), 414.
2. Cook, who was also called Atiatoharongwen, came to be known as "Colonel Louis" when he was commissioned by the Continental Congress in 1779 to lead a company of Oneida and Tuscarora scouts. See Alan Taylor, *Divided Ground: Indians, Settlers, and the Northern Borderland in the American Revolution* (New York: Alfred A. Knopf, 2006), 172–73, 447n.8.
3. David Bindman, "Americans in London: Contemporary History Painting Revisited," in *English Accents, Interactions with British Art c. 1776–1855,* ed. Christina Payne and William Vaughan (Burlington, Vt.: Ashgate Publishing Ltd., 2004), 16.
4. John Trumbull, *Catalogue of Paintings, by Colonel Trumbull; Including Eight Subjects of the American Revolution, with Near Two Hundred and Fifty Portraits, of Persons Distinguished in That Important Period. Painted by Him from the Life* (New Haven: printed by Hezekiah Howe & Co., 1832), 14–15.

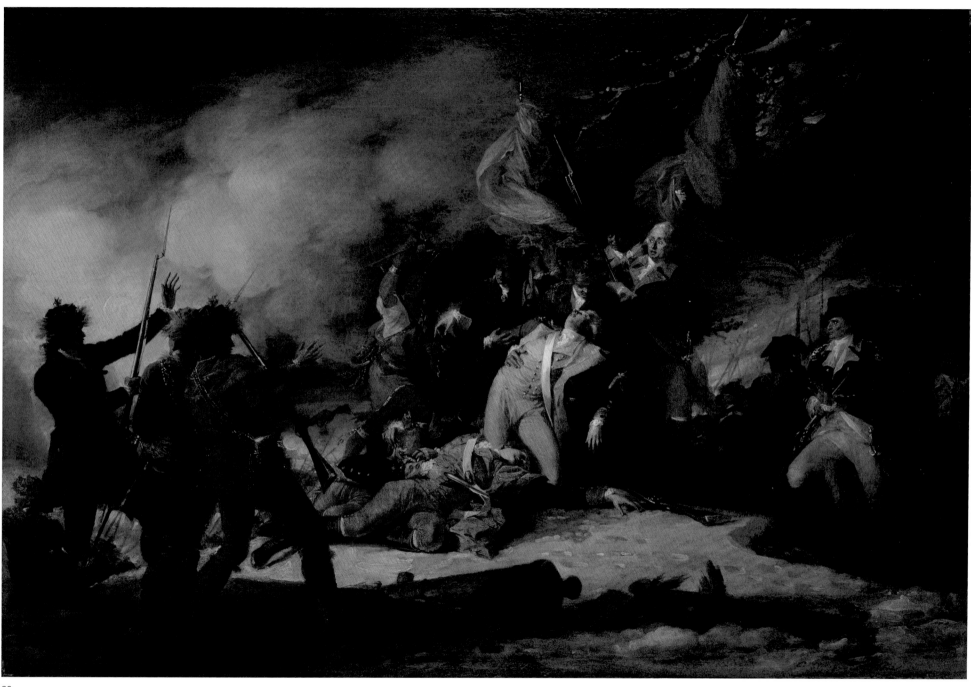

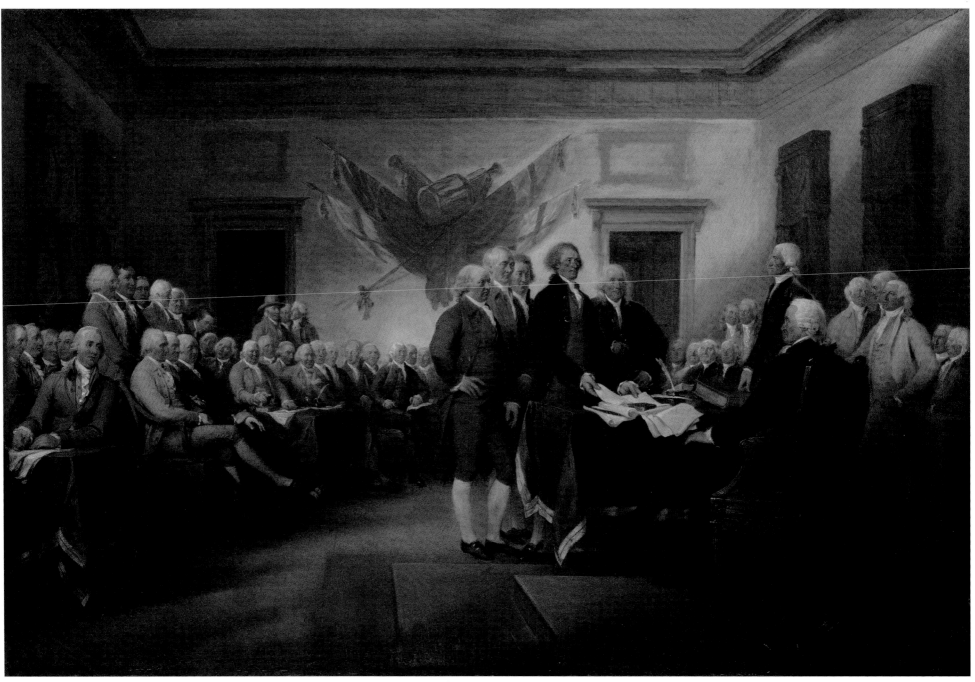

33

33

*The Declaration of Independence, July 4,
1776*, 1786–1820

Oil on canvas, 20⅞ x 31 in. (53 x 78.7 cm)
Trumbull Collection, 1832.3

In 1817, Trumbull received the long-sought
commission from Congress to decorate the
Capitol Rotunda with four life-size scenes
from the Revolutionary War. The sixty-one-
year-old artist wrote to President James
Madison, explaining his decision to begin
with a copy of this painting, *The Declaration
of Independence*:

> I have been constantly occupied with
> the Declaration of Independence, feeling
> the uncertainty of life & Health, & con-
> sidering that Subject as most interesting
> to the Nation, as well as most decisive
> of my own Reputation. . . . The universal
> interest which my Country feels & ever
> will feel in this Event will in some degree
> attach to the painting which will preserve
> the resemblance of Forty Seven of those
> Patriots to whom we owe this memorable
> Act and all its glorious consequences.[1]

Although Trumbull considered the
Declaration of Independence to be his most
important painting, he did not include the
subject in his original plan for a series of
scenes from the Revolutionary War. The sub-
ject came up when the artist visited Thomas
Jefferson in Paris in 1786: it seems likely
that Jefferson, as the chief author of the doc-
ument, suggested that the signing be added
to the history series. Trumbull recalled: "I
began the composition of the Declaration of
Independence, with the assistance of his
information and advice."[2] The two men dis-
cussed the subject in some detail. Jefferson
provided the artist with a firsthand account
of the event and a rough floor plan of the
Assembly Room where Congress had con-

vened (fig. a). On the other side of the page,
opposite Jefferson's floor plan, Trumbull
sketched his first idea for the composition.
Rather than show a single spokesman pre-
senting the document to John Hancock, then
president of Congress, which would have
been historically accurate, Trumbull chose to
portray Jefferson surrounded by the other
members of the drafting committee: John
Adams, Roger Sherman, Robert Livingston,
and Benjamin Franklin. Speaking in the third
person, Trumbull explained his decision:

> In order to give some variety to his
> composition, he found it necessary to
> depart from the usual practice of
> reporting an act, and has made the
> whole committee of five advance to the
> table of the president, to make their
> report, instead of having the chairman
> rise in his place for the purpose: the
> silence and solemnity of the scene,
> offered such real difficulties to a pictur-
> esque and agreeable composition, as to
> justify, in his opinion, this departure
> from custom, and perhaps fact.[3]

The artist's chief goal was to preserve por-
traits of the men who were part of this his-
toric act. However, difficulties presented
themselves immediately: although only ten
years had elapsed since the signing, it was
already hard to determine who should be
represented. He consulted with Jefferson and
John Adams: "Should he regard the fact of
having been actually present in the room on
the 4th of July, indispensable? Should he
admit those only who were in favor of, and
reject those who were opposed to the act?
Where a person was dead, and no authentic
portrait could be obtained, should he admit
ideal heads?"[4] At their suggestion he por-
trayed all signers, including those not actu-
ally present, as well as those congressmen
who opposed the Declaration and did not
sign.[5] Although Trumbull himself described

the signing of the Declaration as taking
place on 4 July, no such formal ceremony
occurred on that or any other day. The artist
represented the moment on 28 June when
the committee appointed to draw up the doc-
ument submitted Jefferson's draft to Congress
for approval. On 2 July, Congress voted for
independence, and on 4 July, the Declaration
of Independence was approved. The actual
signing of the document began in Phila-
delphia on 2 August, and the delegates not
present that day signed during the following
months. Trumbull painted Jefferson (in
Paris) and Franklin and Adams (in London)
directly from life onto the canvas in 1787,
but the majority of the congressmen were
added later from pencil sketches or oil stud-
ies. Where no life image could be obtained
because the individual had died, Trumbull
copied the finest existing likeness. His goal
was absolute authenticity, as far as it could be
achieved. The last portraits were not in place
until 1820, thirty-four years after he began.

Trumbull based his representation of the
Assembly Room on Jefferson's recollections,
but Jefferson made errors in his floor plan,
particularly in the placement of the doors.
The banners, which were not actually present
in the Assembly Room in 1776, may have
been Jefferson's suggestion, since they appear
in Trumbull's sketch. Trumbull took other
liberties with the interior. He gave the room a
formal Doric cornice rather than the more
graceful Ionic one that actually decorated it
and covered the windows with elaborate red
velvet draperies in place of the venetian
blinds that were there. Instead of the sim-
ple wooden Windsor chairs that furnished
the room, he provided the members of
Congress with elegant mahogany armchairs,
placing Hancock in an upholstered and
gilded version. These stylish additions may
have been intended to elevate the tone of a
provincial assembly by conveying a more
sophisticated image of America to a
European audience.[6] H.A.C.

Notes

1. John Trumbull to James Madison, autograph copy,
26 Dec. 1817, Manuscripts and Archives Collection,
Yale University Library, Trumbull Papers.

2. John Trumbull, *Autobiography, Reminiscences and
Letters of John Trumbull from 1756 to 1841* (New York
and London: Wiley and Putnam, and New Haven: B.
L. Hamlen, 1841), 96.

3. John Trumbull, *Catalogue of Paintings, by Colonel
Trumbull; Including Eight Subjects of the American
Revolution, with Near Two Hundred and Fifty
Portraits, of Persons Distinguished in That Important
Period. Painted by Him from the Life* (New Haven:
printed by Hezekiah Howe & Co., 1832), 15.

4. Ibid., 14.

5. There were fifty-six signers of the Declaration of
Independence; Trumbull represented forty-eight.

6. For a complete history of the Assembly Room
interior, see Penelope Hartshorne Batcheler,
"Independence Hall: Its Appearance Restored," in
*Building Early America: Contributions toward the
History of a Great Industry,* ed. Charles E. Peterson
(Radnor, Pa.: Chilton Book Co., 1976), 298–318.

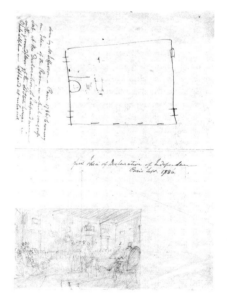

fig. a Thomas Jefferson, Plan of Assembly
Room; John Trumbull, *First Idea of the
Declaration of Independence*, 1786. Graphite
and brown ink on paper, 6 15/16 x 9 1/16 in.
(17.6 x 23 cm). Yale University Art Gallery, Gift
of Mr. Ernest A. Bigelow, 1926.8.1–.2

34

The Capture of the Hessians at Trenton,
December 26, 1776, 1786–1828

Oil on canvas, 20⅛ x 30 in. (51.1 x 76.2 cm)
Trumbull Collection, 1832.5

In this scene, Trumbull commemorates an important American victory. On 25 December 1776, Washington resolved to put an end to the long series of demoralizing military defeats by launching a surprise attack at Trenton against the Hessians, German mercenaries in the British army. After crossing the Delaware on a stormy night, the Continentals besieged the town with cannons and bayonets. The Germans, caught on the morning after their Christmas celebrations, were unable to organize a resistance; the ensuing battle lasted only forty-five minutes. Colonel Johann Gottlieb Rall, the Hessian commander, was mortally wounded and one thousand of his troops taken prisoner, while only three Americans were injured.[1]

The Capture of the Hessians at Trenton portrays the Americans as magnanimous victors. In the center, Washington, attended by two aides, Captain Tench Tilghman and Lieutenant Colonel Robert Harrison, directs Major William Stephens Smith to care for the mortally wounded Colonel Rall, giving his memorable order: "Call our best surgeons to his assistance, and let us save his life if possible."[2] In his *Autobiography*, Trumbull wrote: "[I] composed the picture, for the express purpose of giving a lesson to all living and future soldiers in the service of [their] country, to show mercy and kindness to a fallen enemy,—their enemy no longer when wounded and in their power."[3]

Trumbull had begun the painting in England; by 1789, when he returned to America, it was sufficiently advanced to receive portraits. For the next two years he traveled the East Coast taking likenesses. In New York City, anxious to secure Washington's

portrait for *Trenton*, as well as for *Princeton* and *Yorktown*, Trumbull arranged to dine with the president. After meeting the artist and seeing his paintings, Washington agreed to several sittings over a period of two months and even exercised on horseback at the artist's request.[4] Charles Willson Peale noted that "Washington [is] placed in an amiable point of view," displaying noble bravery in Princeton, and "magnanimous kindness" in Trenton.[5] Benjamin Silliman, Trumbull's nephew and a professor at Yale, recalled that "Col. Trumbull remarked . . . that Washington's face varied extremely in its expression in different circumstances. In this case [*Trenton*], he is looking down from his horse with an expression of deep sympathy and concern. The artist when painting his portrait desired Genl. Washington to place himself as nearly as possible in the position which he occupied at the moment."[6]

Trenton underwent several changes before its completion in 1828. Silliman recorded the origin of one alteration: "The horses of Gen. Washington & Greene standing near to & looking at each other are bowing their heads and curvetting as they are reined in. The artist remarked to me that 'some critics might say—these horses are making bows at each other & so I placed a dead Hessian on the ground between them that the horses might have something to snort at.'"[7] The finished painting drew sharp criticism. When the painter and art historian William Dunlap visited the Trumbull Gallery on the Yale campus in 1834, two years after the gallery had opened to the public, he remarked: "All that is good in this picture was painted in 1789 and shortly after. What is good is very good, but unfortunately the artist undertook, in afterlife, to finish it, and every touch is a blot. To look at the hands and compare them to the heads, excites astonishment. Washington's head and Smith's are jewels—the hands are very bad."[8] H.A.C.

Notes

1. William S. Stryker, *The Battles of Trenton and Princeton* (Boston: Houghton, Mifflin Co., 1898; repr. Spartanburg, S.C.: Reprint Co., 1967), passim.
2. Quoted in John Trumbull, *Catalogue of Paintings, by Colonel Trumbull; Including Eight Subjects of the American Revolution, with Near Two Hundred and Fifty Portraits, of Persons Distinguished in That Important Period. Painted by Him from the Life* (New Haven: printed by Hezekiah Howe & Co., 1832), 19.
3. John Trumbull, *Autobiography, Reminiscences and Letters of John Trumbull from 1756 to 1841* (New York and London: Wiley and Putnam, and New Haven: B. L. Hamlen, 1841), 420.
4. John C. Fitzpatrick, ed., *The Diaries of George Washington*, 4 vols. (Boston and New York: Houghton, Mifflin Co., 1925), 4:93.
5. Charles Willson Peale, diary, 1817, 11, Library of the American Philosophical Society, Philadelphia.
6. Benjamin Silliman, "Notebook," unpublished reminiscences, 1857, Yale University Library, Silliman Family Papers, sec. II:73–74.
7. Ibid., II:74.
8. William Dunlap, *A History of the Rise and Progress of the Arts of Design in the United States*, 2 vols. (New York: George P. Scott and Co., printers, 1834), 1:392.

34

35

35

The Death of General Mercer at the Battle of Princeton, January 3, 1777, ca. 1787–ca. 1831

Oil on canvas, 20⅛ x 29⅞ in. (51.1 x 75.9 cm)
Trumbull Collection, 1832.6.1

The Death of General Mercer at the Battle of Princeton is the third battle scene in Trumbull's series to commemorate the loss of a beloved general and the first to depict an unequivocal American victory. Nonetheless, it is not triumphal in its action.[1] The Battle of Princeton was a turning point in the war, giving General Washington control of New Jersey. Lord Cornwallis, hoping to take the offensive, decided to storm Washington's camp at Assumpink Creek, just north of Trenton. However, in allowing his troops to rest when they reached the far side of the creek on 2 January 1777, Cornwallis gave Washington time to slip past the British camp by night. Washington sent General Hugh Mercer's brigade to destroy a bridge at Stony Brook to prevent a smaller British force from joining Cornwallis. Before Mercer reached the bridge, however, he was forced to stand against a detachment of British soldiers. Armed only with slow-loading muskets, Mercer's troops had no time to recover before the enemy was among them with bayonets. It was not until Washington rushed into the conflict that the American troops rallied and, with reinforcements from General John Cadwalader's brigade, were able to disperse the British. Mercer, who had been bayoneted and clubbed by the British when he refused to beg for mercy, was taken alive from the field but died nine days later.

The composition, ordered into separate groupings of figures, represents different moments in the battle simultaneously. In the center, General Mercer, cut off from his beleaguered men, with his horse shot out from beneath him, is about to be bayoneted by British grenadiers. At the left, where the struggle is most intense, Lieutenant Charles Turnbull bends backward over a cannon, recoiling from a grenadier's blade. The figure on a white horse at the far left is probably General Thomas Mifflin. On the right, British Captain William Leslie drops his sword, vainly attempting to staunch the wound in his chest. In the middle distance, General Washington, on a brown horse, charges into the field, accompanied by Dr. Benjamin Rush and others.

Trumbull wanted his picture to commemorate the commander in chief's noble disregard for his personal safety, which on this occasion gave the American army a crucial victory.[2] "In the short space of nine days," wrote Trumbull, "an extensive country, an entire State, was wrested from the hands of a victorious enemy, superior in numbers, in arms, and in discipline, by the wisdom, activity, and energy of one great mind."[3] He must have decided that Washington's action was more deserving of the central position than Mercer's death, particularly as this was the artist's only opportunity in the American Revolution series to show Washington in a battle. By lowering the position of the head of Mercer's horse, he allowed the general to dominate the composition.

Trumbull held this canvas in high regard. When Benjamin Silliman asked him, hypothetically, which of the paintings in the Trumbull Gallery he would save first from destruction, the artist replied, "I would save this painting of the battle of Princeton."[4] H.A.C.

Notes
1. David Bindman, "Americans in London: Contemporary History Painting Revisited," in *English Accents, Interactions with British Art c. 1776–1855,* ed. Christina Payne and William Vaughan (Burlington, Vt.: Ashgate Publishing Ltd., 2004), 17.
2. Benjamin Silliman, "Notebook," unpublished reminiscences, 1857, Yale University Library, Silliman Family Papers, sec. II:82.
3. John Trumbull, *Catalogue of Paintings, by Colonel Trumbull; Including Eight Subjects of the American Revolution, with Near Two Hundred and Fifty Portraits, of Persons Distinguished in That Important Period. Painted by Him from the Life* (New Haven: printed by Hezekiah Howe & Co., 1832), 22.
4. Silliman, 1857, II:86.

36

The Surrender of General Burgoyne at Saratoga, October 16, 1777, ca. 1822–32

Oil on canvas, 21⅛ x 30⅝ in. (53.7 x 77.8 cm)
Trumbull Collection, 1832.7

Trumbull memorializes the moment when the British general John Burgoyne, attended by General William Phillips, and followed by other officers, offers his sword in surrender to General Horatio Gates. The latter refuses it, with a gesture inviting the generals toward the tent to take refreshment. A number of the principal officers of the American army, headed by Colonel Daniel Morgan, are assembled in the right foreground, while the British troops are crossing the meadows in the background.

Trumbull's rendition of the event closely accords with historical fact. On 17 October 1777, Burgoyne rode out of camp to meet Gates for dinner and to sign the articles of surrender. At first, Gates did not allow American soldiers to witness the event, but when the British regulars marched away, the Continentals lined the road and struck up "Yankee Doodle," whereupon Gates and Burgoyne came out to watch. At this point, Burgoyne handed over his sword, and Gates handed it back, according to military custom.[1]

Trumbull had planned *The Surrender of General Burgoyne at Saratoga* as part of his Revolutionary War series, but he did not begin the Yale picture until at least 1822, after he had produced the large version for the Capitol Rotunda. He completed the Yale painting by 1832, in time for the opening of the Trumbull Gallery. The artist considered *Saratoga* an especially appropriate subject with which to decorate the Capitol of the United States: the surrender, which occurred shortly after two fierce engagements between British and American troops, marked the

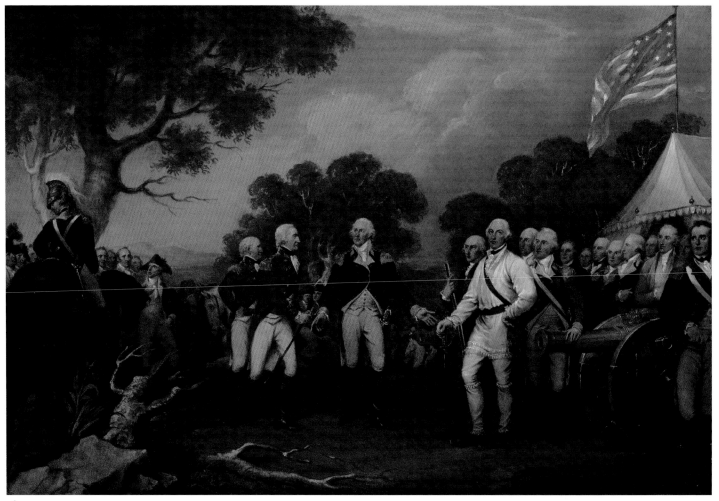

36

turning point in the Revolutionary War. After this victory, the French government officially recognized the American republic. The French troops and weapons bolstered American forces at Yorktown and allowed them to win the battle that ended the war.

The artist collected most of the portraits in the painting from life (cat. no. 40, *William Hull, Ebenezer Stevens, Thomas Youngs Seymour, John Brooks*; cat. no. 44, *Rufus Putnam*; cat. no. 46, *Elnathan Haskell, Philip John Schuyler*) and was so intent on depicting those involved in the event that some of the heads are out of

proportion with the bodies or are awkwardly attached. His focus on heads resulted in a static arrangement of figures at the right, where they are simply lined up to give each face equal emphasis as in a frieze. Among the history paintings, *Saratoga* is unique for its richly colored landscape background. H.A.C.

Note
1. Rupert Furneaux, *Saratoga: The Decisive Battle* (London: Allen & Unwin, 1971), 268–72. In the painting's title, Trumbull erroneously gave October 16 as the date of Burgoyne's surrender.

37

The Surrender of Lord Cornwallis at Yorktown, October 19, 1781, 1787–ca. 1828

Oil on canvas, 21 x 30⅝ in. (53.3 x 77.8 cm)
Trumbull Collection, 1832.4

This scene marks the moment when the principal officers of the British army, colors cased and marching to a tune appropriately entitled "The World Turned Upside Down," came out of Yorktown to lay down their arms—a gesture that signaled the end of the Revolutionary War. At the center of the composition, Major General Benjamin Lincoln, Washington's second-in-command, accepts the official surrender from Lord Cornwallis's deputy, who stands at the head of the British and German soldiers. The defeated forces pass between two lines of victorious troops—the Americans, and the French facing them on the left. The leader of each army rides slightly forward of the ranks, General Rochambeau on the left balancing the slightly larger and more prominent figure of General Washington on the right.

The surrender at Yorktown did not readily lend itself to dynamic or theatrical arrangement in a painting. Trumbull recalled: "The scene was altogether one of utter formality—the ground was level—military etiquette was to be scrupulously observed, and yet the portraits of the principal officers of three proud nations must be preserved, without interrupting the general regularity of the scene. I drew it over and over again, and at last . . . resolved upon the present arrangement."[1] Trumbull's strict adherence to the formality of the occasion resulted in a static composition, with rows of portrait heads stretching out in straight lines on either side. Since the artist considered portraiture more important than narrative in the commemoration of a historical event, this approach satisfied his purpose: "The principal officers of the three nations are brought near together, so as to admit of distinct portraits."[2]

In order to capture the likenesses of the French officers who were at Yorktown, Trumbull took the painting to Paris in 1787. Fortuitously, he found that all those he wished to depict were in Paris, and he rendered their portraits directly onto the canvas in Jefferson's house. Trumbull regarded these likenesses as "the best of my small portraits."[3] When he returned to America, he visited a congressional assembly in New York City to take the likenesses of several of the Americans who were present at Yorktown, including Washington.

In his concern for authentic detail, Trumbull traveled to Yorktown to sketch the site of the event itself. He was apparently less concerned with the historical accuracy of the flags: the national flag, adopted by Congress in 1777, had thirteen stars and thirteen stripes, while the American flag behind Washington displays thirteen stars and fourteen stripes. In fact, Trumbull followed no consistent number or arrangement of stars and stripes in any of his representations of the flag.

Trumbull continued to work on the Yale *Yorktown* while he executed the larger version for the Capitol Rotunda in 1820. The Yale canvas occupied him for almost another decade. H.A.C.

Notes
1. John Trumbull, *Autobiography, Reminiscences and Letters of John Trumbull from 1756 to 1841* (New York and London: Wiley and Putnam, and New Haven: B. L. Hamlen, 1841), 148.
2. Ibid., 429.
3. Ibid., 151.

37

38

*The Resignation of General Washington,
December 23, 1783,* 1824–28

Oil on canvas, 20 x 30 in. (50.8 x 76.2 cm)
Trumbull Collection, 1832.8

The basis of the painting is a scene described in the *Journal of Congress*, when General Washington arose and addressed Congress: "Having now finished the work assigned me, I retire from the great theatre of action, and bidding an affectionate farewell to this august body, under whose orders I have so long acted, I here offer my commission, and take leave of all the employments of public life."[1] As both a scene showing Congress in session and a solemn moment in American history, the artist selected this subject to complement *The Declaration of Independence* (cat. no. 33).

As with the *Declaration,* Trumbull wished the *Resignation* to be a faithful record of the event, but because he did not take up the subject until 1822, when he began the version for the Capitol Rotunda, he had trouble composing a historically accurate picture. The *Journal of Congress* supplied him with the names of those who were present at the Maryland State House on 23 December 1783, but he could find life studies of only a few of these men. He copied the figure of Washington from his own 1792 portrait of the general (cat. no. 58). At least seven of the miniature portraits he had taken between 1790 and 1793 were of participants in this scene (cat. no. 44, *Jacob Read;* cat. no. 45, *Eleanor Parke Custis, Martha Washington;* cat. no. 46, *William Smallwood;* cat. no. 48, *Thomas Mifflin, Arthur Lee*). In 1822, Trumbull sent a printed letter to members of Congress asking them to seek out likenesses of their predecessors.[2] His search was unsuccessful, however, and he was forced to invent some of the faces. He also introduced several persons who were not

in Annapolis at the time, including Martha Washington, her granddaughters, and James Madison. Trumbull explained to Madison, "That I may have all the Virginia Presidents, I have taken the liberty . . . of placing you among the Spectators—It is a Painter's licence [*sic*], which I think the occasion may well justify."[3]

The artist took further liberties with his representation of the Senate Chamber in the Maryland State House. He simplified the architecture, leaving out the windows, for example, to keep the focus on the figure of Washington. He used the same mahogany armchairs as in the *Declaration,* perhaps to reinforce the thematic connections between the two paintings. None of the furniture used in the Annapolis chamber in 1783 had in fact survived to the time of Trumbull's visit in 1822.[4]

Trumbull considered the general's resignation "one of the highest moral lessons ever given to the world."[5] Describing the event in his catalogue of the Yale collection, he wrote:

What a dazzling temptation was here to earthly ambition! Beloved by the military, venerated by the people, who was there to oppose the victorious chief, if he had chosen to retain that power which he had so long held with universal approbation? The Ceasars—the Cromwells—the Napoleons—yielded to the charm of earthly ambition, and betrayed their country; but Washington aspired to loftier, imperishable glory,—to that glory which virtue alone can give, and which no power, no effort, no time, can ever take away or diminish.[6]

By focusing on the moment when Washington returned his commission to the president of Congress, Trumbull created a parallel to his depiction of Jefferson presenting

the Declaration of Independence to John Hancock. But while he represented Jefferson as the leader of a group, Trumbull here emphasized the fact that Washington acted as an individual. He isolated the general at the picture's center, against the bare chimney breast, and directed the room's reflected light toward his head. The cloak on the chair behind Washington suggests a king's robes draped on a throne, a royal emblem on which Washington has turned his back. H.A.C.

Notes

1. Quoted in John Trumbull, *Catalogue of Paintings, by Colonel Trumbull; Including Eight Subjects of the American Revolution, with Near Two Hundred and Fifty Portraits, of Persons Distinguished in That Important Period. Painted by Him from the Life* (New Haven: printed by Hezekiah Howe & Co., 1832), 30.
2. John Trumbull, printed form letter, Washington, D.C., 15 Apr. 1822, Yale University Library, Benjamin Franklin Collection.
3. John Trumbull to James Madison, 1 Oct. 1823, Letterbook, Manuscripts and Archives Collection, Yale University Library, Trumbull Papers.
4. For a history of the Annapolis Statehouse, see Morris L. Radoff, *The State House at Annapolis* (Annapolis: Hall of Records Commission State of Maryland, 1972), 30.
5. John Trumbull, *Autobiography, Reminiscences and Letters of John Trumbull from 1756 to 1841* (New York and London: Wiley and Putnam, and New Haven: B. L. Hamlen, 1841), 263.
6. Trumbull, 1832, 26.

John Trumbull took as an almost divine mission the accurate recording for posterity of those who had been present at the great events of the Revolutionary War. After returning from London in 1789, he spent five years traveling up and down the eastern seaboard of the United States, taking "heads" from life that he called "miniatures," mainly of statesmen and military officers, for his series of history paintings.[1] Most of these portraits were included in the artist's gift to Yale. They remain in their original arrangement, five to a tablet, just as they were when they were first exhibited at the opening of Yale's Trumbull Gallery in 1832.

Executed in oil on mahogany, their brushwork is fluid, with impastos and transparent glazes that produce contrasting textures. Although Trumbull created them as studies for executed and unexecuted paintings, these small works are among the most successful achievements of his career, outstanding for their spontaneity, sensitivity of characterization, and coloristic brilliance. H.A.C.

Note

1. Biographical information on the sitters is taken from the appropriate entry in the *Dictionary of American Biography*, ed. Dumas Malone, 20 vols., suppl. vol. 21, published under the auspices of the American Council of Learned Societies (New York: Charles Scribner's Sons, 1943-44).

39

Henry Laurens, 1791

Oil on mahogany, 3 5/8 x 3 in. (9.2 x 7.6 cm)
Trumbull Collection, 1832.20

John Jay, 1793

Oil on mahogany, 4 x 3 1/4 in. (10.2 x 8.3 cm)
Trumbull Collection, 1832.21

John Adams, 1793

Oil on mahogany, 3 7/8 x 3 1/4 in. (9.8 x 8.3 cm)
Trumbull Collection, 1832.22

George Hammond, 1793

Oil on mahogany, 3 7/8 x 3 1/8 in. (9.8 x 7.9 cm)
Trumbull Collection, 1832.23

William Temple Franklin, 1790

Oil on mahogany, 3 5/8 x 3 1/8 in. (9.2 x 7.9 cm)
Trumbull Collection, 1832.24

The five miniatures in this tablet were done in preparation for a painting (never executed) commemorating the 1783 Treaty of Paris, which ended the Revolutionary War. Shortly after publicly announcing his plans for the subject in 1790, Trumbull began to take portraits of the prominent figures involved in the negotiations. Except for the portrait of Henry Laurens, all were painted in Philadelphia.

Henry Laurens (1724–1792), a leading merchant and planter from Charleston, South Carolina, became active in provincial politics as hostilities with the British arose during the 1760s. After the outbreak of war, he was elected to Congress and later served as an unofficial minister to England. At the treaty negotiations, Laurens inserted an article protecting property, including slaves, from removal by the British army. The portrait was painted in Charleston.

One of the most active statesmen of his age, John Jay (1756–1843) served as a member of Congress, delegate to the Constitutional Convention, minister to Spain, chief justice of the United States, and governor of New York. The year after this portrait was painted, Jay asked Trumbull to serve as his secretary during negotiations for the Jay Treaty. Trumbull's miniature of Jay may also have been done in preparation for the unexecuted *Inauguration of the President*.

Trumbull's first portrait of John Adams (1735–1826), first vice president of the United States, was painted directly into *The Declaration of Independence* (cat. no. 33). When the artist began to prepare for *The Treaty of Peace*, he may have found it necessary to take a likeness of Adams in the formal attire of an American minister. In contrast to Adams's portrait in the *Declaration*, where the hair is natural, in this miniature he wears a wig.

George Hammond (1763–1853) began a distinguished diplomatic career as the secretary to the British delegation at the Treaty of Paris. Trumbull painted Hammond's likeness while the latter was in America serving as the first minister plenipotentiary of Great Britain to the United States.

William Temple Franklin (ca. 1760–1823), the illegitimate child of Benjamin Franklin's son William, was adopted by his grandfather and later appointed secretary to the American delegation at the treaty talks. H.A.C.

Henry Laurens (1724-1792) President of Congress (1777-1778) Painted 1791-1832-20

John Jay (1745-1829) Chief Justice of the United States. Painted 1793-1832-21

John Adams (1735-1826) President of the United States. Painted 1792 1832-22

George Hammond (1763-1853) First British Minister to the United States. Painted 1792-1832-23

William Temple Franklin (c.1760-1823) Grandson of Benjamin Franklin. Painted 1790-1832-24

40

Nathanael Greene, 1792

Oil on mahogany, 4 x 3⅛ in. (10.2 x 7.9 cm)
Trumbull Collection, 1832.25

William Hull, 1790

Oil on mahogany, 4 x 3⅛ in. (10.2 x 7.9 cm)
Trumbull Collection, 1832.26

Ebenezer Stevens, 1790

Oil on mahogany, 3⅞ x 3⅛ in. (9.8 x 8 cm)
Trumbull Collection, 1832.27

Thomas Youngs Seymour, 1793

Oil on mahogany, 3⅞ x 3⅛ in. (9.8 x 7.9 cm)
Trumbull Collection, 1832.28

John Brooks, 1790

Oil on mahogany, 3⅞ x 3⅛ in. (9.8 x 7.9 cm)
Trumbull Collection, 1832.29

The five men depicted here were military officers during the Revolutionary War.

Nathanael Greene (1742–1786) served as a deputy to the Rhode Island Assembly and became a brigadier general in the Continental army at the outbreak of the war. He was promoted to the rank of major general in 1776, fighting in two of the battles that Trumbull intended to paint: *The Battle of Eutaw Springs* (unexecuted) and *The Capture of the Hessians at Trenton* (cat. no. 34), where Greene appears at the right on the light-colored horse. In 1786, when Trumbull heard of Greene's death, he wrote to his brother about the urgency of painting the people he wanted to include in his history paintings, now conscious "of the precariousness as well as the value of many other lives."[1] Trumbull copied the portrait of Greene from the 1783 original by Charles Willson Peale, at Independence Hall, Philadelphia.

William Hull (1753–1825) served almost continuously throughout the Revolutionary War, fighting in important battles at Trenton,

Princeton, and Saratoga, among others. His valor earned him the commendation of General Washington and Congress, as well as a series of promotions that brought him to the rank of lieutenant colonel. The miniature was painted in Boston. In *The Surrender of General Burgoyne* (cat. no. 36), Hull stands to the immediate right of the tree.

Ebenezer Stevens (1751–1823), born in Boston, participated in the Boston Tea Party. He fought in New York in the Battles of Ticonderoga, Stillwater, and Saratoga and accompanied the Marquis de Lafayette to Virginia, where he served part-time as commander of the artillery during the siege at Yorktown. After the war, Stevens was a merchant in New York City and commanded the artillery there during the War of 1812.

The miniature was painted in New York City. In *The Surrender of General Burgoyne*, Stevens leans against the cannon at the far right of the painting.

Thomas Youngs Seymour (1757–1811) became a lieutenant of the Second Continental Dragoons in 1777, during his senior year at Yale College. After General Burgoyne's surrender, Seymour was appointed to escort the captive British officer to Boston. Among the positions he held after his resignation from the army were commander of the Connecticut governor's Horse Guard, Connecticut state attorney, and representative to the Connecticut General Assembly. The miniature was painted in Hartford. In *The Surrender of General Burgoyne*, Seymour is mounted on the black horse at the left.

John Brooks (1752–1825) fought as captain of the Reading Minutemen in the Battle of Concord and commanded the Eighth Massachusetts Regiment as lieutenant colonel. After the war, he resumed his medical career and became a leading physician. The miniature was painted in Boston. In *The Surrender of General Burgoyne*, Brooks stands to the right of center with his hand on a cannon. H.A.C.

Note

1. John Trumbull to Jonathan Trumbull, Jr., 27 Dec. 1786, Manuscripts and Archives Collection, Yale University Library, Trumbull Papers.

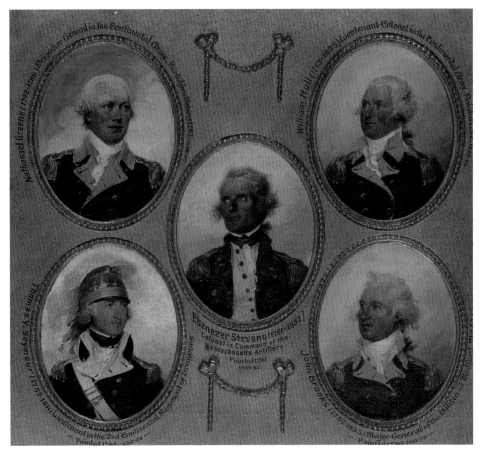

40

41

Rufus King, 1792

Oil on mahogany, 4 x 3¼ in. (10.2 x 8.3 cm)
Trumbull Collection, 1832.30

Fisher Ames, 1792

Oil on mahogany, 3⅞ x 3⅛ in. (9.8 x 7.9 cm)
Trumbull Collection, 1832.31

"The Infant," Chief of the Seneca Indians,
1792

Oil on mahogany, 4 x 3¼ in. (10.2 x 8.3 cm)
Trumbull Collection, 1832.32

John Langdon, 1792

Oil on mahogany, 3⅞ x 3¼ in. (9.8 x 8.3 cm)
Trumbull Collection, 1832.33

John Brown, 1792

Oil on mahogany, 3⅞ x 3¼ in. (9.8 x 8.3 cm)
Trumbull Collection, 1832.34

These five miniatures were painted in
Philadelphia. Four are portrait studies for
Trumbull's unexecuted painting, *The
Inauguration of the President.*

Rufus King (1755–1827) and Trumbull
began their lifelong friendship in Boston in
1778, when they both belonged to a group
of recent Harvard graduates who met to
discuss literature and politics. King served
as a delegate to the Massachusetts general
court (1783–85), was an outstanding speaker
in Congress (1784–87), and a senator from
New York (1789–96). In 1796, he was
appointed minister to England, a post he
held until 1803.

A graduate of Harvard, Fisher Ames
(1758–1808) acquired a reputation as a pow-
erful speaker at the Massachusetts ratifying
convention of 1787. He was a representative
of Dedham in the general court of Massa-
chusetts in 1788 and a member of Congress
from 1789 to 1797.

During the Revolutionary War, John
Langdon (1741–1819) secured supplies for
New Hampshire, built ships for the govern-
ment, financed General John Stuart's expe-
dition against General John Burgoyne, and
led New Hampshire troops in the Rhode
Island campaign. In 1783, Langdon had
hosted Trumbull in Portsmouth while the
young artist waited for his ship to sail to
England. When Trumbull painted this min-
iature, Langdon was president pro tempore
of the Senate.

John Brown (1757–1837) served under
the Marquis de Lafayette in the Revolution-
ary War and studied law under Thomas
Jefferson. He was born in Virginia and moved
to Kentucky in 1782. He represented the
Kentucky district of Virginia in the Virginia
legislature in 1787 and in Congress in 1789,
becoming a central figure in Kentucky's
achievement of statehood in 1792. Brown then
served as a senator from Kentucky until 1802.

Trumbull painted Hauaugaikhon, a
Seneca warrior also known as "The Infant,"
during the sitter's visit to Philadelphia as a
member of a delegation of Indians invited by
George Washington to discuss their role in
ending America's war with tribes in the
Northwest Territory.[1] On the verso, Trumbull
described "The Infant" as "Six feet. four
inches high / wearing his beard as in / the
picture. / in his War Dress." H.A.C.

Note

1. "List of the names and places of residence of the
Sachems and Head Warriors of the Five Nations of
Indians, who were invited . . . to make a visit to the
seat of General Government," *General Advertiser*
(Philadelphia), 28 Mar. 1792, 2.

41

42

42

Giuseppe Ceracchi, 1792

Oil on mahogany, 3¾ x 3⅛ in. (9.8 x 7.6 cm)
Trumbull Collection, 1832.40

Tristram Dalton, 1792

Oil on mahogany, 4 x 3¼ in. (10.2 x 8.3 cm)
Trumbull Collection, 1832.41

"The Young Sachem," A Chief of the Six Nations, 1792

Oil on mahogany, 4 x 3¼ in. (10.2 x 8.3 cm)
Trumbull Collection, 1832.42

Theodore Sedgwick, 1792

Oil on mahogany, 3⅞ x 3¼ in. (9.8 x 8.3 cm)
Trumbull Collection, 1832.43

Oliver Ellsworth, 1792

Oil on mahogany, 3¾ x 3⅛ in. (9.5 x 7.9 cm)
Trumbull Collection, 1832.44

Trumbull painted this set in Philadelphia.
Three were made as portrait studies for his
planned, but never executed, *Inauguration
of the President*. Theodore Sedgwick (1746–
1813) was a congressman and noted jurist
from Massachusetts. In his most famous
case (1783), he successfully defended
a slave against the master from whom she
had fled. Tristram Dalton (1738–1817)
was a Massachusetts senator. Oliver
Ellsworth (1745–1807), one of the most
distinguished Connecticut politicians of
his time, also served as a U.S. senator and
was later appointed chief justice of the
U.S. Supreme Court.

Giuseppe Ceracchi (1751–1802), a fervent
revolutionary, came to America in 1791 hop-
ing to receive a commission for a sculpture
depicting Liberty. While waiting for Congress
to respond to his proposal, Ceracchi exe-
cuted terra-cotta busts and medallions of
leading political figures, including George
Washington, John Adams, James Madison,
and Alexander Hamilton. Only a few of
these studies were carved in marble, and
Trumbull later tried to recover the originals,
but Ceracchi had taken them back to Europe
after his project was voted down. Ceracchi
also modeled a bust of Trumbull, perhaps at
the same time that Trumbull painted
his miniature.[1]

"The Young Sachem," an unidentified
Indian chief, was a deputy from the Six
Nations, a confederation of Iroquois tribes,
who conferred with Congress in 1792 during
diplomatic efforts to end conflicts with
Indians in the Northwest Territory.[2] H.A.C.

Notes
1. John Trumbull to Mr. Irvins, 24 Feb. 1818, Manu-
scripts and Archives Collection, Yale University
Library, Trumbull Papers.
2. Thomas S. Abler has postulated that "the Young
Sachem" can be identified as Governor Blacksnake,
a Seneca chief. See Abler, "Governor Blacksnake as
a Young Man? Speculation on the Identity of
Trumbull's *The Young Sachem,*" *Ethnohistory* 34
(fall 1987), 329–51. I thank Alyssa Mt. Pleasant for
her insights about this miniature.

43

43

George W. Flagg (1816–1897)
After John Trumbull (1756–1843)
Otho Holland Williams, 1842

Oil on mahogany, 3⅞ x 3 in. (9.8 x 7.6 cm)
Trumbull Collection, 1832.45

John Trumbull (1756–1843)
Thomas Pinckney, 1791

Oil on mahogany, 3¾ x 3⅛ in. (9.5 x 7.9 cm)
Trumbull Collection, 1832.46

John Rutledge, 1791

Oil on mahogany, 3¾ x 3⅛ in. (9.5 x 7.9 cm)
Trumbull Collection, 1832.47

Charles Cotesworth Pinckney, 1791

Oil on mahogany, 3¾ x 3 in. (9.5 x 7.6 cm)
Trumbull Collection, 1832.48

William Moultrie, 1791

Oil on mahogany, 4 x 3 in. (10.2 x 7.6 cm)
Trumbull Collection, 1832.49

Otho Holland Williams (1749–1794) was adjutant-general under General Nathanael Greene in the Revolutionary War. In *The Resignation of General Washington* (cat. no. 38), Williams is the fourth figure to the right of Washington. The original of this miniature was painted by Trumbull in Philadelphia in 1790; however, he later removed the painting from its tablet and sold it to Robert Gilmor of Baltimore. Professor Benjamin Silliman borrowed the miniature from Gilmor and, with Trumbull's approval, had it copied by George Flagg to complete the tablet.

The inscriptions on the remaining four miniatures, which were painted in Charleston, South Carolina, suggest that in addition to the fourteen history paintings Trumbull included in the lists he announced in 1790, he considered painting at least two other Revolutionary War scenes: *The Siege of Savannah* and *The Attack on Charleston*. Neither of these was ever executed.

Thomas Pinckney (1750–1828), the younger brother of Charles Cotesworth Pinckney, was special aide to French Admiral Count Charles-Hector Theodat d'Estaing, who, allied with General Benjamin Lincoln, fought the British at Savannah. During the siege at Charleston in 1780, Pinckney was sent to speed the arrival of relief troops and escaped capture when that city fell. The Yale miniature is one of three that Trumbull painted of him in South Carolina in 1791.

John Rutledge (1739–1800) was elected governor of South Carolina in 1779 on the eve of the British invasion of Charleston. Despite his efforts to muster a militia, the city surrendered the following year. In 1781, Rutledge was responsible for raising an army and supplying it and for restoring civil government. He sat in the state House of Representatives from 1784 to 1790 and was elected chief justice of South Carolina in 1791.

Charles Cotesworth Pinckney (1746–1825) served as aide-de-camp to Washington in the Revolutionary War before being commissioned brigadier general in 1783. In 1793, Washington appointed him minister to France, but the Directory declined to recognize his official status, probably because Pinckney had become unsympathetic to the revolutionary movement in France. A candidate for vice president in 1800 and for president in the next two elections, Pinckney served as president general of the Society of the Cincinnati, an organization formed in 1783 by officers of the American Revolutionary army (see cat. nos. 50–52).

As brigadier general, William Moultrie (1730–1805) commanded the 1780 defense of Charleston during the Revolutionary War. When the city fell, he was captured and held for almost two years. He served in the South Carolina House of Representatives and was later elected lieutenant governor and then governor of the state. H.A.C.

44

William Loughton Smith, 1792

Oil on mahogany, 3¾ x 3 in. (9.5 x 7.6 cm)
Gift of Herbert L. Pratt, 1936.116

Rufus Putnam, 1790

Oil on mahogany, 3⅞ x 3¼ in. (9.8 x 8.3 cm)
Trumbull Collection, 1832.51

Jacob Read, 1793

Oil on mahogany, 3⅝ x 3¹⁄₁₆ in. (9.2 x 7.8 cm)
Trumbull Collection, 1832.52

Ralph Izard, 1793

Oil on mahogany, 3¾ x 2⅞ in. (9.5 x 7.3 cm)
Trumbull Collection, 1832.53

John Faucheraud Grimké, 1791

Oil on mahogany, 3⅝ x 3 in. (9.2 x 7.6 cm)
Trumbull Collection, 1832.54

William Loughton Smith (1758–1812), a lawyer and planter from South Carolina, served five terms in Congress and acted as Charleston's agent in 1792 when that city commissioned Trumbull to paint a full-length portrait of Washington (cat. no. 58). As a member of Congress, Smith joined other Southerners to quash antislavery petitions. In the 1790s, the arch-Federalist Smith wrote pamphlets critiquing his party's political rival, Thomas Jefferson. Trumbull painted this miniature of Smith in Philadelphia for the proposed painting *The Inauguration of the President*.

Rufus Putnam (1738–1824) engineered the construction of many fortifications during the Revolutionary War, notably at Dorchester Heights during the winter of 1775–76 to force the British evacuation of Boston. After the conclusion of the war, Putnam superintended the Ohio Company, which was established to distribute western lands to settlers. In 1790, Washington appointed him judge of the Northwest Territory, an area that extended to the Mississippi River. The miniature was painted in New York City. Putnam is the third figure from the left in the group farthest to the right in *The Surrender of General Burgoyne* (cat. no. 36).

During the Revolutionary War, Jacob Read (1752–1816) served as a captain in the Charleston, South Carolina, militia. He was a member of the Continental Congress between 1783 and 1786. In 1787, he was elected speaker of the South Carolina House of Representatives, serving in that body until 1794. Trumbull painted the miniature in Charleston. He shows Read standing in the left doorway in *The Resignation of General Washington* (cat. no. 38).

Born into a wealthy South Carolina planter family, Ralph Izard (1741/42–1804) opened negotiations with the duchy of Tuscany to secure funds for the United States during the Revolutionary War. During the sessions of the Third Congress, Izard was president pro tempore of the Senate. As he was a close friend of Washington, Trumbull painted this miniature in Philadelphia for his proposed *Inauguration of the President*.

John Faucheraud Grimké (1752–1819) was born in South Carolina of French and German parents. He rose to the rank of deputy adjutant-general for South Carolina and Georgia and was taken prisoner by the British at the surrender of Charleston in 1780. After the war, Grimké became a noted jurist, serving as a judge on the South Carolina Superior Court and later as its senior associate. This miniature, painted in Charleston, may have been intended as a study for the unexecuted *Siege of Savannah*. H.A.C.

45

45

Eleanor (Nelly) Parke Custis (Mrs. Lawrence Lewis), 1792

Oil on mahogany, 3⅞ x 3¼ in. (9.8 x 8.3 cm)
Trumbull Collection, 1832.55

Cornelia Schuyler (Mrs. Washington Morton), 1792

Oil on mahogany, 3⅞ x 3⅜ in. (9.8 x 8.6 cm)
Trumbull Collection, 1832.56

Mrs. George Washington (Martha Dandridge, Mrs. Daniel Parke Custis), 1792

Oil on mahogany, 3⅞ x 3¼ in. (9.8 x 8.3 cm)
Trumbull Collection, 1832.57

Sophia Chew (Mrs. Henry Philips), 1793

Oil on mahogany, 4 x 3¼ in. (10.2 x 8.3 cm)
Trumbull Collection, 1832.58

Harriet Chew (Mrs. Charles Carroll), 1793

Oil on mahogany, 4 x 3¼ in. (10.2 x 8.3 cm)
Trumbull Collection, 1832.59

These five miniatures were painted in Philadelphia in 1792 in preparation for *The Resignation of General Washington* (cat. no. 38). Martha Dandridge Custis (1732–1802) became one of the wealthiest women in Virginia upon the death of her husband, Daniel Parke Custis, in 1757. Two years later, she married then Colonel George Washington. During Washington's two terms as president she was a gracious first lady, but she preferred a private life and welcomed their retirement to Mount Vernon. She is the central figure on the balcony in the *Resignation*.

Eleanor (Nelly) Custis (1779–1852) was Martha Washington's granddaughter. Miss Custis, who was thirteen years old at the time Trumbull painted this miniature, was raised in George Washington's household after her father's death. She later married Lawrence Lewis, the son of George Washington's sister.

She stands to the left of Martha Washington in the *Resignation*.

Harriet Chew (1775–1861) and Sophia Chew (1769–1841) were the daughters of Benjamin Chew, Esq., of Philadelphia, one of the wealthiest men in the new nation. Harriet may be the dark-haired woman with an open collar standing at the far left on the balcony. The portraits of Sophia Chew and of Cornelia Schuyler (1776–1808), daughter of Major General Philip John Schuyler (cat. no. 46), cannot be readily identified in the painting. H.A.C.

46

46

William Smallwood, 1792

Oil on mahogany, 3⅞ x 3 in. (9.8 x 7.6 cm)
Trumbull Collection, 1832.60

Elnathan Haskell, 1791

Oil on mahogany, 4 x 3 in. (10.2 x 7.6 cm)
Trumbull Collection, 1832.61

Daniel Morgan, 1792

Oil on mahogany, 3¾ x 2¾ in. (9.5 x 7 cm)
Trumbull Collection, 1832.62

Egbert Benson, 1792

Oil on mahogany, 3¾ x 3⅛ in. (9.5 x 7.9 cm)
Trumbull Collection, 1832.63

Philip John Schuyler, 1792

Oil on mahogany, 3¾ x 3⅛ in. (9.5 x 7.9 cm)
Trumbull Collection, 1832.64

William Smallwood (1732–1792) was a delegate in the Maryland Assembly before he commanded the highly regarded Maryland troops in the Revolutionary War. After the war, he served four terms as governor of Maryland. In *The Resignation of General Washington* (cat. no. 38), Smallwood is the third figure to the right of Washington. Trumbull copied the image of Smallwood from the original, circa 1781–82, by Charles Willson Peale (Independence National Historical Park, Philadelphia).

Elnathan Haskell (1755–1825) was a first lieutenant and adjutant in the Fourteenth Massachusetts Regiment. He later served as General Howe's aide-de-camp. Haskell is the seventh figure from the right in *The Surrender of General Burgoyne* (cat. no. 36). The miniature was painted in Charleston.

Daniel Morgan (1736–1802) was born in New Jersey and moved to Virginia early in 1754. He served as an officer in the Continental army, and later, as commander of the

Virginia militia, aided in suppressing the Whiskey Rebellion, a major challenge to federal authority following the Revolution. Between 1797 and 1799, he served as a member of the House of Representatives from Virginia. In *The Surrender of General Burgoyne*, Morgan is the figure in white to the right of center. Although Trumbull's inscription on the verso says that he painted this miniature in 1792 "from an original by Mr. C. W. Peale," the only known Peale portrait of Morgan dates from about 1794 and does not resemble this miniature.[1] Perhaps Trumbull knew an earlier Peale portrait of Morgan that has yet to be located.

A lawyer from New York, Egbert Benson (1746–1833) actively promoted the Revolutionary cause and the formation of the Union. He represented New York in the first two congresses and was an influential justice in the New York Supreme Court. Benson later became the first president of the New-York Historical Society. This miniature, painted in Philadelphia, was a study for the proposed *Inauguration of the President*.

Philip John Schuyler (1733–1804) first served as a captain and then major in the French and Indian War. In the Continental army, he was chosen as one of four major generals. Trumbull, who first met Schuyler in Albany while traveling to Ticonderoga with General Gates in 1776, painted this miniature in Philadelphia. Schuyler is the third figure from the right in *The Surrender of General Burgoyne*. H.A.C.

Note

1. See Charles Coleman Sellers, *Portraits and Miniatures by Charles Willson Peale* (Philadelphia: American Philosophical Society, 1952), 146.

47

Jonathan Trumbull, Jr., 1792

Oil on mahogany, 4 x 3⅛ in. (10.2 x 7.9 cm)
Trumbull Collection, 1832.65

Jonathan Trumbull, Sr., 1793

Oil on mahogany, 4 x 3¼ in. (10.2 x 8.3 cm)
Trumbull Collection, 1832.66

"Good Peter," Chief of the Oneida Indians,
1792

Oil on mahogany, 4⅛ x 3¼ in. (10.5 x 8.3 cm)
Trumbull Collection, 1832.67

Lemuel Hopkins, 1793

Oil on mahogany, 3⅞ x 3¼ in. (9.8 x 8.3 cm)
Trumbull Collection, 1832.68

John Trumbull, 1794

Oil on mahogany, 3⅞ x 3¼ in. (9.8 x 8.3 cm)
Trumbull Collection, 1832.69

Jonathan Trumbull, Jr. (1740–1809), brother of the artist, acted as paymaster of the Continental army's Northern Division and held the post of military secretary to General Washington from 1781 to the end of the war. After serving in the Connecticut legislature, the first three congresses under the new Constitution, and the Senate, he became lieutenant governor of Connecticut, and then, upon the death of Governor Oliver Wolcott, chief executive of the state. Trumbull painted the likeness of his brother directly into *The Surrender of Lord Cornwallis* (cat. no. 37) in 1786 or 1787 while in London; he is the fifth figure from the left of the group farthest from the right. The miniature, showing Jonathan in civilian dress, was painted five or six years later in Philadelphia during his second term as a representative to Congress, where he served as Speaker of the House in 1791–92.

Jonathan Trumbull, Sr. (1710–1785), the artist's father, began his career with the intention of entering the ministry but established himself in commerce instead. In 1766, he suffered a severe financial reversal. Fortunately, he had pursued politics since 1733, and he became governor of Connecticut in 1769. During the Revolutionary War, he supervised the distribution of supplies to the American troops, making an invaluable contribution to the war effort. This posthumous portrait is taken from a life study (location unknown) of 1783 by Trumbull.

The portrait of Peter Agwrondougwas, or "Good Peter" (ca. 1717–1793), described by Trumbull on the verso of the miniature as the "Great Orator as well as warrior, aged 75," was painted in Philadelphia.[1] Good Peter, an Oneida, was prominent in Iroquois diplomacy during and after the Revolutionary period. He acted as one of the Six Nations' spokesmen during their visit to Philadelphia. There his eloquence was enlisted to serve two different agendas: advocating for his people's land rights against the encroachments of New York's governor and addressing the national government's hope that the Six Nations would help achieve peace between the United States and tribes in the Northwest Territory.

Lemuel Hopkins (1750–1801) was famous as an innovative physician and amateur poet. The only doctor among a group of politically conservative satirists known as the Connecticut Wits, he was the principal author of "The Anarchiad" (1786–87), a poem that attacked the new American political system for giving power to people who had neither wealth nor education. As a physician, he specialized in treating tuberculosis, rejecting such time-honored cures as asses' milk in favor of fresh air and a healthy diet. He also turned his poetry against tradition in such satires on medicine as "Epitaph on a Patient Killed by a Cancer Quack."

John Trumbull (1750–1831), a second cousin of the artist, passed his entrance examination to Yale College at the age of seven. He wrote poetry throughout college and published a satire on collegiate instruction after he graduated. He also studied and practiced law. His most popular poetic work, "M'Fingal," dealt with the ineptness of the British during the Revolutionary War. H.A.C.

Note

1. Good Peter was also known as Gwedelhes or Peter Agwelondongwas, or Agrwrondongwas. I thank Alyssa Mt. Pleasant for her insights about Good Peter. See also Colin G. Calloway, *The American Revolution in Indian Country* (Cambridge and New York: Cambridge University Press, 1995), and Alan Taylor, *The Divided Ground: Indians, Settlers, and the Northern Borderland of the American Revolution* (New York: Alfred A. Knopf, 2006).

47

48

Thomas Mifflin, 1790

Oil on mahogany, 3⅝ x 3 in. (9.2 x 7.6 cm)
Trumbull Collection, 1832.75

Samuel Livermore, 1792

Oil on mahogany, 3¾ x 3⅛ in. (9.5 x 7.9 cm)
Trumbull Collection, 1832.76

Laurence Manning, 1791

Oil on mahogany, 4 x 3 in. (10.2 x 7.6 cm)
Trumbull Collection, 1832.77

Richard Butler, 1790

Oil on mahogany, 3¾ x 2⅞ in. (9.5 x 7.3 cm)
Trumbull Collection, 1832.78

Arthur Lee, 1790

Oil on mahogany, 3⅞ x 3⅛ in. (9.8 x 7.9 cm)
Trumbull Collection, 1832.79

One of the leading men in colonial Pennsylvania, Thomas Mifflin (1744–1800) later became governor of the state and a member of the legislature. During the Revolutionary War, he served with Trumbull as an aide-de-camp to General Washington. Mifflin's involvement with the faction that sought to replace Washington with Horatio Gates, however, undoubtedly cooled his relations with the artist. Mifflin was serving as the president of Congress when Washington resigned his commission as commander in chief. Trumbull probably used this miniature painted in Philadelphia for his two depictions of Mifflin: he appears mounted on a white horse at the far left in *The Death of General Mercer at the Battle of Princeton* (cat. no. 35) and is shown standing at the far left in *The Resignation of General Washington* (cat. no. 38).

Samuel Livermore (1732–1803) was elected to Congress from New Hampshire in 1799 and was in that office when Trumbull painted

his portrait, possibly in preparation for the never-executed *Inauguration of the President*. The Yale miniature is a replica of the one taken from life that is in the Currier Museum of Art (Manchester, New Hampshire).

Laurence Manning (1756–1804), a captain in Lee's Legion, was distinguished by his gallantry at the Battle of Eutaw Springs under General Nathanael Greene. He settled in South Carolina after the war and became an adjutant general in the state militia. Trumbull probably took this miniature, painted in Charleston, for his proposed history painting, *The Battle of Eutaw Springs*.[1]

Richard Butler (1743–1791) began his military career as an Indian agent in western Pennsylvania. He joined the Continental

army after the outbreak of war in 1775, participating in the Battles of Saratoga and Yorktown. He later became a government commissioner for negotiations with a number of eastern tribes, including the Iroquois, Chippewa, Ottawa, and Shawnee. Butler was mortally wounded during a campaign against hostile tribes in the Ohio Country one year after Trumbull painted this portrait in Philadelphia.

In the period leading up to the Revolution, Arthur Lee (1740–1792) published a series of letters in English newspapers protesting Parliament's actions toward America. These letters earned him wide repute as a patriot and, in 1775, he was asked by the Continental Congress to become a confidential

correspondent in London. During the conflict, he acted as an unofficial envoy for the American cause, negotiating several treaties with foreign powers. He was one of the commissioners of the United States at the first treaty with France. Trumbull portrayed Lee among the members of Congress in *The Resignation of General Washington*, where he is seated seventh to the left of Washington. Painted in New York City, this miniature may also have been intended for the unexecuted *Treaty of Peace*. H.A.C.

Note

1. John Hill Morgan, *Paintings by John Trumbull at Yale University* (New Haven: Yale University Press, 1926), 71.

48

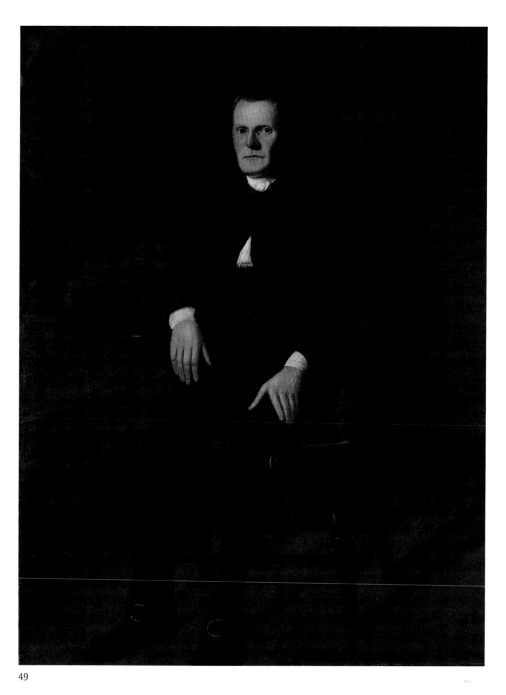

49

49

Ralph Earl (1751–1801)
Roger Sherman, ca. 1775

Oil on canvas, 64 ⅝ x 59 ⅝ in. (164.1 x 126 cm)
Gift of Roger Sherman White, B.A. 1899,
LL.B. 1902, 1918.3

This magisterial portrait displays the awkward grasp of anatomy and perspective that typified Ralph Earl's early productions, while its attention to detail and psychological acuity prefigure characteristics of his later works. The graceless pose reinforces the artist's powerful draftsmanship and is evocative of Roger Sherman's public manner, as described by John Adams: "Sherman is one of the soundest and strongest pillars of the Revolution [even if his] air is the reverse of grace; there cannot be a more striking contrast to beautiful action, than the motion of his hands. . . . Hogarth's genius could not have invented a motion more opposite of grace—it is stiffness and awkwardness itself."[1] In the hard-boiled Sherman (1721–1793), who faces down the curious gaze of posterity with a singularly uncompromising glare, Earl seems to have discovered a sitter whose homespun self-presentation is in sympathy with his own pictorial instincts.

Sherman's attire communicates the tenor of his personality. The plain, fringed muslin cravat and the garnet color of the conservative homespun suit, which exhibits wear on the right knee, would have been considered old-fashioned. In contrast to the dramatic, carefully coordinated costumes in other portraits of the era, this monochrome ensemble indicates Sherman's defiant disregard for the vagaries of sartorial trends. He wears neither a wig nor shirtsleeve ruffles, rejecting continental elegance and, by extension, European values. Only the glittering oval shoe buckles seem to invite attention and may refer to the sitter's training as a shoemaker.

The austere interior reflects Sherman's ascetic persona. The sketchy intangibility of the background focuses attention on the low-back Windsor armchair, a type commonly identified with Philadelphia. The selection of such a chair for this portrait may have been intended to allude to Sherman's recent high-profile role at the Constitutional Convention in that city.[2]

The studied simplicity of Sherman's self-presentation belies his political prestige. Sherman was a prominent Connecticut statesman who had risen from humble origins, having worked in a variety of trades before being admitted to the bar in 1754. A member of the General Assembly of Connecticut, he was later to become a judge of the Connecticut Supreme Court. At the time this portrait was made, he was serving as treasurer of Yale College. Sherman came to be recognized as one of the most indefatigable patriots of the early Revolutionary period, achieving notoriety as the only political figure to sign the Declaration of Independence, the Articles of Association, the Articles of Confederation, *and* the Constitution.

Sherman's political stance was directly opposed to Earl's Loyalist convictions. As the tensions of the early 1770s escalated, Earl's allegiance to George III and his short, unsuccessful career as a British spy would alienate him from his staunchly republican family and eventually cause him, in 1778, to flee the American colonies, his life in peril. G.G.

Notes
1. In Elizabeth Mankin Kornhauser, *Ralph Earl: The Face of the Young Republic* (New Haven: Yale University Press, 1991), 12.
2. Ibid.

50

Possibly by John Cook
(active ca. 1795–1813)
Medal of the Society of the Cincinnati
New York City, 1785–1810

Gold with white, blue, and green enamel and
silk ribbon, 2 x 1⅛ in. (5 x 2.9 cm)
Mabel Brady Garvan Collection, 1930.4885

51

Plate
China, ca. 1785

Porcelain with underglaze blue and overglaze
enamels, diam. 9⁷⁄₁₆ in. (24 cm)
Mabel Brady Garvan Collection, 1930.3164

52

Hot Milk Pot
China, 1785–90

Porcelain with overglaze enamel, 9 x 5 x 6¼ in.
(22.9 x 12.7 x 15.9 cm)
Gift of de Lancey Kountze, B.A. 1899, 1939.79

Named after the famed Roman dictator
Lucius Quinctius Cincinnatus, the Society
of the Cincinnati was formed in 1783 as a
social organization and lobbying group for
officers of the American Revolution. In the
fifth century B.C., Cincinnatus put down his
plow, left his farm, and defended the Roman
empire from a barbarian threat. After his
triumph, he returned home, refusing all
honors and offers of power. The officers of
the Continental army felt that they, like
Cincinnatus, had sacrificed the well-being of
their families and farms to serve their country
and fight for freedom. Inadequately sup-
plied and infrequently paid, they hoped at
least to look forward to a pension; they were
dismayed therefore when the Continental
Congress seemed to prevaricate in guarantee-
ing their later reward. Knowing that once
the army disbanded, they would lose their
bargaining power with Congress, the officers
"planned a national organization . . . that

might maintain the national momentum req-
uisite to protect [their] interests."[1]

Major General Henry Knox, who later
served as George Washington's secretary of
war, had been considering a fraternal orga-
nization of officers as early as 1776, when he
reportedly told John Adams that "he should
wish for some ribbon to wear in his hat, or in
his button hole, to be transmitted to his
descendants as a badge and a proof that he
had fought in defence of their liberties."[2]
Knox's idea of an honorary society was com-
bined with a lobbying organization to form
the Society of the Cincinnati. Its motto was
"*omnia relinquit servare rempublicam*" (he gives
up everything to serve the republic). Mem-
bership was limited to officers with at least
three years of service, with a provision for
honorary members. Each of the thirteen orig-
inal colonies had its own chapter, and an
overseas branch was created for French offi-
cers who had fought in the Revolution. To
perpetuate the society, it was decided that
membership would be hereditary, passing to
each member's eldest son.[3]

The idea of a hereditary order was deeply
disturbing to many Americans, including
Adams and Thomas Jefferson, who feared it
could lead to the establishment of an Ameri-
can nobility and perhaps ultimately to
monarchy. Thomas Paine, however, felt "it is
material to the future freedom of the Country,
that the example of the late Army retiring
to private Life on the principles of Cincin-
natus, should be commemorated."[4] Due in
large part to the reassuring influence of
Washington, who served as its president until
his death, the society was established despite
public apprehension. The Cincinnati set up
a charitable fund to provide for officers' wid-
ows and orphans and continued to lobby
for military pensions, a matter that was not
fully settled until 1828.[5]

In imitation of the European military
orders after which it was modeled, the Society
of the Cincinnati created a special badge for

50

its members (cat. no. 50). Major Pierre
Charles L'Enfant, the military engineer who
would later create the master plan for
Washington, D.C., designed the badge. He
took his drawings to Paris in the fall of 1783,
where they were fabricated by the firm of
Duval and Francastel. American jewelers later
used the first badges made in France as
models to create new ones. Like the original
L'Enfant designs, this cast-gold badge is
shaped like an eagle with a crown of laurels
behind. An enameled medallion is set into
the badge. On the obverse, surrounded by
the society's motto, Cincinnatus is pictured
receiving a sword from Roman senators,
while the reverse depicts him with his plow, a
figure of Fame, and the inscription "Societas
Cincinnatorum Instituta AD 1783." The
hanging loop is engraved with the name of
Leonard Bleecker (1755–1844), the original
owner of this medal and a captain in New
York's Third Regiment during the Revolution.
The badge was probably made by John Cook
of New York City, who advertised Cincinnati

Reverse

eagles in 1802 and provided several badges
to members of the New York chapter. The
medal, suspended from a blue-and-white rib-
bon rosette that represents the unity of the
United States and France, was worn pinned
to the lapel or waistcoat.[6]

While all the members of the Society of
the Cincinnati wore their medals to proclaim
their participation in the Revolutionary War,
some chose to display their membership on
goods for the table as well. Again following
the precedents set by European military
orders such as the Knights of the Garter, they
had Chinese manufacturers create porcelain
decorated with the society's insignia. This
plate is part of a service generally believed to
have belonged to Washington, although
Henry Lee of Virginia owned an identical set
(cat. no. 51). In 1786, Lee purchased a 302-
piece set of Cincinnati porcelain, which
included a breakfast, table, and tea service,
on Washington's behalf for sixty pounds,
presumably acquiring a set for his own use at
the same time. Washington, who was some-

times called "the American Cincinnatus," used his Cincinnati service at Mount Vernon as well as at his residences in New York and Philadelphia. The porcelain service came to the United States from China on the ship *Empress of China* in 1785; the ship's supercargo, Samuel Shaw, was a member of the Cincinnati and had arranged for the creation of the porcelain. The plate's blue-and-white "Fitzhugh" underglaze border is a stock pattern that would have been painted at the kiln site. Then the plates would have been taken to Canton, where armorial designs—in this case the figure of Fame blowing a trumpet and holding the emblem of the society—were hand-painted in enamels.[7]

Other members of the society acquired sets of Cincinnati porcelain throughout the 1780s and 1790s. This hot milk pitcher (cat. no. 52) was owned by Knox, who, in addition to founding the society, served as its secretary general from 1783 to 1799 and its vice president general from 1805 until his death. The pitcher was part of a 150-piece tea service that Knox acquired in 1790 from Shaw. The ovoid-shaped pitcher features a domed lid with a molded rosette finial and is decorated with floral sprays and the society's insignia. The figure of Fame seen on the Washington-type plate is omitted here, and the insignia more closely resembles an actual Cincinnati badge. The initials "HLK" stand for Knox and his wife, Lucy. When Shaw wrote to Knox that he was sending "a set of porcelain for the tea tables of my dear Mrs. Knox," he noted that since Lucy was "one of the most amiable and good of the Sisters of the Cincinnati—the companion of your toils, their sweet reward, and the dear partner of your life in all circumstances, I have taken the liberty of blending her cypher with yours."[8]

As its original members died, the Society of the Cincinnati lost much of its vitality. By 1835, many of the state societies were dormant. The Civil War, the 1876 centennial,

51

52

and colonial nostalgia brought about renewed interest in the American Revolution and led to the revitalization of the society. Its lobbying functions forgotten, it served more as a social organization and a badge of honor for descendants of Revolutionary War officers. But its legacy lives on in the city of Cincinnati, Ohio, which was named in 1790 to honor the society and its members, many of whom were driving forces in the Ohio Company and the settlement of the state.[9] E.E.

Notes

1. Minor Myers, Jr., *Liberty without Anarchy: A History of the Society of the Cincinnati* (Charlottesville: University Press of Virginia, 1983), 15.

2. Diary, 16 Mar. 1788, in Julian P. Boyd et al., eds., *The Papers of Thomas Jefferson*, 31 vols. (Princeton: Princeton University Press, 1950–), 13:11.

3. Ibid.; Myers, 1983, 26–27.

4. Thomas Paine to George Washington, 28 Apr. 1784, in Edgar Erskine Hume, ed., *General Washington's Correspondence Concerning the Society of the Cincinnati* (Baltimore: Johns Hopkins University Press, 1941), 145.

5. Myers, 1983, 18, 48–55, 219.

6. Minor Myers, Jr., *The Insignia of the Society of the Cincinnati* (Washington, D.C.: Society of the Cincinnati, 1998), 14; advertisement, *New York Herald*, 29 May 1802.

7. Myers, 1983, 76; Eleanor Lee Templeman, "The Lee Service of Cincinnati Porcelain," *Antiques* 118 (Oct. 1980), 758; Susan Gray Detweiler, *George Washington's Chinaware* (New York: Harry N.

Abrams, 1982), 83–86, fig. 6, 95–96; Wendy C. Wick, *George Washington, an American Icon: The Eighteenth-Century Graphic Portraits*, exh. cat. (Washington, D.C.: Smithsonian Institution Traveling Exhibition Service and the National Portrait Gallery, 1982), 56. There has been some question as to whether Lee and Washington acquired two separate but identical sets of china or whether they split one extraordinarily large service.

8. Some records refer to the piece as a chocolate pot. John Quentin Fuller, "Collectors' Notes: Society of the Cincinnati Porcelain," *Antiques* 125 (Apr. 1984), 908; Samuel Shaw to Henry Knox, 31 Dec. 1790, New England Historic Genealogical Society, on deposit at the Massachusetts Historical Society, Boston, quoted in Fuller, 1984, 907.

9. Myers, 1983, 112.

53

53

Stephen Badlam (1751–1815),
cabinetmaker
John Skillin (1746–1800) and
Simeon Skillin, Jr. (1757–1806), carvers
Chest-on-Chest
Dorchester Lower Mills and Boston,
Massachusetts, 1791

Mahogany, mahogany veneer on chestnut,
eastern white pine, and red pine,
8 ft. 5⅛ in. x 51½ in. x 23¾ in.
(2.6 m x 130.8 cm x 60.3 cm)
Mabel Brady Garvan Collection, 1930.2003

Following the Revolution, some citizens
sought domestic objects that would express
in the most elaborate ways America's pride
in having achieved independence. Shipping
magnate Elias Hasket Derby (1739–1799), a
prominent citizen of Salem, Massachusetts,
could well afford to do so. In commissioning
this massive piece from Stephen Badlam, a
war veteran in a town south of Boston, Derby
took the unusual step of engaging leading
Boston sculptors to carve figures for the
case's pediment.[1]

Rising to the challenge set by their patron,
John Skillin and his brother Simeon created
a scheme of three females in fashionable
neoclassical dress and distinctive accessories
imbued with allegorical meaning. The figure
on the left, holding an olive wreath and a
palm frond, personifies Peace. On the right is
Plenty, clasping a cornucopia. The central
figure wears the gilt-sun brooch and laurel
wreath associated with Virtue, while the
Phrygian cap on a liberty pole is an attribute
of Liberty. Through this combination of
attributes, she represents America.[2]

Family tradition has it that Derby and his
wife, Elizabeth Crowninshield Derby, gave
this piece as a wedding present to their
daughter Anstis, who married Benjamin
Pickman, Jr., of Salem in 1789. In their mul-
tiplicity of meanings, the allegorical symbols
of the pedimental sculpture group expressed
appropriate wishes for a daughter on the
occasion of her marriage. The trio may also
represent Derby's three daughters, making
it yet more personal. The lag between the
dates of the wedding and the chest's comple-
tion (1791) can be explained by the com-

Detail

plexity of the collaboration required between the Skillin brothers, Badlam, and their demanding client.[3]

The classical arrangement of the figures, inspired by such treatises as James Gibbs's *A Book of Architecture* (1728), together with carved embellishments from Badlam's shop—such as the columns with Ionic capitals framing the upper case and the relief swags and branches on the architrave's drawer front—reflects a growing taste for classical ornament that resonated with the democratic ideals of the new republic. Indeed, Badlam's chest communicates the hopes and ideals of the new nation and its most prosperous citizens. 　　　C.M.H.

Notes

1. Although they were not the only sculptors Derby patronized, the Boston-based brothers also provided architectural carvings and sculpture for Derby's mansion, garden, and yacht.
2. Sylvia Leistyna Lahvis, *The Skillin Workshop: The Emblematic Image in Federal Boston* (Newark: University of Delaware Press, 1992), 121–23.
3. Gerald W. R. Ward, *American Case Furniture in the Mabel Brady Garvan and Other Collections at Yale University* (New Haven: Yale University Art Gallery, 1988), 174–77.

54

54

Edward Savage (1761–1817)
Liberty. In the form of the Goddess of Youth, giving Support to the Bald Eagle, 1796

Stipple engraving printed in colors, 25 x 16⅜ in. (63.5 x 41.6 cm)
Mabel Brady Garvan Collection, 1946.9.344

During the Revolutionary War and the years following independence, Americans embraced a variety of patriotic symbols, such as the figure of Liberty, to inspire and encourage unity within the newly forged country. The transition from colony to nation entailed not just restructuring political institutions but also adopting new cultural icons that would represent the dramatic changes occurring in society.[1] Visual representations of the new nation and expressions of patriotism were important means by which the nation's independence was integrated into everyday life for the citizens. Mapmakers transformed colonies into states, newspaper mastheads incorporated national symbols such as eagles and flags, and decorative objects were adorned with patriotic themes such as depictions of American military victories or visages of war heroes.

Liberty. In the form of the Goddess of Youth, giving Support to the Bald Eagle was engraved in 1796 by American artist Edward Savage after his own painting. In this image, Savage has represented the figure of Columbia in the guise of Liberty—a powerful symbol of America. Savage customized the classical image by adding an array of national symbols, such as the flag bearing thirteen stars and stripes, the bald eagle, and the liberty cap. Furthermore, the artist has given his image a historical context by placing Liberty against the backdrop of Boston Harbor during the British fleet's evacuation—punctuated dramatically by the bolts of lightning flashing above the city. Liberty is draped in a white gossamer gown with gold trim and a

red sash that represents her patriotic fervor. She tramples the symbols of monarchical tyranny—a medal and garter of a royal order, shackles, and the key to the Bastille—under her bare feet.[2]

Americans adopted classical allegorical figures to express patriotic sentiment in part to counter European stereotypes. For decades, written and visual representations of the New World had portrayed it as a wild, savage land. In the seventeenth and eighteenth centuries, for instance, female allegorical representations of "The Four Continents" served as a popular decorative motif in engravings and paintings and on decorative art objects. The figure representing Europe was a classically dressed, white-skinned goddess, surrounded by the accoutrements of cultural refinement and achievement—paintbrushes, scientific instruments, globes, paintings, sculptures, and books. In contrast, the figure representing America was a dark-skinned woman—naked, save for a few feathers—seen among objects representing the "wild nature" of the New World: alligators, armadillos, volcanoes, and exotic plants. Ironically, after independence, Americans often adopted the European personification for themselves: in some post-Revolutionary images, the "lightened" classical figure of America is seen bestowing the gifts of civility and culture on Native Americans.[3]

Trained as a goldsmith in Massachusetts, Savage journeyed to London in 1791 to study under Benjamin West. It is believed that he based his Liberty on a painting of Hebe by William Hamilton, Hebe, the Greek goddess of youth and the cupbearer to the gods, was depicted by Hamilton as a maiden in classical dress holding a ewer in her right hand and a chalice in her left, quenching the thirst of her father, Zeus, who is in the guise of an eagle.[4]

Savage's *Liberty* was very popular and widely distributed. It inspired many copies in

different media—including needlework, watercolor, oils on velvet and silk, and reverse glass paintings, by English, Chinese, European, and American makers. Each of these versions strayed from the original to varying degrees. In one version, a Chinese artist replaced the city of Boston with a Chinese village and transformed the ships into junks.[5] Among the most interesting variations are the needlework compositions by American women, who dedicated countless hours to their completion. Over time, Savage's familiar figure of Liberty would have numerous incarnations, including mourning pictures commemorating the death in 1799 of America's beloved first president, George Washington. K.Y.

Notes
1. Ann Fairfax Withington, "Manufacturing and Selling the American Revolution," in Catherine E. Hutchins, ed., *Everyday Life in the Early Republic* (Winterthur, Del.: Henry Francis du Pont Winterthur Museum, 1994), 287.
2. The keys to the Bastille are especially significant because they were presented to George Washington in 1790 by the French. They are still exhibited at Mount Vernon. For a concise, informative analysis of the details of this print, see Laura K. Mills, *American Allegorical Prints: Constructing an Identity*, exh. cat. (New Haven: Yale University Art Gallery, 1996), 18.
3. Withington, 1994, 287.
4. Louis C. Jones, "Liberty and Considerable License," *Antiques* 74 (July 1958), 40. Jones traces the variations of the Liberty figure.
5. "A Gallery Note: Liberty in the Chinese Taste," *Antiques* 20 (Nov. 1931), 299.

55

Liberty Browne (1776–1831)
Sword and Scabbard
Philadelphia, ca. 1815

Gold, steel, and leather; sword 41½ in. (105.4 cm); scabbard 34½ in. (87 cm)
Purchased with the Josephine Setze Fund for the John Marshall Phillips Collection, the Leonard C. Hanna, Jr., B.A. 1913, Fund, and a gift from Mrs. James Harper Poor Garnett in memory of her mother, Maria J. E. Decatur Mayo Deyo, and her father, Vice Admiral M. L. Deyo, U.S.N., 1994.34.1a–b

The War of 1812, waged between the United States and Great Britain from 1812 to 1815, involved both land battles in North America and naval engagements in the Great Lakes and the Atlantic Ocean. This presentation sword with its original scabbard commemorates the victory of American Captain

Stephen Decatur's ship *United States* over the forty-nine-gun British frigate *Macedonian* off the coast of Africa on 25 October 1812. Decatur's stunning triumph was one of the first American naval successes of the war and the first-ever capture of a British warship by an American officer. The inscription on the blade reads: "Presented by the Commonwealth of Pennsylvania / Simon Snyder Governor / To Commodore Decatur 16 Feb. 1813." This date refers to a resolution passed by both the House and Senate of the Pennsylvania legislature recognizing Decatur's "distinguished gallantry and skill" and commissioning for him and one other native Philadelphian, Lieutenant James Biddle of the USS *Wasp*, "an appropriate sword, the expense of which shall not exceed four hundred dollars." The swords were awarded in March of 1815.[1]

fig. a Thomas Birch, *Engagement between the* United States *and the* Macedonian, 1813. Oil on canvas, 27 ¾ x 35 ⅞ in. (70.5 x 91.2 cm). Museum of Fine Arts, Boston, Anonymous gift and Juliana Cheney Edwards Collection, 1978.180

The maker of both the Decatur and Biddle swords was the Philadelphia silversmith and politician Liberty Browne, a man whose very name and date of birth (4 July 1776) recalled America's Independence Day and the first era of military conflict with Great Britain during the Revolutionary War. Browne, also a city commissioner, had in fact introduced a resolution in December 1812 to award Decatur another presentation sword by the city of Philadelphia, an act that may have earned him the two later sword commissions from the state legislature.[2] Like many other silversmiths of this era who also made swords, Browne probably purchased the steel blade from an ironworker and then attached the gold hilt.

The complex iconography on the hilt mixes classical symbols of maritime power, such as Neptune clutching a trident and trophies of naval warfare, with medieval chivalric emblems and contemporary scenes of the battle. The representation on the counterguard of the battle between the *United States* and the *Macedonian* is taken from a version of Philadelphia artist Thomas Birch's painting of 1813 (fig. a), which also circulated as a print engraved by Benjamin Tanner.[3] A nearly contemporaneous commission for naval presentation swords in Philadelphia urged the swordsmiths to take design inspiration from "Models of antient [*sic*] or modern Knighthood."[4] There were few American officers more deserving of such approbation than Decatur. Renowned for his bravado and chivalrous conduct in battle, he epitomized American military aspirations in an era when the nation's sovereignty rested on its naval prowess. D.A.C.

55

Commonwealth of Pennsylvania 26 (Harrisburg, Pa.: printed by Christian Gleim, 1815), 366.
2. Common Council, 10 Dec. 1812, Philadelphia City Archives, 3:589–90.
3. *Thomas Birch, 1779–1851: Paintings and Drawings*, exh. cat. (Philadelphia: Philadelphia Maritime Museum, 1966), 24.
4. Benjamin Crowninshield, Secretary of the Navy, to George Harrison, Philadelphia, 21 Nov. 1815, George Harrison Collection, Historical Society of Pennsylvania, Philadelphia.

Detail of hilt showing Neptune clutching a trident and trophies of naval warfare

Detail of hilt showing chivalric emblems and contemporary scenes of battle

Notes
1. James Tertius de Kay, *A Rage for Glory: The Life of Commodore Stephen Decatur, USN* (New York: Free Press, 2004), 113–30; *Acts of the Assembly of the Commonwealth of Pennsylvania 1813* (Harrisburg, Pa., 1813), 264; *Journal of the Senate of the*

56

Amos B. Doolittle (1754–1832)
The Hornet and Peacock, Or, John Bull in Distress, 27 March 1813

Hand-colored etching, 10⅛ x 13¼ in.
(25.7 x 33.7 cm)
Yale University Library Transfer, Gift of
C. Sanford Bull, B.A. 1893, 1955.44.20

The War of 1812 marked the introduction of the political cartoon to America. This was in part due to the talents of William Charles, who emigrated from Edinburgh in 1806 and brought with him the eighteenth-century English caricature tradition, as practiced by Thomas Rowlandson and James Gillray, among others.[1] Charles's political caricatures inspired such Americans as the self-taught Connecticut engraver Amos Doolittle to produce similar scathing exposés.[2]

Doolittle's *The Hornet and Peacock, Or, John Bull in Distress* celebrates the victory of the American battleship *Hornet*, under the command of Captain James Lawrence, over the somewhat smaller and less powerful British *Peacock*, under the command of Captain William Peake—a conflict that took place north of British Guyana on 24 February 1813. In the print, a large creature, half-bull, half-peacock, bellows after being stung in the neck by a small hornet. Two small ships in the background mirror the allegorical activity in the foreground. Doolittle's print undoubtedly owes a debt to one of Charles's caricatures of the previous year, *A Wasp Taking a Frolick*, which celebrated the American victories of the vessel *Wasp* over the *Frolic* on 18 September 1812; it also echoes Charles's *The Cock Fight—or another Sting for the Pride of John Bull*, which commemorated the defeat of the *Peacock* by the *Hornet*.[3] But whereas in *The Cock Fight* Charles clearly depicted a hornet, a peacock, and the figure of John Bull, Doolittle here took the pun a step further by cleverly combining the head of a bull (symbolizing John Bull)[4] with the

tail of a peacock (the British ship that was sunk), turning his version into a more sophisticated jab at old England.

A quick study with a knack for caricature, Doolittle adopted certain British conventions in his circa 1812 prints, such as the regular use of speech bubbles, clever punning, and hand-coloring to add emphasis or meaning. Doolittle's cartoons also mimic the British penchant for profiles over full faces and their conflation of animal and human iconography.

The victory of the *Hornet* over the *Peacock* also inspired a bit of patriotic fervor from Amos's younger brother, Eliakim. He composed a song entitled "The Hornet Stung the Peacock," immensely popular in its day, which begins:

Ye Demo's attend and ye Federalists
 too,
I'll sing you a song that you all know
 is new,
Concerning a Hornet, true stuff, I'll
 be bailed,
That tickled the Peacock and lowered
 his tail[5] E.H.

Notes

1. Georgia Brady Barnhill, "Political Cartoons of New England, 1812–61," in *Prints of New England*, ed. Georgia Brady Barnhill, Proceedings of a conference held by the American Antiquarian Society and the Worcester Art Museum, 14 and 15 May 1976 (Worcester, Mass.: American Antiquarian Society, 1991), 84.
2. Lorraine Dwelling Lanmon, "William Charles and His War of 1812 Caricatures," in *Philadelphia*

Printmaking: American Prints Before 1860, ed. Robert F. Looney (West Chester, Pa.: Tinicum Press, 1976), 106. Amos Doolittle was born in Cheshire, Connecticut, and worked as a jeweler and silversmith in New Haven for most of his life. Doolittle taught himself the art of engraving and made a living producing maps, bookplates, music books, allegorical prints, and caricatures.
3. Lanmon, 1976, 93.
4. See catalogue entry 57, Amos Doolittle's *Brother Jonathan*, for a description of the character of John Bull.
5. Rev. William A. Beardsley, M.A., *An Old New Haven Engraver and His Work: Amos Doolittle* (New Haven [?]: ca. 1910), 16–17.

56

57

Amos B. Doolittle (1754–1832)

Brother Jonathan Administering a Salutary Cordial to John Bull, ca. 1813

Hand-colored etching, 9⅝ x 15¼ in.
(24.4 x 38.7 cm)
Yale University Library Transfer, Gift of
C. Sanford Bull, B.A. 1893, 1955.44.24

57

The short, rotund figure of John Bull entered British political caricatures in the decade preceding the Revolutionary War as the personification of the quintessential Englishman—fond of food and drink and patriotic to the core. Soon after, the figure of "Brother" Jonathan, John Bull's youngest son, was created to represent Bull's archrival.[1] Though clearly British-born, the thinner, coarser figure of Brother Jonathan was characterized as the stereotypically shrewd, and often overzealous, American.[2] During the War of 1812, the rivalry between father and son reached its apex, and in American as well as British political prints, John Bull and Brother Jonathan took central roles. In his *Diverting History of John Bull and Brother Jonathan* of 1812, James Kirke Paulding described the latest episode in their longstanding rivalry: "The squire having by far the most boats, resolved . . . to scour the millpond, and get a sweep at Jonathan's boats. Jonathan, who was a pretty keen lad . . . sent out some of his best boats with orders that the hardest should fend off. . . . The first thing Bull heard was, that several of his boats, on trying to seize Jonathan's, had got most bitterly bethumped."[3]

Pictured here is the younger Brother Jonathan, forcing the older, fatter John Bull to drink some "perry." Oliver Hazard Perry was America's premier naval commander during the War of 1812, but here the term "perry" also doubles as the name of a pear liqueur, which, when drunk to excess, was known to

cause severe digestive problems.[4] As with Amos Doolittle's print of *The Hornet and Peacock* (cat. no. 56), this portrayal of Brother Jonathan and John Bull clearly owes a thematic debt to a caricature of the same year by William Charles, *Queen Charlotte and Johnny Bull Get their dose of Perry*.[5] The author of this print, the self-dubbed "Yankee Doodle-Scratcher" (as he signed this print at the lower right), was in fact Doolittle.

In his "historical" account, Paulding sums up the 1812 rivalry between Bull and Jonathan: "I have generally observed, that people get nothing by fighting but black eyes, bloody noses, and the reputation of having

more pluck than brains. So it happened with Squire Bull, who, after putting himself to great expense to have a bout with Jonathan . . . got nothing for his pains . . . only that his pockets were more empty, and he carried a few additional scars on his pate."[6] E.H.

Notes
1. Winifred Morgan, *An American Icon: Brother Jonathan and American Identity* (Newark: University of Delaware Press, 1988), 64.
2. Ibid., 68. As Morgan notes, the character of Brother Jonathan, more than Yankee Doodle or Uncle Sam, was clearly part of the British family, a fact that was acknowledged by American and British caricaturists alike.
3. James Kirke Paulding, *The Diverting History of John Bull and Brother Jonathan, by Hector Bull-us* (pseud.) (New York: Inskeep & Bradford, 1812; repr. New York: Harper & Brothers, 1835), 110.
4. Georgia Brady Barnhill, "Political Cartoons of New England, 1812–61," in *Prints of New England*, ed. Georgia Brady Barnhill, Proceedings of a conference held by the American Antiquarian Society and the Worcester Art Museum, 14 and 15 May 1976 (Worcester, Mass.: American Antiquarian Society, 1991), 86.
5. Unlike Charles, Doolittle clearly had the future independence of his country in mind. Ibid., 88.
6. Paulding, 1835, 113.

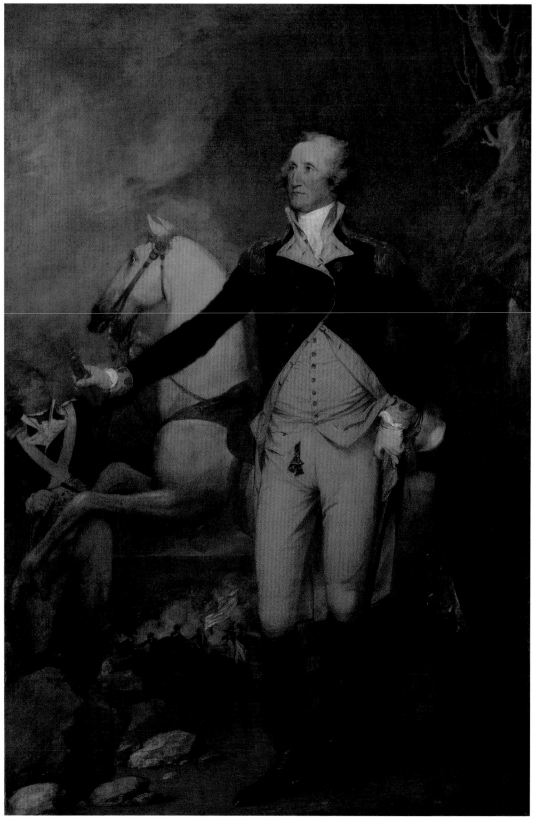

58

John Trumbull (1756–1843)
General George Washington at Trenton, 1792

Oil on canvas, 92 ½ x 63 in. (235 x 160 cm)
Gift of the Society of the Cincinnati in
Connecticut, 1806.1

In 1792, the city of Charleston, South
Carolina, commissioned John Trumbull to
paint a large portrait of George Washington
for its city hall to commemorate the presi-
dent's visit in May 1791. The commission had
personal significance for Trumbull, as he
had served as Washington's second aide-de-
camp during the Revolution. In his *Auto-
biography*, Trumbull recalled that he under-
took the commission "*con amore*" and
endeavored to "give [Washington's] military
character, the most sublime moment of its
exertion—the evening previous to the battle
of Princeton."[1] As the artist explained, that
moment—on the night of 2 January 1777—
was a major turning point of the war:

> When viewing the vast superiority of
> his approaching enemy, and the impos-
> sibility of again crossing the Delaware, or
> retreating down the river, [Washington]
> conceives the plan of returning by a
> night march into the country from which
> he had just been driven, thus cutting off
> the enemy's communication and destroy-
> ing his depot of stores and provisions
> at Brunswick.

Washington's brilliant night maneuvers led
to a decisive victory over the British at
Princeton the following day, putting most of
New Jersey under the control of American
forces and keeping the British from advanc-
ing on Philadelphia. Following closely on the
heels of the American win over the Hessians
at Trenton, the back-to-back victories pro-
vided a much-needed boost to the morale of
Washington's men.

Washington agreed to sit for the artist in
Philadelphia, then the seat of the national
government. Recalling his time with the pres-
ident, Trumbull wrote: "I told the President
my object; he entered into it warmly, and, as
the work advanced, we talked of the scene,
its dangers, its almost desperation. He *looked*
the scene again, and happily transferred to
the canvass, the lofty expression of his ani-
mated countenance, the high resolve to con-
quer or to perish." The resulting work, *General
George Washington at Trenton*, is a significant
departure from Trumbull's previous por-
traits, which drew heavily on English models.
As much history painting as portraiture,
Trumbull's strong diagonal composition,
dramatic sky, and exacting attention to detail
all echo his Revolutionary War battle scenes
(cat. nos. 31–38). However, the artist did not
eschew historical influence: Washington's
pose has much in common with the *Apollo
Belvedere*, but may derive more directly from
a figure standing in relief against a horse in
the Parthenon procession frieze.[2]

Although Trumbull considered the
portrait his best work, the city of Charles-
ton refused it on the grounds that, accord-
ing to the artist, it "would be better satisfied
with a more matter-of-fact likeness, such as
they had recently seen [of President
Washington]—calm, tranquil, peaceful."
Keeping this portrait for himself, Trumbull
painted another likeness of Washington for
Charleston, which shows the city's skyline in
the background (fig. a). The work, which
came to be known as "Trumbull's
Revenge," prominently displays the artist's
reaction to the city's rebuff: a horse's rump.
This original, meanwhile, came into the
possession of the Society of the Cincinnati
in Connecticut and thence to Yale. G.C.B.

Notes
1. All quotations of Trumbull in this text are from
Trumbull, *Autobiography, Reminiscences and
Letters of John Trumbull from 1756 to 1841* (New
York and London: Wiley and Putnam, and New
Haven: B. L. Hamlen, 1841), 164, 166–67.
2. See Helen Cooper, *John Trumbull: The Hand
and Spirit of a Painter*, exh. cat. (New Haven: Yale
University Art Gallery, 1982), 120.

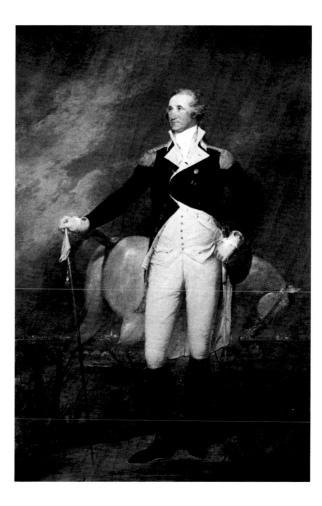

fig. a John Trumbull, *George
Washington at Trenton*, 1792.
Oil on canvas, 90 ½ x 64 in.
(229.9 x 162.6 cm). Collection of
City Hall, Charleston, S.C.

59

60

Amos B. Doolittle (1754–1832)

59

A Display of the United States of America,
1789

Engraving, first state, 21 13/16 x 17 1/8 in.
(55.4 x 43.5 cm)
Yale University Library Transfer, 1954.18.47

60

A Display of the United States of America,
1794

Hand-colored engraving, fifth state,
21 9/16 x 17 15/16 in. (54.8 x 45.6 cm)
Yale University Library Transfer, Gift of
C. Sanford Bull, B.A. 1893, 1955.44.25

In the years following 1783, when the War
for Independence ended British rule of the
North American colonies, the most urgent
issue was the formation of a practical and
acceptable system of government. A federal
convention held in Philadelphia in the sum-
mer of 1787 drafted a constitution that estab-
lished an antimonarchical, representative,
and republican government. Once the Con-
stitution was adopted, general elections
were held, and the only serious candidate for
the office of president was General George
Washington. He was duly elected and
assumed office in April 1789, and in that year
Amos Doolittle's engraving, *A Display of the
United States of America*, appeared to celebrate
both Washington and the new government.

Doolittle was trained as a silversmith, but
he spent his professional life as a copper-
plate engraver in New Haven, producing a
variety of work ranging from bookplates
and reproductions to the publication of his
own designs.[1] Doolittle's artistic abilities were
limited, but he was opportunistic; among
his many engravings the *Display* apparently
proved successful, for six states of the print
appeared between 1789 and 1796.[2]

Doolittle's design is for the most part a symbolic representation of the new American society and government. In the print's definitive form, each of the former colonies and territories is represented by a ring. Within each ring is the state's emblem, while the ring itself shows each state's population and how many representatives it has in the new republican government. At the crest of this ingenious design Doolittle placed the federal government's emblem, the eagle. In the center of the design is a portrait of Washington; in the first edition (cat. no. 59), he appears in three-quarter profile wearing civilian dress, but in subsequent editions (cat. no. 60), he wears his familiar military garb. Doolittle's image primarily celebrates the man rather than the office. At the time Washington's popularity was still of epochal proportions.[3] This idolatry would pass, but in 1789, it was Washington's status and public acclaim that lent legitimacy to the new nation's aspirations. TH.B.

Notes
1. On Doolittle, see E. McSherry Fowble, *Two Centuries of Prints in America, 1680–1880: A Selective Catalogue of the Winterthur Museum Collection* (Winterthur, Del.: Henry Francis du Pont Winterthur Museum, and Charlottesville: University Press of Virginia, 1987). For further bibliographical information, see *The American Print: Originality and Experimentation 1790–1890*, exh. cat. (Storrs, Conn.: William Benton Museum of Art, 1992), 40n.3.
2. On the print, its sources, and its iconography, see Fowble, 1987, no. 212; Laura K. Mills, *American Allegorical Prints: Constructing an Identity*, exh. cat. (New Haven: Yale University Art Gallery, 1996), no. 18; and, especially, Wendy C. Wick, *George Washington, an American Icon: The Eighteenth-Century Graphic Portraits*, exh. cat. (Washington, D.C.: Smithsonian Institution Traveling Exhibition Service and the National Portrait Gallery, 1982), no. 25.
3. Washington's cult status is the subject of Barry Schwartz, *George Washington: The Making of an American Symbol* (New York: Free Press, 1987).

61

Alternate view

William Russell Birch (b. England, 1755–1834)

61

After Gilbert Stuart (1755–1828)
George Washington, 1795 or shortly thereafter

Enamel on copper, 2 5/16 x 1 7/8 in. (5.9 x 4.8 cm), set in lid of snuffbox covered with tortoiseshell
Gift of Mrs. Edward R. Wardwell for the Lelia A. and John Hill Morgan, B.A. 1893, LL.B. 1896, M.A. (HON.) 1929, Collection, 1945.469.2

62

After Ary Scheffer (1795–1858)
Marquis de Lafayette, ca. 1824

Enamel on copper, 2 1/16 x 1 7/8 in. (5.2 x 4.8 cm)
Lelia A. and John Hill Morgan, B.A. 1893, LL.B. 1896, M.A. (HON.) 1929, Collection, 1940.492

During the turmoil of the Revolutionary era and after, portraits were a means of communicating political values: faces of leaders came to represent the moral glue in a fragmented social order. Such portraits executed in miniature recall the jewels of allegiance to the monarch that were fashionable in England during the Elizabethan and Stuart periods. The miniature, a token of affectionate admiration within families, was the perfect vehicle for expressing personal respect for the Founding Fathers, especially George Washington.

British-born enamelist, painter, and engraver William Russell Birch modeled his most celebrated miniatures on full-scale portraits of American heroes. He based his approximately sixty enamel miniatures of Washington on Gilbert Stuart's popular oil portraits of 1795 depicting him as an elder statesman, the country's stern but benevolent patriarch (cat. no. 61). Birch's autobiography includes this vivid account of the genesis of his lucrative portraits, for which he charged between thirty and one hundred dollars:[1]

62

When he [General Washington] was sitting to Stuart, he told him he had heard there was another Artist of merit from London, naming myself; that he would sit to me if I chose. Mr. Stuart brought me the message. I thanked Mr. Stuart and told him that as he has painted his picture, it would be a mark of the highest imposition to trouble the Gen'l to sitt [*sic*] to me, but that when I had copied [*sic*] his Picture of him in Enamel which was my fort[e], that I would show it to the Gen. and thank him for his kind offer. . . . When I saw the Gen'l I put the picture into his hand. He looked at it steadfastly . . . till feeling myself awkward I begun [*sic*] the history of Enamel Painting, which by the time I got through he complimented me upon the beauty of my work.[2]

First brought to England from continental Europe in the 1630s, enamel miniatures remained popular in Britain through the early part of the eighteenth century, when watercolor-on-ivory miniatures eclipsed them. A small number of primarily immigrant artists introduced enamels to America; among them, the most acclaimed was Birch, who settled in Philadelphia in 1794. Enamels are composed of durable pigments in a glassy matrix fused onto a metal support by kiln firing. In contrast to the fragility of watercolor, the permanence of enamel promised that the new nation represented by Washington's likeness would endure.

Birch incorporated his iconic portraits into brooches and pendants. However, their jewel-like sheen and velvety colors are particularly appealing when the miniature is set into a gold oval on the lid of a tortoiseshell-covered snuffbox. This is the only known Birch miniature of Washington set into a snuffbox, an everyday accessory for gentlemen. Its first owner was the Marquis de Lafayette.[3]

Marie-Joseph-Paul-Yves-Roch-Gilbert du Motier, marquis de Lafayette (1757–1834), captured the hearts of American patriots in 1777, when he left his aristocratic life in France to fight under Washington's command. That year he wrote to his wife, "The welfare of America is intimately connected with the happiness of all mankind; she will become the respectable and safe asylum of virtue, integrity, tolerance, and equality, and [of] a peaceful liberty."[4] A force in both the American and the French Revolutions, Lafayette became known as a hero of two worlds.

The aging general returned to America in August 1824, at the invitation of President James Monroe and Congress, for a triumphal thirteen-month tour marking the fiftieth anniversary of the American Revolution.[5] Commemorative portraits played a role in the celebrations: Lafayette gave images of himself to Thomas Jefferson and Monroe and distributed engravings after his favorite portrait, by French artist Ary Scheffer. During Lafayette's visit to Washington, D.C., Scheffer presented the painting to the House of Representatives, where it hangs to the left of the Speaker's rostrum and remains the world's image of Lafayette in his later years (fig. a).

Based on Scheffer's full-length, life-size likeness, Birch created bust-length miniatures in enamel to be marketed during the tour (cat. no. 62). He added an American flag in the upper right, increased the turbulence in the sky so that the shifting wind and light evoke combat, and depicted the Battle of Yorktown in a clearing in the lower left, as if seen in Lafayette's memory. Birch thus paid tribute to the general by memorializing not only his visage but also his part in the climactic confrontation that helped corner the British forces, leading to their surrender.

Like Birch's *Washington*, *Lafayette* honors the exemplary public life of an individual in a private, portable form. Whether the

owner of this miniature knew Lafayette personally or revered him from a distance, having a small portrait of him exemplifies how, through consumption, heroes of the American Revolution became ubiquitous in the American home and psyche. Such miniatures melded together the public and private realms, helping to fashion an American character based on the ownership and internalization of republican ideals. R.J.F.

fig. a Ary Scheffer, *The Marquis de Lafayette*, 1823. Oil on canvas, 92 5/16 x 61 15/16 in. (234.5 x 157.3 cm). Collection of the U.S. House of Representatives, Washington, D.C.

Notes

1. W. M. Horner, Jr., "William Russell Birch, Versatile Craftsman," *Antiquarian* 14 (Feb. 1930), 44. On this miniature and the cult of Washington, see Robin Jaffee Frank, *Love and Loss: American Portrait and Mourning Miniatures*, exh. cat. (New Haven: Yale University Art Gallery, and New Haven and London: Yale University Press, 2000), 97–117. On Stuart's portraits of Washington, see Carrie Rebora Barratt and Ellen G. Miles, *Gilbert Stuart*, exh. cat. (New York: Metropolitan Museum of Art, and New Haven and London: Yale University Press, 2004), 128–90.
2. William Russell Birch, "Autobiography" (typescript, Historical Society of Pennsylvania, Philadelphia, n.d.).
3. Parke-Bernet Galleries, New York, The Erskine Hewitt Collection, 18–21 Oct. 1938, no. 1091, lot 296.
4. Lafayette to Adrienne de Noailles de Lafayette, 7 June 1777, transcribed in *Lafayette in the Age of the American Revolution: Selected Letters and Papers, 1776–1790*, ed. Stanley J. Idzerda, 5 vols. (Ithaca: Cornell University Press, 1977–83), 1:58–59.
5. See Stanley J. Idzerda, Anne C. Loveland, and Marc H. Miller, *Lafayette, Hero of Two Worlds: The Art and Pageantry of His Farewell Tour of America, 1824–1825*, exh. cat. (Flushing, N.Y.: Queens Museum, and Hanover, N.H.: University Press of New England, 1989).

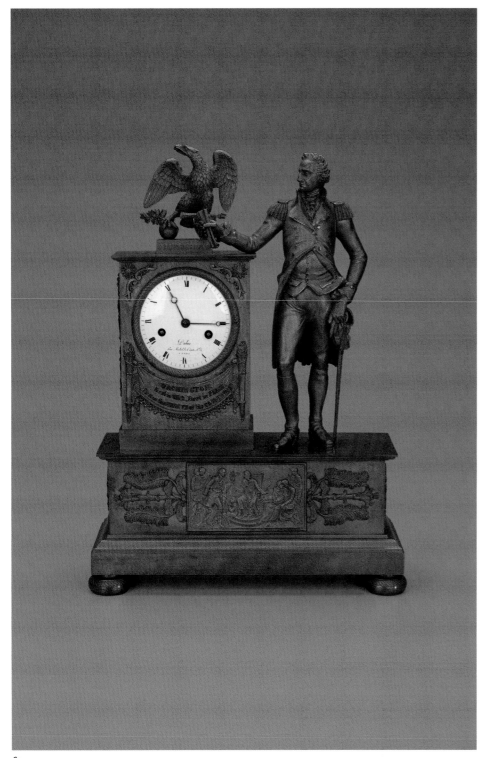

63

64

63

Probably by Nicolas Dubuc
(French, worked ca. 1809–19)
Mantel Clock
Paris, 1809–19

Gilt bronze, 19 ½ x 14 ½ x 5 ½ in.
(49.5 x 36.8 x 14 cm)
Yale University Art Gallery, 2001.1.1

64

Maltby Pelletreau (1791–1846)
Tablespoon
New York City, ca. 1832

Silver, l. 8 ⁷⁄₁₆ in. (21.4 cm), wt. 1 oz., 19 dwt.
(61 gm)
Gift of Frederick C. Kossack, 1985.86.361.1

65

Attributed to Dyottville Glass Works
(ca. 1816–1923)
*George Washington/Zachary Taylor
Quart Flask*
Philadelphia, 1847–60

Full-size mold-blown nonlead aquamarine glass,
h. 8 ¹⁄₁₆ in. (20.5 cm)
Gift of Peter B. Cooper, B.A. 1960, LL.B. 1964,
1996.46.8

Lauded by patriot Henry Lee as "First in war—first in peace—and first in the hearts of his countrymen," George Washington's image has remained a powerful symbol in the more than two hundred years since he first rose to public prominence.[1] Washington memorabilia began appearing in the late 1770s, but it did not really begin to flood the American market until after his death in 1799. During the nineteenth century, the centennial of Washington's birth (1832), the patriotic fervor of the Civil War years, and the centennial of his death (1899) kept Washington's name and image in the forefront of the American imagination. Even in times of localism and division, his image was one thing Americans of all political leanings could accept.

At the end of the Revolution, European manufacturers eagerly opened trade with the new nation, producing a variety of goods featuring American scenery and symbols. This French gilt bronze clock (cat. no. 63) is a multipart homage to Washington, featuring a full-length figure of the great general and statesman as well as a variety of both Classical and American symbols of heroism and liberty. The figure of Washington in military uniform is drawn directly from John Trumbull's 1792 portrait *General George Washington at Trenton* (cat. no. 58). Here Washington holds a scroll rather than the spyglass shown in the painting. This change in accessories helps recast the military figure of Trumbull's painting into that of a distinguished states-man.[2] Washington stands atop a base decorated with neoclassical foliate elements and a relief scene of Washington standing before a group of statesmen wearing classical robes draped over eighteenth-century clothing. It is unclear whether the scene depicts Washington receiving his sword and military command from Congress or relinquishing them to them, but either way the relief is a deliberate homage to the legend of Cincinnatus, the noble Roman farmer-turned-general to whom Washington was frequently compared (see cat. nos. 50–52). The clock mechanisms are housed in a plinth to the figure's right. A neoclassical drapery below the clock face repeats Henry Lee's famous eulogy, while the plinth is topped with an American eagle and the motto *"e pluribus unum,"* taken from the Great Seal of the United States.[3]

The clock's face identifies its maker as a "Dubuc," working at "rue Michel-le-Comte" in Paris. This Dubuc traditionally has been assumed to be one Jean-Baptiste Dubuc (b. 1784), but recent research suggests that Nicolas Dubuc, who may have been Jean-Baptiste's brother, is the actual maker. Dubuc was identified in Paris city

directories as an *"horologer"* and a *"fabricant et magasin de pendules"* (maker and seller of clocks) and appears in their listings at rue Michel-le-Comte between 1809 and 1819. Although popular legend has credited the Marquis de Lafayette with bringing the clocks honoring the man he considered a second father to America during his 1824 visit, the timepieces were actually available in the United States for several years prior to his visit. An 1815 Baltimore newspaper advertisement placed by "DUBUC" indicates that the clocks were ready to be imported.[4]

Not to be outdone by their French counterparts, American artisans and manufacturers also produced a wealth of Washington-

emblazoned goods. This spoon, by New York City silversmith Maltby Pelletreau, features a labeled bust of Washington in military uniform (cat. no. 64). This flatware may have been created in 1832 to capitalize on a renewed mania for Washington-related goods. The double-thread border on the fiddle-shaped handle is part of a design generally known as "king's pattern." Developed in France in the eighteenth century, king's pattern flatware usually features a pendant shell on the handle. Here the shell has been replaced with Washington's image. The leafy border surrounding the bust is similar to the crowns of laurel that adorned the nation's hero in many prints.

Other spoons and forks with the same pattern bear the mark "Harland." Either the dies to create this pattern were commercially available to silversmiths or these products were made by one silversmith and retailed by another. Pelletreau had been in business in New York City since at least 1813, but during the late 1820s, he entered into partnerships in Charleston, South Carolina, to import silver from New York to the South. It seems feasible that he may also have been exporting silver to New Orleans, where Henry Harland was working as a watchmaker and jeweler by 1815.[5]

Although placing his image on utensils seems an odd way to memorialize America's

65

Reverse

Founding Father, manufacturers in the nineteenth century were not overly concerned about the propriety of the items they produced. They saw Washington's image as a tool, a marketing technique to improve their sales. Additionally, some scholars maintain that pictures of Washington helped reconcile American consumers to new products such as die-cut flatware, copperplate printed textiles, transfer-printed earthenware, and Parian statuary by linking a novelty with the solid, respectable, and trustworthy figure of Washington.[6] Nineteenth-century politicians used Washington's image in a similar manner—to confer legitimacy on their campaigns by promoting themselves as heirs to his virtues and his office.

This flask (cat. no. 65), attributed to the Dyottville Glass Works outside of Philadelphia, links Washington to Zachary Taylor, hero of the Mexican-American War and president of the United States from 1849 to 1850. Pairing the two men must have seemed like a natural step to the Whig politicians who masterminded Taylor's ascent to the presidency. Like Washington, he first came to national attention as a military commander: as a major general during the Mexican-American War, Taylor commanded the army in victories at Palo Alto, Monterrey, and Buena Vista. The press made him a national hero, and by December 1846 many Whig congressmen, including the young Abraham Lincoln, had founded a Taylor club in Washington to promote his candidacy in the 1848 election.[7]

The flask depicts Taylor in military uniform, a costume he rarely wore even on the battlefield. One of his officers observed, "he looked the picture of a Green Mountain farmer in summertime."[8] The inscription above Taylor, "I have endeavour'd to do my duty," alludes to his oft-repeated commitment to his country. Although the exact source of this quotation has not been identified, many of Taylor's speeches, including his inaugural address and his dying words to his wife, make reference to duty and honor.

While this flask portrays Taylor as a soldier, it depicts Washington as a statesman. Washington, wearing a toga, is a generic classical figure that would be hard to identify were it not for the phrase "the father of his country" above the portrait. This now-familiar epithet was first used in a 1779 Pennsylvania German almanac, which described "Waschington" as "Des Landes Vater."[9]

At least twenty-five different variations on the Washington/Taylor flask have been identified. Yale's is generally attributed to the Dyottville Glass Works, which was founded in Philadelphia in 1816 as the Kensington Glass Works. Under the management of Thomas Dyott, the company became one of the earliest producers of historical and figured glass flasks. Some flasks produced by American glassworks during the first half of the nineteenth century bear not only Washington's image but also those of other famous Americans, including Andrew Jackson and the Marquis de Lafayette, or patriotic emblems, most notably the American eagle. Washington flasks were a low-cost, mass-produced means for middle-class men to express their patriotism and carry their liquor.[10] E.E.

Notes

1. Henry Lee, *A Funeral Oration, in Honor of the Memory of George Washington* . . . (New Haven: Read & Morse, 1800), 19.
2. Jonathan Snellenberg, "George Washington in Bronze: A Survey of the Memorial Clocks," *Antiques and Fine Art* (winter 2001), 199.
3. Though the basic components of the Washington clocks are the same, several variations exist with notable differences in the apparent age of the Washington figure, the features of the eagle, and changes in the applied decorations on the plinth's sides. At least two different sizes of the clocks were

manufactured. Yale's is of the larger type. See Snellenberg, 2001, for further information on the variations.
4. I am indebted to Ann Wagner and Laura Pascalli for sharing Pascalli's research on the Washington Clocks, including the new information suggesting that Nicolas Dubuc was their maker. Advertisement, *Poulson's American Daily Advertiser,* March 28, 1815, p. 3.
5. Kathryn C. Buhler and Graham Hood, *American Silver: Garvan and Other Collections in the Yale University Art Gallery,* 2 vols. (New Haven and London: Yale University Press, 1970), 1:247, no. 367; Ian M. G. Quimby with Dianne Johnson, *American Silver at Winterthur* (Winterthur, Del.: Henry Francis du Pont Winterthur Museum, and Charlottesville: University Press of Virginia, 1995), 112 and no. 71 a–l; Deborah Dependahl Waters, ed., *Elegant Plate: Three Centuries of Precious Metals in New York City,* 2 vols. (New York: Museum of the City of New York, 2000), 2:377.
6. William Ayres, "At Home with George: Commercialization of the Washington Image, 1776–1876," in *George Washington: American Symbol,* ed. Barbara J. Mitnick (New York: Hudson Hills Press, 1999), 91.
7. K. Jack Bauer, *Zachary Taylor: Soldier, Planter, Statesman of the Old Southwest* (Baton Rouge: Louisiana State University Press, 1985), 218.
8. Charles S. Hamilton, "Memoirs of the Mexican War," *Wisconsin Magazine of History* 14 (Sept. 1930), 66.
9. David Rittenhouse, *Der gantz neue verbesserte nordamericanische Calender, auf das 1779ste Jahr* (Lancaster, Pa.: printed by Francis Bailey, 1778), cited in Wendy C. Wick, *George Washington, an American Icon: The Eighteenth-Century Graphic Portraits,* exh. cat. (Washington, D.C.: Smithsonian Institution Traveling Exhibition Service and the National Portrait Gallery, 1982), 9.
10. Helen McKearin and Kenneth M. Wilson, *American Bottles & Flasks and Their Ancestry* (New York: Crown Publishers, 1978), 413–16, 522–39. An 1822 advertisement for Dyott's Kensington Glass Works provides the earliest provable date for the production of historical and figured flasks.

66

Reverse

fig. a Manneville Elihu Dearing Brown, *The Gold & Silver Artificers of Phil.ª in Civic Procession, 22 Feb. 1832*, 1832. Lithograph, 9 x 14 ¾ in. (23 x 37 cm). The Library Company of Philadelphia

66

Gold & Silver Artificers of Philadelphia
Medal for the Centennial Anniversary of the Birth Day of George Washington, 1832

Silver, wt. 16 gm, 12:00, 32 mm
Gift of Walter M. Jeffords, B.A. 1905, 1951.8.1

George Washington was celebrated as a national hero during his lifetime, but it was not until after his death in 1799 that remembrances of his life and career reached epic proportions. Perhaps the largest and most dramatic commemoration was the Philadelphia civic procession held in honor of the centennial of Washington's birth, on 22 February 1832. Although hastily organized by the city fathers, the "handsome display," which lasted from half past ten in the morning until six in the evening, included twenty thousand participants and attracted over one hundred thousand spectators. Included in the procession were thirteen divisions, comprising government officials, veterans of the Revolution and War of 1812, clergymen, the military, police officers, firemen, and the masters and journeymen of over forty trades.[1]

Among the tradesmen were cigar-makers, who dispensed cigars to the crowd, and "bakers with an oven in which bread was baked during the procession" and given to spectators. Hatters made hats to be presented to the Marquis de Lafayette and the mayor, while "brick-makers had working cars showing the manufacture from preparing the clay to burning the bricks," and comb-makers made combs to distribute to the throngs.[2] As one scholar notes, the procession "was as much a salute to manufacturers' influence as a commemoration of the patriot hero."[3]

The Gold & Silver Artificers, seen in an 1832 lithograph of the procession (fig. a), struck and distributed a medal bearing the likeness of Washington.[4] The medals distrib-

uted to the crowd were made of tin, but impressions in silver were given to the officers of the procession, and a single example in gold was made for later presentation to Lafayette.[5] Each medal was issued with a ring in which it could be placed to be worn as a pin or suspended by a ribbon. Its obverse, which appeared on the banner carried by the Artificers, bears an oval cameo of Washington carried by an eagle in flight with an aureole emanating from its head.[6] Below Washington is a ribbon with the Latin inscription "PATRIAE PATER," a variation of "Pater Patriae" or "Father of the Fatherland"—a Roman honorific title first bestowed upon the orator Cicero by the Senate in 63 B.C. for outstanding service to the empire. The same inscription is found on an 1824 portrait of Washington by the Philadelphia painter Rembrandt Peale (1778–1860), which was exhibited widely and sold to the U.S. Senate in 1832. The reverse reads: "STRUCK /& DISTRIBUTED IN / CIVIC PROCESSION / FEB.RY. 22.ND. 1832 / THE CENTENNIAL / ANNIVERSARY OF THE / BIRTH DAY OF / WASHINGTON / BY THE GOLD & SILVER / ARTIFICERS OF / PHILAD." G.C.B.

Notes

1. J. Thomas Scharf and Thompson Westcott, *History of Philadelphia, 1609–1884*, 3 vols. (Philadelphia: L. H. Everts, 1884), 1:633–34.
2. Ibid., and Susan G. Davis, *Parades and Power: Street Theatre in Nineteenth-Century Philadelphia* (Philadelphia: Temple University Press, 1986), 128.
3. Davis, 1986, 127.
4. Scharf and Westcott, 1884, 1:633–34.
5. William Spohn Baker, *Medallic Portraits of Washington* (1885; repr. Iola, Wis.: Krause Publications, 1965), 68–69.
6. Russell Rulau and George Fuld, *Medallic Portraits of Washington* (Iola, Wis.: Krause Publications, 1985), 115.

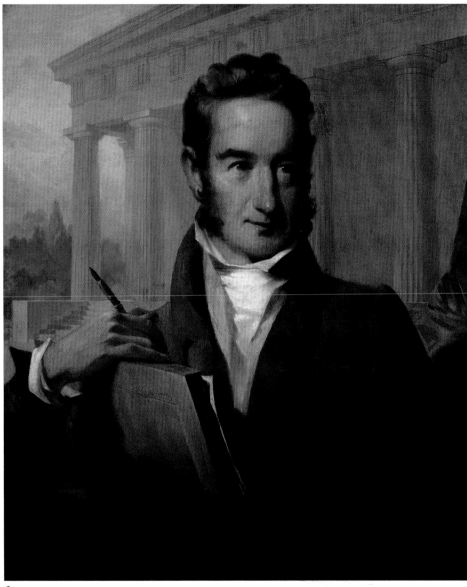

67

67

John Neagle (1796–1865)
William Strickland, 1829

Oil on canvas, 30 x 25 in. (76.2 x 63.5 cm)
Mabel Brady Garvan Collection, 1950.731

On 13 May 1818, the board of the Second Bank of the United States placed a notice in the *Philadelphia Gazette and Daily Advertiser* soliciting proposals for a marble structure imitating "Grecian Architecture, in its simplest and least expensive form."[1] William Strickland (1787–1854), who had apprenticed with the nation's premier Greek Revivalist architect, Benjamin Henry Latrobe, responded with a design modeled on the restoration drawings of the Parthenon that had appeared in James Stuart and Nicholas Revett's *The Antiquities of Athens* of 1762.[2] Strickland's edifice, with its impressive ancient pedigree, lent much-needed stability to the bank: it was the second attempt at a national banking system (the charter of the First Bank of the United States had lapsed in 1811), and its foundations were far from solid, its future anything but secure. The very year in which John Neagle painted this portrait, the newly elected president, Andrew Jackson, mounted his assault upon the bank, alleging that it was unconstitutional, politically corrupt, and at odds with the interests of the common American citizen. He employed tactics such as shifting government funds into private banks to hasten the institution's demise, and, indeed, when the bank's charter expired in 1836, it was not renewed. The building served for a time as the United States Bank of Pennsylvania, and in 1844 it was turned into a customs house.[3]

In this portrait by a fellow Philadelphian, Strickland poses with an air of self-assurance before the bank, which visually frames the architect's head, crowning the mind that gave rise to it. Yet there is a strong contrast between the way the figure is rendered—with the loose, unfussy brushwork characteristic of Neagle's mentor and father-in-law, Thomas Sully (cat. no. 120)—and the way the bank's Doric facade is depicted, somewhat schematically, with crisp, thin outlines. This idiom, reminiscent of architectural drawing, links it with the drawing board in Strickland's hand, as a testament not only to the many commissions the bank's fame had earned him after its completion in 1824, but also to the graphic beginnings of all buildings.[4] Neagle thus seems to envision the architect—whom he knew well through their efforts to reform the Pennsylvania Academy of the Fine Arts, beginning in 1828—as, like him, an artist whose vision was mediated by the two-dimensional plane.[5]

The portrait's juxtaposition of painterly and linear styles underscores the divide between the arts of architecture and painting. In a letter of July 1829, Neagle used architectural language to argue for painting's distance from such rational endeavors. Unlike the architect, the painter was not beholden to mathematical laws or measurements: "His only compass is the eye, and he depends on his mind for the conception of character." Neagle admitted that the "architect of true genius" undoubtedly formulated his monuments in the mind's eye before setting his plans down on paper. But the painter's art seemed to him the more natural medium for flashes of intuitive vision, which, in his own work, meant going beyond the mere registration of a sitter's outward appearance to capture something of his interior life, his vivacity.[6]

Unlike Strickland's lively face, the bank building—the product of the dynamic workings of his mind—appears cold and impenetrable. Neagle's privileging of the figure may reveal not only his artistic biases but his social and political attitudes as well. Following in the tradition of the early Philadelphia por-

trait painter Charles Willson Peale, Neagle sought to create an interactive brand of portraiture that would draw the viewer into a dialogue with the sitter, inspiring him to serve the young republic in some comparably honorable manner. In this example, Neagle subtly suggested that the nation's claim to republican virtue and its ability to endure would be measured less by its grand edifices than by the character of the individual citizen. J.A.G.

Notes

1. The notice is cited in full in Agnes Addison Gilchrist, *William Strickland: Architect and Engineer 1788–1854* (Philadelphia: University of Pennsylvania Press, 1950), 53.

2. James Stuart and Nicholas Revett, *The Antiquities of Athens and Other Monuments of Greece* (1762; repr. London: Henry G. Bohn, 1858), 47–56.

3. For more on the Second Bank of the United States, see Ralph C. H. Catterall, *The Second Bank of the United States* (1902; repr. Chicago: University of Chicago Press, 1960).

4. Strickland's neoclassical architecture shaped the face of young Philadelphia, earning him the sobriquet of "City Architect." Gilchrist, 1950, "Appendix A: A Chronologic, Bibliographic and Descriptive Catalogue of the Architectural and Engineering Work of William Strickland," 45–118.

5. Having experimented early in his career with landscape painting, printmaking, and book illustration, Strickland was a particularly well-rounded artist. He was secretary and Neagle was president of the Resident Artists of Philadelphia. (See frame 1180, reel 3656, of Neagle's "Blotter Book" at the Archives of American Art, Smithsonian Institution, Washington, D.C.) It is possible that Strickland himself could have painted the contours of his building onto this portrait.

6. Neagle, quoted in Robert W. Torchia, *John Neagle: Philadelphia Portrait Painter*, exh. cat. (Philadelphia: Historical Society of Pennsylvania, 1989), 44.

68

John Wolfe Forbes (1781–1864)
Pitcher
New York City, 1827

Silver, h. 11⅝, diam. base 4½ in. (29.5 x 11.4 cm), wt. 27 oz., 8 dwt. (853 gm)
Gift of Carl R. Kossack, B.S. 1931, M.A. 1933, 1995.23.79

This pitcher honors Oliver M. Lownds, who was instrumental in modernizing the New York City police department. One side of the pitcher is engraved, "Presented by / Adelphi Lodge No. 91 / to W.P.M. Oliver M. Lownds / as a tribute of respect & esteem / New York / AL5827," and the other side has a coat of arms in a tilted oval cartouche with a crest above and the motto "Integrity" below. Lownds was admitted to the Adelphi Masonic lodge in New York City in late 1821 or early 1822. After joining, he held numerous offices in the organization, including junior warden (1822–23), senior warden (1823–24), and master (1824–26). The letters "W.P.M." and the Masonic date 5827, for 1827, indicate that the pitcher was presented to Lownds when he stepped down as master and assumed the title of Worshipful Past Master.

The use of heraldic symbols during the colonial period signaled Americans' allegiance to the British system of aristocratic hierarchy. Coats of arms fell out of favor following the Revolution, but beginning in about 1820, Americans increasingly adopted them as symbols of ownership. Widespread immigration in the early nineteenth century made the population more heterogeneous, and the use of heraldry may be seen as a means of asserting Anglo-American hegemony. Lownds's adoption of British arms mirrors other ways in which he looked to Britain for models.

The period from 1825 to 1830 witnessed unprecedented growth in the economy of New York State. The opening of the Erie Canal in 1825 increased commerce and positioned New York City to be the financial capital of the country. But as its economy and population grew, so did crime, vice, and disorder. The focus of Lownds's professional life was law enforcement. When he served as master of Adelphi Lodge No. 91 and grand secretary of the Grand Lodge of New York, he was also sheriff of New York City. In 1836, he submitted a report to Mayor Cornelius Lawrence advocating a full-time professional police department for the city similar to those in London and Liverpool. The Common Council rejected the proposal; it was not until 1845, a year after Lownds's death, that the Municipal Police Act made New York the first American city with a full-time professional police force.[1] P.E.K.

Note

1. Patricia E. Kane, "A Silver Presentation Pitcher by John Wolfe Forbes," *Yale University Art Gallery Bulletin* (2001), 22–31.

68

69

69

Masonic Jewel

Northeastern United States, 1790–1810

Silver, 2 5/16 x 1 5/8 in. (5.9 x 4.1 cm), wt. 4 dwt. (16 gm)

Mabel Brady Garvan Collection, 1930.4886

70

Keene Glass Works (1815–41)

Masonic Flask

Keene, New Hampshire, 1815–30

Mold blown glass, 7 1/4 x 4 1/4 x 2 1/2 in. (18.4 x 10.8 x 6.4 cm)

Gift of Mrs. Glen Wright, 1941.147

Although Freemasonry traces its roots back to the building of King Solomon's temple in Jerusalem, the fraternal organization began in London around 1717. By the 1730s, it had expanded to the American colonies, where both Boston and Philadelphia housed early lodges. The fraternity attracted the colonies' most prominent men, many of whom would play crucial roles in the founding of the nation, including Benjamin Franklin, John Hancock, Paul Revere, and George Washington. By the end of the Revolution, there were Masonic lodges in all thirteen states, and they soon spread westward with the population. As Freemasonry grew in popularity, its symbols appeared with increasing frequency on a wide variety of objects, including this silver jewel and glass flask.[1]

Freemasons describe their fraternity as "a matchless and almost perfect system of morality taught by symbols." In America, there are three basic degrees—Entered Apprentice, Fellowcraft, and Master Mason—each of which has a complex iconography. In each degree, the working tools of stonemasons are imbued with symbolism that makes them instructional aids to Masonic philosophy, a blend of Christian theology and Enlightenment thinking. Masonic medals or "jewels" in the

shapes of these tools serve as mnemonic devices for the values each tool symbolizes. In the eighteenth and nineteenth centuries, each lodge had a special set of jewels for its officers, and, especially from 1780 to 1820, individuals often wore small personal medals as well. An eighteenth-century exposé of Freemasonry noted that such personal medals were "worn on [Masons'] public days of meeting, at funeral processions, & c. in honour of the craft." Although there were no explicit standards for the design of these jewels, there are many similarities among them, suggesting that Masonic prints were being used as sources of iconography.[2]

Yale's jewel is engraved with more than twenty-five Masonic symbols (cat. no. 69). Every design element, even the tessellated border, has meaning. Encircling the entire design, the border symbolically binds the many signs on the medal into a single entity and represents the blessings and comforts bestowed on humanity by Providence. The symbols include an all-seeing eye, representing watchfulness and the Supreme Being; two columns, inscribed "B" and "J" to represent Boaz and Jachin, the two columns flanking the entrance to King Solomon's temple; and a checkered floor or pavement, another reference to Solomon's temple and an example of the duality that plays an important role in Masonic philosophy (fig. a). The square and compass, the symbol most associated with Freemasonry, "square [Masons'] actions, and keep them within bounds," while the open Bible acts as "the Rule of [Masons'] faith." More Masonic emblems surround the central designs. The "No" to the right of the coffin at the bottom of the medal is usually followed by a number in other Masonic jewels, indicating the lodge to which its owner belonged. The lack of a lodge number on this piece is puzzling and may indicate that the engraving was unfinished. Alternately, the engraver may

have simply run out of space. The reverse of the jewel bears the name "I·BAILEY," probably its original owner.[3]

Although many objects with Masonic decorations were custom-made, early manufacturers also mass-produced objects calculated to appeal to members of lodges. The Keene Glass Works in Keene, New Hampshire, produced this glass flask (cat. no. 70). The factory operated from 1815 to 1841, producing bottles with Masonic imagery from its earliest years, perhaps because both Henry Schoolcraft, one of its founders, and Justus Perry, who bought the factory in 1817, were Freemasons.[4]

The bottle and the jewel share many design elements, most notably the two columns and pavement, the all-seeing eye, and the square and compass. On the flask, the columns are topped by an archway with a

fig. a Frontispiece from R. S., *Jachin and Boaz; or, an Authentic Key to the Door of Free Masonry . . .* (Albany, N.Y.: Charles R. and George Webster, 1797). Beinecke Rare Book and Manuscript Library, Yale University

keystone. This is a symbol of Royal Arch Masonry, a specialized degree of Freemasonry. Other Masonic symbols are ranged outside the archway, including the sun, the seven stars, and a skull and crossbones. The reverse of the flask features imagery drawn from the Great Seal of the United States and an oval cartouche containing the word "Keene." The combination of Masonic and American symbols is no coincidence. Following Freemasonry's example, American artists and artisans used patriotic symbols to teach the principles of the new nation, just as Freemasonry used symbols to teach its own moral system.[5]

More than forty-six varieties of Masonic flasks were produced in American glasshouses between 1815 and 1830. They have been called "the most significant American products with Masonic symbols" and seem to have been produced only in this country. Production of such flasks ended abruptly after 1830, coinciding with the rise of the temperance movement and the Morgan scandal. The 1826 disappearance of William Morgan, a New York Mason who had threatened to expose the secrets of the fraternity, led many critics of Freemasonry to speculate that he had been kidnapped and murdered by Masons. This caused a national outcry against the organization, culminating in the formation of the Antimasonic political party in 1828. That the American glass industry reacted so quickly to political and social changes shows how accurately the decorative arts of this period expressed Americans' social and political feelings.[6] E.E.

Notes

1. W. Kirk MacNulty, *Freemasonry: A Journey through Ritual and Symbol* (London: Thames and Hudson, 1991), 14; Scottish Rite Masonic Museum of Our National Heritage, *Masonic Symbols in American Decorative Arts* (Lexington, Mass.: Scottish Rite Masonic Museum and Library, 1976), 11.

2. Delmar Duane Darrah, *History and Evolution of Freemasonry* (Chicago: Charles T. Powner Co., 1951), 286, quoted in *Masonic Symbols*, 1976, 19; R. S., *Jachin and Boaz; or, An Authentic Key to the Door of Free Masonry . . .* (Albany, N.Y.: Charles R. and George Webster, 1797), 7; John D. Hamilton, *Material Culture of the American Freemasons* (Hanover, N.H.: University Press of New England, 1994), 126, 139.

3. Jeremy L. Cross, *The True Masonic Chart, or, Hieroglyphic Monitor* (New Haven: Flagg & Gray, 1819), 11; *Jachin and Boaz*, 1797, guide to frontispiece.

4. Helen McKearin and Kenneth M. Wilson, *American Bottles & Flasks and Their Ancestry* (New York: Crown Publishers, 1978), 101–2.

5. On this flask, the skull is very indistinctly molded, but it is found on other Masonic flasks of the same type. *Masonic Symbols*, 1976, 31.

6. McKearin and Wilson, 1978, 591–601; *Masonic Symbols*, 1976, 37–38. For more on the Morgan scandal and Antimasonry, see Paul Goodman, *Towards a Christian Republic: Antimasonry and the Great Transition in New England, 1826–1836* (New York: Oxford University Press, 1988), 3–9.

70

Reverse

Reverse

fig. a Robert Scot, engraver, *Eagle* (reverse), so-called "Chicken Eagle." United States Mint, Philadelphia, 1795. Gold, wt. 17.50 gm, 12:00, 33 mm. The American Numismatic Society, New York, ANS 1908.93.60

71

Robert Scot (b. England, d. 1823), engraver

Eagle (Ten Dollars)

United States Mint, Philadelphia, 1799

Gold, wt. 17.47 gm, 6:00, 32 mm
Yale University Library Numismatic Collection
Transfer, 2001, 2001.87.4

Among the problems the United States faced as a fledgling nation was the need to create and regulate its coinage. In order to gain the confidence of the American people, coins had to be of uniform weight and metal content and had to look substantial and trustworthy. In 1792, Congress passed the Coinage Act, which established the United States Mint in Philadelphia. The legislation required a ten-thousand-dollar bond of each of the Mint's officers and set the denominations, weights, and precious-metal-to-alloy ratios of coins. It further specified that coins should bear "an impression emblematic of liberty, with an inscription of the word Liberty, and the year of the coinage," and the reverse of gold and silver coins should display "the figure or representation of an eagle" and the inscription, "United States of America."[1]

The Mint was not able to begin production immediately due to the high bond required of its officers before they could work with gold or silver, and it was only after Congress reduced the requirements in 1794 that the minting of silver and gold coinage could commence. The first gold coin, the five-dollar Half Eagle, was not minted until July 1795, and the largest denomination, the ten-dollar Eagle, followed two months later. Designed by the Mint's chief engraver, Robert Scot, the Eagle's obverse, as required by Congress, features a bust of Liberty wearing a turbanlike cap encircled by fifteen stars (one for each state), the word "LIBERTY," and the year. The reverse (fig. a), based on a first-century B.C. Roman onyx cameo, depicts a spread-winged eagle perched on a palm frond with a laurel wreath in its beak.[2] The small stylized eagle proved unpopular with the citizenry, who called it a "chicken eagle." This prompted Scot to reconsider his design.[3]

The so-called Heraldic Eagle first appeared in 1797. In this example of 1799, the obverse remained unchanged, except that the number of stars had been reduced to thirteen, as the star-per-state scheme had begun to clutter the design. The redesigned obverse features an eagle derived from the Great Seal of the United States. Under a cloud form known as a glory and a constellation of thirteen stars, the eagle—behind an escutcheon with thirteen stripes—carries a ribbon with the Latin inscription "E PLURIBUS UNUM" ("From many, one") in its beak, and a bundle of thirteen arrows and an olive branch in its right and left talons, respectively. Curiously, Scot reversed the placement of the arrows and olive branch found on the Great Seal, placing the arrows—symbolizing military might—in the eagle's right or "dexter" talon, and the olive branch—symbolizing peace— in its left or "sinister" claw. In heraldic terms, this placement conveys a message of war. The error stood, however, until President Thomas Jefferson, responding to the loss of America's gold coinage to overseas bullion dealers, halted all production of the Eagle in 1804.[4]

G.C.B.

Notes

1. "The Coinage Act of 1792," facsimile, Library of Congress, Washington, D.C.

2. Walter Breen, *Walter Breen's Complete Encyclopedia of U.S. and Colonial Coins* (New York: Doubleday, 1988), 512, 544.

3. Numismatic Guaranty Corp., "1795–98 Half Eagle Draped Bust Small Eagle," www.coinsite.com/ CoinSite-PF/PParticles/$5smeagl.asp.

4. Breen, 1988, 514–15, 545–46.

72

Reverse

72

Fireman's Trumpet
New York City, 1852

Silver, l. 21⅝, diam. 10⅜ in. (54.9 x 26.4 cm),
wt. 34 oz., 10 dwt. (1070 gm)
Mabel Brady Garvan Collection, 1934.371

"Fire in the Bowery," screamed New York City headlines on 18 March 1852. Early in the morning on the day before, a blaze had broken out in a paperhanging business and spread to a neighboring cabinet shop, where flames consumed the stairs and cut off "all retreat for the inmates of the house." According to the *Tribune*:

> From the third story could be seen men, women, and children extending their arms through the windows and imploring for help. A ladder was instantly procured . . . two men made their escape . . . the women were still afraid to venture down. At this critical moment, James Mount, foreman of Hose Company No. 14, at the risk of his life, rushed up the ladder four times and succeeded in saving two women and two children, bringing them down in his arms.[1]

The silver horn commemorates this brave act in exquisite detail. On the flared end, a chased wreath of flowers encloses the inscription that hails James R. Mount (b. 1826) for saving Mary Koephe, Mrs. Miller, and her two children from the conflagration.[2] Although two men reached safety, two others, including Mr. Miller, perished. The twenty-six-year-old foreman, according to one account, nearly succumbed as well, from the heat, smoke inhalation, and the exertion of carrying Ms. Koephe, who weighed 225 pounds.[3] On the obverse of the long side of the horn, several men steady the ladder on a "hogshead," while the lone hero rescues a female as flames and smoke belch from the gambrel-roofed terrace house (see Lamar, fig. 12). The reverse shows a line of twenty-odd firemen charging forward, pulling a hose from its carriage. Added details—the applied hose, the backdrop of cascading sheaths of water, and three other wreaths enclosing Neptune, a fire carriage, and a trophy of firemen's tools—all glorify firefighting.

The ceremonial trumpet was presented nearly two months after the blaze at the second annual parade of the New York Fire Department, when more than four thousand men marched four abreast along a route that wended its way through lower Manhattan. Mount's company, thirty strong, pulled a "carriage handsomely fitted out" for the occasion.[4] Such pageants served both to commend heroic deeds and to galvanize the ranks of "New York's Bravest." Volunteer hook-and-ladder and hose companies, successors to the old bucket brigades, functioned as fraternal organizations, attracting ever-younger laborers and journeymen. At mid-century they had gained a reputation for rough behavior (brawls often broke out between companies for control over fires) and corruption (William Marcy "Boss" Tweed got his start here). After the Civil War, paid professionals unseated volunteers, as horses and steam replaced manpower for pulling carriages and pumping water. C.M.H.

Notes

1. *New York Tribune*, 18 Mar. 1852.
2. For the inscription, see Kathryn C. Buhler and Graham Hood, *American Silver: Garvan and Other Collections in the Yale University Art Gallery*, 2 vols. (New Haven and London: Yale University Press, 1970), 2:267–68, no. 1014.
3. Augustine E. Costello, *Our Firemen: A History of the New York Fire Departments, Volunteer and Paid* (New York: Augustine E. Costello, 1887), 188.
4. *New York Herald*, 15 June 1852.

THE LIFE OF A FIREMAN.
The Ruins. "Take up" "Man your rope"

73

THE LIFE OF A FIREMAN.
The new era. Steam and Muscle.

74

73

Unknown lithographer
Published by **N. Currier** (active 1834–56)
After Louis Maurer (1832–1932)
The Life of a Fireman: The Ruins.—"Take Up."—"Man Your Rope," 1854

Hand-colored lithograph, 21 7/16 x 29 3/8 in.
(54.5 x 74.6 cm)
Mabel Brady Garvan Collection, 1946.9.1042

74

Unknown lithographer
Published by **Currier & Ives** (active 1857–1907)
After Charles Parsons (1821–1910)
The Life of a Fireman: The New Era. Steam and Muscle, 1861

Hand-colored lithograph, 19 13/16 x 28 in.
(50.4 x 71 cm)
Mabel Brady Garvan Collection, 1946.9.1043

Currier & Ives—self-described "publishers of cheap and popular pictures"—was the largest, longest surviving, and most successful American lithographic publishing house of the nineteenth century.[1] Among the themes Currier & Ives addressed most frequently was firefighting, which became the subject of two major series. The first series, *The Life of a Fireman*, consists of seven prints: the first five were executed by Louis Maurer in 1854; the last two were added by Charles Parsons in 1861 and John Cameron in 1866.[2] The popularity of firefighting imagery at Currier & Ives was no mere coincidence. Both Nathaniel Currier and James Merritt Ives were volunteer firefighters with New York City's Excelsior Company No. 2, located at 21 Henry Street, only a short distance from their firm's office at 152 Nassau Street.[3]

The Life of a Fireman: The Ruins.—"Take Up."—"Man Your Rope" (cat. no. 73) portrays the aftermath of a major blaze, perhaps the disastrous fire at the clothing store of William

T. Jennings & Co. at 231 Broadway on 25 April 1854. The conflagration broke out at eight o'clock in the evening and "defied all the efforts of the firemen." By the next morning, twenty firemen had been injured and the lifeless remains of eleven pulled from the ruins.[4]

In his prints Maurer depicted several fire companies "taking up" their gear after doing battle. The once-great fire is now controlled by a single hoseman. The artist showed a panoply of equipment indicative of the division of labor among fire companies: in 1854, New York City had forty-eight engine companies, fifty-seven hose companies, fourteen hook-and-ladder companies, and four hydrant companies, amounting to a total of 2,955 volunteers.[5] In the right foreground, a hose company rolls up its hose; beside them, a hydrant company secures the hydrant's stopcock. Three engine companies with their different pump wagons can be seen, as well as a hook-and-ladder company in the background. All of the engines pictured are manual pumpers. Firefighters were slow to adopt steam engines, not only because the earliest prototypes were cumbersome but also because the use of manpower as a sign of strength was a source of pride among fire companies. With the development of lighter, more powerful steam engines, this would quickly change.

Charles Parsons's *The Life of a Fireman: The New Era. Steam and Muscle* (cat. no. 74), published in 1861, heralds the dawn of a new mechanical age in firefighting. By May of that year, ten fire companies, including Excelsior Company No. 2, were actively "doing duty" with steam fire engines, and steamers had been authorized for another four companies, bringing the city's total force to sixteen.[6] This print depicts the fire at the corner of Murray and Church Streets on 9 September 1861, a short distance from City Hall, whose characteristic cupola can be seen in the

background. The composition is marked by its stunning juxtaposition of a glowing blaze against a dark night sky. In the foreground, two prominently placed steam engines flank a manual pumper—a vestige of the "old era." Steam engines were not only able to emit higher and steadier streams of water—significant as buildings got taller—but also required far less manpower. Whereas the old manual pumper required the labor of more than twenty men, the steam engines needed only a half-dozen men each. As firefighters became increasingly convinced of their efficiency, steam engines were employed in greater numbers. By 1865, thirty-four steam engines were in use, and manual engines were quickly phased out entirely.[7]

By the 1850s, most U.S. cities had moved to professionalize their firefighting services, citing disorder and a lack of discipline in the ranks of the volunteers. In 1865, New York City created America's first full-time paid fire department.[8] As the volunteer system celebrated by Currier & Ives's prints was being dismantled, but before the new Metropolitan Fire Department was fully operational, it was feared that the volunteers would refuse to fight fires. Yet, with few exceptions, the volunteer firemen of New York City cooperated and continued to fight fires until their services were no longer required. Praising the volunteers, the editor of the *New York Herald* wrote: "Their action proves, what we have always believed to be true, that the Fire Department proper was composed of a gallant, fearless, and honorable body of our citizens . . . [and] although the Volunteer Firemen's organization is no longer to comprise one of our local institutions, to have been a member of it will be a lasting honor."[9] G.C.B.

Notes

1. The firm of Currier & Ives was founded in New York City in 1834 by Nathaniel Currier. James Ives, the brother-in-law of Nathaniel Currier's brother Charles, joined the firm as a bookkeeper in 1852 and was made a full partner in 1857.

2. The second series, *The American Fireman*, of 1858, is composed of four heroic scenes by Maurer.

3. Among the firefighters pictured in the print *The Life of a Fireman: The Night Alarm—"Start her Lively, boys"* (1854) are James Ives, his brother George, and Nathaniel Currier, who rushes in from the left to join his comrades. Frederic A. Conningham, *Currier & Ives Prints* (New York: Crown Publishers, 1970), 160.

4. Augustine E. Costello, *Our Firemen: A History of the New York Fire Departments, Volunteer and Paid* (New York: Augustine E. Costello, 1887), 254–56.

5. Ibid., 128.

6. Ibid., 140.

7. Ibid., 625.

8. Margaret H. Hazen and Robert M. Hazen, *Keepers of the Flame: The Role of Fire in American Culture, 1775–1925* (Princeton: Princeton University Press, 1992), 128.

9. Editorial, *New York Herald*, 3 Apr. 1865, quoted in Costello, 1887, 779.

Class, Race, and Conflict

75

William Sidney Mount (1807–1868)
After Dinner, 1834

Oil on wood, 10⁷⁄₈ x 10¹⁵⁄₁₆ in. (27.6 x 27.8 cm)
Stanley B. Resor, B.A. 1901, Christian A.
Zabriskie, and John Hill Morgan, B.A. 1893,
LL.B. 1896, M.A. (HON.) 1929, Funds, 1972.33

From a young age, William Sidney Mount
was surrounded by music. As a boy, he lived
with his uncle, a musician and composer of
considerable talent and reputation, who
taught him to play the violin, and the artist
passionately pursued his playing through-
out his life. In 1824, Mount began his artistic
career as an ornament painter in his brother's
New York City sign shop. He eventually
became an active member and regular exhib-
itor at the recently founded National
Academy of Design.[1] In 1834, Mount exhib-
ited *After Dinner* at the Academy to a mostly
favorable critical response. One critic noted,
"There is much very clever in this little
sketch; The figure in the cap with the cigar
is very characteristic and original . . . ," but
continued, "we wish the third figure had
been represented without a hat, as it makes
an unpleasant blot in the generally quiet
tone of the piece."[2] While *After Dinner* is

permeated with the melody of the violin, it
is nonetheless a *quiet* piece, not only in its
modest scale and warm, dark tonal quality
but also in the fact that two of its subjects
seem on the verge of sleep. Indeed, the men's
full bellies and glasses of claret account for
some of the scene's drowsy feel, but the vio-
linist is the active agent of sleep, lulling the
listeners with his melody.

Poised at the group's center, the violinist,
who resembles Mount's 1832 *Self-Portrait*
(fig. a), provides the fulcrum for a scale,
which balances, through music, two disparate
social types. On the left, the gentleman's
high hat and side-whiskers mark him as mid-
dle class, while the less refined but equally
distinctive dress of the man on the right sig-
nifies his working-class status. His red
Monmouth cap and coarse pea coat identify
him as a laborer, perhaps a sailor, of the sort
Mount would have encountered at his uncle's
wharfside tavern. The red cap—looking
much like a rooster's comb—together with the
man's brazen outward gaze, implies a certain
cockiness. Additionally, the way the bright
red cap punctuates the composition, juxta-
posed with the glowing tip of its owner's
cigar, suggests a hotheaded or fiery tempera-
ment, while his ruddy complexion is a sign
of intoxication. These implications, coupled
with the figure's reddish beard, are consis-
tent with Irish stereotypes at this time.[3] The
artist's home was not far from New York's
infamous Five Points neighborhood, which
in the early 1830s had already become a
haven for recent Irish immigrants.

Mount's depiction draws upon popular
clichés but avoids blatant caricature, reveal-
ing each figure's distinctive character. For
Mount, music had the uncanny ability to
reveal the essential quality of a situation or
individual. In 1843, he wrote, "My violin
has been the source of a great deal of amuse-
ment. It has enabled me to see a great deal
of character."[4] G.C.B.

Notes
1. The National Academy of Design was founded in
New York City in 1825. Mount became an associate
in 1831 and was elected a full academician in 1832.
2. "Miscellaneous Notices of the Fine Arts,
Literature, Science, the Drama, & c," *American
Monthly Magazine* 3 (1 June 1834), 283.
3. See L. Perry Curtis, Jr., *Apes and Angels: The
Irishman in Victorian Caricature* (1971; rev. ed.,
Washington, D.C.: Smithsonian Institution
Press, 1996).
4. Alfred Frankenstein, *William Sidney Mount*
(New York: Harry N. Abrams, 1975), 66.

fig. a William Sidney Mount, *Self-Portrait*, 1832. Oil on canvas, 24½ x 20¼ in.
(62.2 x 52.4 cm). The Long Island Museum of American Art, History &
Carriages, Stony Brook, N.Y., Gift of Mr. and Mrs. Ward Melville, 1950

75

Painted by William Hall Lith'd of J.T. Bowen.

LOG CABIN POLITICIANS

76

John T. Bowen (1801–1856), lithographer
After a painting by William Hall
(active mid-19th century)
Log Cabin Politicians, 1841

Hand-colored lithograph, 19⅞ x 23⅞ in.
(50.5 x 60.7 cm)
Mabel Brady Garvan Collection, 1946.9.632

The 1840 presidential race between incum-
bent Democrat Martin Van Buren and Whig
challenger General William Henry Harrison
is regarded as America's first modern presi-
dential campaign, replete with organized
rallies, calculated advertising, partisan songs,
and popular slogans. The campaign was
vicious, with insults and character assassina-
tions lobbed incessantly between the two
sides. Whigs painted Van Buren as a foppish,
champagne-swilling aristocrat with a pen-
chant for all things French.[1]

Democrats in turn characterized Harrison
—who had achieved national prominence as
an "Indian fighter" at the Battles of Tippe-
canoe and Thames River nearly thirty years
earlier—as a simple country rube long past
his political prime. Positing how best to get
rid of Harrison, the Washington correspon-
dent for the pro–Van Buren *Baltimore
Republican*, quipped: "Give him a barrel of
hard cider, and settle a pension of two thou-
sand a year on him, and my word for it, he
will sit the remainder of his days in his log
cabin by the side of a 'sea coal' fire, and
study moral philosophy."[2] The jab backfired,
as Whigs took up the log cabin and hard
cider as symbols of Harrison's humble
origins and homespun values—despite the
fact that Harrison was the scion of a wealthy
family of Virginia planters. Whig boosters
built log-cabin campaign headquarters, pub-
lished log-cabin tracts and songbooks,
dispensed log-cabin ciders, and sold whis-
key in log cabin–shaped flasks.[3]

The colorful rhetoric of the election provided ample fodder for artist-satirists. In 1841, John T. Bowen produced *Log Cabin Politicians*, a lithograph after a painting by William Hall, which depicts a gathering outside the "Harrison Hotel." Three men sit around a cider barrel, presumably talking politics. Broadsides announce meetings in support of Harrison and his running mate, John Tyler ("Tippecanoe and Tyler, too!"). One of the men gestures toward a poster, simultaneously calling attention to a patch where the plaster has fallen away, revealing the establishment to be a log cabin. The hotel's wooden sign depicts Harrison on horseback and bears the proprietor's name "L. STILMAN"—perhaps a Whig patron of Hall's or a reference to the "still man," or distiller who made cider brandy or apple-jack, a libation equally associated with Whig gatherings.

With the image's multiple allusions to Harrison and the campaign of 1840, it is difficult to tell whether the print celebrates the ingenuity of Whig politicians or ridicules them for their repetitious propaganda. Whatever the artist's intentions, the "log-cabin politicians" were successful in putting their man in the White House, winning a decisive 234 to 60 victory over Van Buren in the Electoral College. On 4 March 1841, Harrison gave a two-hour inaugural address—the longest on record. Harrison caught a cold that day, which turned into pneumonia, and he died thirty-one days later, becoming the shortest-serving president in American history and the first to die in office. G.C.B.

Notes

1. See Richard Hildreth, *The Contrast, or, William Henry Harrison versus Martin Van Buren* (Boston: Weeks, Jordan, 1840), 62–63.
2. John de Ziska, *Baltimore Republican*, 11 Dec. 1839, quoted in Robert Gray Gunderson, *The Log-Cabin Campaign* (Lexington: University of Kentucky Press, 1957), 74.
3. Ibid., 76, 129.

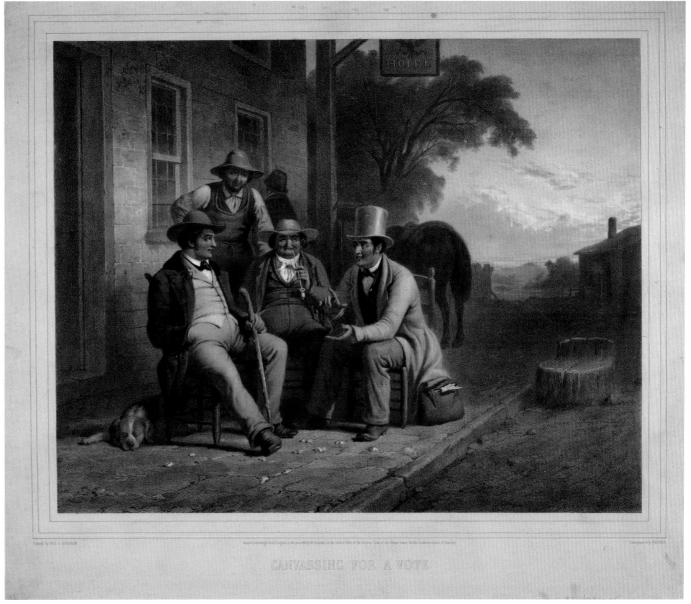

77

CANVASSING FOR A VOTE

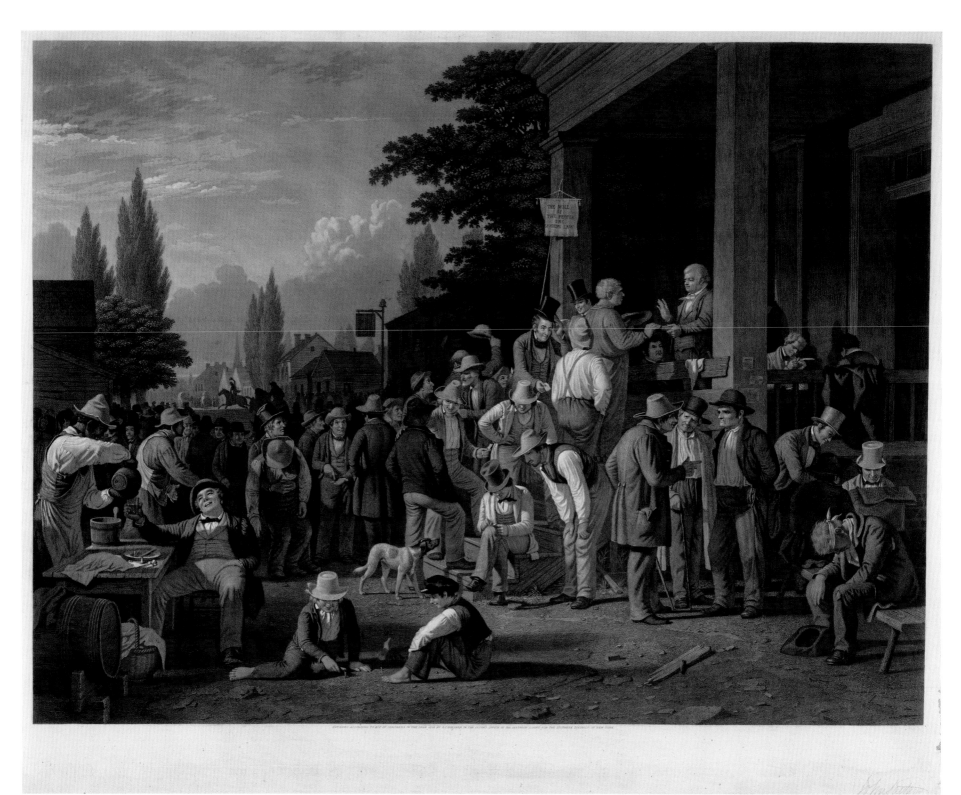

THE WILL
OF
THE PEOPLE
THE
SUPREME LAW

77

Claude Régnier (b. France,
active in America, 1852–54),
lithographer
After a painting by George Caleb
Bingham (1811–1879)
Canvassing for a Vote, 1853

Hand-colored lithograph, 18 ½ x 22 in.
(47 x 56 cm)
Mabel Brady Garvan Collection, 1946.9.630

78

John Sartain (1808–1897), lithographer
After a painting by George Caleb
Bingham (1811–1879)
The County Election, 1854

Engraving, mezzotint, and etching with stippling,
proof before title letters, 25 ⅜ x 31 ½ in.
(64.5 x 80 cm)
Yale University Art Gallery, 1994.1.17

The 1840 presidential race between William
Henry Harrison and Martin Van Buren
excited widespread national interest in poli-
tics. Among those swept up in the fervor
was the artist George Caleb Bingham, who
was named a delegate to the 1840 and 1844
Missouri Whig state conventions and was
commissioned to paint political banners. In
1846, Bingham accepted his party's nomina-
tion for state representative and after a hard-
fought campaign won by three votes, only
to have the results overturned by the Demo-
cratic majority in the Missouri legislature.
In the midst of the partisan maneuvering,
Bingham declared, "As soon as I get through
with this affair, and its consequences, I
intend to strip off my clothes and bury them,
scour my body all over with sand and water,
put on a clean suit, and keep out of the mire
of politics *forever*."[1] Bingham's vow did not
last long; in 1848, he won the seat he had
been stripped of two years earlier and took
his place in the legislature. Not surprisingly,
Bingham's political activity became a subject
for his painting, forming an "election series"

comprising six canvases: *The Stump Orator*
(1847), *Country Politician* (1849), *Canvassing
for a Vote* (1852), *The County Election* (1852),
Stump Speaking (1853–54), and *The Verdict of
the People* (1854–55).[2]

In 1851, the French art publisher and
dealer Goupil & Co. commissioned Bingham
to paint *Canvassing for a Vote*, from which
they intended to create a print for distribution
by their New York branch. The subsequent
lithograph, by Claude Régnier, appeared
in 1853 (cat. no. 77). Here Bingham borrowed
characters—a portly, pipe-smoking gentle-
man and an enthusiastic candidate—from an
earlier canvas, *Country Politician*, but moved
them outdoors to a hotel porch. The com-
position is indebted to the English artist
William Hogarth's *Canvassing for Votes*, but
may have a more direct precedent in *Log
Cabin Politicians*, a Whig print from the
campaign of 1840 (cat. no. 76).[3]

With the exception of the title and the
eagle on the signboard, there are no obvious
indications that the subject is politics. The
juxtaposition of the politician with the horse's
rump suggests that Bingham retained a
sense of humor about the occasionally asinine
nature of politics. Another subtle detail—
the sleeping dog—has been interpreted as
"Bingham's perception of the voters' enthu-
siasm" and alternately as a commentary on
the volatile slavery issue facing Missouri leg-
islators, a caveat to "let sleeping dogs lie."[4]
Moreover, the men pictured represent dif-
ferent classes: the standing man's coarse attire
suggests the work clothes of a farmer, while
the ample girth of the seated gentleman with
the pipe implies he is well fed, prosperous,
and lives an easy life.

Even more reflective of Bingham's demo-
cratic ideals, however, is his *County Election*,
engraved by the Philadelphia printmaker
John Sartain in 1854 (cat. no. 78). As voting
laws changed, granting suffrage to all white
male adults (not just property owners), a
socioeconomically diverse electorate began to

participate in the political process. Wanting
to reach a national audience, Bingham sought
to have the work engraved and therefore
approached the American Art-Union, the
1847 distributors of an engraving of his *Jolly
Flat Boat Men* (cat. no. 172). Due to the time
and expense required to engrave such a
large and detailed composition, the Art-
Union declined, leaving Bingham to commis-
sion the engraving on his own. He settled on
Sartain, who charged Bingham two thousand
dollars—half his normal rate—to engrave
the steel plate, telling Bingham he would take
on the job "as a work of love."[5]

While Sartain was working on *The County
Election*, Bingham wrote to him with instruc-
tions to change the name of the newspaper
in the right-hand corner of the work from the
Missouri Republican to *The National Intelligen-
cer*, a Washington, D.C., publication: "There
will be nothing to mar the *general character* of
the work, which I design to be as *national* as
possible—applicable alike to every Section
of the Union, and as illustrative of the
manners of a free people and free institu-
tions."[6] The plate was finished in May 1854,
and shortly thereafter Bingham sold it
and the copyright to Goupil & Co., ensur-
ing the engraving's wide distribution. *The
County Election*, as one scholar notes, repre-
sents "the harmonious participation of all
classes of society in the great experiment of
self-government."[7] Under a banner reading
"The Will of the People the Supreme Law,"
with the Union Hotel in the background,
a motley assemblage of men—farmers and
merchants, rustics and sophisticates, of all
ages—meet to carry out their civic duty.

However much Bingham celebrated the
democratic process, he made no attempt to
sugarcoat the less dignified aspects of voting
day. As the picture shows, elections—which
typically lasted three days—were large pub-
lic gatherings, often festive in nature, in
which alcohol played a major role. Although
Bingham's Whig Party had embraced hard

cider as the drink of the people, the artist was
himself a teetotaler. It has been suggested
that Bingham included three figures—"the
portly man on the far left; the man in the
left middleground passed out in the arms of
a campaign worker; and the bandaged figure
slumped on the bench on the far right"—as a
"subtle temperance warning," reminding
viewers that "overindulgence, whatever a
man's social station, impairs his judgment as
a citizen" and may lead to total degradation.[8]
Caveats aside, *The County Election* is an
essentially positive view, depicting citizens
engaged in the political process. As
Bingham's friend James Rollins wrote in
1852, it illustrates "the power and influence
which the ballot exerts over our happiness
as a people."[9]

G.C.B. *and* E.H.

Notes

1. George Caleb Bingham, 2 Nov. 1846, in C. B.
Rollins, ed., "Letters of George Caleb Bingham to
James S. Rollins," *Missouri Historical Review* 32
(1937–38), 15.

2. *The Stump Orator* is now lost; *Country Politician*
is in the collection of the Fine Arts Museums of San
Francisco, and *Canvassing for a Vote* is at the
Nelson-Atkins Museum of Art in Kansas City, Mo.
The remaining canvases in the series are all owned
by the Saint Louis Art Museum.

3. Barbara S. Groseclose, "Paintings, Politics, and
George Caleb Bingham," *American Art Journal* 10
(Nov. 1978), 8.

4. See Groseclose, "Politics and American Genre
Painting of the Nineteenth Century," *Antiques* 120
(Nov. 1981), 1212, and Nancy Rash, *The Painting
and Politics of George Caleb Bingham* (New
Haven: Yale University Press, 1991), 127.

5. Bingham, 27 June 1852, in Rollins, 1937–38, 25–26.

6. Bingham to Sartain, 4 Oct. 1852, quoted by Gail
E. Husch, "George Caleb Bingham's *The County
Election*, Whig Tribute to the Will of the People,"
Critical Issues in American Art, ed. Mary Ann Calo
(Boulder, Colo.: Westview Press, 1998), 83, 90n.29.

7. Husch, 1998, 79.

8. Ibid., 84–85.

9. Rollins to Andrew Warner, 11 Jan. 1852, quoted in
ibid., 82, 90n.28.

THE POWER OF MUSIC

79

MUSIC IS CONTAGIOUS!

80

Alphonse-Léon Noël
(b. France, 1807–1884), lithographer
After paintings by William Sidney
Mount (1807–1868)

79

The Power of Music!, 1848

Color lithograph, 18 x 22 in. (45.7 x 55.9 cm)
Mabel Brady Garvan Collection, 1946.9.633

80

Music is Contagious!, 1849

Color lithograph, 19 1/8 x 20 15/16 in.
(48.5 x 53.2 cm)
Mabel Brady Garvan Collection, 1946.9.629

Best known for his depictions of everyday life in rural Long Island, William Sidney Mount was among the most celebrated painters of late antebellum America (cat. no. 75). Mount's renown was due in large part to the many prints of his work, which sold well in both Europe and the United States. The largest single disseminator of Mount's work was the Paris-based firm Goupil, Vibert & Co., later Goupil & Co., which between 1848 and 1857 reproduced seven of his paintings as lithographs.[1] Among them were *The Power of Music!* (cat. no. 79) and *Music is Contagious!* (cat. no. 80), lithographed by the French printmaker Alphonse-Léon Noël in 1848 and 1849, respectively. *Music is Contagious!* was executed after an 1845 Mount canvas entitled *Dance of the Haymakers,* while *The Power of Music!* derives from Mount's 1847 painting of the same name, originally exhibited as *The Force of Music.*[2]

These prints marked the beginning of Mount's popularity abroad. In 1849, the *International Art-Union Journal* noted that the lithograph *Music is Contagious!* "has been greatly admired by all the artists and amateurs of Paris," forming "a necessary companion to that popular print, 'The Power of Music,' now so widely disseminated throughout the country."[3] The *Courrier des Etats-Unis* gave "thanks to Messrs. Goupil & Co., who, with their usual tact, have availed themselves of the talent of the most national, and as well as richly endowed of the American Artists." Of Mount, the *Courrier* continued: "This painter is, indeed, the pure expression of the artistic genius of the United States—a genius still in its adolescence, and wanting in the experience of old civilization, but full of sap, and fecundated by the Love of Country."[4] While Europeans admired Mount for his American qualities, American observers likely understood the rich albeit subtle racial and political content of his work.

In *The Power of Music!* a black man stands beside an open barn door, discreetly listening to the musical performance of a young violinist revealed within. Although spatially segregated from the other men, he appears to listen with the greatest intensity. An 1847 review of the painting remarked that the "old man" seated beside the musician "loves music, and swallows it without stopping to analyse its quality," while the other man "don't enjoy the melody, but wonders at the skill." The "triumph of the picture," continued the reviewer, "is the negro standing outside the door, out of sight of the main group but certainly not out of hearing. He is an amateur, plays himself, and listens critically, at the same time delightedly. We never saw the faculty of listening so exquisitely portrayed as it is here. Every limb, joint, body, bones, hat, boots, and all, are intent upon the tune."[5] Mount thoughtfully individualized each of the figures in the painting, including the black man, who, unlike many other contemporary depictions of African Americans, is completely devoid of caricature. The young violinist has been identified as Mount's nephew, John Henry Mount; the black listener is thought to be Robin Mills, who may have been owned by the family of the "old man," Caleb, before New York's 1827 emancipation of slaves.[6]

While structurally similar to *The Power of Music! Music is Contagious!* contains several important differences. In it, the black figure does not simply listen to the musical performance, he participates in it, drumming the beat on the open barn door. Unlike the former composition, in which only white men appear within the confines of the barn, *Music is Contagious!* depicts two young female listeners—one white, one black—eagerly grinning in the hayloft. As one scholar points out, when taken together, "the two scenes are fully integrated: female and male, young and old, black and white participate."[7] However, Mount's personal views on matters of racial equality were notoriously complex and occasionally contradictory. He condescendingly observed that "a Negro is as good as a White man—as long as he behaves himself,"[8] but is known to have held the blacks who worked on his family's farm—all former slaves—in high esteem and even, in the case of one black violinist, "near-reverence."[9]

Politically, Mount allied himself with the conservative branch of the New York Democratic Party—the so-called Old Hunkers—who staunchly opposed the Wilmot Proviso, an 1846 congressional bill that would have outlawed slavery in any lands acquired from Mexico. The term "hunker," which means to squat close to the ground, implies immovability and stubbornness—in the case of the conservative Old Hunkers, an unyielding desire to preserve the status quo. Their abolitionist opponents were known as the Barnburners, charged with being "none too good to be guilty of burning barns," which is to say, destroying the existing state of affairs.[10] In Mount's *Power of Music!* and *Music is Contagious!* the barns are very much intact, and despite the artist's straightforward portrayal of African Americans, the compositions may reveal a conviction that blacks were best kept in their place—outside the doors of white society.

G.C.B.

Notes
1. Bernard F. Reilly, Jr., "Translation and Transformation: The Prints after William Sidney Mount," in *William Sidney Mount: Painter of American Life,* ed. Deborah J. Johnson (New York: American Federation of Arts, 1998), 141.
2. Collections of the Long Island Museum of American Art, History & Carriages, Stony Brook, New York, and the Cleveland Museum of Art, respectively. While two years separate the completion of the paintings, a single sheet of about 1845 contains studies for both compositions, proving they were conceived of simultaneously. Martha V. Pike, "Catching the Tune," in *Catching the Tune: Music and William Sidney Mount,* ed. Janice Gray Armstrong (Stony Brook, N.Y.: Museums at Stony Brook, 1984), 11, 14.
3. *International Art-Union Journal* 1 (1849), 100.
4. Quoted in translation, *Bulletin of the American Art-Union* 9 (Dec. 1851), 150.
5. "The Fine Arts," *Literary World* 1 (5 June 1847), 419.
6. Frederick C. Moffatt, "Barnburning and Hunkerism: William Sidney Mount's *The Power of Music!,*" *Winterthur Portfolio* 29 (spring 1994), 26.
7. Ibid., 29.
8. Mount to William Schaus, 9 Sept. 1852, Collection of the New-York Historical Society, quoted in Alfred Frankenstein, *William Sidney Mount* (New York: Harry N. Abrams, 1975), 164.
9. Elizabeth Johns, *American Genre Painting: The Politics of Everyday Life* (New Haven: Yale University Press, 1991), 116.
10. Moffatt, 1994, 20.

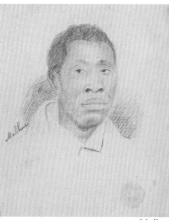

Malhue

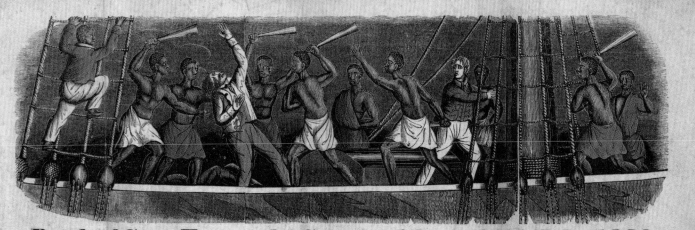

Death of Capt. Ferrer, the Captain of the Amistad, July, 1839.

Don Jose Ruiz and Don Pedro Montez, of the Island of Cuba, having purchased fifty-three slaves at Havana, recently imported from Africa, put them on board the Amistad, Capt. Ferrer, in order to transport them to Principe, another port on the Island of Cuba. After being out from Havana about four days, the African captives on board, in order to obtain their freedom, and return to Africa, armed themselves with cane knives, and rose upon the Captain and crew of the vessel. Capt. Ferrer and the cook of the vessel were killed; two of the crew escaped; Ruiz and Montez were made prisoners.

81

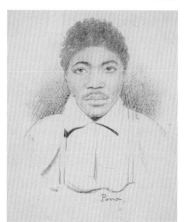

Pona

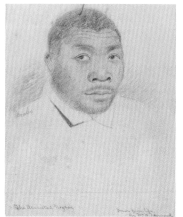

82

Grabo

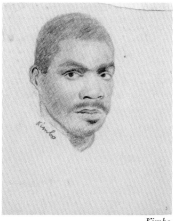

Kimbo

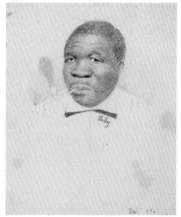

Saby

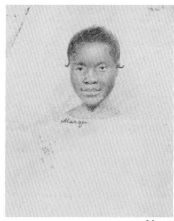

Marqu

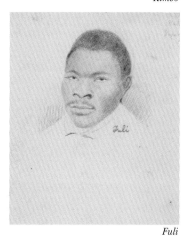

Fuli

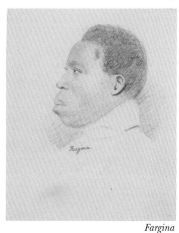

Fargina

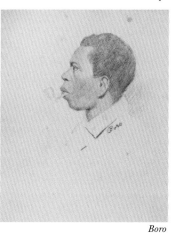

Boro

Little Kale

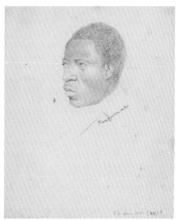

Farquanar

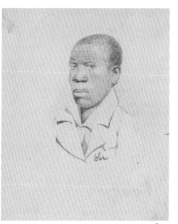

Sar

81

John Warner Barber (1798–1885)
Death of Capt. Ferrer, the Captain of the Amistad, July, 1839, 1840

Hand-colored woodcut and watercolor,
8⅛ x 18½ in. (20.6 x 47 cm)
Yale University Art Gallery, 1984.3.63

82

William H. Townsend (1822–1851)
Sketches of the Amistad Captives, ca. 1840

Graphite
Beinecke Rare Book and Manuscript Library,
Yale University, General manuscript no. 335

Malhue, 6⅝ x 5½ in. (16.8 x 14 cm)

Pona, 6¾ x 5⅜ in. (17.2 x 13.7 cm)

Grabo, 6¼ x 4½ in. (15.9 x 11.4 cm)

Kimbo, 5½ x 5⅛ in. (14 x 13 cm)

Fuli, 6⅝ x 5½ in. (16.8 x 14 cm)

Little Kale, 6¾ x 5⅜ in. (17.2 x 13.7 cm)

Saby, 6½ x 5⅜ in. (16.5 x 13.7 cm)

Fargina, 6¼ x 4½ in. (16 x 11.4 cm)

Farquanar, 6⅝ x 5½ in. (16.8 x 14 cm)

Marqu, 6½ x 5½ in. (16.5 x 14 cm)

Boro, 7½ x 5⅞ in. (19.7 x 14.9 cm)

Sar, 7½ x 6 in. (19.7 x 15.2 cm)

In a desperate effort to return to the homes from which they had been kidnapped and sold into bondage, a group of West Africans led by Sengbeh Pieh, or Joseph Cinqué, mutinied aboard the schooner *Amistad* during a voyage in July 1839 from Havana to Puerto Principe, Cuba. After killing the captain and cook who had tortured and starved them, the Africans directed the two remaining Spanish captors to sail east, but the men deceived them, turning the boat around each night. The *Amistad* and its passengers drifted up the American coast until the U.S. Navy

took them into custody in Long Island Sound. Spain demanded that America return the men and girls, whom they viewed as property, while abolitionists countered that the group had been enslaved illegally by planters José Ruiz and Pedro Montez, who had falsified documents to evade prohibitions against importing slaves into Cuba. The Africans were jailed in New Haven, where their struggle for freedom became a cause célèbre in America's debate over slavery.

The case inspired a torrent of popular responses. Boston artist Amasa Hewins composed *The Massacre on Board the Schooner Amistad*, a panorama painting that sensationalized the captain's murder, depicting his collapse under a rain of blows struck with sugarcane knives, which were to be the slaves' instruments of toil. Inspired by the panorama, New Haven historian, artist, and engraver John Warner Barber began copying it on 24 April 1840 (cat. no. 81).[1] He published a hand-colored woodcut of the insurrection as the frontispiece of his pamphlet *A History of the Amistad Captives*—which recounted the mutineers' legal battles—and circulated the image in untinted form to advertise the book. To elicit sympathy for their cause, Barber interviewed the Africans through a translator, compiling biographies that described their lives before and after their entry into slavery and enumerated their efforts at "intellectual and moral improvement." Yale College students and faculty taught the group English and converted them to Christianity to affirm that they were "civilized," in keeping with abolitionists' insistence that the Africans' humanity was the cornerstone of their argument for freedom.

Despite Barber's belief that the Africans were "men of integrity" and his desire, evident in his text, to humanize his subjects for an audience unaccustomed to viewing blacks as equals, his frontispiece portrays the captives as vengeful murderers.[2] Yale professor Benjamin Griswold, one of the mutineers' keenest supporters, doubted the wisdom of such violent depictions: "The moral effect . . . I do think will be bad."[3] Captain Ferrer's blood, applied in garish red watercolor to the somewhat crudely made print, did little to assuage whites' fears about the dissolution of slavery—already inflamed by Nat Turner's rebellion in Virginia eight years earlier.

The only other depictions of the Africans in Barber's text—profiles based on casts made by Sidney A. Moulthrop of New Haven—treat the prisoners as scientific specimens. The phrenological analysis that accompanies Cinqué's silhouette in the Barber pamphlet underscores this perception. Phrenology, a popular pseudoscience at the time, posited that the contours of the skull could reveal an individual's character. The group's jailer even exhibited the Africans as oddities to a curious public, charging a fee for admission.[4]

In contrast, New Haven artist William H. Townsend's undated pencil sketches portray the captives compassionately, as courageous individuals committed to preserving their liberty (cat. no. 82).[5] The twenty-two surviving sheets present busts of the men and children, whose sensitively delineated faces avoid racial stereotyping and convey a range of emotions. Grabo—or Grabeau, as his name was also spelled—had joined Cinqué in commandeering the *Amistad*, testifying that shipboard abuse had "made their hearts burn," an intensity of emotion transmitted by his gaze. To redress their mistreatment, Fuli, or Fuliwa, sued Ruiz for assault, kidnapping, and false imprisonment, demonstrating blacks' right to initiate civil proceedings in America.[6] Although the drawings' ultimate purpose is unknown, Townsend's sympathetic likenesses answered abolitionists' calls for positive images of the *Amistad* captives that, like Nathaniel Jocelyn's heroic portrait

of Cinqué, would influence public opinion during and after their trial (fig. a).[7]

After a protracted legal struggle, the prisoners won their freedom in 1841 with the assistance of former president John Quincy Adams, whose argument on their behalf before the Supreme Court became a widely circulated abolitionist tract. Despite their vindication, the *Amistad* group's return to Africa proved difficult. Pona's and Malhue's weary expressions, and Sar's uncertainty, may reflect the toll exacted by the captives' unresolved status. Further legal maneuvers were required to remove Marqu, or Margru, one of three female children, from the jailer's custody, so that the group would not be separated. The vivid, half-smiling young girl and the more sober boy, Little Kale, joined the adults in raising money for their journey by speaking, singing, and reenacting the mutiny before abolitionist audiences. In November 1841, the group sailed for

Africa in the company of missionaries, who were among the most devoted proponents of the antislavery gospel (cat. no. 87). Some former prisoners returned to their homes, while others, including Marqu, built a mission in Sierra Leone. Marqu took the name Sarah Kinson and later attended Oberlin College in preparation for a teaching career in Africa.[8]

Although their victory did little to resolve the plight of American slaves, the *Amistad* captives' declaration of human rights in opposition to bondage articulated persistent questions that would be answered only by the Civil War. Barber's and Townsend's conflicting images of the Africans encapsulated Americans' increasingly divided attitudes toward slavery. A.K.L.

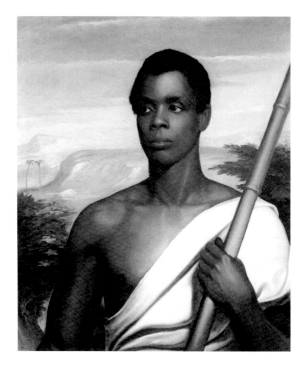

fig. a Nathaniel Jocelyn, *Cinqué*, ca. 1840. Oil on canvas, 30¼ x 25½ in. (76.9 x 64.7 cm). New Haven Museum and Historical Society, New Haven, Conn., Gift of Dr. Charles Purvis, 1898, NHMHS 1971.205

Notes

1. John Warner Barber, diary, 1813–83, Box 1, Folder A, John Warner Barber Papers, New Haven Museum and Historical Society, New Haven, Conn. The painting was exhibited in New Haven from 16 Apr. until at least 8 May 1840. See advertisements in the *Evening Palladium* (New Haven), 15 Apr.–8 May 1840, 3.

2. John Warner Barber, *A History of the Amistad Captives* (New Haven: E. L. and J. W. Barber, 1840), 24.

3. Quoted in Richard J. Powell, "Cinqué: Antislavery Portraiture and Patronage in Jacksonian America," *American Art* 11 (fall 1997), 56.

4. Clifton H. Johnson, "The Amistad Case and Its Consequences in U.S. History," *Journal of the New Haven Colony Historical Society* 36 (spring 1990), 18.

5. Charles Allen Dinsmore, "Interesting Sketches of the Amistad Captives," *Yale University Library Gazette* 9 (Jan. 1935), 51–55.

6. Quoted from letter to the *Journal of Commerce*, 8 and 15 Oct. 1839, repr. in Howard Jones, *Mutiny on the Amistad: The Saga of a Slave Revolt and Its Impact on American Abolition, Law, and Diplomacy* (New York and Oxford: Oxford University Press, 1987), 85, 91.

7. Powell, 1997, 60–64.

8. Marlene D. Merrill, *Sarah Margru Kinson: The Worlds of an Amistad Captive* (Oberlin, Ohio: Oberlin Historical and Improvement Organization, 2003), 4; Jones, 1987, 255n.27.

83 Reverse

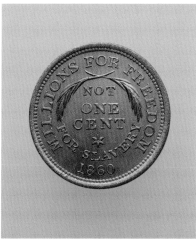

84 Reverse

83

Gibbs, Gardner and Company
(active 1830s), manufacturer
American Anti-Slavery Society
(1830–70), publisher
"Am I Not a Woman & a Sister," so-called Hard Times Token
Belleville, New Jersey, 1838

Copper, wt. 10.81 gm, 12:00, 29 mm
Yale University Numismatic Collection Transfer, 2001, 2001.87.3464

84

William Leggett Bramhall
(1839–1902), designer
Scovill Manufacturing Company
(incorporated 1850), manufacturer
Abraham Lincoln Presidential Campaign Medal
Waterbury, Connecticut, 1860

Brass, wt. 5.96 gm, 12:00, 24 mm
Yale University Numismatic Collection Transfer, 2001, Gift of Irving Dillaye Vann, B.A. 1897, 2001.87.3460

In an effort to control rampant inflation and stop speculation in government land, on 11 July 1836 President Andrew Jackson issued the Specie Circular, declaring that after 15 August of that year, public lands could be purchased only with gold and silver coinage. The decree caused a run on the nation's financial institutions, resulting in the suspension of all coin payments on 10 May of the following year. The Panic of 1837, which caused a five-year depression and record unemployment, left a dearth of small change in circulation, particularly copper cents. In order to remedy the crisis, entrepreneurs, businesses, and municipalities began to issue their own coinage, which came to be known as "Hard Times" tokens.[1]

The mottoes and motifs found on "Hard Times" tokens often commented on major social and political issues of the day, and

none was more burning than slavery. The American Anti-Slavery Society, established in Philadelphia in 1833 by William Lloyd Garrison (1805–1879), was the nation's largest abolitionist organization; by 1838, it had grown to 1,350 chapters with a quarter million members.[2] In November 1837, *The Emancipator*, the society's official weekly paper, advertised "Anti-Slavery COPPER MEDALS, similar in appearance to new cents." The society intended to sell them to "friends of liberty" at its New York headquarters. The ad described the medal, noting, "On one side is a female slave, in chains, in an imploring attitude, with the motto, 'Am I not a woman and a sister?' [cat. no. 83] . . . On the reverse side is, in the centre, the word 'LIBERTY,' surrounded by a wreath—and outside, in a circle, 'United States of America.'"[3]

The motif of the suppliant slave derives from the seal of Great Britain's Society for the Abolition of the Slave Trade, founded in 1787. That year, the English potter Josiah Wedgwood, a leading member of the society, produced jasperware cameos bearing the emblem for free distribution to the organization's supporters (fig. a).[4] In 1788, when Wedgwood sent a quantity of the cameos to Benjamin Franklin, president of the Pennsylvania Society for the Abolition of Slavery, the elder statesman commented that the "Figure of the Suppliant . . . may have an Effect equal to that of the best written Pamphlet in procuring favour to those oppressed People."[5] The image, which has been called "the single most common visual representation of a black slave," would become popular on both sides of the Atlantic, inspiring the female counterpart used by the American Anti-Slavery Society.[6] The editors of *The Emancipator* declared, "The friends of liberty have it in their power to put a medal into the hands of every person in the country, without cost, containing *a sentiment* of immense value. It is a tract that

will not be destroyed. If it falls into the hands of an enemy of liberty, he will 'read and circulate.'"[7]

Even after the era of "Hard Times," tokens continued to be a popular vehicle for political expression because they were small, relatively inexpensive to produce, and easily disseminated. During the presidential election of 1860, William Leggett Bramhall, one-time curator at the American Numismatic Society and an ardent Republican, designed and issued a pro-Lincoln antislavery token or "medalet" (cat. no. 84).[8] According to Bramhall, the medalet, which was a slightly altered version of one he had issued the previous year, was originally "intended both as a political toy and as material for exchange with other collectors." The obverse of the medalet features an American eagle surrounded by the slogan, "SUCCESS TO REPUBLICAN PRINCIPLES." The reverse, dated 1860, depicts two crossed palm fronds, a symbol of triumph, and a six-pointed star, amid the

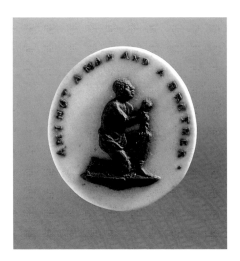

fig. a Josiah Wedgwood, *Medallion of the Seal of the Society for the Abolition of the Slave Trade*. Staffordshire, England, ca. 1787. Jasperware, diam. 1⅛ in. (2.9 cm). Chipstone Foundation, Milwaukee, Wisc.

motto "MILLIONS FOR FREEDOM NOT ONE CENT FOR SLAVERY." The inscription is derived from the statement, "Millions for defense, but not one cent for tribute," which was first uttered by Congressman Robert Goodloe Harper of South Carolina in an address in 1798; by 1800, it had become a popular slogan referring to America's refusal to pay annual tribute to the Barbary States—Algiers, Morocco, Tripoli, and Tunis—for free passage along their coast. Bramhall's paraphrasing of the motto was undoubtedly intended to equate the savagery of the Barbary pirates with the brutality of slavery. The medalets were struck by the Scovill Manufacturing Company of Waterbury, Connecticut, which produced seven in silver, seventy-five in copper, and fifteen thousand in brass, including the present example.[9]

The antislavery sentiment expressed by Bramhall's token proved popular with abolitionists. On 5 December 1861, after the onset of the Civil War, Martin F. Conway, Kansas's first member of Congress and leader of its free-state movement, repeated the epigram in a speech before Congress. He declared the federal government's first priority should be the immediate and unconditional emancipation of all slaves. Until then, Conway vowed he would "not vote another dollar or man for the war."[10] Although his wish would be partially realized on 1 January 1863, when Lincoln issued the Emancipation Proclamation freeing all slaves in Confederate-held territory, the complete abolition of slavery in the United States was not accomplished until the ratification of the Thirteenth Amendment in December 1865. G.C.B.

Notes

1. Russell Rulau, *Standard Catalog of United States Tokens, 1700–1900*, 2nd ed. (Iola, Wisc.: Krause Publications, 1997), 75–76; and Eric P. Newman, "The Promotion and Suppression of Hard Times Tokens," *The Token: America's Other Money*, ed. Richard G. Doty (New York: The American Numismatic Society, 1995), 120–21.

2. Louis Filler, *The Crusade Against Slavery, 1830–1860* (New York: Harper & Brothers, 1960), 66–67.

3. "Medals," *The Emancipator* 2:30 (23 Nov. 1837), 177. See also Newman, 1995, 114–16.

4. The emblem was modeled after the seal by William Hackwood (d. 1836), who worked for Wedgwood from 1769 until 1839. See Robin Reilly, *Josiah Wedgwood, 1730–1795* (London: Macmillan, 1992), 286–87, 292. See also Sam Margolin, "'And Freedom to the Slave': Antislavery Ceramics, 1787–1865," in *Ceramics in America*, ed. Robert Hunter (Milwaukee: Chipstone Foundation, 2002), 80–82.

5. Benjamin Franklin to Josiah Wedgwood, quoted in Sidney Kaplan, *The Black Presence in the Era of the American Revolution, 1770–1800* (Washington, D.C.: National Portrait Gallery, 1973), 235.

6. Kirk Savage, *Standing Soldiers, Kneeling Slaves: Race, War, and Monument in Nineteenth-Century America* (Princeton: Princeton University Press, 1997), 21–23.

7. See n. 3.

8. Howard L. Adelson, *The American Numismatic Society, 1858–1958* (New York: The American Numismatic Society, 1958), 22, 313–14n.8, 356.

9. William Leggett Bramhall, "The Bramhall Medalets," letter to the editor of the *American Journal of Numismatics* 2:4 (Aug. 1867), 40–41.

10. Thomas L. Harris, "Conway, Martin Franklin," *Dictionary of American Biography* 4 (New York: Charles Scribner's Sons, 1930), 363–64.

85

Pitcher
Probably New Jersey, 1853 or
shortly thereafter

Cream-colored earthenware with
Rockingham glaze, 8¾ x 8¾ x 5⅝ in.
(22.2 x 22.2 x 14.3 cm)
Mabel Brady Garvan Collection, 1931.1806

This pitcher depicts one of the best-known
artworks of the nineteenth century, Hiram
Powers's *The Greek Slave*. Little more than a
decade after the Greek War of Independence
(1821–32), Powers created his idealized sculp-
ture of a young Christian woman about to
be sold into slavery by Turkish captors.[1]
Many Americans were horrified by the atroc-
ities in the Mediterranean, one of the first
wars to be reported via transatlantic cable,
but the sculpture also addressed the nation's
growing anxiety over the issue of slavery.
Unveiled in London in 1844, the piece won
tremendous critical acclaim, and a copy
toured the United States a few years later.
Powers also had marble busts made and
licensed British potteries to produce smaller
versions in unglazed porcelain.[2]

The popularity of Powers's sculpture led
an American potter to replicate the image on
a ceramic pitcher. Although the manufac-
turer may have owned a Parian version of *The
Greek Slave*, he more likely saw a full-size
replica that was exhibited at the New York
Crystal Palace in 1853. Also on view was
Powers's *Eve Tempted*, conceived in 1842–43;
the same figure appears on the other side of
this pitcher. But for a repositioning of Eve's
left hand, a nod to the modesty of the day,
the modeler faithfully copied the earlier
nude.[3] Only a modeler of exceptional skill
could have replicated Powers's sculpture.
Though many nineteenth-century American
potteries made brown-glazed Rockingham
ware, only a handful of itinerant modelers
were capable of this level of work, among

them Charles Coxon, Daniel Greatbach,
Josiah Jones, and Stephen Thiess.[4] Despite
its powerful subject matter, Yale's Greek
Slave/Eve pitcher is rare, which suggests it
was never produced in a significant quantity.
Whether made as a special commission, a
souvenir, or a trial product, the elaborately
conceived and controversial imagery on this
Rockingham piece remains an anomaly in
the history of American pottery.[5] C.M.H.

Notes
1. Sylvia E. Crane, *White Silence: Greenough,
Powers, and Crawford, American Sculptors in
Nineteenth-Century Italy* (Coral Gables, Fla.:
University of Miami Press, 1972), 203–4.
2. Ellen Paul Denker, "Parian Porcelain Statuary:
American Sculptors and the Introduction of Art in
American Ceramics," *Ceramics in America* 2
(2002), 66–67.
3. Joy S. Kasson, *Marble Queens and Captives:
Women in Nineteenth-Century American
Sculpture* (New Haven and London: Yale
University Press, 1990), 176–78, fig. 70. It is also
possible that the modeler copied printed engrav-
ings of his subjects.
4. Diana Stradling, *"Fancy Rockingham" Pottery:
The Modeller and Ceramics in Nineteenth-Century
America* (Richmond, Va.: University of Richmond
Museums, 2004).
5. The most credible source on the subject of
Rockingham ware is Jane Perkins Claney,
*Rockingham Ware in American Culture, 1830–1930:
Reading Historical Artifacts* (Hanover and London:
University Press of New England, 2004).

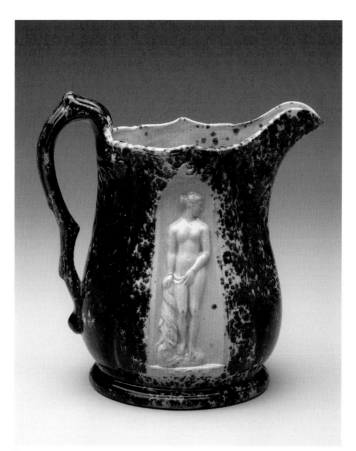

85

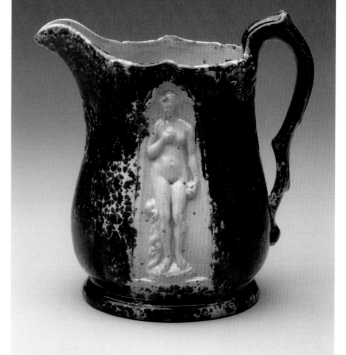

Reverse

86

Henry Ossawa Tanner (1859–1937)
Spinning by Firelight—The Boyhood of George Washington Gray, 1894

Oil on canvas, 46½ x 66½ in. (118.1 x 168.9 cm)
Leonard C. Hanna, Jr., B.A. 1913, Fund, 1996.58.1

Spinning by Firelight—The Boyhood of George Washington Gray offers a rosy vision of the Ohio frontier childhood of Gray (1834–1919), a Chicago minister, educator, abolitionist, and social reformer.[1] The African American Henry Ossawa Tanner painted *Spinning by Firelight* sometime between May and August 1894, just before returning to Europe, where he had gone in 1891 to escape racial prejudice. He traveled to Chicago in August 1893 to deliver a speech at an auxiliary Congress on Africa linked to the World's Columbian Exposition, and there he stayed with Gray, who extended to Tanner the warmth of hearth and home. In the era of Jim Crow, when accommodations were segregated, Gray's offer of lodging was no small gesture. The painting served as partial thanks for the minister's hospitality, and Gray's patronage gave Tanner much-needed funds for his return to France, where he was to remain permanently and where he would achieve international recognition.

When Tanner envisioned his white sitter's youth in *Spinning by Firelight*, it was at a pivotal moment for both men, and the resulting painting can be read as a meditation on the painter's life as well as Gray's. Tanner was on the verge of leaving his parents, whose support had been critical to his success as an artist, and here he contemplates family bonds through the medium of Gray's portrait, lovingly unifying mother, father, and son through palette and pose. And like his youthful alter ego, who stacks corncobs by the fire, Gray had recently embarked on a building program, opening a settlement house in January 1894 to shelter the eighty-four

thousand Chicagoans left unemployed after the close of the World's Columbian Exposition.[2]

The nostalgia surrounding the World's Columbian Exposition pervades Tanner's painting. Against a backdrop of industrialization, urbanization, immigration, and labor strife, the years preceding the four hundredth anniversary of Columbus's arrival in the New World were defined by a yearning for the era of homespun and hard work. Gray's mother exemplifies these values, her spinning wheel radiating energy and light like the monumental Corliss engine whose churning powered the fair. The spinning wheel and the rifle, as well as the log cabin that serves as the imagined setting for Gray's youth, double as icons of a national heritage that privileged the history of Anglo-Americans over those of other early settlers, recent immigrants, and former slaves—a view enshrined in the Columbian Exposition's White City. While white visitors celebrated their English roots at the fair's New England Kitchen, African Americans were largely excluded until Colored Jubilee Day, when they were confronted by such stereotypes as Aunt Jemima and handed free watermelon. Painted in the exposition's aftermath as an empathetic tribute to a friend, *Spinning by Firelight* embodies Tanner's struggle to transcend racial conflict, an endeavor possible only in the bohemian enclaves of the Old World. On seeing Tanner's paintings at the Musée du Luxembourg in Paris, Booker T. Washington wrote: "Few people ever stopped . . . when looking at his pictures, to inquire whether Mr. Tanner was a Negro painter, a French painter, a German painter. They simply knew that he

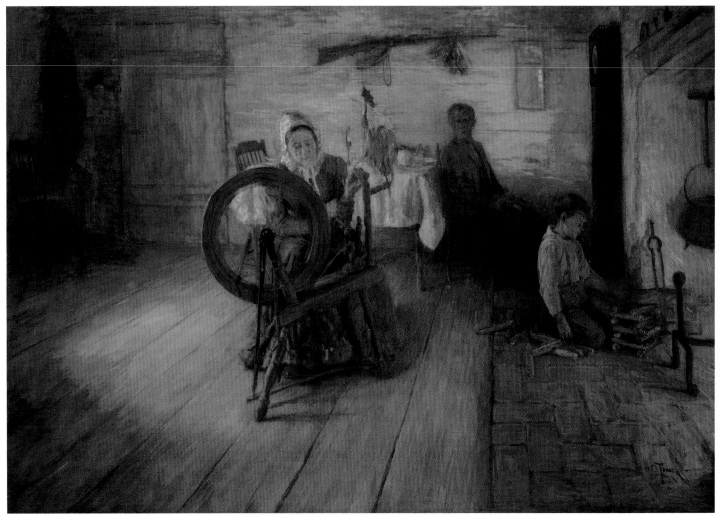

86

was able to produce . . . a great painting—and the matter of his color did not enter into their minds."[3] A.K.L.

Notes

1. For a more complete discussion of the painting, see Amy Kurtz, "'Look Well to the Ways of the Household, and Eat Not the Bread of Idleness': Individual, Family, and Community in Henry Ossawa Tanner's *Spinning by Firelight—The Boyhood of George Washington Gray*," *Yale University Art Gallery Bulletin* (1997–98), 52–67.
2. Rev. G. William Lankton, "George W. Gray" (unpublished typescript, Chicago History Museum, n.d.), 9. On post-Exposition unemployment, see, for example, "Idle Men Pouring In," *Chicago Daily Tribune*, 31 July 1893, 1.
3. Booker T. Washington, *Up from Slavery* (1901; repr. New York: 1963), 202.

87

Wood and Hughes (active ca. 1845–99)
Hot Milk Jug
New York City, 1862

Coin silver, h. 9¼, w. 5⁵⁄₁₆, diam. 4 in.
(23.5 x 13.5 x 10.1 cm), wt. 17 oz. (481.9 gm)
Marie-Antoinette Slade Fund and Gift of
Mrs. Paul Moore, by exchange, 1993.36.1

In January 1862, a group of New York City's African American citizens gave this silver hot milk jug to the Reverend George Barrell Cheever (1807–1890), the Congregationalist pastor of the Church of the Puritans. According to its inscription, the jug was "presented to Geo. B. Cheever, D.D., by his colored friends as a small token of their high regard for him as a faithful Minister of the Gospel, and the fearless Advocate of Liberty to the Oppressed Slave." It may have been given to Cheever as a New Year's present in recognition of his support for the immediate emancipation of slaves during the fall and winter of 1861. "Strike down slavery," he wrote in a sermon that year, "and the whole object of the rebellion is taken away, and the whole South will be peacefully subdued without another blow."[1]

Cheever was a dedicated reformer whose uncompromising determination to expose social ills launched him into controversies over temperance, capital punishment, and the abolition of slavery. In 1835, after publishing a scathing temperance tract titled "Inquire at Deacon Giles' Distillery," Cheever was publicly assaulted, sued for libel by a local deacon, and jailed for thirty days.[2] In the 1850s, he turned his attention to abolition, giving speeches and writing books such as *God Against Slavery* (1857) and *The Guilt of Slavery and the Crime of Slave-Holding, Demonstrated from the Hebrew and Greek Scriptures* (1860). His outspoken speeches and sermons alienated him from conservative Congregationalists, caused an irreparable split in his church, and nearly cost him his pulpit. Although Cheever essentially retired from the pulpit after the Civil War, he continued to agitate for the rights of African Americans and other oppressed minorities.

The urn-shaped pitcher was made by the New York firm of Wood and Hughes. Founded in 1845 by Jacob Wood and Jasper W. Hughes, by 1860 the firm employed ninety-six workers and produced three hundred dollars' worth of wares annually.[3] The pitcher features a scroll handle, bands of applied Vitruvian molding, and a fan-shaped spout with a stylized palmette design. The domed cover is topped by an anchor intertwined with a ram's horn. The anchor is a Christian symbol of the hope of salvation, while the ram's horn may represent the shofar, a horn blown on Jewish high holidays to remind the faithful of God's mercy. It is unclear whether this was a stock piece or specially commissioned for Cheever, but the pitcher's iconography does seem especially suited for a minister. E.E.

Notes

1. Quoted in Robert M. York, "George B. Cheever, Religious and Social Reformer, 1807–1890," *University of Maine Bulletin*, University of Maine Studies, 2nd ser., 69 (1955), 187.
2. Ibid., 72–81.
3. Deborah Dependahl Waters, ed., *Elegant Plate: Three Centuries of Precious Metals in New York City*, 2 vols. (New York: Museum of the City of New York, 2000), 2:593.

Detail of inscription

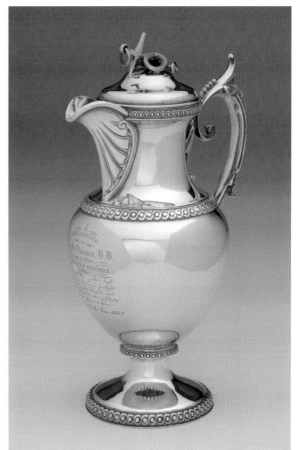

87

88

Fitz Henry Lane (1804–1865)
Lighthouse at Camden, Maine, 1851

Oil on canvas, 23 x 34 in. (58.4 x 86.4 cm)
Gift of the Teresa and H. John Heinz III
Foundation, 1992.122.1

Fitz Henry Lane was part of the generation
of American painters who, following Thomas
Cole's example, invested their depictions
of the native landscape with symbolic depth.
In paintings like *Lighthouse at Camden, Maine*,
Lane transformed the traditionally docu-
mentary genre of maritime painting into a
subtle meditation on national destiny. Charac-
teristic of Lane's work from this period, the
painting unites topographic precision with
spectacular atmospheric effects, emphasizing
mood over narrative. The rising sun saturates
both sky and water, creating a visual har-
mony and simultaneously dividing the com-
position between a large schooner loaded
with lumber—Maine's primary export—and
the silhouetted form of Negro Island (now
Curtis Island) and its lighthouse.[1] African
Americans in nineteenth-century Maine in
general lived isolated lives in the towns; how-
ever, Negro Island was one of nine islands
off the coast that were identified with them.

With the passage of the Fugitive Slave Act
and the Compromise Bill in 1850, Northern
anxiety about the spread of slavery into the
western territories reached new heights and
took on an unprecedented political dimen-
sion. Many Northern politicians were careful
to distinguish the righteous "free labor" of
their region from the corrupted slave labor
of the South in order to demonstrate the
economic and societal disadvantages of the
Southern institution.[2] Lane, who had recently
returned from a trip to Baltimore, contrasted
the mercantilism of his native New England
with a nominal invocation of slavery, Negro
Island. The lighthouse may suggest the
North's complicity in the continued existence

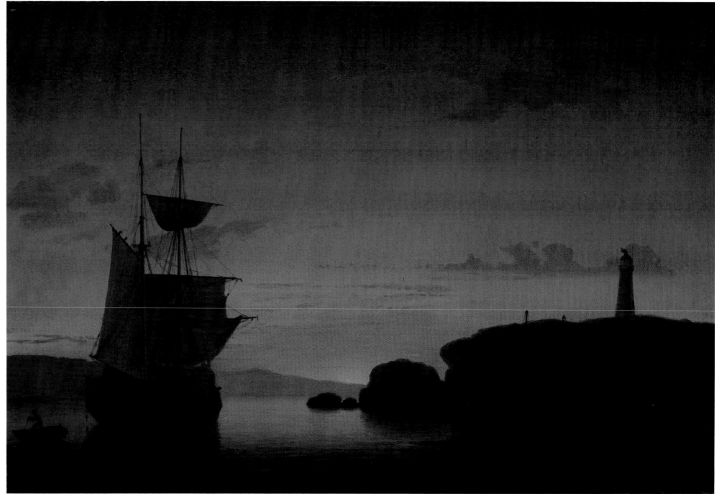

88

of slavery through its trade with the region,
while also symbolizing the promise of
escape for fugitive slaves, who often gained
their freedom by hiding on commercial
vessels. With its dual symbolism veiled
behind a placid and picturesque celebration
of the rugged Maine coast, Lane's work
epitomizes the apprehensive ambivalence of
many Northerners in the years leading up
to the Civil War. R.S.

Notes
1. I am grateful to John Panayotoff of Camden,
Maine, for his help in identifying the lighthouse.
2. See Eric Foner, *Free Soil, Free Labor, Free Men*
(New York: Oxford University Press, 1970).

89

Charles Coxon (b. England, 1805–1868), modeler
Millington, Astbury, and Paulson (1859–70), manufacturer
Pitcher
Trenton, New Jersey, ca. 1861

Porcelain, 8¼ x 8½ x 7½ in. (21 x 21.6 x 19.1 cm)
Mabel Brady Garvan Collection, 1931.1843

An extraordinary scene, rooted in a dark moment in the Civil War, is molded in relief on one side of this pitcher. The ghostly white figures commemorate the violent deaths of Elmer Ephraim Ellsworth, a charismatic Union officer, and James W. Jackson, a steadfast secessionist innkeeper. On the morning of 24 March 1861, Ellsworth and his company landed in Alexandria, Virginia. They marched up King Street; then Ellsworth split off with four men to take the telegraph office.

Spying a Rebel banner atop the Marshall House Hotel, he and his men detoured and made their way to the hotel roof to cut down the flag. As they came down the stairs, Jackson, the hotel's proprietor, shot Ellsworth and was in turn shot and bayoneted by Ellsworth's men.[1]

Both Ellsworth and Jackson became martyrs overnight, inspiring men on both sides to enlist, and Abraham Lincoln insisted that Ellsworth's body lie in state in the East Room of the White House. As the Union army's first fallen hero, Ellsworth inspired prints, memorials (figs. a, b), poetry, needlework, songs, and this pitcher, perhaps the earliest example of American-made ceramics commemorating a historical event.

The ability of Richard Millington and John Astbury's pottery to produce this tribute in just a matter of months owes much to the skill of Charles Coxon, the seasoned Staffordshire-trained modeler who was working in Trenton at the time.[2] Coxon chose recognizable details of the stairs and the soldiers' voluminous Zouave-style trousers, which are more pronounced in versions of this pitcher that were painted red and blue.[3] The pottery intended this pitcher for a market sympathetic to the Union cause by modeling the reverse side with patriotic emblems—an eagle attacking a snake, an American flag with tented rifles, and the words "Union and the Constitution"—in addition to the clear labeling on the main side. Most examples of this pitcher are made of white granite, a type of earthenware often referred to as ironstone. The translucency and lack of crazing in the glaze on this example suggest that it is porcelain. It also shows fine incised and punched detailing further delineating the molded-relief decoration. C.M.H.

Notes

1. An account of the event by one of Ellsworth's corporals appeared in Trenton's *Daily True American* (28 May 1861). See David J. Goldberg, "Charles Coxon: Nineteenth-Century Potter, Modeler-Designer, and Manufacturer," *American Ceramic Circle Journal* 9 (1994), 45.
2. Although Edwin Atlee Barber and others have attributed the Ellsworth pitcher to Josiah Jones (cat. no. 155), credible evidence firmly establishes Coxon as the originator of this design. See Goldberg, 1994, 29–64. This possibility was alluded to previously in Arthur W. Clement, *The Pottery and Porcelain of New Jersey* (Newark, N.J.: Newark Museum, 1947), 58, no. 178.
3. For a painted version, see *Antiques* 165 (Jan. 2004), 40.

fig. a Abbott and Company, *Mourning Medal for Col. Elmer E. Ellsworth*, 1861. Gilt tin, melainotype, and silk, wt. 3.9 gm, 12:00, 25.5 mm, including ribbon. Yale University Art Gallery, Numismatic Collection Transfer 2001, Duyckinck Gift, 1937, 2001.87.3444

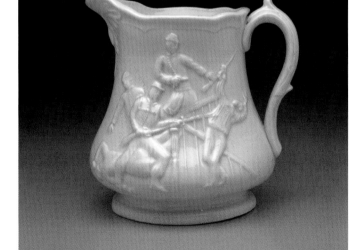

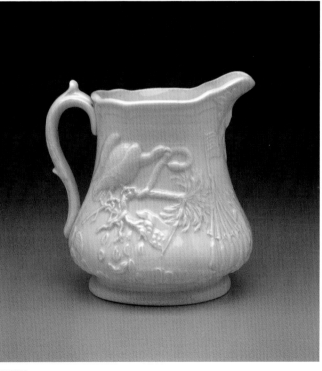

fig. b Reverse of fig. a

89

Reverse

90

Alexander Gardner (1821–1882)
What Do I Want, John Henry?, plate 27
from *Gardner's Photographic Sketch Book
of the Civil War*, 1862

Albumen print, 12 x 15¾ in. (30.5 x 40 cm)
Gift of William A. Turnage, B.A. 1964, B.A. 1965,
1978.148.2

91

George N. Barnard (1819–1902)
Rebel Works in front of Atlanta, 1864–65

Albumen print, 16¹⁄₁₆ x 20⅛ in. (40.8 x 51.1 cm)
Everett V. Meeks, B.A. 1901, B.F.A. 1917, M.A.
(HON.) 1919, Fund, 2003.107.1

Photography played a significant and unprecedented role in the journalistic documentation of the Civil War. Its popularity with citizens hungry for firsthand accounts of the combat, as well as with professional illustrators and artists who used the images as source material, was predicated in part on the perception that the photographic image provided an unmediated and truthful reproduction of life. Alexander Gardner was one of a handful of enterprising photographers who hauled his camera to the battlefields in order to provide Americans with images of the national conflict. As he noted in the brief introduction to his album of war photographs, *Gardner's Photographic Sketch Book of the Civil War* (1866), "Verbal representations of such places, or scenes, may or may not have the merit of accuracy, but photographic presentment of them will be accepted by posterity with an undoubting faith."[1] While photographers like Gardner and his colleague George N. Barnard claimed that they expected their pictures to speak for themselves, both men shaped the interpretation of their images by adding text and publishing them in albums such as this. Their photographs, marketed to a primarily

Northern audience, literally "brought the war home," into the comfort of middle-class living rooms—often incorporating signs of martial and racial violence into a hopeful narrative of restoration and progress, rationalizing the carnage for the greater good of a unified country. Pictures like Gardner's *What Do I Want, John Henry?* (cat. no. 90) and Barnard's *Rebel Works in front of Atlanta* (cat. no. 91) present ostensibly candid representations of life during wartime. Yet both were carefully constructed. By subtly investing past events and distant places with a sense of peace and reconciliation, these photographs helped calm a country still anxious about the prospect of incorporating a recently emancipated slave population and a defeated South.

The wet-plate photographic process utilized by mid-nineteenth-century photographers required bulky equipment (including a makeshift darkroom often contrived in the back of a wagon or inside a tent) for the delicate on-site preparation of unwieldy glass-plate negatives. Thus, it was not the dramatic charge of battle that was the usual subject of these works but rather moments of everyday life in between combat, as well as scenes of the carnage in a battle's wake. Gardner's photograph, *What Do I Want, John Henry?* presents an apparently unrehearsed moment of repose at an officers' camp in Warrenton, Virginia, in November 1862, fairly early in the war. John Henry, the African American man standing among the white officers, was, according to the accompanying text, "discovered" near Richmond and subsequently employed to serve the regiment captain; in this image he is shown offering the captain a plate of food and a demijohn of whiskey. Fugitive slaves such as Henry who were taken in by Northern troops were considered "contraband" of war—like any other assets seized from the enemy—and they occupied an ambiguous position in military culture. While

contributing significantly to the Union cause, such men could not wholly escape racism or even servitude and were often given the most demeaning tasks around the camps. According to the caption, the title of the photograph refers to the droll rhetorical question that Henry's new master liked to pose; Gardner informs the reader that it was always answered with his "commissary" of food and drink.[2] In this apparently offhand slice of life, the hierarchy of race and military rank is dramatized for the camera. Henry's master presents himself as a man of leisure with his pipe casually hanging from his fingers, surrounded by signs of his status: his subordinate officers, the sword lying at his feet, and his private servant.

Unlike most of the one hundred pictures included in Gardner's album, *What Do I Want, John Henry?* does not depict an important place or event that is part of the larger narrative of the war. Nevertheless, the image contributes to the book's general purpose to create a sense of postbellum closure and reconciliation by depicting a freed slave as an obliging member of the Union effort in order to placate white audiences anxious about the future of societal relations. By presenting such a highly staged scene within a larger narrative of Civil War imagery, Gardner crafted a photograph that naturalized unequal race relations, assuring viewers that despite the tumultuousness of the war, certain fundamental values would remain unchanged.

Barnard, certainly influenced by the success of Gardner's album, released his own collection, *Photographic Views of Sherman's Campaign* (1866), including Southern themes omitted in Gardner's book. While Gardner augmented his own album with pictures taken by other wartime photographers (including Barnard), Barnard's consists almost exclusively of his own images, taken while traveling with General William T. Sherman on his

infamous march through Georgia and to the sea. *Rebel Works in front of Atlanta* was one of five photographs of the subject contained in Barnard's album. The shot shows one of the many defensive outposts surrounding the Southern capital that were abandoned by Confederate forces as Sherman's army approached. Barnard's photograph captures four Union soldiers relaxing by a tent, the battle lines receding in the distance. But it also includes one soldier surveying the landscape, his musket suggesting defiant protection as much as scenic appreciation. He is perched high above the broad expanse of landscape and sheltered by a majestic, detailed sky (produced using a separate negative, further evidence of the image's artifice), with a far-off gaze that makes Atlanta and its environs seem both safe and filled with possibilities. Barnard claimed in the introduction to his album that "the rapid movement of Sherman's army during the active campaign rendered it impossible to obtain at the time a complete series of photographs which should illustrate the principal events and most interesting localities."[3] While the chaotic speed of modern warfare may have kept him from documenting what was considered the most savage campaign of the entire war, Barnard, like his colleagues, used the delay built into the medium to occlude the unseemly realities of war and, in turn, to construct the hope of future reconciliation. R.S.

Notes
1. Alexander Gardner, preface, *Gardner's Photographic Sketch Book of the Civil War*, vol. 1 (Washington: Philp and Solomons, 1866).
2. Ibid., pl. 27.
3. George N. Barnard, *Photographic Views of Sherman's Campaign* (1866; repr. New York: Dover, 1977), xviii.

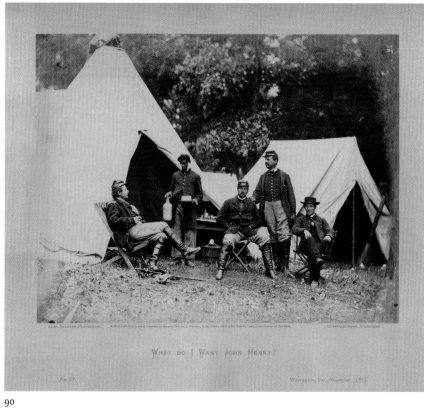

WHAT DO I WANT, JOHN HENRY?

No. 87. Warrenton, Va., November, 1862.

90

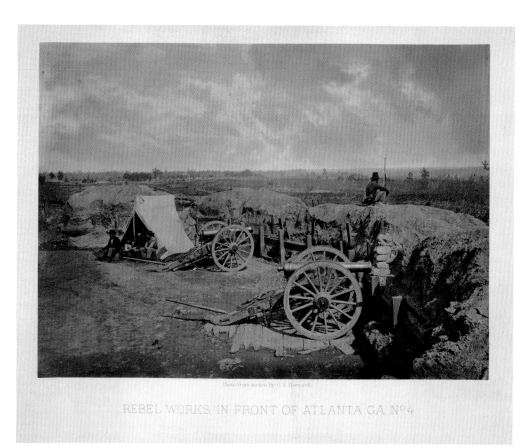

Photo from nature By G. N. Barnard

REBEL WORKS IN FRONT OF ATLANTA, GA. Nº 4

91

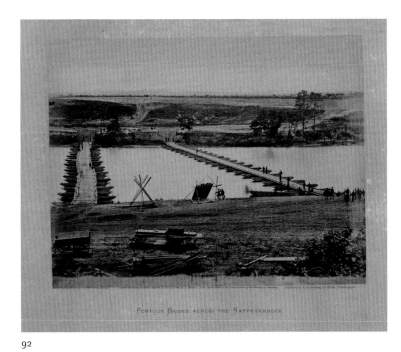

PONTOON BRIDGE ACROSS THE RAPPAHANNOCK

92

Photo from nature By: G N Barnard

TRESTLE BRIDGE AT WHITESIDE

93

92

Timothy O'Sullivan (1840–1882)
Pontoon Bridge across the Rappahannock,
plate 32 from *Gardner's Photographic
Sketch Book of the Civil War*, 1863

Albumen print, 10 ⅛ x 12 ⅛ in. (25.7 x 30.8 cm)
Gift of William A. Turnage, B.A. 1964, B.A. 1965,
1978.148.3

93

George N. Barnard (1819–1902)
Trestle Bridge at Whiteside, 1864

Albumen print, 15 ¾ x 19 ¹³/₁₆ in. (40 x 50.4 cm)
Stephen Carlton Clark, B.A. 1903, Fund, 1996.4.2

The American Civil War, like many military
engagements before and after it, was both a
force of staggering physical destruction and
a catalyst for extraordinary technological
innovation. Along with the appearance of
such military inventions as the repeating rifle,
grenades, and steam-powered ironclad war-
ships, new developments in the venerable
technology of bridges and the relatively
young technology of photography emerged
during the war. Confederate forces often
destroyed bridges to prevent Union troops
from easily traversing rivers and valleys, and
the rapid deployment of pontoon bridges
and construction of wooden trestle bridges
became an important component of the
North's military strategy. During the war,
dozens of photographers were hired by the
Union army to make reproductions of maps,
document the landscapes of battlegrounds
as a form of military reconnaissance, and, as
in these two pictures, record examples of
modern military engineering. The photo-
graphs of bridges by Timothy O'Sullivan and
George Barnard form part of a large body
of such imagery produced during the Civil
War. Although this work was considered
technical documentation, it was quickly inte-
grated into the war's historical archive and

the burgeoning aesthetic appreciation of
the still novel medium.

O'Sullivan spent three years traveling
with the Army of the Potomac, documenting
their travels and particularly focusing his
camera on the efforts of the Corps of Engi-
neering. His sustained effort as a field pho-
tographer is evidenced by his representation
in Alexander Gardner's *Photographic Sketch
Book of the Civil War*, where he is credited with
taking nearly half of the one hundred
images.[1] In *Pontoon Bridge across the Rappa-
hannock* (cat. no. 92), O'Sullivan presented
two pontoon lines that, according to the
text accompanying the image in Gardner's
Sketch Book, were originally set by the First
and Sixth Corps as part of the Union army's
unsuccessful siege of Fredericksburg in
December 1862. At that time, enemy fire pre-
vented Union soldiers from completing the
chain of boats to the opposite bank of the
river. This photograph, taken over a year
after the first attempt, depicts the river after
the Confederate forces had abandoned the
city, and it documents the most common
form of pontoon bridge, formed by stringing
together collapsible boats made from thick
canvas attached to wooden frames. One such
vessel is the subject of another plate in Gard-
ner's *Sketch Book*, also taken by O'Sullivan
(fig. a). Wooden planks were then laid across
the row of boats, allowing men and wagons
to cross the river.

Barnard was hired by the Topographical
Branch of the Department of Engineers in
December 1863 to oversee the Army of the
Cumberland's photographic operations.
Trestle Bridge at Whiteside (cat. no. 93), one of
the images included in Barnard's *Photographic
Views of Sherman's Campaign* (New York:
Press of Wynkoop & Hallenbeck, 1866),
records the impressive four-story construc-
tion built to replace a stone bridge destroyed
by retreating Confederate troops during
the Battle of Chickamauga (two masonry

pillars of the original structure are still vis-
ible). Such temporary bridges became essen-
tial to maintaining railroad connections used
to transport troops and supplies to Union
outposts throughout the South. Along with
this shot of the trestle bridge taken from
below, Barnard included other views of the
structure captured at track level.

By setting up a textural contrast between
the glassy surface of the water and the rig-
orous grid of the bridge, Barnard, like
O'Sullivan, invested his images with a sense
of calm and order that counters any chaotic
connotations of war. His decision to include
figures (sitting on the wooden beam at cen-
ter and wooden structure at right) and to
photograph his subject at an oblique angle
alludes to certain compositional tropes seen
in picturesque landscape paintings. In fact,
military officers repeatedly commented on the
beauty of Barnard's "objective" photographs
and even requested additional copies of the
images for individual framing.[2]

The presence of nine photographs of
bridges in Gardner's album and four in
Barnard's attests to the popular appeal of this
subject matter beyond its documentary value.

Northern audiences may have seen such
marvels of engineering as powerful symbols
of their side's industrial authority, which was
frequently used to justify the martial vio-
lence against what the North regarded as the
corrupted and undeveloped slave-based
economy of the South. Bridges were also
natural metaphors for the reunification of the
country that would need to take place after
the war: through their apparent objectivity
and manifestly technological subject matter,
these depictions served as subtle (and con-
sequently very persuasive) components of the
postwar effort to forge a cohesive account
of a chaotic and complex event. R.S.

Notes

1. Alexander Gardner, *Gardner's Photographic
Sketch Book of the Civil War* (1866; repr. New
York: Dover, 1959).
2. Keith F. Davis, *George N. Barnard, Photo-
grapher of Sherman's Campaign* (Kansas City,
Mo.: Hallmark Cards, Inc., 1990), 73.

fig. a Timothy O'Sullivan,
*Pontoon Boat, Brandy Station,
Virginia*, 1864, from *Gardner's
Photographic Sketch Book of
the Civil War* (Washington:
Philp & Solomons, 1865–66).
Beinecke Rare Book and
Manuscript Library, Yale
University

94

Winslow Homer (1836–1910)
In Front of Yorktown, probably between 1863 and 1866

Oil on canvas, 13¾ x 19½ in. (33.6 x 49.6 cm)
Gift of Samuel Rossiter Betts, B.A. 1875, 1930.15

Although best known for his images of New England, Winslow Homer first established himself as the preeminent American painter of the Civil War.[1] As an artist-correspondent for *Harper's Weekly*, Homer traveled to Virginia, where he documented the daily experiences of New York's 61st Infantry Regiment in a series of wood engravings for the magazine. The advent of photography, the impersonal technology of modern warfare, and the ambivalence inherent in national strife made it difficult for artists to portray the Civil War in a romantic light. Rather than focusing on heroic exploits or the idealized deaths of military leaders, typical subjects of the "grand manner" of history painting, Homer chose to represent the boredom and loneliness of camp life.[2]

The painting depicts five soldiers stationed on picket duty, miles ahead of the main camp, patrolling the front lines for enemy action. A makeshift shelter has been constructed from the surrounding pine trees. These trees have also supplied the wood and kindling for a campfire whose flames reach high into the night, filling the air with an ominous cloud of smoke and projecting ghastly tints onto the soldiers' flesh. The large central tree, the most striking compositional element in the painting, separates the soldiers from one another, emphasizing their isolation, and positions the viewer as a hidden observer, suggesting the soldiers' vulnerability.

In his choice of subject, Homer astutely distills the principal aspect of General George McClellan's strategy for his Peninsular Campaign, which began in March 1862. In an attempt to capture Richmond, McClellan decided to lay siege to Yorktown some sixty miles south of the Confederate capital, a process that required weeks of preparation. When McClellan finally decided to begin his offensive in early May, the enemy forces withdrew, leaving his troops provisionally triumphant but disappointed after so much waiting. The Peninsular Campaign would ultimately end in a Union defeat. Homer, who knew the outcome of the siege by the time he painted this work, portrayed the unrequited apprehension and exhaustion of the Army of the Potomac in the soldiers' impassive faces and listless postures.

While Homer was frequently praised for the unflinching realism of his paintings, even many of his earliest canvases contain complex symbolism. Like the Hudson River School artists who preceded him, he invested the natural landscape with expressive potential. The large central tree with two smaller offshoots splintering from it and the expanse of bark stripped from it can be read as a symbol of the divided nation suffering from the ravaging effects of war. The tree's tripartite structure also may invoke the presence of God among these soldiers. In "The Battle Hymn of the Republic," which soldiers often sang around campfires, the Lord is said to be seen "in the watch fires of a hundred circling camps." By juxtaposing the tree and fire, Homer in essence literalizes the song's conceit. *In Front of Yorktown*, one of Homer's first oil paintings, integrates the symbolic tradition of landscape painting with an unprecedented journalistic realism to forge a new approach to depicting historical events. R.S.

Notes

1. For a discussion of Homer's Civil War–era art, see Marc Simpson, *Winslow Homer, Paintings of the Civil War*, exh. cat. (San Francisco: Fine Arts Museum of San Francisco, 1988).

2. On the transformation of history painting in the nineteenth century, see William H. Gerdts and Mark Thistlewaite, *Grand Illusions, History Painting in America*, exh. cat. (Fort Worth: Amon Carter Museum, 1988), esp. 45–49.

95

Thomas Eakins (1844–1916)
The Veteran (Portrait of George Reynolds),
probably 1885

Oil on canvas, 22¼ x 15 in. (56.4 x 43.8 cm)
Bequest of Stephen Carlton Clark, B.A. 1903,
1961.18.20

During the mid-1880s, Thomas Eakins painted almost exclusively portraits of students, friends, and the intellectual luminaries of his native Philadelphia. In works like *The Veteran*, he integrated the detailed anatomy that had informed his earlier paintings with an unprecedented psychological depth, forging a new mode of portraiture in American art. As postwar industrial and economic expansion leveled previously rigid differences between social classes, new methods of representing individual distinction developed. In Eakins's dark and often austere portraits, personality is conveyed through introspective facial expression and poignant bodily gesture rather than through material accoutrements such as clothing, furniture, or landscape.[1]

The subject of *The Veteran* is George Reynolds, one of Eakins's students at the Pennsylvania Academy of the Fine Arts in Philadelphia. Reynolds served as a private in the Ninth Regiment Cavalry of the Union army from 1861 to 1864 and was awarded the Medal of Honor (which is just visible on the lapel of his jacket) for capturing the enemy's flag in battle. With his unkempt hair and beard, herringbone jacket, and burgundy silk scarf, Reynolds is depicted as both romantic bohemian and haunted former soldier. The dual foci of Reynolds's face (particularly his eyes) and his hands may indicate the sitter's sharp visual perception and technical ability as a painter. Yet by calling it *The Veteran*, Eakins invested the distinctly individual image with a more universal meaning.

Reynolds was a living monument to the war; his furrowed brow and distant, thoughtful gaze combine with his clasped hands to suggest lingering anxiety about the fate of the reunified country.

Eakins presented Reynolds as an archetypal Civil War veteran, and the subject's hands, which seem to float independent of the rest of his body, seem particularly significant. One of the most gruesome consequences of the war was the enormous number of amputees returning from the battlefield. Reynolds's apparently disembodied hands might initially seem a strange and macabre symbol of the over 45,000 amputations performed during the war. Yet their ghostly presence invokes a medical phenomenon—the "phantom limb"—that was explicitly associated with Civil War veterans and was first diagnosed by Eakins's friend the well-known Philadelphia physician and novelist S. Weir Mitchell. In 1866, Mitchell first published a story in which an amputee continues to feel the presence of a missing limb long after its removal. Writing in 1871, Mitchell noted, "There is something almost tragical, something ghastly, in the notion of these thousands of spirit limbs haunting as many good soldiers."[2] Eakins may have viewed amputation and the resultant phantom limbs as the ideal metaphor for the persistent legacy of grief and division that possessed so many Americans. In *The Veteran*, Eakins's characteristically unflinching realism, based on scientific empiricism, captures the physical scars of warfare (like the one visible on Reynolds's forehead) and its less tangible, but equally authentic, psychological consequences. R.S.

Notes
1. For an engaging interpretation of the increased subjectivity in late-nineteenth-century portraiture and Eakins's role in the trend, see David Lubin,

Acts of Portrayal: Eakins, Sargent, James (New Haven: Yale University Press, 1985).
2. S. Weir Mitchell, "Phantom Limbs," *Lippincott's Magazine of Popular Literature and Science* 8 (Dec. 1871), 565–66.

Cultural and Material Aspirations

A Changing America
and the Emergence
of a Modern Democratic Nation

In the fall of 1773, James Boswell and Dr. Samuel Johnson embarked on a tour to the Hebrides in Scotland. On their way they spent two days at Armadale on the Isle of Skye, waiting for a favorable wind for their vessel to carry them northward. While at Armadale, Boswell wrote:

We performed, with much activity, a dance which, I suppose, the emigration from Skye has occasioned. They call it *America*. Each of the couples . . . successively whirl round in a circle, till all are in motion; and the dance seems intended to shew how emigration catches, till a whole neighborhood is set afloat. Mrs. M'Kinnon told me, that last year when a ship sailed from Portree for America, the people on shore were almost distracted when they saw their relations go off; they lay down on the ground, tumbled, and tore the grass with their teeth. This year there was not a tear shed. The people on shore seemed to think that they would soon follow. This indifference is a mortal sign for the country.[1]

What Boswell and Dr. Johnson were witnessing was a climactic year in the ever-increasing migration of English and European peoples to the British colonies from the time the first settlers had arrived at Jamestown, Virginia, in 1607, and Pilgrims and Puritans at Plymouth and Boston in 1620 and 1630. Their numbers had expanded greatly after 1682, when William Penn's Pennsylvania colony became a refuge for English Quakers. They were soon joined by Lutherans, Mennonites, and other Protestants from the German states, who were fleeing war, starvation, and religious persecution. By the mid-eighteenth century, one-third of the citizens in Pennsylvania were German-speaking.[2]

The variety of settlers coming to the New World was astounding. In 1624, the Dutch West India Company created the colony of New Netherland on the island of Manhattan and in the Hudson River Valley. Eight years later, George Calvert, first Lord Baltimore, received a Crown grant for ten million acres, which he named Mary Land in honor of King Charles I's Catholic wife. It was to be a refuge for Catholics, but by 1649, the pressure of Protestant settlers was so great that Calvert's son, Cecilius, adopted an Act of Toleration extending religious freedom to Protestants as well.[3]

Meanwhile, in 1663, both native Englishmen and English planters from the sugar island of Barbados settled South Carolina. Then in 1732, General James Oglethorpe, anxious to provide a refuge and second chance for debtors and the poorer classes of England, founded the colony of Georgia. Over time French Huguenots became a significant minority presence in Boston and South Carolina (cat. no. 6), and a small number of Jewish migrants appeared in the port towns on the East Coast (cat. nos. 108–9). In 1664, British troops occupied Dutch New Amsterdam and renamed the colony New York; there, both Dutch and English peoples thrived (cat. nos. 99–101).[4]

Of utmost significance, however, were the common goals and hopes all emigrants shared in coming to America. The most common reason for emigration was a search for both religious *and* political freedom. The second was the expectation of a better life. In every colony, new

arrivals had an opportunity to acquire land, on which they could raise familiar crops, and with land ownership often came the right to vote. Equally attractive to settlers was the right to maintain their native cultures, domestic habits, and familiar lifestyles, raise their families, and make use of their skills as farmers, craftsmen, and merchants.

Despite Indian hostilities and periodic involvement in European wars, the colonial economy prospered, so that by the eve of the American Revolution, cities like Boston, New York City, Philadelphia, and Charleston were serving as trade depots and manufacturing hubs.[5] But equally important, these towns were ports from which sailing vessels, many owned by wealthy merchants, engaged in a transatlantic trade with England, Western Europe, and the sugar islands of the Caribbean. So prominent were these merchants that they had become an aristocracy of sorts, who, imitating the English upper classes and minor nobility, built elegant houses, imported fine china, silver, and furniture, and dressed in the latest fashions from London (cat. no. 104). In the desire to demonstrate success and a refined lifestyle, they were joined by successful lawyers, physicians, English colonial government officials, and well-to-do landowners. Skilled furnituremakers, silversmiths, and artists found patrons and customers among these urban elites.

The Southern colonists boasted a different sort of upper class, composed of planters who had made fortunes from raising tobacco in Maryland and Virginia, and rice, indigo, sugarcane, and sales of deerskins and timber in South Carolina and Georgia. The Southern economy was dependent on black slave labor—indeed, so dependent in the case of South Carolina that by the 1770s, slaves made up half of that colony's population.[6]

Southern planters had no quarrel with the British, their best customers, and they did their best to imitate the living habits of the British nobility (cat. no. 112). They sent their sons to England to be educated and frequently claimed descent from English gentry, often without evidence. In short, America possessed a wealthy upper class, an aspiring professional class, and an emerging middle class composed of skilled craftsmen and shopkeepers. Farming, the most widespread and basic industry of every colony, returned more modest incomes, but in the Southern colonies, a yeoman class of white farmers found itself squeezed between the wealthy planters above them and the slave population below. Class resentment and racial prejudice were to erupt in many forms and produce crises in the years to come.

By 1750, slaves were present in all the colonies—both Northern and Southern. They stood as a fundamental contradiction of the goals of white colonists: religious freedom, financial well-being, and a new life under British rule. African American slaves, unlike all other colonists, had not come willingly to the New World, and once here they were denied freedom and any right to preserve their native cultures.

During the eighteenth century, still another group of colonists was pouring into British America: the Scotch-Irish from Northern Ireland and Scotland. Scots had been lured to Northern Ireland by the English Crown to thwart the Catholic Irish. There they succeeded in farming, cattle- and sheep-raising, and the manufacture of woolen cloth. But over the decades the English decided the Scotch-Irish products were a threat to their own trade in these items, with the result that Parliament imposed debilitating trade restrictions on the Northern Irish, forbade them to acquire land in fee simple (unqualified ownership), and imposed religious restrictions on the dissenting Presbyterians.

This group thus came to America with an abiding dislike of English authority and a driving ambition to succeed. By the 1740s, the Scotch-Irish were flooding into the colonies, especially into Pennsylvania. Finding that land was unavailable in the coastal regions, they moved west to frontier Pittsburgh and then down the Shenandoah Valley to the western regions of North and South Carolina, and, by the outbreak of the American Revolution, into Kentucky and Tennessee. These colonists retained their traditions in farming and weaving and held to their Presbyterian beliefs and a desire for an educated ministry, which led later generations to send their sons to the College of New Jersey, soon to be called Princeton.[7] It was one example of the Scottish impulse to migrate to America that James Boswell and Dr. Johnson witnessed on the Isle of Skye in 1773.

By the mid-eighteenth century, emigrants coming to America found familiar institutions, established merchants, a brisk import market in English and French china, and a plenitude of talented artisans and craftsmen imitating English fashions in furniture and silver (cat. nos. 106, 111). Local artists found jobs painting the family portraits of rich merchants, lawyers, physicians, and government officials, echoing the style of portraits of English nobility (cat. no. 110). The message to England and Europe was clear: in America there was greater mobility than in Europe. Here a rising middle class could achieve not only economic success but social status as well.

The Revolution itself (1775–83) proved to be one of the most educational as well as liberating developments in the whole of American history. Revolutionary ideals were political, economic, and secular rather

than religious. Its leaders were followers of the Enlightenment and believed in the rights of man rather than in any particular sectarian religion. Without any conscious intention, inhabitants of the thirteen colonies had become experts in business and trade despite their overwhelming devotion to agriculture. Over a century of experience with their colonial legislatures and fights with their English royal governors had taught Americans a great deal about self-government, knowledge that aided in the creation of thirteen state constitutions from 1776 onward. Their self-confidence was dramatically demonstrated in the founding of Congress, which, though beset by difficulties, became a national voice.

Although the colonies seemed to represent a great diversity of people and attitudes, they were nonetheless all products of the English cultural and political heritage. They were largely Protestant, believed in the rights of Englishmen, and practiced elected representation. For over a century they had fought wars against Indians and foreigners on behalf of their British sovereign, efforts that gave the colonists a sense of accomplishment and a certain degree of unity.[8]

The Revolution was also educational in that it moved people around. Local militiamen, who seldom left their home colonies, found themselves fighting as soldiers in Boston, New York, Pennsylvania, and later on the frontiers in the South. Moreover, British troops occupied Boston, New York, Philadelphia, Charleston, and Savannah, and troops of other nations were on the ground as well. American diplomats and frontiersmen found themselves dealing with Spain in the Mississippi Valley, and after the American victory at the Battle of Saratoga in 1777, newly allied French troops mixed with Continental troops. This new relationship with France was epitomized by George Washington's friendship with a young French aristocrat, the Marquis de Lafayette (cat. no. 62).

The Revolution also stimulated the applications of science in everyday life and the improvement of civic life. Benjamin Franklin's advocacy of newspapers and printing, his experiments with electricity, and his invention of the Franklin stove inspired Americans with great pride. Franklin was also known for his efforts in civic life, seeking to improve street lighting, water systems, and fire fighting in Philadelphia (fig. 1). His countrymen also came to appreciate his acquaintance with French philosophes and scientists, and they could not fail to be impressed when the adoring Parisians called him "the American Voltaire." It was Franklin, always both innovative and practical, whose investigation of East Coast weather patterns introduced

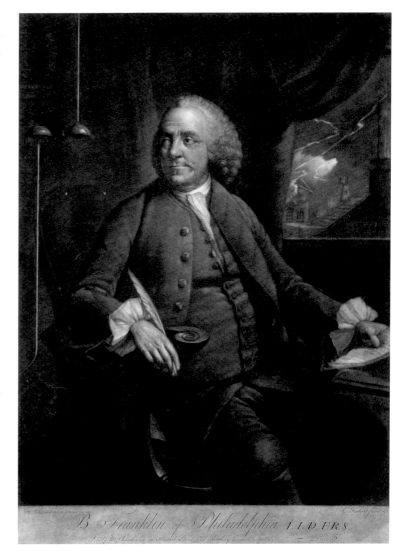

B. Franklin of Philadelphia L.L.D. F.R.S.

Americans to weather forecasting. Meanwhile, other American naturalists came to prominence, among them John Bartram, whose firsthand reports of the flora of Tennessee and Georgia were published in England.[9]

The rise of colleges, such as Harvard (1636), William and Mary (1691), Yale (1701), Princeton (1746), Columbia (1754), Brown (1764), and Rutgers (1766), point to Americans' intense interest in higher education, for men at least (cat. nos. 115–16). After the Revolution, no one represented the commitment to higher education better than Ezra Stiles, president of Yale College from 1778 to 1795. In his portrait by Samuel King (fig. 2; cat. no. 114), he wears the black garb and plain linen neckpiece of a seventeenth-century Puritan minister. But although he is holding one book, presumably a Bible, in the background we see volumes by Livy, Newton, and other famous European writers. In fact, Stiles sought knowledge wherever he could find it—in the Bible, in Hebrew and Latin texts, and in contemporary European literature. In addition, he cultivated explorers and mapmakers of the New World, kept abreast of science, and encouraged young Eli Whitney in his enthusiasm for inventing such practical things as the cotton gin and interchangeable parts for firearms. During Stiles's tenure at Yale, he began a movement to elevate the college to university status. In his way, he was a Yale version of Franklin, with whom he in fact corresponded.

Stiles's influence on higher education reached far beyond his own campus. When the founders of the University of Georgia were debating whether to adopt Jefferson's secular University of Virginia plan or the model of Yale College, Stiles sent a detailed set of instructions to them, urging them to imitate Yale. At the same time, Stiles adhered to the established purposes of higher education: to train students for careers in the ministry and in government service. Harvard's devotion to Congregationalism and Princeton's to Presbyterianism also reflected those goals. Stiles set great store in conferring degrees, certificates, and other symbols of intellectual achievement. He took special pleasure in awarding Phi Beta Kappa keys to undergraduates for outstanding academic excellence, a tradition that has continued to the present (cat. no. 117).

In America, as in Europe, medals for all kinds of achievements became common in the nineteenth century. They honored persons from all walks of life, including the patriot-artist John Trumbull, depicted in a handsome bronze American Art-Union medal (cat. no. 123). The American Art-Union, a nonprofit organization established in 1839 to

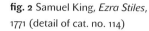

fig. 2 Samuel King, *Ezra Stiles,* 1771 (detail of cat. no. 114)

Howard R. Lamar

cultivate "the talent of artists" and "promote the popular taste," collected paintings or reproductions thereof by American artists and distributed them by lottery to subscribers. In 1849, they awarded over a thousand works by lottery among their 18,960 subscribers. Also after 1800, art schools were being established and a movement to found art museums developed.

The artist began to emerge as an important public figure in this period (cat. no. 119). Americans were proud of Benjamin West, who was highly respected in England and taught many of the finest early American painters, such as John Singleton Copley, Ralph Earl, S.F.B. Morse, Charles Willson Peale, Gilbert Stuart, and John Trumbull. Trumbull painted Washington and a series of Revolutionary scenes (cat. nos. 31–38, 58). Stuart's portraits of Washington

remain famous today. Peale, with his son Rembrandt, captured the likenesses of hundreds of renowned Americans (cat. no. 107). Peale also founded a remarkable museum in his home city of Philadelphia that displayed prehistoric and historic artifacts found in America, along with the collections brought back by Lewis and Clark after their historic trip to the West Coast (fig. 3). The museum's lasting popularity suggests how fascinated Americans were by their own ancient and recent past and by American exploration.

After the Revolution, orators, political leaders, writers, and artists turned out in force to celebrate the future of America. Foremost among the writers and poets was a patriotic Connecticut group called the Hartford Wits, whose members included the poet John Trumbull (the artist's cousin) (cat. no. 47), Timothy Dwight, David Humphreys, and Joel Barlow. In the style of contemporary English satirists, they alternately made fun of French revolutionary ideas and Jeffersonian republicanism or praised the nation's future.

In contrast, Philip Freneau, poet, sea captain, and editor of the *National Gazette* in Philadelphia, became a noted pro-Jefferson, anti-Federalist writer with his patriotic poetry and articles, and was one of the first truly professional American journalists.[10] Poet William Cullen Bryant, whose *Thanatopsis* of 1817 won him instant fame, pursued a mix of melancholy themes and "joyous broodings" on nature. His intense patriotism, devotion to freedom, and moralizing made him one of the most respected and popular American poets of the nineteenth century. As one critic has observed, Bryant "moved from Federalism, Calvinism, and Classicism, to Democracy, Unitarianism, and Romanticism."[11]

Other prominent American writers, poets, and novelists of the period between 1830 and 1860 were celebrated not only in this country but also abroad. Ralph Waldo Emerson, Congregational minister, philosopher, poet, and lecturer, published his first book, *Nature*, in 1836, but it was his many essays that earned him a national reputation. Among these, his earliest and most famous was *The American Scholar* (1837), which Oliver Wendell Holmes described as the American "intellectual Declaration of Independence." In his search for what Emerson called the "Over Soul," he experimented with new forms of religion and in the end concluded that we are all part of God. He was the most intellectual yet mystical of American thinkers and the chief exemplar of the remarkable Transcendental movement in New England.

Other New England writers—Henry Wadsworth Longfellow, Oliver Wendell Holmes, Sr., and Nathaniel Hawthorne—became wide-ranging

fig. 4 *Miniature Panorama: Scenes from a Seminary for Young Ladies*, ca. 1810–20 (detail). Watercolor and ink on silk, 7 1/16 x 96 5/8 in. (17.9 x 245.4 cm). Saint Louis Art Museum, Museum Purchase and funds given by the Decorative Arts Society

poets, essayists, and novelists. The Quaker poet and editor John Greenleaf Whittier became a crusader against slavery, but he is best known for his charming, simple poems celebrating rural life, such as "Snow Bound" (1866). Among the most impressive forces in both the cultural and political life of pre–Civil War America was Margaret Fuller. A teacher, poet, critic, and essayist, Fuller, with Emerson, founded the Transcendentalist journal *The Dial* in 1840 and became its first editor. Starting in 1844, she served as literary critic for the *New York Tribune*, and later as its correspondent in Europe. She was a social reformer committed to prison reform, abolitionism, and educational and political equality for women and minorities. Chief among the many other literary women who emerged as cultural figures was the more politically conservative Sarah Josepha Hale, poet, novelist, children's book writer, and editor from 1833 to 1877 of *Godey's Lady's Book*, the women's magazine with the greatest circulation in its era. Equally popular was the prolific poet, journalist, and novelist Lydia Sigourney, known as the "Sweet Singer of Hartford." Astoundingly, she wrote sixty books, which are suffused with a strong belief in Christianity and feature themes such as responsibility, old age, and death. Harriet Beecher Stowe achieved both national and international fame with her powerful and controversial abolitionist novel *Uncle Tom's Cabin* (1852). Although the historical significance of that antislavery book has eclipsed her other work, Stowe's literary portraits of life in New England reveal a remarkable talent for storytelling and humanizing characters.

One of the most original of the acclaimed pre–Civil War writers was Edgar Allan Poe, poet, short-story writer, editor of literary magazines, and a penetrating critic. He is credited with writing the first detective story, *Murder in the Rue Morgue* (1841), which shaped that literary genre. Well known abroad, he is said to have influenced Alfred, Lord Tennyson, Algernon Charles Swinburne, Dante Gabriel Rossetti, Robert Louis Stevenson, Sir Arthur Conan Doyle, and Charles Baudelaire.[12]

Yet the Revolution did not solve all problems. In 1783, Americans had no clear ideas about the key role of public education in the new nation. There were no plans for education generally, nor was there any real awareness that women's education had been ignored. As Abigail Adams reminded her husband, John, as he went to Congress in 1776, "If you complain of neglect of Education in sons, What shall I say with regard to daughters, who every day experience the want of it."[13]

Progress was soon under way, however. Between 1790 and 1850, women's schooling expanded rapidly (fig. 4). Ironically, the reasons were usually religious and patriotic rather than intellectual. Republican mothers were seen as virtuous citizens, and the second Great Awakening pictured Christian wives and mothers as teachers and moral guides to the young. These two beliefs combined powerfully to justify the education of women (cat. no. 124).[14]

Circumstances strengthened the hands of those promoting women in education. Teachers were in demand for increasing numbers of elementary schools, a need to which New England women in particular responded by founding female academies, one in Philadelphia in 1787 and another in Litchfield, Connecticut, as early as 1791. Nearly three decades later, Emma Willard founded the Troy Seminary, which she and her family owned and ran for three generations. In 1832, Catharine Beecher and her sister founded the highly successful Hartford Seminary. Mary Lyon Phelps opened Mount Holyoke Seminary in 1837, which

fig. 5 Julius Hutawa, *View of St. Louis*, ca. 1847. Lithograph, 20 5/16 x 23 1/2 in. (51.6 x 59.7 cm). Chicago History Museum, ICHi-20371

served as a model for other women's institutions in the Midwest and Far West as well as in the South.

Teaching was not the sole interest of able women. Susan B. Anthony and the Grimke sisters crusaded for abolition and temperance, while others wrote novels, edited women's magazines such as *Godey's*, campaigned for better divorce laws, worked for prison reform, or advocated chastity among male college youth. In 1848, at Seneca Falls, New York, Lucretia Mott and Elizabeth Cady Stanton demanded female admission to male schools and the right to vote. After 1850, women agitated for access to higher education, a movement that got an unexpected boost when Congress passed the Morrill Land Grant Act in 1862, which allowed men, women, and black American males to attend state normal schools in most states—they were restricted to whites only in the South.

The end of slavery and the granting of the vote to black American males after 1865 forced a reconsideration of the status of women as well. By the 1870s, coeducation became more dominant in public and private universities. Between 1865 and 1900, four national women's colleges appeared: Vassar (1861), Smith (1871), Wellesley (1875), and Bryn Mawr (1884). Women's colleges in the South were also founded: Judson in Alabama (1838), Mary Baldwin in Virginia (1842), Goucher in Baltimore (1885), Agnes Scott in Georgia (1889), and Randolph-Macon in Virginia (1891). A religiously sponsored new school finally brought coeducation to Massachusetts, when Boston University, founded by Methodists, admitted women to all of its programs (1872). Although there were still periodic rebellions against coeducation, "the number of females enrolled in institutions multiplied almost eightfold from eleven thousand to eighty-five thousand."[15] These women came from the broad and expanding middle class, often the offspring of doctors, lawyers, ministers, professors, and teachers who believed in a well-rounded education, including the study of the liberal arts.[16]

Undoubtedly the most spectacular long-range heritage of the American Revolution was the acquisition from the British of the western region between the Appalachian Mountains and the Mississippi River, transferred by the Treaty of Paris of 1783.[17] Despite sustained conflicts with the Indians and the War of 1812, white settlers began to pour into the Mississippi Valley, and by 1820, fully 25 percent of the population of 9.6 million Americans lived west of the Appalachians.[18] Fortunately, Congress had already established a scientific survey of public lands and instituted a territorial system of government for the future states.[19]

VIEW OF ST. LOUIS.

The splendid vision of a larger transcontinental American West came closer to reality in 1803, when Jefferson purchased from France the vast province of Louisiana, which included lands along the Upper Missouri and all the way to the Pacific Northwest. At Jefferson's bidding, Meriwether Lewis and William Clark crossed the continent from St. Louis, Missouri, to the Columbia River on the Pacific coast and back, a historic trek that lasted from 1804 to 1806 (cat. nos. 18–20). Their report on the nature of the country's newest acquisition was invaluable.[20]

By 1825, St. Louis was the major city on the Mississippi River. It became the port for a growing steamboat and river trade to New Orleans and the jumping-off place for government expeditions (fig. 5).[21] It was also a center for the booming fur trade carried on by large fur companies that, rather than depending on Indians for their supply, used white trappers in the field. These intrepid souls, who came to be called "mountain men," traversed the uncharted regions of the West.[22] Their intriguing exploits became the subject of a popular novel by James Fenimore Cooper, *The Prairie* (1827). A decade later, America's most famous author, Washington Irving, wrote about the fur trade and its

trappers in three books: *A Tour on the Prairies* (1835), *Astoria* (1837), and *The Adventures of Captain Bonneville* (1837) (cat. no. 174).[23]

Meanwhile, the city of St. Louis came to play an even more important role in the entire trans-Mississippi West.[24] Missourians marked the first wagon trail to Santa Fe, New Mexico, in 1821 and developed a lively trade in manufactured goods there, returning to Missouri with Mexican silver, mules, buffalo hides, and furs (cat. no. 192). By 1840, it had become a million-dollar business.

The Santa Fe trade marked the first encounter between Anglo-Americans and the Hispanic people of New Mexico, who had settled there after 1598 and who now numbered more than thirty thousand. Americans were unfamiliar with the Spanish language and the distinctive Catholic culture they found there. They were amazed to find peaceable, farming Indians, the Pueblo, but by the same token felt threatened by the nomadic, warlike Comanche, Apache, and Navajo Indians. Over time, however, the Missouri and New Mexico economies became so closely tied that traders from St. Louis and Westport Landing, Missouri, often settled in New Mexico, married into Hispanic families, and secured large land grants from the cooperative governors of the province. Not surprisingly, when the Mexican War broke out in 1846, the New Mexico economy was so dependent on the American trade that its leaders surrendered to invading U.S. army forces without a shot being fired.[25]

In the early 1820s, two Missouri citizens, Moses and Stephen F. Austin, secured a large land grant from Mexican officials to establish a colony in Mexican Texas. Beginning in 1821, Stephen F. Austin and other colonizers, called "empresarios," brought in a great many American settlers—often planters from the South, along with their slaves. They soon outnumbered the native Tejanos and refused to respect the latter's Catholic religion or Mexican laws against slavery.

By 1835, conflicts and outbreaks of violence had become so common that American settlers pushed for political autonomy. When Mexican forces under General Antonio López de Santa Anna attacked and killed American defenders of the Alamo at San Antonio, Anglo Texans declared for independence. With the aid of volunteers from the United States, the Americans, led by General Sam Houston, defeated Santa Anna at the Battle of San Jacinto.

The political entity that resulted, which called itself the Independent Republic of Texas, elected its hero, Houston, to be its first president in 1836. After ten turbulent years, however, the Lone Star State accepted the invitation of President John Tyler and the Congress to join the Union, which it did in February 1846.[26]

During the 1830s, Americans also became interested in the Oregon Country as a new farming paradise. Their knowledge of Oregon derived from somewhat biased sources: eastern propagandists who praised the region, American missionaries who were in Oregon trying to convert Indians to Christianity, and fur traders and merchants who were competing with the Hudson's Bay Company for pelts in the region. The problem was that the Oregon Country was still jointly occupied by Great Britain and the United States. With the knowledge that wagons could now travel all the way from the Mississippi to Oregon, an "Oregon fever" had broken out. Between 1838 and 1846, six thousand American pioneers succeeded in crossing the Oregon Trail, aided by both official and unofficial trail guides, many of whom were experienced mountain men.

Perhaps the most popular image of the occupation of the American West is that of a pioneer family in a covered wagon moving across a vast and dangerous landscape (fig. 6). As one historian commented, the wagon symbolized "the ark of Manifest Destiny lost in a sea of grass. Somehow the family must escape the Indians and make it to the wagon train ahead, to the fort, to water, to Oregon, or to Golden California. The image is a stereotype and therefore misleading, but it is an enduring symbol of one of the most common mass frontier experiences in the history of the United States."[27]

The participants themselves saw the journey, often lasting three to six months, as the most daunting challenge of their life, and they wrote more personal accounts—diaries and journals—of the Oregon and California trails than of any other American experience except the Civil War. Altogether some seven hundred thousand men, women, and children traveled the two trails between the 1830s and the coming of the Union Pacific Railroad in 1869.

Once the Oregon pioneers arrived, they ignored British authority, organized their own government in 1843, and petitioned to make Oregon a part of the Union. Despite threats of war, Great Britain ultimately agreed to move north of the 49th parallel to British Columbia. Oregon eventually became a U.S. territory in 1849, and ten years later a state.

A different type of migration paralleled the Oregon trek. A new American religious group calling themselves the Mormons (the Church of Jesus Christ of Latter-day Saints), founded by Joseph Smith in 1830, had faced two decades of hostility from American Protestants in Ohio,

Howard R. Lamar

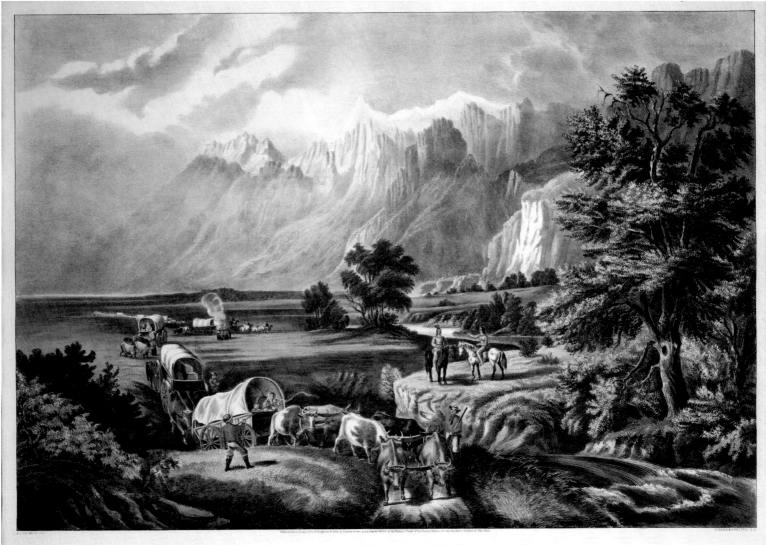

fig. 6 Frances F. Palmer, published by Currier & Ives, *The Rocky Mountains, Emigrants Crossing the Plains*, 1866. Lithograph, 19 3/16 x 25 3/16 in. (48.7 x 64 cm). Beinecke Rare Book and Manuscript Library, Yale University

fig. 7 Andrew J. Russell, *East and West shaking hands at laying last rail*, from portfolio of photographs taken during construction of the Union Pacific Railroad, vol. 2, 1869. Yale Collection of Western Americana, Beinecke Rare Book and Manuscript Library, Yale University

Illinois, and Missouri. In 1847, they moved to the Utah Basin and founded their own state of Deseret. Led by Smith's successor, Brigham Young, the Mormons thrived in Salt Lake City and in outlying settlements. In 1850, Deseret became the Territory of Utah.

During the 1840s, American politicians and expansionists argued that it was our "manifest destiny" to overrun the continent and acquire not only Texas and Oregon but California as well. Thus, in 1846, when Mexico refused to acknowledge the American annexation of Texas, President James K. Polk used an incident in which Mexican forces attacked U.S. troops on Texas soil as a pretext and declared war with congressional assent.

With eventual victories in northern Mexico by General Zachary Taylor, and a brilliant campaign by General Winfield Scott, who landed troops at Vera Cruz and marched overland to take Mexico City, Americans won the war. Meanwhile, General Stephen W. Kearny, having peacefully occupied New Mexico, set out across Arizona to conquer California. After initial resistance by California troops, officials there surrendered the province. By the Treaty of Guadalupe Hidalgo (1848), the United States acquired the northern half of the Mexican nation: Arizona, California, Nevada, New Mexico, Utah, part of Colorado, and Texas.

While Congress debated what to do with the new territory and whether to permit slavery in any region but Texas, gold was discovered in California. On 24 January 1848, James W. Marshall, a carpenter working for Colonel John Sutter of Sacramento, found gold particles while building a millrace on the American River, forty miles east of

Howard R. Lamar

Sacramento. That discovery rapidly transformed the isolated Mexican province of Alta California into "El Dorado," as news of it quickly spread in the winter and spring of 1848 (cat. nos. 175–76, 179, 201 fig. a).[28] By the end of the year, news of gold had generated such a frenzy of interest that President Polk included mention of it in his annual message to Congress on 5 December 1848.

The president's message created a "gold fever" throughout the nation, and thousands of Americans, especially young unmarried males, struck out for California. As one gold seeker wrote, "The stories from the mines breathed the spirit of the Arabian tales, and visions of 'big lumps' floated before our eyes." In the words of a song of the period, "Like Argos of the ancient times / I'll leave this modern Greece: / I'm bound to California mines, / To find the Golden Fleece."[29] Some sixteen thousand "Argonauts" reached California in 1849 by sailing around Cape Horn, and nearly twelve thousand more came in 1850. Between thirty-five thousand and fifty thousand others sailed to the Isthmus of Panama and crossed either Panama or Nicaragua, hoping to find ships on the Pacific side to take them up to California.

Meanwhile, tens of thousands of gold seekers planned their trips overland, organizing emigrant companies of neighbors and friends. By March and April 1849, they had traveled by railroad, steamboat, or wagon to the jumping-off places of St. Joseph and Independence, Missouri. There they had to buy draught animals, wagons, and supplies, then often waited hours or days for ferries to take them across the Missouri River. Cholera struck in 1849, killing more men than had died in the Mexican War. Once on the trail, there was always the danger of stampeding oxen or mules, drowning in swollen streams, or falling ill. While nearly all of the earlier versions of the gold rush stressed the frontier qualities of the experience—the rampant individualism of the gold seekers, armed with guns and quick to take offense, and the fighting, drinking, gambling, and thievery in the outfitting towns—many "Argonauts" were in fact well-educated, responsible young men from loving, deeply religious families, who organized in emigrant companies that included lawyers, doctors, ministers, editors, farmers, and mechanics. A typical company, the Wolverines from Michigan, elected officers, agreed to obey rules on the trail, observe the Sabbath, and take turns cooking in their separate messes. The superb diary of William Swain, a Youngstown, New York, native who joined the Wolverines, shows that he was homesick for his wife and family throughout, but while on the trail he was seldom without company. Like so many others,

Swain returned home disappointed: after two years, he had only five hundred dollars in his pocket and was seriously ill from a fever caught while crossing the Isthmus of Panama.[30]

By 1850, whole families were beginning to come to California. Women found ready employment as bakers, laundresses, boardinghouse operators, and even as bartenders. By 1850, California had been admitted to the Union as a state, and overnight San Francisco became a major port city, through which flowed gold seekers from Mexico, Chile, Australia, China, and Europe (cat. nos. 177–78). Thousands of shrewd merchants, bankers, and small businessmen also came to the city from the East.[31]

California gold changed the old Jeffersonian view that the West would be an agricultural empire. Instead, it came to be seen as a fabulous mineral empire awaiting discovery and exploitation. The myth actually came true when prospectors found gold and silver in Nevada and Colorado in 1859–60, in Idaho and Montana in the 1860s, in Arizona and Dakota Territory in the 1870s, and in Alaska during the 1890s (cat. no. 180).[32]

As the largest city west of St. Louis, San Francisco marked the coming of urban culture to the Far West, with theater, music, and concerts, writers like Bret Harte and Mark Twain, bookstores, and scores of newspapers and public schools. Its businessmen made it an imperial city that soon dominated the Far West economically. The gold rush forced the development of cross-country travel and communication. Colorful attempts by overland stagecoach lines and the pony express to carry mail more effectively gave way to telegraph lines even before the Civil War, and the completion of the transcontinental railroad, the Union Pacific, in 1869 (cat. no. 191). Two companies, one building from Omaha west and one from Oakland, California, east, finally joined at Promontory Point, Utah (fig. 7). As an enthusiastic journalist present at that historic ceremony rhapsodized: "Two engines on a single track, half a world behind each back."[33] California and the entire American West had now become an integral part of the nation.

Easterners, originally fascinated with the heroic saga of the Oregon Trail and the expansion of the western mineral empire, had by the 1870s moved on to an intense interest in the last tragic Indian wars and the confining of Indian tribes to reservations, where attempts were made to turn them into farmers and to Christianize and educate them in Western fashion. At the same time, a new industry—open-range ranching—arose in the West, made possible by the unchecked slaughter

fig. 8 Cover illustration, from *Buffalo Bill's Wild West and Congress of Rough Riders of the World* (Chicago: Blakely Printing Co., 1893). Yale Collection of Western Americana, Beinecke Rare Book and Manuscript Library, Yale University

fig. 9 Frederic Remington, *What an Unbranded Cow Has Cost*, 1895 (detail of cat. no. 194)

fig. 10 Thomas Cole, *View from Mount Holyoke, Northampton, Massachusetts, After a Thunderstorm (The Oxbow)*, 1836. Oil on canvas, 51½ x 76 in. (130.8 x 193 cm). The Metropolitan Museum of Art, Gift of Mrs. Russell Sage, 1908 (08.228)

of buffalo for their hides (cat. no. 173). Huge areas in Texas and the Great Plains, with their abundant grasses, were now opened to cattle ranching.

Ironically, it was ranching that gave the nation its latest folk hero—the cowboy. In reality the cowboy was usually a young, poorly paid ranch employee who herded cattle, branded them at roundups, and drove large herds to markets hundreds of miles away. Even so, the cowboy had to be a skilled horseman and roper, someone who could deal with stampedes and dangerous river crossings in any kind of weather. He had to know how to shoot a gun to ward off animal predators and cattle thieves. At first viewed as a rough-and-ready delinquent youth who sometimes shot up the end-of-trail midwestern towns while on a drunken binge, his unusual skills with horse and lariat were soon displayed in rodeos. As these became popular events, Buffalo Bill Cody launched his commercial Wild West Show in 1883, eventually touring the larger cities in the United States and Europe for more than three decades. Buffalo Bill created a lasting romantic image of the cowboy that made him an American folk hero (fig. 8).

The cowboy also became a favorite subject for painters, most notably Frederic Remington and Charles M. Russell, who each painted cowboys and the ranching life in his own distinctive style. A former cowboy himself, Russell portrayed the cowboy in a humorous way, echoing his rambunctious life, while Remington, who had briefly tried to ranch in the West, was totally devoted to cowboy life and determined to preserve its memory in any way he could. Nevertheless, he showed his awareness of the darker side of this way of life, with its frequent feuds and gun battles (fig. 9; cat. no. 194), and painted memorable scenes of the passing of open-range ranching. Remington's friend Owen Wister, after visiting the West, wrote *The Virginian* (1901), a classic novel about the cowboy as hero.[34]

In many ways, the American West had become a multifaceted symbol of the entire nation, highlighting a series of economic miracles, accommodating racially diverse peoples—Indians, Hispanics, Asians, Euro-Americans, African Americans, Anglo-Americans (cat. nos. 181–82)—and establishing the cowboy as an icon of American valor and virility. In the long run, however, the most exciting symbol of the West was its spectacular landscape of incredible mountains, vast natural parks, almost legendary rivers, and a magnificent seacoast. It is to the discovery and appreciation of the aesthetic West that we now turn.

The first appreciation of the majestic landscape of the American West began in the East with urban writers and artists, who had eagerly

adopted the views of English Romantic writers like Samuel Taylor Coleridge, Lord Byron, John Ruskin, and others. By the 1840s, it was commonplace for the eastern and even European literati to make excursions into the wilds, collect "impressions," and then "write of love of scenery and solitude in the grand Romantic manner."[35]

The first artist to celebrate the American wilderness was Thomas Cole, who in 1825 began to paint the wilder regions of the Catskill Mountains of New York. After several years in Europe, he returned to assert the unique and glorious features of American scenery. God, he said, was the creator, not man, and in viewing his "undefiled works . . . the mind is cast into the contemplation of eternal things."[36] In fact, Cole's paintings, such as *View from Mount Holyoke, Northampton, Massachusetts, After a Thunderstorm (The Oxbow)* (fig. 10), idealized a combination of the sacred wild and the civilized.

Cole's successors, in particular his student Frederic E. Church, continued the portrayal of the wilderness, as demonstrated in paintings such as *Mt. Ktaadn* (cat. no. 136) and *Twilight in the Wilderness* (1860, Cleveland Museum of Art). The next generation of landscape artists, however, found their wilderness subjects in the Far West. By the 1860s, Albert Bierstadt had begun to depict the Rocky Mountains on huge canvases. His great success with those works led him to visit and paint the "early show places" of the West: Yosemite (cat. no. 201), Yellowstone, and the Grand Canyon.

The Yellowstone paintings of British-born Thomas Moran are said to have influenced Congress to set aside that area of the West as a national park in 1872 (fig. 11). Photographers were capturing the same scenery with their cameras at that time. William Henry Jackson (cat. nos. 199–200) actually worked with Moran, and Bierstadt came to know and admire the California and Yosemite photographs of Carleton Watkins (cat. nos. 195–97) and Eadweard Muybridge (cat. no. 198).[37]

More than any other artist, it was Bierstadt whose vision and imagination shaped Americans' attitude toward the West, "a West that embodied a sense of sublime scale, of naturalistic wonder, of geological drama, and nationalistic pride."[38] By the 1870s, he was internationally renowned and perhaps the most popular American painter of his era, whose works brought him substantial income from rich buyers. As much as anyone, he made the national parks sacred American spaces, which they remain today.

The dramatic expansion of the United States westward to the Pacific Coast, between 1800 and 1860—a movement often highlighted by national sectional and political crises—has in the past led historians to ignore the concurrent spectacular rise of American cities. In 1790, the nation's largest city, Philadelphia, had only 54,388 persons, according to the census of that year (cat. no. 144). After 1790, East Coast cities like Boston, New York, Philadelphia, and Baltimore started to boom. By 1860, almost one in six Americans could claim to be an urban dweller.[39]

From the start, the four largest cities competed with one another to capture the trade of states west of them. Their strategies were obvious: each constructed rival transportation routes to the West—first by building turnpikes, then by digging canals. The magnificent 323-mile Erie Canal, completed in 1825, connected New York City to Buffalo and the Great Lakes, opening the entire upper Old Northwest to trade with New York (cat. nos. 145–47). A westward craze for canals led other states to near bankruptcy as they set about constructing canals to connect natural waterways with the port of New Orleans or to link Pittsburgh with Philadelphia. By the 1830s, however, the "all-conquering steam railroad" had become the key to controlling regions and reaching markets nationally (cat. no. 171).[40] A brilliant combination of the Erie Canal and west-going railroads made New York the most successful port in the nation: its population, sixty thousand in 1800, grew to eight hundred thousand by 1860.[41]

This rate of growth meant that New York and all other eastern cities from Boston to Charleston, as well as those in the West like Pittsburgh, Cincinnati, Chicago, and St. Louis, had to scramble in order to survive. They faced monumental tasks: providing adequate water supplies, sewage disposal, garbage collection, street lighting, and fire fighting; reordering and paving streets; and preventing crime. In addition, they found themselves dealing with public health issues such as vaccinations and hospitals. And from the start, they had to respond to business demands for adequate marketing facilities.[42] Miraculously, the cities successfully responded to these challenges with numerous innovations that put them well ahead of European cities in the provision of services. Let us consider the remarkable example of New York City between the 1830s and 1870s.

At first, the city depended on spring-fed ponds, local wells, water carried in from outside the city, and rainwater collected in cisterns or tanks.[43] After a great fire in 1835, which leveled twenty blocks, the city finally agreed to dam the Croton River in Westchester County and pipe its water into Manhattan. Seven years later, in 1842, the 40.5-mile Croton Aqueduct was opened, and for the next seventy-five years it was the main source of water for Manhattan residents. By tapping additional streams, the Croton Aqueduct system had by 1890 increased to three times its original size.

Sewage from the city was initially dumped into the river or an open canal, but eventually New York built wood and, later, brick and stone pipes. Only in 1849 did the city begin a comprehensive sewer system, which constantly expanded so that by the 1890s, "New York city had 464 miles of sewers, more than any American or European city except Chicago." It is worth noting that in 1894, half the residents of the city's tenements lived in houses with flush toilets. Garbage collection was first provided by private contractors. By 1866, with the establishment of a Metropolitan Board of Health, the city instituted a more scientific approach to garbage collection and disposal, and by the 1890s, street sweepers could be seen in their characteristic white duck uniforms.[44]

Volunteer fire fighters could be found in every major city by the late eighteenth century (fig. 12; cat. no. 72). New York actually formed a municipal fire department in 1778, which by the 1800s boasted hook-and-ladder units and thirty-four engine companies staffed by more than one thousand volunteers. Given the incredible growth of the city, the system underwent considerable reorganization after 1865 (cat. nos. 73–74).[45]

The city pioneered in developing public transportation, introducing the omnibus, a horse-drawn vehicle, in 1831, and it soon became a leading manufacturer of such vehicles in the United States (cat. no. 147). Omnibuses were joined by street railways, essentially a horse-drawn carriage on rails. They were supplemented by cable cars, but because of strenuous local opposition to poles and overhead wires, electric streetcars were not introduced until 1900. Boston, already using elevated street railways, was the first to introduce the subway; New York did not begin to construct subways until around 1900.[46]

The story of lighting in New York City is one of both swift evolution and endless competition. Early in the nineteenth century, oil-burning streetlamps were replaced by those burning gas manufactured from coal. The first gas company was incorporated by the state legislature in 1823, and although it had an exclusive franchise from the city for thirty years to lay underground pipes, other companies got into the business, and between 1858 and 1878 there was intense competition and a drop in prices. In 1880, the Brush Electric Light Company introduced the dazzling electric-arc streetlights and also built the city's first central electric station. Almost immediately, however, Thomas A. Edison eclipsed the arc light with his direct-current incandescent bulb. Edison's company was soon challenged when Westinghouse and other firms introduced the alternating current.[47]

Although New York boasted constables and marshals appointed by the mayor as early as 1800, crime was rampant, resulting in many complaints. Inspired by the creation of the metropolitan police force in London during the early 1840s, New York officials decided to create a full-time professional police force (cat. no. 68). After an initial success, it became so mired in political corruption from the 1870s to 1900 that critics called it a major failure in urban public services.[48]

It is little appreciated that the real heroes of this era were the professionals who worked in and with city government: engineers, insurance underwriters, public utility magnates, labor union officers, and bankers. Professional engineers, for example, built the cities' modern streets and constructed remarkable bridges such as the Brooklyn Bridge (cat. no. 225).[49]

Any story of American cities must acknowledge their central role in shaping American culture. Cities lavishly patronized arts and letters, creating "a varied and vital intellectual life . . . of which any nation might be proud."[50] In the cities could be found magazines for every taste, many newspapers, and publishing houses, most prominently in Boston and New York. Although Americans did not lead in architecture, theater and art flourished. New York City, home to the National Academy of Design (1825) and the Metropolitan Museum of Art (1870), became in effect "the nation's art center." Other museums and historical

fig. 12 *Fireman's Trumpet.* New York City, 1852 (detail of cat. no. 72)

and cultural societies were founded, among them the American Museum of Natural History (1869) and the Metropolitan Opera Company (1883), which eventually built an impressive opera house with 3,700 seats at Broadway and Nineteenth Street.[51]

American cities from San Francisco to Chicago vied with New York in modernizing and applying technology to their infrastructure. By 1900, Chicago had water, sewage, fire fighting, and lighting systems that were even more impressive than New York's, leading urban experts to assert that American cities were the most modern in the world (cat. no. 227).[52]

Water- or steam-powered textile mills appeared in Lowell, Massachusetts, as early as 1823. At the same time, other small factories were built in the North and the older Midwest. They were often located in villages and small towns still favored with tree-lined streets, traditional churches, and a rural setting. But soon items such as Hitchcock chairs, Connecticut shelf clocks, and various kinds of glassware were being produced in bulk and nationally distributed, often by Yankee peddlers in the South and the Midwest (cat. nos. 148–49). The construction of a mill was usually welcomed by the local people, who saw it as a potential new source of employment and tax revenue. Far from thinking it could be a threat to their lifestyle and environment, they saw industry changing the "wilderness" into a "garden" and viewed steam power as the means of manufacturing new products that would bind the nation together (cat. nos. 156–57).

Between 1840 and 1860, however, large-scale industrialization did occur, most often but not exclusively in major cities (cat. nos. 137, 156–57). At first embraced by the nation, in time these booming industries came to be seen as a threat to agriculture, which had always been the largest business and the chief source of livelihood in the United States, especially for the farming population in the South. After 1830, political debate erupted in Congress over whether to enact a high tariff to protect infant industries or to continue a low one favoring the export of American agricultural products overseas. Southerners, in particular, came to feel that Yankee factories, businesses, and banks were overcharging them and getting rich at their expense. That sense of grievance on the part of Southern farmers and planters helped kindle sectional hostility, eventually resulting in the South's secession from the Union and the tragic Civil War.

By contrast, a more democratic and reform-minded culture had developed in the North and the Midwest. Voting rights had expanded, but still excluded women and non-whites. During 1830–31, Charles G. Finney and others led a powerful religious revival—often called "the Second Great Awakening"—which converted many Americans to an emotional, evangelical, and more optimistic view of humankind and the ability to overcome sin, be saved, and reform society. In 1831, William Lloyd Garrison began his abolitionist newspaper, the *Liberator*, and two years later founded the American Anti-Slavery Society, dedicated to the abolition of slavery in the United States. Religious reform, social reform, and the antislavery crusade combined to produce what was certainly the most extensive and profound impulse for reform in our history (cat. no. 87). The widening religious and democratic vistas gave rise to a new generation of poets, Walt Whitman among them, writers, and women novelists; petitions for women's rights; an enormous expansion of public schools; and more humane treatment of the insane, as well as fascinating experiments in communitarian life.[53]

The American South, however, having already experienced slave rebellions in 1822 and 1831, became convinced that the future of slave labor, the institution on which they depended for their livelihood, was being threatened by the abolitionists. Ninety percent of the South's four million slaves worked on plantations and farms, which by 1860 were producing 4.8 million bales of cotton a year—by far the largest commercial crop raised in that region.

While the farming populations of the North and the Midwest had greatly benefited from a technological revolution of their own—the development of the steel plow by John Deere in 1837 and the mechanical reaper by Cyrus McCormick in 1834—no comparable technological breakthrough had aided the South since it had adopted Whitney's cotton gin after 1793.

Increasingly the South became a closed society that defended slavery, while its leaders proposed the extension of that institution westward into Texas and eventually Kansas and Nebraska. By the 1850s, the Northern and Southern Methodist and Baptist churches had split, and famous Northern writers like Emerson, Henry David Thoreau, James Russell Lowell, and others were producing antislavery literature. Then in 1852 Harriet Beecher Stowe wrote her powerful abolitionist novel, *Uncle Tom's Cabin*. Meanwhile, the new Republican Party rose to prominence advocating free soil.

The climax came in 1859, when John Brown, an abolitionist who had not hesitated to use violence in the service of his cause, conducted a raid on the federal arsenal at Harpers Ferry, Virginia. Inevitably, Southerners saw a vast conspiracy behind the raid; in the words of James

McPherson, they "identified Brown with the abolitionists, abolitionists with the Republicans, and the Republicans with the whole North." In the election of 1860, Abraham Lincoln, the Republican candidate, won a major victory over three other candidates but received no Southern votes in the electoral college.[54]

The mournful saga of the Civil War, in which 620,000 young men died, needs no recounting here; it suffices to note that even before the Union forces defeated the Confederacy, Lincoln had freed the slaves, and Congress gave them citizenship and the right to vote by passing the Fourteenth and Fifteenth Amendments. Congress then imposed more than a decade of military occupation and political reconstruction on the South, which ended only in 1877. Although the South was glad to be back in the Union, a new generation of leaders, calling themselves "the Redeemers," favored commercial and industrial development but clung to a belief in white supremacy. Over time they effectively denied the right to vote and civil rights to black Americans.[55]

Moreover, the South, by uniting with the Southern wing of the Democratic Party, became a one-party section for the next hundred years. And while the older great plantations disappeared and new industries developed, most black Americans were bound to the new economic system of sharecropping, which kept them tied to the land in a dependent position.

During the Civil War years, Union farms were blessed with abundant harvests and increased demands from the war economy. After the war, and despite Indian hostilities throughout the Great Plains, western agriculture expanded dramatically, creating both competition and enticement for eastern farmers. In fact, more land in the Great Plains region was settled and brought into cultivation between 1870 and 1900 than in any previous period of American agricultural history. The Union farming population took full advantage of the 1862 Homestead Act, which promised 160 acres to a homestead applicant if certain conditions were met within five years.[56] During the 1870s and 1880s, new techniques in the Dakotas, called "bonanza" farming, enormously increased the American grain supply.

This initial halcyon period, in which agriculture came to be seen as the truest American way of life, was soon disrupted. Farmers realized that the railroad companies were charging them excessive shipping fees and that eastern bankers were imposing usurious rates on their mortgages. They also felt that they were being victimized by the grain-elevator owners and middlemen. In a series of responses, farmers organized

to protest these practices and eventually succeeded in passing some state laws that restricted excessive railroad and other fees.[57]

It was now midwestern and Great Plains farmers, rather than Southerners, who felt cheated of their fair share. By the 1890s, farmers resorted to political counterattack by forming protest parties such as the Farmers' Alliance and by winning seats in Congress in 1892. In 1896, under the banner of the Populist Party, they allied themselves with the Democratic Party in the national election of that year, strongly challenging the eastern urban dominance of the country. Their agrarian faith was brilliantly expressed by the Democratic candidate, William Jennings Bryan, who in a famous speech exclaimed: "Burn down your cities and leave our farms and your cities will spring up again as if magic. But destroy our farms and the grass will grow in the streets of every city in the country."[58]

Ironically, it was the East and the cities that triumphed in 1896 with the election of William McKinley. A Republican ascendancy—reinforced by a renewed prosperity in 1897, due partly to the onset of the Spanish-American War and the return of good weather to the Great Plains after a ten-year drought—ended the last great agrarian protest and set the nation on a course to an even more powerful big-business and urban America. Census figures clearly illustrate the story of change. In 1870, the United States had a rural population of twenty-nine million, while the urban population numbered ten million. By 1900, the rural population was forty-five million, but urban dwellers numbered thirty million, and at least six American cities each boasted a population of over a million.[59]

In the short span between 1870 and 1900, a social, economic, political, and cultural revolution took place in the United States, out of which emerged a new American society and culture. Writers still speak with awe of some of its major features. In that period, New York, Chicago, and Los Angeles became three of the fastest-growing cities in the world, due in part to a tremendous influx of immigrants from Germany, Ireland, Italy, and Eastern Europe, along with Jews from Russia seeking asylum from czarist persecution. By 1900, 40 percent of Chicago's population was foreign born, and similar figures could be duplicated in many other major cities (cat. no. 227). America had become a melting pot of peoples.[60]

The most visible and powerful change occurred in the world of business, where new inventions and new techniques of mechanization

enabled industries to operate huge plants, recruit and control large labor forces, and sell products across the nation through an impressive, complex system of railroads. Certain industries grew to immense size, partly because of new methods of incorporation that separated shareholders from the managers of the corporation and allowed stocks to be sold to the public in massive quantities.[61]

By 1890, the most famous figures in the nation were not political leaders but a select number of multimillionaire businessmen, such as Andrew Carnegie, the leading producer of iron and steel in the United States, and Jay Gould, whose brilliant but sometimes illegal business tactics resulted in a near-total control of American railroads. The New York firm J. P. Morgan and Company was probably the most prominent banking and investment firm in the country, and Morgan, along with other Wall Street businessmen, dominated the nation's powerful financial structure. In the same period, John D. Rockefeller brought the wildly expanding oil industry of the 1860s under control through his Standard Oil Company.

Big industries themselves had moved beyond large eastern cities to Pittsburgh, Cleveland, and Chicago, and west to California. Textile mills, originally located in New England, seeing a cheaper labor supply among unskilled rural Southerners, moved to the Piedmont towns of North and South Carolina, conveniently located on major rail lines. United States Steel took advantage of coal and iron discoveries in Alabama to create the industrial city of Birmingham almost overnight. The "incorporation of America," as Alan Trachtenberg has called it, had, in fact, the most significant impact on American life and culture of any developments between the Civil War and World War I. Big-business spokesmen naturally defended the New Economic Order, as Carnegie, for example, did in his best-selling book, *The Gospel of Wealth* (1900).

Soon there were many agitated critics of the New Economic Order. In 1873, Mark Twain and Charles Dudley Warner wrote a best-selling novel entitled *The Gilded Age*. The characters were based on real people—corrupt senators, city strongmen like Boss Tweed, and naive persons who tried in vain to make a fast dollar in speculation—and the book included sensational events such as murder, seduction, and steamboat fires.[62]

"The Gilded Age" became a sobriquet for the era. The phrase stuck because industry had produced incredible new wealth that seemed merely a veneer over an unsophisticated lot of climbers: gilded, not solid gold. A class of super rich emerged, who were able to erect huge mansions, especially in New York City, Philadelphia, Pittsburgh, and Chicago, and equally grandiose mansions in summer resorts like Newport, Rhode Island, and Bar Harbor, Maine. They filled these houses with paintings by European artists, imported or commissioned the most elegant fashionable furniture available (cat. nos. 180, 212)—often gilt—and flaunted their new wealth by hosting elaborate dinners and balls, acquiring yachts, and making grand tours of Europe. They stayed at the best hotels and tried to gain acceptance to English society by marrying off daughters to English noblemen, a practice Edith Wharton dissected in her novel *The Buccaneers*. Meanwhile, they sent their children to exclusive boarding schools and to the most prestigious colleges, such as Harvard, Yale, and Princeton. The flaunting of their wealth led Thorstein Veblen, a critical young economist and social philosopher born in rural Wisconsin but educated at Johns Hopkins and Yale, to call their behavior "conspicuous consumption" because of their deliberate extravagance and wastefulness.[63]

The novelist William Dean Howells added his own perspective on the new era of big business by rejecting the older romantic and optimistic tradition in American fiction writing for a tough new realistic approach. In his best-known novel, *The Rise of Silas Lapham* (1885), he demonstrated how his title character had abandoned his belief in honesty and morality to get ahead in business; after being ruined and disgraced, he "rises" to a new appreciation of ethical standards.[64]

Critics of the new rich could not deny, however, that they had not only elevated the standard of living in the United States but were also largely responsible for founding or sponsoring nearly all the major museums and art galleries in the cities. Their largesse and sincere interest in the fine arts led to the founding of the Museum of Fine Arts, Boston (1870), the Metropolitan Museum of Art in New York (1872), the Philadelphia Museum of Art (1875), and the Art Institute of Chicago (1879).[65]

Aspiring American artists, now including both men and women, could be professionally trained in academies in Chicago, Cincinnati, and Philadelphia, at the Art Students League in New York, and in France, Germany, and Italy. With equal enthusiasm, wealthy donors sponsored symphony orchestras, the Metropolitan Opera Company, and endowed music schools and museums of history and science. Certainly one of the most generous donors was Carnegie, who founded museums and galleries in Pittsburgh and endowed public libraries in cities and smaller towns throughout the nation.[66]

fig. 13 Joseph Byron, *Slum Interior*, 1896. Gelatin silver print. Museum of the City of New York, The Byron Collection

Who would patronize these remarkable new monuments to the fine arts once they were built? Here again, industry and big business played a crucial role by creating a whole generation of urban professionals, a new middle class of salaried employees: managers, technicians, clerks, and engineers "who served the industrial corporation, and the extended government bureaucracy of the cities, including public schools."[67] This large prosperous group joined those in the traditional middle and upper classes: lawyers, physicians, teachers, successful writers, journalists, and skilled craftsmen.

The new professionals could afford houses in the suburbs and to stock them with good home furnishings (cat. nos. 160, 217–18), to maintain a garden in which their children could play, and to buy newspapers and magazines. It was these citizens who thronged the museums and art galleries, used public parks, rode bicycles, and attended serious theater as well as vaudeville shows. Their values centered on living an honorable life, maintaining strong moral and religious beliefs, and seeking self-betterment through the arts and education. They also were devoted to good health through exercise, good diet, and a sensible mix of work and play.[68]

The experience of urban immigrants, often living in crowded city tenements, was by contrast much grimmer (fig. 13). Often isolated by language barriers, treated as unwelcome intruders, and laboring under harsh working conditions in factories, they found refuge in communities of fellow immigrants. They attended church or synagogue and kept alive familiar customs, festivals, and lifestyles of the old country. They survived for the most part, but often led a hand-to-mouth existence.[69]

There were signs of a change for the better, however, on several fronts. After 1870, Americans became firm believers in public education from kindergarten through high school. School eased the adjustment of sons and daughters of immigrants to American lifestyles, as did the popular game of baseball, which by the 1870s had become a national sport.[70]

By then an impressive array of public parks had been created in every large city. Ironically, the initial promoters of such parks had been wealthy Americans who had traveled abroad and were impressed by the magnificent array of parks and public places in Berlin, London, Munich, and Paris. The elite founders of Central Park in the 1860s at first envisaged it as a place where they could drive their carriages, ice-skate in winter, and visit on weekends with their well-dressed families to enjoy the scenery and show off. At first, sporting events other than ice-skating were forbidden, and ethnic minorities and working-class

people were discouraged from using the park (cat. nos. 204–5). But inevitably Central Park and parks all over the country provided sporting facilities, public concerts, and other events that were open to everyone.[71]

Certainly one of the most important developments during the Gilded Age was the crusade for women's rights, including female suffrage and the movement to provide higher education for women. There was a notable rise of distinguished women's colleges, as we have discussed earlier, and increased coeducation at the Morrill land-grant colleges, especially in the South and Midwest.

A different kind of self-betterment occurred in urban areas, where specialized vocational courses to train women as nurses, dressmakers, stenographers, and typists sprang up, as did manual training schools for boys. Strongly advocated by businessmen who also believed in "vocational education," such courses were soon taught in regular public schools throughout the nation.[72] What was tragically missing in this array of expanded educational opportunities was any adequate program for black Americans, particularly in the South, despite some notable efforts at Howard University and the Tuskegee Institute.

The revolutionary changes that had created a new urban, incorporated America came about in tandem with a cultural revolution achieved by new generations of writers, novelists, and artists. In 1884, the brilliant young Henry James began a long career as a writer of fiction about America and American society. His novels about wealthy American women at home and abroad were powerful and penetrating, and James served as a model for later novelists such as Wharton. Hamlin Garland, who was fully devoted to realism in literature, produced powerful novels about the hard life of Great Plains families. At the turn of the century, Theodore Dreiser stunned the public with his candid portrayal of a woman of the streets in *Sister Carrie* (1900), in what came to be called a naturalistic approach.

Writers joined in a dramatic effort to bring economic justice and reform to a nation unfairly taxed and dominated by big business. Henry George published his powerful *Progress and Poverty* (1879), while Henry Adams denounced political corruption in his little-known novel *Democracy* (1882). Meanwhile, Edward Bellamy, in his utopian novel, *Looking Backward* (1888), criticized the present by depicting a future socialist society in which everyone lived a happy, prosperous, and consumer-oriented life.[73]

The new generation of brilliant American artists included Winslow Homer, Thomas Eakins, Martin Johnson Heade, Eastman Johnson,

Mary Cassatt, John Singer Sargent, and sculptors such as Augustus Saint-Gaudens. They covered a wide range of topics: nostalgic renderings of the old rural scene in New England, sports—whether of women playing croquet, men's boxing matches, rowers, or boys swimming—and, in the case of Eakins, vivid portrayals of doctors performing operations (cat. nos. 141, 202, 206–7, 138, 140, 142, 135).[74]

Artists have long found women a favorite subject, but artists of this age evidence a profound new appreciation of them as subjects of individual portraits, in the workplace, dancing, or attending museums (cat. nos. 210–11, 228–29). Even more significant is the fact that many promoters of high culture in this era were women, who became key supporters of exhibitions, symphonies, and lectures. Women artists were now attending art schools in both the United States and Europe, and many had begun to teach art in large universities. Cassatt, America's most prominent female artist, brought avant-garde French art to the attention of American collectors. The increased freedom of women to pursue the arts was one of the great achievements of the Gilded Age, reflecting the growth and prosperity in an era in which wealth per capita had more than doubled and the standard of living had risen dramatically.[75] Women's vastly improved status and visibility in American life, as schoolteachers, workers, or writers and crusaders for political and moral reform, enabled many, like Jane Addams, to address the problems of poverty, disease, and the terrible life in urban tenements.[76]

As has been noted throughout this narrative, European immigrants to America from the time of the first colonists at Jamestown and Massachusetts Bay had dreamed of a better life and over the centuries had pursued both cultural and material goals with spectacular success. Fittingly, a wonderful symbolic climax to their myriad aspirations occurred in 1893, when Chicago commemorated the four-hundredth anniversary of Christopher Columbus's discovery of America in 1492 with the World's Columbian Exposition. The theme of this most striking and beautiful world's fair was the celebration of the progress of humankind everywhere, but particularly America's coming of age as a great nation.

The idea of a world's fair to honor Columbus's achievement began in 1890, when the cities of Chicago, New York, and Washington, D.C., asked Congress to sponsor such an event. After a spirited and bitter competition, Chicago won out. Fortunately, Chicago boasted the presence of Daniel H. Burnham, a brilliant architect and city planner

who was, in the words of John W. Reps, "the towering figure of the period—a gifted designer within the style he chose to adopt, the chosen leader of his associates and a vigorous champion of civic order and beauty."[77] Assembling hundreds of artists and sculptors and scores of distinguished architects, among them Frederick Law Olmsted, the designer of Central Park and the Stanford University campus, Burnham and his team drew plans for the most ambitious fair in history. They chose a 686-acre site on Lake Michigan in Jackson Park and adjoining Midway Island. One hundred eighty-eight acres were devoted to buildings dedicated to specific subjects. In tribute to the great architectural achievements of ancient Greece and Rome, Burnham designed all structures around a Central Court of Honor in classical styles, with columns and domes in great supply (fig. 14). Thousands of workmen erected the plaster buildings with miraculous speed and painted them a creamy white. After the fair opened in May 1893, it was soon called the White City. "The sight of the gleaming white buildings disposed symmetrically around the formal court of honor echoing the classic buildings of antiquity, impressed almost every visitor."[78] The fairgrounds were illuminated by seven hundred arc lights and one hundred twenty thousand incandescent lamps.[79] Many enterprises and themes were represented. To honor American manufactures, Burnham included a building that for its time "was the largest such structure on earth." As William Cronon has written, "The fair aimed at nothing less than including exhibits of every human accomplishment. Leading the list were buildings devoted to Agriculture, Machinery, Transportation, and Electricity." In recognition of the signal achievements of women, a large Woman's Building was featured.[80] But equally impressive was the effort to present what every one of the thirty-six nations and forty American states felt were their contributions to the growth of civilization. This meant that the liberal arts were represented not only by the fine arts but also by literature and history. Famous scholars from all over the world gave lectures. It was here that the soon-to-be-honored young historian Frederick Jackson Turner gave his paper "The Significance of the Frontier in American History"—a declaration of the uniqueness of the frontier experience in shaping American democratic institutions.[81]

Burnham's classical Beaux-Arts architecture for the exposition inspired hundreds of American cities over the next two decades to copy the style for their own public buildings, notably those erected in Washington, D.C., in the first years of the twentieth century.[82] Indeed, as John Reps has observed, "The Fair seemed a vision of some earthly paradise that might yet be created in the coming era."[83] Despite its slums, Chicago was a pioneer in building skyscrapers by such architects as Louis Sullivan, for whom there were two views of future cities—one classical and one modern.

In addition to inspiring city planning and beautification as never before, the fair created a sense of progress for both city and country. As Cronon concludes in his book *Nature's Metropolis: Chicago and the Great West*, the fair symbolized that city and country "had emerged from the same past, and would grow toward the same future."[84]

In contrast to the serious political, economic, and labor turmoil of the 1890s, the World's Columbian Exposition demonstrated that the twenty-six million people who visited it from metropolis and hinterland stood far more united than not. Henry Adams articulated this feeling most aptly when he observed that the White City "expressed American thought as a unity."[85] Americans, ambitious and future-oriented as always, were now ready for the twentieth century.

Notes

1. James Boswell, *A Journal of a Tour to the Hebrides with Samuel Johnson LL.D.*, 3rd ed. (1786), published as George B. N. Hill, ed., *The Life of Johnson*, rev. ed. Lawrence Fitzroy Powell, 6 vols. (Oxford: Clarendon Press, 1934–64), 5:277–78. Gordon Turnbull, general editor of the Boswell Editions, Yale University, provided me with the Boswell quotation with which I began this essay.

2. See Philip S. Klein and Ari Hogenboom, *A History of Pennsylvania*, 2nd ed. (University Park: Pennsylvania State University Press, 1980); Mary Maples Dunn and Richard S. Dunn, eds., *The World of William Penn* (Philadelphia: University of Pennsylvania Press, 1986); and Aaron Spencer Fogleman, *Hopeful Journeys: German Immigration, Settlement, and Political Culture in Colonial America, 1717–1775* (Philadelphia: University of Pennsylvania Press, 1996).

3. Alice P. Kenney, *Stubborn for Liberty: The Dutch in New York* (Syracuse, N.Y.: Syracuse University Press, 1975); Bernard Bailyn and Philip D. Morgan, eds., *Strangers Within the Realm: Cultural Margins of the First British Empire* (Chapel Hill: University of North Carolina Press for the Institute of Early American History and Culture, Williamsburg, Va., 1991). See also Lois G. Carr, Russell R. Menard, and Lorena S. Walsh, *Robert Cole's World: Agriculture and Society in Early Maryland* (Chapel Hill: University of North Carolina Press for the Institute of Early American History and Culture, Williamsburg, Va., 1991).

4. Robert M. Weir, *Colonial South Carolina: A History* (Millwood, N.Y.: KTO Press, 1983); Kenneth Coleman, *Colonial Georgia: A History* (New York: Charles Scribner's Sons, 1976); Jon Butler, *The Huguenots in America: A Refugee People in New World Society* (Cambridge, Mass.: Harvard University Press, 1983); Michael Kammen, *Colonial New York: A History* (New York: Charles Scribner's Sons, 1975); and Abraham J. Karp, *Haven and Home: A History of the Jews in America* (New York: Schocken, 1985).

5. Jon C. Teaford, *The Municipal Revolution in America: Origins of Modern Urban Government, 1650–1825* (Chicago: University of Chicago Press, 1975), 17.

6. Peter H. Wood, *Black Majority: Negroes in Colonial South Carolina from 1670 through the Stono Rebellion* (New York: Alfred A. Knopf, 1974).

7. Ian Charles C. Graham, *Colonists from Scotland: Emigration to North America, 1707–1783* (Ithaca, N.Y.: Cornell University Press for American Historical Association, 1956) is the best survey, but see James Graham Leyburn, *The Scotch-Irish: A Social History* (Chapel Hill: University of North Carolina Press, 1962), and a summary account in Howard R. Lamar, ed., *The New Encyclopedia of the American West* (New Haven: Yale University Press, 1998), 1029–30, hereafter cited as *NEAW*.

8. T. H. Breen, *The Marketplace of Revolution: How Consumer Politics Shaped American Independence* (New York: Oxford University Press, 2004).

9. Biographies of Benjamin Franklin are so numerous and so outstanding that one need cite only the works of two recent authors: Edmund S. Morgan, *Benjamin Franklin* (New Haven and London: Yale University Press, 2002), and Gordon S. Wood, *The Americanization of Benjamin Franklin* (New York: Penguin Press, 2004).

10. Max J. Herzberg, ed., *The Reader's Encyclopedia of American Literature* (New York: Thomas Y. Crowell, 1964), 360, 436–37.

11. "W. C. Bryant," in ibid., 119.

12. Regarding America's writers, I have depended on entries in Herzberg, 1964, esp. 885–90.

13. Abigail Adams to John Adams, 14 Aug. 1776, *Adams Family Papers: An Electronic Archive*, Massachusetts Historical Society, http://www.masshist.org/digitaladams/.

14. On women's education, I am indebted to Barbara Miller Solomon, *In the Company of Educated Women: A History of Women and Higher Education in America* (New Haven: Yale University Press, 1985), xviii, 2, 14, 16.

15. Ibid., 24.

16. Ibid., 45–46, 58, 64–65, 78–93.

17. Howard R. Lamar, "An Overview of Westward Expansion," in *The West as America: Reinterpreting Images of the Frontier, 1820–1920*, ed. William H. Truettner, exh. cat. (Washington, D.C.: Smithsonian Institution Press, 1991), 1–2.

18. John Mack Faragher, *Daniel Boone: The Life and Legend of an American Pioneer* (New York: Henry Holt, 1992).

19. John Porter Bloom, ed., *The American Territorial System: Conference on the History of the Territories of the United States*, National Archives Conference, 5 (Athens: Ohio University Press, 1973); Peter S. Onuf, *Statehood and Union: A History of the Northwest Ordinance* (Bloomington: University of Indiana Press, 1987).

20. Gary E. Moulton, ed., *The Journals of the Lewis and Clark Expedition* (Lincoln: University of Nebraska Press, 1983–2001); Stephen E. Ambrose, *Undaunted Courage: Meriwether Lewis, Thomas Jefferson, and the Opening of the American West* (New York: Simon & Schuster, 1996); also J. L. Loos, "Lewis and Clark Expedition," in *NEAW*, 637–40.

21. Edwin James and Major Stephen H. Long, *Account of an Expedition from Pittsburgh to the Rocky Mountains . . .* (Philadelphia: Carey and Lea, 1823). More recent editions by Maxine Benson and others are available.

22. William H. Goetzmann, *Exploration and Empire: The Explorer and the Scientist in the Winning of the American West* (New York: Alfred A. Knopf, 1966); see esp. ch. 4, "The Mountain Men," 105–45.

23. Peter Antelyes, *Tales of Adventurous Enterprise: Washington Irving and the Poetics of Western Expansion* (New York: Columbia University Press, 1990).

24. Howard R. Lamar, *St. Louis in the Development of the American West* (St. Louis: St. Louis Mercantile Library, 2000).

25. Howard R. Lamar, *The Far Southwest, 1846–1912: A Territorial History* (Albuquerque: University of New Mexico Press, 1966; rev. ed., 2000).

26. T. R. Fehrenbach, *Lone Star: A History of Texas and the Texans* (New York: Macmillan, 1968, 1985); see esp. pts. 2, 3.

27. Howard R. Lamar, "Rites of Passage: Young Men and Their Families in the Overland Trails Experience, 1843–1869," in *Charles Redd Monographs in Western History* 8 (Provo, Utah: Brigham Young University Press, 1978), 34ff.

28. Peter J. Blodgett, *Land of Golden Dreams: California in the Gold Rush Decade, 1848–1858* (San Marino, Calif.: Huntington Library, 1999), 11, is the best recent summary. See also Rodman W. Paul, *Mining Frontiers of the Far West, 1848–1880* (1963; rev. ed. Albuquerque: University of New Mexico Press, 2001). The revised edition has additional chapters by Elliott West.

29. Blodgett, 1999, 33.

30. Using Swain's diaries and five hundred others, James S. Holliday traces Swain's 1849 trek across the continent and his life in California. J. S. Holliday, *The World Rushed In: The California Gold Rush Experience* (New York: Simon & Schuster, 1981; rev. ed. Norman: University of Oklahoma Press, 2002); see esp. foreword, ix–xiii.

31. Paul, 2001, 37–199.

32. Blodgett, 1999, 8. See also Gunther P. Barth, *Instant Cities: Urbanization and the Rise of San Francisco and Denver* (New York: Oxford University Press, 1965); Roger W. Lotchin, *San Francisco, 1846–1856: From Hamlet to City* (1974; rev. ed. Urbana: University of Illinois Press, 1997); and Franklin Walker, *San Francisco's Literary Frontier* (Seattle: University of Washington Press, 1939; Americana Library ed., 1969).

33. *NEAW*, 1136–38.

34. Edward Everett Dale, *The Range Cattle Industry* (1930; rev. ed. Norman: University of Oklahoma Press, 1960); Louis Pelzer, *The Cattleman's Frontier: A Record of the Trans-Mississippi Cattle Industry . . .* (Glendale, Calif.: Arthur H. Clark, 1936); Terry G. Jordan, *North American Cattle-Ranching Frontiers* (Albuquerque: University of New Mexico Press, 1993); "Cowboy," in *NEAW*, 265–68; Howard R. Lamar, "The Cowboys," in *Buffalo Bill and the Wild West*, exh. cat. (New York: Brooklyn Museum, 1981), 57–67.

35. Roderick Nash, *Wilderness and the American Mind* (1967; rev. ed. New Haven: Yale University Press, 2003), 44.

36. Thomas Cole, quoted in ibid., 81.

37. Ibid., 83.

38. William H. Goetzmann and William N. Goetzmann, *The West of the Imagination* (New York: W. W. Norton, 1986), 166–68.

39. Arthur M. Schlesinger, Sr., "A Panoramic View: The City in American History," in *The City in American Life: A Historical Anthology*, ed. Paul Kramer and Frederick L. Holborn (New York: G. P. Putnam's Sons, 1970), 19–20.

40. Ibid., 21–22.

41. Ibid., 22–23, and U.S. Bureau of the Census, *Historical Statistics of the United States, Colonial Times to 1970*, Bicentennial ed. (Washington, D.C., 1975), Census of 1860, 1–43. See also Robert A. Divine, T. H. Breen, George M. Frederickson, and R. Hal Williams, *America, Past and Present* (Dallas: Scott Foresman, 1984), 556–57.

42. Schlesinger, 1970, 17.

43. Kenneth T. Jackson, ed., *The Encyclopedia of New York City* (New Haven and London: Yale University Press, and New York: New-York Historical Society, 1995), s.v. "Water."

44. Ibid., 1041–43.

45. Ibid., 408–12.

46. Jon C. Teaford, *The Unheralded Triumph: City Government in America, 1870–1900* (Baltimore: Johns Hopkins University Press, 1984), 234.

47. Jackson, 1995, 673–75.

48. Ibid., 910–13.

49. Ibid., 560–63, and Teaford, 1984, 214, 227.

50. Schlesinger, 1970, 25, 31.

51. Jackson, 1995, 317, 755–56.

52. Teaford, 1984, 218.

53. Vernon L. Parrington, *Main Currents in American Thought*, vol. 2, *The Romantic Revolution in America, 1800–1860* (New York: Harcourt, Brace, 1930), pts. 2–4, 317–460. Pt. 2, "The Rise of Liberalism"; pt. 3, "The Transcendental Mind"; and pt. 4, "Other Aspects of the New England Mind," exhibit such overwhelming understanding and impressive command of detail that even after seventy-five years the book remains the best source on the subject. I have depended on Parrington, 1930, and Philip Foner and John A. Garraty, eds., *The Reader's Companion to American History* (Boston: Houghton Mifflin, 1991), and on more specific studies throughout the following pages. But see especially Betty Fladeland, *James Gillespie Birney: Slaveholder to Abolitionist* (Ithaca, N.Y.: Cornell University Press, 1955), as well as excellent summary chapters in John Mack Faragher, Mari Jo Buhle, Daniel Czitrom, and Susan H. Armitage, *Out of Many: A History of the American People* (Englewood Cliffs, N.J.: Prentice Hall, 1994), 373–403.

54. James McPherson, *Ordeal By Fire: The Civil War and Reconstruction* (New York: Alfred A. Knopf, 1982). The McPherson quotation is found in Divine et al., 1984, 404.

55. McPherson, 1982, 591–615.

56. Solomon, 1985, 6–47; "Morrill Land Grant Act of 1862," in *NEAW*, 234.

57. "Agrarian Movements" and "Granger Laws," in *NEAW*, 16–18 and 445–46, respectively.

58. "Populism," in *NEAW*, 899–901; and "'Boy Orator' Scores a Great Hit," *Chicago Tribune*, 10 July 1896, 11.

59. Schlesinger, 1970, 32–33.

60. Faragher et al., 1994, 581.

61. See Alan Trachtenberg and Eric Foner, *The Incorporation of America: Culture and Society in the Gilded Age* (New York: Hill and Wang, 1982).

62. Herzberg, 1964, 355.

63. Thorstein Veblen, *The Theory of the Leisure Class* (1899; repr. Boston: Houghton Mifflin, 1973).

64. Herzberg, 1964, 961–62; see also Vernon L. Parrington, *Main Currents in American Thought*, vol. 3, *The Beginnings of Critical Realism in America* (Norman: University of Oklahoma Press, 1987), pt. 1, "The Gilded Age," 7–179; pt. 2, "New Patterns of Thought," 189–253, but especially see his treatment of William Dean Howells, 241–53.

65. Jackson, 1995, 755–57.

66. Harold C. Livesay, *Andrew Carnegie and the Rise of Big Business* (Boston: Little, Brown, 1975); Joseph F. Wall, *Andrew Carnegie* (New York: Oxford University Press, 1970).

67. Kenneth T. Jackson, *The Crabgrass Frontier: The Suburbanization of the United States* (New York: Oxford University Press, 1985). Faragher et al., 1994, 605–6.

68. Faragher et al., 1994, 605–6.

69. Richard Plunz, *A History of Housing in New York City: Dwelling Type and Social Change in the American Metropolis* (New York: Columbia University Press, 1990). See also Jackson, 1995, 1161–63.

70. Foner and Garraty, 1991, 317–27.

71. Jackson, 1995, 177–79.

72. Faragher et al., 1994, 608–9.

73. Ralph Henry Gabriel, *The Course of American Democratic Thought*, 3rd. ed. (New York: Greenwood Press, 1986). See especially his accounts of Henry George, 208–15; Edward Bellamy, 220–24; and Henry Adams, 324–33.

74. James Thomas Flexner, *The World of Winslow Homer, 1836–1910* (New York: Time, Inc., 1969); John Wilmerding, *Winslow Homer* (New York: Praeger, 1972); Gordon Hendricks, *The Life and Work of Thomas Eakins* (New York: Grossman, 1974); Theodore E. Stebbins, Jr., *The Life and Work of Martin Johnson Heade: A Critical Analysis and Catalogue Raisonné* (New Haven and London: Yale University Press, 2000); Nancy Mowll Mathews, *Mary Cassatt* (New York: Abrams with National Museum of American Art, Smithsonian Institution, 1987).

75. Divine et al., 1984, 556–57.

76. Elisabeth Griffith, *In Her Own Right: The Life of Elizabeth Cady Stanton* (New York: Oxford University Press, 1984); Nancy F. Cott, *The Grounding of Modern Feminism* (New Haven and London: Yale University Press, 1987); Ellen Carol DuBois, *Feminism and Suffrage: The Emergence of an Independent Women's Movement in America* (Ithaca, N.Y.: Cornell University Press, 1978). In addition, see Allen F. Davis, *American Heroine: The Life and Legend of Jane Addams* (New York: Oxford University Press, 1973).

77. John W. Reps, *The Making of Urban America: A History of City Planning in the United States* (Princeton: Princeton University Press, 1965), 497. See also Thomas S. Hines, *Burnham of Chicago, Architect and Planner* (New York: Oxford University Press, 1974). For a pictorial presentation, see *Glimpses of the World's Fair: A Selection of Gems of the White City* (Chicago: Laird & Lee, 1893), and *World's Columbian Fair, Chicago* (Chicago: 1893) in the collection of the Beinecke Rare Book and Manuscript Library, Yale University.

78. Reps, 1965, 498.

79. William Cronon, *Nature's Metropolis: Chicago and the Great West* (New York: W. W. Norton, 1991), 341.

80. Ibid., 342.

81. Ibid., 31.

82. Ibid., 368.

83. Reps, 1965, 498.

84. Cronon, 1991, 396.

85. Henry Adams, quoted in ibid., 367. See also Trachtenberg and Foner, 1982, and Neil Harris, *Grand Illusions: Chicago's World's Fair of 1893* (Chicago: Chicago Historical Society, 1993).

96

Jeremiah Dummer (1645–1718)
Pair of Candlesticks
Boston, probably 1686

Silver, each 10 13/16 x 7 7/16 x 7 7/16 in.
(27.5 x 18.9 x 18.9 cm), wt. (1935.234) 25 oz.,
19 dwt. (804 gm); wt. (1953.22.1) 25 oz., 4 dwt.
(781 gm)
Mabel Brady Garvan Collection, 1935.234 and
1953.22.1

These candlesticks demonstrate the taste for
ostentatious display of the British merchant
class that rose to power in Boston in the late
seventeenth century, eclipsing the dominance
of the founding Puritan oligarchs. Made by
Jeremiah Dummer, the first native-born New
England silversmith, the candlesticks, the
earliest surviving American-made examples
known, have traditionally been associated
with the marriage of Elizabeth Usher and
David Jeffries in Boston in 1686. Their ini-
tials "J[I]/DE" are engraved on the under-
side, and the Lidgett arms are engraved on
one corner of the base. Elizabeth was the
granddaughter of Peter Lidgett (d. ca. 1676)
and Elizabeth Scammon, who married in
Barbados about 1655 and were in Boston by
1670. The candlesticks were a wedding gift to
Elizabeth, perhaps from her grandmother

or her uncle Charles Lidgett. Based on
cluster-column candlesticks made in both
England and the Netherlands, they are more
lavish than earlier silver made in Boston,
and the arms are the earliest use of heraldic
engraving on Boston silver. With their large
square bases and splayed flanges and lips,
they are firmly anchored and stake out a
commanding presence, just as the new class
of British merchants was attempting to do
in Boston.[1]

In Boston, tension was growing between
the old-guard Puritans and the merchants
with royalist leanings. It coalesced around
Sir Edmund Andros, who sought to estab-
lish the authority of the king after he was
appointed governor of the Dominion of New
England in 1686. In reference to the mar-

riage commemorated by the candlesticks,
Samuel Sewall noted that it was performed
"before Mr. Ratcliff," that is, Robert Ratcliffe,
an Anglican minister who arrived on the
ship that also brought news that the Mass-
achusetts charter had been revoked by the
Crown. Only four months before the Usher-
Jeffries marriage, Ratcliffe had read liturgy
from the Book of Common Prayer for the
first time in Boston. Sewall recorded this
event and noted "Charles Lidgett there."[2]

The descendants of the first generation of
Puritans, such as Sewall, smarted under the
imposition of Anglican services in their Bible
commonwealth. On the day the first service
was to take place, Sewall and one of his sons
read Isaiah 26 and sang Psalm 141—passages
that seek God's deliverance from persecu-

tors, and which Sewall felt were therefore
"exceedingly suited to this day." Later that
summer, Sewall set down an account of
the nighttime revels of Lidgett and his
cronies, including their rowdy coach ride
through town "inflamed with Drink" and
their stop at Justice Morgan's to "drink
Healths, curse, swear, talk profanely and
baudily" and behave with "such high-
handed wickedness as hardly been heard of
before in Boston." The candlesticks' com-
manding scale and heraldic allusions to
British aristocracy offer visible proof of
this clash of cultures.[3] P.E.K.

Notes

1. See Kathryn C. Buhler and Graham Hood,
American Silver: Garvan and Other Collections in

96

the Yale University Art Gallery, 2 vols. (New Haven and London: Yale University Press, 1970), 1:14–17. For information on David Jeffries, see "Memoirs of Prince's Subscribers," New England Historic Genealogical Register 15 (Jan. 1861), 14, hereafter cited as NEHGR; "Genealogical Gleanings in England," NEHGR 53 (Jan. 1899), 23; "Seals from the Jeffries Manuscripts," NEHGR 31 (Jan. 1877), 61. For information on Peter Lidgett, see Ancestry.com, The Town Officials of Colonial Boston, 1634–1775 (Provo, Utah: MyFamily.com, Inc., 2004), 38; "Gleanings Concerning the Scammon Family," NEHGR 13 (Apr. 1859), 139. For Charles Lidgett, see "Letters of Charles Lidgett to Francis Foxcroft, 1690–91," NEHGR 33 (Oct. 1879), 406–10.

2. M. Halsey Thomas, ed., The Diary of Samuel Sewall, 1674–1729, 2 vols. (New York: Farrar, Straus and Giroux, 1973), 1:116, 122; Sydney E. Ahlstrom, A Religious History of the American People (New Haven and London: Yale University Press, 1972), 215.

3. Thomas, 1973, 1:116, 121.

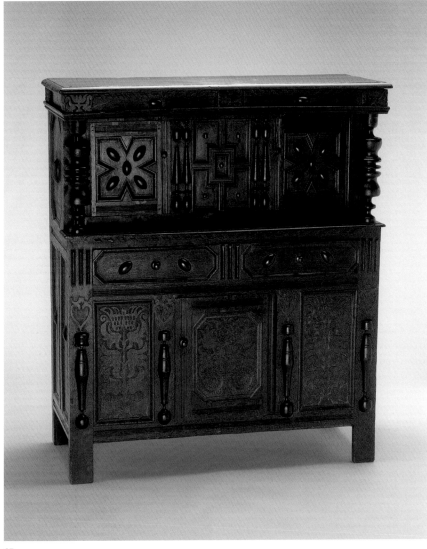

97

97

Attributed to Peter Blin (d. 1725)
Cupboard
Wethersfield, Connecticut, 1675–90

White oak, southern yellow pine, yellow poplar, maple, and eastern red cedar, 56 1/4 x 49 1/2 x 21 1/2 in. (142.9 x 125.7 x 54.6 cm)
Bequest of Charles Wyllys Betts, B.A. 1867, 1887.7

This cupboard belongs to a large group of similar cupboards and chests attributed to joiner Peter Blin, who settled in Wethersfield, Connecticut, by 1675 and presumably worked there until his death in 1725. Of the examples that retain provenance to the original owner, most have histories in the Wethersfield area or in central Connecticut, including one Blin cupboard in the Yale collection (YUAG 1942.255), which may have descended in the family of Thomas Atwood, a physician, of Wethersfield, and another that belonged to the Reverend Joseph Rowlandson, also of Wethersfield, whose inventory in 1678 lists a cupboard valued at two pounds in the parlor of his house. As the lofty professions of these individuals suggest, such expensive cupboards were owned predominantly by families with high social status and were used for storage and display.[1]

The top, which may originally have been covered with a textile, served as a shelf for displaying fine domestic goods, such as metalwork, ceramics, and glass.[2] In the range of other locally made furniture forms available to customers in the Connecticut River Valley during the late seventeenth century, this cupboard would have been one of the largest and most elaborately decorated. The carved panels and applied classical ornament provide a rich texture of contrasting surfaces. The original painted decoration on the frames surrounding the panels on the front and sides imitates exotic figured woods, and the turned ornaments and columns are painted black to look like ebony,

an expensive imported wood. The doors conceal compartments for storage. The geometric panels, overhanging entablature supported by large turned columns, and other details of classical architectural motifs derive from the northern European and late Renaissance traditions of furnituremaking that were fashionable in England by the early seventeenth century. The longevity and relative stability of Blin's designs into the eighteenth century indicate the conservative nature of the furniture trade and its consumer base in the Wethersfield area during the second generation after settlement.[3] D.A.C.

Notes

1. Patricia E. Kane, "The Joiners of Seventeenth Century Hartford County," *Connecticut Historical Society Bulletin* 35 (July 1970), 74–75; Gerald W. R. Ward, *American Case Furniture in the Mabel Brady Garvan and Other Collections at Yale University* (New Haven: Yale University Art Gallery, 1988), 383; Susan Prendergast Schoelwer, "Connecticut Sunflower Furniture: A Familiar Form Reconsidered," *Yale University Art Gallery Bulletin* (spring 1989), 20–37.
2. The 1714 inventory of Jonathan Hollister of Wethersfield lists one "cupboard & cloth 15s," suggesting the common practice of covering the tops of cupboards with textiles. See Gerald W. R. Ward and William N. Hosley, Jr., eds., *The Great River: Art and Society of the Connecticut Valley, 1635–1820*, exh. cat. (Hartford: Wadsworth Atheneum, 1985), 198.
3. Kevin M. Sweeney traces the diverse settlement patterns in Wethersfield prior to the mid-seventeenth century in his essay "From Wilderness to Arcadian Vale: Material Life in the Connecticut River Valley, 1635–1760," in Ward and Hosley, 1985, 18. On the use of classical architectural motifs, see Joseph Manca, "A Matter of Style: The Question of Mannerism in Seventeenth-Century American Furniture," *Winterthur Portfolio* 39 (spring 2003), 12.

98

John Coney (1656–1722)
Monteith
Boston, ca. 1705

Silver, 8⅝, diam. lip 10¾, diam. base 6¹¹⁄₁₆ in. (21.9 x 27.3 x 17 cm), wt. 50 oz., 4 dwt. (1556 gm)
Mabel Brady Garvan Collection, 1948.148

The fashion for luxurious display in dining and eating accoutrements, introduced to England from the Continent with the return of King Charles II and his court in 1660, continued throughout the seventeenth century, eventually filtering down to the gentry and merchants. The scale of monteiths and their function—to chill wineglasses—made them the ultimate examples of sumptuous tableware, especially in silver. This piece by John Coney, the leading Boston silversmith of the early eighteenth century, is the earliest American silver monteith known. Its contrasting gadrooned foot and fluted body, the rich chased and cast ornament of its crenellated rim including cherubs' heads, fluted urns, and lion-head handles, and the original gilt interior set this monteith apart as an unusually elaborate example. It was made about 1705 for the Boston merchant John Colman, whose coat of arms is displayed in the center of the basin.[1]

At the turn of the eighteenth century, dazzling jewel-like flint glasses would have been regarded as a luxury, since the English flint-glass industry was still in its infancy. Glassware, whether the very thin glass imported from Venice or the thicker flint glass produced in England, was fragile and expensive. The chilled wineglasses, whose stems would rest in the notches of the monteith's rim, whose feet would be restrained by the baroque scrollwork framing the cherubs' heads, and whose bowls would bathe in the chilled water inside the monteith, were an overt display of wealth. When glassware

became more widely available after 1730, monteiths quickly went out of fashion.

Colman's social ambitions may have been furthered by his ownership of such an elaborate piece of tableware. Shortly after Colman married Judith Hobby in Boston in 1694, he and a group of other merchants founded the Brattle Street Church. In 1698, he and Thomas Cooper had provided land for the church, and the group issued a manifesto in 1699 justifying the formation of a new church along "broad and catholic" lines.[2] Colman's brother, Benjamin, became its first pastor. Colman's rise in Boston government was slow but steady, and he held many prestigious posts as his career advanced. Recalling individuals who had died since he had left Boston in 1748, Daniel Henshaw noted that Colman was "formerly a great Mercht."[3] P.E.K.

Notes

1. Kathryn C. Buhler and Graham Hood, *American Silver: Garvan and Other Collections in the Yale University Art Gallery*, 2 vols. (New Haven and London: Yale University Press, 1970), 1:38–41.
2. Sydney E. Ahlstrom, *A Religious History of the American People* (New Haven and London: Yale University Press, 1972), 161–62; Frederick Tuckerman, "Thomas Cooper, of Boston, and His Descendants," *New England Historic Genealogical Register* 44 (Jan. 1890), 53.
3. "Daniel Henshaw's List of his Acquaintances in Boston, Who Died after his Removal," *New England Historic Genealogical Register* 37 (Jan. 1883), 58.

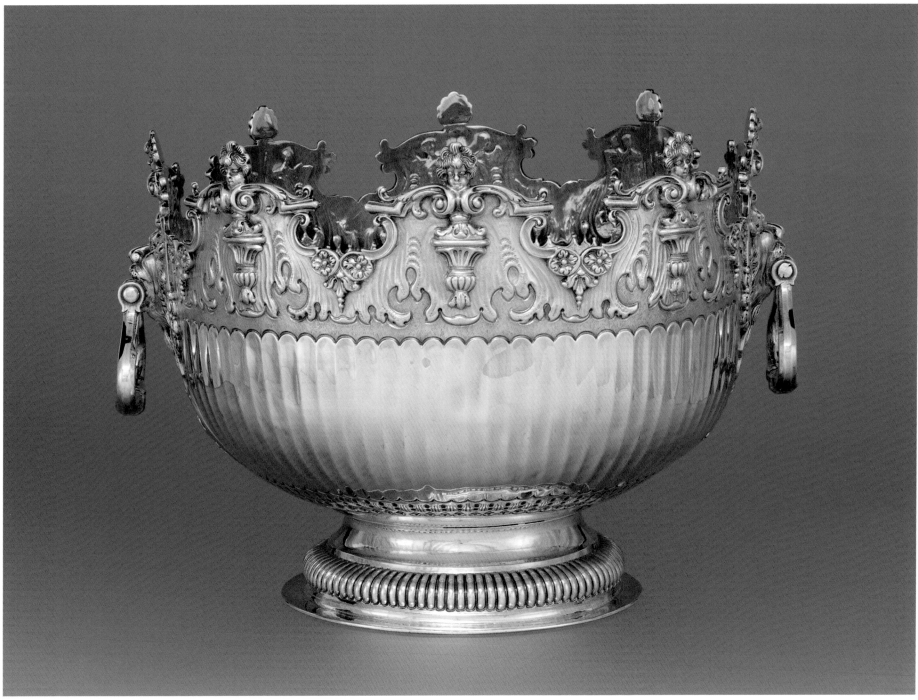

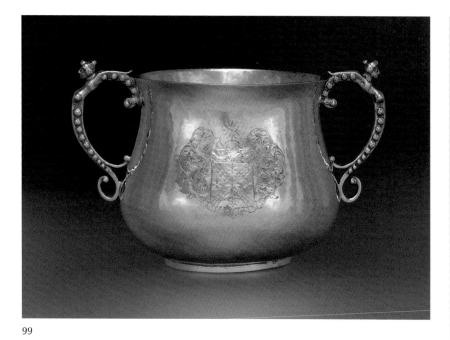

99

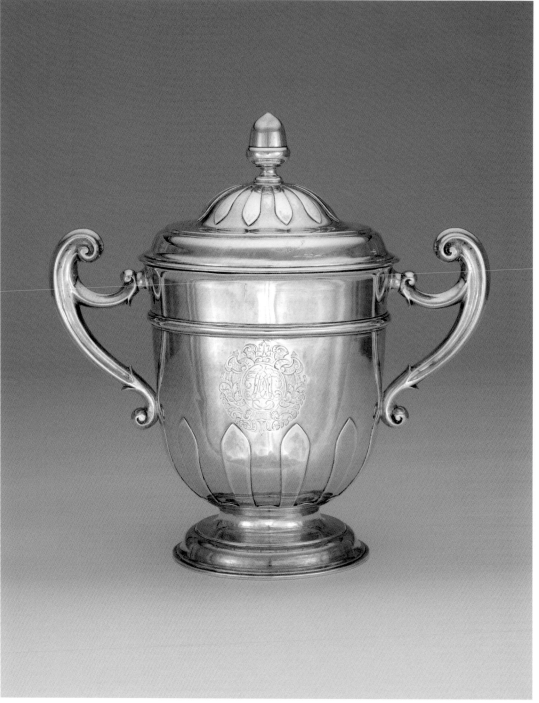

100

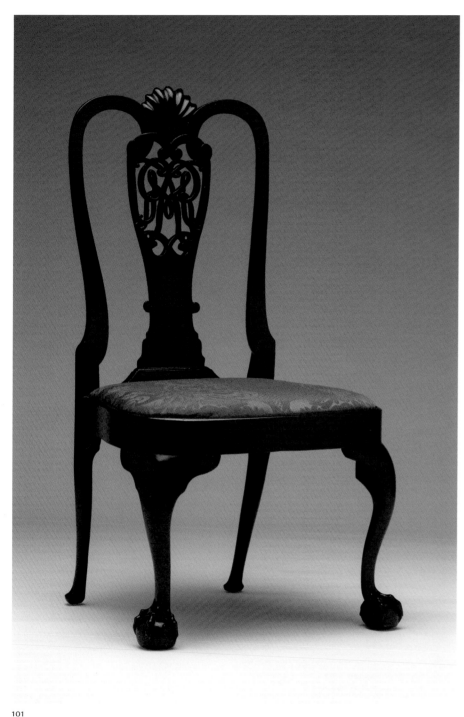

99

Gerrit Onckelbag (ca. 1670–1732)
Caudle Cup
New York City, 1690–1713

Silver, h. 5¾, w. 9⅜, diam. rim 5⅞ in.
(14.6 x 23.8 x 14.9 cm), wt. 23 oz., 1 dwt.
(715 gm)
Anonymous gift for the John Marshall Phillips
Collection, 1953.10.2a

100

Charles Le Roux (1689–1745)
Covered Cup
New York City, 1725–45

Silver, h. 10¼, w. 10⁵⁄₁₆, diam. rim 5⅞ in.
(26 x 26.2 x 14.9 cm), wt. 55 oz.,
18 dwt. (173.3 g)
Mabel Brady Garvan Collection, 1935.229

101

Side Chair
New York City, 1750–70

Mahogany, white oak, eastern white pine,
and beech, 41¹³⁄₁₆ x 18⅛ x 19½ in.
(106.2 x 46 x 49.5 cm)
Mabel Brady Garvan Collection, 1952.20.2

Settled and governed by the Dutch West India Company as a commercial venture until the British seized it in 1664, New York City was one of the most ethnically diverse American communities in the colonial period. Despite the varying ethnicities of both owners and craftsmen, the majority of fashionable objects made in the city after the British takeover increasingly reflected London styles. These three items illustrate this trend over three generations.

The two-handled cup made by Gerrit Onckelbag (cat. no. 99) is of a type called in Britain a porringer, posset pot, or caudle cup more or less interchangeably, indicating that it was used to serve a variety of foodstuffs. Uncommon in New York silver, the form is identical to contemporary cups from England and New England, including an

example of 1680–85 by John Coney of Boston. Despite its inherently English character, both the maker and patrons of this piece were of Dutch heritage. A native of New York, Onckelbag was trained by his stepfather, the immigrant Dutch silversmith Ahasuerus Hendricks. The original owners were another Dutch immigrant, Stephanus Van Cortlandt, and his wife, Gertruyd Schuyler. In New York it may have been customary to own this type of cup together with another English form, sometimes known as a syllabub cup. A syllabub cup made by Cornelius Kierstede between 1698 and 1720 is also engraved with the Van Cortlandt arms and originally also may have belonged to Stephanus Van Cortlandt. Onckelbag marked a similar pair of caudle and syllabub cups, both engraved with the same arms and monogram.[1]

Charles Le Roux, the son and apprentice of an immigrant Huguenot silversmith who had trained in Europe, made a covered cup characteristic of the simple monumental style of contemporary Huguenot craftsmen working in London (cat. no. 100). Essentially the same in form as the one made by Onckelbag, updated and elaborated in the late baroque style, these larger cups functioned less as drinking vessels and more as ostentatious display objects, frequently commemorating personal or historical events. As with the Onckelbag cup, the Le Roux cup was acquired by a family of Netherlandish ancestry; according to family tradition, it was a christening gift to Frederik De Peyster (1731–1773), the son of Abraham and Margaretta (Van Cortlandt) De Peyster. Frederik never married, and the cup descended directly to its last owner from Frederik's first cousin, Pierre Guillaume De Peyster II (1746–1807), who presumably purchased or received it from one of his relatives. The mirror-cipher of "FDP" engraved on the cup, and the fact that no other family members in this generation had names beginning with "F," would indicate that Frederik was

indeed the original owner. Such a sumptuous gift would have been appropriate for the male heir of a leading family whose wealth was embodied by silver ownership. His paternal grandparents, Abraham and Catharina (De Peyster) De Peyster, owned the largest stone house in New York City, filled with imported furniture and silver. His maternal grandparents, Jacobus and Eva (Philipse) Van Cortlandt, owned two silver tankards and a syllabub cup; Stephanus Van Cortlandt, who owned the Onckelbag caudle cup, was Frederik's great-uncle.[2]

Like much New York furniture, the side chair has features associated with English furniture, most notably its broad proportions and squared rear legs (cat. no. 101). Chairs with similar arched crest-rails, rounded seat frames, and claw-and-ball feet were popular in England between about 1720 and 1740, although the pierced cipher monogram in the back splat, an exceptionally rare feature, relates to English chairs made in the third quarter of the eighteenth century. The side chair originally was part of a set of at least eight. The RML monogram stood for the first owners, Robert R. Livingston and his wife (and second cousin), Margaret Beekman, who were married in 1742; the chairs descended directly through six generations to the last family owner. Although of Scots origin, by the middle of the eighteenth century, the Livingstons had intermarried repeatedly with families of Dutch ancestry. Both Robert Livingston and his wife apparently enjoyed things made in the Georgian rococo style then fashionable in London, including portraits of themselves painted by the English-trained artist John Wollaston and silver with rococo engraving of the Livingston arms by Myer Myers.[3]

These three examples of furniture and silver typify the most opulent goods available in New York City for patrons at the top of the political, social, and economic hierarchy.

The progenitors of the Van Cortlandt, De Peyster, and Livingston families amassed substantial wealth from mercantile activities and gained considerable political power. Stephanus Van Cortlandt and Abraham De Peyster both served as mayors of New York; Van Cortlandt also served as chief justice of the province, and De Peyster held the position of treasurer of New York and New Jersey. Following the traditions of the aristocracies in their native countries, these men sought to make their power and wealth hereditary. The Van Cortlandt and Livingston families adopted a strategy of land ownership, unique to New York in colonial America, that legally converted large tracts of land into manorial holdings. The lord of the manor was granted quasi-aristocratic authority over this territory, collecting rents from tenant farmers, controlling rights to game and other natural resources, appointing ministers to the parish churches, and, by virtue of their property, holding seats in the Colonial Assembly. Robert Livingston was heir to the estate of Clermont, which had been divided from Livingston Manor; his wealth allowed him to pursue a career in public service, as judge of the Admiralty Court in 1760, judge of the Supreme Court in 1763, and chairman of the Stamp Act Congress in 1765. These political positions could also become hereditary: both De Peyster's son Abraham and his grandson Frederik inherited the post of treasurer of New York and New Jersey.[4] D.L.B.

Notes
1. For terminology, see James Lomax, *British Silver at Temple Newsam and Lotherton Hall: A Catalogue of the Leeds Collection* (Leeds: Leeds Art Collections Fund, 1992), 51–52. For the Coney cup, see Kathryn C. Buhler and Graham Hood, *American Silver: Garvan and Other Collections in the Yale University Art Gallery*, 2 vols. (New Haven and London: Yale University Press, 1970), 1: no. 22. The Onckelbag cup descended directly to the last owner through seven generations of the family;

see Buhler and Hood, 1970, 2:24, 27. For the Kierstede and Onckelbag syllabub cups, see Milo M. Naeve, "Dutch Colonists and English Style in New York City: Silver Syllabub Cups by Cornelius Kierstede, Gerrit Onckelbag, and Jurian Blanck, Jr.," *American Art Journal* 19 (1987), 40–53. The Kierstede cup possibly was inherited by Johanna (Livingston) Van Cortlandt, the wife of Stephanus Van Cortlandt's grandson Pierre, and she may have given it to her sister Margaret, who married Peter Stuyvesant in 1764 and from whom it apparently descended (Ruth Lawrence, *Genealogical Histories of Livingston and Allied Families* [New York: National Americana Society, 1932], 20). For the other Onckelbag caudle cup, see *The Collection of Mr. and Mrs. Eddy Nicholson* (New York: Christie's, 27–28 Jan. 1995), lot 621. A brandywine bowl, also by Onckelbag, is engraved with the same arms and initials. See Deborah D. Waters, ed., *Elegant Plate: Three Centuries of Precious Metals in New York City, Museum of the City of New York*, 2 vols. (New York: Museum of the City of New York, 2000), 1: no. 54.
2. For cups made in London by Huguenot makers, see J. F. Hayward, *Huguenot Silver in England, 1688–1727* (London: Faber and Faber, 1959), pls. 3, 4, 6. Frederik de Peyster bequeathed his estate, including his plate, to his brother James and James's sons Joseph and Frederick; see *Abstracts of Wills on File in the Surrogate's Office, City of New York*, 8 (Collections of the New-York Historical Society, 32) (New York: New-York Historical Society, 1899), 143; see also Waldron Phoenix Belknap, Jr., *The De Peyster Genealogy* (Boston, 1956), 24–26, 57–59. For the silver owned by Jacobus and Eva Van Cortlandt, see Buhler and Hood, 1970, 2: no. 549; Waters 2000, 1: no. 34; Naeve, 1987, 48–50.
3. The most thorough discussion of the Livingston chairs and their provenance is found in Henry Hawley, "A Livingston Chair," *Bulletin of The Cleveland Museum of Art* 76 (Nov. 1989), 326–31. For English prototypes, see Ralph Edwards, *The Shorter Dictionary of English Furniture* (London: Country Life, 1964), 133, fig. 66; *English Chairs*, 3rd ed. (London: Her Majesty's Stationery Office, 1970), pls. 53–54. For the Livingston portraits and silver, see David L. Barquist, Jon Butler, and Jonathan D. Sarna, *Myer Myers: Jewish Silversmith in Colonial New York*, exh. cat. (New Haven: Yale University Art

Gallery, and New Haven and London: Yale University Press, 2001), nos. 28, 29, 124, 125.
4. Patricia U. Bonomi, *A Factious People: Politics and Society in Colonial New York* (New York: Columbia University Press, 1971), esp. 5–10. For Stephanus Van Cortlandt, see L. Effingham de Forest, *The Van Cortlandt Family* (New York: Historical Publication Society, 1930), 4, 14–15. For Abraham de Peyster, see Belknap, 1956, 5–8, 23–24; Albert Welles, *Family Antiquity* (New York: Society Library, 1881), 22–23.

102

102

Daniel Christian Fueter
(b. Switzerland, 1720–1785)
Whistle and Bells
New York City, 1761–65

Gold and coral, l. 5³/₁₆ in. (13.2 cm), wt. 2 oz.,
6 dwt. (72 gm)
Mabel Brady Garvan Collection, Gift of Mrs.
Francis P. Garvan, James R. Graham, Walter M.
Jeffords, B.A. 1905, and Mrs. Paul Moore, 1942.91

More so than the proverbial silver spoon,
this sumptuous child's toy—a rattle with a
whistle at one end and coral for teething at
the other—declared its family's status in the
hierarchical society of colonial New York.
An engraved inscription indicates that it
was presented to Mary Duane by her grand-
mother and namesake, Mary (Thong)
Livingston. The elder Mary, granddaughter
of Governor Rip Van Dam, belonged to the
colony's Dutch-descended elite. Her hus-
band, Robert Livingston, Jr., headed one of
the colony's wealthiest families as the third
lord of Livingston Manor, a 160,000-acre
tract along the Hudson River that had been
conferred on his grandfather in 1686.[1]

For this precious object, Mary Livingston
turned to Daniel Christian Fueter, whose
career underscored the cosmopolitan charac-
ter of luxury trades in New York. Born and
trained in Bern, Switzerland, Fueter worked
in London for two years before immigrating
to New York in 1754 as part of a Moravian
congregation. During the fifteen years he
lived in New York, Fueter produced many
exceptional forms. "Whisels & Bells" (as
they were advertised in local papers) were
rarely made by colonial American silver-
smiths but rather were the work of specialist
makers in London. Fewer than six American
examples in gold have survived, all marked
by New York craftsmen. The embellishments
of spiral fluting, rococo shellwork, and a
cherub on this example, as well as the superb

quality of its execution, demonstrate Fueter's
fluency with European designs and gold-
chasing techniques. He may have created the
decoration himself, although he is more
likely to have employed a specialist gold
chaser. Fueter advertised in 1769: "Mr. John
Anthony Beau, Chaiser, from Geneva, works
with him; where Chaising in general, viz.
Snuff Boxes, Watch Cases, & c. & c. is done
in the best and cheapest Manner."[2] D.L.B.

Notes

1. On Livingston Manor, see catalogue entry 101.
Edwin Brockholst Livingston, *The Livingstons of
Livingston Manor* (New York: Knickerbocker Press,
1910), 545; Reuben Hyde Walworth, *Livingston
Genealogy* (Rhinebeck, N.Y.: Friends of Clermont,
1982), 69. For the inscription, see Kathryn C. Buhler
and Graham Hood, *American Silver: Garvan and
Other Collections in the Yale University Art Gallery*,
2 vols. (New Haven and London: Yale University
Press, 1970), 2:134–35.
2. For gold whistles, see Peter J. Bohan, *American
Gold 1700–1860*, exh. cat. (New Haven: Yale Univer-
sity Art Gallery, 1963), 10–11, nos. 22–26; Morrison
H. Heckscher and Leslie G. Bowman, *American
Rococo, 1750–1775: Elegance in Ornament*, exh. cat.
(New York: Harry N. Abrams and the Metropolitan
Museum of Art, 1992), 115–17. Fueter's advertisement
ran in *The New-York Gazette, and The Weekly
Mercury*, 31 July 1769, 3. For more on Fueter's career,
see Ian M. G. Quimby with Dianne Johnson, *Ameri-
can Silver at Winterthur* (Winterthur, Del.: Henry
Francis du Pont Winterthur Museum, and Charlottes-
ville: University Press of Virginia, 1995), 230; David
L. Barquist, Jon Butler, and Jonathan D. Sarna, *Myer
Myers: Jewish Silversmith in Colonial New York*,
exh. cat. (New Haven: Yale University Art Gallery,
and New Haven and London: Yale University Press,
2001), 40–41.

fig. a John Greenwood's portraits of, from left to right, Katherine Cutt Moffatt, Samuel Cutt Moffatt, Katharine Moffatt Whipple, and John Moffatt, ca. 1750–52, as installed in the parlor of the Moffatt-Ladd House, Portsmouth, N.H., built in 1763. Courtesy Moffatt-Ladd House and Garden, The National Society of The Colonial Dames of America in the State of New Hampshire

103

John Greenwood (1727–1792)
Elizabeth Moffatt Sherburne, ca. 1750

Oil on canvas, 36 1/8 x 28 3/8 in. (91.8 x 72 cm)
John Hill Morgan, B.A. 1893, LL.B. 1896, M.A.
(HON.) 1929, and Robert W. Carle, B.A. 1897,
Funds, 1983.18

Elizabeth Moffatt Sherburne's portrait is
one of a set that the Boston-born John
Greenwood painted around 1750 of members
of the prominent John Moffatt family of
Portsmouth, New Hampshire (fig. a).[1] The
painting's original rococo frame, matching
those on the other Moffatt portraits, testifies
to the family's refinement. Analysis of the
woods suggests that the extravagant frame on
the portrait of Elizabeth's sister (fig. a, sec-
ond from right) was imported from England,
and that the other frames were copied from it
in native white pine.[2] In addition to cele-
brating family ties, the portrait of Elizabeth
(1729/30–1762/3), who was in her early
twenties, may have been commissioned to
celebrate her marriage to merchant John
Sherburne in about 1750.

Like many colonial artists, the largely
self-taught Greenwood often borrowed the
poses of his figures from popular sources, in
this instance, a widely circulated English
mezzotint of Princess Anne (fig. b).[3] The
painter modified the print to present his sitter
as a cultivated lady, suitable for marriage to
a prominent gentleman. Greenwood replaced
Anne's flowing garments with a dress tightly
laced over high, rigid stays, which help cre-
ate an elegantly attenuated silhouette. He
further altered the original composition by
straightening Elizabeth's posture, lowering
her right arm, and substituting a book for
Anne's pearls—all changes that contribute to
the characterization of the sitter.

The book is theatrically presented
to the viewer; its title, "SPECTATOR VOL. 7,"
indicates that it is one of the collected issues
of Joseph Addison and Richard Steele's
periodical. The *Spectator*, originally pub-
lished in London a generation earlier, had
by the mid-eighteenth century become pop-
ular in the American colonies. The maga-
zine presented a new form of reading for
pleasure, which combined philosophical
contemplations with cultural and literary
criticism in an effort to instill ideals of mod-
esty and polite conduct in its audience, par-
ticularly young women.[4] The artist's appre-
ciation for the *Spectator*'s message of
feminine virtue is evident in his *Greenwood-
Lee Family* (Museum of Fine Arts, Boston), in
which he depicted his cousin exhibiting a
volume of the periodical.[5] Essays about
authors such as Milton and Sappho catered
to refined tastes, while articles on contem-
porary theater and popular ballads
addressed more vernacular forms of enter-
tainment. This new format appealed to
members of the rapidly growing middle
class. Elizabeth's prominent display of the
Spectator indicates that, despite her provincial
upbringing, she possessed a sophisticated
awareness of transatlantic literary culture
and an enthusiasm for the journal's emphasis
on social refinement. Previously, when an
American woman was portrayed with a book,
it was likely to be the Bible or other devo-
tional text, such as the moralizing *Watts
Mesianys* (probably the artist's misspelling of
"Miscellaneous"), a copy of which is visible
under the elbow of Elizabeth's mother, the
representative of an earlier generation
(fig. a, far left).[6] Eschewing the austerities
associated with older Puritan definitions of
self, this fashionably dressed young woman
and her chosen reading matter announce
her affinity for the modern, secular world
of middle-class manners and letters that
is wittily conveyed in the *Spectator*'s pages
and reflected in Greenwood's lively
portrait. A.K.L. *with the assistance of* G.G.

Notes

1. Four of the six portraits still hang in the Moffatt-
Ladd House in Portsmouth, New Hampshire. One
is unlocated.
2. Brock Jobe, ed., *Portsmouth Furniture: Master-
works from the New Hampshire Seacoast* (Boston:
Society for the Preservation of New England
Antiquities, 1993), 407.
3. See Richard H. Saunders and Ellen G. Miles,
American Colonial Portraits: 1700–1776 (Washing-
ton, D.C.: Smithsonian Institution Press, 1987), 172.
4. On the *Spectator*'s role in women's education,
see Davida Tenenbaum Deutsch, "The Polite Lady:
Portraits of American Schoolgirls and Their
Accomplishments, 1725–1830," *Antiques* 135
(Mar. 1989), 745–49.
5. *American Paintings in the Museum of Fine Arts,
Boston*, 2 vols. (Boston: Museum of Fine Arts,
1969), 1:125.
6. The book referred to is likely Isaac Watts's *Rel-
iquiae Juveniles: Miscellaneous Thoughts in Prose
and Verse On Natural, Moral, and Divine Subjects*,
first published in the early eighteenth century.

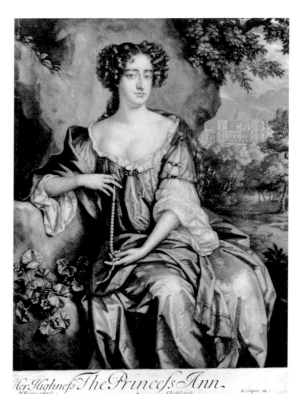

fig. b Isaac Beckett after William
Wissing, *Her Highness The Princess
Anne*, ca. 1683. Mezzotint,
13 1/16 x 9 7/8 in. (33.2 x 25.1 cm).
Courtesy Winterthur Museum,
Winterthur, Del., Gift of Mrs.
Waldron Phoenix Belknap

104

Joseph Richardson, Sr. (1711–1784)
Teakettle on Stand
Philadelphia, 1745–54

Silver and wood, h. 11 1/16, w. 11 1/8, diam. base
3 1/8 in. (28.1 x 28.3 x 7.9 cm), wt. 62 oz.,
10 dwt. (1938 gm)
Mabel Brady Garvan Collection, 1932.93

Bearing the Plumstead arms, this teakettle on stand offers evidence of the aristocratic British lifestyle that some colonists strove to re-create in the New World. Its monumental size and profusion of flowers, ruffled shells, and lion's and bird's heads make it the most lavish example of mid-eighteenth-century American silver. The Philadelphia merchant Clement Plumstead and his wife Mary have traditionally been identified as the original owners.[1] Clement Plumstead rose to positions of power and wealth in Philadelphia and maintained close ties to London, the probable place of his birth. The earliest evidence of his presence in Philadelphia dates from 1697. He was elected to the common council in 1712, to the board of aldermen in 1720, and to his first term as mayor in 1723. The records of the Philadelphia Monthly Meeting of Friends show that he traveled to Barbados in 1709 and to London in 1716. Following the death of his second wife in 1720, he married Mary (perhaps Curry), who was not a Quaker, in 1722. At the close of his first term as mayor, he journeyed to London again with his son, William, and stayed for the greater part of a year.[2]

The teakettle on stand probably was commissioned by Mary Plumstead between the time of her husband's death, in 1745, and 1754, when she made her own will. Among other bequests, Clement left his wife the income of six pounds a year from a tenement that Joseph Richardson rented, as well as the "Custody, Care, and Tuition" of his granddaughter Elizabeth. Mary's will noted the handsome provision left to Elizabeth by her grandfather and bestowed upon her as "a token of the great love and affection" her grandmother's plate and "also the Silver TeaKettle & Lamp."[3] One may speculate that Joseph Richardson gave the teakettle to Mary Plumstead in lieu of rent.

The existence of two English teakettles with virtually identical, albeit truncated and cruder, wind screens and similar legs, made in London by William Cripps in 1745/46 and Thomas Heming in 1749/50, raises questions about how a colonial craftsman like Richardson was able to deliver wares that closely paralleled London models.[4] To make this complex form, Richardson might have imported the stand from a specialist standmaker—the same source Cripps and Heming used. The finer detail on the Richardson stand may even indicate that he imported a London-made teakettle on stand through his agents and simply applied his mark in order to supply his client with silver in the latest London fashion. P.E.K.

Notes
1. Kathryn C. Buhler and Graham Hood, *American Silver: Garvan and Other Collections in the Yale University Art Gallery*, 2 vols. (New Haven and London: Yale University Press, 1970), 2:189–91.
2. John W. Jordan, ed., *Colonial and Revolutionary Families of Pennsylvania*, 3 vols. (New York and Chicago: Lewis Publishing Company, 1911), 1:412–14.
3. Clement Plumstead will, Philadelphia County, Pa., Will Book G, 211–17, City Hall, Philadelphia; Mary Plumstead will, Philadelphia County, Pa., Will Book K, 256–57, City Hall, Philadelphia.
4. Robert B. Barker to author, 24 Apr. 1995, discussed a teakettle made by William Cripps, in *Important Silver Objects of Vertu and Russian Works of Art* (New York: Christie's, 11 Apr. 1995), lot 389. Oswaldo Rodriguez Roque to author, 27 Dec. 1988, referenced a teakettle by Thomas Heming in the Metropolitan Museum of Art, inv. no. 38.21.9a-c. Both letters are in the YUAG Object Files.

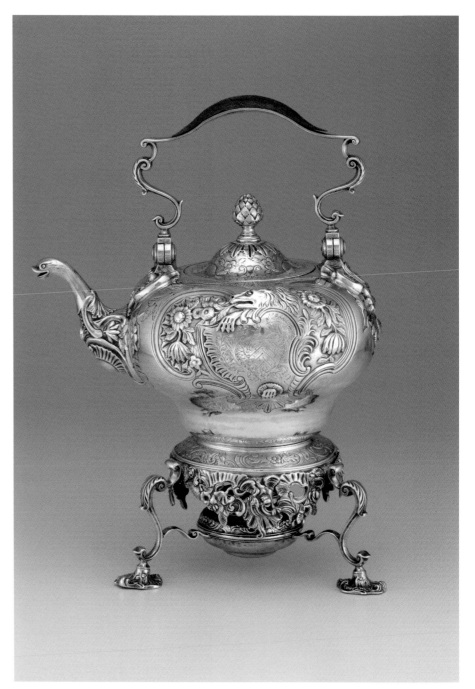

104

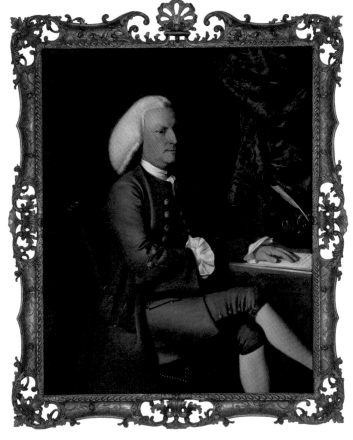

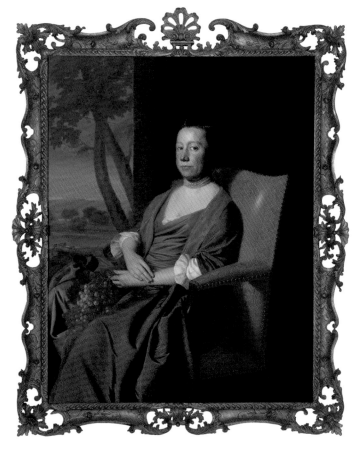

105

105

John Singleton Copley (1738–1815)
Mr. Isaac Smith and *Mrs. Isaac Smith
(Elizabeth Storer)*, 1769

Oil on canvas, each 50⅛ x 40⅛ in.
(127.3 x 101.9 cm)
Gift of Maitland Fuller Griggs, B.A. 1896, L.H.D.
1938, 1941.73 and 1941.74

John Singleton Copley's three-quarter-length portraits of Mr. and Mrs. Isaac Smith attest to the status and achievements of both the artist and the sitters. Isaac Smith was a wealthy Boston merchant. The uncle of Abigail Adams, and thus by marriage of John Adams, he was a moderate Whig and a Congregationalist, a member of Brattle Street Church.[1] His wife was Elizabeth Storer Smith.

Copley was born in 1738, the son of a tobacconist on Long Wharf in Boston. After his father's early death, his mother continued to run the shop and subsequently married the mezzotint engraver Peter Pelham. Through his talent as an artist, Copley prospered financially and ascended the social ladder. Only a few months after these portraits were completed, he married Susanna Clarke, a daughter of the Boston agent for the English East India Company; acquired a property with several houses, adjacent to John Hancock's mansion on Beacon Hill; and painted likenesses of other wealthy sitters, such as the contemporary full-length portraits of Mr. and Mrs. Jeremiah Lee of Marblehead (figs. a, b).

Both pairs of portraits celebrate the attachment of wealthy Americans to their possessions on the eve of the Revolutionary War. Painted at the zenith of Copley's American career, these portraits in their gilt frames were expensive, high-end items, the sort that only the richest Bostonians could afford.[2] We know from the surviving bill that the portraits of the Smiths cost fourteen

guineas each, and their elaborate Chippendale frames, attributed to John Welch of Boston and purchased through Copley, cost nine pounds each.

Although Copley himself had married into a Loyalist family and throughout his career painted sitters of different religious and political persuasions and occupations, he would have found the Smiths particularly congenial representatives of the kind of material success to which he had aspired and which he had now achieved through his extraordinary ability.[3]

Isaac Smith (1719–1787) sits at a worktable covered in green baize, his left hand resting on a letter or business document. His side

chair has an upholstered seat fastened with brass tacks that echo the gold buttons on his plum-colored jacket and britches. A blue damask drapery falls behind the inkstand and sealing wax on the table. Smith's face and white wig are the brightest elements in the picture, immediately drawing the viewer's attention to his head, which is bracketed between the ear of the chair's crest rail to the left and the drawn drapery on the right. The march of buttons up the jacket, the arrow formed by the stockinged legs, and the arc of the quill pen on the desk also direct attention to the head.

The quality of the chair and fabrics makes it clear that Smith is wealthy, an impression

reinforced stylistically by the rich, deeply saturated colors. The strong flood of light on his face highlights his right side and casts the left into deep shadow, creating the effect of a profile and conveying a sharp decisiveness of character. With one hand tucked into his waistcoat and the other resting on the papers on the table, Isaac Smith is a man in control of himself and in charge of his affairs, with the implicit strength of character to control others. He does not look at the viewer; he is a man to be looked up to, not engaged in light banter.

Mrs. Smith (1726–1786) sits in an armchair upholstered in yellow damask. In contrast to the severity of her husband's dress and the enclosed setting of his portrait, she wears a loose-fitting gown over a blue undergarment, posed in front of a background wall that opens onto a river landscape. In her lap she holds a bunch of glowing green grapes, their shape echoed in the brass tacks of the armchair and the nacreous pearls in her hair, around her neck, and on her sleeves. Whereas her husband aloofly looks off to the right, Mrs. Smith gazes directly at the viewer. Her face is serious, but not unfriendly. The colors in the portrait are also rich, but brighter and higher in key, offering a more cheerful appearance. The furniture is upholstered, not severe; the landscape opens up the space, unlike the restricting brown background of the pendant portrait; and the grapes hint at fruitfulness and fecundity. Indeed, at the time her portrait was painted, Mrs. Smith, forty-three years old, was soon to give birth to their last child, who would bear her name.[4]

Copley provided his sitters with images that are simultaneously realistic and idealized. Using formal elements of composition, color, and chiaroscuro to blend realistic likeness with subtle indications of personal qualities and values, he offered a sense not

only of how the Smiths actually looked but also the way in which they wanted to be perceived, their ideal self-images. It is no wonder that Copley prospered in Boston. J.D.P.

Notes

1. For information on the Smiths and these portraits, see Jules David Prown, *John Singleton Copley*, 2 vols. (Cambridge, Mass.: Harvard University Press, 1966), 1:68–70, 142–43, and Carrie Rebora et al., *John Singleton Copley in America*, exh. cat. (New York: Metropolitan Museum of Art, 1995), 253–58.
2. Prown, 1966, 1:70–71; Rebora et al., 1995, 258–62; Morrison H. Heckscher, "Copley's Picture Frames," in Rebora et al., 1995, 154–55 and 155, fig. 144.
3. Prown, 1966, 1:66–67 and 192–93.
4. Rebora et al., 1995, 257–58.

fig. a John Singleton Copley, *Portrait of Jeremiah Lee*, 1769. Oil on canvas, 95 x 59 in. (241.3 x 149.9 cm). Wadsworth Atheneum Museum of Art, Hartford, Conn., The Ella Gallup Sumner and Mary Catlin Sumner Collection Fund

fig. b John Singleton Copley, *Portrait of Mrs. Jeremiah Lee (née Martha Swett)*, 1769. Oil on canvas, 95 x 59 in. (241.3 x 149.9 cm). Wadsworth Atheneum Museum of Art, Hartford, Conn., The Ella Gallup Sumner and Mary Catlin Sumner Collection Fund

106

106

Desk and Bookcase
Probably Newport, Rhode Island,
1760–90

Mahogany, American black cherry, chestnut,
and eastern white pine, 9 ft. 8¼ in. x
44¹¹⁄₁₆ in. x 25³⁄₁₆ in. (2.7 m x 113.5 cm x 64 cm)
Mabel Brady Garvan Collection, 1940.320

This mahogany desk and bookcase is a mon-
umental expression of the architectural char-
acter of eighteenth-century American furni-
ture. The block-and-shell facade accentuates
its tall, attenuated form. Behind the lockable
bookcase doors and fall-front desktop are
compartments for organizing papers, books,
and account ledgers, and small drawers for
storing valuables and writing implements.
The graduated drawers in the lower case offer
space for larger items, such as folded clothes
and bedding. This versatile domestic object
thus served simultaneously as office, library,
bank, and storage chest.

According to its traditional history, the
desk and bookcase descended in the family
of the original owner, wealthy Providence
merchant John Brown.[1] Brown belonged to
an influential family of businessmen whose
trading networks extended far beyond the
borders of the American colonies to the West
Indies, Europe, Africa, and the Far East.
The Browns were also civic leaders involved
in pursuits important to the growth of Provi-
dence as a cultural center, such as the found-
ing of the Providence Athenaeum in 1753 and
the relocation to that town in 1770 of the
College of Rhode Island, which eventually
became Brown University.[2] The desk and
bookcase is an emblem of Brown's vast com-
mercial success and his interest in literature
and classical architecture, popular avocations
for fashionable and educated gentlemen in
the eighteenth century.

A desk and bookcase was among the most
expensive items available for purchase from a
Rhode Island cabinetmaker in this period.[3]

The use of mahogany imported from the
Caribbean reflects the cosmopolitan charac-
ter of Brown's furnishings and the wealth
accumulated by the seaport merchants of
Rhode Island. Brown's brothers Nicholas,
Joseph, and Moses owned three of the other
known examples of this form, two of which
now survive.[4] Although at least one of the
Browns' desks and bookcases may have been
purchased as early as 1766 from the Newport
cabinetmaker John Goddard, the persis-
tence of this form in Rhode Island makes the
Yale example difficult to date. It may have
been meant for Brown's first house in Provi-
dence, but it undoubtedly was in his second
home, a large Georgian mansion on Power
Street, designed by Joseph Brown and
completed in 1788.[5] D.A.C.

Notes
1. Gerald W. R. Ward, *American Case Furniture in
the Mabel Brady Garvan and Other Collections at
Yale University* (New Haven: Yale University Art
Gallery, 1988), 342.
2. James B. Hedges, *The Browns of Providence
Plantations: The Colonial Years* (Providence: Brown
University Press, 1968), 194–99.
3. Newport cabinetmaker Benjamin Baker's account
book (Newport Historical Society, Newport, R.I.)
lists a "mahogni full hed Desk" for £300 in Decem-
ber 1765. A Newport merchant ordered a desk and
bookcase from William Robson in 1734 for £25 and
also supplied the mahogany timber (Grant v.
Robson, Newport County Court of Common Pleas,
May term 1737, Rhode Island Judicial Records Center
Archives, Pawtucket, R.I.). Christopher Townsend
offered a desk and bookcase to Abraham Redwood
for £60 in 1738 (Newport Historical Society, MS
1993–96).
4. The examples belonging to Joseph (Rhode Island
Historical Society, Providence) and Nicholas (private
collection) survive, while that of Moses is believed
to have been destroyed in a fire. Wendy A. Cooper,
"The Purchase of Furniture and Furnishings by John
Brown, Providence Merchant, Part I: 1760–1788,"
Antiques 103 (Feb. 1973), 334.
5. Ibid., 334, 336.

107

Charles Willson Peale (1741–1827)
William Buckland, 1774 and 1789

Oil on canvas, 27½ x 36⅝ in. (69.9 x 93 cm)
Mabel Brady Garvan Collection, 1934.303

William Buckland was among the first build-
ers in America to call himself an architect.[1]
Charles Willson Peale's portrait depicts
Buckland at the zenith of his career: he had
recently begun his magnum opus, the
Matthias Hammond House in Annapolis,
Maryland. The relaxed and confident archi-
tect sits poised over the plans, drafting pen
aloft, in the midst of perfecting his design;
behind him is the Hammond House. When
painting a portrait, Peale would "watch for
the moment of awakened interest, the expres-
sion most characteristic and most pleasing."[2]
Here, Peale has captured not only Buckland's
enthusiasm for his art, betrayed by his smile,
but also the architect's creative vivacity in his
sparkling eyes.

Born in England, Buckland was appren-
ticed briefly to the London workshop of his
uncle, a joiner, and later to John Whiteaves of
the Carpenter's Company, where he learned
carpentry, cabinetmaking, and classical
Palladian architecture.[3] In 1755, he became an
indentured servant to Thomson Mason, who
brought him to Virginia, where Buckland
demonstrated his emerging design abilities by
completing Gunston Hall, the home of
statesman George Mason. Released from his
indenture in 1759, Buckland procured
numerous private and public commissions
before moving to Annapolis in 1771. In
1773, Hammond, a wealthy tobacco planter,
hired Buckland to design a stately home.
Around this time, Buckland met Peale, a fel-
low Annapolitan, who was already enjoying
considerable success as a portrait painter.

In the spring of 1774, just months before
Buckland's sudden death at the age of forty,

the architect commissioned a portrait from
Peale. The artist derived Buckland's pose
from a portrait of himself with *porte-crayon* in
hand (fig. a), painted by his teacher Benjamin
West about 1768 while Peale was in London.[4]
Only the head and shoulders were painted
before Buckland's death, and Peale did not
finish the work until 1789, when it was com-
pleted at the request of the architect's daugh-
ter. While the portrait depicts the sitter's
handsome, pleasant visage, Peale's primary
aim was to capture Buckland's intellect.
As the artist once explained, "It is the mind
I would wish to represent through the
features of the man, and he that does not
possess a good mind, I do not desire to
Portray his features."[5] Although the plans for
Hammond House provide ample material
evidence of Buckland's "good mind," the
attention paid to the architect's lively,
gleaming eyes suggests the creative spark
that lies within. G.C.B.

Notes

1. In a legal document from 1772, Buckland referred
to himself as an architect. *Richmond County Deed
Book* 13, 7 Nov. 1772, 457–59, quoted in Luke Becker-
dite, "William Buckland Reconsidered," *Journal of
Early Southern Decorative Arts* 8 (Nov. 1982), 46.
2. Charles Coleman Sellers, *Charles Willson Peale*
(New York: Charles Scribner's Sons, 1969), 88.
3. See Georgina Louise Joyner, "William Buckland
in England and America" (master's thesis, Univer-
sity of Notre Dame, 1985). I extend special thanks
to Hugh Howard for bringing this source to
my attention.
4. David Steinberg, "Charles Willson Peale Portrays
the Body Politic," in *The Peale Family: Creation of
a Legacy, 1770–1870*, ed. Lillian B. Miller, exh. cat.
(New York: Abbeville Press, and Washington, D.C.:
National Portrait Gallery, Smithsonian Institution,
1996), 120.
5. Lillian B. Miller, Sidney Hart, and Toby A. Appel,
eds., *The Selected Papers of Charles Willson Peale
and His Family*, vol. 3: *Charles Willson Peale: The
Belfield Farm Years, 1810–1820* (New Haven and
London: Yale University Press, 1991), 628.

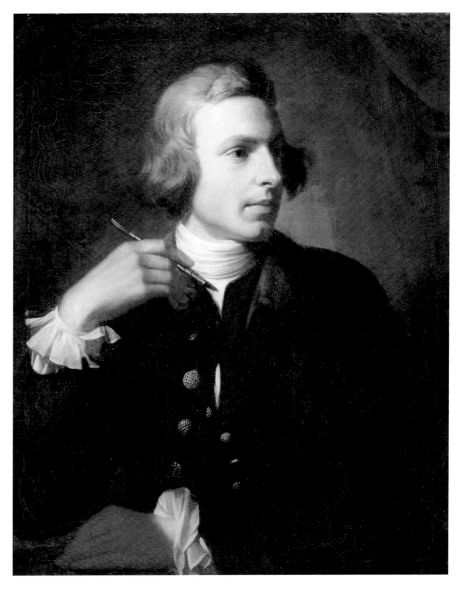

fig. a Benjamin West, *Charles Willson Peale*, 1767–69. Oil on canvas, 28¼ x 23 in. (71.8 x 58.4 cm).
Collection of The New-York Historical Society, 1867.293

108

108

Myer Myers (1723–1795)
Dish Ring
New York City, 1770–76

Silver, h. 4 5/16, diam. base 8 7/8 in. (11 x 22.5 cm),
wt. 14 oz., 6 dwt. (445 gm)
Mabel Brady Garvan Collection, 1936.136

This spectacular dish ring was made by Myer Myers at the height of his career for his most important patrons of the early 1770s, Samuel Cornell and Susannah (Mabson) Cornell. An ambitious, largely self-made man, Cornell had political and personal aims that evidently required opulent material expression. His success as both a West Indies merchant and a landowner in North Carolina enabled him to provide significant financial support to Governor William Tryon, who appointed Cornell to the North Carolina Provincial Council in 1771. It was probably at that time that the Cornells commissioned a substantial group of silver objects from Myers, including a dish ring, bread basket, and pair of bottle stands. Myers's dish ring is the only extant colonial American example of its form.[1]

Dish rings were used on dining-room tables to support bowls or plates containing hot foods, probably more for decoration than for protecting the table. Given the object's prominent placement, the design of large S-curves repeated around its midsection may well have alluded to the names of Samuel and Susannah Cornell. The design is also an exceptionally rare example of pierced ornament on a piece of American silver in the rococo style. It is possible that the piercer was an Irish immigrant; the spool-shaped dish ring was uncommon in both England and its American colonies, whereas significant numbers were made in Dublin after 1760. The openwork piercing scatters light across the ring's surface, creating a glittering effect, and makes it seem delicate and airy despite its large size. The use of these and other techniques to diminish the overall mass of forms was typical of the later rococo style.[2]

Myers marked the dish ring in an unusual and very personal way. By striking his surname mark twice, he emphasized that his surname was the double of his given name, a characteristic of many Ashkenazi Jews, who lacked conventional English family names. Moreover, by placing his surname mark on the small reserves flanking the Cornells' monogram—on the "front" where anyone looking at this dish ring would see them—Myers claimed this exceptional object as his own creation and asserted his equality, as a Jew and as a craftsman, with the wealthy patrons of his labor. D.L.B.

Notes
1. John Cornell, *Genealogy of the Cornell Family* (New York: T. A. Wright, 1902), 190; Alonzo Thomas Dill, *Governor Tryon and His Palace* (Chapel Hill: University of North Carolina Press, 1955), 128–54; William S. Powell, ed., *The Correspondence of William Tryon and Other Selected Papers*, 2 vols. (Raleigh, N.C.: Division of Archives and History, Department of Cultural Resources, 1981), 2:661, 740. For more on the Cornells and Myers's dish ring, see David L. Barquist, Jon Butler, and Jonathan D. Sarna, *Myer Myers: Jewish Silversmith in Colonial New York*, exh. cat. (New Haven: Yale University Art Gallery, and New Haven and London: Yale University Press, 2001), 59–60, 174–78.
2. Charles James Jackson, *An Illustrated History of English Plate, Ecclesiastical and Secular*, 2 vols. (London: B. T. Batsford, 1911), 2:933–39.

109

Myer Myers (1723–1795)
Pair of Shoe Buckles
New York City, 1768–70

Gold and steel, each 1¾ x 2⁵⁄₁₆ in. (4.4 x 5.9 cm),
gross wt. 1 oz., 9 dwt. (45 gm)
Mabel Brady Garvan Collection, 1936.166, and
Gift of Mr. and Mrs. Philip Holzer, 1989.77.1

During the second half of the eighteenth century, upper-class dress in Britain and its colonies reached new heights of elegance and artificiality that rarely have been equaled. Made of gold and exquisitely worked, these shoe buckles would have been part of a man's attire that included costly silk fabrics and a powdered wig. Although Benjamin Franklin and some other colonists promoted the image of Americans as simple, rustic folk, New York City newspapers were filled with adver-tisements for mantua makers, "peruke," or wig, makers, furriers, hatters, and jewelers. A specialist jeweler or gold chaser undoubt-edly executed the superb chasing on these buckles, which were marked and retailed by New York silversmith Myer Myers. The openwork design and delicately rendered flowers and beading are characteristic of the late rococo style that appeared in the colonies about 1765.[1]

A commemorative inscription, "The Gift of Robert Arcdeckne [*sic*] Esqr. To Danl. McCormick," is engraved on the underside of each buckle. The original owner, Daniel McCormick, was a prominent attorney in New York City, although when he paid for his freemanship in 1769, his profession was recorded as "Gentleman." Renowned for his opulent dress, he was later described as "one of the most polished gentlemen in the city.

. . . He stuck to short breeches and white stockings and buckles to the last. He wore hair-powder as long as he lived, and believed in curls." Born in Ireland, presumably of Scotch-Irish ancestry, he was a member and trustee of the First Presbyterian Church as well as a president of St. Patrick's Society. Many of his business relationships were with fellow Irishmen and Presbyterians, and it is possible that McCormick received his gift from Arcedeckne in gratitude for legal assis-tance provided. The donor, Robert (also known as "Robin") Arcedeckne, was from an Irish family that had settled in Jamaica in the 1710s. He served as a member of Jamaica's House of Assembly and owned plantations in St. Catherine and St. Mary's Parish, as well as over two hundred slaves. In 1765, it was reported that he was "at present very ill with the Gout in his Stomach." After sign-ing a will in St. Catherine on 3 April 1768, Arcedeckne departed for New York City "for the Recovery of his health," but he died there before year's end.[2] D.L.B.

Notes

1. Rita Susswein Gottesman, *The Arts and Crafts in New York, 1726–1776: Advertisements and News Items from New York City Newspapers. Collections of The New-York Historical Society* 69 (New York: New-York Historical Society, 1936), 64–74, 323–34.
2. For McCormick, see David L. Barquist, Jon Butler, and Jonathan D. Sarna, *Myer Myers: Jewish Silver-smith in Colonial New York*, exh. cat. (New Haven: Yale University Art Gallery, and New Haven and London: Yale University Press, 2001), 138; Walter Barrett [Joseph Alfred Scoville], *The Old Merchants of New York City*, 5 vols. (New York: Worthington Company, 1889), 2:249, 252–53. For Arcedeckne, see *Travel, Trade, and Power in the Atlantic, 1765–1884, Camden Miscellany* 35 (Cambridge, England, and New York: Cambridge University Press for the Royal Historical Society, 2002), 9 (quotation), 16n.32, 23n.68, 57n.155, 64, 71 (quotation). I am indebted to Robert Barker for this reference.

109

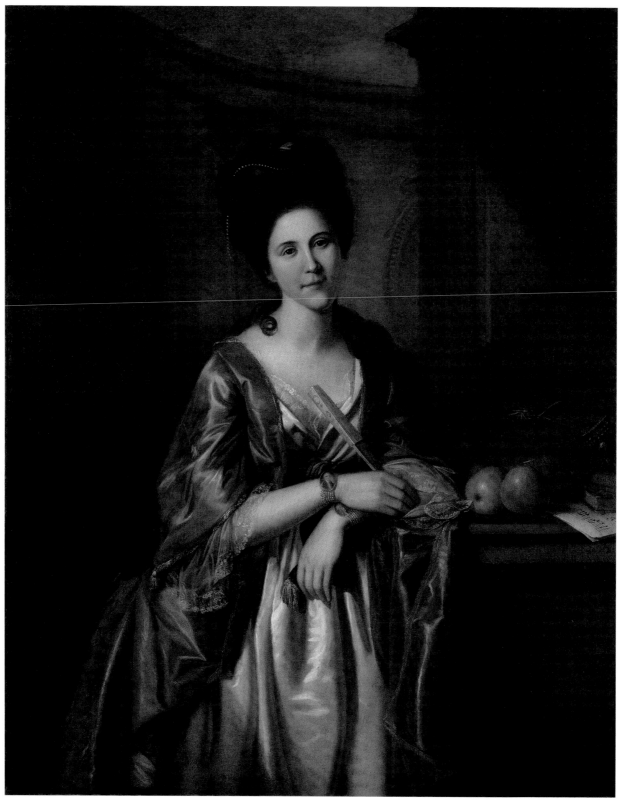

110

Charles Willson Peale (1741–1827)
Mrs. Walter Stewart (Deborah McClenachan), 1782

Oil on canvas, 50⅛ x 40⅛ in. (127.3 x 101.9 cm)
Gift of Robert L. McNeil, Jr., B.S. 1936s,
1991.125.2

When Irish-born Walter Stewart (1756–1796) married eighteen-year-old Deborah McClenachan (1763–1823) in April 1781, he marked the occasion by commissioning her full-scale portrait, as well as miniatures of both of them, from Charles Willson Peale, who was among America's best portraitists.[1] The miniatures would act as surrogates for each other during Colonel Stewart's absences; he served in the Revolutionary War as an aide-de-camp to General Horatio Gates, rising to brigadier general before retiring to pursue a career as a Philadelphia merchant. In Peale's easel portrait, the miniature gracing the young bride's left wrist is probably an image of her father; the one on her right, her new husband. With her arms delicately crossed, it is the latter's portrait that overshadows the former, articulating the new allegiance a woman forms upon marriage. Walter Stewart may have kept his wife's likeness hidden in his vest pocket, close to his heart, while her portrait of him is displayed on her person as a public declaration of love, wealth, and taste.

Deborah Stewart's miniature of her husband, set in a multistrand pearl bracelet, recalls the miniature of King George III that Queen Charlotte received as a wedding gift and wore in paintings that were widely reproduced as engravings (fig. a). In his diary, John Adams recorded first seeing such jewelry in America in 1777.[2] Colonists resisted their English rulers politically while embracing their sense of style, and increasingly, on both sides of the Atlantic, couples exchanged miniatures to celebrate romance.

In Peale's portrait of Mrs. Stewart, the ease with which she leans on a pier table conveys grace, while the sheet music, guitar, and books indicate her cultured upbringing as the daughter of a well-to-do Philadelphia merchant. The flawless oval of her face, echoed by the shape of the high-style neoclassical frames on either side, invokes the era's association between ovals and female beauty and the belief that such outward perfection mirrors inner harmony.[3] Set against the dark recess of the oval space, Mrs. Stewart's pale skin unblemished by sun or work, the cascading pearls in her hair, the transparent lace trim, the glimmering white dress with cross-over bodice and fringed sash—a variant of the fashionable Turkish masquerade attire that appears frequently in English portraits—reflect her husband's affluence, as does his centrally placed likeness painted on ivory and set in precious gold and pearls.[4]

The position of his miniature over his wife's womb and beside pieces of fruit, a time-honored symbol of fertility, suggests the marriage's promise. The Stewarts would have seven children: George Washington was godfather to their eldest son and namesake to their youngest and gave their daughter Anna in marriage to a relative of Alexander Hamilton. In their lineage and progeny, Revolutionary accomplishments, and mercantile occupation, the Stewarts exemplified America's new aristocracy. R.J.F.

Notes
1. See Charles Coleman Sellers, *Portraits and Miniatures by Charles Willson Peale* (Philadelphia: American Philosophical Society, 1952), 201–2. On depictions of people wearing miniatures, see Robin Jaffee Frank, *Love and Loss: American Portrait and Mourning Miniatures* (New Haven: Yale University Art Gallery, and New Haven and London: Yale University Press, 2000), 10–35.
2. Lyman Henry Butterfield, ed., *Diary and Autobiography of John Adams*, 4 vols. (Cambridge,

Mass.: Belknap Press of Harvard University Press, 1962), 2:260.
3. On the iconography of ovals, see David Steinberg, "Charles Willson Peale Portrays the Body Politic," in *The Peale Family: Creation of a Legacy 1770–1870*, ed. Lillian B. Miller, exh. cat. (New York: Abbeville Press, and Washington, D.C.: National Portrait Gallery, Smithsonian Institution, 1996), 127–29.

4. An itemized bill dated 30 Apr. 1782 from Marcus McCausland to Walter Stewart relates to the Turkish attire worn here; the bill includes "a pair of lace ruffles," as well as the materials to make a "White Mantua Habbit & Coat" and "olive Mantua Circassian Dress." Winterthur Library, Winterthur, Del., Joseph Downs Collection of Manuscripts and Printed Ephemera, No. 90 x 69.

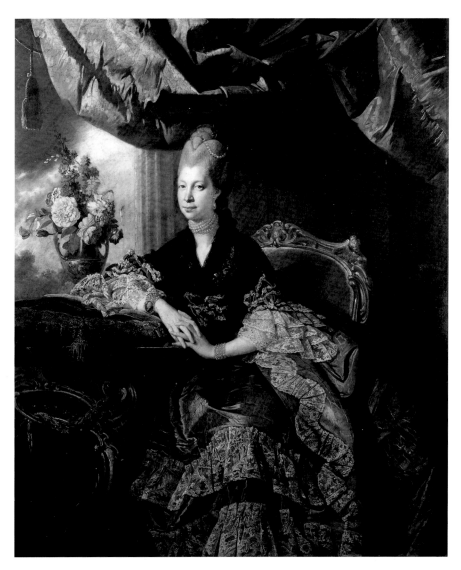

fig. a Johann Zoffany, *Queen Charlotte*, 1771. Oil on canvas, 64⅛ x 54 in. (162.9 x 137.2 cm). The Royal Collection, Her Majesty Queen Elizabeth II

111

Paul Revere (1735–1818)
Teapot
Boston, ca. 1795

Silver, 6 x 3½ x 11⅜ in. (15.2 x 8.9 x 28.9 cm),
wt. 19 oz., 12 dwt. (608 gm)
Mabel Brady Garvan Collection, 1930.959

In his fluted teapots, Paul Revere successfully wed technology and the emerging aesthetics of the neoclassical style. The flutes, or creases, evoke a classical column, adding strength and stability to the sheet-silver walls of the vessel, and the oval plan alludes to another classical decorative device, the patera, or shallow round dish. The engraving is used imaginatively, with tassels and swags playing off against the fabriclike creases. The design of the teapot probably was not originated by Revere and may have been suggested to him by wares he imported from England. English examples identical in almost every detail are known.[1]

Revere exemplifies the entrepreneurial spirit displayed by many Americans in the early years of political independence following the American Revolution. During his military service from 1775 to 1780, he ceased silversmithing, and in his absence, his son, also named Paul, ran the shop. By 1783, the two were working as Paul Revere & Son and also starting to retail imported silver-plated ware, hardware, pewter, and other products to meet the demands of the consumer society that emerged in the late eighteenth century.

In addition to silversmithing and retailing, Revere established a foundry in 1788 to smelt iron and brass. By 1800, Revere had left oversight of the silversmithing shop to his son in order to focus his energies on his copper-rolling mill in Canton, Massachusetts.

After the Revolution, new fabrication methods boosted the productivity of the silversmithing shop. Revere acquired a plating mill in 1785, which enabled him to produce sheet silver, the material used in the fabrication of this teapot. An analysis of the shop's daybooks indicates that the quantity and type of goods produced changed dramatically in the years following the Revolution. Fewer hollow-ware forms, but many more objects overall, were made, and flatware forms proliferated. Wares for serving tea predominated, with fifty-five teapots recorded between 1779 and 1797. Standardization of forms and new technology fueled the increase in production.[2]

P.E.K.

Notes
1. For example, a teapot by Robert Hennell, London, 1788, in Percy Hennell, "The Hennells: A Continuity of Craftsmanship," *Silver* 20 (Jan.–Feb. 1987), 23.
2. See Deborah A. Federhen's entry on Revere in Patricia E. Kane, ed., *Colonial Massachusetts Silversmiths and Jewelers: A Biographical Dictionary Based on the Notes of Francis Hill Bigelow & John Marshall Phillips* (New Haven: Yale University Art Gallery, 1998), 795–848.

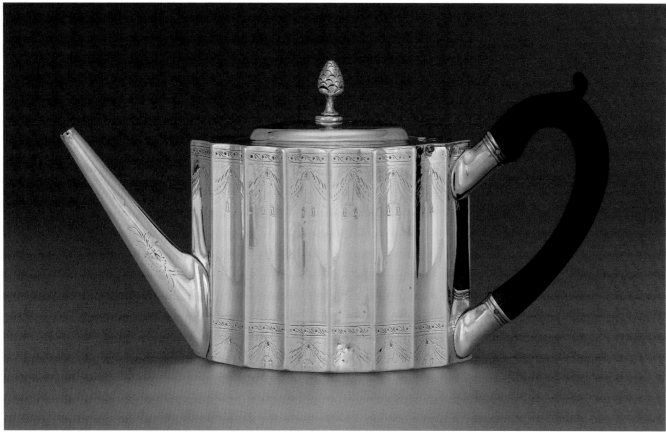

111

112

Sideboard

Charleston, South Carolina, 1790–1810

Mahogany, mahogany veneer with light- and
dark-wood inlays, red gum or black gum,
yellow poplar, southern yellow pine, southern
red cedar, and eastern white pine, 57 ¼ x
89 ¾ x 30 ⅝ in. (145.4 x 228 x 77.8 cm)
Mabel Brady Garvan Collection, 1930.2308

During the neoclassical period, the increased
popularity of the dining room created a need
for specialized dining furniture, including
the sideboard. With a broad surface to hold
food and serving pieces and shelves or draw-
ers to hold linens, ceramics, silver, and liquor
bottles, it provided a wealthy household
with storage as well as an opportunity for
display. Like the court cupboards popular in
the seventeenth century, the sideboard was
a perfect place to exhibit one's taste and
wealth. This large example was owned by
Colonel William Alston, whom George
Washington described as "a gentleman of
large fortune and esteemed one of the neatest
Rice planters in the State of So. Carolina."
It could have been used in his Charleston
town house or his country plantation.
Although its maker is unknown, cabinetmak-
ers in Charleston were advertising sideboards
as early as 1790.[1]

The design of the sideboard's case is taken
from Thomas Sheraton's *Cabinet-Maker and
Upholsterer's Drawing-Book* (first published in
1791), while the gallery is similar to one in
his 1803 *Cabinet Dictionary*. The gallery shelf
served as an additional surface on which to
show off the family's silver or ceramic hollow
ware (there are no grooves for plates), while
still allowing enough space on the side-
board's top for food and serving implements.
The sideboard is divided into five sections.
The center portion features a large drawer
over a set of sliding tambour doors, and it
curves inward, creating what is known as a

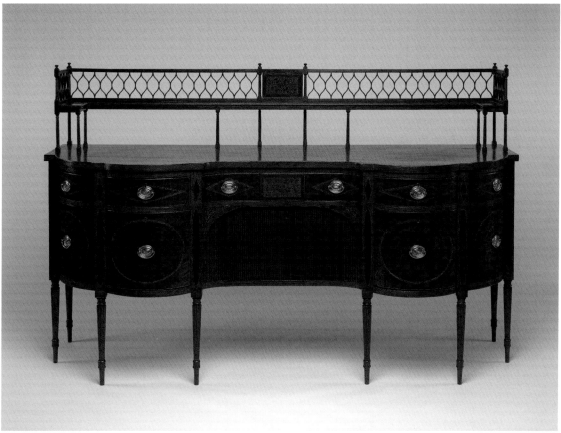

112

"hollow front." According to Sheraton, such
fronts were useful because "if the sideboard
be near the entering door of the dining-
room, the hollow front will sometimes secure
the butler from the jostles of the other ser-
vants." Drawers are fitted on either side of
the center section. The top drawer is divided
into compartments for storage, and the deep
bottom drawer is set up to hold bottles of
spirits. On the outside of the case are two
cabinets with doors designed to look like the
drawers. The elaborate use of inlay is unusual
for Charleston sideboards, and the pictorial
panels with floral imagery were likely
imported. The spandrels on either side of the
tambour door feature inlaid designs of oak
leaves and acorns. Two plaques of floral inlay

decorate the front drawer and the gallery.
These may be jasmine, hollyhocks, and other
flowers that symbolize plenty and endurance,
making them fitting images for use in the
dining room of a successful planter.[2] E.E.

Notes

1. The Yale University Art Gallery also owns Alston's
library bookcase (1930.2023a–e). Ronald L. Hurst
and Jonathan Prown, *Southern Furniture, 1680–1830:
The Colonial Williamsburg Collection* (Williamsburg,
Va.: Colonial Williamsburg Foundation, 1997), 514;
Bradford L. Rauschenberg and John Bivins, Jr., *The
Furniture of Charleston, 1680–1820*, 3 vols. (Winston-
Salem, N.C.: Museum of Early Southern Decorative
Arts, 2003), 2:619; George Washington, 29 Apr. 1791,
in John C. Fitzpatrick, ed., *The Diaries of George
Washington, 1748–1799*, 4 vols. (Boston: Mount
Vernon Ladies' Association of the Union and
Houghton Mifflin, 1925), 4:169; E. Milby Burton,
Charleston Furniture, 1700–1825, Contributions
from the Charleston Museum, vol. 12 (Charleston,
S.C.: Charleston Museum, 1955), 55. For related
sideboards, see Rauschenberg and Bivins, 2003,
2:643–49.

2. Gerald W. R. Ward, *American Case Furniture in
the Mabel Brady Garvan and Other Collections at
Yale University* (New Haven: Yale University Art
Gallery, 1988), 430, no. 222; Rauschenberg and
Bivins, 2003, 2:619, 644. Thomas Sheraton, *The
Cabinet-Maker and Upholsterer's Drawing-Book*
(London: T. Bensley, 1793), 366; Deanne Levison,
"The Symbolism of Floral Inlay," *Antiques* 145 (May
1994), 710.

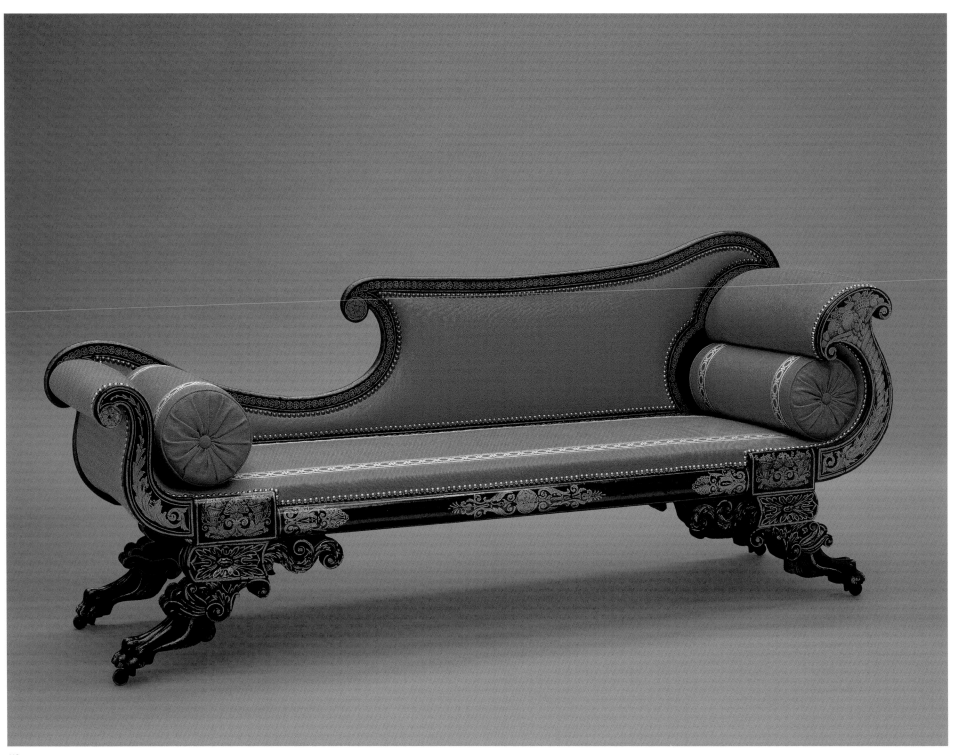

113

Couch
New York City, 1820–30

White pine, ash, tulipwood, and cherry,
29 15/16 x 20 3/4 x 60 in. (76 x 52.7 x 152.4 cm)
Mabel Brady Garvan Collection, 1930.2622

This couch stands out for its grand, sweeping curves and robustly carved feet borrowed from ancient Greek and Roman furniture, its rich surface ornament of gilt images of anthemia and cornucopias, and its costly wool upholstery. Made in New York City, it is a bold expression of luxury and opulence. Adding to its character is the function of the object, which invites its user to recline. One would lie on one's left side, head propped on the couch's right-hand arm, in a posture that the period associated with decadent indulgence. As the entry for "Grecian" notes in the English furniture designer Thomas Sheraton's 1803 *Cabinet Dictionary*, "The old Romans sat at meat as we do, till the Grecian luxury and softness had corrupted them; and then they lolled, or reclined at dinner after the Grecian manner . . . [they] had borrowed this idle mode."[1]

In this passage, Sheraton tied Grecian luxury to corruption and idleness. In doing so, he revealed a change in the course of classicism, wherein objects like this couch diverged from the politically invested Greco-Roman furniture style that had prevailed in the first decades of the American republic. This earlier style was marked by the straight lines, solid forms, and restrained decoration of classical architecture (cat. no. 53). Far removed from the flamboyant designs and luxurious character of this couch, the simple, geometric attributes were understood to embody the republican ideals of the Founding Fathers and the values of virtue, civic interest, and selflessness that they hoped to emulate from the example of the ancient Greeks.[2]

The couch's distance from the earlier model of classicism and its ideological underpinnings were tied to a much larger shift in American culture. During the decade when the object was produced, the United States was experiencing a market revolution, as a generation of enterprising entrepreneurs, a growing transportation network, and changes in government policy worked together to build a rampant capitalist economy. Under the pressure of this new structure, the public-spirited values of the Founders gradually gave way to those of self-interest. Material comfort and luxury rather than public service became the primary signifiers of social status and success.[3] The opulent design and indulgent function of the couch were consistent with these new criteria. Indeed, the cornucopias that embellish the object, seemingly positioned to drop their fruit into the reclining individual's mouth, explicitly connect the couch to the energies of the new marketplace. Images of cornucopias were commonplace in the American visual culture of the 1810s and 1820s. They figured most prominently in still-life paintings by artists such as James Peale, who borrowed from the visual traditions of an earlier capitalist hegemony—seventeenth-century Holland—to document the wealth and abundance of the paintings' owners and the new, free-market United States.[4]

E.L.

Notes

1. Thomas Sheraton, *The Cabinet Dictionary* (London: printed by W. Smith, 1803, repr. New York: Praeger, 1970), 245–46.
2. Wendy Cooper, *Classical Taste in America, 1800–40* (New York: Abbeville Publishers, 1993), 8.
3. Joyce Appleby, *Capitalism and a New Social Order* (New York: New York University Press, 1984), 91. See also Cary Carson, "The Consumer Revolution in Colonial British America: Why Demand?" in *Of Consuming Interests: The Style of Life in the Eighteenth Century*, ed. Cary Carson, Ronald Hoffman, and Peter Albert (Charlottesville: University Press of Virginia, 1994), 682.
4. John Wilmerding, *Important Information Inside: The Art of John Peto and the Idea of Still Life Painting in Nineteenth-Century America* (New York: Harper & Row, 1983), 38.

Education and Discovery

114

Samuel King (1748/49–1819)
Ezra Stiles, 1771

Oil on canvas, 34 x 28 in. (86.4 x 71.1 cm)
Bequest of Dr. Charles Jenkins Foote, B.A. 1883,
M.D. 1890, 1955.3.1

A 1746 graduate of Yale College, Ezra Stiles (1727–1795) returned as the school's seventh president in 1778. Stiles, a respected Newport minister, was one of the town's most erudite citizens. Fluent in several ancient languages, he read Greek and Roman history, philosophy, and the Cabala. In the sciences, Stiles proved no less inquisitive. He corresponded with Benjamin Franklin and conducted some of the earliest electrical experiments in America. Through his study of astronomy, Stiles became acquainted with Samuel King, whose father, a nautical instrument maker, had made a sextant for the Newport scholar.[1] The younger King, a self-taught painter, is best known for this portrait.

In his 1771 diary account of the picture, Stiles described his posture and gesture as "a Teaching Attitude" and offered a detailed account of the composition, listing the titles of the books visible on the shelves in the background, including works on Roman and Chinese history, Christian and Jewish theology, and Newtonian science. Among the emblems in the portrait is a circle and ellipse inscribed on the column in the background, which signifies "the Newtonian or Pythagorean System of the Sun & Planets & Comets." At the top of the column, a luminous disk filled with religious symbols representing "the Universe or intellectual World" bears the Hebrew letters for "God" beneath the overarching motto "All Happy in God."[2] King included this unusual symbol at the behest of Stiles, who had drawn it in his diary the same year.

For Stiles, the use of such symbolism was essential to capturing his character. He wrote, "These Emblems are more descriptive of my Mind, than the Effigies of my Face."[3] King was already familiar with the idea that a man could be portrayed through a composite of emblems. In 1763, the artist made a watercolor drawing entitled *A Free Mason Form'd out of the Materials of his Lodge*,[4] in which Masonic symbols are combined to form a human figure (fig. a). Below the figure, an inscription reads:

Behold a Master Mason rare,
Whose mistic Portrait does declare,
The secrets of *Free Masonry*,
Fair for all to read and see,
But few there are to whom they're
 known,
'Tho they so plainly here are
 shown.

King's "mistic Portrait" of Stiles, an exceptional example of emblematic portraiture, functions similarly by declaring the "secrets" of the clergyman's intellect "for all to read and see." G.C.B.

Notes

1. See Edmund S. Morgan, *The Gentle Puritan: A Life of Ezra Stiles, 1727–1795* (Chapel Hill: University of North Carolina Press, 1962), 153–57.

2. These Hebrew characters, known as the "Tetragrammaton," are typically transliterated as "YHWH" or "JHVH," Yahweh or Jehovah, the biblical name for God.

3. Ezra Stiles, 1 Aug. 1771, in Franklin Dexter, ed., *The Literary Diary of Ezra Stiles,* D.D., LL.D., 3 vols. (New York: Charles Scribner's Sons, 1901), 1:13.

4. King copied the work from an English engraving. See Brandon Brame Fortune and Deborah J. Warner, *Franklin and His Friends: Portraying the Man of Science in Eighteenth-Century America*, exh. cat. (Washington, D.C.: Smithsonian, National Portrait Gallery, and Philadelphia: University of Pennsylvania Press, 1999), 68–70.

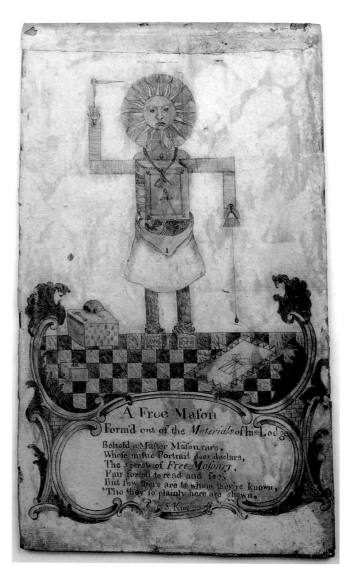

fig. a Samuel King, *A Free Mason Form'd out of the Materials of his Lodge*, 1763. Ink and watercolor on paper, 12 15/16 x 8 3/16 in. (32.9 x 20.8 cm). The Lodge of St. Andrew, A.F. & A.M., Boston

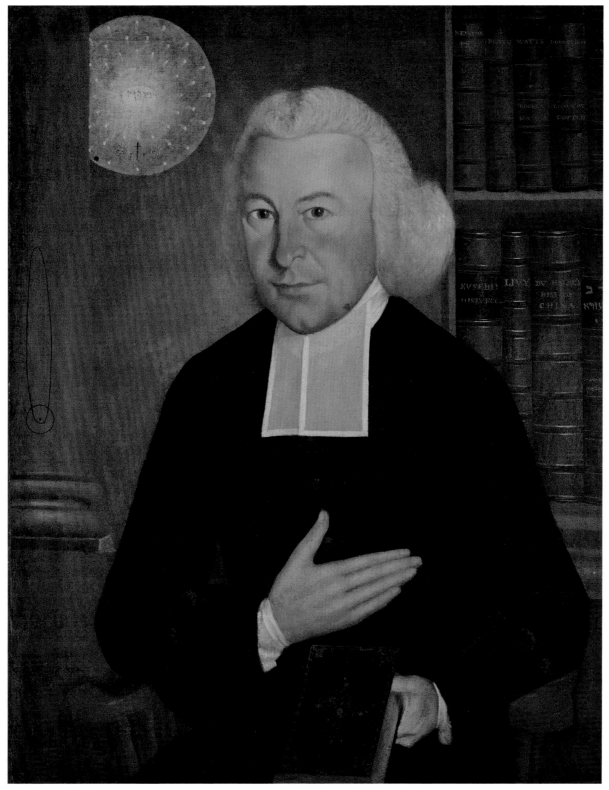

114

115

Samuel Minott (1732–1803)
Cann
Boston, 1770

Silver, h. 5 5/16, diam. lip 3 1/8, diam. base 3 7/16 in.
(13.5 x 7.9 x 8.7 cm), wt. 11 oz., 18 dwt. (368 gm)
Mabel Brady Garvan Collection, 1930.1382

In 1636, an act of the General Court of Massachusetts created Harvard College to serve as a training ground for Congregational ministers in the colonies. Each college class had one tutor who oversaw its entire education; there were only two to four tutors in residence at Harvard at any given time in the seventeenth and most of the eighteenth centuries. Tutors had to be single, possess a baccalaureate degree, and intend to become a minister. Following a precedent set by English colleges at Cambridge and Oxford, graduating classes presented silver to their tutors as partial compensation for their education. A gift of silver augmented the tutor's income, which consisted of a salary from the college plus a fee collected from each student. The diaries of tutor Henry Flynt (1675–1760) suggest that the tutors knew not only who was contributing to the gifts but also how much they were giving. As it was the tutor's job to rank the students, such a gift was not simply a token of gratitude on the students' part but also an opportunity for personal advancement.[1]

This cann is part of a three-piece gift presented to tutor Joseph Willard in 1770. It is the latest-surviving American example of tutorial presentation plate, which was most popular at Harvard in the seventeenth and early eighteenth centuries. Willard graduated from Harvard in 1765 and became a tutor shortly thereafter. He was elected president of Harvard College in 1781 and held that office until his death in 1804. Translated from Latin, the cann's engraved inscription reads: "Joseph Willard reports that this small gift was received from the students of Harvard starting their third year under his tutelage, at the beginning of the year 1770." The inscription, enclosed in a foliate frame, is much more elaborate than the simple "ex dono pupillorum" that appears on most earlier tutorial plate.[2]

Made by Boston silversmith Samuel Minott, the cann has a pear-shaped body with scroll handle and applied lip and foot. Minott created several similarly shaped pieces that were bequests to churches. Along with Benjamin Burt and Paul Revere, Minott was one of Boston's leading silversmiths and jewelers. In addition to creating his own pieces, he also had a large retail operation, buying silver goods from Revere and a number of other Boston-area silversmiths for resale in his own shop.[3] E.E.

Notes

1. Janine E. Skerry, "'Ancient and Valuable Gifts': Silver at Colonial Harvard," in *New England Silver and Silversmithing, 1620–1815,* ed. Jeannine Falino and Gerald W. R. Ward (Boston: Colonial Society of Massachusetts, 2001), 191; Edward Thomas Dunn, *Tutor Henry Flynt of Harvard College, 1675–1760* (Ann Arbor, Mich.: University Microfilms, 1968), 380–81, quoted in Skerry, 2001, 193.

2. A matching cann and tankard are in the collections of the Museum of Fine Arts, Boston. Skerry, 2001, 194; *Harvard Tercentenary Exhibition*, exh. cat. (Cambridge, Mass.: Harvard University Press, 1936), 114.

3. Patricia E. Kane, ed., *Colonial Massachusetts Silversmiths and Jewelers: A Biographical Dictionary Based on the Notes of Francis Hill Bigelow & John Marshall Phillips* (New Haven: Yale University Art Gallery, 1998), 689.

115 Inscription

116

Cornelius Kierstede (1674–1757)
Bowl
New Haven, Connecticut, 1745

Silver, h. 3 3/8, diam. rim 7 1/2, diam. base 3 7/16 in.
(8.6 x 19.1 x 8.7 cm), wt. 11 oz., 17 dwt. (368 gm)
Bequest of Miss Helen S. Darling, in memory of
Thomas Darling, B.A. 1836, M.A. 1839, 1913.688

Silver presentations, though common at
Harvard, were rare at Yale College in the
colonial period. In fact, only three such
pieces associated with Yale are extant today.[1]
Two were given in 1745: this bowl, offered by
Yale's Class of 1745 to its tutor, Thomas
Darling (tutor at Yale, 1743–45),[2] and a tea-
pot by Jacob Hurd from the student body to
Thomas Clap (rector/president of Yale,
1739–66) (YUAG 1986.71.1.1).[3] Though contem-
poraneous, the two objects are very differ-
ent. The Clap piece is an English-style apple-
form teapot typical of period Boston style,
while the Kierstede gift, though based on
English bowl forms, bears Dutch-inspired
chasing and repoussé floral decoration typi-
cal of New York two-handled punch bowls
from four decades earlier.[4]

This hybrid character of New York City
silver, which entered Connecticut through
trade with the city and the migration of New
York silversmiths like Kierstede, became
increasingly popular in western Connecticut
during the early eighteenth century. By
1745, such intensely Dutch ornament was out
of fashion in New York City; however, the
bowl's lack of handles, the presence of
Kierstede's post-1728 mark, and the chased
vertical lines on the sides, stopping just
below the rim to allow room for the inscrip-
tion, all indicate that this piece was made at
the time of commission.

The impetus behind the use of such an
archaic style may have been the religious
debate of the time. As western Connecticut
became more culturally diverse and trade-
oriented, the colony's cultural, economic, and
religious ties to Massachusetts began to
weaken. To counteract these changes and
regain the support of Massachusetts, religious
leaders in Connecticut adopted a Presbyte-
rian version of Congregationalism. The
resultant regimentation of church practices,
the persecution of non-Congregationalists,
and the centralization of the church's power
in a general assembly ended up dividing
Connecticut's faithful.

When Clap, a follower of this new version
of the church, arrived at Yale, he embarked
on a campaign to strengthen the ministry
there. He instituted a series of stringent rules
based on these new ideals, thereby extend-
ing the spiritual divide into the Yale commu-
nity. Tensions peaked when Yale expelled
John and Ebenezer Cleveland for attending
a Separatist church service with their parents
during the fall of 1744, just a few months
before Darling's bowl was commissioned.

Darling, himself a theology scholar (Yale
Class of 1740), was exceedingly displeased
with Clap's policies. In his highly critical
piece, "Some Remarks on President Clap's
History," written in 1755, he called Clap's
Yale a "ministry-factory," which the president
was using to gain legislative favor by pro-
ducing ultraconservative theologians. He also
stated that Clap's intolerant and dictatorial
version of the church was medieval and had
no place in contemporary religious education
and thought.

Many of Darling's students may
have shared his beliefs, especially non-
Congregationalists like Jeremiah Leaming,
who became an Anglican minister after
graduating from Yale. This bowl may be
seen as a material expression of their stand
on the matter. By choosing a former
New York silversmith and a style of decora-
tion that was associated with New York,
Darling and/or his students affirmed
their belief in religious freedom and
acceptance of Connecticut's increasingly
diverse population. K.W.

116

Notes

1. Janine E. Skerry, "'Ancient and Valuable Gifts':
Silver at Colonial Harvard," in *New England Silver
and Silversmithing, 1620–1815,* ed. Jeannine Falino
and Gerald W. R. Ward (Boston: Colonial Society
of Massachusetts, 2001), 206n.4.

2. It is unclear whether this bowl was given to
Darling by his students or commissioned by Darling
himself with a monetary gift from the class. The
inscription reads, in part: "Domino THOMAE: DARLING
Tutori: DIGnissimo: hos: Damus Cyathos: aeterni:
Pigniis: Amoris Classis: sua 1745" (To Master Thomas
Darling, most worthy tutor, we his class give this
cup as a token of eternal love).

3. David B. Warren et al., *Marks of Achievement:
Four Centuries of American Presentation Silver,*
exh. cat. (Houston: Museum of Fine Arts, and New
York: Harry N. Abrams, 1987), 50–51, no. 44. Also
in 1745, Yale College revised its charter.

4. See Gerrit Onckelbag's brandywine bowl in
Deborah Dependahl Waters, ed., *Elegant Plate:
Three Centuries of Precious Metals in New York
City,* 2 vols. (New York: Museum of the City of
New York, 2000), 1:172, no. 54.

117

Phi Beta Kappa Key, 1842

Gold, 2 1/8 x 15/16 in. (5.4 x 2.4 cm), wt. 0.25 oz.
(7 gm)
Mabel Brady Garvan Collection, 1935.249

As America grew, fraternal orders provided men of similar economic, political, and educational backgrounds with a means of social cohesion. Among the earliest of these fraternities was Phi Beta Kappa, which was founded at the College of William and Mary in 1776 and derived its name from the initials for the Greek motto "*Philosophia Biou Kubernetes*" (Philosophy the Guide of Life). Phi Beta Kappa had all the trappings of a secret fraternal order, including "ritual, oath, signs, badge, and motto."[1] Just as the Freemasons purportedly traced their roots to the Knights Templar of the Crusades, certain texts endowed Phi Beta Kappa with origins grander than a mere college. In 1831, one author asserted that the society "was imported into this country from France by Thomas Jefferson." Another records that Phi Beta Kappa had been linked with the Illuminati, a late-eighteenth-century Bavarian secret society, perhaps because both were founded in the same year.[2]

As a public sign of their membership, members wore gold badges like this one bearing the insignia of the society. It was originally a medal, and sometime in the early nineteenth century a stem was added, converting the badge into a pocket watch key that could be worn as a fob.[3] The obverse of the badge is inscribed with six stars at the upper left and a pointing hand set diagonally at lower right. The six stars refer to the six chapters of the society active at the time: Harvard (1779), Yale (1779), Dartmouth (1787), Union College (1817), Bowdoin (1825), and Brown (1830); the original chapter at William and Mary was inactive between

1781 and 1851. (Today the society has 270 chapters, so the badge has a pointing finger and only three stars, which symbolize the three principles of the society—friendship, morality, and learning.[4]) The reverse of the badge or key bears the member's name, "F. D. Beman." Frederick Dan Beeman of Warren, Connecticut, was a member of Yale's Class of 1842 and went on to become a lawyer and county clerk of Litchfield County, Connecticut.[5] Below Beeman's name (which is misspelled) are the letters "SP," standing for *Societas Philosophiæ* (Philosophical Society). Beneath that is "Dec. 5th, 1776," the date the society was founded.

In September 1826, William Morgan, who had written a book exposing the secrets of Freemasonry, mysteriously disappeared and was widely believed to have been murdered by Freemasons. The ensuing Morgan affair, with its bitter anti-Masonic sentiment, had a profound effect on all secret societies, including Phi Beta Kappa.[6] Former President John Quincy Adams, a Harvard alumnus, was able to persuade his alma mater's chapter "to make public its so-called secrets and become an open, honorary organization."[7] Harvard immediately sent an envoy to New Haven, who was successful in persuading Yale to do the same. Having "dropped its oath and sold its paraphernalia to the old-clothes man," Phi Beta Kappa donned the mantle of an academic honor society, which it wears to this day.[8]

G.C.B.

Notes

1. William J. Whalen, *Handbook of Secret Organizations* (Milwaukee: Bruce Publishing Co., 1966), 42–43. Portions of the following are excerpted from Graham C. Boettcher, "'Masked from the Common Eye': Fraternity, Ritual and Secrecy at Yale" (unpublished paper, YUAG Object Files, 1998), 3–7.
2. Avery Allyn, *A Ritual of Freemasonry* (Boston: John Marsh and Co., 1831), 302; Albert C. Stevens, *The Cyclopædia of Fraternities* (New York: E. B. Treat, 1907), 344–46, 358.

3. William T. Hastings, *The Insignia of Phi Beta Kappa* (Washington, D.C.: United Chapters of Phi Beta Kappa, 1964), 7.
4. Originally, "literature" was the society's third aim. See Hastings, 1964, 5–6n.3.
5. *Biographical Record of the Class of 1842* (New Haven: Tuttle, Morehouse & Taylor, 1878), 21–22.
6. See William T. Hastings, *Phi Beta Kappa as a Secret Society with Its Relations to Freemasonry and Antimasonry* (Washington, D.C.: United Chapters of Phi Beta Kappa, 1965).
7. Stevens, 1907, 331.
8. Charles W. Ferguson, *Fifty Million Brothers* (New York: Farrar & Rinehart, Inc., 1937), 36–37.

117

Reverse

118

Columbian Anacreontic Society Medal
New York City, 1795–1803

Silver and silver gilt, 2⅞ x 1¾ in. (7.3 x 4.4 cm), wt. 11.5 dwt. (18 gm)
Gift from the Estate of Geraldine Woolsey Carmalt, 1968.36

One of several musical societies formed in the early United States, the Columbian Anacreontic Society was inspired by a similar organization in England. Eighteenth-century Londoners celebrating wine, women, and song looked to the sixth-century B.C. Greek lyric poet Anacreon for inspiration. Anacreon's poetry was a refined celebration of the pleasures of life, and his works struck a chord with London's upper crust. In his honor, they formed an Anacreontic Society in the late eighteenth century, where members read poetry, played music, sang songs, and drank in a men-only environment. The society is best remembered for one of its most popular ballads, "To Anacreon in Heaven," written by composer John Stafford Smith. In 1814, Baltimore lawyer Francis Scott Key borrowed the melody of the song for his ballad "The Defence of Fort M'Henry," known today as "The Star-Spangled Banner."[1]

The New York City club, the Columbian Anacreontic Society, was founded in 1795 and was active until about 1803; clubs in Baltimore and Philadelphia were established in the 1820s and 1830s. The New York society met once a month from October through June and held a special dinner and ladies' concert each season. During New York City's memorial service for George Washington, the Anacreontic Society marched with the Philharmonic Society, "in complete Mourning—the Grand Officers bearing Wands, decorated with Crape—the Members wearing their Badges with Crape and Bows of Love Ribbon."[2]

This Columbian Anacreontic Society badge belonged to William Dunlap, whose miniature portrait is also in the Yale collection (fig. a). The silver badge is shaped like a harp crowned with a rayed sun. Dunlap's name is engraved on the crossbars, while "Columbian Anacreontic Society" runs along the harp's curved sides. The word "Honor" appears on the reverse. Dunlap was an artist, playwright, and author who has been called "the father of American drama" and "the American Vasari." He managed several theaters during his career, in addition to painting miniatures and oils. His translations of French and German plays helped expose American audiences to contemporary European theater. Two of his many books, *History of the American Theatre* (1832) and *History of the Rise and Progress of the Arts of Design in the United States* (1834), are still regarded as authorities in their field. His interest in drama and culture made him a natural candidate for membership in the Anacreontic Society, as did his business partnership with actor-manager John Hodgkinson, who served as the society's president for its first four years.[3] E.E.

Notes

1. Oscar George Sonneck, *Early Concert-Life in America, 1731–1800* (Leipzig: Breit Kopf and Hartel, 1907; repr. New York: Da Capo Press, 1978), 204.
2. *Laws and Regulations of the Columbian Anacreontic Society* (New York: G. F. Hopkins, 1800), 5, 10; New York (City) Committee of Arrangements for Washington Observation, "From the Office of the Daily Advertiser, The Following Interesting Description, is from the Committee . . . " (New York, 1800), in American Antiquarian Society, ed., *Early American Imprints, 1639–1800*, ser. 1, no. 38097 (New York: Readex, 1984), microfilm. Dorothy C. Barck, "The Columbian Anacreontic Society of New York, 1795–1803," *The New-York Historical Society Quarterly Bulletin* 16:4, 115–23. I thank Margaret K. Hofer for the reference.
3. *Dictionary of American Biography*, s.v. "Dunlap, William"; Sonneck, 1978, 205.

118

Reverse

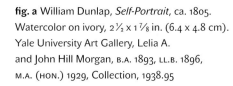

fig. a William Dunlap, *Self-Portrait*, ca. 1805. Watercolor on ivory, 2½ x 1⅞ in. (6.4 x 4.8 cm). Yale University Art Gallery, Lelia A. and John Hill Morgan, B.A. 1893, LL.B. 1896, M.A. (HON.) 1929, Collection, 1938.95

119

John Trumbull (1756–1843)
Self-Portrait, ca. 1802

Oil on canvas, 29 ¾ x 24 ⁹/₁₆ in. (75.5 x 62.4 cm)
Gift of Marshall H. Clyde, Jr., 1981.129.1

Painted during his residence in London as a member of the Jay Treaty Commission, John Trumbull's dignified *Self-Portrait* fits Benjamin Silliman's description of the artist as an "elegant, graceful gentleman."[1] Here Trumbull fashioned himself as an artist, a soldier, and a statesman. With his hands resting on the golden hilt of his sword, Trumbull wears a blue coat, with a yellow waistcoat peeking out from its collar, that recalls the uniform he wore as an officer in the Continental army, where he served as George Washington's second aide-de-camp. Displayed beside his sword, a palette and brushes stand for his vocation as an artist. The "grand manner" format of the picture—a luxurious red drape drawn to reveal a dramatic sky—is eminently appropriate for an artist's self-portrait, but it was also the prevailing mode for depicting statesmen, conferring on the sitter both importance and European erudition. The folded paper beneath Trumbull's palette may be a more explicit reference to his diplomatic endeavors with the Jay Treaty.[2]

The attributes of the soldier-cum-painter depicted in this portrait would define Trumbull throughout his life and even after his death. Silliman's epitaph for Trumbull's tomb reads: "Col. John Trumbull, Patriot and Artist . . . to his Country he gave his SWORD and his PENCIL."[3] The tomb, now located inside the Yale University Art Gallery itself, is part of a unique arrangement that Trumbull made with the school. In 1831, he sold most of the canvases he owned, including the now iconic *Declaration of Independence* (cat. no. 33), to Yale College in exchange for a permanent gallery in which to house them and a one-thousand-dollar annuity. Located on what is today Old Campus and known simply as the Trumbull Gallery, the neoclassical structure was designed by the artist in collaboration with architects Ithiel Town and A. J. Davis, and it became the first college museum in America (fig. a). According to the terms of the agreement, Trumbull and his wife, Sarah, were interred in a vault beneath the gallery, below the artist's full-length portrait of Washington (cat. no. 58). When Silliman eulogized the multitalented Trumbull, he invoked the manifold ways in which the artist saw himself: "The soldier, the artist, the man of letters and varied talents—the man of the world, the accomplished gentleman and the man of policy and diplomacy were all united in him. . . . Long may his works remain and longer still his fame."[4] G.C.B.

Notes

1. Benjamin Silliman, "Notebook," unpublished reminiscences, 1857, I:6, 19, quoted in Helen A. Cooper, *John Trumbull: The Hand and Spirit of a Painter*, exh. cat. (New Haven: Yale University Art Gallery, 1982), 159.
2. The Jay Treaty Commission was organized to settle commercial and frontier disputes between the United States and Britain. Trumbull was appointed secretary to the commission by Chief Justice John Jay in 1794 and became a member of it in 1797. The folded paper may also refer to Trumbull's work in architectural design (Cooper, 1982, 10, 11; 159n.2).
3. Ibid., 159n.2.
4. Silliman, "Notebook" II:2, 129, quoted in Cooper, 1982, 19n.101.

VIEW OF TRUMBULL GALLERY.

fig. a John Warner Barber, *View of the Trumbull Gallery*, from Ezekiel Porter Belden, *Sketches of Yale College* (New Haven: Sidney Babcock, 1843). Collection of Graham C. Boettcher

120

120

Thomas Sully (1783–1872)
*Self-Portrait of the Artist Painting His Wife
(Sarah Annis Sully)*, ca. 1810

Oil on canvas, 26¾ x 21⅞ in. (67.9 x 55.6 cm)
Mabel Brady Garvan Collection, 1937.15

One of the most striking features of this double portrait, a tender image of a love affair that would last over sixty years, is Sarah Sully's withdrawn demeanor. Her white transparent veil and downcast eyes accord with the accepted dress and comportment of a woman in mourning.[1] Great sadness haunts this picture: Sully's older brother and Sarah's first husband, Lawrence, died unexpectedly in a street brawl in 1804, and the Sullys' infant son, Thomas Jr., died in 1810.[2] The work likely commemorates the death of this child, who died in Philadelphia while his father was in London studying with the esteemed expatriate painter Benjamin West.[3]

A mother mourning a profound loss, Sarah Sully can also be understood in this portrait as representing the consciousness of the artist, who depicts himself in the process of bringing her into being. Above his head is the corner of the canvas on which he paints her visible likeness. The unresolved patches of paint—at the base of her neck, around the edges of her bodice—are a calculated display of the artist's hand. Through him, through the movement of his brush, shown in the bottom left corner, he brings her forth in a burst of light at the center of a dark, undefined space: a common trope for expressing the Romantic imagination. The work is a meditation on the act of creation in all its precariousness and possibility. The fictional canvas depicting Sarah appears to oscillate between materialization and imaginative figment; she seems always on the verge of evaporating, anticipating later criticism that Sully's works looked "as if you could blow them away."[4]

How different from the model provided by Sully's master, Benjamin West (fig. a).[5] West's *Self-Portrait* possesses none of the vivacity of the Sully; his picture has a terseness, whereas Sully's aims for something evocative—a sympathetic merging of painter's and viewer's consciousness. The portrait can thus be seen not only as a testament to Sully's love for his wife and to the sadness the couple felt at the tragedies that lay in their history together, but also to the young artist's ambition to outdo his master and wonder at the conjuring powers of the imagination. It presents a much more complicated view of an artist who was often criticized for attending more to his sitters' artificial aspects—the veneer with which they covered

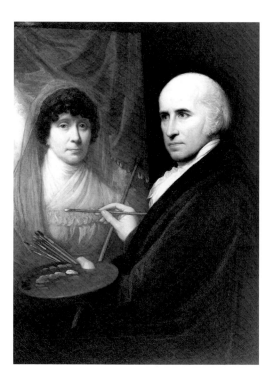

fig. a Benjamin West, *Self-Portrait*, 1806. Oil on canvas, 36⅛ x 28⅛ in. (91.8 x 71.4 cm). Courtesy of the Pennsylvania Academy of the Fine Arts, Philadelphia, Gift of Mr. and Mrs. Henry R. Hallowell, 1964.11

themselves in public—than to their inner character. Here Sully takes interiority itself as his subject. J.A.G.

Notes

1. On mourning comportment and attire, see Phillis Cunnington and Catherine Lucas, *Costume for Births, Marriages & Deaths* (New York: Barnes & Noble Books, 1972), 147, 152; and Robin Jaffee Frank, *Love and Loss: American Portrait and Mourning Miniatures* (New Haven: Yale University Art Gallery, and New Haven and London: Yale University Press, 2000), 123–24.

2. Sully married Sarah on 27 June 1806. On Lawrence Sully and his relationship to Thomas, see William Dunlap, *History of the Rise and Progress of the Arts of Design in the United States*, vol. 2 (New York: George P. Scott and Co., 1834), 102–10; Charles Henry Hart, "Thomas Sully's Register of Portraits, 1801–1871," *Pennsylvania Magazine of History and Biography* 32 (1908), 389–90; and James Bailey, "The Sullys: Searchers After Beauty," *Virginia Cavalcade* 9 (summer 1959), 42.

3. On the picture's date and the reason for Sarah's demeanor, see Monroe H. Fabian, *Mr. Sully, Portrait Painter: The Works of Thomas Sully (1783–1872)* (Washington, D.C.: Smithsonian Institution Press, 1983), no. 6, 45, and no. 7, 46; and Steven Eric Bronson, "Thomas Sully: Style and Development in Masterworks of Portraiture, 1783–1839" (PH.D. diss., University of Delaware, 1986), 71–73.

4. Thomas Sully, "Recollections of an Old Painter," *Hours at Home: A Popular Monthly of Instruction and Recreation* 10 (Nov. 1869), 72.

5. West's painting was on view at the Pennsylvania Academy of the Fine Arts from 1808. Newly settled in Philadelphia at the close of 1807, Sully surely would have seen it before departing to study with West in 1809, though he may have painted his rendition after his return in 1810. For an earlier model, see Charles Willson Peale's ca. 1782–85 *Self-Portrait with Angelica and a Portrait of Rachel* (Museum of Fine Arts, Houston).

121

Reverse

122

123

Charles Cushing Wright (1796–1854), engraver

121

Peter Paul Duggan (b. Ireland, 1810–1861), designer, obverse and reverse
Struck at the United States Mint, Philadelphia
American Art-Union Medal Depicting Washington Allston, 1847

Bronze, wt. 134.1 gm, 12:00, 64.5 mm
Yale University Numismatic Collection Transfer, 2001, 2001.87.2999

122

Salathiel Ellis (b. Canada, 1806, active 1842–64), designer, obverse
Peter Paul Duggan (b. Ireland, 1810–1861), designer, reverse
Struck at the United States Mint, Philadelphia
American Art-Union Medal Depicting Gilbert Stuart, 1848

Bronze, wt. 137.2 gm, 12:00, 64 mm
Yale University Numismatic Collection Transfer, 2001, Old University Collection, 2001.87.1091

123

Robert Ball Hughes (b. England, 1806–1868), designer, obverse
Peter Paul Duggan (b. Ireland, 1810–1861), designer, reverse
Struck at the United States Mint, Philadelphia
American Art-Union Medal Depicting John Trumbull, 1849

Bronze, wt. 119.7 gm, 12:00, 64 mm
Gift of Miss Maria Trumbull Dana, 1957.11.1

Established in 1839 as the Apollo Association for the Promotion of the Fine Arts in the United States and renamed the American Art-Union in 1844, the New York City–based organization stated its objectives as "the

promotion of the Fine Arts in the United States, and the cultivation and improvement of the public taste; affording to Artists additional encouragement by the purchase of their works, and distributing the same among the people." To accomplish these aims, the Art-Union charged its members five dollars annually; the proceeds, after covering operating costs, were "devoted, first, to the engraving and printing of some choice picture for distribution among the members; and, next, to the purchase of such works of American Artists." These works were distributed by lottery to members at the Art-Union's annual meeting, held each December in New York City.[1] The organization's geographically and socioeconomically diverse membership contributed to the democratization of art patronage in the United States, which had previously relied almost exclusively on the support of the wealthy northeastern elite. Initially, the works of art acquired by the Art-Union consisted primarily of oil paintings, such as George Caleb Bingham's *The Jolly Flat Boat Men*, which was distributed in the lottery of 1847 and selected to be engraved for subscribers (cat. no. 172). That same year, however, the Art-Union commissioned the first in a series of three medals honoring eminent American artists.

The first medal (cat. no. 121) commemorates the Romantic painter Washington Allston (1779–1843). It was designed and modeled by Peter Paul Duggan, an Irish-born portrait artist and member of the National Academy of Design (NAD), and engraved by Charles Cushing Wright, a founding member of the NAD and widely considered America's foremost die-engraver. The portrayal of the youthful Allston found on the obverse may have been derived from a bust of the artist by Shobal Vail Clevenger, which Duggan could have viewed in the permanent collection of the NAD.[2] The medal's reverse depicts "the Genius of America

rewarding the Arts."[3] A female personification of America—wearing classical dress and a crown of stars—stands poised against a striped shield recalling the Great Seal of the United States, as a toga-clad painter—carrying his palette, brushes, and maulstick—and a sculptor in Renaissance garb—identifiable by his mallet and dividers—bow their heads to receive laurels from her. "This is very literal," as one contemporary publication noted, "for the Genius of America don't crown such kind of people with anything else, as they say in the Bowery."[4]

At the Art-Union's annual meeting of 1847, fifty medals in silver and two hundred fifty in bronze were allotted to members. In the Art-Union's *Transactions* for that year, the Committee of Management reported that "they knew their constituents would participate in their own gratification in being able to make this earliest contribution to the noble art of Medallurgy [*sic*], instrumental also in perpetuating the fame of one who united to great professional skill such lofty imaginative power, and whose genius is honored as well in the old world as in the new."[5] Indeed, the Art-Union's first foray into medallic art seems to have been generally well received. One publication called the medal "superior to any work of the kind that has hitherto been executed in this country,"[6] and Wright was awarded a silver medal at the 1848 Fair of the American Institute for his work.[7]

Also that year, the Art-Union commissioned a medal in honor of the portraitist Gilbert Stuart (1755–1828) and "his early and conceded prominence in the history of American Art." In the *Transactions for 1848*, the Committee of Management, asserting that members did not sufficiently appreciate or understand the medallic art, offered extensive commentary on its historic importance:

Coeval with the polished nations of antiquity, this art has served to perpetuate to posterity the portraits and names

of their heroes, and the memory of their illustrious deeds, and to dispel much of the obscurity of their ancient history. In the transit of centuries, the heroic monument will crumble, the canvas fade, the parchment decay; but the humble medal, from amid the ashes of temples and dust of departed nations, will commemorate to succeeding ages all that was glorious of their past history, or worthy of emulation and renown. . . . Surely, in our own land, where orders of knighthood and honors of heraldry await not those excelling in Art, these tokens of meritorious remembrance should not be regarded as of little worth.[8]

Wright again cut the dies for the medal, and Duggan's reverse, which had become the seal of the Art-Union, was reused with only the date changed. The obverse (cat. no. 122) was designed and modeled by Salathiel Ellis, a Canadian-born cameo-cutter and sculptor, who went on to design several presidential Indian peace medals for the United States Mint.[9] Ellis, who had also received a silver medal at the 1898 Fair of the American Institute for "Best Medallion Likenesses," prepared a bas-relief portrait of Stuart (now in the collection of the New-York Historical Society), which he based on a bust made from Stuart's life mask by John Henri Isaac Browere for a portrait gallery of famous Americans.[10] Two hundred fifty Stuart medals and two hundred Allston medals were to be distributed at the annual meeting of 1848. Of the forthcoming lottery, the Art-Union *Bulletin* remarked, "We have our heart set upon one or other of certain pictures; but if we cannot have it, we shall be very grateful for one of these medals."[11] Not everyone deemed the medals a fair substitute for a picture. Stuart's daughter Jane was in New York at the time of the Art-Union drawing and overheard one young man ask another what he had gotten, to which he replied, "I

did not draw one devilish thing worth having, but a medal of that old Stuart. I shall throw it out of the window."[12]

Despite such detractors, the Art-Union commissioned its third and final medal to be distributed in 1849. The medal commemorates John Trumbull (1756–1843), the painter and patriot (cat. no. 123; also cat. no. 119), "whose position in the department of historic painting is inferior to that of no American artist, and whose representations on canvas, of our country's earlier scenes and worthies, still speak so vividly to every patriot heart."[13] As with the previous two medals, Wright was chosen to sink the die, and Duggan's reverse was used unchanged save for the date. The obverse, however, was designed by Robert Ball Hughes, a British-born sculptor who, after arriving in New York City in 1829, befriended Trumbull. Hughes's design is based on his own marble bust of the artist, begun in 1833 (fig. a). One scholar argues that this is the "most attractive" of the three medals because "Trumbull was a very handsome man with features which loaned themselves to sculpturing."[14] The medal's success probably has more to do with the fact that Hughes was the only one of the three designers to have known his subject and portrayed him from life.

The American Art-Union was dissolved in 1852, after the New York State Supreme Court ruled that its lotteries violated the state's antigambling statutes. On 17 December 1852, the final day of the Art-Union's three-day liquidation sale, the remaining eighty examples of each medal were sold.[15] Though short-lived, the American Art-Union contributed significantly to popularizing the medal in the United States and ushering in the proliferation of American medallic art in the second half of the nineteenth century, culminating in the hundreds of medals and tokens made to commemorate the World's Columbian Exposition in 1893. G.C.B.

Notes

1. American Art-Union, pamphlet (New York, 1844). Collection of Sterling Memorial Library, Yale University.
2. Georgia Stamm Chamberlain, *American Medals and Medalists* (Annandale, Va.: Turnpike Press, Inc., 1963), 13.
3. American Art-Union, *Plan of the Institution, List of Its Officers and Catalogue of Its Paintings* 12 (15 Aug. 1847), 4.
4. "Gossip of the Month," *United States Magazine and Democratic Review* 21 (Oct. 1847), 372.
5. American Art-Union, *Transactions for 1847* (New York: printed by G. F. Nesbit, 1848), 17–19.
6. See n. 4.
7. "The Fair of the American Institute," *Scientific American* 4 (18 Nov. 1848), 66.
8. American Art-Union, *Transactions for 1848* (New York: printed by John Douglas, 1849), 44.
9. See "Bas-Relief Portraits By Salathiel Ellis," in Chamberlain, 1963, 23–25.
10. The bust resides in the Redwood Library in Newport, R.I. (Chamberlain, 1963, 13).
11. American Art-Union, *Bulletin* 15 (25 Nov. 1848), 38.
12. Jane Stuart, "Anecdotes of Gilbert Stuart," *Scribner's Monthly* 14 (July 1877), 376.
13. American Art-Union, *Transactions for 1849* (New York: printed by John Douglas, 1849), 45.
14. Chamberlain, 1963, 13.
15. American Art-Union, *Bulletin*, ser. for 1851, 10 (1 Dec. 1852), 8.

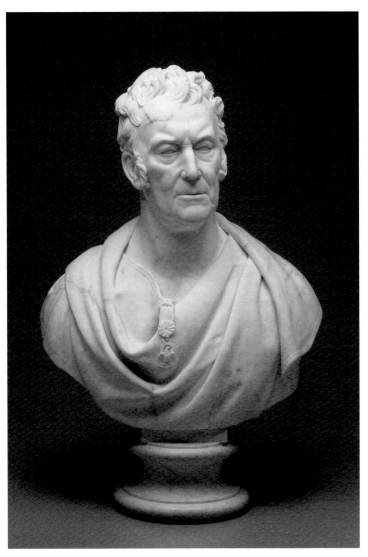

fig. a Robert Ball Hughes, *John Trumbull*, 1834. Marble, 24 x 20 ¼ x 9 ¼ in. (61 x 51.4 x 23.5 cm). Yale University Art Gallery, University Purchase, 1851.2

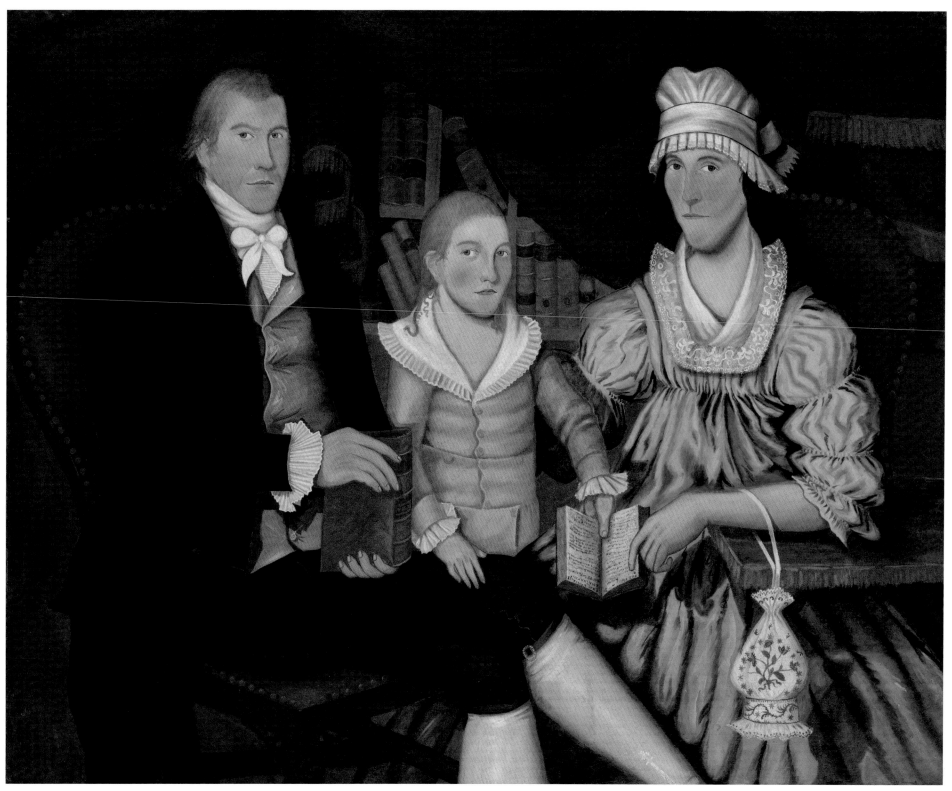

124

Jonathan Budington (1779–1823)
Portrait of George Eliot and Family,
probably 1798

Oil on canvas, 44 5/8 x 55 7/8 in. (113.3 x 141.9 cm)
Gift of the descendants of Reverend Jared Eliot,
B.A. 1806, and the relatives of Nellie P. Eliot,
Yale Medal, 1965, 1983.98

With a strong sense of flat pattern typical of nonacademically trained artists, Jonathan Budington of Fairfield, Connecticut, captured dignified likenesses of George Eliot, Jr. (1767–1828), Patience Lane Eliot (1769–1852), and their only son, Ely Augustus (1791–1870), of Killington (now Clinton) in a rare group portrait of ambitious scale.[1] The artist, who was Patience's cousin, took great care to immortalize the ties that bind the solemnly posed Eliot family to their society and to one another. Budington's affluent sitters confidently engage the viewer; he places them before an array of leather-bound books framed by drapery to portray them as successful and educated. Identifiable from the words "SMITH / WEALTH OF / NATIONS" on one volume (to the right of Ely's head) is Adam Smith's *An Inquiry into the Nature and Causes of the Wealth of Nations* (1776). George, a prominent farmer, property owner, and Jeffersonian Democrat, undoubtedly embraced Smith's economic philosophy, which called for less government regulation. Patience, a woman of independent means through inheritance, is defined by the embroidered drawstring bag hanging from her arm; it characterizes her as someone who had the leisure to attain the skills needed to create such an elegant accessory.

One of Budington's most endearing portraits, *George Eliot and Family* epitomizes the modern family that emerged in the late eighteenth century, when a less authoritarian style of parenting opened a new era in the history of childhood. Seated in parallel poses, the parents protect Ely Augustus, who stands respectfully between them. Both parents are painted in equal scale, reflecting a new emphasis on companionship between husband and wife.

Ely wears an outfit called a skeleton suit, which became fashionable for boys between the ages of three and nine and reflected a growing awareness of the stages of child development. Consisting of long, high-waisted trousers buttoned over a short jacket, and worn with an open-collar shirt, such suits provided greater freedom of movement for play than the earlier frock coats and breeches, which were modeled on adult male dress. Children, once viewed as sinful, were now thought to be inherently good and were celebrated within families linked by bonds of affection, expressed here through touch: Ely's hand resting on his father's leg, Patience's arm embracing her son while she points with her other hand to the book he holds.[2] Its prominence reveals the love of reading that his parents, posed before their library, wished to pass on to their son through example.

Ely proudly attests to his good behavior and reading skills by displaying *The Child's Instructor; Consisting of Easy Lessons for Children; On Subjects which are familiar to them, in Language adapted to their Capacities* by John Ely, a distant relative of the Eliots. The book, first printed in Philadelphia in 1792, is open to the chapter entitled "Duty to Parents."[3] The subtitle of this popular book advertises the importance lately accorded to age-appropriate juvenile literature. *The Child's Instructor* used moral and religious coaching to instill respect for hard work, personal empathy, civic responsibility, piety, and family. In the preface, the author urged, "As . . . we prize our own happiness, as we regard the welfare of society, as we love our children, let us attend to their instruction."[4]

Set against the painting's earth-tone palette, Patience's vibrant blue dress gives her visual weight as she tutors her son. Mothers enjoyed new respect after the Revolution, being recognized for their vital role in educating their children in a nation that depended on a public-spirited citizenry. Ely Augustus would go on to become a successful merchant, president of the New Haven and New London Railroad, an active participant in local politics and the Congregational church, a husband, and the father of three sons. Budington's family portrait conveys the intellectual and moral leadership that parents, especially mothers, were expected to impart through gentle guidance. The lessons learned at home provided the foundation not only for the child pictured here but also for a young democracy that was growing into a mature republic. R.J.F.

Notes
1. See Paula B. Freedman, "In the Presence of Strangers: Jonathan Budington's *Portrait of the George Eliot Family*," *Yale University Art Gallery Bulletin* 40 (spring 1988), 22–30. See also Arthur and Sybil Kern, "Jonathan Budington: Face Maker," *Folk Art* 22 (fall 1997), 41–49.
2. On family history, see Philippe Ariès, *Centuries of Childhood: A Social History of Family Life*, trans. Robert Baldick (New York: Vintage Books, 1962); Carl N. Degler, *At Odds: Women and the Family in America from the Revolution to the Present* (New York: Oxford University Press, 1980); Lawrence Stone, *Family, Sex and Marriage in England, 1500–1800* (New York: Harper Collins, 1983).
3. Identified by Lindsay B. Buchanan in "Reading the Book: *Portrait of George Eliot and Family*" (unpublished paper, YUAG Object Files, 1997).
4. [John Ely], *The Child's Instructor*, 2nd ed. (Philadelphia: John M'Culloch, 1793), iv.

125

125

Embroidered Coat of Arms
Boston, 1740–60

Black silk with silk and metallic threads in white
pine frame with gilded metal mounts, 33 x 33 in.
(83.8 x 83.8 cm)
Bequest of Josephine Setze, 1982.61.3

Elaborately embroidered coats of arms are a
form of schoolgirl needlework unique to
eighteenth-century Boston schools. They
celebrated both their creator's talent with a
needle and her family's heritage. Although
few New Englanders were entitled to bear
coats of arms, these symbols of nobility and
prestige were nonetheless popular among
the region's elite. Heraldic embroideries have
long been confused with hatchments—
painted coats of arms that were initially dis-
played over the doorways of the homes of
the recently deceased and then moved to the
family's church. Although embroidered
coats of arms were probably derived from
hatchments, there is no evidence that they
were ever used as part of mourning rituals.[1]

This embroidery features the Hoskins
family arms, including a shield, helmet, crest,
mantling, and a motto ribbon, embroidered
with silk and metallic threads on a black
silk background. The shield has a *gules* (red)
and *azure* (blue) background and a chevron
or (a gold bent stripe, facing upward), with
three *argent* (silver) lions *rampant* (rearing).
Another silver lion serves as the crest. The
mantling consists of elaborate leafy scrolls.
In other embroideries, the motto ribbon
contains a name identifying the coat of arms,
but in this example it has been left blank.
The creator of this embroidery probably went
to the shop of John Gore and his son Samuel
to have the pattern painted on the silk back-
ground. The Gore shop, which provided pat-
terns for many of the Boston schoolgirls
who created heraldic works, owned several
books on heraldry, and the design for this

embroidery is derived from one of them, John
Guillim's *Display of Heraldry*, first published
in 1610. Sometimes the embroideries con-
tained the arms of both the sewer's parents,
but it was more common to depict that of the
father's side of the family. Sometimes stu-
dents made errors, inadvertently working the
wrong coat of arms for their family.[2]

The interlaced metallic work on the motto
ribbon, helmet, and chevron of this piece are
typical of embroideries worked at the Misses
Cumings' school in the late 1760s and early
1770s. When schoolmistress Jeanette Day
left Boston for England in 1768, Anne and
Elizabeth Cuming (also spelled Cumming, or
Cummins) took over the establishment. In
1769, they advertised instruction in "Embroi-
dery, Coat of Arms, Dresden, Catcut, and
all Sorts of colour'd Work." Harassed during
the Revolutionary period for selling imported
goods, the Loyalist Cuming sisters left
Boston for Nova Scotia in 1776.[3] E.E.

Notes
1. Betty Ring, *Girlhood Embroidery: American
Samplers & Pictorial Needlework, 1650–1850*,
2 vols. (New York: Alfred A. Knopf, 1993), 1:60–61,
75; Harold L. Bowditch to John Marshall Phillips,
26 June 1942, YUAG Object Files.
2. See the embroidery by Elizabeth Cutts in Ring,
1993, 1:72.
3. Betty Ring to Patricia E. Kane, 20 Aug. 1991, YUAG
Object Files; *Boston Gazette, and Country Journal*,
24 Apr. 1769, repr. in Ring, 1993, 1:70 and front end-
papers; Ring, 1993, 1:71.

126

126

Jacob Hurd (1702–1758)
Thimble
Boston, 1730–40

Gold, h. ¾, diam. base ⅝ in. (1.9 x 1.6 cm),
wt. 3.9 dwt. (6 gm)
Mabel Brady Garvan Collection, 1944.73

127

Joseph Richardson, Jr. (1752–1831)
Chatelaine Hook
Philadelphia, 1790–99

Gold, 2 ⁵⁄₁₆ x ⁷⁄₁₆ in. (5.9 x 1.1 cm), wt. 7 dwt.
(11 gm)
Mabel Brady Garvan Collection, 1938.313

127

"In the country life of America there are many moments when a woman can have recourse to nothing but her needle for employment," Thomas Jefferson wrote to his daughter Martha in 1787. He noted that it was a useful skill "in a dull company and in dull weather" and asked, "Without knowing [how] to use [the needle] herself, how can the mistress of a family direct the works of her servants?" Although Jefferson believed that women should be educated in more than just needlework, he recognized the practical and social benefits of sewing. Girls from all stations of life learned the basics of plain sewing, but the daughters of wealthy families also learned fancy embroidery work. For them, learning how to sew was about more than constructing or repairing clothes; it made a statement about their families' wealth and their own suitability for marriage. Only the well-to-do could afford to send their daughters to the numerous boarding schools that taught embroidery, painting, and other refined arts.[1]

Accessories such as this thimble and chatelaine hook were functional tools to help women with their sewing, but they were also artfully considered props that helped a woman show off her skills and accomplishments before admiring friends, visitors, and, most important, suitors. Even after marriage, women of means continued to use these practical but decorative tools as status symbols.

This gold thimble was crafted by Boston silversmith Jacob Hurd in the 1730s for Elizabeth Gooch (cat. no. 126). It is engraved "Eliz Gooch 1714," but the date is a later addition. The thimble may have been a gift to Elizabeth at the time of her second marriage. Her first husband, John Hubbard, died in 1714, and she married John Franklin, Benjamin Franklin's oldest brother, sometime after 1734. Both she and her second husband served as postmasters of Boston.[2]

Thimbles could be bought from a number of sources, including peddlers, "toy" shops, silversmiths, or jewelers. Most silversmiths kept silver thimbles in stock, but more expensive gold thimbles were most likely made to order for a specific customer. The domed top of this thimble was soldered to its base, which was made from a seamed sheet of gold. The top is punched with small indentations for pushing a needle, and the sides are engraved with foliate scrolls in between dogtooth borders. The background of the engraved area has been crosshatched. Some thimbles came in their own special cases.[3] They might also have been stored in workboxes or tables or they could have been part of a chatelaine belt assemblage. Although this thimble would certainly have been used for sewing, it was probably valued as much for its visual impact as for its functional benefits. A gold thimble spoke to both the sewing prowess and the wealth of its owner.

The shop records of Philadelphia silversmiths Joseph Richardson and his son, Joseph Richardson, Jr., show that they produced and retailed a variety of sewing implements for the genteel women of the city, including thimbles, knitting needles, bodkins, needle cases, silver bands for pincushions, and chatelaine hooks. This chatelaine hook by the younger Joseph Richardson is engraved "SW" in flowing script with

delicate floral sprigs curving around the letters (cat. no. 127). It belonged to Sarah Wetherill of Philadelphia, who married Joshua Lippincott around 1799. Sarah's father was Samuel Wetherill, one of the founders of the Free or "Fighting" Quakers, a group that broke from the main Society of Friends during the American Revolution and bore arms for the colonies in defiance of Quaker theology.[4]

Hooked to a woman's belt or waistband, the chatelaine served as storage for various domestic accessories and as a piece of jewelry. Thimbles, pincushions, needle cases, and personal goods such as watches, keys, vinaigrettes (for smelling salts), and coin purses could all be suspended on chains or ribbons from the chatelaine's hook. In this case, the chains would have passed through the narrow horizontal slot on the front of the hook, but another chatelaine by Richardson features six separate holes for chains. Some expensive European chatelaine hooks and accessories were sold as matched sets, but a set could also be assembled from a variety of sources. Some items, such as knitted pincushions, could be made at home, while others were made by local or foreign artisans. While the habit of carrying needlework tools at the waist dates to medieval times, the word "chatelaine" is a nineteenth-century term that has been adopted by collectors. In the late eighteenth century, waist-hanging accessories were called *équipages* (French for "equipment") in trade cards and advertisements. Colonial silversmiths' records also indicate they were sometimes called "hearts" because of the shape of the hook plates.[5] E.E.

Notes
1. Thomas Jefferson to Martha Jefferson, 28 Mar. 1787, in Edwin Morris Betts and James Adam Bear, Jr., eds., *The Family Letters of Thomas Jefferson* (Columbia: University of Missouri Press, 1966), 35; Davida Tenenbaum Deutsch, "The Polite Lady: Portraits of American Schoolgirls and Their Accomplishments, 1725–1830," *Antiques* 135 (Mar. 1989), 745.
2. There is some confusion about Elizabeth Gooch's identity. Some records confuse her with Mary Gooch (John Franklin's first wife), while others confuse her with her daughter Elizabeth Hubbard (sometimes spelled Hubbart) Partridge. For evidence that Elizabeth was postmistress of Boston after John Franklin's death, see Carl Van Doren, *Benjamin Franklin* (New York: Viking, 1957).
3. Edwin F. Holmes, *A History of Thimbles* (New York: Cornwall Books, 1985), 57.
4. Martha Gandy Fales, *Joseph Richardson and Family: Philadelphia Silversmiths* (Middletown, Conn.: Wesleyan University Press for the Historical Society of Pennsylvania, 1974), 136, 139, 181, 196; YUAG Object Files; *Dictionary of American Biography*, s.v. "Wetherill, Samuel."
5. Martha Gandy Fales, *Jewelry in America, 1600–1900* (Woodbridge, Suffolk, England: Antique Collectors' Club, 1995), 60; Genevieve E. Cummins and Nerylla D. Taunton, *Chatelaines: Utility to Glorious Extravagance* (Woodbridge, Suffolk, England: Antique Collectors' Club, 1994), 15–16, 190.

128

Robert McGuffin (active ca. 1806–11), maker
Henry Connelly (1770–1826), retailer
Work Table
Philadelphia, 1808

Satinwood with satinwood, rosewood, and ebony veneers, eastern white pine, mahogany, and yellow poplar, 28 3/4 x 26 1/8 x 13 in. (73.1 x 66.5 x 33.1 cm)
Mabel Brady Garvan Collection, 1936.306

Young women in the late eighteenth and early nineteenth centuries were expected to master a wide variety of sewing skills. They stored the fruits of that knowledge in work bags and baskets or, if they were wealthy enough, in special tables. Usually placed in a parlor, a sewing table like this one provided a suitably elegant setting for gentlewomen to display their fancy needlework for the benefit of visitors and suitors. Although work tables were produced in France as early as 1750, they did not become fashionable in America until the late eighteenth century, when specialized furniture forms geared toward women became popular. This table, one of the earliest dated examples of the form, was made in 1808 for Susan Theresa Pratt of Philadelphia, daughter of Thomas Pratt, a wealthy merchant who owned Lemon Hill, an elegant neoclassical country house on the outskirts of Philadelphia.[1]

The table has astragal or semicircular ends, typical of work tables made in the mid-Atlantic states. It was crafted in the Philadelphia shop of Henry Connelly and is signed on the underside of one of the compartments by Robert McGuffin, a journeyman in his shop. The contrast between the table's wooden elements and its fabric-covered sides gives it a delicate, feminine appearance. The veneered top is hinged, lifting up to reveal one large central and two smaller side compartments. A small interior drawer hangs beneath each side compartment. These various storage areas would have held Susan Pratt's sewing supplies and accessories, as well as any work-in-progress. The table's legs combine carving, reeding, turning, and inlay. The 1811 Philadelphia price book lists an astragal-end table at a base price of four dollars. Taking into account the table's size, inlay, veneer, carving, and upholstery, the cost of this particular table would have been closer to fifteen dollars—comparable to the price of a desk or a chest of drawers.[2] E.E.

Notes
1. David L. Barquist, *American Tables and Looking Glasses in the Mabel Brady Garvan and Other Collections at Yale University* (New Haven: Yale University Art Gallery, 1992), 274; Beatrice B. Garvan, *Federal Philadelphia, 1785–1825: The Athens of the Western World*, exh. cat. (Philadelphia: Philadelphia Museum of Art, 1987), 42–43.
2. The swagged upholstery is a reproduction based on a period design from Thomas Sheraton. David Barquist suggests that a pleated treatment might be more appropriate, as it would complement the reeding on the table's legs. Barquist, 1992, 291, no. 162; *The Journeymen Cabinet and Chair Makers' Pennsylvania Book of Prices* (Philadelphia: Society of Journeymen Cabinet and Chair Makers, 1811), 65–66.

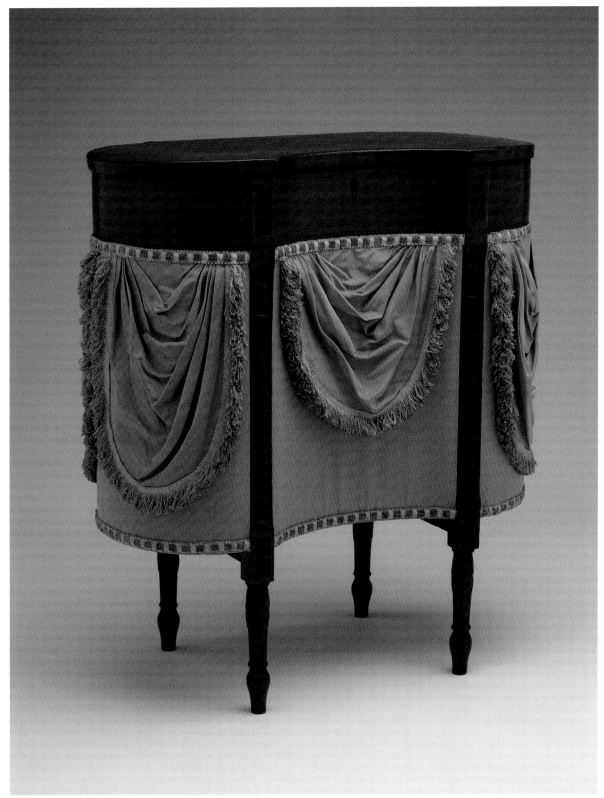

129

129

Sarah Hooker Leavitt (1797–1837)
Smith and Norton (active 1810),
gilders and framers
Needlework Mourning Picture
Deerfield and Northampton,
Massachusetts, 1809–10

Silk with silk and metallic threads and
watercolor in gessoed and gilt pine frame,
22 ½ x 26 ¹⁄₁₆ in. (57.2 x 66.2 cm)
Mabel Brady Garvan Collection, 1930.4000

America's grief over George Washington's
death in 1799 generated an outpouring of
memorial prints. In the nation's numerous
female academies, these prints provided
patterns for a wealth of embroidered mourn-
ing pictures. Many embroideries honored
the country's Founding Father, but some
schoolgirls and their instructors were inspired
by the presidential mourning prints to cre-
ate embroideries honoring deceased mem-
bers of their own families. This mourning
picture was created by Sarah Hooker Leavitt
to honor her grandfather Ezra Stiles (cat.
no. 114). Stiles, a Congregationalist minister,
was president of Yale College from 1778
until his death in 1795. Leavitt had not yet
been born when her grandfather died, and
she did not create her mourning embroidery
until 1810. Although some mourning embroi-
deries were created in the immediate after-
math of a family member's death, most, like
Leavitt's, were embroidered years after the
fact. They were made for decoration and to
serve as a family record rather than as an
expression of fresh bereavement.[1]

Sarah Hooker Leavitt and her sister Mary
Holmes Leavitt both attended Deerfield
Academy during the spring and summer
terms of 1808 and 1809. Sarah's embroidery
may have been done there under the super-
vision of Jerusha Williams, the academy's
preceptress from 1806 to 1812. Williams main-
tained contact with the Leavitt family after

the girls had left the academy, visiting them
at their Greenfield home in 1824. The piece
has also been attributed to the South Hadley,
Massachusetts, school run by Abby Wright,
but it has greater stylistic similarities to
other works made by Deerfield students, par-
ticularly in the textured and stylized trees
and leaves, the treatment of the ground cover,
and the embroidery's color palette.[2]

Worked on silk cloth, the embroidery has
a large garland-topped monument inscribed
"In Memory / of / President Stiles / Aged
67 / 1796" as its central element; the year of
death appears to be an error. A mourning
young woman, dressed in a fashionable white
neoclassical-style gown, stands next to the
memorial. She is painted in watercolor, as is
much of the scene's background, a pastoral
landscape with willow trees, shrubs, and
flowering plants. The white church to the
monument's left has traditionally been iden-
tified as the Second Congregational Church
in Newport, where Stiles was minister, while
the small brick buildings on the right have
been interpreted as part of Yale's campus, but
to date this cannot be confirmed. Leavitt
finished her embroidery sometime before the
end of 1810: the back of the piece bears a label
from the framing firm of Smith and Norton in
Northampton, who were in partnership only
from July to December of that year.[3] E.E.

Notes
1. Betty Ring, *Girlhood Embroidery: American
Samplers & Pictorial Needlework, 1650–1850*, 2 vols.
(New York: Alfred A. Knopf, 1993), 1:20–21.
2. Suzanne L. Flynt, *Ornamental and Useful Accom-
plishments: Schoolgirl Education and Deerfield
Academy, 1800–1830*, exh. cat. (Deerfield, Mass.:
Pocumtuck Valley Memorial Association and Deer-
field Academy, 1988), 22, 30; Betty Ring, "Needle-
work Pictures from Abby Wright's School in South
Hadley, Massachusetts," *Antiques* 130 (Sept. 1986),
492, pl. XI; Flynt, 1988, fig. 16, pls. 2, 3.
3. Ring, 1986, 492–93, fig. 6; YUAG Object Files.

130

Robert Walter Weir (1803–1889)
The Microscope, 1849

Oil on canvas, 30 x 40 in. (76.2 x 101.6 cm)
John Hill Morgan, B.A. 1893, LL.B. 1896, M.A.
(HON.) 1929, and Olive Louise Dann Funds,
1964.15

The mid-nineteenth-century American fasci-
nation with science and devotion to domes-
tic education are both captured in *The
Microscope*.[1] Jacob Whitman Bailey (1811–
1857), the father of American microscopy,
instructs his sons and his daughter, Maria,
nicknamed Kitty, who stands behind her
father's chair.[2]

Men's jobs increasingly took them away
from home, but Bailey, a professor, lived
and worked at West Point and was actively
involved in his children's education. The
boys' radiant faces attest to their eagerness
to peer through their father's microscope.
Watching him catch lamplight with the mir-
ror, the children are enlightened through
his manipulation of the instrument, their
minds opening like the cabinet door above.
The sharpening focus from right to left along
the microscope, extending from Bailey's
head to his sons', underscores his fatherly
role in transmitting knowledge.

At a time when the education of most
girls emphasized music, dancing, and nee-
dlework, Bailey taught his daughter science.
Her hand-over-heart gesture is tender and
maternal—and thus in keeping with expected
feminine behavior—but it is also suspense-
ful, conveying her excitement about using
the microscope. Kitty's position near the
eyepiece, the alignment of her profile with her
father's, and the similarity of their hoods
suggest that she is his apprentice.

The Baileys' historic attire, cobbled
together from Weir's studio props, alludes
indirectly to Galileo Galilei, the Italian Renais-
sance scholar commonly misidentified as

130

the inventor of the microscope. Their eccen-
tric costumes enhance the sense of magic sur-
rounding the microscope, tempering rational
scientific inquiry with romantic wonderment.

As they became affordable tools for
home teaching in the 1840s, microscopes took
on moral and religious purposes. They
unveiled "the inner labyrinths of creation"
revealing the extension of divine order
beyond the scope of the naked eye—a capac-
ity that gave the apparatus "a higher office to
fulfill."[3] A devout Christian, Weir drama-
tized this aspect of microscopy by dressing
Bailey in monastic robes, posing Kitty's
hand in a pious gesture near her pearl cross,

and projecting a shadow onto the scientist's
palm in the shape of a papal cross. Weir's por-
trayal of Bailey as both scientist and father
encapsulates contemporary beliefs about the
sacred duty of children's education.　A.K.L.

Notes

1. See the author's unpublished paper, "Domestic
Science: Fatherhood and Family in Robert W. Weir's
The Microscope" (YUAG Object Files, 1997).
2. *Dictionary of American Biography*, ed. Dumas
Malone, 20 vols., suppl. vol. 21, published under the
auspices of the American Council of Learned Soci-
eties (New York: Charles Scribner's Sons, 1943–44),
1:498, s.v. "Bailey, Jacob Whitman." Kent Ahrens
first posited that *The Microscope* depicts Bailey;

see his "Robert Walter Weir (1803–1889)" (PH.D.
diss., University of Delaware, 1972), 51. In a letter,
Bailey clarifies the issue: "Weir is also painting a
picture which is to immortalize my microscope. . . .
My phis [*sic*] somewhat altered, appears in the act
of gazing through the instrument, to relieve which
Kitty's bright countenance is represented as she
leans over the back of my chair." Bailey to Mary
Keeley, 29 Jan. 1849, Bailey Family Collection,
University of New Brunswick, Fredericton, N.B.
Bailey and Weir were colleagues at West Point,
where the artist taught drawing.
3. John Brocklesby, *Views of the Microscopic World:
Designed for General Reading and as a Hand-Book
for Classes in the Natural Sciences* (New York:
Pratt, Woodford and Co., 1851), 3, 5.

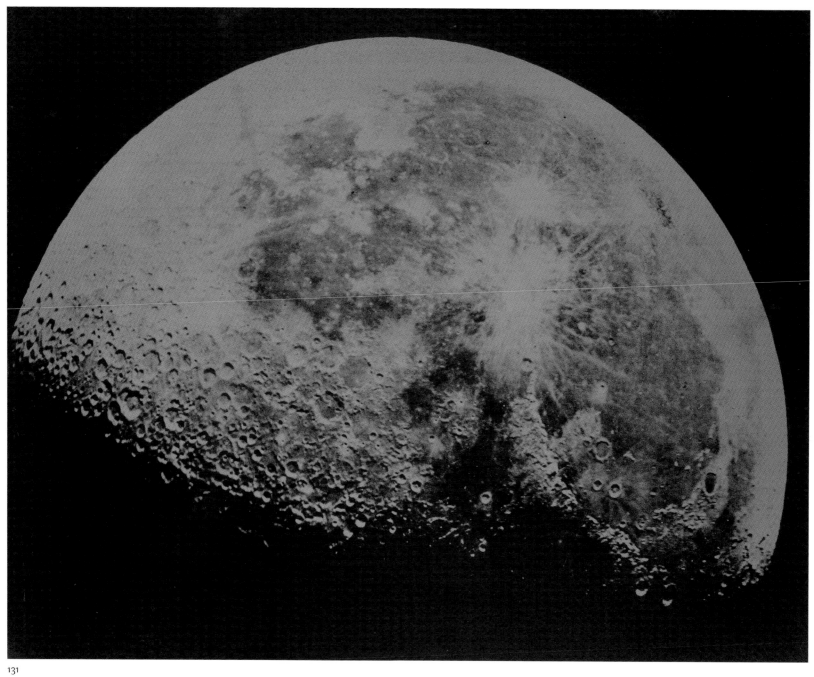

131

George Frederic Barker (1835–1910)
The Moon, 1864

Albumen print, 16¾ x 21⅛ in. (42.5 x 53.7 cm)
Gift of Elinor Wallace Hendrickson in memory of
her great-grandfather, Thomas Wallace, 1993.48.1

Americans' quest to broaden their knowledge
of the universe led them to probe the celestial realm. Interest in astronomy among both
amateurs and professionals had been building since the 1840s, when the opening of
several major observatories generated great
public enthusiasm. Although the telescope
first revealed the moon's wonders in the
seventeenth century, astronomers had been
unable to capture faithfully the cratered
lunar surface until the introduction of photography in 1839. Observers made sketches
of what they saw through the telescope, but
without a direct means of transcribing the
moon's topography, the likenesses produced
were more fanciful than scientific (fig. a).
Astronomers quickly recognized that photography would prove invaluable in documenting and studying celestial bodies—providing
a permanent, detailed, consistent record of
their appearance and movement—and in
recording transitory phenomena, such as
comets and eclipses. However, the low sensitivity of early photographic processes, the
weakness of lunar light, and the difficulty of
compensating for atmospheric distortion
and the Earth's rotation combined to prevent
photographers from taking a successful image
of the moon for over a decade.[1] Finally,
working with astronomers at the Harvard
College Observatory, Boston photographer
John Adams Whipple made a daguerreotype
of the moon in 1851, which he exhibited that
year to international acclaim at London's
Crystal Palace exhibition. Working in an era
when scholarly research and popular science
still overlapped, Whipple rephotographed
his daguerreotypes to obtain glass negatives,

printing numerous copies of his lunar photographs for sale to a public eager to understand the heavens.

When he made this photograph of the
moon in 1864, George Frederic Barker built
on the innovations represented by Whipple's
lunar image, which he probably saw during
a visit to the Crystal Palace as a teenager.[2]
A chemist, physician, and physicist whose
breadth of expertise conveys the fluidity of
mid-nineteenth-century scientific enquiry,
Barker studied at Yale's Sheffield Scientific
School. As an academic, he was renowned
for his ability to communicate scientific ideas
to the general public. Barker may have taken
this photograph to support a particular
hypothesis. In any case, he continued to
engage in camera-aided astronomical observation throughout the 1870s. As a professor
of physics at the University of Pennsylvania,
he traveled to Rawlins, Wyoming, on an
expedition organized by Dr. Henry Draper,
an important early photographer of the
moon, to study a solar eclipse in July 1878.
Barker analyzed the spectrum of the sun's
corona to help determine its composition,
verifying his conclusions with Draper's
landmark photographs of the solar event.[3]
Barker continued to endorse the potential
of photography as a scientific tool. In 1884,
he became a member of the University of
Pennsylvania committee that oversaw the
pioneering motion studies of photographer
Eadweard Muybridge (cat. nos. 132–34)
and was originally slated to contribute
an essay to Muybridge's book *Animal
Locomotion*.[4] A.K.L.

Notes

1. Melissa Banta, *A Curious and Ingenious Art:
Reflections on Daguerreotypes at Harvard* (Iowa
City: University of Iowa Press for the Harvard
University Library, 2000), 37.
2. "George Frederic Barker," *Scientific American* 57
(8 Oct. 1887), 231.

3. George F. Barker, "On the Results of the Spectroscopic Observation of the Solar Eclipse of July 29,
1878," *American Journal of Science and Arts* 17
(Feb. 1879), 125.
4. Perhaps because of the expense of printing
Muybridge's eleven folio-size volumes of plates, the
university dropped plans to accompany the illustrations with essays. Lloyd Goodrich, *Thomas Eakins*,
2 vols. (Cambridge, Mass.: Harvard University
Press for the National Gallery of Art, 1982), 1:276.

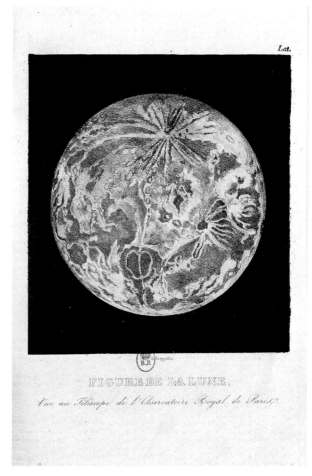

fig. a Kaeppelin, *Figure de
la lune vue au télescope
de l'Observatoire Royal de Paris*,
ca. 1830. Lithograph, 8⅝ x 5⅞ in.
(22 x 15 cm). Bibliothèque
nationale de France, Paris

132

133

Eadweard Muybridge
(b. England, 1830–1904)

132

Horse & Rider, plate 630 from
Animal Locomotion, 1887

Collotype, 18¾ x 23¾ in. (47.6 x 60.3 cm)
Henry S. F. Cooper, B.A. 1956, Fund, 1973.37.1

133

Jumping, Running Twist High Jump,
plate 158 from *Animal Locomotion*, 1887

Collotype, 18¾ x 23¾ in. (47.6 x 60.3 cm)
The Lawrence and Regina Dubin Family
Collection, Gift of Dr. Lawrence Dubin, B.S.
1955, M.D. 1958, 1995.68.6

134

Woman Throwing a Ball, plate 305
from *Animal Locomotion*, 1887

Collotype, 18¾ x 23¾ in. (47.6 x 60.3 cm)
Henry S. F. Cooper, B.A. 1956, Fund, 1973.37.2

*All matter, whether living or dead . . . is
constantly changing form: in other words, is
constantly moving. . . . The great panorama
of life is interesting because it moves.*

—J. Bell Pettigrew, 1873

Following his 7 March 1839 visit to the Paris studio of Louis Jacques Mandé Daguerre, Samuel F. B. Morse—the American artist, physician, and inventor of the electric telegraph—described the new photographic process he had observed in a letter to his brother Sidney, editor of the *New-York Observer*. Morse was taken with the degree of detail in Daguerre's "drawing," which "no painting or engraving could ever hope to touch." Despite its wonders, Morse also realized the limitations of the daguerreotype process, including the fact that the required long exposure time made it impossible to capture the likeness of anything that could not remain perfectly still: "Objects moving are not impressed," he wrote. "The Boulevard, so constantly filled with a moving throng of pedestrians and carriages, was perfectly solitary, except an individual who was having his boots brushed. His feet were compelled, of course, to be stationary for some time, one being on the box of the boot-black, and the other on the ground. Consequently, his boots and legs [are] well defined, but he is without body or head because these were in motion."[1]

Less than thirty-five years after the invention of the daguerreotype, Eadweard Muybridge would successfully arrest motion photographically. He would transform a medium that once captured movement far more slowly than a person could perceive it into one capable of arresting it far more quickly than the human eye. As Rebecca Solnit has noted, Muybridge's photographic innovations would henceforth make discernible, "as the telescope and microscope had before it," a hidden world: "Those other worlds had been hidden by scale and space, but this world had been hidden by time. It was the world of everyday things whose motion had always been mysterious. With the railroad, human beings had begun to move faster than nature. With the telegraph, they communicated faster. With photography, they would come to see faster, to see what had been hidden in time."[2]

In 1872, Muybridge was well known in the San Francisco area for his outstanding images of Yosemite Valley (cat. no. 198). That year, he was approached by former governor Leland Stanford, president of the Central Pacific Railroad—a racing enthusiast and owner of a horse farm—who had theorized that at some point in a trotter's stride it lifts all four feet off the ground at the same time. Stanford commissioned Muybridge to photograph his famous horse Occident in motion, hoping to obtain photographic evidence to prove his hypothesis. By 7 April 1872, Muybridge had done so.[3]

Yet Muybridge—who was more interested in the mechanics and chemistry of the experiment than in proving Stanford's point—was not satisfied, and he convinced Stanford to support further motion experiments. In 1877, Muybridge devised a shutter capable of releasing at one one-thousandth of a second, and by early June of 1878, he was making the first successful serial photographs of Stanford's horses in motion. These achievements were largely due to the equipment Muybridge designed with the help of a team of mechanics and electricians underwritten by Stanford, including twelve Scoville cameras fitted with "fast" stereo lenses manufactured by Dallmeyer of London and Muybridge's electrically controlled mechanism for operating the camera's double-slide shutters.[4] On 15 June 1878, Stanford invited journalists from California's newspapers to gather at his Palo Alto stock farm to witness Muybridge photographing the horse Edgington pulling a sulky: wires were laid at twenty-one-inch intervals and were let loose as the sulky's wheels struck them, successively releasing the shutters of a line of cameras. In order to photograph an unharnessed horse, Allie Gardner, the threads were stretched three feet above the track so that she activated the shutters as she ran, thus "taking her own picture," as the press observed.[5]

By 1883, Muybridge was eager to pursue his motion studies more extensively and in a more sophisticated manner. On 7 August, the trustees of the University of Pennsylvania agreed to sponsor him.[6] For the next three years, Muybridge would set up his experiments on the grounds of the university's hospital, across the street from its new veterinary school, and at other locations in Philadelphia. In the summer of 1884, Muybridge photographed animals at the Zoological Gardens, including an elephant, a zebra, a llama, a sloth, a cockatoo, an eagle, a vulture, and a stork in flight. His early human subjects included a woman ascending and descending steps, throwing water, and dressing; and a man shooting, performing the broad jump and high jump, and throwing a hammer. Later human subjects included a male model beating time with his hands, playing notes of a scale on the piano, and picking up a pencil; later animal subjects included a red-tailed hawk, a horned owl, a Bengal tiger, a pine snake, a baboon, and a buffalo.

By August 1885, the *Philadelphia Evening Telegraph* reported that more than fifteen thousand negatives had been shot. Muybridge was dissatisfied with many of them, however, and between November 1885 and May 1886, he rephotographed more than five hundred of his 1,540 subjects. In 1887, the University of Pennsylvania published the results of Muybridge's work under the title *Animal Locomotion*. The complete set of 781 plates was printed in collotype (a form of gelatin relief similar in appearance to photogravure), mounted on nineteen-by-twenty-four-inch sheets of linen paper, and sold in portfolios of one hundred plates each.

Muybridge's remarkable serial photographs had a profound effect on scientists and artists at the time of their publication and well beyond. *Animal Locomotion* remains the most exhaustive pictorial analysis of the subject ever made and is still the lexicon most consulted in questions concerning how humans and animals move in space.[7] E.H.

Notes
The epigraph is from Dr. J. Bell Pettigrew, introduction, *Animal Locomotion, or Walking, Swimming, and Flying, with a Dissertation on Aeronautics* (London: International Scientific Series 7, 1873), 2, quoted by Anita Ventura Mozley in the introduction to *Muybridge's Complete Human and Animal Locomotion: All 781 Plates from the 1887 Animal*

Locomotion (New York: Dover Publications, 1979), vii.

1. Samuel F. B. Morse to Sidney Morse, 9 Mar. 1839, "The Daguerrotipe [*sic*]," *New-York Observer*, 20 Apr. 1839, 62.

2. Rebecca Solnit, *River of Shadows: Eadweard Muybridge and the Technological Wild West* (London: Viking, 2003), 83.

3. As Solnit notes, in the spring of 1872, "everything seemed to be in motion." That year, the Western Railroad Association met in St. Louis to consider a proposal to create standardized time zones; Greenwich Mean Time became standard for all British post offices; and Jules Verne published his enormously popular *Around the World in Eighty Days*. Solnit, 2003, 70–73.

4. See Mozley, 1979, xvii. In the fall of 1879, Muybridge debuted his zoopraxiscope, or, as he originally called it, his zoogyroscope, for Stanford and his guests. This machine, which projected single images in rapid motion so that they appeared to be strung together, combined three different technologies—photography, zootrope strips, and magic lanterns—and was the precursor of modern cinema. See also Solnit, 2003, 200.

5. Mozley, 1979, xvii.

6. Muybridge's project was sponsored in large part due to the persuasive efforts of the university's professor, painter Thomas Eakins.

7. The complete set of 781 plates (representing 19,347 individual photographs) was organized in eight portfolios and sold for six hundred dollars. Only thirty-seven "perfect" sets of the entire series were produced. This monumental work was the "completion," as Muybridge called it, of his photographic investigation of human and animal locomotion. Mozley, 1979, vii.

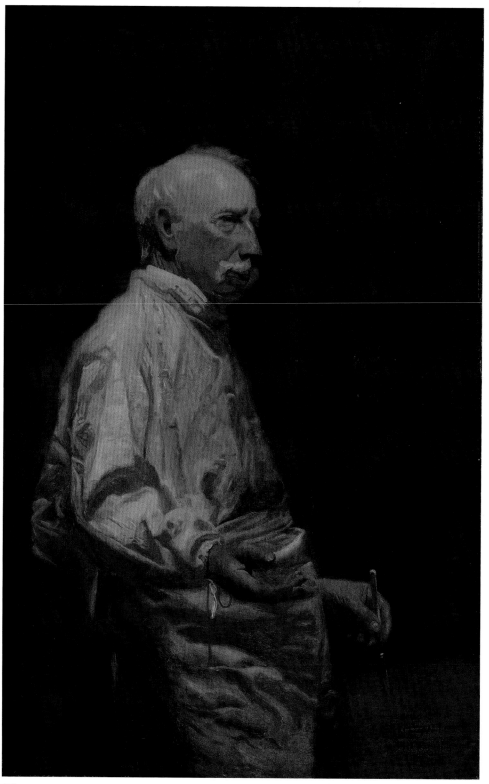

135

135

Thomas Eakins (1844–1916)
Dr. Agnew (Dr. D. Hayes Agnew), 1889

Oil on canvas, 49 x 31½ in. (124.5 x 80 cm)
Bequest of Stephen Carlton Clark, B.A. 1903,
1961.18.16

In 1889, the medical class graduating from
the University of Pennsylvania asked Thomas
Eakins if he would accept seven hundred
fifty dollars to paint a portrait of their
beloved professor, the eminent surgeon
D. Hayes Agnew (1818–1892), who was retir-
ing. Although the students had asked for
just the "head" of Dr. Agnew, Eakins immedi-
ately offered to paint a picture for the same
sum that would show not only Agnew con-
ducting a surgical clinic with his assistant
physicians but also portraits of members of
the class. The commission, the most ambi-
tious of Eakins's career, allowed the artist to
return to the realm of anatomical and sur-
gical research that had always fascinated
him, and which had fourteen years earlier
found expression in *The Gross Clinic* (jointly
owned by the Philadelphia Museum of Art
and the Pennsylvania Academy of the Fine
Arts). In preparation for *The Agnew Clinic*
(fig. a), Eakins observed Agnew performing
surgery many times. Completed in three
months, it would be the largest work Eakins
ever painted.[1] It depicts a moment during
an operation for breast cancer, when Dr.
Agnew pauses to address the assembled assis-
tants and students. Despite the imposing
clinic setting and dramatic surgery taking
place, the white-haired surgeon commands
the stage, a paragon of self-confidence
and directness.

Eakins developed the figure of Dr. Agnew
in this nearly life-size studio study. The artist's
purpose was akin to that of a scientist: to
identify the most essential traits of the sub-
ject he is studying. The painting's varying
degrees of finish reveal Eakins's areas of con-

centration: quick, summary strokes of paint
create the surgeon's gown and deep back-
ground; however, Dr. Agnew's head and
hands are brightly illuminated and meticu-
lously finished, with the drawstring cuff
calling further attention to his right hand
projecting into the viewer's space. As a like-
ness of a physician who was venerated for
his surgical ability and encyclopedic knowl-
edge, it is a vivid portrait of a man actively
engaged in his life's work. Eakins's con-
tained and serious style of somber color and
strong contrast of dark and light under-
scores the character of the sitter—free from
all uncertainty in thought or form. Dr.
Agnew's white gown immediately identifies
him as a practicing surgeon; more impor-
tantly, it reveals his adoption of the modern
principles of antisepsis, which were not yet
widely practiced.[2] In his left hand he holds a
scalpel, the primary instrument of his pro-
fession, while his right hand, extended with
its palm upward, signals a momentary sus-
pension of the surgical proceedings as he
makes a point to his students. No blood
appears on Agnew's hands or gown, as it does
in the final work; Eakins had removed this
bit of descriptive truth at the sitter's request,
perhaps because the portrait was not meant
to be seen by a wider public.[3]

Eakins often sought to portray doctors
and scientists whom he admired for their
contributions to modern science.[4] As a sub-
ject, Dr. Agnew held particular appeal for
the artist. Years earlier, a young Eakins had
supplemented his meager art education at
the Pennsylvania Academy of the Fine Arts
by studying anatomy at Jefferson Medical
College, where he would have known of
Agnew's important work at the nearby
School of Anatomy.[5] Later, when Eakins
became an instructor at the Pennsylvania
Academy, he based his teaching on a thor-
ough study of anatomy and dissection. By
the time of the commission, Eakins, like
Agnew, considered an understanding of the

fig. a Thomas Eakins, *The Agnew Clinic*, 1899. Oil on canvas, 84 ⅜ x 9 ft. 10 ⅛ in. (214.5 x 300 cm).
Courtesy of the University of Pennsylvania Art Collection, Philadelphia, Pa.

human body to be the foundation of his
craft, and both men honored teaching as a
central part of their profession. H.A.C.

Notes
1. For a full description of the circumstances sur-
rounding the commission and the public reception
of *The Agnew Clinic* as well as of *Dr. Agnew*, see
Lloyd Goodrich, *Thomas Eakins*, 2 vols.
(Cambridge, Mass.: Harvard University Press,
1982), 2:40–51.
2. Many American surgeons openly resisted the
procedures based on Louis Pasteur's germ theory of
disease and developed by Joseph Lister in the 1860s.
Because of Agnew's prominence in the medical
community, his embrace of antisepsis is considered
to have contributed to its general acceptance in
the United States. See Margaret Supplee Smith,
"The Agnew Clinic: 'Not Cheerful for Ladies to Look
At,'" *Prospects* 11 (1987), 165.
3. *Dr. Agnew* was purchased from the artist by
Dr. Albert C. Barnes in 1914 for the Barnes

Foundation. It was purchased by Stephen C. Clark
in 1944.
4. See Kathleen A. Foster, "Portraits of Teachers
and Thinkers," in Darrell Sewell, *Thomas Eakins*
(Philadelphia Museum of Art, 2001), 309.
5. For Eakins's continuing interest in anatomy and
surgery, see Elizabeth Johns, *Thomas Eakins, The
Heroism of Modern Life* (Princeton: Princeton
University Press, 1953), 46–81.

Changing Landscape and the Rise of Industry

136

Frederic Edwin Church (1826–1900)
Mt. Ktaadn, 1853

Oil on canvas, 36¼ x 55¼ in. (92.1 x 140.3 cm)
Stanley B. Resor, B.A. 1901, Fund, 1969.71

Frederic Edwin Church traveled to this isolated peak in northern Maine for the first time in 1852, not long after the publication of Henry David Thoreau's "Ktaadn and the Maine Woods" (1848). The landscape Thoreau called "exceedingly wild and desolate" is subtly brought under control in Church's *Mt. Ktaadn*.[1] Signs of civilization in the foreground—cows, sawmill, bridge, buggy, and men—domesticate the landscape without appearing to disturb its natural character. The labor of settlement has been erased. Rather than being surrounded by tree stumps and piles of lumber, the mill is situated between hearty forests and the finished products of its industry: a wooden bridge and a buggy bound for the woods.

While the picture's emphatic namesake in the background remains outside the bounds of such pastoral cultivation, the mountain (now spelled Katahdin) nevertheless submits to a different kind of containment. Katahdin's profile is exactingly outlined against the horizon, its body described by gradations of shadow and minute lines as if it were the product of a topographical survey. Yet, at the same time, the painting metaphorically evokes the divine destiny of a young country, the land bathed in the spiritual assurance of the sunset's glow.

Church's simultaneous aesthetic and topographic vision of the landscape echoes Thoreau's. At the writer's funeral, Ralph Waldo Emerson eulogized Thoreau as one who "liked to throw every thought into a symbol," an idealist who found "poetic suggestion" in the quotidian aspects of life. But, in Emerson's estimation, Thoreau also possessed a "habit of ascertaining the measures and distances of objects" such as trees, ponds, and mountains, an interest that "made him drift into the profession of land-surveyor."[2]

The figure who most closely represents the land surveyor in *Mt. Ktaadn* is the boy seated beneath the tree. He also bears a striking resemblance to the figure in John Mix Stanley's work of the same year, *Coeur d'Alene Mission, St. Ignatius River* (cat. no. 187), executed for the U.S. Pacific Railroad Expedition and Surveys. Like Church's boy, this man is seated in the left foreground at the edge of a lake, clothed in red, facing out toward forested hills and the nascent signs of civilization. Pencil and pad in hand, Stanley's figure doubles, as did Stanley himself, as surveyor and artist. *Coeur d'Alene Mission* makes explicit what *Mt. Ktaadn* quietly implies: topographical labor defines and controls the landscape.

Church's figure seems to be optically "marking" the scene before him, calling our attention to the painter's own marks. He seems to be both a boy lost in a daydream and a man who earns his living at the edge of the frontier, at once the artist and the engineer, a person both mysterious and pragmatic. In his journals, Emerson wrote that Americans "want the Exact and the Vast; we want our Dreams, and our Mathematics."[3] *Mt. Ktaadn* exists as a testament to these seemingly paradoxical desires, desires that are here intimately and inextricably bound together. J.C.R.

Notes

1. Henry David Thoreau, "Ktaadn and the Maine Woods," *Union Magazine* (1848); repr. in Thoreau, *The Maine Woods*, 2nd ed. (Boston: Ticknor and Fields, 1864), 70.
2. Ralph Waldo Emerson, *Selected Writings*, ed. Brooks Atkinson (New York: Modern Library, 1940, 1950), 896–97, 908.
3. Ralph Waldo Emerson, *A Modern Anthology*, ed. Alfred Kazin and Daniel Aaron (New York: Dell, 1958), 23, quoted in Barbara Novak, *American Painting of the Nineteenth Century: Realism, Idealism, and the American Experience*, 2nd ed. (New York: Harper & Row, 1979), 120.

137

Johann Hermann Carmiencke
(b. Germany, 1810–1867)
Poughkeepsie Iron Works (Bech's Furnace),
1856

Oil on canvas, 29 x 36¼ in. (73.7 x 92.1 cm)
Bequest of Evelyn A. Cummins, 1971.111.5

Johann Hermann Carmiencke's painting of
the Poughkeepsie Iron Works, or Bech's
Furnace, presents a benevolent interpretation
of the impact of the factory on the American
landscape.[1] The ironworks, nestled between
the Hudson River and a hill peppered with
grazing goats and kerchiefed country folk,
coexists harmoniously with the landscape,
becoming an integral part of it. Heightening
the sense of their interconnection, the bril-
liant azure sky seems to issue forth from one
of the ironworks' brick chimneys, which

belches bright blue smoke. The overall pic-
ture is placid and quiet, with no hint of the
noise and pollution caused by the pig-iron
blast furnaces and smeltery. In reality, the
ironworks created a constant din and stench,
prompting one historian of Poughkeepsie to
note that "without the snorting of the blow-
ing engine at the 'Lower Furnace' residents
of the southern section of Poughkeepsie
scarcely knew how to go to sleep at night."[2]

The Poughkeepsie Iron Works Co. was
owned by Edward Bech, a Danish-born busi-
nessman who probably commissioned the
painting directly from Carmiencke to com-
memorate his thriving business.[3] Born in
Hamburg in 1810, Carmiencke received his
early artistic training from the Norwegian
landscape painter Johan Christian Dahl in
Dresden from 1831 to 1834, but left to pursue
further study at the academy in Copenhagen,
where he enjoyed tremendous success. In

1846, he became court painter to the king of
Denmark, a position he held until 1851, when
anti-German sentiment stemming from the
Dano-Prussian War (1848–49) propelled him
to the United States.[4] Carmiencke and Bech
may have met through their mutual connec-
tion with the Danish Crown; King Frederik
VII, Carmiencke's former patron, knighted
Bech in 1854.

While Carmiencke painted a view of the
Hudson River, his specific subject matter
and compositional techniques reflect his
European training. Whereas industrial land-
scapes are very scarce in American painting
until the last quarter of the nineteenth cen-
tury, they appear in the work of Carmiencke's
northern European contemporaries as early
as 1830. Like his colleagues, Carmiencke
rusticated his portrayal of Bech's Furnace with
the inclusion of peasants and goats, stan-
dard props that lend the image a benign,
bucolic air, where industry exists as a matter
of fact, not as a blight on the landscape.
Carmiencke's painting is also a portrait, cap-
turing an enduring likeness of an ambitious
immigrant industrialist through his works—
his ironworks.

G.C.B.

Notes

1. Catherine Lynn first identified the subject of this
painting in "Factory on the Hudson" (unpublished
paper, YUAG Object Files, 1977), 7.
2. Edmund Platt, *The Eagle's History of
Poughkeepsie from the Earliest Settlements, 1683
to 1905* (Poughkeepsie: Platt & Platt, 1905), 143.
3. No record of the transaction exists, but
Carmiencke's preparatory drawing for the painting
(Yale University Art Gallery, inv. no. 1978.20) is
annotated in Danish (Carmiencke's mother tongue
was German), suggesting that the artist intended
to show the study to his Danish patron.
4. Carmiencke was appointed painter to the court
of Christian VIII (r. 1839–48) and continued in that
position for three years after Frederik VII (r. 1848–
63) ascended to the throne.

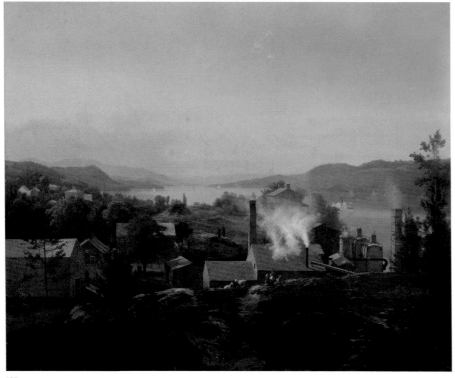

137

138

Martin Johnson Heade (1819–1904)
Lynn Meadows, 1863

Oil on canvas, 12⅜ x 30⅜ in. (31.4 x 77.2 cm)
Gift of Arnold H. Nichols, B.A. 1920, 1967.19

A critic writing about this painting in 1866
noted simply "a very successful effect of a
sunset beyond a dreary level."[1] Indeed, the
tidal mudflats of Lynn, Massachusetts, tra-
versed by the invasive horizontal element of
a railroad track, constitute the unlikely
subject matter of Martin Johnson Heade's
radical composition. Heade used a canvas
almost three times as wide as it is high, rather
than one with the standard two-by-three ratio.
This choice of format, like that of Sanford
Robinson Gifford (cat. no. 139), alludes to the
panorama, a keynote of the popular visual
culture of the period. But Gifford's pan-
oramic view encompasses mountain and river
scenery long acclaimed for its beauty, whereas
Heade lays bare a stretch of pointedly
featureless terrain.

In the distance, on the water, are some
old-fashioned square-riggers. But it is the
railroad that makes the most dramatic state-
ment, cutting a geometrically precise line
(the artist clearly used a ruler) across the
center of the composition, with a train, to the
far right, polluting the air with filthy coal
smoke.[2] Through these elements, Heade
insisted on the modernity of the scene—an
unusual choice in an era when many land-
scape painters favored the pristine subject
matter of the American wilderness. Heade did
not see the expansion of the railroad network
as a triumph of man over nature. The track
looks fragile and poorly constructed; the
locomotive is diminutive and disappears from
sight. Its smoke, at the right margin of the
composition, seems to reach out toward the
sun and echo the clouds that catch the dawn
sunlight at the left of the canvas. Through
this connection, the golden sunlight on the

Changing Landscape and the Rise of Industry

138

reddening clouds becomes a portent of a dawning industrial apocalypse, an emblem of both the glory and the imminent despoliation of God's nature. While there is no direct allusion to the Civil War, which was raging as Heade made this painting, new technologies such as the railroad and the manual machine gun greatly escalated the ferocity of the conflict.

The tiny human figures in the middle ground appear lost beneath this elemental drama of nature versus industry. They are digging clams out of the mud, a traditional form of labor. These isolated and hard-pressed figures, however, are not the contented peasantry of the pastoral landscape tradition, but modern proletarians. The parallel between a natural timetable—the tides—and a man-made one—the railroad

schedule—deftly alludes to the transformation of the new machine-driven concept of time under industrial capitalism.

In the foreground, abandoned on a hillock, are a jacket and beer bottle. Perhaps they have been left there by one of the clam-diggers. But they may serve as a surrogate for the artist himself, whose work is otherwise visible only through the manipulation of paint on the canvas. Heade seems to suggest that he, too, is a field-worker, whose role is to record the industrial transformation of the American landscape. T.B.

Notes

1. *Albion*, 24 Nov. 1866, quoted in Theodore E. Stebbins, Jr., *The Life and Work of Martin Johnson Heade: A Critical Analysis and Catalogue Raisonné*, exh. cat. (Boston: Museum of Fine Arts, and New Haven: Yale University Press, 2000), 228. Stebbins's

definitive writings on Heade have informed all other discussions of the artist, including this catalogue entry.

2. On this subject, see Susan Walter Danly, *The Railroad in the American Landscape: 1850–1950*, exh. cat. (Wellesley, Mass.: Wellesley College Museum, 1981); Susan Danly and Leo Marx, eds., *The Railroad in American Art: Representations of Technological Change* (Cambridge, Mass.: MIT Press, 1988).

139

Sanford Robinson Gifford (1823–1880)
Hook Mountain, near Nyack, on the Hudson, 1866

Oil on canvas, 8⅛ x 19 in. (20.6 x 48.3 cm)
Gift of Miss Annette I. Young, in memory of
Professor D. Cady Eaton, B.A. 1860, and
Mr. Innis Young, 1969.113.3

One of the masterpieces of American land-scape painting, *Hook Mountain, near Nyack, on the Hudson* combines the fresh eloquence of a sketch from nature with the evocative subtlety and technical assurance of the finest studio painting. Sanford Robinson Gifford spent his childhood in Hudson, New York. The nearby Catskill Mountains became his favorite subjects, as they had been for Thomas Cole, whose death in 1848 robbed American landscape painters of their figurehead. Gifford slowly emerged from the influence of Cole and of his precocious contemporary Frederic Edwin Church (cat. no. 136), and by the 1860s, he had begun to specialize in tranquil and luminous views of river and coastal scenery. Unlike many of Gifford's earlier works, *Hook Mountain* forgoes the wilderness in favor of an area familiar to urban tourists and much frequented by both commercial and leisure craft. Gifford evoked the distant sails of yachts and barges with deft touches of white, while also allow-ing the funnel of a steamer to symbolize modernity's incursions into the landscape. Yet his seemingly effortless mastery of per-spective allows the broad expanse of the Hudson River to take on a pristine appear-ance, reflecting the duck-egg blue of the evening sky above.

The painting derives from Gifford's return journey, in September 1866, from a sketching trip to the Adirondacks. Hook Mountain, 730 feet high, lies on the banks of the lower Hudson River just north of the Tappan Zee. The southward view in this painting is taken from Croton, on the east bank of the Hudson. The mountain is reflected in the still waters of Haverstraw Bay, forming a dark mass in the center of the composition.[1]

The striking horizontal format is retained from pencil sketches made on the spot.[2] The choice of a panoramic format, however, may reflect the influence on Gifford of the popular culture of New York City, where giant painted panoramas were all the rage in the 1840s and 1850s. The relative proximity of New York City, however, is negated by the exquisite tranquil effect of *Hook Mountain* and the artist's ability to suggest a vast, open landscape with the simplest pictorial means. Another painting of almost the same size, *Morning on the Hudson, Haverstraw Bay* (1866, Terra Foundation for the Arts, Chicago), may have been painted as a pendant to *Hook Mountain*; both canvases remained in Gifford's possession until his death in 1880. Several other paintings derived from the same studies survive, but none rivals the serenity and simplicity of *Hook Mountain*. T.B.

Notes
1. For further topographical information, see the catalogue entry by Kevin Avery in John K. Howat, ed., *American Paradise: The World of the Hudson River School* (New York: Metropolitan Museum of Art, 1988), 228–29, and John K. Howat, *The Hudson River and Its Painters* (New York: Viking Press, 1972), 142–43 and map on 56.
2. The leaves are preserved in Gifford's "Sketchbook of New Hampshire and New York Subjects" of 1865–66 (Francis Lehman Loeb Art Center, Vassar College, Poughkeepsie, N.Y.). See Nicolai Cikovsky, Jr., in *Sanford Robinson Gifford (1823–1880)*, exh. cat. (Austin: University of Texas Art Museum, 1970), nos. 36a, 36b, 36c, and Kevin Avery and Franklin Kelly, eds., *Hudson River School Visions: The Landscapes of Sanford R. Gifford* (New York: Metropolitan Museum of Art, and New Haven and London: Yale University Press, 2003), 182.

139

140

Martin Johnson Heade (1819–1904)
Sudden Shower, Newbury Marshes,
ca. 1866–76

Oil on canvas, 13¼ x 26 5/16 in. (33.7 x 66.8 cm)
Gift of Theodore E. Stebbins, Jr., B.A. 1960, in
memory of H. John Heinz III, B.A. 1960, and
Collection of Mary C. and James W. Fosburgh,
B.A. 1933, M.A. 1935, by exchange, 1989.51.1

Between 1859 and 1904, Martin Johnson
Heade made about 120 paintings of salt
marshes, a series whose content is minimal—
haystacks, rivulets, a few harvesters in the
sunset—and yet whose visual and emotional
impact is profound.[1] In *Sudden Shower,
Newbury Marshes*, Heade's mastery of perspec-
tive allows the small canvas to convey a sense
of the broad, flat landscape of the Massa-
chusetts coast. The horizon is very low, and,
as in *Lynn Meadows* (cat. no. 138), Heade
eschewed vertical framing elements on either
side of the composition, such as the trees
used by almost every landscape painter from
seventeenth-century French artist Claude
Lorrain to Thomas Cole. The felling of these
trees is an act of pioneering reformation, a
telling removal of the father figures of land-
scape painting, which opens up new
panoramic possibilities.

The seven haystacks are deployed with
extreme care within the composition, deftly
indicating, through their differing sizes, the
subtle recession of the flat plane of the salt
marsh. We are invited into the painting's
quiet world by the serpentine line running
from the center foreground to the left.
Despite its quotidian referent—a dike of salt
water—this element is made fascinating by
Heade's superb handling of cloud shadow
and the reflection of the sky in the water.

While the oncoming storm suggests an
impending natural drama, the painting's true
subject is the interaction of mankind and

nature. Agriculture has shaped the landscape;
the hay is being harvested, even from this
marshy and difficult terrain. There are only
two tiny figures here, subtly indicated but
clear enough to reveal that one of them is
male and one female. No Adam and Eve, they
are vulnerable, laboring figures, representing
an outmoded way of life. The first effective
harvesting machinery, made in America, had
been exhibited in London at the Great Exhi-
bition of 1851. Such inventions would prove
useless on these treacherous salt marshes,
and the land, now barely of economic value,
would eventually fall out of cultivation alto-
gether. The two figures, then, are emblematic
of a direct relationship with nature that
modernity would undermine. The haystack
in the foreground likewise suggests the fra-
gility of Heade's rural ecology. Built on
stilts, it stands on a plinth in order to avoid
being ruined by the encroaching tide.

This is more than a naturalistic land-
scape. In the deeply religious milieu of
Heade's Pennsylvania youth, signs of God's
handiwork were sought in everyday events.
Perhaps the oncoming storm clouds bear
hints of the mysteries of divine providence.
Many Northerners felt that the Civil War
represented yet another act in the divinely
inspired, providential history of the United
States. Although the dating of *Sudden
Shower, Newbury Marshes* is a matter of spec-
ulation, it may reflect the shadow that war
cast over the American polity, one that
Heade surely acknowledged in his great
black painting *Approaching Thunder Storm*
(1859, Metropolitan Museum of Art, New
York). Here, too, a change in the weather
may signal a storm of more symbolic and
apocalyptic dimensions. T.B.

Note
1. For the definitive account of Heade's life and
work, on which this entry and all other Heade

scholarship rely, see Theodore E. Stebbins, Jr., *The
Life and Work of Martin Johnson Heade: A Critical
Analysis and Catalogue Raisonné*, exh. cat.
(Boston: Museum of Fine Arts, and New Haven
and London: Yale University Press, 2000).

141

Winslow Homer (1836–1910)
Old Mill (The Morning Bell), 1871

Oil on canvas, 24 x 38⅛ in. (61 x 96.8 cm)
Bequest of Stephen Carlton Clark, B.A. 1903,
1961.18.26

A complex and enigmatic painting, Winslow Homer's *Old Mill* captures the general unease about the future of the country that many Americans felt in the years following the Civil War.[1] The efforts of Reconstruction brought about extensive industrialization, increased urbanization, and the arrival of large numbers of immigrants. Facing these drastic social transformations, many Americans longed for simpler times. In his paintings from the 1870s, Homer responded to this national wistfulness, representing nostalgic scenes from rural America: old one-room schoolhouses, agrarian genre scenes, and, in *Old Mill*, a bucolic depiction of industry. In many of these works Homer shunned clear narratives, opting instead for imagery that yielded ambiguous or multivalent interpretations. By depicting the uncertainty of post–Civil War culture in such a modern manner, he was able to suggest a sense of melancholic regret embodied in *Old Mill* in the isolated central female figure.

Despite its title, the main focus of *Old Mill* is the solitary woman in a bright red jacket carrying a lunch pail, who has just ascended the makeshift ramp in the foreground and now turns onto the bridge that leads over a river to the old mill. The bridge, illuminated by the rising sun, teeters like an unbalanced scale, linking the right and left sides of the composition and physically connecting the rural past to the industrial present. Arriving from another direction on the right side of the picture are three women uniformly clad in dark homespun dresses and talking among themselves. A bell tolls above the mill's roof, signaling the start of another

workday and summoning the four figures to their destination.

During this period in his career, Homer began creating works in series, with figures that would reappear from one painting to another. The more elaborately dressed woman walking across the bridge looks like the schoolteacher (whose rib-boned hat is hung above the blackboard) pictured in *The Country School* (fig. a), a painting Homer exhibited with *Old Mill* in 1871. One contemporary critic connected the two canvases, calling them "companion studies."[2] That link is not merely visual. In the middle of the nineteenth century, the fate of workers—especially women mill workers—and the role of education were considered interdependent. A small hand-bell on the teacher's desk in Homer's schoolhouse ties this image to *Old Mill* by suggesting that the young students have already been indoctrinated into the regulated time of modern life well before they start to earn a living. In putting the teacher in a central position, not only in the school-house but also in *Old Mill*, Homer acknowl-edged the figure's crucial role in the creation of a work force. She stands in the middle of the bridge as the fulcrum between the factory managers who strive to create more efficient laborers and the mill workers who have been conditioned to arrive at their jobs at the sound of the bell. R.S.

Notes

1. For a summary of the various interpretations of the painting, see Nicolai Cikovsky, Jr., and Franklin Kelly, *Winslow Homer*, exh. cat. (Washington, D.C.: National Gallery of Art, 1996).
2. "Art at the Century Club," *New York Evening Post*, 7 Nov. 1871.

fig. a Winslow Homer, *The Country School*, 1871. Oil on canvas, 21¼ x 38¼ in. (54 x 97.2 cm). The Saint Louis Art Museum, Museum Purchase

Eastman Johnson (1824–1906)
Cranberry Pickers, probably 1878–79

Oil on canvas, 27 x 54⅛ in. (68.6 x 137.5 cm)
Bequest of Christian A. Zabriskie, 1970.56.1

From his vacation home on Nantucket Island in October 1879, celebrated genre painter Eastman Johnson confessed to a friend: "I was taken with my cranberry fit as soon as I arrived (some people have Rose fever yearly—I have the cranberry fever) as they began picking down on the meadow a day or two after we arrived."[1] Johnson's obsession with capturing the quintessential image of his neighbors gathering cranberries inspired his most productive painting campaign, culminating in his masterwork *The Cranberry Harvest, Island of Nantucket* (Timken Museum of Art, San Diego). He executed nearly twenty preparatory studies, but most of them led toward this composition, which rivals the final Timken painting in scale and ambition.

Against a panoramic view of a bog on the island's north shore, Johnson contrasted figures at work and at rest. Scattered pickers combing the ground for berries and the woman straining to carry a heavy bucket in the middle distance counterbalance the group conversing near barrels and baskets in the right foreground. That placement highlights the foremost woven rattan basket with an oak handle. Known as a lightship basket, this unique form of the ancient craft was made on lightships off Nantucket beginning in the last half of the nineteenth century, and the summer people—like Johnson, who went there from New York for over thirty years—were a prime market.[2] Following the decline of Nantucket's whaling industry, the once thriving economy languished until the island began to develop as a resort in the 1870s and 1880s. A yearning for a liv-ing colonial past—the quaint buildings, craft traditions, and slower pace—drew urbanites like Johnson to the island.

In *Cranberry Pickers*, the harvesters, dressed in earth-tone clothing and partly buried in meadow grass, seem rooted in the ground, evoking a timeless bond with the land. But Johnson was not sentimentalizing America's rural past; he was recording contemporary reality, albeit through the eyes of a city dweller. Like his previous maple-sugaring pictures set in Maine, scenes of communal activity on Nantucket helped fulfill the continuing demand for pictures that offered an escape from the encroachment of industrialization, while assuring his urban audience that America's democratic agrarian heritage was not yet extinct. The annual cranberry harvest, an activity barely twenty years old with serious importance to the economy, produced an especially good crop in 1879.[3] Its fiscal success depended on the participation of town residents, not regular agricultural laborers. Newspaper accounts of cranberry picking stressed the "pleasant and profitable employment" and "neighborly helpfulness," which the reader might contrast with the harsh conditions, low wages, and anonymity of factory work.[4] Johnson emphasized how that sense of community brought together generations: at the left, an old man works beside a child; behind them, a young couple lean toward each other; in the right corner, a baby sleeps. Avoiding specific narrative, the artist hints at the relationships between the faceless figures, whose body language suggests any number of stories. The most fully realized character is the sunlight, caressing a shoulder, a sleeve, a bonnet.

Reflecting a stylistic sophistication acquired from study in Düsseldorf, Holland, and Paris, Johnson's canvas conveys a love of the oil sketch forged in the studio of French master Thomas Couture. Johnson's efforts began with "beauties that strike you, startling effects, natural poses"—a freshness of observation still palpable in *Cranberry Pickers*. Its powerful sense of an American place also eloquently answers Couture's call for his students to be true to their own cultures, "as they of Athens were Athenian."[5] R.J.F.

Notes
1. Eastman Johnson to Jervis McEntee, 12 Oct. 1879, Archives of American Art, Smithsonian Institution, quoted in Marc Simpson, "Taken with a Cranberry Fit: Eastman Johnson on Nantucket," in Marc Simpson, Sally Mills, and Patricia Hills, *Eastman Johnson: The Cranberry Harvest, Island of Nantucket*, exh. cat. (San Diego: Timken Art Gallery, 1990), 32. See this catalogue for a full discussion.
2. On Nantucket baskets, see Charles H. Carpenter, Jr., and Mary Grace Carpenter, *The Decorative Arts and Crafts of Nantucket* (New York: Dodd, Mead and Company, 1987), 185–93.
3. "Local Items," *Nantucket Journal*, 15 Oct. 1879; cited in Appendix I, Simpson et al., 1990, 97.
4. Charles Nordhoff, "Cape Cod, Nantucket, and the Vineyard," *Harper's New Monthly Magazine* 51 (June 1875), 59–60, quoted in Simpson et al., 1990, 43.
5. Thomas Couture, *Conversations on Art Methods*, trans. S. E. Stewart (New York: G. P. Putnam's Sons, 1879), 12, 186, quoted in Sally Mills, "'Right Feeling and Sound Technique': French Art and the Development of Eastman Johnson's Outdoor Genre Paintings," in Simpson et al., 1990, 58, 57.

142

143

John Carwitham (active 1723–41)
After William Burgis (active 1718–31)
A South East View of the Great Town of Boston in New England, ca. 1731–36

Hand-colored engraving, 11 ¾ x 17 ⅝ in.
(29.8 x 44.8 cm)
Mabel Brady Garvan Collection, 1946.9.1743

144

George Heap (d. 1752)
An East Prospective View of the City of Philadelphia, in the Province of Pennsylvania, in North America: taken from the Jersey Shore, 1778, after a view of 1752

Hand-colored engraving, 10 ¾ x 16 ⅝ in.
(27.3 x 42.2 cm)
Mabel Brady Garvan Collection, 1946.9.1780

A South East View of the Great Town of BOSTON in New England in America.

143

Topography influences where an urban center takes root and how it is laid out, but the city itself develops around the dominant social and economic structures of its inhabitants. Any depiction of a city, whether done in the fifteenth century or the present, must acknowledge those less tangible structures if it pretends to any sense of accuracy other than topographic. So it is with these views of Boston and Philadelphia, two of the most important cities in eighteenth-century North America. They were maritime and commercial centers, and their harbors—Philadelphia's on the Delaware River and Boston's on the Atlantic Ocean—figure significantly in these engravings not just because the open water offered an unobstructed vista, but because the harbors played a dominant role in the cities' economic well-being. The many ships and boats shown riding at anchor in each harbor, the cities themselves, and their numerous buildings are signs of Boston's and Philadelphia's prosperity and modernity.

To their eighteenth-century audience, these images, constructed from an artificially high vantage point, reveal as well the extent and density of the cities. Dominating the skyline are the church spires. The majority of buildings might be depicted cursorily, unless they could claim civil importance, but the spires, like the ships in the harbor, have their own significance. Not only were they the tallest structures of their time, but they gave concrete evidence of the religious character of the city and are thus identified in the legend. The British flags flying from the ships in John Carwitham's portrayal of Boston (cat. no. 143) proclaim English sovereignty. Commerce, religion, and governance are the narratives of Carwitham's urban view of 1731,

when Boston was only a large town and the sparsely populated hills and countryside of the Massachusetts colony loomed in the distance.

The Philadelphia print (cat. no. 144) is based on an original drawing by George Heap from 1752. The later engraving presents a metropolis that, while much condensed from Heap's original, still offers many of the elements seen in the 1731 Boston view, with the notable exception of British flags. Carwitham's depiction was presumably based on the much larger 1723 *South East View* of Boston by William Burgis (active 1718–31).[1] Carington Bowles of London published Carwitham's version and also published the 1778 *View of the City of Philadelphia*. Heap's

1752 drawing, when engraved in London and published in 1754, reached almost seven feet in length.[2] Despite its imposing size, the first edition of 450—done on four plates by Gerard Vandergucht (1696–1776)—and all but three impressions from the second edition of 250 sold out in Philadelphia.[3] The 1778 view of Philadelphia was published in the midst of the War for Independence and, like the Boston image, is dominated by its port and churches. By necessity, Bowles's was a reduced version of Heap's, because it was published as part of a set of 271 pictures that were "designed to be used in the Diagonal Mirror, an Optical Pillar machine, or peep show."[4] These perspectives, which were meant to be looked at in a "*vue d'optique*"

38. *An East Perspective View of the* CITY *of* PHILADELPHIA, *in the* PROVINCE *of* PENSYLVANIA, *in* NORTH AMERICA: *taken from the* JERSEY *Shore*

144

box, were very popular in the late eighteenth century, and it was for this market that the image was intended.[5] Compared with the Carwitham engraving of almost fifty years earlier, Philadelphia appears far more formidable and larger, an indication of how the colonial urban centers had grown over the course of the eighteenth century. TH.B.

Notes

1. Regarding Carwitham's print, see Gloria Gilda Deák, *Picturing America 1497–1899*, 2 vols. (Princeton: Princeton University Press, 1988), 1:53, no. 86, who dates it to 1731-36. Burgis is discussed by John W. Reps, "Boston by Bostonians: The Printed Plans and Views of the Colonial City by Its Artists, Cartographers, Engravers, and Publishers," in *Boston Prints and Printmakers 1670–1775: A Conference*

Held by the Colonial Society of Massachusetts 1 and 2 April 1971 (Boston: Colonial Society of Massachusetts, 1973), 33-42; and Richard B. Holman, "William Burgis," in *Boston Prints*, 1973, 57-81; and reference is made to his view of Boston in Amy R. W. Meyers, "Imposing Order on the Wilderness: Natural History Illustration and Landscape Portrayal," in Edward J. Nygren with Bruce Robertson, *Views and Visions: American Landscape before 1830*, exh. cat. (Washington, D.C.: Corcoran Gallery of Art, 1986), 20-21.

2. There are a number of versions based on Heap's original drawing. For notes on these and further bibliographic information, see E. McSherry Fowble, *Two Centuries of Prints in America, 1680–1880: A Selective Catalogue of the Winterthur Museum Collection* (Winterthur, Del.: Henry Francis du Pont Winterthur Museum, and Charlottesville: University Press of Virginia, 1987), 70-73; Deák, 1988,

61-63, no. 99; and the catalogue of the Milton Wohl collection by Christopher Lane and Donald Cresswell, *Prints of Philadelphia* (Philadelphia: Philadelphia Print Shop, 1990), 19-20.

3. Fowble, 1987, 71.

4. This phrase, taken from a 1790 Bowles sales catalogue, is quoted in Lane and Cresswell, 1990, 20.

5. An example of this apparatus is reproduced in Sinclair Hitchings, "London's Images of Colonial America," in *Eighteenth-Century Prints in Colonial America to Educate and Decorate,* ed. Joan D. Dolmetsch (Williamsburg, Va.: Colonial Williamsburg Foundation, 1979), 20.

145

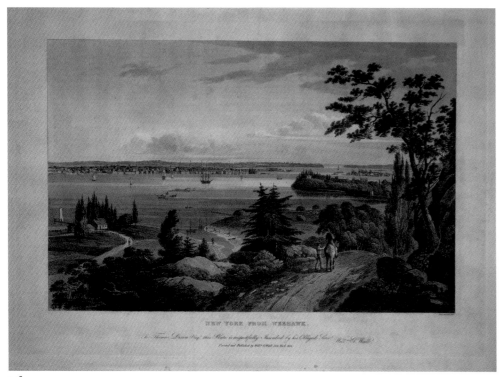

146

Changing Landscape and the Rise of Industry

John Hill (b. England, 1770–1850), engraver
After watercolors by William Guy Wall
(b. Scotland or Ireland, 1792–after 1863, active in America, 1818–after 1836)

145

New York from Heights near Brooklyn, 1823

Hand-colored etching and aquatint, first state,
22⅛ x 31 in. (56.2 x 78.7 cm)
Mabel Brady Garvan Collection, 1946.9.283

146

New York from Weehawk, 1823

Hand-colored etching and aquatint, first state,
22⅛ x 31 in. (56.2 x 78.7 cm)
Mabel Brady Garvan Collection, 1946.9.284

These two colored aquatints by John Hill, made after original watercolors by William Guy Wall,[1] are among the most important printed views of the city of New York executed in the years following the War of 1812. They are closely related to the images of New York's Hudson River Valley that constitute the renowned *Hudson River Portfolio*, another Wall-Hill collaboration, and the series for which the two artists are perhaps most recognized in this country.

 Known as the "Wall View of New York from Brooklyn" (cat. no. 145) and the "Wall View of New York from Weehawk" (cat. no. 146), these scenes were conceived as a pendant pair—with the view from Brooklyn to be hung to the left of or above the view from Weehawken—together forming a panoramic portrait of lower Manhattan.[2] Marketed by subscription in 1823 to a population growing tired of imported interpretations of the American landscape, they were sold in New York by Thomas Dixon for twelve dollars to subscribers and fourteen dollars to nonsubscribers.[3] The popularity of these images can likely be attributed to the fact that, although there were many picturesque views taken

from various points along the upper Hudson, there were relatively few views of New York City itself.[4] So intriguing were these images that during his year-long visit to America in 1823, British Staffordshire potter Andrew Stevenson reproduced these two views on transfer-printed earthenware platters (figs. a, b).[5]

In 1823, both Wall and Hill were relatively recent arrivals to America.[6] Hill's forte was his ability to transfer the designs of watercolors and paintings by other artists into aquatint. Although he was usually faithful to their compositions, he would occasionally alter certain details of the views in order to make them more scenic, and thus more marketable, as prints. In his adaptation of Wall's *New York from Heights near Brooklyn*, for example, Hill turned Wall's threatening, stormy day into a sunny one and added a set of figures in the center foreground, gesturing at the view. In *New York from Weehawk*, Hill replaced Wall's haycart with a pair of figures, one on horseback and the other on foot.

New York from Heights near Brooklyn and *New York from Weehawk* capture a moment of fervent nationalism and idealism after the War of 1812. America was finally beginning to achieve true financial and material independence from Britain and to turn its attentions inward, celebrating its native beauties and resources. In images such as these, rural and urban America coexist in harmonic equilibrium, each sustaining and nourishing the other. Here, the cultivated yet rustic foregrounds, filled with a variety of conifers and other plants and dotted with figures, dominate and imbue each view with a sense of quiet and leisure. The pastoral foregrounds are separated physically (and hence psychologically) from the city at the middle ground by a body of water—the East and Hudson Rivers, respectively. Thus the subject of each view, Manhattan, is experienced at a remove. Isolated geographically by water, the city—

symbol of industry and progress—remains contained as an island. Commerce is thus controlled and *controllable*—physically bound and hence prevented from expansion eastward or westward, to the shores of New Jersey or Brooklyn. E.H.

Notes

1. Wall's original watercolors for these views are in the collection of the Metropolitan Museum of Art: The Edward W. C. Arnold Collection of New York Prints, Maps, and Pictures, Bequest of Edward W. C. Arnold, 1954, inv. no. 54.90.109 (Weehawk) and inv. no. 54.90.301 (Brooklyn).
2. Kevin J. Avery, *American Drawings and Watercolors in the Metropolitan Museum of Art.* Vol. 1, *A Catalogue of the Works by Artists Born before 1835*, exh. cat. (New York: Metropolitan Museum of Art, and New Haven and London: Yale University Press, 2002), 139.
3. These views were so popular, in fact, that they were reissued well into the 1830s. Richard J. Koke, *A Checklist of the American Engravings of John Hill (1770–1850)* (New York: New-York Historical Society, 1961), 41–43.
4. Wall himself noted this in his advertisement for the prints: "Correct views of the City of New-York, have long been a desideratum, and it has been a subject of surprise, that no attempt has been made to exhibit to the public, the leading features of a city, which possesses so great an interest from its political and commercial importance, as well as from the natural beauties of its situation." William G. Wall, *Commercial Advertiser*, 26 June 1823, quoted in I. N. Phelps Stokes, *The Iconography of Manhattan Island 1498–1909*, 6 vols. (New York: R. H. Dodd, 1915–28; repr. New York: Arno Press, 1967), 3:578.
5. See Frank Stefano, Jr., "Andrew Stevenson, Staffordshire Potter, in New York," *Antiques* 108 (Oct. 1975), 709.
6. For biographical information on Hill and Wall, see Avery, 2002, 139–40, 104–6, 313–14, 360–61.

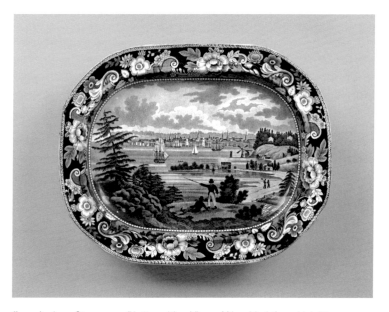

fig. a Andrew Stevenson, *Platter with a View of New York from Heights near Brooklyn*. Cobridge, Staffordshire, England, 1808–29. Blue, transfer-printed earthenware, 12 1/2 x 16 in. (31.8 x 40.6 cm). Yale University Art Gallery, Mabel Brady Garvan Collection, 1934.292

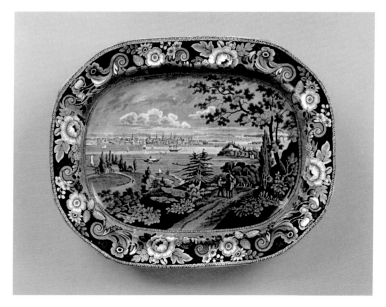

fig. b Andrew Stevenson, *Platter with a View of New York, from Weehawk*. Cobridge, Staffordshire, England, 1808–29. Blue, transfer-printed earthenware, 14 1/2 x 18 1/2 in. (36.8 x 47 cm). Yale University Art Gallery, Mabel Brady Garvan Collection, 1930.3104

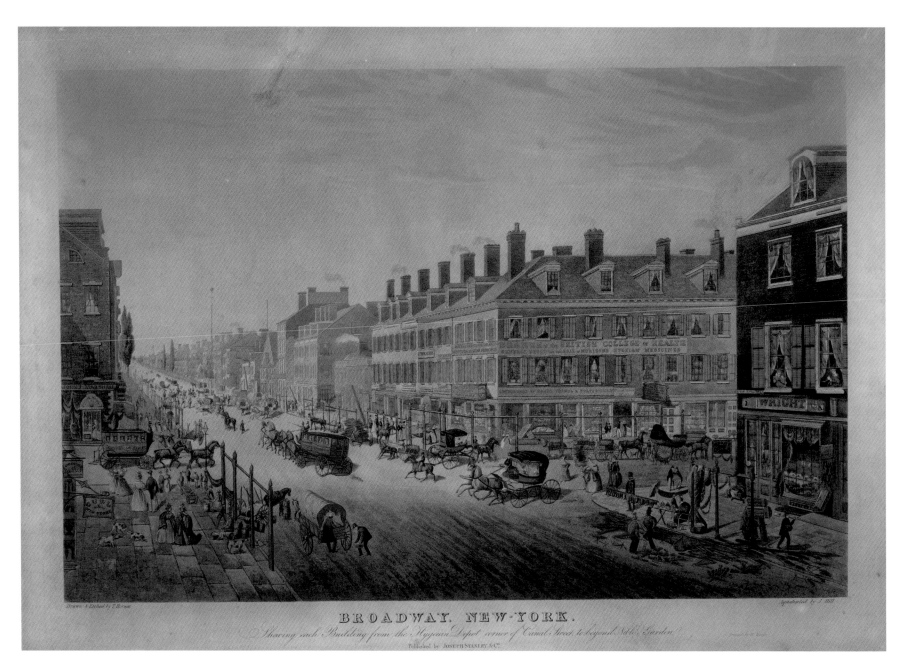

BROADWAY. NEW-YORK.

Showing each Building from the Hygean Depot corner of Canal Street to beyond Noble's Garden.

Published by JOSEPH STANLEY & Cᵒ.

147

147

Drawn and etched by **Thomas Hornor** (active 1828–44)
Aquatinted by **John Hill** (b. England, 1770–1850)
Published by **Joseph Stanley & Co.**, New York (active 1836)
Broadway, New-York / Shewing each Building from the Hygeian Depot corner of Canal Street to beyond Niblo's Garden, 1836, from a drawing of 1834

Hand-colored etching with aquatint,
22 x 30 13/16 in. (55.9 x 78.3 cm)
Mabel Brady Garvan Collection, 1946.9.293

Known as the "Hornor View of Broadway," this early depiction is important for its detailed rendering of the various businesses that boasted storefronts along this section of the busy avenue in the mid-1830s.[1] The view is north, up Broadway, from just below the intersection with Canal Street. The establishment of Joseph Stanley, the print's publisher, is portrayed near the center of the print. Other enterprises identified in Hornor's view include the British College of Health, or Hygeian Depot; John Wright's hat, cap, and fur shop; Jonas Greene's curbside display of footwear; the Bank Coffee House; William West, upholsterer; Tattersall's horse market, riding school, and livery stable; John J. Marshall's fabric store; and a curl and wig shop. Mentioned by Hornor in his title, but not discernible in the diminishing perspective of the view, is Niblo's Garden—located at the northeast corner of Broadway and Prince Street—a theater, hotel, and garden, known as the best entertainment spot in the city.

This period in New York City's history was notable for the number and variety of horse-drawn vehicles that crowded the streets. Hornor illustrated the traffic here, and Charles Dickens noted it in the published ruminations on his travels to America in 1842: "The great promenade and thoroughfare . . . is Broadway; a wide and bustling street, which, from the Battery Gardens to its opposite termination in a country road, may be four miles long. . . . No stint of omnibuses here! Half a dozen have gone by within as many minutes. Plenty of hackney cabs and coaches too; gigs, phaetons, large-wheeled tilburies, and private carriages."[2]

Several milestones of civil engineering are evidenced in this print, including the gas streetlights that line Broadway. A decade earlier, in 1823, the New York Gas-Light Company laid its first pipes in lower Manhattan, and by 1830, gas lampposts were a common sight.[3] The 1830s also witnessed experimentation with various types of street pavements, from cobblestone to wood to tar. Of all the advances of the decade, however, perhaps the most important was the construction of an adequate sewer system to manage the waste of a ballooning urban population. City officials, roused by the outbreaks of yellow fever throughout the 1820s and by the cholera epidemic of 1832, took seriously the need for a better water-carriage system of waste disposal.[4] By the mid-1830s, closed-conduit sewers made of stone, brick, or cement were being dug at a rapid pace; Hornor showed this energetic activity in the right foreground of this print, where two workers are excavating a trench along the southeast corner of Broadway. E.H.

Notes
1. Gloria Gilda Deák, *Picturing America 1497–1899*, 2 vols. (Princeton: Princeton University Press, 1988), 1:290–91; I. N. Phelps Stokes, *The Iconography of Manhattan Island 1498–1909*, 6 vols. (New York: R. H. Dodd, 1915–28; repr. New York: Arno Press, 1967), 3:616–17.
2. Charles Dickens, *American Notes for General Circulation*, 2 vols. (London: Chapman and Hall, 1842), 1:191–93, quoted in E. McSherry Fowble, *Two Centuries of Prints in America, 1680–1880: A Selective Catalogue of the Winterthur Museum Collection* (Winterthur, Del.: Henry Francis du Pont Winterthur Museum, and Charlottesville: University Press of Virginia, 1987), nos. 262, 379.
3. Marshall B. Davidson, *New York: A Pictorial History* (New York: Charles Scribner's Sons, 1977), 121. Until about 1830, New York City was lighted by whale-oil lamps set on posts, which yielded minimal visibility in the darkness.
4. Joanne Abel Goldman, *Building New York's Sewers: Developing Mechanisms of Urban Management* (West Lafayette, Ind.: Purdue University Press, 1997), 44–55.

148

148

Eli Terry (1772–1852)
Shelf Clock
Plymouth, Connecticut, 1816–25

Mahogany, yellow poplar, cherry, and white oak,
28⅞ x 16⅞ x 4⅛ in. (73.3 x 42.9 x 10.5 cm)
Bequest of Olive Louise Dann, 1962.31.26

Eli Terry played a central role in changing clockmaking from a craft to an industry, making it possible for more Americans to accurately measure the passage of time. He began his career making tall-case clocks in Connecticut in the 1790s, but soon discovered that although there was plenty of demand for timepieces in the United States, tall-case clocks were too expensive and cumbersome for most households. His first modification was using wooden clock-movements instead of brass. Wooden works were not only more economical than metal ones but also easier to mass-produce. Terry was able to market hundreds, even thousands, of clocks per year rather than only a few at a time. Between 1807 and 1809, he contracted with Edward and Levi Porter to produce four thousand wooden clock-movements, becoming one of the first to use mass-production techniques and interchangeable parts in the fabrication of domestic goods.[1]

Terry's most important contribution to clockmaking was popularizing the cheap and easily portable shelf clock over the tall-case models. He began to produce them between 1812 and 1814, receiving his first patent for the design in 1816. This example probably represents the third generation of Terry's design, which was put into production at his Bristol, Connecticut, factory in 1817–18. It is called a "pillar and scroll" clock because its case features turned columns at the front corners and a scrolled veneered pediment topped by three brass urn finials.

The wooden dial has painted Arabic numerals and a painted and gilded floral design in the spandrels, or corners. In addition to pewter hour and minute hands, the face has a visible escapement wheel, the device that regulates the clock's movement: situating it on the clock face made it more easily accessible for maintenance. The bottom panel of the glass door features an *églomisé* (reverse-painted) depiction of Mount Vernon, a popular motif in the decades after George Washington's death, when a craze for items memorializing the late president swept the nation (cat. nos. 63–66). A paper label inside the case indicates that the clock was patented, invented, made, and sold by Terry himself rather than one of the many other Connecticut manufacturers who produced timepieces using his designs and methods, both with and without his permission. Terry's wooden-movement shelf clocks and their imitators dominated the market until the 1840s, when mass-produced brass movements became affordable.[2] E.E.

Notes

1. Philip Zea and Robert C. Cheney, *Clock Making in New England, 1725–1825: An Interpretation of the Old Sturbridge Village Collection* (Sturbridge, Mass.: Old Sturbridge Village, 1992), 121; Kenneth D. Roberts, *Eli Terry and the Connecticut Shelf Clock* (Bristol, Conn.: K. Roberts Publishing Co., 1973), 27–28.
2. Zea and Cheney, 1992, 127; Lockwood Barr, "Eli Terry Pillar and Scroll Shelf Clocks," supplement to the *Bulletin of the National Association of Watch and Clock Collectors* (Dec. 1952), 5; Chris Bailey, *Two Hundred Years of American Clocks and Watches* (Englewood Cliffs, N.J.: Prentice-Hall, Rutledge Books, 1975), 124–32.

149

Lambert Hitchcock (1795–1852)
Side Chair
Hitchcocksville, Connecticut, 1825–32

Beech, maple, white pine, oak, and yellow poplar,
33 5/16 x 14 3/4 x 15 1/2 in. (84.6 x 37.5 x 39.4 cm)
Gift of Mr. and Mrs. Richard Stiner, B.A.
1945W, in honor of Dr. Joseph Weiner, 1916S,
1977.48.4

Innovative craftsmen in rural New England
played a key role in transforming the tradi-
tional mixed agricultural economy into a
more centralized production economy during
the early national period. Many of the inno-
vations took place in the countryside before
steam, gas, and electric power permitted
manufacturing in urban centers. Changing
demographics of the period, particularly
population growth, led more rural residents
to pursue artisanal activity to offset the
shrinking size of their farms, and more con-
sumers to seek the products of these shops.
In furnituremaking and clockmaking espe-
cially, rural craftsmen intensified current
craft practices and began to organize their
work to serve larger, more distant markets.[1]

Lambert Hitchcock gained valuable expe-
rience in the large Litchfield, Connecticut,
shop of cabinetmaker Silas Cheney. Even in
the early 1810s, Cheney kept ahead of his
competitors by outsourcing piecework to
craftsmen as far away as Lenox, Massachu-
setts; using a mechanical lathe to turn furni-
ture parts; and hiring a number of special-
ists, such as the ornamental painter Charles
T. West, to cater to a growing local market.
Hitchcock left Cheney's shop in 1818 and
decided to focus on chairmaking, establish-
ing a shop on the Farmington River near
Barkhamsted, Connecticut. This location pro-
vided him with easy access to materials
(maple and birch for turned parts, yellow
poplar and white pine for splats and sawn
elements, and reeds for flag seats), depend-

able water power, and a labor pool of part-
time skilled villagers. Initially he supplied
parts, which were assembled and decorated
elsewhere, to peddlers working the
Southern market.[2]

In 1825, Hitchcock built a three-story
brick building just downriver from the orig-
inal shop and centralized his production.
On the first floor and in an adjacent turning
mill, artisans processed lumber from a
nearby sawmill into chair parts. Craftsmen
working on the second floor assembled these
parts, and decorators on the third floor, many
of them women and children, painted and
stenciled the pieces. Hitchcock also began
to specialize in fancy chairs, a type character-
ized by turned frames, rush or cane seats,
and painted decoration. He made the chairs
affordable by streamlining existing shop
practices (for example, turning chair stock in
quantity); using water power to drive lathes
and circular saws; graining the local hard-
woods to look like imported mahogany or
rosewood; using stencils to eliminate the cost
of hiring specialized painters and to ensure
consistent decoration; relying on bronze
powders to simulate the effect of inlay and
brass mounts; and developing brand recog-
nition by stenciling his name and location
on the back seat rail. By centralizing produc-
tion, standardizing decoration, and focusing
on marketing, Hitchcock offered an afford-
able, stylish product, seen here, that was
shipped overland to Albany, Boston, Hart-
ford, New Haven, and Providence. At its
peak, Hitchcock's shop employed more than
one hundred people and produced fifteen
thousand chairs a year. E.S.C.

Notes

1. For more on the intensification of rural furniture-
making, see Edward S. Cooke, Jr., *Making Furniture
in Preindustrial America: The Social Economy of
Newtown and Woodbury, Connecticut* (Baltimore:
Johns Hopkins University Press, 1996), esp. 33–48,
and 190–99.

2. The best source on Hitchcock remains the senti-
mental biography by John Tarrant Kenney, *The
Hitchcock Chair* (New York: Clarkson Potter, 1971).

149

150

151

152

150

Decanter

Probably midwestern United States, ca. 1825

Colorless blown and cut lead glass, h. 10 ⁵⁄₈, diam. base 4 ¹⁵⁄₁₆ in. (27 x 12.5 cm)
Gift of M. Lelyn Branin, 1927 GRD, 1991.17.9

151

Boston and Sandwich Glass Works,
(1826–88)
Salt

Sandwich, Massachusetts, 1827–50
Pressed blue glass, 1 ⁹⁄₁₆ x 3 ⁷⁄₁₆ x 1 ⁷⁄₈ in.
(4 x 8.7 x 4.8 cm)
Mabel Brady Garvan Collection, 1930.1976

152

Compote

Probably northeastern United States, 1830–45

Pressed yellow lead glass, 6 x 10 ⁷⁄₈ x 9 ⅛ in.
(15.3 x 27.6 x 23.2 cm)
Mabel Brady Garvan Collection, 1931.1193

The 1820s and 1830s were a period of intense growth for the American glass industry. In New England and the Midwest, new technologies allowed glasshouses to compete with imported European products, placing American companies on an equal footing with their rivals across the Atlantic. This decanter, used to hold wine at the dinner table, is made from cut glass—the most stylish, desirable, and expensive type of glassware available in the nineteenth century (cat. no. 150). Much of America's domestically produced cut glass came from the newly developing city of Pittsburgh. In 1826, the editor of a city directory boasted, "The glass of Pittsburgh and the points adjacent is known and sold from Maine to New Orleans. Even in Mexico they quaff their beverages from the beautiful white flint of Mssrs. Bakewell, Page, and Bakewell of our city."[1]

The majority of American glassworks produced utilitarian bottles, window glass, and tableware. Only a few glass manufacturers could afford to produce ornamental cut-glass vases and tableware, whose facets showed off the brilliant color and sparkle of flint, or lead, glass. The body and stopper of this decanter were blown, then cut with a pattern of strawberry diamonds and radiating fans, a design motif taken directly from Anglo-Irish glass. Strawberry diamonds were so named because the diamond shapes were textured with many small faceted cuts resembling the surface of a strawberry. The minuscule facets covering this decanter give it texture, dimension, and sparkle, revealing the cutter's fine skill with the cutting wheel. American glasshouses tried to compete with European imports by hiring European-trained glass cutters. Only a highly trained artisan could cut and engrave glass, since a slip of the hand could irreparably damage a piece. Highly trained artisans demanded correspondingly high wages, adding more expense to what was already a luxury item. Not all glasshouses had their own expert cutters, and they often sent out blank pieces for finishing. The French immigrant Alexander Jardelle, for example, owned his own cutting shop and probably worked with several different glasshouses in the Pittsburgh area before eventually joining the Bakewell firm.[2]

In the mid-1820s, the development of press-molding radically changed the glass-making industry. Workers placed gathers of molten glass in the molds of a machine press and applied pressure, forcing the glass into the contours of an elaborately decorated mold. In mere minutes, one relatively unskilled worker could duplicate the work of several skilled artisans. It could take as little as two to four weeks to train a worker to run a glass press. But while press-molding made glass production faster and cheaper, it also took away the glassmaker's creativity,

handing it off to specialized designers and mold makers.[3]

This vibrant blue table salt is a rare marked product from the Boston and Sandwich Glass Works, founded in 1825 by Deming Jarves (cat. no. 151). The company was an innovator in pressed glass, and the term "Sandwich glass" came to be generically applied to pressed glass produced in a variety of factories. Shaped like one of the side-wheeled steamboats that churned the country's waterways during the mid-nineteenth century, this salt reflects the steamboat's growing importance in American life. By the end of the 1820s, hundreds of steamboats plied the Great Lakes, the Hudson River, and, most important, the Mississippi, making it easier, cheaper, and faster than ever to transport goods and people along the country's waterways. The name on this salt, "LAFAYET," also represents America's obsession with one of its most beloved Revolutionary War heroes. In 1824–25, the Marquis de Lafayette made a grand tour of the United States, and many were thrilled to see one of the last living heroes of the American Revolution. Within weeks of Lafayette's landing in New York City, people could purchase souvenirs of this momentous visit, including "the head of LaFayette, in miniature, engraved by [Asher B.] Durand, and an admirable likeness, stamped on watch ribbons, ladies' belts, gloves, etc." (cat. no. 62). The public's taste for Lafayette memorabilia did not abate when the marquis returned to France in 1825. The Boston and Sandwich Glass Works' books first record the production of this salt in 1827. It was highly popular and was soon copied by the Stourbridge Flint Glass Works in Pittsburgh.[4]

The decorations on early pressed-glass forms mimicked the designs of cut glass, but American glass factories soon devised new patterns that took advantage of press-molding's capacity for ornate detail. By

1830, Anglo-Irish geometric designs such as fans, strawberry diamonds, and ribbing were being replaced by distinctly American patterns incorporating scrolls, beading, and floral motifs. These designs were nicknamed "lacy glass" because of their intricate patterns and stippled backgrounds. They helped camouflage some of the problems associated with early machine pressing, such as the cloudiness caused when molten glass came into contact with the cooler metal of the mold, while the characteristic stippling of lacy patterns made the glass more refractive, disguising the shear marks left when molten gathers of glass were cut into pieces.[5]

Press-molding was a highly versatile manufacturing technique. This compote is composed of two parts—a large shallow dish and a base—which were molded separately and then joined by a wafer of molten glass (cat. no. 152). The mold used to create the dish section of the compote was also used to make the base of a covered vegetable dish. The delicate curving design of scrolls and the stippled background of the dish section contrast sharply with the simple heavy lines of the base, indicating that the two pieces were probably not designed together.[6] Hostesses anxious to present an elegant table to their guests often elevated dishes above the surface of the dining table for added drama and visual impact. Available in yellow, amethyst, grayish blue, sapphire blue, blue-green, olive green, and colorless glass, this compote would have made an elegant but affordable alternative to cut glass for the table.

Pressed glass became so popular that Meissen, the German porcelain manufacturer, imported a large quantity of American pressed glass in the 1830s. These pieces were used as models for a new line of porcelain that quickly became one of Meissen's top sellers. A Meissen sales report from the 1832 Michelmas Fair in Leipzig noted, "The best selling lots were porcelains with simple gold

decoration in cut glass patterns." Copies of glass dishes were cast in porcelain, and the raised designs of scrolls and flowers were decorated with gilding. American glassmakers must surely have been pleased to know that their products, initially made to imitate and compete with imported goods, were now being copied by the Europeans themselves.[7] E.E.

Notes

1. Samuel Jones, *Pittsburgh in the Year 1826* (Pittsburgh: Johnson & Stockton, 1826), quoted in Lowell Innes, *Pittsburgh Glass, 1797–1891: A History and Guide for Collectors* (Boston: Houghton Mifflin, 1976), 108.

2. Innes, 1976, 111.

3. The exact date of the process, along with the name of its creator, was lost in the 1839 fire at the U.S. Patent Office. For a discussion of the development of pressing techniques, see Kenneth M. Wilson, *American Glass, 1760–1930*, 2 vols. (New York: Hudson Hills Press and the Toledo Museum of Art, 1994), 1:265–72. Kirk J. Nelson, "The New England Glass Co. vs. George W. Robinson, Machinist," *Acorn: Journal of the Sandwich Glass Museum* 1 (1990), 56, repr. in Wilson, 1994, 265; Kenneth M. Wilson, *New England Glass and Glassmaking* (New York: Thomas Y. Crowell, 1972), 261.

4. The salt has also been found in clear, opalescent, opaque white, opaque light blue, canary yellow, and sapphire glass. There has been some debate over which steamboat the salt is modeled after. See Vincent Short, "Model for the LAFAYET Salt," *Antiques* 72 (Aug. 1957), 155, and Wilson, 1994, 295. John A. H. Sweeney, "Lafayette in the Decorative Arts," *Antiques* 72 (Aug. 1957), 136; *New York Evening Post*, 4 Sept. 1824; Arlene Palmer, *Glass in Early America: Selections from the Henry Francis du Pont Winterthur Museum* (Winterthur, Del.: Henry Francis du Pont Winterthur Museum, 1993), nos. 234–35.

5. John W. Keefe, "American Lacy and Pressed Glass in the Toledo Museum of Art," *Antiques* 100 (July 1971), 106–8.

6. See examples in Jane Shadel Spillman, *American and European Pressed Glass in the Corning Museum of Glass* (Corning, N.Y.: Corning Museum, 1981), nos. 266, 269; and Wilson, 1994, nos. 502–3.

7. Joachim Kunze, "Meissen Porcelain Designed from Glass Patterns (1831 to 1835)," in *Glass Club Bulletin of the National Early American Glass Club* 153 (fall 1987), 4, trans. by Henry Pachter from original in *Keramos* 105 (July 1984), 17–34. Kunze quotes the Meissen sales reports gleaned from the State Archives, Dresden, Location 36 342, VI, 82. For many years, American glass scholars believed that these pressed patterns were copied from Meissen porcelains rather than the reverse. See Ruth Webb Lee, *Ruth Webb Lee's Sandwich Glass Handbook* (Wellesley Hills, Mass.: Lee, 1939), pls. 151–52. These designs were also being copied by other American glasshouses; Innes, 1976, 277.

153

Reverse

154

155

153

Salamander Works (1825–96), manufacturer
Daniel Greatbach (active 1834–66), modeler
Pitcher
Woodbridge, New Jersey, 1839–42

Earthenware with Rockingham glaze, 10 ¼ x 10 x 8 in. (26 x 25.4 x 20.3 cm)
Mabel Brady Garvan Collection, 1931.1792

154

Fenton's Works (1847–48), manufacturer
Pitcher
Bennington, Vermont, 1847–48

Parian ware, 8 ³⁄₁₆ x 5 ⁷⁄₁₆ x 7 ⁵⁄₈ in. (20.8 x 13.8 x 19.4 cm)
Mabel Brady Garvan Collection, 1931.1774b

155

Charles Cartlidge and Company (1848–56), manufacturer
Josiah Jones (1801–1887), modeler
Pitcher
Greenpoint, Brooklyn, New York, ca. 1853

Porcelain, 6 ¹⁵⁄₁₆ x 3 ¹⁴⁄₁₆ in. (17.6 x 9.8 cm)
Mabel Brady Garvan Collection, 1931.1845

Before 1825, most domestic ceramic production was limited to utilitarian redware or stoneware that fulfilled household or dairy needs. For fine earthenware, stoneware, or porcelain, Americans purchased European and Asian imports. The potteries in Staffordshire, England, in particular, catered to an aspiring American middle class eager to purchase finer wares; they exported massive quantities of well-made, inexpensive goods to the United States, making it difficult for American potters to break into the market. Through the efforts of enterprising Americans and immigrant—largely English—potters, who carried their trade "in their packs, so to speak," the industry began to take root in America, using native clays.[1] These three pitchers demonstrate the tremendous strides that the fledgling American pottery and porcelain industry had made by the middle of the nineteenth century. Together they show how the transfer of artistic style, technical knowledge, and factory organization across the Atlantic was beginning to produce American-made ceramics that could compete with English imports.

Press-molded yellowware, such as the large brown-glazed pitcher by Salamander Works, was the backbone of the industry for most of the 1800s (cat. no. 153). Used to hold water for mixing with beer and other beverages, the low-fired pitcher has unglazed porcelain letters applied to the shoulder that identify the owner as Lewis Ford, a grocer whose shop was on the Bowery not far from where the pottery later had a showroom at 54 Cannon Street.[2]

The design and its motifs—a handle in the shape of a hound, relief hunting scenes on both sides, and lambrequin and relief borders of acorns and leaves circling the neck—derive from a type produced by Phillips and Bagster of Hanley, England, but variations were made by a number of American potteries.[3] Examples showing similarly lean canines seated on their haunches with paws and pointy snouts hanging over the rims have been attributed to the modeler Daniel Greatbach. The Staffordshire native immigrated by 1839 and modeled his first hound-handled pitcher for David Henderson's American Pottery Company in Jersey City, New Jersey.[4] Hound-handled pitchers made by Salamander Works rival those made in Jersey City, causing speculation that the Woodbridge pottery purchased plaster molds directly from Greatbach. Although unmarked, this pitcher is distinguished from Jersey City examples by the clawlike depressions on the hounds' forepaws where they meet the rim—a convention of the potter who secured the handle in place. Even with Greatbach's excellent molds, the pottery would have relied on immigrant pressers, finishers, and other skilled as well as unskilled workers to execute his design. Press-molding revolutionized production by enabling even mid-size potteries, which could not afford to hire a full-time modeler, to turn out substantial quantities of well-made wares with enviable designs.

In striking contrast to the robust press-molded hunting pitcher by Salamander Works is the crisply cast, sugary white floral pitcher marked "Fenton's Works" (cat. no. 154). The Bennington, Vermont, factory was the first American pottery to produce Parian ware, a type of unglazed porcelain that had been introduced by Copeland's in Staffordshire, England, only a few years earlier. Christopher Webber Fenton obtained his knowledge of Parian ware by recruiting highly trained workers and importing models or plaster molds of this style of pitcher from England. At the time the pitcher was made, Enoch Wood, named for his forebear who was "the Father of English Pottery," worked at Bennington as a mold maker and would have had a hand in its production, which entailed pouring the porcelain slip into a mold.[5] The pattern is identified by the large tulip and sunflower on either side; this version, however, features inverted Gothic arches along the base and zippering up the walls under the spout and handle. The pleasing floral design was also made in England; a version by Cork and Edge appeared in the British Section at the Paris Universal Exhibition in 1855.[6] As if to reinforce its Englishness, Fenton's factory mark appears to be styled after the scrolled-edge, rectangular cartouche used by Jones and Whalley of Cobridge, England.

A few years after this pitcher was made, Greatbach, lured from the American Pottery Company, created several new designs for the United States Pottery Company, as Fenton's firm was subsequently called, to display at the Crystal Palace exhibition of the Industry of All Nations, held in New York in 1853. At this, the nation's first world's fair, Fenton exhibited tried-and-true English designs like this pitcher, alongside ambitious Parian statuary and novel designs like the Niagara water pitcher modeled by Greatbach (fig. a).

Following production methods similar to those used to make the Bennington pitcher, the third pitcher, of glazed soft-paste porcelain, was made in the Greenpoint section of Brooklyn by the manufactory founded by the Englishman Charles Cartlidge (cat. no. 155). Before 1860, few American makers were able to sustain production of the challenging white-bodied ware.[7] Though not a potter, Cartlidge had many useful ties to the industry. He came to New York initially as a

representative of William Ridgway; when that firm failed, he stayed on to start a porcelain manufactory. His earliest samples, ready before the kiln was finished, were sent to Jersey City to be fired at Henderson's American Pottery Company.

With the aid of a machine press newly developed in England, Cartlidge prevailed as a maker of porcelain buttons and door and furniture trimmings. Marketed widely, Cartlidge's door furniture was promoted in Canada with the claim that it could "withstand the rigours of the severe Winters of the North."[8] He also aspired to make hollow ware, procuring molds from abroad as well as from Josiah Jones, his brother-in-law and a talented modeler, who contributed this design. The composition consists of ears and stalks of native corn in relief on an ovoid form shaped to resemble maize. Designed to appeal to patriotic Americans, the "Maize" pitcher became the firm's most popular item; it was also made by William Boch and Brothers and Cartlidge's later firm, the American Porcelain Manufacturing Company.[9] Corn pitchers came in several sizes, from a nearly eleven-inch-tall saloon model to a three-inch toy version, and many were gilded and painted. Those attributed to Cartlidge's earlier venture are not marked and probably date to before 1853, when he showed several at the New York Crystal Palace.

These three pitchers represent the rapid industrialization of ceramic manufacture in the United States, which was to have a significant economic impact. Through the combined efforts of skilled immigrant potters like Greatbach, Wood, and Jones; enterprising businessmen like Henderson, Fenton, and Cartlidge; and aided by favorable tariffs on imported goods, these factories succeeded in producing ceramics of high quality and aesthetic merit. C.M.H.

Notes
1. Frank Thistlewaite, "The Atlantic Migration of the Pottery Industry," *Economic History Review* 2 (Dec. 1958), 264.
2. The view that Salamander Works operated a pottery at 54 Cannon Street, as Edwin Atlee Barber wrote in *Marks of American Potters* (Philadelphia: Patterson & White Company, 1904), was disproved to Barber's satisfaction in correspondence with a liquidating trustee for the firm, according to Arthur Clement in *Our Pioneer Potters* (New York: privately published, 1947), 42.
3. Phillips and Bagster's version dates to ca. 1818–23 and likely was modeled by Leonard James Abington. He became a partner of William Ridgway, who issued the pitcher by 1831. Richard K. Henrywood, *An Illustrated Guide to British Jugs* (Shrewsbury, England: Swan Hill Press, 1997), 129.
4. The chronology of Greatbach's movements continues to be debated; most scholars accept Spargo's account: John Spargo, *The Potters and Potteries of Bennington* (Boston: Houghton Mifflin and Antiques Incorporated, 1926), 221–34.
5. Spargo, 1926, 234–35.
6. Kathy Hughes, *Collector's Guide to Nineteenth-Century Jugs* (Dallas: Taylor Publishing Company, 1991), 48.
7. The Philadelphia-based porcelain productions of Bonnin & Morris, 1771–72, and of William Ellis Tucker, which flourished in the late 1820s and 1830s, may be considered exceptions.
8. *Montreal Gazette*, 14 Apr. 1851, quoted in Elizabeth Collard, *Nineteenth-Century Pottery and Porcelain in Canada*, 2nd ed. (Kingston and Montreal: McGill-Queen's University Press, 1984), 196; and Alice Cooney Frelinghuysen, *American Porcelain: 1770–1920*, exh. cat. (New York: Metropolitan Museum of Art, 1989), 23.
9. Frelinghuysen, 1989, 110–13, nos. 21, 22.

156

John Hill (b. England, 1770–1850), engraver
After O. Neely (active mid-nineteenth century)
Matteawan. Manufacturing Village, Near Fishkill Landing. N. York, 1832

Hand-colored aquatint, 19 5/8 x 25 7/8 in. (49.8 x 65.7 cm) (irregular)
Mabel Brady Garvan Collection, 1946.9.1872

Printed views of American cities and towns, initially designed to be framed and displayed in the home, developed during the nineteenth century into overt advertisements for urban enterprise. In this depiction of Matteawan, long-established conventions for portraying cities and towns within a pastoral landscape give way to literal representation.[1] Cows and observers on a rocky perch in the foreground are familiar conventions from the English picturesque tradition, but there are no enframing trees to determine a single-point perspective. Instead, orderly rows of trees and buildings are recorded from multiple perspectives to allow full appreciation of the company's holdings, and it is size and color that establish the Matteawan Company's mill as the industrial heart of the village.

Newspaper accounts of *Matteawan* give no information about the artist but note that O. Neely sketched the village (now part of Beacon, New York) from a site overlooking the water that powered the mill.[2] The stagecoach, freight wagon, and fashionably dressed figures enjoying village amenities confirm Matteawan's prosperity, and Neely's attention to detail at the expense of painterly style links the print to other advertisements for corporate communities. Indeed, the legend on a later state of this print catalogues the company's activities in both English and Spanish.[3]

156

Although American illustrations of cities and towns were commonly used to encourage industrial growth, promotional prints were usually published in lithography—an inexpensive process that could replicate the original image in almost unlimited quantities. Remarkably, *Matteawan* was executed by the celebrated English-born engraver John Hill in aquatint, the printmaking technique that best simulated watercolors in the picturesque style.

Hill may have been commissioned by Philip Hone, who in 1832 became the Matteawan Company president. For nineteenth-century capitalists, industry was a valued addition to the natural landscape, and industrial artifacts demonstrated how technology made nature accessible and useful. Hone, one of the most sophisticated art patrons in New York, very probably believed that only Hill's skilled use of aquatint could convey the beauty of Matteawan's industrial culture. Almost certainly it was Hill who added the pastoral conventions commonly seen in his framing prints (cat. nos. 145–46) to Neely's boosterish record. In any event, for Hone the equivalence between the two landscapes, natural and industrial, was so complete that he could write, "Matteawan never looked more beautiful and it wanted nothing but a good dividend to make it a terrestrial paradise."[4] S.L.C.

Notes

1. Sally Lorensen Gross [Conant], *Toward an Urban View: The Nineteenth-Century American City in Prints*, exh. cat. (New Haven: Yale University Art Gallery, 1989).
2. Similar to an estate view with multiple perspectives that labels sections according to their relationship with the manor, the news articles describe both the buildings seen in Hill's rendition and the buildings' tenants in terms of their connection with the company. Weldon F. Weston, "Presented with Old Picture of Matteawan," *Evening Journal:*
Official Village Paper [Matteawan], 10 Mar. 1910; "Matteawan Long Ago," *Fishkill Daily Herald*, 10 Mar. 1910.
3. Sally Lorensen Conant, "'Always Beautiful in My Eyes': An American Industrial Entrepreneur and the Picturesque," *Imprint* 26 (spring 2001), 25–31.
4. The New-York Historical Society holds the diary of Philip Hone (1828–51). Published versions do not include Hone's visits to Matteawan or investors' meetings in New York.

157

John Perry Newell (1832–1898)
Published by **Robertson, Seibert, and Shearman** (1854–61)
Lazell, Perkins & Co. Bridgewater, Mass., ca. 1860

Hand-colored lithograph, 17 5/8 x 22 5/16 in. (44.8 x 56.7 cm)
Mabel Brady Garvan Collection, 1946.9.1746

In 1856, when Bridgewater, Massachusetts, celebrated its bicentennial, speakers gave full credit for the town's success to industrial enterprise. They acknowledged industry's profound effect on "old familiar scenes," but believed it would bring fulfillment of the "mighty destiny before us as a people." One orator even suggested that the "cloud of discord and disunion," seemingly a reference to the impending Civil War, could be dis-pelled with "prosperous industry."[1] This, he believed, supplied "one of the strongest elements of our national union," because it made "one part of this great continent dependent upon another for the sources of its wealth and prosperity, as well as of individual comfort and luxury."[2]

This lithograph, a forthright advertisement published about the same time,[3] reflects a similarly positive view of industry. Lazell, Perkins & Co. was one of the largest ironworks in the country, with five steam engines, eleven waterwheels, and a mountain of scrap metal for forging. However, the print illustrates the "change from a wilderness to a garden, from barbarism to high civilization,"[4] as an orderly cluster of tidy buildings with black smoke drifting harmlessly upward into a pastoral framework of fluffy white clouds.[5]

Smoke rising from the factories echoes the pattern of that issuing from the train, and

LAZELL, PERKINS & CO. BRIDGEWATER, MASS.

157

this visual link, together with the track leading from train to factory, suggests the vital economic ties between the two. Although the works opened as early as 1785, production was limited until the railroad brought coal to fuel the powerful steam engines. Once large-scale manufacturing began, the railroad that carried raw materials to the factory not only delivered iron goods to market but was in itself a customer for the company's iron.[6] The steam engine that powered both ironworks and railroad, noted the Bridgewater Bicentennial Committee, was "the very 'king of machines'; superseding, in a great measure, the former cumbrous methods of locomotion, and . . . revolutionizing the country."[7] S.L.C.

Notes

1. *Celebration of the Two-Hundredth Anniversary of the Incorporation of Bridgewater, Massachusetts* (Boston: John Wilson and Son, 1856), 78–79.
2. Ibid., 63. Ironically, the works at Bridgewater produced guns, cannon, and plate for warships, including the Civil War ironclad USS *Monitor*. John Leander Bishop, *A History of American Manufactures from 1608–1860*, 3 vols. (1868; repr. New York: Johnson Reprint Corp., 1967), 3:488–91.
3. Although Bishop wrote that the company was incorporated as Bridgewater Iron Manufacturing Company in 1825, and David R. Moore, Bridgewater Historical Commission, dates the railroad to 1845, Marshall B. Davidson dates the print ca. 1860 in *Life in America*, 2 vols. (Boston: Houghton Mifflin, 1951), 1:534–35. This accords with the publishers' dates in Harry T. Peters, *America on Stone* (1931; repr. New York: Arno Press, 1976), 336.
4. *Celebration*, 1856, 113.
5. Relating smoke to cloud formations is a common device in railroad imagery of the period. See Leo Marx, "Introduction: The Railroad in the American Landscape," in Susan Walter Danly, *The Railroad in the American Landscape: 1850–1950*, exh. cat. (Wellesley, Mass.: Wellesley College Museum, 1981), 15.
6. By 1860, trains and railroad tracks consumed nearly half of all the iron and steel produced in America. Davidson, 1951, 534.
7. *Celebration*, 1856, 151–52.

158

Reverse

158

Charles Farley (1791–1877), silversmith
David G. Johnson (active 1825–45), engraver
Medal
Portland, Maine, 1826

Silver, wt. 41 gm, 12:00, 63 mm
Mabel Brady Garvan Collection, 1930.4871

On the Fourth of July, 1826, the city of Portland, Maine, celebrated the fiftieth anniversary of the United States' independence. Along with processions, speeches, and toasts, local citizens could also view an exhibition mounted by the Maine Charitable Mechanic Association, featuring the works of the association's apprentices. Ten silver medals were awarded to the apprentices who had made the most outstanding pieces. Daniel Woodman, Jr., an apprentice at Wyer, Noble, and Company and the recipient of this medal, was praised for his copper teakettle, which was "manufactured with skill and judgment." The medals were made by Portland silversmith Charles Farley, and David G. Johnson engraved them with bright-cut decoration and the recipients' names. Similar medals were often given to students to recognize academic achievement at school.[1]

Farley had a brief partnership with Eleazar Wyer, a goldsmith and one of Woodman's employers, from 1814 to 1818. After the dissolution of the partnership, Farley continued working with silver, while Wyer joined with coppersmith Joseph Noble to focus on the cast-iron stove industry. By 1826, Farley was running ads in the local paper for a "military store," where he sold swords, epaulets, and other military accessories along with silver goods.[2]

The Maine Charitable Mechanic Association was established in 1815 for the "promotion of industry, the encouragement of enterprize, and the amelioration of the condition of the unfortunate." Farley, Noble, and Wyer were all founding members, and Woodman joined in 1841. The Maine Charitable Mechanic Association and other mechanics' groups were designed to enhance the practical education a young man received during apprenticeship. They hoped to turn workers into not only moral citizens but also innovators who could further the cause of American industry. The Maine organization's activities were geared mainly toward providing educational opportunities and social assistance for the state's skilled workers and their families. The association opened a library in Portland in 1820 that is still in operation today. Its 1826 exhibition was the association's first of several attempts to present members' accomplishments to the public.[3] E.E.

Notes

1. "Exhibition of Manufactures," *Eastern Argus* (Portland, Me.), 11 July 1826. For more on Johnson, see Martha Gandy Fales, "An Unrecognized Portland Engraver," *Old-Time New England* 57 (winter 1967), 77–79.
2. Laura Fecych Sprague, "Patterns of Patronage in York and Cumberland Counties, 1784–1830," in *Agreeable Situations: Society, Commerce, and Art in Southern Maine, 1780–1830*, ed. Laura Fecych Sprague (Kennebunk, Me.: Brick Store Museum, 1987), 166; *Eastern Argus*, 11 July 1826. For more on Farley, see Edwin A. Churchill, "Crafts in Transition: A Case Study of Two Portland Silversmiths in the Early Nineteenth Century," *Maine Historical Society Quarterly* 24 (winter 1985), 298–337.
3. *Constitution of the Maine Charitable Mechanic Association* (Portland, Me.: Francis Douglas, 1817), 5; *Constitution and History of the Maine Charitable Mechanic Association with Lists of Officers and Members* (Portland, Me.: Bryant Press, 1965), 79–101; Harold W. Stubblefield and Patrick Keane, *Adult Education in the American Experience: From the Colonial Period to the Present* (San Francisco: Jossey-Bass Publishers, 1994), 95.

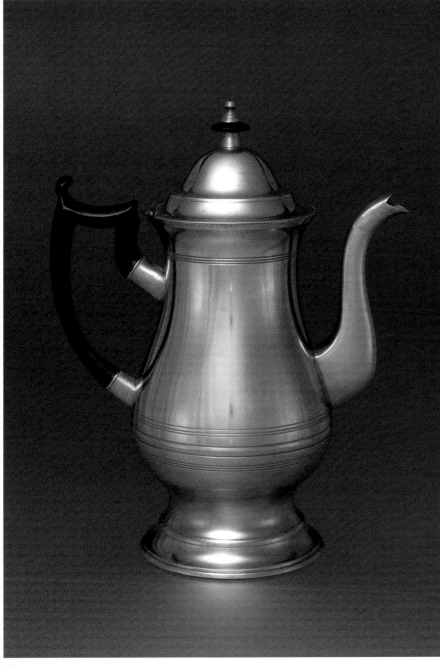

159

159

Roswell Gleason (1799–1887)
Coffeepot
Dorchester, Massachusetts, 1830–71

Britannia with wooden handle and finial,
h. 12 ⅛, w. (with handle) 9 ¼, diam. base 5 ¼ in.
(30.8 x 23.5 x 13.3 cm)
Gift of Mrs. Nigel Cholmeley-Jones, 1965.38

In the late eighteenth century, pewterers faced increased competition from domestic and imported ceramics. In response, they began to work in britannia, a harder variant of pewter. Britannia production developed in Great Britain during the late eighteenth century. The alloy was produced in the United States in the first decade of the nineteenth century, and by the 1820s, it was being worked in large quantities by manufacturers throughout the Northeast. It possessed a silverlike sheen, leading pewterers to market it to customers who wanted the look of silver without its high price. Britannia goods contained less metal, on average, than comparable pewter pieces and were correspondingly cheaper, which helped britannia manufacturers compete against ceramics in the domestic housewares market. Because it could be worked into thinner sheets than pewter, britannia was an ideal material to take advantage of new manufacturing techniques. Prior to the Industrial Revolution, most pewter goods were cast in molds. Britannia objects, by contrast, could be spun or stamped, often using the latest steam-powered machinery.[1]

With the advent of britannia production, pewter-making made the leap from craft to industry. Roswell Gleason, whose Dorchester, Massachusetts, factory manufactured this coffeepot, was one of many individuals who took advantage of the transition. He served his apprenticeship with a tinsmith, eventually taking over the business when his master retired in 1822. The small shop gradually grew into a factory manufacturing tin and pewter.

At its peak, the factory employed 125 workers, many of whom were former pewterers.[2]

His factory produced a wide variety of britannia forms that won awards from the Massachusetts Charitable Mechanic Association in 1837 and 1841. In 1848, Gleason advertised that since receiving the awards, "great improvements have been constantly [made] in patterns, style and finish." In 1851, he was included in an encyclopedia of Massachusetts' wealthiest men.[3] Gleason closed his factory and retired in 1871.

This coffeepot could have been produced at any point during the factory's years of operation, but its simple pyriform, or pear-shaped, profile probably dates it to the earlier decades of his operation, before Gleason began producing more highly ornamented Victorian forms. The shape of the pot's body is reminiscent of rococo silver designs, while the squared scroll handle recalls the handles on many neoclassical tea and coffee wares. E.E.

Notes

1. The author is grateful for the assistance of Catherine Lanford, History of Art Department, Yale University, who graciously shared information on Roswell Gleason from her forthcoming doctoral dissertation. Charles F. Montgomery, *A History of American Pewter* (New York: Praeger, 1973), 39–41.
2. John Whiting Webber, "Roswell Gleason," *Antiques* 20 (Aug. 1931), 87–89; Richard L. Bowen, Jr., "Some of Roswell Gleason's Early Workers," *Bulletin of the Pewter Collectors Club of America, Inc.* 8 (Sept. 1981), 148–61.
3. Advertisement, *Norfolk Democrat* (Dedham, Mass.), 11 Feb. 1848; *"Our First Men," or, a Catalogue of the Richest Men of Massachusetts . . .* (Boston: Fetridge and Company, 1851), 167; Webber, 1931, 88.

160

Hatting, Meyer & Warne (active 1857)
Water Pitcher
Philadelphia, ca. 1857

Silver-plated white metal, 12 x 8⅞ x 6¹⁵/₁₆ in.
(30.5 x 22.6 x 17.7 cm)
Frederick C. Kossack Fund, 1992.115.1

The buying power of the growing middle class made the silver-plating industry highly profitable in mid-nineteenth-century America. Those who could not afford solid silver goods could now own plated ware, which sold for a fraction of the cost. In an 1862 article on silver-plating technology, *Scientific American* reflected on the widespread availability of these goods: "Not many years ago, people of wealth were ambitious of a display of silver plate as it was held to be an evidence of position in society. This order of

things has passed away, as plated ware rivaling the solid in form and brilliancy can now be manufactured for a tithe of the cost, and all classes have adopted it."[1] The first silver-plating patent was granted to Elkington and Company of Birmingham, England, in 1840.[2] Soon thereafter, American manufacturers began trying to replicate the process, and silver-plating companies sprang up across the country. A few large firms dominated the field, such as Reed and Barton and the Meriden Britannia Company (cat. nos. 217–18), while numerous other small companies that merely plated white-metal goods produced by other manufacturers struggled to carve out a section of the market.

This rococo-revival pitcher was made by Hatting, Meyer & Warne, a Philadelphia silver-plating firm. The company appears in Philadelphia directories only in 1857, but the firm of Meyer and Warne was in operation

from 1857 until at least 1880. An 1857 account of manufacturing in Philadelphia noted that Meyer and Warne was "now producing a metal that is truly remarkable for its strength, whiteness, and cheapness, while it has a ring somewhat resembling silver." The pitcher's pyriform shape and scroll handle are reminiscent of silver designs of the eighteenth century, but the textured background and foliation are more typical of the nineteenth-century reinterpretation of rococo style. The pitcher's floral decoration resembles a technique known as "Baltimore repoussé," referring to the finely chased masses of flowers found on silver of the period, particularly in the work of Baltimore's Samuel Kirk (cat. no. 220). Vertical ribs divide the pitcher's body into four panels, three of which contain relief images of classical figures, while the fourth contains the pitcher's handle. The three groups of figures—an embracing couple,

a dancing woman, and a man holding a chained cherub—may allude to the myth of Cupid and Psyche, or they may simply be meant to evoke a generic "spirit" of classicism. As with many objects in revival styles, in this pitcher historical accuracy was secondary to appearance and effect.[3]　　　E.E.

Notes
1. "Substitute for Silver in the Arts," *Scientific American* 6 (18 Jan. 1862), 36.
2. Charles L. Venable, *Silver in America, 1840–1940: A Century of Splendor*, exh. cat. (Dallas: Dallas Museum of Art and Harry N. Abrams, 1995), 20n.19.
3. YUAG Object Files; Dorothy T. Rainwater and Judy Redfield, *Encyclopedia of American Silver Manufacturers*, rev. 4th ed. (Atglen, Pa.: Schiffer Publishing, 1998), 218; Edwin T. Freedley, *Philadelphia and Its Manufactures: A Hand-book . . . in 1857 . . .* (Philadelphia: Edward Young, 1858), 351; Venable, 1995, 59.

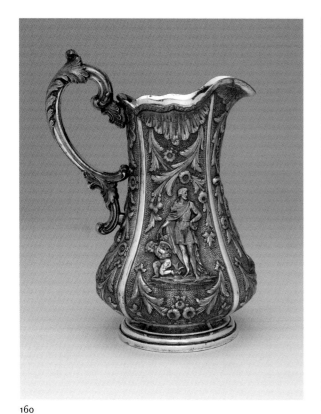

160

Spout

Reverse

161

161

Frances F. Palmer (1812–1876), artist and lithographer
Published by **N. Currier** (active 1834–56)
New York Crystal Palace. For the Exhibition of the Industry of All Nations, 1853

Hand-colored lithograph, 22 ⅜ x 28 3/16 in. (56.8 x 71.6 cm)
Mabel Brady Garvan Collection, 1946.9.1625

162

Medal of the 1853 Exhibition of the Industry of All Nations, 1853

White metal, wt. 144.72 gm, 12:00, 73.5 mm
Ruth Elizabeth White Fund, 2007.3.1

163

Unknown lithographer
Published by **Currier & Ives** (active 1857–1907)
Burning of the New York Crystal Palace, On Tuesday Oct. 5th 1858. / During its Occupation for the Annual Fair of the American Institute, 1858

Hand-colored lithograph, 20 ½ x 28 ¼ in. (52.1 x 71.8 cm)
Mabel Brady Garvan Collection, 1946.9.1626

The London Crystal Palace, which opened amid great fanfare in Hyde Park on 1 May 1851, was the first major international exhibition of arts and industries, marking the beginning of the world's-fair tradition.[1] After visiting the London exposition, Edward Riddle, a patriotic Boston merchant, returned home determined to realize an American Crystal Palace of even greater size and importance than the British model. Riddle amassed a core of investors to back the endeavor, and together they successfully petitioned the Board of Aldermen of New York City. Reservoir Square was allocated as the site for the Exhibition of the Industry of All Nations—

162

Reverse

a piece of land that today occupies the blocks between Fortieth and Forty-second Streets and between Fifth Avenue and the Avenue of the Americas.

Like the London version, the New York Crystal Palace was constructed almost entirely of iron and glass, but instead of a rectangular plan, it took the shape of a Greek cross, with arms of equal length. Visitors entered through one of the twenty-seven-foot-wide entrances located at the north, west, and south arms of the cross. The center was surmounted by a huge dome, 100 feet in diameter and 125 feet high at its crown—the largest dome in the entire Western Hemisphere at the time. Several of these architectural details are keyed beneath Frances "Fanny" Palmer's depiction of the newly opened Crystal Palace, in which trolleys and carriages bring visitors to the exhibition hall (cat. no. 161).

The initial construction budget for the Crystal Palace was two hundred thousand dollars, but costs would ultimately climb to triple that figure by the time the building was completed.[2] These financial problems, plus a series of construction delays, caused the opening date to be postponed twice. Finally, on 14 July 1853, President Franklin Pierce gave the inaugural address to ten thousand visitors who packed the palace despite the fact that only about one-third of the exhibits were in place on opening day.[3]

Visitors paid ten dollars for a season ticket, fifty cents for a single ticket, and twenty-five cents for a child. The Crystal Palace's 5,272 exhibitors, about half of whom came from twenty-three other nations, displayed articles such as fine furniture, fabrics, porcelain, jewelry, and metalwork; recent inventions such as fire engines, sewing machines, and steam-powered pumps; and products such as Goodyear's India rubber goods, Linus Yale's "Patent Magic Locks," and guns from the makers Colt, Sharps, and Whitney. Exhibitors were awarded medals of excellence for their inventions and designs: Samuel F. B. Morse received a silver medal—the highest honor—for his telegraph; Tiffany & Co. was also awarded a silver medal for its silverware and jewelry; and Mathew Brady won a bronze medal for his daguerreotypes.[4] In addition to the medals given to exhibitors, inexpensive souvenir medals of white metal or spelter (a zinc-rich alloy) were available to visitors. One such medal (cat. no. 162) features the Crystal Palace on its obverse, while personifications of Europe, Asia, Africa, and South America adorn the reverse. These figures allude to the truly international character of the exhibition. Souvenirs of this sort would become pervasive at subsequent world's fairs; at Chicago's Columbian Exposition of 1893, hundreds of different medals and tokens by various makers were sold to commemorate the event, its buildings, and exhibitions (cat. no. 167).

The exhibition marked a turning point: it was the first time Americans were exposed to industrialized forms of so many utilitarian objects and processes. As Robert C. Post has observed: "The very idea of *mechanizing* all sorts of things from sewing to shooting was novel. . . . One senses that Americans had definitely discovered their own inventive bent, that they knew—and now *knew* they knew—how to make things well, and make lots of them alike, and mechanize just about anything assigned in the old world to manual skill."[5] The experience of the New York Crystal Palace inspired and emboldened American entrepreneurs and inventors. In the next two decades, momentous strides in technology would be made in this country, from improvements in precision factory machinery to breakthroughs in oil and steel beginning in the 1860s and to electric power beginning in the 1870s.[6]

The New York Crystal Palace has come down in history as something of an ill-fated venture: operationally, financially, and, finally, physically, when on 5 October 1858, it burned to the ground, reportedly in less than half an hour (cat. no. 163). Although it had been dubbed "fireproof" at the time of its construction, the Crystal Palace went up in flames during the annual fair of the American Institute. Reports noted that about two thousand people were in the building at the time, but that no one was killed in the blaze. In the words of New York diarist George Templeton Strong, "So bursts a bubble rather noteworthy in the annals of New York. To be more accurate, the bubble burst some years ago, and this catastrophe merely annihilates the apparatus that generated it."[7]

E.H. *with the assistance of* G.C.B.

Notes

1. Conceived by Prince Albert, the London Crystal Palace, also known as "The Great Exhibition," was intended to symbolize the industrial, military, and economic superiority of Victorian England by inviting countries from around the globe to exhibit recent achievements beside those of Great Britain.

2. Charles Hirschfeld, "America on Exhibition: The New York Crystal Palace," *American Quarterly* 9 (summer 1957), 107.

3. When word got out that the exhibitions were incomplete, many visitors stayed away. Only after it was announced on 5 September that all the exhibits were fully installed did visitors begin pouring into the palace. Hirschfeld, 1957, 108. The financial and operational difficulties that continued to plague the enterprise were noted by George Templeton Strong, who wrote in his diary on 11 Oct. 1853: "At the Crystal Palace tonight . . . more impressed at each visit by the variety and beauty of the collection. But it won't pay; the stock's at 55 with a downward impetus, and those holders who bought at 175 will be badly bit." Allan Nevins and Milton Halsey Thomas, eds., *The Diary of George Templeton Strong*, 4 vols. (New York: Macmillan, 1952), 2:132.

4. *New York Industrial Exhibition. General Report of the British Commissioners* (London: Harrison and Son, [1854]), 24, 42.

5. Robert C. Post, "Reflections of American Science and Technology at the New York Crystal Palace Exhibition of 1853," *Journal of American Studies* 17 (Dec. 1983), 342, 346.

6. Post, 1983, 356.

7. Nevins and Thomas, 1952, 2:416.

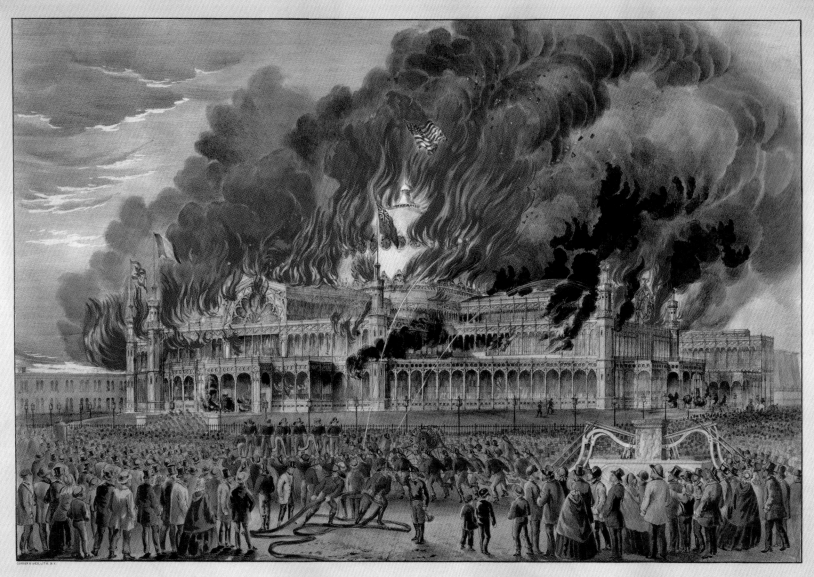

BURNING OF THE NEW YORK CRYSTAL PALACE,
on Tuesday Oct. 6th 1858.
DURING ITS OCCUPATION FOR THE ANNUAL FAIR OF THE AMERICAN INSTITUTE.

163

164

Reverse

164

Philadelphia Centennial Exhibition, Women's Pavilion Medal, 1876

Porcelain, wt. 22.28 gm, 1:00, 57 mm
Yale University Numismatic Collection Transfer, 2001, Gift of Irving Dillaye Vann, B.A. 1897, 1931, 2001.87.8

As the United States grew into a significant economic and political force, it hosted a number of expositions to show off American ingenuity and productivity. The country's first "world's fair," New York's 1853 Crystal Palace exhibition, was plagued by financial and operational difficulties (cat. no. 161), and it was not until 1876, the hundredth anniversary of American independence, that another major fair was attempted. This time it was a tremendous success. After nearly a decade of planning, the Centennial Exhibition was opened by President Ulysses S. Grant in Philadelphia's Fairmount Park on 10 May 1876. During its six-month run, the fair attracted more than eight million visitors, who attended a variety of exhibits representing the art and industry of nearly fifty countries. Among the many inventions shown to the public for the first time were the telephone, the typewriter, and electric lights.

The Centennial Exhibition was the first world's fair to highlight the contribution of women, who had their own building, the Women's Pavilion (fig. a). The *New Century for Woman*, a weekly paper published by women at the Pavilion, described the building as "rigidly utilitarian" but noted that "entering the door . . . the strictly useful idea relaxes, and the beautiful is felt at once pervading the atmosphere within." Inside "are the rich fruits of earnest thought and toil,—of busy brain, and gentle heart, and fair, skilful hand."[1] These "fruits" ranged from the useful to the curious. Seventy-four inventions patented by American women were on display, including a dishwasher, a life-saving mattress

for nautical use, and a night-signaling device used by the U.S. Navy.[2] Among the more unusual products of women's creativity were a sculpture made of butter, the Lord's Prayer rendered in human hair, and fish-scale jewelry made by the granddaughters of Thomas Jefferson.[3]

The Women's Pavilion is commemorated in this porcelain souvenir medal, the obverse of which depicts the exterior of the building under the motto "HER WORKS PRAISE HER," a paraphrase of Proverbs 31.31, which was inscribed over the front entrance to the Pavilion in six languages.[4] Encircled by the dates 1776 and 1876 and the words "AMERICAN CELEBRATION," a variation of the Great Seal of the United States marks the reverse. Although souvenir medals were usually made of metal, here the use of porcelain, though unusual, is appropriate, given its strong association with women's handicrafts such as porcelain painting, which was on display in

the Pavilion. Furthermore, the beauty and delicacy of porcelain connote femininity itself. Despite the quirkiness of some of its exhibits, the success of the Women's Pavilion paved the way for an even larger celebration of women's work at America's next great extravaganza, the World's Columbian Exposition of 1893. G.C.B.

Notes
1. "The Exposition: The House We Live In," *New Century for Woman* 1 (13 May 1876), 1.
2. "The Women's Pavilion," *Centennial Record* 1 (July 1876), 7.
3. *Frank Leslie's Illustrated Historical Register of the Centennial Exposition, 1876* (1876; facs. New York: Paddington Press Ltd., 1974), 156; *Centennial Record*, 1876, 7.
4. The medal is recorded in Henry W. Holland, "Centennial Medals," *American Journal of Numismatics* 12 (Oct. 1877), 44, no. 74.

fig. a "Women's Pavilion, on Belmont Avenue, near the Horticultural Grounds," from Frank H. Norton, ed., *Frank Leslie's Historical Register of the United States Centennial Exposition, 1876* (New York: Frank Leslie's Publishing House, 1877). Arts of the Book Collection, Arts Library, Yale University

165

Reverse

166

Reverse

167

Reverse

165

Francis N. Mitchell (active 1840–76),
engraver
Struck at the United States Mint,
Philadelphia
Metropolitan Mechanics' Institute Medal,
1853–55

Silver, wt. 36 gm, 12:00, 40 mm
Evelyn and Henry Kirschenbaum Collection,
2000.78.7

166

Charles Cushing Wright (1796–1854),
designer and engraver
Michigan State Agricultural Society Medal
New York City, 1866

Bronze, wt. 69 gm, 12:00, 54 mm
Evelyn and Henry Kirschenbaum Collection,
2000.78.4

167

Augustus Saint-Gaudens (1848–1907),
designer, obverse
Charles E. Barber (1840–1917),
designer, reverse
United States Mint, die-sinker; struck at
Scovill Manufacturing Co., Waterbury,
Connecticut
*Medal of the World's Columbian Exposition,
1893*, 1894–96

Bronze, wt. 210.46 gm, 12:00, 76 mm
Yale University Numismatic Collection Transfer,
Gift of Dr. William Gilman Thompson, 2001.87.7

As the number and variety of products made
by American factories grew, so did the desire
to display them to generate consumer inter-
est and also to demonstrate the country's
rapidly expanding industrial might. In 1853,
when New York City hosted the Crystal
Palace exhibition, which showcased Ameri-
can goods in an international context (cat.
no. 161), the first exhibition of the Metro-
politan Mechanics' Institute "for the Promo-
tion and Encouragement of Manufactures,

Commerce, and the Mechanic and Useful Arts" was held in Washington, D.C. As the nation's capital, no other venue could "be more likely to contribute to the permanent and wide-spread reputation of works of superior merit, or to render greater service to the cause of American labor." The exhibitors were "Manufacturers, Mechanics, Artists, Inventors, and all others desiring to display the results of their labor, skill, ingenuity, and taste, from all portions of the Union." A panel of judges examined the various exhibits and gave medals bearing the likeness of the city's namesake, George Washington, to those deemed "of superior merit."[1]

Engraved by Francis N. Mitchell and struck at the United States Mint in Philadelphia, the medals were produced in brass, bronze, copper, and silver, as in this example from the institute's first or second exhibition (cat. no. 165). The portrait of Washington on the obverse derives from the life cast taken by the French sculptor Jean-Antoine Houdon at Mount Vernon in 1785.[2] On the reverse, a ribbon reading "PRESENTED BY THE METROPOLITAN MECHANICS INSTITUTE" surrounds an ornate cartouche on which the name of the recipient is engraved, complete with misspelling, "Wheeler & Witson, N. York, Sewing Machine for Family use." The Wheeler & Wilson Manufacturing Company was founded in Watertown, New York, in 1851. The company's machines incorporated a special rotary hook-and-bobbin combination and a four-motion feed, which moved the fabric after every stitch—a feature found on all sewing machines today. In the 1850s and 1860s, Wheeler & Wilson sewing machines were the most popular in America, but they were ultimately eclipsed in the late 1860s by the Singer Manufacturing Company, which acquired the firm in 1905.[3]

State fairs, of which New York's was the first in 1838, provided another venue for the display of American ingenuity. America's

second-oldest state fair was established in 1849, when the Michigan State Agricultural Society held a three-day show in which exhibitors displayed more than six hundred entries in diverse categories such as livestock, paintings and drawings, and even "needle, shell and wax work."[4] State fairs were intended to promote modernization and "encourage interaction between rural agriculture and urban industry."[5]

In 1866, at the Michigan State Agricultural Society's Eighteenth Annual Meeting, judges awarded a silver medal to West & Comly (presumably a local retailer) for a Wheeler & Wilson sewing machine (cat. no. 166). The medal, designed and engraved by Charles Cushing Wright, a New York die engraver and founding member of the National Academy of Design (cat. nos. 121–23), features Ceres, Roman goddess of agriculture, on its obverse. Flanked by a cityscape on the left and farm implements on the right, the deity visually balances the interests of town and country. An ornate cartouche provides a throne for the goddess and also frames the city in the distance, which is almost certainly Detroit. The sun rises optimistically over the waters beyond the city, where a steamboat and lighthouse can be seen. On the right, a sheaf of wheat, plow, shovel, hay rake, and granary signify the state's agrarian interests. The reverse of the medal was mostly blank so that it could be engraved with the recipient's name and entry and used for several decades.

The Michigan State Fair was held continuously until a hiatus in 1893, in deference to the World's Columbian Exposition, the ne plus ultra of American fairs. Held in Chicago from May to October 1893, the exposition celebrated the quadricentennial of Columbus's landing, with forty-six nations participating at a cost of over $28 million. Nearly 70,000 exhibitors provided over 250,000 displays for the almost 26 million visitors

who attended the fair. In all, 23,757 awards were given to 21,000 exhibitors. There was only one class of award, and prizes consisted of a printed diploma and a bronze medal.[6]

The fair's Executive Committee on Awards commissioned America's leading sculptor, Augustus Saint-Gaudens, to design the medal, which was not completed until the close of the exposition. His original model for the reverse of the medal featured a nude boy, representing the Spirit of America, holding a torch and three laurel wreaths, supporting a long shield bearing an eagle and escutcheon with stars and stripes (fig. a). Although Secretary of the Treasury John Griffin Carlisle had accepted the design, colleagues pressured him to withdraw his

approval "on the grounds that the nude was offensive."[7] Although Americans were accustomed to seeing female nudes in artistic works, especially allegorical figures, male nudity, by contrast, was only rarely depicted in American art and became increasingly taboo as conservative Victorian mores prevailed. A long public controversy ensued, and artists, incensed by the slight to Saint-Gaudens, rallied to his support. Saint-Gaudens eventually modified his design for the reverse, presenting a largely text-based image that eliminated the nude entirely and was decorated only with the eagle-and-shield motif from his original, encircled by a laurel wreath.[8] This one, too, was rejected, while a model for the reverse, secretly com-

fig. a Augustus Saint-Gaudens, *World's Columbian Exposition Commemorative Presentation Medal*, Galvano for Rejected Reverse, 1892–94. Bronze, diam. 8¼ in. (21 cm). Courtesy of The Department of the Interior, National Park Service, Saint-Gaudens National Historic Site, Cornish, N.H.

missioned from Charles E. Barber, chief engraver of the United States Mint (1879–1916), was accepted. Saint-Gaudens was offended that his design for the obverse would be combined with Barber's work and wrote that "the rare shamelessness of such offense will be appreciated by all my confrères at home and abroad."[9] Eventually, however, he conceded defeat.

While the hubs and dies for the medal were produced at the United States Mint in Philadelphia between 1894 and 1896, the final medal was struck by the Scovill Manufacturing Company of Waterbury, Connecticut.[10] Saint-Gaudens's obverse (cat. no. 167) depicts Columbus, head turned heavenward as a sign of divine providence, stepping onto the shore of the New World. In the background, a member of his retinue bears a billowing standard. At the upper right are the Pillars of Hercules—symbolizing the Rock of Gibraltar—flanking three caravels (the *Niña*, the *Pinta*, and the *Santa Maria*), and the inscription "PLVS VLTRA," indicating there is "more beyond" the bounds of the Old World.[11]

Barber's reverse features two seminude female angels: one, holding a pair of laurels and a trumpet, symbolizes Fame; the other, holding a tablet while pointing to a globe with a stylus, symbolizes History and records Columbus's deeds for posterity. On the large central tablet, a small insert die bears the honoree's name, in this case, E. B. Estes & Sons. A New England firm established in 1847, Estes billed itself as "the most extensive wood turning establishment in the world," whose products included bowling balls, tenpins, office furniture, wooden toys, and toothpicks.[12]

In April 1896, the medal was distributed to prizewinners in a velvet-lined aluminum case (also produced by Scovill), accompanied by an award diploma designed by the artist Will Low. Despite being distributed two and a half years after the fair's end, the medal quickly became an emblem of excellence for American manufacturers who had exhibited at the fair, appearing in advertisements, trade cards, and even on a paving brick made by the Robinson Clay Products Company.[13]

G.C.B.

Notes

1. Metropolitan Mechanics' Institute leaflet, Washington, D.C., 1853. Folder 6, Portfolio 201, Printed Ephemera Collection, Library of Congress, Washington, D.C.
2. William Spohn Baker, *Medallic Portraits of Washington* (1885; repr. Iola, Wisc.: Krause Publications, 1965), iv, 140.
3. From *The Encyclopedia of Antique Sewing Machines*, 3rd ed., quoted in Charles Law, "Antique Sewing Machine Resource—Wheeler & Wilson Sewing Machines," http://www.geocities.com/ Heartland/ Plains/3081/w_w.html.
4. Julie A. Avery, "Early County Fairs: Community Arts Agencies of Their Time," in *Agricultural Fairs in America,* ed. Julie A. Avery (East Lansing: Michigan State University, 2001), 59.
5. Michigan Historical Center, "A Brief History of Michigan's State Fair," http://www.michigan.gov/ hal/0,1607,7-160-1745_18670_18793-53223--,00.html.
6. Chicago Historical Society, "History Files—The World's Columbian Exposition," http://www. chicagohs.org/history/expo/ex2a.html.
7. Thayer Tolles, "'A Bit of Artistic Idealism': Augustus Saint-Gaudens's *World's Columbian Exposition Commemorative Presentation Medal*," in *The Medal in America*, ed. Alan M. Stahl, vol. 2, Coinage of the Americas Conference, 8–9 Nov. 1997, Proceedings no. 13 (New York: American Numismatic Society, 1999), 136, 146.
8. Ibid., 2:146–48.
9. Homer Saint-Gaudens, ed., *The Reminiscences of Augustus Saint-Gaudens*, 2 vols. (New York, 1913), 2:72, quoted in Tolles, 1999, 2:149.
10. Tolles, 1999, 2:150.
11. Ibid., 2:136.
12. Advertisement, E. B. Estes and Sons, 1890, YUAG Object Files.
13. Steven D. Blankenbeker, "The Paving Brick Industry in Ohio," *Ohio Geology* 3 (1999), 4.

Transportation and Moving West

168

Fletcher and Gardiner (1808–38)
Covered Two-Handled Urn
Philadelphia, 1830

Silver, h. 21, w. body 12¼, w. base 6⅜ in.
(53.3 x 31.1 x 16.2 cm), wt. 144 oz. (4503 gm)
Gift of Joseph B. Brenauer, 1942.245

Objects such as this urn, presented to the president of a canal company, reflect the dramatic changes taking place in the United States during the nineteenth century. A revolution in transportation technology was sweeping over the young nation, and improvements such as canals were opening up new trade routes, to the great benefit of the economy. The 1820s heralded the appearance of a "new American hero . . . the businessman," who by the later decades of the century had eclipsed military and political figures in popularity.[1] According to the inscription, this urn, surmounted by a figure of the sea god Neptune, was presented on 7 June 1830 to James C. Fisher, Esq., by the proprietors of the Chesapeake and Delaware Canal for his "faithful and useful Services as President of the Company."

For generations, individuals with an eye for improvement had recognized the economic advantage of connecting the Delaware River and Chesapeake Bay, two mighty bodies of water separated by only a thin strip of land. Finally, in 1802, the Chesapeake and Delaware Canal Company was incorporated with this goal in mind. Construction began two years later but was abandoned due to financial difficulties. In 1822, the company was reorganized and the project resumed with the help of funds from the federal government, the states of Delaware, Maryland, and Pennsylvania, and private investors. The canal was completed in 1829 for a total cost of over $2.5 million, making it one of the most expensive structures of its kind in that period. The U.S. Army Corps of Engineers purchased the canal in 1919 and brought it down to sea level. Today it remains one of the busiest working canals and is a National Historic Landmark.

The canal company's proprietors certainly knew whom to turn to for a stylish piece of presentation silver. Fletcher and Gardiner specialized in such wares and dominated the industry between 1810 and 1830. The partners successfully tapped into this desire both by importing goods from abroad and by creating silver pieces of their own that reflected current fashions.[2]

K.Y.

Notes

1. David B. Warren, "From the New Republic to the Centennial," in David B. Warren et al., with an introduction by Gerald W. R. Ward, *Marks of Achievement: Four Centuries of American Presentation Silver*, exh. cat. (Houston: Museum of Fine Arts, and New York: Harry N. Abrams, 1987), 75.
2. Donald L. Fennimore, "Elegant Patterns of Uncommon Good Taste: Domestic Silver by Thomas Fletcher and Sidney Gardiner" (master's thesis, University of Delaware, 1971).

168

169

170

Enoch Wood and Sons (active 1820–46)

169

Plate with a View of the Chief Justice Marshall
Stoke-on-Trent, Staffordshire, England, 1825–46

Blue transfer-printed earthenware,
diam. 8½ in. (21.6 cm)
Mabel Brady Garvan Collection, 1930.3131

170

Plate with a View of the Erie Canal, Aqueduct Bridge at Rochester
Stoke-on-Trent, Staffordshire, England, 1825–46

Blue transfer-printed earthenware,
diam. 7½ in. (19.1 cm)
Mabel Brady Garvan Collection, 1934.248

The first steamboat plied the Hudson River in 1807, and within a short time Robert Fulton's invention had revolutionized transportation, particularly in the Mississippi Valley and the South. It was ideally suited to America's extensive system of navigable but shallow rivers. The image for the *Chief Justice Marshall* plate seems to have been taken from an advertisement for a "Grand Canal Celebration" on 4 November 1825 (cat. no. 169).[1] This steamship was part of the Troy Line, which operated between New York City and Albany. Named in honor of John Marshall, arguably America's most famous jurist, the ship was referred to fondly as the "race horse of the North River." In 1832, the Hartford Steamboat Company moved the *Chief Justice Marshall* to the Connecticut River. In 1835, a decade after the ship was built, its career ended in a storm off New Haven. Accuracy was apparently not of the utmost concern to the British potters: Enoch Wood and Sons later used the same image on a plate celebrating the "Union Line," another steamboat company.

The Erie Canal was a great source of pride for Americans: when it was completed in 1825, it was the longest canal in the world. It cost $9 million to construct, a sum that was paid off within twelve years. The Erie Canal was crucial to the economic development of the United States interior because it united the Northeast with the developing region of the Upper Midwest, connecting the Atlantic Ocean to Lake Erie. The image on this plate is based on a drawing by J. Bights, engraved by Rawdon, Clark and Company in Albany and published by C. D. Colden in his 1825 memoir (cat. no. 170). On it are the words "ERIE CANAL / AQUEDUCT BRIDGE / AT ROCHESTER." Spanning the Genesee River is the Aqueduct Bridge, 850 feet long and comprising ten stone arches. The town of Rochester can be seen in the background. Originally settled by the Seneca Indians, the Rochester area experienced dramatic growth and prosperity after the canal was constructed.[2]

British pottery makers capitalized on Americans' pride in their new nation by manufacturing items that celebrated various aspects of life in the United States. Enoch Wood (ca. 1757–1840), often called the father of English pottery, was the first of the Staffordshire manufacturers to develop the market for blue transfer-printed American views. Hundreds of designs depicting American scenes, heroes, buildings, and new forms of transportation found their way onto the surfaces of plates, pitchers, and tea sets at this time. The images were frequently taken from published contemporary prints or sketches made by traveling artists.[3] Wood was also among the first British manufacturers to introduce this new type of ceramic to America, where it became extremely popular. The export market for blue-transfer-print ware reached its zenith between 1825 and 1830.[4] The two plates were produced during this lucrative period for the company, which after 1820 was called Enoch Wood and Sons. They represent two significant moments

that changed the face of American transportation and stimulated the growth of the nation's economy. K.Y.

Notes
1. Randall J. LeBoeuf, Jr., "Staffordshire and Steam," *Antiques* 85 (June 1964), 668.
2. The most complete source for this topic is Ellouise Baker Larsen, *American Historical Views on Staffordshire China* (New York: Doubleday, Doran and Company, Inc., 1939), 29–31.
3. W. L. Little, *Staffordshire Blue: Underglaze Blue Transfer-Printed Earthenware* (New York: Crown Publishers, 1969), 27, 57.
4. George L. Miller, Ann Smart Martin, and Nancy C. Dickinson, "Changing Consumption Patterns: English Ceramics and the American Market from 1770 to 1840," in *Everyday Life in the Early Republic,* ed. Catherine E. Hutchins (Winterthur, Del.: Henry Frances du Pont Winterthur Museum, 1994), 221.

171

Mount Vernon Glass Works (1810–44), renamed **Saratoga Mountain Glass Works** (1844–90)
Pint Flask
Vernon and Mount Vernon, New York, 1830–45

Olive mold-blown nonlead glass, h. 6 13/16 in. (17.3 cm)
Gift of Peter B. Cooper, B.A. 1960, LL.B. 1964, 1996.46.18

In the early decades of the nation, fledgling industries in the United States struggled to produce goods that could compete with European imports. Boosters invoked patriotic sentiment to encourage American consumers to buy domestic products that were often considered inferior in quality and appearance. Nationalism and consumerism were conflated further by objects whose decorative motifs incorporated aspects of American economic, cultural, and social life. Popular themes included achievements in industry, transportation technology, agriculture, and commerce.

Adorned on both sides with the proclamation "Success to the Railroad" and an image of a horse and cart on a rail, this flask celebrates the introduction of the railroad as a new mode of transportation. The first American horse-and-cart railroad was established at Quincy, Massachusetts, in 1826, and in the succeeding years numerous railroad companies were incorporated. Many glass companies produced "Success to the Railroad" flasks, including the Mount Vernon Glass Works, located in central New York, and its successor, the Saratoga Mountain Glass Works.[1] According to newspaper advertisements, they sold their goods wholesale and retail to merchants, traders, and peddlers in the area.[2] The company relocated in 1844–45 because of the depletion of wood supplies in Mount Vernon; its new site was located a few miles from the village of Saratoga because nearby spring-water

171

companies would require a steady supply of bottles.

Incorporated in 1810, the Mount Vernon Glass Works was one of the many American glassworks founded in the early years of the nineteenth century. A series of political events—Jefferson's Embargo Act of 1807, the Nonintercourse Act of 1809, the Napoleonic Wars, and the War of 1812—sharply curtailed foreign imports, raising the hopes of American manufacturers. The end of war with Britain in 1815 may have been good for the nation, but it was disastrous for America's infant industries, most of which went bankrupt in the face of renewed foreign competition. In 1824, the U.S. Congress finally adopted a stronger protective tariff, which offered some relief.[3] By the 1840s, the domestic glass industry was more firmly established, although imports from Bohemia, England, France, and Germany were still popular. To a large extent, the success of the American glassworks depended on the emulation of European styles and the expertise of immigrant glassblowers, cutters, and engravers, who were familiar with Old World techniques. K.Y.

Notes

1. According to Helen McKearin and Kenneth M. Wilson, the mold for this flask was taken to the Saratoga works, but no one knows where it was produced. The design, which first appeared in 1830, remained popular for quite some time. Helen McKearin and Kenneth M. Wilson, *American Bottles & Flasks and Their Ancestry* (New York: Crown Publishers, 1978), 95-98, 493-94.

2. Ibid., 96.

3. For an overview of the domestic glass industry, see Arlene Palmer, *Glass in Early America: Selections from the Henry Francis du Pont Winterthur Museum* (Winterthur, Del.: Henry Francis du Pont Winterthur Museum, 1993).

172

Thomas Doney (b. France, active in America, 1844–49), lithographer
After a painting by George Caleb Bingham (1811–1879)
The Jolly Flat Boat Men, 1847

Hand-colored intaglio, mixed technique (mezzotint, etching, and engraving), 24 ¹³⁄₁₆ x 19 ¹¹⁄₁₆ in. (63 x 75.4 cm)
Mabel Brady Garvan Collection, by exchange, 1946.131

As America expanded westward, prints provided many curious easterners with their first glimpse of the frontier. Among the most successful chroniclers of frontier life was George Caleb Bingham, a painter from Missouri known for his quotidian scenes of the Missouri and Mississippi Rivers. His work was widely disseminated through the American Art-Union (cat. nos. 121–23). Founded in 1839 "for the promotion of the fine arts in the United States," the American Art-Union was supported by subscribers nationwide, whose five-dollar annual fee went, in part, "*to the production of a large and costly Original Engraving* from an American painting." In 1847, members were furnished with an engraving of *The Jolly Flat Boat Men*, by Thomas Doney, after the original canvas by Bingham.[1] Before producing the large engraving, Doney made a small etching of the work, which was included in the *Transactions* of the American Art-Union for 1846 and mailed to its subscribers.

Bingham's composition met with mixed reviews. A critic for the *Literary World* complained, "We regret . . . the Committee did not select some other subject for engraving than the 'Jolly Flat Boatman' [*sic*]—the very name of which gives a death blow to all one's preconceived notions of 'HIGH ART.' The picture is tolerably well in its way; but it is by no means what a student in art would

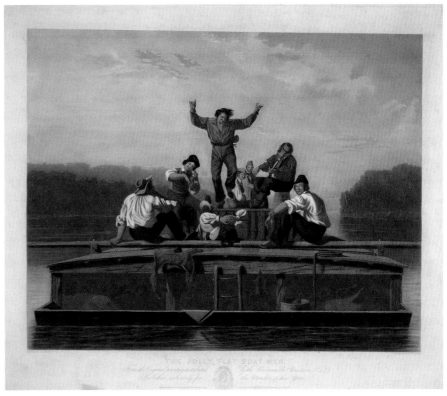

172

select as a standard of taste, and it contains no redeeming sentiment of patriotism. Nevertheless, it will please a portion of the subscribers, whose tastes are yet to be formed."[2] These comments point to an important shift in American artistic sensibilities occurring at the time.

Until the 1840s, history painting, portraiture, and landscapes accounted for the bulk of art produced in this country. At mid-century, however, artists began to eschew loftier subjects and looked increasingly to daily life for their subject matter. As the public developed a taste for these genre paintings, popular demand increased. Although in this example Bingham depicted contemporary life on the river, he nevertheless drew on established artistic convention, modeling the central dancer's pose on the figure of Christ in Raphael's *Transfiguration* (1517–20)

and employing the dominant pyramidal composition found in Renaissance religious imagery.[3] One critic rebuked Bingham for doing so, noting that "Mr. B should be aware that the regularity of the pyramid is only suitable to the scenes of the utmost beauty and repose."[4] By employing this structure, however, Bingham elevated the ordinary to the extraordinary, providing his *Jolly Flat Boat Men* with a stagelike setting. The direct outward gaze of the seated figure on the right eliminates any doubt that the composition aims to engage the viewer as the audience for the spirited dance. This immediacy, coupled with the novelty of the scene, accounts for the picture's tremendous popular success: 9,666 engravings were distributed to Union members in 1847, and an additional 8,000 were struck from the original plate in 1860.[5] Although the engraving was

issued in black, the present example was subsequently colored by hand, a popular pastime during the nineteenth century, especially for young women. The palette used is completely unique, suggesting that whoever colored the engraving never saw Bingham's original painting.

G.C.B.

Notes

1. American Art-Union, *Plan of the Institution, List of Its Officers, and Catalogue of Its Paintings* 5 (1 May 1847), 3, 4. Bingham's canvas is now in the Manoogian Collection.

2. Anonymous, *Literary World* 1 (3 Apr. 1847), 209.

3. Raphael's *Transfiguration* is in the Vatican Pinacoteca. Françoise Forster-Hahn, "Inventing the Myth of the American Frontier," in *American Icons: Transatlantic Perspectives on Eighteenth- and Nineteenth-Century American Art,* ed. Thomas W. Gaehtgens and Heinz Ickstadt (Santa Monica, Calif.: Getty Center for the History of Art and Humanities, 1992), 132–33.

4. Anonymous, *Literary World* 2 (23 Oct. 1847), 277.

5. Joseph L. Tucker, "A Collector's View of the Prints of George Caleb Bingham," *Imprint* 14 (fall 1989), 4.

LIFE ON THE PRAIRIE.

The Trapper's defence "Fire fight Fire"

173

173

Unknown lithographer
Published by **Currier & Ives**
(active 1857–1907)
After a painting by Arthur Fitzwilliam
Tait (b. England, 1819–1905)
*Life on the Prairie: The Trappers Defence,
"Fire Fight Fire,"* 1862

Hand-colored lithograph, 24 x 31 in.
(61 x 78.7 cm)
Mabel Brady Garvan Collection, 1946.9.1268

The English-born American painter Arthur
Fitzwilliam Tait produced more than seven-
teen hundred works in his nearly seventy-
year career. Tait was perhaps best known for
his Adirondack hunting and fishing sub-
jects, as well as scenes of western and frontier
life, even though they constituted only a
small portion of his output. This renown was
thanks to the medium of lithography: begin-
ning in 1852, Currier & Ives published prints
of about three dozen of Tait's works, making
his art available to a mass audience.

Among Tait's paintings of the American
West is *Life on the Prairie: The Trappers Defence,
"Fire Fight Fire"* of 1861, which was published
as a lithograph by Currier & Ives the follow-
ing year.[1] This highly dramatic scene depicts
a group of frontiersmen in the midst of a
tremendous grass fire. As the sky blackens
and the blaze looms ever closer, buffalo stam-
pede to escape its path. One trapper strug-
gles to subdue the spooked horses, while his
compatriots try to safeguard themselves by
lighting a backfire. "Fire Fight Fire" was a
known and trusted strategy among frontiers-
men: by intentionally burning a surround-
ing ring of grass, they starved the fire of its
fuel supply, thereby saving themselves and
their animals.

Though the composition is dramatic, it is
Tait's attention to detail that lends the work
a high degree of authenticity. This is surpris-
ing in an artist who never traveled to the

frontier: Tait's knowledge of the West was
strictly secondhand, gleaned principally by
studying portfolios of prints by Karl Bodmer
and George Catlin at New York's Astor
Library.[2] Tait's choice of subject matter may
also have been influenced by contemporary
accounts of frontier life, many of which
described prairie fires. One of the most pop-
ular and detailed renditions was by Frederick
Law Olmsted, the famed landscape archi-
tect. His *A Journey through Texas* of 1857
includes an episode entitled "A Fight With a
Prairie Fire," in which Olmsted described a
tiring battle with a blaze that was ultimately
quelled by lighting a backfire. For Olmsted,
the awesome force of the prairie fire had a
transformative power, one that could turn
even a mild-mannered gentleman into a sav-
age: "There is something peculiarly exciting
in combating with a fierce fire. It calls out
the energies and strength of a man like actual
war." He continued, "We amused ourselves
with each other's appearance, our faces, red

with heat, being painted in a very bizarre
fashion, like Indian warriors."[3] Tait's fron-
tiersmen also blur the racial line between
white and red, engaging in "Indian" activities
and donning native garb. In a companion
print, *The Buffalo Hunt* (fig. a), the men are
shown hunting buffalo, and buffalo kill is
also evident in the foreground of the prairie-
fire scene. The kneeling trapper wears buck-
skin, and the muttonchop of his beard is
obscured so it resembles a braid. With his
reddened face turned to the smoke of the
backfire, it is difficult to tell if the figure is
Indian or Caucasian. G.C.B.

Notes
1. The original painting, *Prairie on Fire*, is in the
collection of Mr. Frederick P. Caffrey. *A. F. Tait:
Artist in the Adirondacks*, exh. cat. (Blue Mountain
Lake, N.Y.: Adirondack Museum, 1974), 39, pl. 19.
2. Warder H. Cadbury, *Arthur Fitzwilliam Tait:
Artist in the Adirondacks* (Newark: University of
Delaware Press, 1986), 31.
3. Frederick Law Olmsted, *A Journey through Texas,
or, a Saddle-trip in the South-Western Border*
(New York: Dix, Edwards & Co., and London:
S. Low Son & Co., 1857), 220.

LIFE ON THE PRAIRIE.
The Buffalo Hunt.

fig. a Unknown lithographer, published by
Currier & Ives, after a painting by Arthur
Fitzwilliam Tait, *Life on the Prairie: The Buffalo
Hunt*, 1862. Hand-colored lithograph,
23 3/8 x 24 5/16 in. (59.3 x 61.8 cm). Yale University
Art Gallery, Mabel Brady Garvan Collection,
1946.9.1267

174

Albert Bierstadt (b. Germany, 1830–1902)
The Trappers' Camp, 1861

Oil on academy board, 13 x 19 in. (33 x 48.3 cm)
Whitney Collections of Sporting Art Fund, given in memory of Harry Payne Whitney, B.A. 1894, and Payne Whitney, B.A. 1898, by Frances P. Garvan, B.A. 1897, M.A. (HON.) 1922, 1969.48

As the United States approached the Civil War, Albert Bierstadt came to national prominence with his imposing paintings of the American West, presenting an idyllic land of promise and abundance to an anxious and ambitious eastern audience. Bierstadt made his first trip west in 1859, accompanying Frederick William Lander's expedition to South Pass, Montana. There he drew sketches that he would later use to produce large finished canvases in his New York studio. Rather than re-creating western vistas with topographical verisimilitude, Bierstadt combined various motifs from his studies to generate imaginary landscapes. His meticulous brushwork and copious details nonetheless made these scenes entirely believable. In *The Trappers' Camp*, an uncharacteristically small work, the artist presented a romantic, moonlit landscape in which the dark, mysterious wilderness is tempered by a sense of cozy companionship on the range.

Under a shelter of overhanging rocks, two trappers relax around a radiant campfire, while a third member of their party stands with a horse in the adjacent field. Bierstadt skillfully portrayed two sources of light—the trappers' blazing campfire and the cool moonlight—symbolically contrasting the progress of civilization with the untamed wilderness, a common theme in depictions of the American West at the time. Yet these two extremes of western experience found a mediating presence in the fur trappers' regular trade with the Indians. Nestled within their cavelike dwelling, Bierstadt's trappers appear more like primordial savages than agents of west-moving civilization. Washington Irving, in one of his popular accounts of western trappers, wrote, "It is a matter of vanity and ambition with them to discard everything that may bear the stamp of civilized life, and to adopt the manners, habits, dress, gesture, and even walk of the Indian."[1] Surrounded by the all-encompassing reddish glow of the fire, these rugged men seem to take on the stereotypical skin color of their alter egos.

Painted more than a decade after the collapse of the fur trade, which occurred as the fashion for beaver pelts faded and beavers themselves became increasingly scarce, Bierstadt's subjects share more than just a visual resemblance with the similarly declining ranks of American Indians. In the relentless charge to settle the West, civilization gradually overtook the independent existence exemplified by the trappers' life, leaving a trail of small cities modeled on their eastern predecessors. In its nocturnal melancholy and bifurcated composition, *The Trappers' Camp* suggests the waning fortunes of the mythic mountain men who first ventured into the American West, as well as the intimate relationship between western expansion and the driving force of eastern industry.[2] R.S.

Notes
1. Washington Irving, *Adventures of Captain Bonneville, U.S.A., in the Rocky Mountains and the Far West* (New York: G. P. Putnam, 1850), 85.
2. For a discussion of the intimate relationship between western expansion and eastern industrialization, see Richard Slotkin, *The Fatal Environment: The Myth of the Frontier in the Age of Industrialization, 1800–1890* (New York: Atheneum, 1985).

174

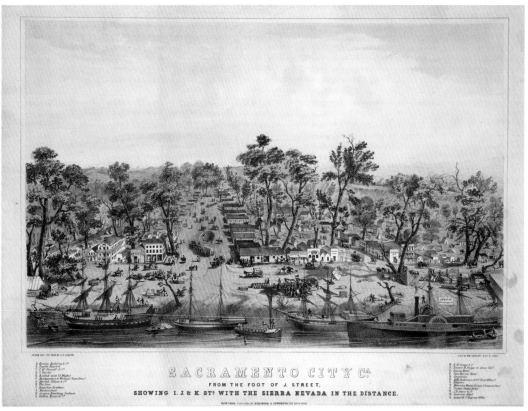

SACRAMENTO CITY Cᵃ.

FROM THE FOOT OF J. STREET,

SHOWING I. J. & K. Sᵗˢ WITH THE SIERRA NEVADA IN THE DISTANCE.

175

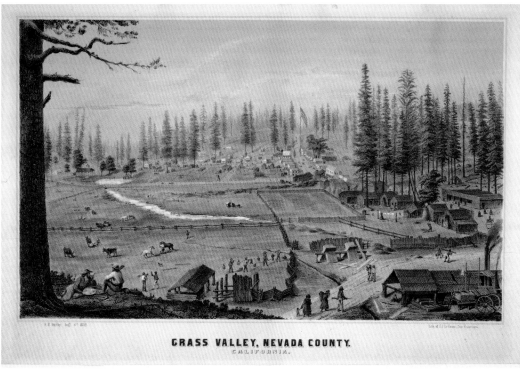

GRASS VALLEY, NEVADA COUNTY.

CALIFORNIA.

176

175

Unknown lithographer
Published by **William Endicott & Co.**
(active 1849–52)
After George V. Cooper (1810–1878)
Sacramento City, C.ª From the Foot of
J. Street, showing I. J. & K. St.ˢ with the
Sierra Nevada in the Distance, ca. 1849

Tinted lithograph with additional hand-
coloring, 18¾ x 25¼ in. (47.6 x 64.1 cm)
Mabel Brady Garvan Collection, 1946.9.1927

176

Josiah J. Le Count (1827–1878),
lithographer
After Robert E. Ogilby (b. England,
1825–1884)
Grass Valley, Nevada County. California,
1852

Tinted lithograph with additional hand-coloring,
18¼ x 27⅜ in. (46.4 x 69.5 cm)
Mabel Brady Garvan Collection, 1946.9.1893

In the summer of 1839, Captain John Sutter, an ambitious Swiss immigrant, established a fort at the confluence of the Sacramento and American Rivers. Sutter cut a two-mile road from his fort through the forest to the banks of the Sacramento, where he established a wharf—the Embarcadero—to bring supplies from San Francisco. Sutter's Fort soon became the center of activity in the valley, housing coopers, blacksmiths, saddlers, granaries, and even a distillery.[1] In late 1847, Sutter sent James Marshall into the Sierra foothills to erect a sawmill. Sometime in January 1848, while building Sutter's Mill, Marshall discovered gold in the waters of the American River. News of the find soon reached San Francisco, and "gold fever" quickly spread from California throughout much of the world.

The gold rush proved disastrous for Sutter. Workers abandoned the fort to prospect in the hills, and teeming hordes of min-ers squatted on Sutter's land, trampled his crops, and slaughtered his cattle, killing sixty thousand dollars' worth in a single day. Yet the Embarcadero boomed, overtaking the fort in commercial and social significance, and by 1849, the riverside settlement became known as Sacramento City.[2] This lithograph of Sacramento City (cat. no. 175), based on an 1849 view by George V. Cooper, depicts a town in the midst of a population boom: in April, Sacramento had a population of 150; by December, it was up to 3,500.[3] Among the numerous businesses depicted is the Eagle Theater, California's first theater, which opened on 18 October 1849. Connected to the Eagle, the Round Tent, a gambling emporium, "offered such diversions as music, a handsomely decorated bar, and a picture gallery of girls in the half-together and the altogether."[4] Docked along the Embarcadero is the steamer *Senator*, which became the first ship to make the round trip between Sacramento and San Francisco in a single day.[5]

In the fall of 1849, as Sacramento was booming, a cluster of crude cabins cropped up sixty miles to the northeast, on the banks of Wolf Creek. The small settlement was the beginning of Grass Valley, which would quickly become one of California's richest mining towns. The spring of 1850 brought more gold seekers to Grass Valley, and a store and hotel sprang up, as well as a mill to provide lumber for housing.[6] Sometime in the fall of 1850, a rich vein of gold quartz was found on a hill above Wolf Creek. Shortly thereafter, another vein was found on Ophir Hill. Unlike placer gold, which washed from stream gravel, quartz gold required elaborate extraction methods and therefore held the promise of steady employment. By 1851, Grass Valley had grown by nearly tenfold, boasting four thousand residents.[7] The quartz veins proved extremely rich: by 1852, Gold Hill alone had yielded four million dollars.[8]

On 6 August 1852, Robert E. Ogilby, an English-born artist and topographer, made a drawing of Grass Valley just as its tremendous prosperity had transformed it from a placer camp into an orderly town. Reproduced as a hand-colored lithograph in San Francisco by Josiah J. Le Count, the view shows a bustling community (cat. no. 176). Beneath the American flag in the distance is Mill Street—Grass Valley's main street—which is lined with whitewashed buildings with uniform wooden awnings. In the foreground, a sawmill belches smoke as it mills timber cut from the surrounding hills.

Although Ogilby rendered the buildings of Grass Valley with care, its inhabitants seem to be his real subject. In the left foreground, two prospectors take a break from their digging, and down the hill a group of Native Americans walks into town. Identifiable by their dress and characteristic conical basket, they are probably Nisenan, a branch of the Maidu Nation that inhabited the Sacramento Valley and Sierra Nevada. Behind the Nisenan, a group of Chinese peddlers carries their wares suspended from yokes. While the scene shows Grass Valley's diversity, it reveals nothing of the racial discord that prevailed in the town.

In May 1850, in revenge for white settlers' transgressions, a tribal party attacked two sawmills near Grass Valley, killing a white man. Whites retaliated with a series of attacks on Nisenan villages before making peace late in the year. One contemporary author described the Nisenan, generally regarded as inferior by white settlers, as "mere animals although mostly of good physical development."[9] Nisenan camps eventually became spectacles for white curiosity-seekers. By 1855, one quarter of the Nisenan were confined to a reservation.

Equally derided by white settlers were the Chinese. By 1852, two thousand Chinese immigrants were living in Nevada County. While some whites praised the Chinese, describing them, for example, as "the most sober, honest and industrious people in this country," many more viewed the Chinese with suspicion and distrust because of their alien language, religious practices, and "clannishness."[10] Although the Chinese were always prohibited from working in quartz mines (they usually worked placer claims that whites had abandoned), whites were still fearful of Chinese taking over "American" land and jobs. This sinophobia led to the imposition of the Foreign Miner's Tax in 1852, a large monthly tax that technically applied to all foreign-born miners but in reality was enforced only against Chinese and Mexicans. Racial and ethnic violence in Grass Valley and other California mining towns seems to have been commonplace. As *Graham's American Monthly* observed in February 1855: "News from California is, as usual, favorable. The mining in all parts of the state was carried on successfully. . . . Crimes and accidents were in the customary number and variety—Mexicans, Chinese, Frenchmen, Irish, Anglo-Saxons, killing one another with a murderous vivacity."[11] G.C.B.

Notes

1. Thor Severson, *Sacramento, An Illustrated History: 1839 to 1874, from Sutter's Fort to Capital City* (San Francisco: California Historical Society, 1973), 29–36.
2. Incorporated by the first California legislature on 27 Feb. 1850, the word "City" was dropped at the next legislature (ibid., 42, 66–67, 96).
3. Ibid., 53, 90.
4. Ibid., 55.
5. Ibid., 166.
6. In 1850, Grass Valley had 454 residents. Ralph Mann, *After the Gold Rush: Society in Grass Valley and Nevada City, California, 1849–1870* (Stanford, Calif.: Stanford University Press, 1982), 13–15.
7. Severson, 1973, 61.
8. Mann, 1982, 26.
9. Ibid., 51.
10. Ibid., 53.
11. "Monthly Summary," *Graham's American Monthly Magazine of Literature, Art and Fashion* 46 (Feb. 1855), 185.

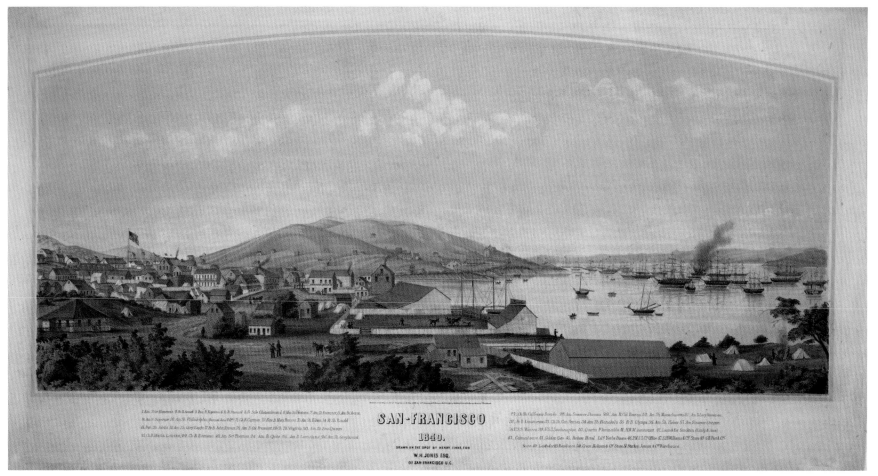

177

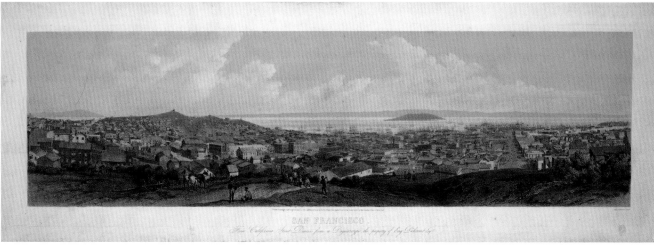

178

177

Arvah J. Ibbotson (active ca. 1849–ca. 1862), lithographer
After a drawing by Henry Firks (active ca. 1849)
Printed by **Thomas S. Sinclair**, Philadelphia (ca. 1805–1881), for William Henry Jones, San Francisco (b. ca. 1808)
San-Francisco, 1849

Tinted lithograph, first state, 18 ½ x 34 ⅝ in. (47 x 88 cm)
Mabel Brady Garvan Collection, 1946.9.1931

178

Unknown lithographer, drawn from a daguerreotype
Printed in France by **Rose-Joseph Lemercier** (1803–1887)
Published by **M. Knoedler & Co.** (founded 1846)
San Francisco, From California Street, 1855

Hand-colored lithograph, second state, 12 ¹⁵⁄₁₆ x 36 ¹¹⁄₁₆ in. (32.8 x 93.2 cm)
Mabel Brady Garvan Collection, 1946.9.1929

This view from 1849 (cat. no. 177) is quite possibly the earliest printed depiction of the developing city of San Francisco.[1] Executed just six years later, the lithograph (cat. no. 178) shows how San Francisco had grown from harbor town to small city, the "golden gateway" to the Far East. Well situated geographically and economically, and well endowed with a rich variety of natural resources, San Francisco was, even in 1849—twenty years before the completion of the transcontinental railway—America's principal western port of call.

San-Francisco (1849) pictures a fledgling harbor settlement transitioning from its makeshift beginnings (indicated by the canvas tents in the right foreground) to a signifi-cant seaport (indicated by a number of low commercial structures, such as S. H. Williams & Co., lining the shore). Residential buildings, including Parkers Hotel, crop up farther inland. Dominating the right half of Firks's composition is the Pacific Ocean entrance to the harbor, even then known as the Golden Gate.[2] A full forty-two of the fifty-one references keyed beneath this print name the schooners, freighters, and launches that crowd the harbor, emphasizing the important role that international shipping traffic played in the development of the city. Even during these early years, the bay rarely held fewer than four or five hundred boats at a time—from America as well as from Austria, Britain, Chile, France, Germany, and Holland.[3] This fact was duly noted by Bayard Taylor during his travels to California in 1849: "At last we are through the Golden Gate—fit name for such a magnificent portal to the commerce of the Pacific! Yerba Buena Island is in front [visible at the far right margin of this print]; southward and westward opens the renowned harbor, crowded with the shipping of the world, mast behind mast and vessel behind vessel, the flags of all nations fluttering in the breeze!"[4] Once on land, Taylor would discover a city with an international flavor, with "buildings of all kinds, begun or half-finished . . . and covered with all kinds of signs, in all languages." He also noted an eclectic citizenry, "as diverse and bizarre . . . as the houses: Yankees of every possible variety, native Californians in *sarapes* and sombreros, Chilians, Sonorians, Kanakas from Hawaii, Chinese with long tails, Malays armed with their everlasting creeses [daggers], and others in whose embrowned and bearded visages it was impossible to recognize any especial nationality."[5]

By 1855, San Francisco had grown signifi-cantly—from a population of twenty thou-sand in 1849–50 to almost fifty thousand in 1855.[6] The wider perspective of the litho-graph, looking down California Street to the bay, pictures the extent of the city's growth, with streets laid out in an organized grid. In the rustic foreground are various figures, such as a woman in Dutch dress, gold miners of European descent, and a group of Chinese men, strolling and conversing. Thus the focus of the later print is not mainly on the ships that crowd the harbor or on individual city landmarks (there is no key below the image); rather, this view, taken from a daguerreotype, emphasizes the city's picturesque qualities.

In the years that intervened between these two views, the city had suffered a marked economic decline, precipitated by the over-supply of gold, which had flooded the mar-ket. Of the one thousand commercial build-ings available in 1854, only three hundred were listed as occupied—and rents dropped accordingly by 20 to 30 percent. This grow-ing strain led to the "Black Friday" of 23 Feb-ruary 1855, when the banking firm of Adams & Co. failed to open its doors and panic spread, bringing about the downfall of about two hundred banks and businesses and wip-ing out many personal fortunes.[7] Despite this setback, San Francisco would remain California's center of commerce, finance, and shipping. Other industries, especially agri-culture, gradually supplanted mining, as flour mills, wagon shops, blacksmith shops, saddle shops, bakeries, soda works, confectioneries, fruit-processing industries, and the like sprang up throughout the city.[8] This print, executed in 1855 after Black Friday, attests to the fortitude and resilience of the rapidly growing metropolis of San Francisco. E.H.

Notes
1. John W. Reps, *Cities on Stone: Nineteenth Century Lithograph Images of the Urban West*, exh. cat. (Fort Worth: Amon Carter Museum, 1976), 10.
2. Gloria Gilda Deák, *Picturing America 1497–1899*, 2 vols. (Princeton: Princeton University Press, 1988), 1:395.
3. Marshall B. Davidson, *New York: A Pictorial History* (New York: Charles Scribner's Sons, 1977), 249.
4. Bayard Taylor, *Eldorado, or, Adventures in the Path of Empire*, 2 vols. (New York: George P. Putnam, 1850), 1:52–53.
5. Ibid., 55.
6. Mel Scott, *The San Francisco Bay Area: A Metropolis in Perspective* (Berkeley, Los Angeles, and London: University of California Press, 1985), 31.
7. Ibid., 36–37.
8. Ibid., 39–41.

179

Reverse

179

Moffat & Company (1849–53)
George Albert Ferdinand Küner
(b. Germany, 1819–1906),
possible engraver
Teaspoon
San Francisco, 1849

Gold, l. 6 in. (15.2 cm), wt. 1 oz., 1 dwt. (33 gm)
Gift of Walter M. Jeffords, B.A. 1905, 1949.242

Although several coining companies sprang up in San Francisco after gold was discovered at Sutter's Mill in the winter of 1848, Moffat & Company was one of the few firms deemed reputable and the only one of the initial crop to survive the first year of business. The company was founded by John Little Moffat, who left New York on the bark *Guilford* on 15 February 1849, landing in San Francisco five months later. Moffat came neither as a prospector nor a goldsmith, as the maker's mark on this spoon might suggest, but as a metallurgist and assayer.[1] Moffat's intention was to establish a sort of mint for producing coins and ingots from gold dust that the firm smelted and assayed.[2] He and his "proper assistants" came prepared with letters of introduction, testimonials, and a cargo of machinery to perform the work.

Judging by the engraved inscriptions on its handle, this gold teaspoon appears to be a special issue. The reverse declares proudly, "Made of native gold / by Moffat & C°. / Sanfrancisco. Cal². 1849," suggesting a souvenir; the tender words on the obverse, "SHW to his Mother," attest to its rarity. The engravings may be the handiwork of George Albert Ferdinand Küner, who arrived in San Francisco in July 1849 from Bavaria via New York City and was immediately engaged to cut the dies for Moffat's first ten-dollar gold coin with a design mimicking the United States Mint's ten-dollar piece.[3] The monogram belongs to Samuel H. Ward, a young partner in Moffat & Company, who worked for Moffat in New York City sometime after 1839, when he graduated from Wesleyan University, and before 1849, when he sailed for California. He sent this spoon with its delicate later-neoclassical styling, fiddle-shaped handle, and pointed bowl to his mother, who probably still lived in East Hartford, Connecticut, when she received the gift.[4]

In September 1850, Moffat & Company's good standing won the firm an enviable contract with the U.S. Department of the Treasury to set up an assay office, effectively ending private coinage. The quasi-official mint, run by Joseph R. Curtis, Philo P. Perry, and Ward (after Moffat's retirement), was subsumed by the first United States Branch Mint of San Francisco. Sadly, Ward died before this last achievement was realized. On 21 April 1853, only months before Curtis and Perry sold the machinery to the new mint, Ward perished en route to Honolulu onboard the brig *Zoe*. The cause of death was given as "consumption, a predisposition to pulmonary complaint," otherwise known as tuberculosis, hastened by "exposure to the noxious vapors of the assaying room." Ward was remembered in the *Daily Alta California* for being "scrupulously honest in matters of business, affable and kind in demeanor" and for his "intellect and social worth."[5] C.M.H.

Notes

1. Impressed mark "MOFFAT & Co." For the most complete history of Moffat & Company, see Edgar Holmes Adams, *Private Gold Coinage of California, 1849–55: Its History and Its Issues* (Brooklyn, N.Y.: E. H. Adams, 1913), 13–56.
2. Excerpted from the *New York Tribune* in Adams, 1913, 90.
3. A biography of Küner appears in Adams, 1913, 93–97.
4. Although the full provenance is unknown, the spoon has a history of ownership in Connecticut.
5. *Daily Alta California* 7:111 (21 Apr. 1853), 2.

180

Tiffany & Co. (founded 1837)
Napkin Clips
New York City, 1879

Sterling silver, gilding, and enamel, 2½ x 3⁷⁄₁₆ in.
(6.3 x 8.7 cm), wt. 30.2 dwt. (47 gm)
Gift of Mrs. John Hill Morgan and Mrs. Joseph
Hersey, by exchange, and Mr. and Mrs.
Philip Holzer, 1991.51.1.1–.2

The history of these napkin clips demonstrates how the vast natural resources of the West catapulted some Americans to extraordinary wealth and social prominence. In 1873, John W. Mackay discovered the largest silver vein in the United States—the Comstock Lode—in Virginia City, Nevada. When Mackay's wife, Marie Louise Hungerford, saw the silver in the mine in 1874, she asked her husband for some of the ore to make a silver service. The Mackays commissioned Tiffany & Co. to make 1,250 pieces, and, in 1876, sent half a ton of silver to the Tiffany plant on Prince Street in New York City. Even with more than two hundred craftsmen working on it, the company took two years to complete the service, finishing just in time for it to be exhibited in the American Pavilion of the Paris Exposition Universelle of 1878.

In the following two years, the Mackays ordered two sets of twelve butterfly-shaped napkin clips, the first set in 1879 and the second on 8 October 1880. The clips, made of gilt sterling silver, each with a unique enameled design on the front and back of its wings, most likely were used to embellish the folded napkins of a set table.[1] A drawing for the enameling on the clips survives (fig. a), but the identity of the designer is unknown. Three of Tiffany's designers were responsible for the service: Charles T. Grosjean designed the service's hollow ware; the company's design director, Edward C. Moore, oversaw the fashioning of the entire set and also designed the flatware; and James H. Whitehouse created the heraldic arms seen on all pieces of the set. Despite their small size, the two dozen clips, using 38.2 troy ounces of silver and costing $2,527.40, were an expensive afterthought and, like the rest of the service, were meant to showcase the family's new wealth.

After their windfall, Mrs. Mackay moved to New York City, where, as the wife of a once-poor Irish immigrant, she was snubbed by New York society. She soon moved to Paris, where the family's extreme wealth, combined with her social ambition and knowledge of French language and culture (from her French grandmother), secured her ascent to the top of the social ladder. The banquets and parties she hosted, presumably using the Tiffany service, were talked of for years and placed her among the international social elite.[2]

K.W.

Notes
1. The first dozen clips are marked "TIFFANY & Co./ STERLING" on one wing and "5627/M/1125" on the other, inside the body cavity. The design's pattern number is 5627, while 1125 is the order number. It is the same order number as the centerpiece commissioned in 1879, which gives these clips a secure commission date. The second dozen clips were in order number 6557. Each clip is further identified three times—once on each wing and once on the body itself—with a number for assembly purposes indicating to which butterfly of the batch that part belonged. Yale's butterflies are marked "11" (inv. no. 1991.51.1.2) and "12" (inv. no. 1991.51.1.1). The numbers on the watercolor designs for the enameling of the wings are different. Only watercolor "X," the design for Yale's butterfly "12," is extant. Both the watercolor designs and the pattern ledgers are in the Tiffany & Co. Archives in Parsippany, N.J.
2. Charles H. Carpenter, Jr., and Janet Zapata, *The Silver of Tiffany & Co., 1850–1987*, exh. cat. (Boston: Museum of Fine Arts, 1987), 14.

180

fig. a *Enamel Design Sketch for Butterfly Napkin Clip 12* (Yale University Art Gallery, 1991.51.1.1), 1879. Pencil and watercolor on paper, 2⁷⁄₁₆ x 1½ in. (6.2 x 3.8 cm)

181

Karl L. H. Mueller (b. Germany, 1820–1887), modeler
Union Porcelain Works (1863–ca. 1922), manufacturer
Heathen Chinee Pitcher
Greenpoint, Brooklyn, New York, 1875–85

Porcelain painted over the glaze and gilded, h. 9⅝, diam. 5¾ in. (24.4 x 14.6 cm)
Bequest of Doris M. Brixey, by exchange, 1999.77.1

With a fierce walrus for a spout and a polar bear forming the handle, this pitcher celebrates the United States' expansion into the Pacific Northwest while playfully suggesting the object's function as a bar pitcher. Also telling of the push westward are the scenes depicted in unglazed relief on a pale-green

ground, in the manner of Wedgwood jasper, on either side of the main body under painted neo-Grec borders. On one side is the image of King Gambrinus, the mythical Flemish inventor of beer, handing a glass to Brother Jonathan, the American "everyman" (cat. no. 57).

In contrast, the opposite side illustrates the growing ethnic tensions in the West.[1] The scene depicts the climactic moment from a popular poem by Bret Harte in which a card game between a frontiersman, Bill Nye, and a Chinese immigrant, Ah Sin, goes awry:

> Then I looked up at Nye,
> And he gazed upon me;
> And he roze with a sigh,
> And said, "Can this be?"
> "We are ruined by Chinese cheap labor,"—
> And he went for that heathen Chinee.

In the scene that ensued
 I did not take a hand,
But the floor it was strewed
 Like the leaves on the strand
With the cards that Ah Sin had
 been hiding
In the game "he did not understand."[2]

Chinese men arrived in large numbers during the late 1800s to work in the mines, construct railroads, and do other jobs on the developing frontier. With foreign customs, dress, and language, they became a focal point for the racial prejudices of many Americans, particularly Irish day laborers in San Francisco with whom they competed for jobs. Rather than vilify the Chinese immigrant, Harte parodied his plight. The verse shows that Ah Sin sought to outwit his opponent, who had been cheating only moments before.[3]

The poem captivated easterners hungry for news of the West, making Harte an overnight sensation. Widely distributed under the title "The Heathen Chinee," illustrated versions appeared, and the same episode was selected for the cover of sheet music for a popular song.[4] Like Gambrinus, Ah Sin and Nye's brawl would have been instantly familiar to most Americans of its day. Karl Mueller, chief modeler at Thomas C. Smith's Union Porcelain Works, adapted his view from one of many published versions available.

Hired to create special pieces to show off Smith's exceptional porcelain at the Centennial Exhibition held in Philadelphia, the German-born sculptor reveled in the disparate images of his adopted homeland. Buffalo, butterflies, farmers, factory workers, frontiersmen, Washington, and Liberty all figure in Mueller's designs. Inventing American-themed decoration was an important step in the development of an industry predisposed to copying successful imported designs. The *Heathen Chinee* pitcher became one of the Union Porcelain Work's most popular items.[5]

C.M.H.

Notes

1. Ellen Paul Denker, *After the Chinese Taste: China's Influence in America, 1730–1930*, exh. cat. (Salem, Mass.: Peabody Museum of Salem, 1985), 38–49.
2. *The Old Fashioned Couple and the Heathen Chinee* (Chicago: published for the Rock Island and Pacific Railroad by J. J. Spaulding & Company, printers, 1873). Harte's poem first appeared under the title "Plain Language from Truthful James" in the *Overland Monthly Magazine* in Sept. 1870.
3. Gary Scharnhorst, *Bret Harte: Opening the American Literary West* (Norman: University of Oklahoma Press, 2000), 51–57.
4. "The Heathen Chinee," words by Bret Hart, music by Francis Boott (Boston: Oliver Ditson & Co., 1870).
5. J. G. Stradling, "American Ceramics and the Philadelphia Centennial," *Antiques* 110 (July 1976), 146–58; Alice Cooney Frelinghuysen, *American Porcelain, 1770–1920*, exh. cat. (New York: Metropolitan Museum of Art, 1989), 37–43, 174–93.

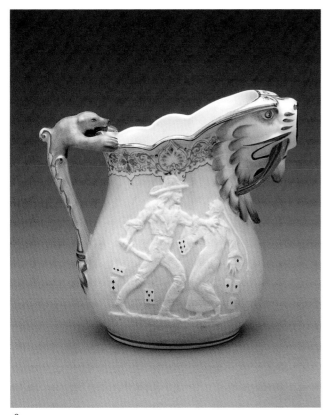

181

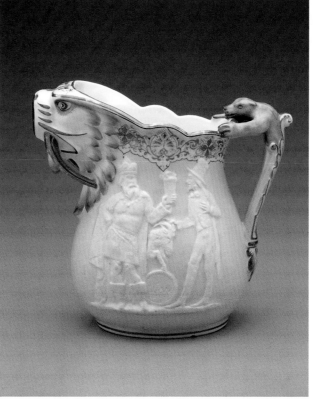

Reverse

182

Arnold Genthe (b. Germany, 1869–1942)
The Morning Market, ca. 1895–1900

Vintage gelatin silver print, 7 x 11 in.
(17.8 x 27.9 cm)
Emerson Tuttle, B.A. 1914, M.A. (HON.) 1946,
Fund, 2004.53.1

In China during the middle and late nineteenth century, a series of droughts, floods, and periods of famine—compounded by the ineffective rule of the last of the Manchu emperors—spurred many Chinese citizens to look outside their country for economic opportunity and social stability.[1] News of a gold strike in California brought the first wave of Chinese immigrants to this country, followed by successive generations who came to work on the transcontinental railroad or to seek employment as cooks, merchants, ranch hands, gardeners, and journalists.

As the principal port of entry for Asians from the 1850s onward, San Francisco's Chinatown (known to the Chinese as *Tangrenbu*, "port of the people of Tang") quickly became the national hub of Chinese American economic, political, and cultural activity.[2] In the early 1850s, Chinatown clustered around Portsmouth Square, but by the 1890s, it had expanded over a ten-block grid—north-south from Broadway to Sacramento Street, and east-west from Kearny to Stockton—and was home to several thousand Bay-area Chinese. From the beginning, Chinese encountered harsh xenophobia and were segregated geographically, psychologically, and even economically and politically because of race.[3]

When Arnold Genthe arrived in San Francisco from Hamburg in 1895, he was captivated by the sights and smells of Chinatown and was inspired to take up photography as an amateur. Unlike his predecessor Isaiah West Taber, who had photographed

182

the area from the 1870s through the early 1880s, Genthe did not seek to pose his subjects but rather tried to catch them unawares, as suggested by the slightly blurred central figure in this image, who looks fleetingly toward the camera. Many considered Genthe one of the first "street photographers."[4]

Pictured here is Kong Wo, a pawnbroker whose business at 639 Jackson Street (the middle structure, sandwiched between two grocers) was strategically located near Chinatown's major concentration of gambling rooms. Whether Genthe was aware of it or not, his image-taking followed a common pattern of objectification of Chinese American culture.[5] Not only did Genthe photograph his Chinese subjects without their permission, but he often focused on "exotic" qualities such as their dress or braid of hair hanging down the back. He even cropped or retouched many of his negatives in order to remove non-Asian pedestrians or signs. E.H.

Notes

1. Thomas W. Chinn, *Bridging the Pacific: San Francisco Chinatown and Its People* (San Francisco: Chinese Historical Society of America, 1989), 1, 65.
2. Ibid., 3.
3. In the 1870s, the city of San Francisco began to enact a series of unconstitutional laws aimed at restricting Chinese competition in the labor market, culminating in the 1882 Exclusion Act, which barred further Chinese immigration to the United States. The act was extended indefinitely and made permanent in 1902; it was not repealed until 1943. Anthony W. Lee, *Picturing Chinatown: Art and Orientalism in San Francisco* (Berkeley and Los Angeles: University of California Press, 2001), 48–49.
4. John Kuo Wei Tchen, *Genthe's Photographs of San Francisco's Old Chinatown* (New York: Dover, 1984), 89. Genthe would later become the teacher of one of the most celebrated street photographers of the twentieth century, Dorothea Lange.
5. Edward Said has described such practices of orientalizing Asian culture as ways of "dealing with it by making statements about it, authorizing views of it . . . in short: Orientalism as a Western style for dominating, restructuring, and having authority over the Orient." Edward Said, *Orientalism* (New York: Vintage, 1979), 3.

JOHN MIX STANLEY AND THE ISAAC I. STEVENS RAILROAD SURVEY EXPEDITION OF 1853

In 1830, the very year that America's first steam-powered locomotive, the *Tom Thumb*, made mechanized rail travel a reality, a proposal for a transcontinental railroad appeared in an article in the *New York Courier and Enquirer*.[1] Asa Whitney wrote to Congress on the matter in 1845.[2] But it was not until 1853 that Congress authorized Secretary of War Jefferson Davis to organize four expeditions to locate a "practicable and economic" route for such a railroad: one taking a southern route along the 32nd parallel from central Texas to El Paso, then via the Gila River to Fort Yuma and San Diego, to be led by Captain John Pope; another going south along the 35th parallel from Arkansas via Albuquerque, Arizona, and the Colorado River into the Mojave Desert and California, under A. W. Whipple; a third striking a central route, between the 37th and 39th parallels, from Independence, Missouri, via the Kansas and Arkansas Rivers through Cochetopa Pass to the Salt Lake Basin, under Lieutenant John W. Gunnison (and later E. G. Beckwith); and, finally, one exploring a northern route, from St. Paul, roughly following that of Lewis and Clark up the Missouri River, over the Rockies, down the Columbia River and north to Puget Sound, under the leadership of Isaac I. Stevens, who had just been named both governor and superintendent of Indian Affairs for the new Washington Territory.

The reports of these expeditions were to provide Congress with sufficient scientific and economic data to reach an objective decision on what was turning out to be a politically and economically contentious competition for the transcontinental railroad route.[3] Each expedition included botanists, geologists, zoologists, meteorologists, surveyors, engineers, guides, soldiers, and artists. In recruiting John Mix Stanley (1814–1872) for the northern route, Stevens found an artist who had already been recognized by the Smithsonian Institution for the rich visual and ethnographic content of his paintings. Stanley first began making Indian portraits in the 1830s. In 1839 at Fort Snelling, Minnesota, he set out to compile an "American gallery," following the precedents of George Catlin, Charles Bird King, James Otto Lewis, and others who sought to document the already diminishing Native American tribes. During eight of the next fourteen years, Stanley worked in Arkansas, Texas, New Mexico, Arizona, and California, also serving as the artist on the Stephen Watts Kearney Expedition across the Southwest in 1846. On reaching California, Stanley continued northward, passing many months studying the Indians living in the Washington Territory. Before returning to New York and Washington, he spent a year in Hawaii.[4] Given Stanley's knowledge of and sensitivity to the many Indian cultures of the greater Northwest, it is clear why Stevens entrusted him with broad responsibilities, which included heading smaller exploratory parties, representing the governor at several tribal councils, and assisting with the written as well as the visual record of the expedition.[5]

The Stevens Expedition departed St. Paul on 6 June 1853, passed through what are now Fargo, Jessie, Harvey, and Minot, North Dakota, and reached Fort Union at the junction of the Missouri and Yellowstone Rivers by the first of August. The party left Fort Union on the ninth, following the Missouri and Milk Rivers, through the Bear Paw Mountains and across the Marias River, arriving at Fort Benton near the junction of the Teton and the Missouri in early September. On the sixteenth, Stevens moved on, crossing the Continental Divide through what was probably Lewis and Clark Pass (as was always the case, other members explored alternative routes, such as Cadotte's Pass), reaching Fort Owen (now Stevensville, Montana) via the Blackfoot River on the twenty-eighth. From Fort Owens, Stevens passed over the Bitterroot Mountains into what is now northeastern Idaho, reached the mission of Coeur d'Alene (today's Cataldo) on 12 October, traveled north to Colville, Washington (18 October), and south onto the plain of the Columbia River. He continued south to Fort Walla-Walla, arriving on the first of November. From there he proceeded by canoe down the Columbia to Vancouver, arriving on the sixteenth; the last leg was again overland to Olympia. Finally, on 28 November, in his role as governor, Stevens made the required proclamation establishing the government of Washington Territory. On 9 January, Stanley returned to Washington, D.C., to begin preparing the voluminous publication; he would not return to the West.

The modest excerpts from Stevens's 1860 narrative that we have printed here give an idea of the detail and general flavor of the prose that accompanied Stanley's fifty-six lithographed illustrations (two of which are included here with their watercolor originals: cat. nos. 183–84, 187–88).[6] Both images and texts are flatly declarative, carefully descriptive, and unexpectedly peaceful. They are nearly devoid of hints of the unknown, the hardships of a forbidding wilderness, or the threats of hostile societies. In fact, the compositions suggest an orderly and friendly environment. There are few dramatically raised horizon lines; a measured recession of forms articulates carefully planned spaces, and the colors of Stanley's original sketches tend toward gentle contrasts on the blue-green-yellow portion of the spectrum. The lithographs are drawn in carefully graded grays, which are then enhanced with subtle tint stones. These serve the double function of adding a warm or cool tone to major parts of the compositions, while reserving white areas of the paper for added accents and details. The individual figure is treated as a comfortable accessory to the landscape,

while peoples meet in grand and controlled schemes sufficiently touched with informality to appear familiar. In short, the language of the watercolors is deliberately conservative, quite like that of early-nineteenth-century European topographical studies.

For the readers and viewers of Stevens's report, the West might seem to have already been won, pacified, domesticated, and converted; those whom one might encounter on the way from St. Paul to Seattle are portrayed as amenable to the suggestions and needs of the Great Father in Washington. Unlike Stanley's carefully observed but sentimentally tinged oil paintings—typified by *Last of Their Race* (1857, Buffalo Bill Historical Center, Cody, Wyo.), which depicts a family of handsome Native Americans pushed to the very shores of the Pacific—the watercolors and the remarkably faithful copies made on stone for the color lithographs of the expedition report depict just the kind of homespun scenery and plentiful resources that railroad investors needed to see. Stanley had spent too much time in the West not to feel kinship with both the land and its inhabitants. Perhaps it is ironic that Stanley's personal sympathy with Native American cultures may have made him an unwilling instrument of their demise. His watercolors offered a poignant means by which Native Americans could be remembered, even as they played a role in the "Extinguishment of Indian Titles."[7] R.S.F.

Notes

1. Hartwell Carter's article is cited in Henry R. Wagner and Charles L. Camp, *The Plains and the Rockies: A Critical Bibliography of Exploration, Adventure, and Travel in the American West, 1800–1865*, 4th rev. ed., ed. Robert H. Becker (San Francisco: J. Howell-Books, 1982), 461. The most informative study of artist John Mix Stanley's role in the Stevens expedition is in Robert Taft, *Artists and Illustrators of the Old West, 1850–1900* (New York: Charles Scribner's Sons, 1953), esp. 1–21 and the extensive notes on 252–78. I have not consulted Julie Ann Schimmel, "John Mix Stanley and Imagery of the West in Nineteenth-Century American Art" (PH.D. diss., New York University, 1983).

2. The gist of Whitney's "Memorial" is conveyed in Alfred Frankenstein, "The Great Trans-Mississippi Railroad Survey," *Art in America* 64 (Jan./Feb. 1976), 56.

3. On the politics and economics of the railroad routes, see William H. Goetzmann, *Army Exploration in the American West, 1803–1863* (New Haven: Yale University Press, 1959), and his *Exploration and Empire: The Explorer and the Scientist in the Winning of the American West* (New York: Alfred A. Knopf, 1971).

4. See Ron Tyler et al., with introduction by Peter H. Hassrick, *American Frontier Life: Early Western Painting and Prints*, exh. cat. (New York: Abbeville Press, and Fort Worth: Amon Carter Museum, 1987), esp. Herman J. Viola (with H. B. Crothers and Maureen Hannan), "The American Indian Paintings of Catlin, Stanley, Wimar, Eastman, and Miller," 130–65.

5. Isaac Ingalls Stevens, Letter IIs (24 Jan. 1859), *Letters to His Wife and Mother-in-Law*, Western Americana Collection, Beinecke Rare Book and Manuscript Library, Yale University, New Haven, Conn. Earlier, in the 1855 octavo edition of the *Report of Exploration* (see n. 6 below), Stanley had written, "Sketches of Indians should be made and colored from life, with care to fidelity in complexion as well as features. In their games and ceremonies, it is only necessary to give the characteristic attitudes, with drawings of the implements and weapons used, and notes in detail of each ceremony represented. It is desirable that drawings of their lodges, with their historical devises carvings and etc., be made with care." Cited by Taft, 1953, 275n.58.

6. The quotations are from Isaac I. Stevens, *Explorations and Surveys for a Railroad Route from the Mississippi River to the Pacific Ocean . . .* , Octavo edition, vol. 12 (Washington, D.C.: William A. Harris, 1859), pages as noted. The reports of all four railroad expeditions appeared in two major forms (with variations): a preliminary "Octavo" report was issued in 1855, entitled *Report of Exploration of a Route for the Pacific Railroad near the Forty-Seventh and Forty-Ninth Parallels from St. Paul to Puget Sound by I. I. Stevens, Governor of Washington Territory. Washington: [1854 or 1855].* This report did not contain any illustrations. The final "Quarto" report was published between 1855 and 1861 in twelve (physically thirteen) volumes. The last two volumes contained the reports from the Stevens Expedition; vol. XII bears the title, *Explorations and Surveys for a Railroad Route from the Mississippi River to the Pacific Ocean. War Department. Supplementary Report of Explorations for a Route for the Pacific Railroad, near the Forty-Seventh and Forty-Ninth Parallels of North Latitude from St. Paul to Puget Sound. By I. I. Stevens, Governor of Washington Territory. 1855* (despite the fact that the internal sections bear the imprint "Washington: William A. Harris, 1859"). Vol. XII appeared again during the following year, with the imprint "Washington: Thomas H. Ford, Printer, 1860." Both the 1859 and 1860 volumes contained the seventy color lithographs after Stanley and Gustav Sohon (who accompanied only the 1855 extension of the expedition), although in the 1859 volume they were printed by J. Bien, New York, and in the 1860 volume by Sarony, Major, & Knapp, New York. A list of the lithographs is published in Wagner and Camp, 1982, 503–5. An interesting discussion of the publication of the illustrations is contained in Martha A. Sandweiss, "The Public Life of Western Art," in Nancy K. Anderson et al., *Discovered Lands, Invented Pasts, Transforming Visions of the American West*, exh. cat. (New Haven: Yale University Art Gallery and New Haven and London: Yale University Press, 1992), 117–33.

It should be borne in mind that Steven's enthusiastic narrative was not nearly as important as the illustrated engineering and scientific data furnished in other parts of the expedition report. The significance Congress attached to these publications may be inferred from one scholar's estimate that all of the railroad expeditions of the 1850s were budgeted at $450,000, while the enormous volume of illustrated publications—fifty-three thousand copies of the Stevens-Stanley report alone—probably cost more than $1 million. See Taft, 1953, 256.

7. From the title of Section XVII of the 1855 preliminary *Report of Exploration*.

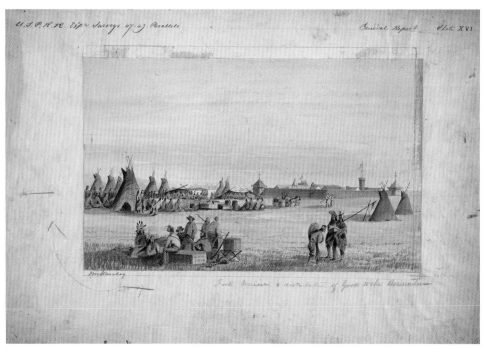

183

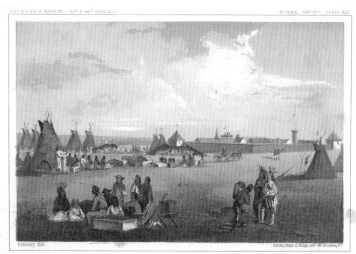

184

183

Fort Union & Distribution of Goods to the Assinniboines, August 1853

Watercolor and graphite, 10 ½ x 15 ⅞ in.
(26.6 x 40.3 cm)
Paul Mellon, B.A. 1929, Collection, 1982.39.10a

184

Sarony, Major & Knapp (1857–67),
lithographers
Fort Union, and Distribution of Goods to the Assinniboines, 1860

Color lithograph, 8 ⅜ x 11 ½ in. (21.4 x 29.2 cm)
Paul Mellon, B.A. 1929, Collection, 1982.39.10b

Fort Union is situated on the eastern bank of the Missouri River, about 2 ⅜ miles above the mouth of the Yellowstone. It was built by the American Fur Company in 1830, and has from that time been the principal supply store or depot of that company. . . . On the seventh of August there was a distribution of presents to the Assinniboines, at which I [Isaac I. Stevens] was present. I now took a deep interest in the welfare of these Indians, from their kind treatment of my party at their camp before crossing the Côteau du Missouri; and I took this occasion to give my mite in the way of cultivating friendly feelings on their part towards their own agents and the government of the United States. . . . Mr. Stanley, the artist, was busily occupied during our stay at Fort Union with his daguerreotype apparatus, and the Indians were greatly pleased with their daguerreotypes.
—Explorations and Surveys, 85 and 87

185

Distribution of Goods to the Gros Ventres,
August 1853

Watercolor and graphite, 10½ x 15¾ in.
(26.7 x 40 cm)
Paul Mellon, B.A. 1929, Collection, 1982.39.13a

Let some of your principal men come with me to
Fort Benton and we will try to settle the difficulty
between the tribes. . . . We continued the talk for
some time, after which the Indians were invited
to come over to the camp of the main party and
witness the firing of the howitzer. . . . The Indians
around the camp behave with great propriety.
I have not yet heard of the smallest article being
missed, although they are seated around every-
where, and many loose articles are lying about.
They express great friendship for the whites, and
evince the kindest feeling to our men. About
5 o'clock we made a distribution of the presents
and provisions designed for this tribe, consist-
ing of blankets, shirts, calico, knives, beads,
paint, powder, shot, tobacco, hard bread, etc.
—Explorations and Surveys, 95

186

Marias River, September 1853

Watercolor and graphite, 10½ x 15⅞ in.
(26.7 x 40.3 cm)
Paul Mellon, B.A. 1929, Collection, 1982.39.17a

The interesting characteristics of these buttes apply
equally to all the high ranges near the Missouri
and Yellowstone as far as they have been
explored. While southward they present insuper-
able obstacles to the direct passage of a railroad
westward, thus making the valley of the Missouri
indispensable as a route; they, at the same time,
by their vicinity to its branches, form inexhaust-
ible sources of supply of excellent timber, and
ameliorate the climate around them by increas-
ing the precipitation of rain, which supplies the
numerous rivers of this still almost unknown
country. . . . Marias River, which we crossed
about seventy miles from its mouth, there flows in
a channel two or three hundred feet below the
prairie level, and is tolerably well wooded. The
water was at that time one hundred and fifty feet
wide and two to four feet deep, slightly milky,
with a swift current and pebbly bottom.
—Explorations and Surveys, 112

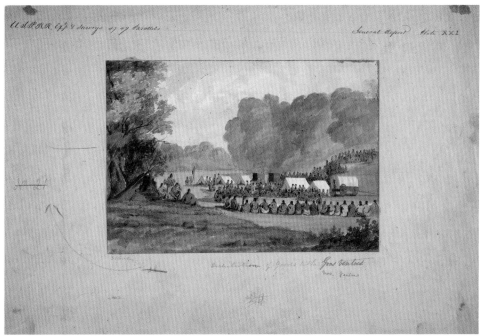

185

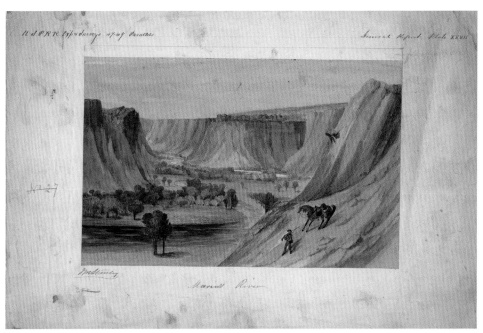

186

187

188

187

Coeur d'Alene Mission, St. Ignatius River,
October 1853

Watercolor and graphite, 10 ½ x 15 ¹³⁄₁₆ in.
(26.6 x 40.2 cm)
Paul Mellon, B.A. 1929, Collection, 1982.39.24a

188

Sarony, Major & Knapp (1857–67),
lithographers
Coeur d'Alene Mission, St. Ignatius River,
1860

Color lithograph, 8 ⅜ x 11 ½ in. (21.4 x 29.2 cm)
Paul Mellon, B.A. 1929, Collection, 1982.39.24b

*The Mission is beautifully located upon a hill
overlooking extensive prairies stretching to the
east and west toward the Coeur d'Alene moun-
tains and the Columbia river. About a hundred
acres of the Eastern prairie adjoining the
Mission are enclosed and under cultivation,
furnishing employment to thirty or forty Indians,
men, women and children. I observed two
ploughing, which they executed skillfully; others
were sowing wheat, and others digging potatoes.
. . . Brother Charles has charge of the buildings
and attends to the indoor work, cooks, makes
butter and cheese, issues provisions, and pays
the Indians for their work, which payment is
made in tickets bearing a certain value, "good
for so many potatoes or so much wheat," etc.
By this management the Indians are able
to procure their subsistence in the summer by
hunting and fishing, and leave tickets in store
for living during the winter. They are well
contented, and I was pleased to observe habits
of industry growing upon them.*
—*Explorations and Surveys,* 133

189

Peluse Falls, November 1853

Watercolor and graphite, 15 7/8 x 10 1/2 in.
(40.3 x 26.6 cm)
Paul Mellon, B.A. 1929, Collection, 1982.39.27a

The Peluse river flows over three steppes, each of which is estimated to have an ascent of a thousand feet. The falls descend from the middle of the lower of these steppes. There is no timber along the course of this stream, and but few willow or other bushes; yet the soil is fertile, and the grass nutritious and abundant even in winter. The fall of water, which is about 30 feet wide, cannot be seen from any distant point; for flowing through a fissure in the basaltic rock, portions of which tower above in jagged pinnacles, it suddenly descends some 125 feet into a narrow basin, and thence flows rapidly away through a deep cañon from a point from which the annexed view was sketched.

—*Explorations and Surveys*, 151

190

Kettle Falls Columbia River, November 1853

Watercolor and graphite, 10 1/2 x 15 7/8 in.
(26.7 x 40.3 cm)
Paul Mellon, B.A. 1929, Collection, 1982.39.31a

The Columbia at Fort Colville is about three hundred and fifty yards wide just above the Sometknu or Kettle Falls. These consist of two pitches, one of fifteen feet and another below it of ten, and the river is narrowed to two hundred yards. An extensive and fertile bottom land borders the river here, and extends back towards the east for some miles. This continues to border this river, with an average width of half a mile, for twenty miles down the stream, when the wooded hills come closer to the banks, higher and with numerous ravines opening on the river, which makes a route close to its banks impossible.

—*Explorations and Surveys*, 159

189

190

191

Frances F. Palmer (b. England, 1812–1876), artist and lithographer, and **James Merritt Ives** (1824–1895) Published by **Currier & Ives** (active 1857–1907)
Across the Continent. "Westward the Course of Empire Takes its Way," 1868

Hand-colored lithograph, 24 ⅛ x 32 ⅝ in. (61.3 x 82.8 cm)
Mabel Brady Garvan Collection, 1946.9.1361

Across the Continent is considered one of the masterworks of Frances F. Palmer, who was among the most prolific artists in the Currier & Ives stable of artist-printmakers.[1] It was published just one year before the "golden spike" joined the Union Pacific Railroad tracks with those of the Central Pacific at Promontory Point, Utah.

Pictured here is an invented site somewhere along the transcontinental railroad route; it stands for the many towns that cropped up as the train line extended westward. The print is organized around a dramatic swath of train track, traversed by the "Through Line New York–San Francisco," which diagonally bisects the composition and separates a fledgling white township at the left foreground from an uncultivated wilderness at the right. The small but bustling town boasts a public school, a church, and a handful of homes, as well as citizens busily clearing trees and laying telegraph lines. The settlement stands in marked contrast to the sparsely populated land across the tracks, with a pair of Native Americans on horseback and a herd of buffalo in the far distance. Palmer clearly juxtaposed the activity of the white settlers with the comparative inactivity of the Indians at the right of the composition, who have literally been stopped in their tracks by the black smoke billowing toward them from the train.

Known familiarly as Fanny, Palmer was the most important woman lithographer of her time in America, credited with producing about two hundred lithographs for Currier & Ives between 1849 and 1868.[2] Her friend and colleague Louis Maurer noted that despite Palmer's many talents, she had difficulty drawing the human figure and often depended on colleagues for help in completing her prints. Apparently, James Merritt Ives regularly imposed himself rather rudely in her work and took it upon himself to draw in figures—including those in the foreground of *Across the Continent*. Ives also likely subtitled the print *"Westward the Course of Empire Takes its Way,"* directly quoting from the last stanza of an eighteenth-century poem by Bishop George Berkeley (cat. no. 1). In 1862, this poem had inspired Emanuel Leutze's vast mural for the U.S. Capitol, which depicts scenes of exploration and discovery from biblical times to his era.

Palmer's epic print portraying opposing forces has come down in history as one of the most illustrative images of the concept of Manifest Destiny: in the left distance, a wagon train travels away from the town, carrying settlers westward; and on the near banks of the river at the middle right of the print, two white men set out to explore the "wild" terrain in canoes. These tiny but important vignettes confirm America's post–Civil War expansionist zeal. Here the railroad—the great symbol of national unification—ironically separates "natural" America from the man-made one, wilderness from civilization, old from new—and, ultimately, America's past from its now inevitable future. E.H.

Notes
1. Palmer's work on *Across the Continent* began as early as 1862 with two drawings that are housed in the Harry T. Peters Collection at the Museum of the City of New York.
2. Frances Flora Bond, later Palmer, was born in

Leicester, England, and began her career as a print-maker there before immigrating to America in 1844. See Mary Bartlett Cowdrey, "Fanny Palmer, An American Lithographer," in *Prints: Thirteen Illustrated Essays on the Art of the Print, Selected for the Print Council of America by Carl Zigrosser* (New York: Holt, Rinehart and Winston, 1962), 217–34.

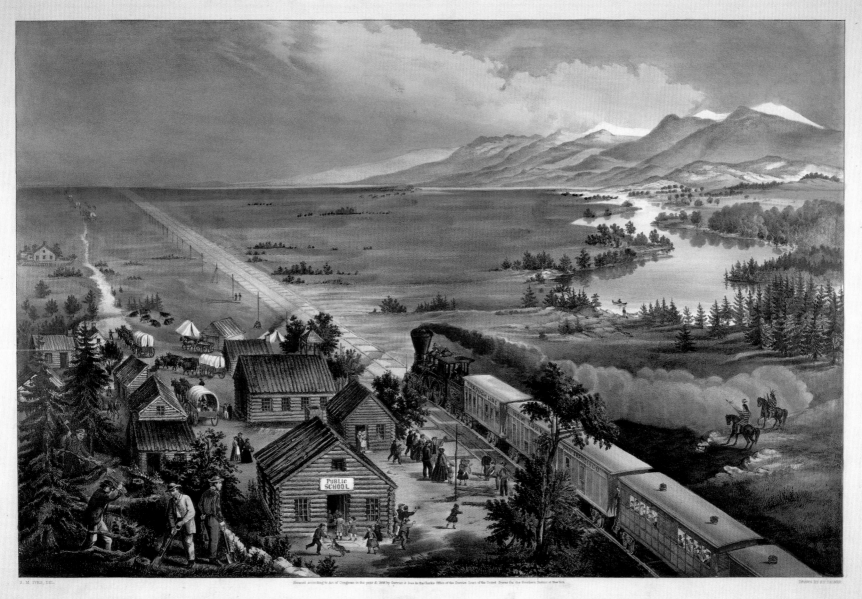

ACROSS THE CONTINENT.

"WESTWARD THE COURSE OF EMPIRE TAKES ITS WAY."

NEW YORK. PUBLISHED BY CURRIER & IVES 125. NASSAU STREET.

Junction of the Platte Rivers
June 1866 W. W. Whittredge

192

192

Worthington Whittredge (1820–1910)
Junction of the Platte Rivers, June 1866
Spanish Peaks from Raton Pass, July 1866
Sante Fe, July 20, 1866

Oil on paper laid down on canvas, 8½ x 23 in.
(21.6 x 58.4 cm); 7⅛ x 23¼ in. (18.1 x 59.1 cm);
8 x 23¼ in. (20.3 x 59.1 cm)
Gift from the estate of William W. Farnam, B.A.
1866, M.A. 1869, to the Peabody Museum of
Natural History, Yale University, 1929.780.2,
1929.780.3, 1929.780.1

Junction of the Platte Rivers

Unlike most American artists who traveled west to record the natural wonders of the expanding frontier, Worthington Whittredge focused on the boundless austerity of the prairies and southwestern deserts rather than the majestic grandeur of the Rocky Mountains. He was a civilian member of General John Pope's 1866 expedition into the western territories, whose task was to patrol the transportation routes for hostile Indians. Whittredge was thus able to see a large section of the region firsthand and produced nearly forty oil sketches during the three-month journey. Although they were conceived as preliminary studies for large-scale canvases that he would paint upon returning to his New York studio, Whittredge decided to mount these modest sketches on canvas and have them framed. In works such as *Junction of the Platte Rivers*, *Spanish Peaks from Raton Pass*, and *Sante Fe* (which the artist misspelled), Whittredge created an evocative visual language for a part of the country that had been typically considered uninhabitable, more a place to pass through than a destination in its own right. In the seemingly endless horizon of the plains and desert, Whittredge found a sublime equivalent to the vertiginous rise of the mountains.

With the date and location inscribed on the bottom corner of each study, Whittredge's sketches provide an approximate travelogue of the expedition's campaign from Fort Leavenworth, Kansas, following the South Platte River across the Great Plains into the Rocky Mountains, and ending in the old Spanish cities of Albuquerque and Santa Fe. Viewing them in their successive order from east to west conveys a sense of an evolving civilization, from the striking barrenness of the Nebraska plains to the tree-scattered foothills of the Sangre de Cristo range to, finally, the long-established community of Santa Fe. Yet even in his depiction of the desolate Platte junction, Whittredge included a distant trail of dust produced by a wagon train in the left middle ground, which is visually balanced to its right by what appears to be a group of small campsites, suggesting the looming and perhaps inevitable course of western migration. A more conventional landscape is presented in his depiction of a wagon train crossing Raton Pass, a notoriously treacherous portion of the Santa Fe Trail between Colorado and New Mexico. Here, trees and mountains invest the landscape with a sense of scale, making the terrain spatially comprehensible. The presence of trees indicates fertile soil and a relatively moist climate, suggesting that the environment is physically habitable and countering the popular presumption that all of the Southwest was an arid desert. In *Sante Fe*, Whittredge highlighted the area's long history of human inhabitation, documenting the enduring signs of European civilization in the region with the castellated church in the far left of the composition and emphasizing the city's state of picturesque disrepair, evident in the dilapidated fence in the foreground and the generally disorganized arrangement of the buildings. By implying a progressive, but nevertheless incomplete, evolution within his imagery (perhaps due to the artist's own gradual acclimation to the new landscape), Whittredge presented the West as both capable of domestication and full of possibilities.

Whittredge captured the experience of a vast, seemingly endless vista by choosing a strikingly severe horizontal format. Besides providing the ideal proportions to express the wide-open spaces of the western plains and deserts, the narrow, horizontal dimensions of the images likewise evoke the popular entertainment of moving panoramas. These consisted of long bands of painted canvas slowly unwound between two large spools and presented upon a dramatically lit stage, providing audiences with the simulated experience of motion or, more precisely, the illusion of viewing passing scenery from a moving train or boat. Such panoramas reached their peak of popularity in the United States in the 1840s, when various versions of a boat ride down the Mississippi River toured the country to great acclaim, allowing urban audiences to encounter far-off and inaccessible places from the comfort of their local theater. By applying panoramic proportions and compositional strategies to these landscapes, Whittredge conferred a sense of inevitability and expectation on the progress he depicted, as if the distant wagon trains would soon roll into the foreground, or over the next mountain pass, and the barren plain would smoothly be transformed into a busy metropolis.[1] Whittredge's understated landscapes are a subtle foil to the operatic bombast characteristic of most nineteenth-century western landscape painting, epitomized by the work of Albert Bierstadt (cat. no. 201). With the expansion of the transcontinental railroad, the passage of the Homestead Act in 1862, the ensuing destruction of the buffalo herds, and the forced expulsion of the native Indian population, Whittredge's images present a calm and peaceful vision of a region entering a period of rapid growth and violent confrontation. R.S.

Note

1. For a discussion of the role of the panorama in depictions of American landscape, see Angela L. Miller, *The Empire of the Eye: Landscape Representation and American Cultural Politics, 1825–1875* (Ithaca, N.Y.: Cornell University Press, 1993).

Within the painting, handwritten inscription: *Raton Pass / July 9 . 66 / Spanish Peaks*

Spanish Peaks from Raton Pass

Sante Fe

193

193

Attributed to **Johann Michael Jahn**
(b. Germany, 1816–1883)
Sewing Table
New Braunfels, Texas, 1870–80

Walnut and yellow pine, 30 ½ x 20 ½ x 16 ¾ in.
(77.5 x 52.1 x 42.5 cm)
Gift of Natalie H. and George T. Lee, Jr., B.A.
1957, 2001.93.1

More than a symbol of its owner's talents
and accomplishments, this sewing table also
served as a small oasis of refinement amid
the rough life on the Texas frontier. In 1845,
more than two hundred German immigrants
settled in the Texas hill country and founded
the town of New Braunfels. Sponsored by
the Society for the Protection of German
Immigrants in Texas, they were part of a large
wave of German migrants to the area who
were motivated by a desire for better eco-
nomic conditions. Many of the new settlers
were craftsmen who had lost their jobs as
Germany's furniture trade became increas-
ingly mechanized; they hoped to continue
working in America. These newcomers
brought their own customs and heritage to
the Texas frontier, leading landscape archi-
tect Frederick Law Olmsted to note, during
an 1856 visit to a New Braunfels inn, that
"in short, we were in Germany."[1]

German artisans in Texas worked largely
in cultural isolation until the 1870s. This
allowed them to preserve European styles and
construction techniques in the goods they
produced, which were marketed to a largely
German audience. This sewing table is built
in the Biedermeier style, a German interpre-
tation of the neoclassical mode in which the
primary decorative feature of furniture is
the color and grain of the wood. It is attrib-
uted to New Braunfels cabinetmaker Johann
Michael Jahn on the basis of a similar piece
that descended in his family. A vase-shaped
pedestal supports three elaborately scroll-

sawn legs that resemble architectural details
found on many nineteenth-century New
Braunfels houses. The table's single drawer
is divided into compartments to hold a vari-
ety of sewing projects and supplies. It was
made for Katherine Seidler Hartenstein, who
immigrated to New Braunfels from Germany
in 1854.[2]

Jahn had been apprenticed to a cabinet-
maker in Prague and worked in Switzerland
before immigrating to Texas in 1844. His
metropolitan training gives his pieces a more
stylish aspect than much of the furniture
made by other Texas craftsmen. Jahn's busi-
ness flourished in the 1850s and 1860s, when
the German settlements were in their infancy
and there was a great demand for home fur-
nishings. As early as 1866, he began import-
ing factory-made furniture from New York
and the Midwest to sell alongside pieces
made in his own shop, and the focus of the
business gradually shifted from cabinet-
making to retail.[3] E.E.

Notes
1. Lonn Taylor and David B. Warren, *Texas
Furniture: The Cabinetmakers and Their Work,
1840–1880* (Austin: University of Texas Press, 1975),
33; Donald L. Stover, *Tischlermeister Jahn*, exh.
cat. (San Antonio: San Antonio Museum
Association, 1978), 9; Frederick Law Olmsted,
*A Journey through Texas, or, a Saddle-Trip on the
Southwestern Frontier*, Barker Texas History
Center 2 (New York: Dix, Edwards & Co., 1857;
Austin: University of Texas Press, 1978), 143.
2. Taylor and Warren, 1975, 33; YUAG Object File;
Stover, 1978, 16, 42.
3. Taylor and Warren, 1975, 299.

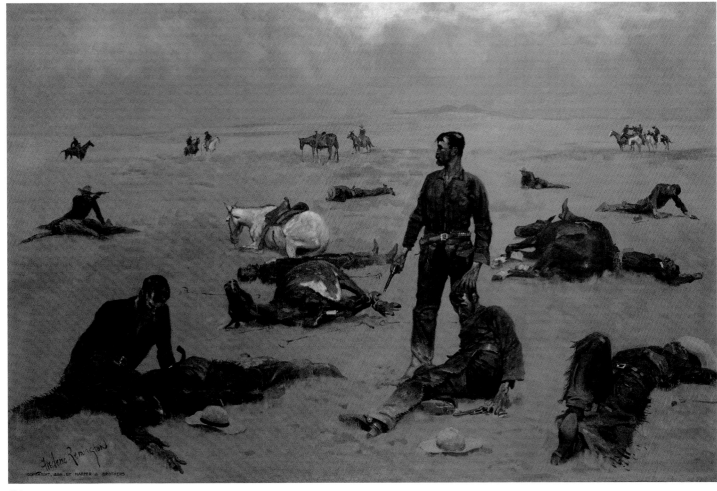

194

194

Frederic Remington (1861–1909)
What an Unbranded Cow Has Cost, 1895

Oil on canvas, 28 1/16 x 35 1/8 in. (71.3 x 89.2 cm)
Gift of Thomas M. Evans, B.A. 1931, 1977.114

Loosely inspired by the "cattle wars" of the 1880s and 1890s, in which wealthy cattle barons gradually conquered independent homesteaders and small-scale ranchers, the apocalyptic *What an Unbranded Cow Has Cost* depicts the aftermath of a gun battle over the ownership of an unbranded cow, shown tethered in the center of the composition with branding irons strewn around it. The painting was reproduced in an 1895 issue of *Harper's Monthly* to illustrate an article by Frederic Remington's friend Owen Wister, whose popular western novel *The Virginian* would be published in 1902. In "The Evolution of the Cow-Puncher," Wister claimed that the American cowboy represented a nineteenth-century incarnation of the medieval knight, descended from a lordly strain of Anglo-Saxons bent on domination. Playing on his readers' xenophobia, inflamed by rising rates of immigration, he suggested that the masterful spirit of this "slumbering untamed Saxon" might be reawakened to do something about the "hordes of encroaching alien vermin" that were "turning our citizenship into a hybrid farce."[1] Remington's illustration for Wister's article responds to the perceived threats of immigration, depicting a fantasy of the West in which supremacy is determined by Darwinian imperatives. Like Wister and many others, he sought solace in the image of the cowpuncher as a two-fisted savior, delivering order and Anglo-Saxon supremacy to the masses.[2]

Yet the ambivalence of Remington's dreamlike image of a massacre's aftermath suggests a deeper anxiety about the frontier's place in American culture. The horizon line

seems perfunctory, and the fallen figures appear to float in the friezelike space. The central figure, the last man standing, may be under fire from the attacker at the left, but he does not react. The unusually flat picture plane evokes the page of a book, and at its approximate center lay the brands them-selves—the "pictograms" that occasioned the slaughter—spelling out the region's troubled history.[3]

The brand—a form of pictorial writing that designates possession—recalls the text of Remington's western fantasies, which he penned during the 1890s for magazines like *Harper's*. But the vividness of his literary and visual portrayals underscores their remote-ness from the present. His elegiac works sought to celebrate the cowpuncher, but instead they emphasized the fact that this mythic figure and his world were long gone.[4] The central gunman is a doomed relic of a bygone era, an exclamation point on the final page. The excessiveness of the carnage lends an otherworldly clarity to the denoue-ment, but it also questions the isolated hero's continued relevance. Trying to bring the West of his imagination back to life to miti-gate foreign influences, Remington succeeded in limning its epitaph. G.G.

Notes
1. Owen Wister, "The Evolution of the Cow-Puncher," *Harper's Monthly* 91 (Sept. 1895), 603–4.
2. Despite Wister's and Remington's identification of cowboys as Anglo-Saxon in origin, the cowboy tradition is in fact rooted in cowherding techniques of medieval Spain, which were brought to the New World by Spanish colonists. Americans first encountered cowboys in cattle-rich parts of north-ern Mexico, especially areas that would eventually become Texas and New Mexico, adopting the language and attire of Hispanic *vaqueros* to create this essentially American icon. Jonathan Haeber, "Vaqueros: The First Cowboys of the Open Range," *National Geographic News* (15 Aug. 2003), http://news.nationalgeographic.com/news/2003/08/0814_030815_cowboys.html.

3. This interpretation is indebted to that of Alexander Nemerov in *Frederic Remington and Turn-of-the-Century America* (New Haven and London: Yale University Press, 1995), 141–42.
4. A disheartened Remington wrote to his wife in 1900: "Shall never come west again—it is all brick buildings—derby hats and blue overalls—it spoils my early illusions—and they are my capital." Allen P. Splete and Marilyn D. Splete, eds., *Frederic Remington: Selected Letters* (New York: Abbeville Press, 1988), 318.

195

197

196

Carleton E. Watkins (1825–1916)

195

Yosemite Falls, 2634 ft., ca. 1865–66

Albumen print, 13⅞ x 10⅞ in. (35.3 x 27.6 cm)
Gift of George Hopper Fitch, B.A. 1932,
1992.53.207

196

Bridal Veil Fall, Yosemite, ca. 1865–66

Albumen print, 12⅛ x 8 in. (30.8 x 20.3 cm)
Yale University Art Gallery, 1975.10

197

The Three Brothers, 4480 ft., Yosemite,
ca. 1865–66

Albumen print, 8¹/₁₆ x 12¹/₁₆ in. (20.4 x 30.6 cm)
A. Conger Goodyear, B.A. 1899, Fund, 1975.72.1

In the summer of 1861, Carleton Watkins
made his first trip to Yosemite Valley. It was
his tenth year in California and his sixth as a
photographer.[1] In preparation for his trip,
Watkins had a large camera fitted with a
backing that could accommodate 18-by-22-
inch glass negative plates and a lens spe-
cially designed for landscape photography.[2]
During his first trip, Watkins successfully
captured approximately one hundred stereo-
graphs and, most significant, at least thirty
mammoth glass negatives—the first major
landscape photographs, as well as the largest,
made in the United States.

With an increasing variety of cameras,
Watkins made several subsequent trips to
Yosemite. In 1865–66, as part of the Califor-
nia State Geological Survey, he brought with
him a camera to take moderate-size images
(9½ by 13 in.) suitable for mounting in sale-
able albums.[3] These three photographs are
likely part of that year's production. He
returned to Yosemite in 1872, 1875, 1878, and
1879–81.

During each trip Watkins would journey
to new sites to capture fresh views of the

valley to market to his patrons. But he returned to locations again and again—sites that his rival photographers, including William Henry Jackson and Eadweard Muybridge, also photographed repeatedly. Indeed, it was because of their repeated depiction that these would become the "quintessential" Yosemite views that the public could readily identify, and that drew increasing numbers of visitors to the valley every year. Most of these sites—such as Yosemite Falls (cat. no. 195), Bridalveil Fall (cat. no. 196), and the Three Brothers (cat. no. 197)—carried names bestowed on them by European Americans from the time of the earliest exploratory trips to Yosemite in 1851. They typically gave Yosemite's natural formations such designations as "sentinels, brothers, and captains, on the one hand, and cathedrals, spires, domes, and columns, on the other . . . names that associate the natural landscape with human beings or their creations."[4]

More than any other photographer working in Yosemite during the 1860s and 1870s, Watkins inspired both the general public and prominent artists and writers to visit the valley—including, in 1862, the preeminent landscape painter Albert Bierstadt. Bierstadt was apparently so taken with Watkins's Yosemite photographs that he dubbed him the "Prince of Photographers" and thenceforth would occasionally use Watkins's images as models for his paintings.[5] As early as the 1860s, photography critics noted that Watkins's landscapes were often distinguishable from those of his contemporaries because he usually omitted the conventional figures that regularly appeared in the photographs of Timothy O'Sullivan and William Henry Jackson.[6] This "purity" of image appears to have influenced Bierstadt's own work: his paintings from the mid-1860s onward gradually deemphasize the human

presence in the landscape. As the canvases themselves grow in size, so does the focus on pure landscape (cat. no. 201).

If Bierstadt has come down in history as the preeminent painter of the American West, Watkins retains his status as its preeminent early photographer. Together, their images define Yosemite for the average American, even today. E.H.

Notes
1. Born in Oneonta, New York, Watkins traveled to San Francisco in 1851, at the height of the gold rush, and subsequently to Sacramento, where he worked for his childhood friend future railroad magnate Collis P. Huntington delivering supplies to the mines. In 1854, Watkins inadvertently began his photography career, filling in for a photographer who had abruptly left the studio of Robert Vance.
2. Peter E. Palmquist, *Carleton E. Watkins: Photographer of the American West*, exh. cat. (Albuquerque: University of New Mexico Press for the Amon Carter Museum, 1983), 11. Palmquist notes that it is unclear whether the camera was completely new or was reconfigured to accommodate larger glass plates.
3. Ibid., 25.
4. Martin A. Berger, "Overexposed: Whiteness and the Landscape Photography of Carleton Watkins," *Oxford Art Journal* 26 (2003), 11. Bridalveil Fall, for instance was named in 1855 by James Mason Hutchings. See his *In the Heart of the Sierras* (Oakland: Pacific Press Publishing House, 1886), cited in Peter Browning, *Yosemite Place Names* (Lafayette, Calif.: Great West Books, 1988), 16.
5. See Palmquist, 1983, 14.
6. Berger, 2003, 20.

198

Eadweard Muybridge (b. England, 1830–1904)
Published by **Bradley & Rulofson**, San Francisco (1860–ca. 1886)
Falls of the Yosemite (2,600 feet), from Glacier Point, plate 36 from *Valley of Yosemite, Sierra Nevada Mountains, and Mariposa Grove of Mammoth Trees*, 1872
Albumen print, 21¼ x 16¾ in. (54 x 42.5 cm)
Gift of Harrison H. Augur, B.A. 1964, 1980.27.3

Eadweard Muybridge's initial success and future reputation as a unique and innovative photographer began in Yosemite Valley. Yosemite provided Muybridge with his first intimate experience of the natural world. It was also in Yosemite that he first comprehended the technical scope and capabilities of the photographic apparatus.[1] Muybridge took up photography in the early to mid-1860s; his first important large-format scenes were shot in the Yosemite Valley in 1867 and published in 1868.

In 1872, Muybridge made a more extensive photographic trip to Yosemite, this time carrying a camera capable of making negatives up to 20 by 24 inches—larger than any previously made in the American West.[2] By 1872, Yosemite had become one of the most photographed sites in California, almost to the point of cliché; Muybridge was just one of an estimated nine practitioners working in the valley that year.[3] However, by journeying to places that had never been photographed and bringing his own unique aesthetic to the task, Muybridge created a body of work wholly different from those of his contemporaries.

Waterfalls and craggy rocks were Muybridge's favorite Yosemite subjects, as is evidenced by this dramatic view of the falls of the Yosemite. Here, Muybridge paid homage to compositional conventions of

eighteenth- and nineteenth-century landscape painters and printmakers who had cultivated the vogue for grand panorama. In its crisp contrast of light and shadow and its dramatic posing of the spectator, this photograph also owes much to the techniques that Muybridge had honed in his early work in stereoscopic photography. Here, he orchestrated a true compositional crescendo, skillfully conducting the viewer's eye from the shadowed foreground with a figure perched on a rocky precipice, to the vast and glorious middle chasm, and ultimately to the lofty peaks in the distance. The image's strong vertical orientation, as well as its sheer size, enhances Muybridge's masterful direction; they are devices to help convey, in two dimensions, the experience of witnessing the grandeur of the Yosemite Valley in person. E.H.

Notes
1. While creating this body of work, Muybridge made the first of his many photographic innovations—the "sky shade"—a makeshift moving shutter that could be successively lowered to give the exposure time needed to capture the foreground, middle distance, and sky within a single glass negative.
2. Carleton Watkins's mammoth plates, executed during trips to Yosemite in 1861 and 1865–66, measured just 18 by 22 inches (cat. nos. 195–97). Anita Ventura Mozley, introduction to *Muybridge's Complete Human and Animal Locomotion: All 781 Plates from the 1887 Animal Locomotion* (New York: Dover, 1979), xi.
3. The year 1872 was also when the world's first national park, the 2.2-million-acre Yellowstone National Park, was created by President Ulysses S. Grant.

MUYBRIDGE, Photo.

BRADLEY & RULOFSON,
429 Montgomery St., S. F., Publishers.

FALLS OF THE YOSEMITE.

(2,650 feet.) See Glacier Point.

No. 37.

AT RED FALLS FOOT OF MT BLACKMORE, M.T.

3806. CHEYENNE FALLS. W.H.J. & Cº

William Henry Jackson (1843–1942)

199

Arched Falls, Foot of Mt. Blackmore M.T.,
1872

Albumen print, 13⅛ x 9⅝ in. (33.3 x 24.4 cm)
Gift of Alexis I. du Pont Bayard in memory of
Thomas F. Bayard, Jr., B.A. 1890, 1979.52.6

200

Cheyenne Falls, ca. 1882–85

Albumen print, 9⅞ x 5⅞ in. (25.1 x 14.9 cm)
Anonymous Purchase Fund, 1977.131.2

In the late 1860s, a restless America, eager to resume the process of expansion and appropriation that had been disrupted by the bitter Civil War, turned its attention once again to the "territories." Work on the transcontinental railroad was moving ahead at full speed, and towns such as Virginia City, Salt Lake City, Denver, and Omaha were becoming major station stops along its lines. But these were only a handful of oases that clung to the relative safety of the rails; they fringed a large section of the country—the expanses of southern California, Nevada, and the territories of Utah, Colorado, Arizona, New Mexico, and southern Montana and Wyoming—about which very little was known. In the post–Civil War recovery, Congress was prepared to authorize significant sums for exploratory missions to the territories to determine what resources these lands could offer the country. First in line to garner these appropriations, armed with detailed proposals and years of experience in exploratory fieldwork, were four exceptional geologists and topographers, who would lead what would become known collectively as the four Great Surveys of the American West.[1]

Concurrent with the organization of the Great Surveys, a photographic technology suitable for picturing expeditionary findings

was coming of age. The collodion "wet-plate" process had been perfected during the Civil War; the images produced on its battlefields were strong evidence of the growing importance of the medium for documentary fieldwork.[2] Ferdinand Vandeveer Hayden, commander of the U.S. Geological and Geographical Survey of the Territories (1867–79), understood the advantages of having a skilled photographer on his team, and in 1869 he hired Omaha-based William Henry Jackson to secure "faithful views of the many unique and remarkable features of newly explored territory."[3] Jackson, who had previously taken portrait pictures, finally found his calling as an expedition photographer. As he later wrote in his autobiography, "For Dr. Hayden and the veterans it was more or less routine . . . but for me the expedition was priceless—it gave me a career."[4]

The kind of photographic fieldwork the surveys demanded was daunting. The wet-plate process was tremendously cumbersome: true to its name, glass negatives had to be sensitized and developed on site, with fresh solutions. A photographer had to carry with him all the materials he would need to make a photograph—not only his cameras and lenses but also a portable darkroom, a full stock of chemicals, and several glass plates. Jackson described a typical day's activity thus: "My invariable practice was to keep [my dark box] in the shade, then, after carefully focusing my camera, return to the box, sensitize a plate, hurry back to the camera while it was still moist, slip the plate into position, and make the exposure. Next step was to return to the dark box and immediately develop the plate. Then I would go through the entire process once more from a new position. Under average conditions a 'round trip' might use up three-quarters of an hour."[5]

During the 1872 season Jackson added a larger format, 11-by-14-inch camera to his

equipment, and it is likely the one he used in mid-September to take this dramatic view titled *Arched Falls, Foot of Mt. Blackmore M.T.* (cat. no. 199).[6] As this and hundreds of other outstanding Jackson photographs attest, the summer of 1872 was perhaps the most fruitful and successful season of his near decade-long involvement with Hayden. As the photographer later recalled, "Subject matter, equipment . . . and working conditions, all contrived to give me a series of exceptional photographs."[7] The year 1872 was an extraordinary one for the Hayden Survey in another significant way: on 1 March, President Ulysses S. Grant signed the Yellowstone Park bill, which had passed swiftly through both houses of Congress with overwhelming approval. Its approval was in great part due to the Hayden Survey's reports of the natural wonders of Yellowstone, which included Jackson's photographs as "indisputable" illustrations.

The late 1870s and early 1880s marked the real beginning of a western tourist trade in the United States. It was spurred on not only by the completion of the transcontinental railway in 1869, but also by the magnificent images by Jackson, Timothy O'Sullivan, Carleton Watkins, and others, which flooded the eastern market and enticed would-be tourists to journey west. In 1881, Jackson was employed by the Denver & Rio Grande Railway to document sites along its route for just such promotional purposes. Cheyenne Falls (cat. no. 200) (today known as Seven Falls, located outside of Colorado Springs) was a major attraction along this route, one that Jackson photographed numerous times.

In 1882, naturalist James Hull, fearing that the scenic beauty of the canyon was being threatened by logging, purchased the property surrounding Cheyenne Falls for $1,300.[8] Hull then advertised the area as a scenic resort, "improving" it by constructing a road through the canyon to the falls and

building a stairway to take visitors to its base. Access to the falls was largely by carriage or burro, amenities that were offered by a local entrepreneur named Hunter, who took passengers—such as those pictured here—to and from the falls for twenty-five cents each. E.H.

Notes

1. For more than a decade, the Great Surveys would contribute significant geological and geographical information on the undocumented sections of the continental United States. In 1879, the U.S. government, wary of spreading its resources so thinly, consolidated the surveys under a single organization, the United States Geological Survey (or U.S.G.S.), which is still active today.

2. The collodion wet-plate process was valued because the transparency of the glass negative produced a high resolution of detail in both the highlights and the shadows of the resulting prints. In addition, exposure times were shorter than those for a daguerreotype. Perhaps most important, numerous images could be printed from a single negative and published in multiple survey reports.

3. Ferdinand Vandeveer Hayden, *Ninth Annual Report of the United States Geological and Geographical Survey of the Territories . . .* (Washington, D.C.: U.S. Government Printing Office, 1877), 22–23.

4. William Henry Jackson, *Time Exposure: The Autobiography of William Henry Jackson*, introduction by Ferenc M. Szasz (New York: G. P. Putnam's Sons, 1940; repr. Albuquerque: University of New Mexico Press, 1986), 190–91.

5. Jackson, 1986, 198.

6. Ferdinand Hayden named this ten-thousand-foot Montana peak in memory of Mary Blackmore, the recently deceased wife of William Blackmore, a British entrepreneur who accompanied the Hayden Survey as a guest.

7. Jackson, 1986, 209.

8. Hull was one of Colorado's earliest environmental protectors. He had previously purchased 160 acres to the west and in 1885 added an additional 80 acres.

201

Albert Bierstadt (b. Germany, 1830–1902)
Yosemite Valley, Glacier Point Trail, ca. 1873

Oil on canvas, 54 x 84¾ in. (137.2 x 215.3 cm)
Gift of Mrs. Vincenzo Ardenghi, 1931.389

A golden sky dominates Albert Bierstadt's *Yosemite Valley, Glacier Point Trail*, which the artist painted around 1873. The sky refines earlier California artists' fascination with the baser gold found in the ground. Pictures such as Joseph Warren Revere's *Gold Washing* of 1849 (Huntington Library) concentrate on the cradle-and-pan operations of mining, with the distant clouds and mountains only an afterthought.[1] Even so, some artists had already focused on the tension between gold diggings and golden skies, revealing the incompatibility Bierstadt tried to resolve. By examining their work, we can return to his picture with a greater sense of its cultural aims.

E. Hall Martin's *Mountain Jack and a Wandering Miner* (fig. a), painted in Sacramento about 1850, shows a traveling gold miner standing on a mountaintop, while a gnomish man called Mountain Jack sits at his side, pointing down at the earth. The miner, meanwhile, aligns with the sky: the brim and crown of his hat match the distant peaks; his beard echoes the fluffy clouds; and his body stands out against the heavens. The wooden handle protruding from his backpack is the elevated rejoinder to Mountain Jack's downward-pointing finger. Though the miner is torn (he looks down at the ground; his weight compresses downward as he leans on his rifle; and the straps crisscrossing his torso suggest that he is pulled in different directions), he is foremost a dreamer, his head in the clouds. Mountain Jack, in contrast, emphasizes the more immediate matter beneath his feet. In Bierstadt's picture of some twenty-three years later, however, only the dreaminess remains.

The changing definitions of the word "prospect" indicate the social basis of the tension and Bierstadt's attempt to resolve it. In 1839, the British travel writer and novelist

fig. a E. Hall Martin, *Mountain Jack and a Wandering Miner*, ca. 1850. Oil on canvas, 39½ x 72 in. (100.3 x 182.9 cm). Oakland Museum of California, Gift of Concours d'Antiques, Art Guild

Frederick Marryat first used "prospect" to indicate digging in the earth.[2] By then, however, the word had long referred to a distant view, taking in a prospect from an elevated vantage. Martin showed these two kinds of prospecting at odds. His painting hints at the conflicts driving the largely middle-class population to seek wealth in the California gold fields, both before they became Argonauts and after: "the inconsistencies between their own moral standards and what was necessary to get ahead in a competitive economy."[3] One could not be simultaneously high- and low-minded— one could not focus on both spiritual goals and immediate gains—without revealing a split between the two prospects. The genius of Martin's painting is the depiction of that strain.[4]

In *Yosemite Valley, Glacier Point Trail*, however, we see only the grand view. The mountain guide at lower left pointing into the distance, telling his tourist-clients where to look, is a prospector only of the more elevated sort. By 1873, with the heyday of the gold rush over, and the establishment of middle-class morality now a cultural priority, high-mindedness prevails in the contemplation of northern California. Landscape painting was the perfect vehicle for that heightened expression, and Bierstadt replaced genre painters like Martin (who died in 1851) not just by virtue of his talent, ambition, and novelty but because his broad vistas embodied the flattering new emphasis on would-be refinement and an erasure of baser motivations.

Clarence King's book *Mountaineering in the Sierra Nevada* (1872) matches the rhetoric of Bierstadt's painting. King linked spiritual seeing to mountain vistas and starkly contrasted these grand scenes with the crude world of acquisition below. To him, the mountain scenery, "lifted above the bustling industry of the plains and the melodramatic mining theatre of the foot-hills," possessed "a grand, silent life of its own, refreshing to contemplate even from a hundred miles away."[5]

The moral contrast between high and low spaces dominates King's book. At twelve thousand feet, the traveler finds that "deep and stirring feelings come naturally and a calmness born of reverent reflections encompasses the soul." Down below, pig farmers and other holdovers from the Westward Ho days congregate in a "dreary brotherhood," a valley-bound money-grubbing class speaking a crude dialect: "Goin' somewhere, ain't yer?" King's lofty account bespeaks an obvious class bias, but it also suggests his wish as a genteel American to erase the vulgar profit-seeking of his own class, so that only feelings of elevation and high moral worth remain as a form of self-expression.[6] Bierstadt's coeval picture of the same time strives to do the same.

The sun's golden orb, thickly painted, sits like an ingot in the sky. Partly, the sun shows Bierstadt's talents of resolution. The shining emblem of riches is made one with a spiritual vision, wealth and elevated sensibility becoming a unified golden aura. Bierstadt converted disparate prospects into a singular dramatic view in a way that artists like Martin lacked the means, or the interest, to conceive. Bierstadt's genius was to resolve instead of expose the dilemma of a class's conflicting self-definitions, and it is

Detail

no wonder that wealthy collectors sought his pictures to demonstrate both riches and refinement.

But the conflict between the two concepts still animates *Yosemite Valley, Glacier Point Trail*. The grandiose size of the picture and its broad golden sky leave little doubt that we should be reminded of opulence wherever we look. The transubstantiation of metal into haze only intensifies the effusion of value across the scene. Wealth is in the air. In King's terms, the dialect of the valley is alive and well in Bierstadt's mountains, where transcendence is spoken in slang. A.N.

Notes

1. For Revere's picture, see Peter J. Blodgett, *Land of Golden Dreams: California in the Gold Rush Decade, 1848–1858* (San Marino, Calif.: Huntington Library, 1999), 59. As valuable compendia of gold-rush imagery, see Blodgett's book and Janice T. Driesbach, Harvey L. Jones, and Katherine Church Holland, *Art of the Gold Rush* (Oakland: Oakland Museum of California, 1998).

2. Marryat described "*finders*, who would search all over the country for what they called a good *prospect*, that is, every appearance of a good vein of metal" (Frederick Marryat, *A Diary in America*, 3 vols. [London: Longman, Orme, Brown, Green, & Longmans, 1839], 2:129). His usage is the first one cited in *The Oxford English Dictionary*, 20 vols. (Oxford: Clarendon Press, 1989), 12:668.

3. Brian Roberts, *American Alchemy: The California Gold Rush and Middle-Class Culture* (Chapel Hill: University of North Carolina Press, 2000), 14. Roberts, in his excellent book, argues that middle-class gold-seekers sought to escape the confinement of bourgeois propriety, rebelling against their own class to find freedom and adventure, even as they ultimately reinscribed the values of their class, maintaining "their respectable pasts and positions" and asserting the act of rebellion against respectability as, ironically, a powerful means of securing class status (Roberts, 2000, 15).

4. See also Martin's related picture, *The Prospector* (1850, Oakland Museum), which combines both forms of prospecting—high and low—in the lone figure of the miner. Another picture of this type, William McIlvaine's *Panning Gold, California* (ca. 1850, Karolik Collection, Museum of Fine Arts, Boston), shows one prospector focusing on the immediate task of sifting a pan while another stares idly at a distant prospect. Both are reproduced in Driesbach et al., 1998, 12, 19.

5. Clarence King, *Mountaineering in the Sierra Nevada* (Boston: S. R. Osgood, 1872; repr. New York: Penguin, 1989), 20. One of the figures in King's book, a California landscape painter identified as Hank G. Smith, disparages Bierstadt's work (179–80). I am more interested, however, in the rhetoric shared by King's book and *Yosemite Valley, Glacier Point Trail*.

6. King, 1989, 250, 83. William Howarth, in his introduction to the Penguin edition of King's book, attributes King's condescension to "self-loathing," xix.

The Gilded Age

202

Winslow Homer (1836–1910)
A Game of Croquet, 1866

Oil on canvas, 23¾ x 34⅝ in. (60.3 x 87.9 cm)
Bequest of Stephen Carlton Clark, B.A. 1903,
1961.18.25

With the end of the Civil War in 1865, Americans struggled to find stability after nearly five years of violence and social discord. For Winslow Homer, an artist whose career had been established during the war, the peacetime transition was particularly challenging. In *A Game of Croquet*, Homer discovered a worthy subject from the world of popular culture, a source previously untapped by American artists. Between 1865 and 1869, he created a series of images focusing on the theme of croquet. In these images of secluded recreation, the artist captured the attitude of carefree oblivion that many people adopted soon after the war's end.

Croquet became a favorite pastime for wealthy Americans during this time. The object of the game is to hit one's ball, using a mallet, through a series of wickets while trying to deter one's opponents from doing the same by "croqueting" their balls—launching them far afield. The game provided a rare opportunity for members of the opposite

sex to compete in an outdoor sport on equal footing. Moreover, the playfully vindictive nature of the game, which allowed a player to select a victim from the opposing team and "croquet" his or her ball, imbued the sport with a flirtatious ingredient that further increased its popularity.[1]

In *A Game of Croquet*, two well-dressed women are seen mid-game in a tree-lined pasture late in the afternoon. The woman in red aims her mallet in an effort to propel her ball through the hoop in the center foreground. The figure in blue places her hand on her head in a gesture of dismay over the possible outcome of the shot. Characteristically, Homer avoided presenting a definitive

narrative in his canvas. Nonetheless, considering the work within the context of his war paintings reveals a subtle irony. Only months before, a similar gesture may have suggested sorrow at receiving news of a loved one's death, but now it is an idle diversion that causes consternation. The aggression displayed earlier on the battlefields between the "blue and the gray" has been transformed into the innocuous competition between the "blue and the red" in these calmer pastures, notably divided by a stone wall in the background. In his meticulous rendering of the women's clothing and jewelry, Homer connected the sudden enthusiasm for the game with the stylish dress of its participants,

making a commentary on the frivolousness of fashion. The colorfully banded hem of the woman's blue dress resembles the striped ball to her right, and her hoop skirt puns the hoop at which her competitor aims her ball. The lighthearted play portrayed in Homer's croquet scenes may have provided an antidote to the still-vivid memories of war. R.S.

Note

1. For a good summary of the social history of croquet, see David Park Curry, *Winslow Homer: The Croquet Game*, exh. cat. (New Haven: Yale University Art Gallery, 1984).

202

203

John Frederick Kensett (1816–1872)
Rocky Pool, Bash Bish Falls, 1865

Oil on paper, 40 x 25 in. (101.6 x 63.6 cm)
Estate of James W. Fosburgh, B.A. 1933,
M.A. 1935, 1979.13.2

In contrast to the heroic western landscapes
of his contemporary Albert Bierstadt,
John Kensett's landscapes were of popular
tourist sites in the east, all within easy reach
of railroad stations and hotels.[1] When he
painted *Bash Bish Falls*, the site in southwestern Massachusetts was already a fashionable
destination, famous as much for its
eighty-foot-high twin waterfalls, a series
of cascades leading into a steep gorge, as
for the legend of Bash Bish, in which a
beautiful Indian woman accused of adultery
was sentenced to death in the falls, where
she is said to appear from time to time in
the mists. Kensett gives no hint of the
travelers who flocked to the site. Instead,
he captures the sense of fresh discovery,
of a journey into the recesses of the wilderness, as if the tiny red-clad figures on the
cliff are the first visitors to come upon this
secret woodland.

With a palette restricted largely to earth
tones, Kensett used a range of brushwork to
animate the scene—rapid, angular strokes
in the trees, small stippling in the waterfall,
sweeping gestures in parts of the sky, and,
in the underbrush, varied impastos and transparencies. Tiny flicks of light glint off the
rocks, sharpening the details of their crystalline and granite surfaces. Kensett's concentration on the rocks reflects the period's passion for geology. "Of all the studies which
relate to the material universe," wrote one
critic, "there is none, perhaps, which appeals
so powerfully to our senses or which comes
into such close and immediate contact with
our wants and enjoyments, as that of geology."[2] Paintings like *Bash Bish Falls* played a
role in the geological enthusiasms of the
period, helping to promote American landscape tourism.[3]

Trained in his youth as an engraver of
maps and bank notes, Kensett carried over
his care for detailed draftsmanship to his
work as a leading figure of the Hudson River
School. His method was to make realistic,
detailed pencil sketches outdoors and then to
develop the sketches into finished paintings
in his New York studio.[4] Kensett's reverence
for nature's simple nobility influenced all
his work, imbuing the topographical, geological, and botanical character of each site
with such specificity that his viewers could
easily match painting and place.[5] H.A.C.

Notes
1. Rebecca Bedell, *The Anatomy of Nature:
Geology & American Landscape Painting,
1825–1875* (Princeton: Princeton University Press,
2001), 85.
2. *North British Review*, 1850, n.p., YUAG Object
Files.
3. Bedell, 2001, ix, xi.
4. See John Paul Driscoll and John K. Howat, *John
Frederick Kensett* (New York and London:
Worcester Art Museum in association with W. W.
Norton, 1985).
5. Bedell, 2001, 94.

203

CENTRAL-PARK, WINTER.
THE SKATING POND.

204

THE GRAND DRIVE, CENTRAL PARK N.Y.

205

Currier & Ives (active 1857–1907), publishers

204

Lyman W. Atwater (1835–1891), lithographer
After a painting by Charles R. Parsons (1821–1910)
Central-Park, Winter. The Skating Pond, 1862

Hand-colored lithograph, 21 15/16 x 31 7/8 in. (55.8 x 81 cm)
Mabel Brady Garvan Collection, 1946.9.1616

205

The Grand Drive, Central Park N.Y., 1869

Hand-colored lithograph, 22 x 32 in. (55.9 x 81.3 cm)
Mabel Brady Garvan Collection, 1946.9.1614

In the 1820s, New York City's Bowery was still graced by overarching trees. But the urban clutter of narrow streets, dense housing, and vanishing open space brought on by mounting numbers of immigrants and inhabitants after 1830 altered forever the eighteenth-century character of the city.[1] By mid-century, the continued urbanization of Manhattan raised the demand for open space in the city, and in April 1851, Mayor A. C. Kingsland asked the Common Council to support proposals for a public park.[2] Subsequently, and by an act of the state legislature in 1853, the land between Fifth Avenue and Eighth Avenue extending from Fifty-ninth Street to 106th Street—and by 1858 to 110th Street—was purchased. The park's design was intensely competitive, and on 21 April 1858, the commission and two-thousand-dollar prize were awarded to the partnership of Frederick Law Olmsted and Calvert Vaux.

The peak construction years for the park were 1859–60, but as early as December 1858, the partially filled lake near West Seventy-third Street drew large numbers of skaters on weekends.[3] The park's appeal was immediate: it filled a social and recreational role in the life of the city, as attested by these lithographs by the firm of Currier & Ives. For the first several years of the park's history, pedestrians, horseback riders, and carriages entering its gates were counted, and even if the numbers are of questionable accuracy, their sheer scale—an average of three to four million users annually—demonstrates its success.[4] For example, the *New York Times* published a brief note in January 1862 on winter activities, including this passage about recreation on the lake:

> Quite a goodly number of ladies gladdened the scene by their presence, and indulged in the healthy pastime of skating. Quadrille parties were formed, and the "Lancers" were skimmed through. Figure 8's were cut upon the ice by fancy skaters, who would occasionally glide backward, then forward, and every other way imaginable, that at last you begin to think they were more at home upon skates than upon their ordinary foot-gear. Tyro's were also there, who, if they did occasionally tumble, would laugh just as loud as those who were more expert, scramble up and off again, determined to persevere and overcome the skater's art.[5]

This lake is the setting for the Currier & Ives lithograph from the same year, *Central-Park, Winter. The Skating Pond* (cat. no. 204), with its hordes of skaters, the skate house on the right, and, a short distance beyond, the Bow Bridge.

The Skating Pond emphasizes the recreational and healthful aspects of winter sports that the park afforded most classes of New Yorkers, while *The Grand Drive, Central Park N.Y.* (cat. no. 205), published in 1869, is a parade of the fashionable on foot and in carriages. The area of the park depicted in *The Grand Drive* lies to the south and east of the lake, above the Fifty-ninth Street entrance. The building shown is the Arsenal, which predated the park and which the city bought from the federal government in 1856. The park is depicted as bucolic and sylvan, a place where nature is accessible, albeit planned, and where the city, just visible on the horizon, appears to be miles away. Both of these Currier & Ives lithographs are filled with people, and the reality of the park was not very different. Olmsted himself saw the purpose of Central Park as the socialization of the city's people, and he wrote in 1870, with more than a tinge of idealism, that only in Central Park will one find people mingling "with an evident glee in the prospect of coming together, all classes largely represented, . . . each individual adding by his mere presence to the pleasure of all others, all helping to the greater happiness of each."[6] Although the history of the park is one of contentious politics, opportunism and utopianism, the Currier & Ives images celebrate only its most positive aspects, and the social optimism of the scenes is typical of the company's output.[7] TH.B.

Notes
1. Clarence C. Cook, *A Description of the New York Central Park* (New York: F. J. Huntington, 1869; repr. New York: Benjamin Blom, 1972), 10–13. Cook provides an interesting history of the park by a contemporary prior to about 1858, 9–28.
2. Cook, 1869, 18, quotes in full the mayor's message to the council.
3. Noted in Roy Rosenzweig and Elizabeth Blackmar, *The Park and the People: A History of Central Park* (Ithaca, N.Y.: Cornell University Press, 1992), 211.
4. Cook, 1869, 30.
5. "At Central Park," *New York Times*, 3 Jan. 1862, 7.
6. Frederick Law Olmsted, *Public Parks and the Enlargement of Towns* (Boston: American Social Science Association, 1870; repr. New York: Arno Press, 1970), 18.
7. For Currier & Ives in general, see Harry T. Peters, *Currier and Ives: Printmakers to the American People* (Garden City, N.Y.: Doubleday, Doran, 1929–31); and *Currier & Ives: A Catalogue Raisonné*, 2 vols. (Detroit: Gale Research Co., 1984).

Thomas Eakins (1844–1916)

206

John Biglin in a Single Scull, 1874

Oil on canvas, 24 ⅜ x 16 in. (61.9 x 40.6 cm)
Whitney Collections of Sporting Art, given in
memory of Harry Payne Whitney, B.A. 1894, and
Payne Whitney, B.A. 1898, by Francis P. Garvan,
B.A. 1897, M.A. (HON.) 1922, 1932.263

207

The Schreiber Brothers (The Oarsmen), 1874

Oil on canvas, 15 x 22 in. (38.1 x 55.9 cm)
John Hay Whitney, B.A. 1926, M.A. (HON.) 1956,
Collection, 1982.111.1

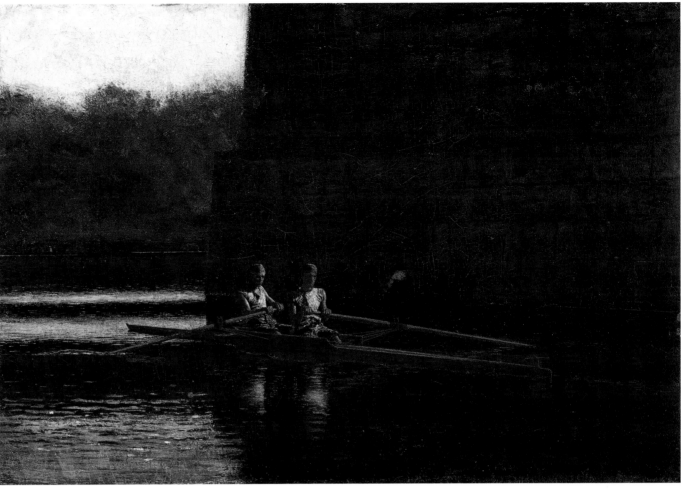

207

Upon returning to his native Philadelphia in
1870 after three years of studying art in Paris,
Thomas Eakins began a series of paintings
depicting men training for and competing in
rowing races on the Schuylkill River.[1] With
an attention to veracity unprecedented in
American art, Eakins merged the fashion for
healthful athleticism with the equally popu-
lar faith in mechanical precision to forge a
new mode of realism. He received his first
public recognition for a rowing painting, *The
Champion Single Sculls* (1871, Metropolitan
Museum of Art, New York), and the rowing
series represents a declaration of both his
creative philosophy and his artistic indepen-
dence from the still-dominant influence of
Europe. Painted just before the country
would celebrate its centennial in Fairmount
Park, near the banks of the same river used
by the city's rowers, these works present a
new model of heroic masculinity for the
new century.

Originally created as a study for a water-
color, *John Biglin in a Single Scull* (cat. no.
206) demonstrates Eakins's characteristic
meticulous brushwork, particularly evident
in the rhythmic reflections upon the water
and the thin metallic rods that support the
sculler's oars. Trained in calligraphy by his
father and in mechanical drawing in high

school, Eakins applied these skills to the
rowing pictures, executing gridded, geo-
metrical preparatory sketches and calculat-
ing the precise dimensions of the objects
painted in order to arrange them in correct
perspective. Despite this exacting ground-
work, Eakins imparted a compelling fresh-
ness to the scene, capturing the quivering
river surface and the delicate shadows that
fall upon the rower. Eakins was an avid
rower himself, and his painstaking prepara-
tory studies are artistic counterparts to the
rigorous training that was crucial to the sport
he loved.

Eakins's firsthand knowledge of rowing
enabled him to depict it with technical accu-

racy, which is evident in both the faithful
construction of Biglin's boat and the cham-
pion oarsman's form: his fully extended arms,
slightly arched back, and expression of total
concentration. A minor celebrity of his day
and a paragon in the world of rowing, John
Biglin came to Philadelphia in 1872 with his
brother Barney to compete for the world
championship in a pair-oared race. A profes-
sional rower, the twenty-eight-year-old John
worked at various times as a fireman,
mechanic, laborer, and boatman; he domi-
nated the sport as a single sculler, winning
almost every race he entered. Here he is at
practice. Within a vertical format that denies
the horizontality of the flowing river, Eakins

isolated and elevated Biglin, making him an
iconic figure, in charge of his own destiny
and the center of his own world.

In contrast, *The Schreiber Brothers* (cat. no.
207) illustrates the recreational and collab-
orative aspects of the sport. Set amid the
shadowy waters under the Columbia
Bridge, Eakins's friends Henry and Billy
Schreiber propel a pair-oared shell, a form of
rowing only recently popularized in the
United States by the Biglins. Eakins
included subtle signs of the rowers' amateur
status in such details as their slightly twisted
torsos and slackened arms. Using glowing
colors and dramatic lighting, he set the
brothers against the imposing stonework of

the pier. The artist portrayed their strenuous teamwork as just one of many forms of activity on the river. People fish from a boat in the shadows of the pier, and in the distant background near the opposite riverbank, a couple sits in a small rowboat. A barge on the riverbank, half-concealed behind the pier, identifies the waterway as part of the city's industrial landscape and, with its visual correspondence to the horizontal stern of the rowers' shell, emphasizes the Schreibers' exercise as a dynamic and overtly masculine form of leisure.

Like Winslow Homer's paintings of croquet players from nearly a decade earlier (cat. no. 202), Eakins's rowing paintings focused on a theme that previously had been documented only in popular prints. But whereas Homer portrayed the social aspects of leisure sports, Eakins emphasized athletic prowess. He depicted in detail the exact places, personalities, and equipment of his subject, and his images can be considered a modern form of history painting, ostensibly a record of the commonplace, that continues the example of Homer's Civil War paintings (cat. no. 94). Celebrating the heroism of daily life rather than military or political achievement, Eakins's rowing portraits such as *John Biglin* also exhibit a degree of idealism found in older forms of history painting, for instance, in their novel portrayal of the seminude, muscular male body. Moreover, in his choice of subject, Eakins invoked the most famous example of history painting in America, Emanuel Leutze's celebrated *Washington Crossing the Delaware* (1851, Metropolitan Museum of Art, New York), a subject often reproduced through engravings and one Eakins himself would render as a sculptural relief for a battle monument in 1894. By illustrating both single and paired rowers, Eakins articulated the twin poles of virtuous individualism and republican solidarity in American culture, a fact reiterated in the patriotic colors worn by the rowers in both paintings and reflected in the water like a fluttering Old Glory. For the generation of Americans who came of age after the Civil War, physically demanding pastimes provided a crucial means of exhibiting their individual spirit and gallant courage in a world increasingly structured by industrial management and bureaucratic conformity. R.S.

Note

1. See Helen A. Cooper, *Thomas Eakins, The Rowing Pictures*, exh. cat. (New Haven: Yale University Art Gallery, and New Haven and London: Yale University Press, 1996).

208

Thomas Eakins (1844–1916)
Rail Shooting on the Delaware, 1876

Oil on canvas, 22⅛ x 30¼ in. (56.2 x 76.8 cm)
Bequest of Stephen Carlton Clark, B.A. 1903, 1961.18.21

Hunting for the henlike rail in the marshes south of Philadelphia was a favorite pastime for many middle-class city dwellers, including Thomas Eakins. Hunters set off into the marshes of the Delaware River during high tide, when the water was deep enough to allow their boats to navigate through the narrow channels in order to drive the usually elusive birds from the protective cover of the reeds. In Eakins's painting, Will Schuster aims his rifle at an unseen bird, while Dave Wright, his poleman or pusher, steadies the boat, anticipating the force from the firearm's recoil. Schuster's fingers squeezing the trigger and Wright's bare feet gripping the boat in preparation for the ensuing reverberation provide the image with a sense of immediacy and anticipation.

This work was part of a series Eakins created between 1874 and 1876 depicting various moments in the hunt for rail. Like the artist's earlier sculling paintings, these images took as their theme a distinctively American subject and one from the world of popular sport. With the rise of urbanization and industrialization after the Civil War, many writers and physicians began to recommend the virtues of a balanced life that included both intellectual and physical activity. The marshlands of Philadelphia provided an ideal rural foil for the pressures of city life, and in the eminently masculine activity of hunting, urban "brain workers" found a needed expression of their manliness at a time when many professional men felt ineffectual and dispossessed by large corporate institutions.[1]

A similar balance between work and leisure is embodied in the two protagonists on Eakins's canvas. While both figures hold in their hands long, cylindrical tools that are crucial to the hunt, Schuster's rifle identifies him as the more powerful and technologically advanced of the two. Set within an American culture obsessed with the novel power of machines (and painted by a man whose initial artistic training was in mechanical drawing), *Rail Shooting* demonstrates that the same division between brain and brawn that characterized the industrial workplace also pervaded the world of leisure and was, moreover, racially coded.[2] Whereas Schuster's primary task as hunter involves visual acuity, Wright's role, although undeniably important, is mostly physical. Like a steam engine, which propels a larger craft, the pusher steers the boat across the marsh with his piston-rodlike pole. Even the hunter's unseen target alludes to the technological forces shaping American society. Just as the term "pusher" had explicit mechanical connotations in late-nineteenth-century America as a name for a common machine part, so did "rail" suggest the ubiquitous tracks covering the landscape and the mighty steam engines that traveled upon them. While acknowledging the inescapability of industry, *Rail Shooting* offers a vision of man as both master and murderer of the machine—the very implement that brought him into the marsh in the first place. R.S.

Notes

1. In *Man Made: Thomas Eakins and the Construction of Gilded Age Manhood* (Berkeley: University of California Press, 2000), Martin Berger provides an extensive reading of Eakins's oeuvre in light of the cultural and economic changes of late-nineteenth-century America.
2. The prevalence of machine culture in American society at the turn of the century has been explored most persuasively in Mark Seltzer's book *Bodies and Machines* (New York: Routledge, 1992).

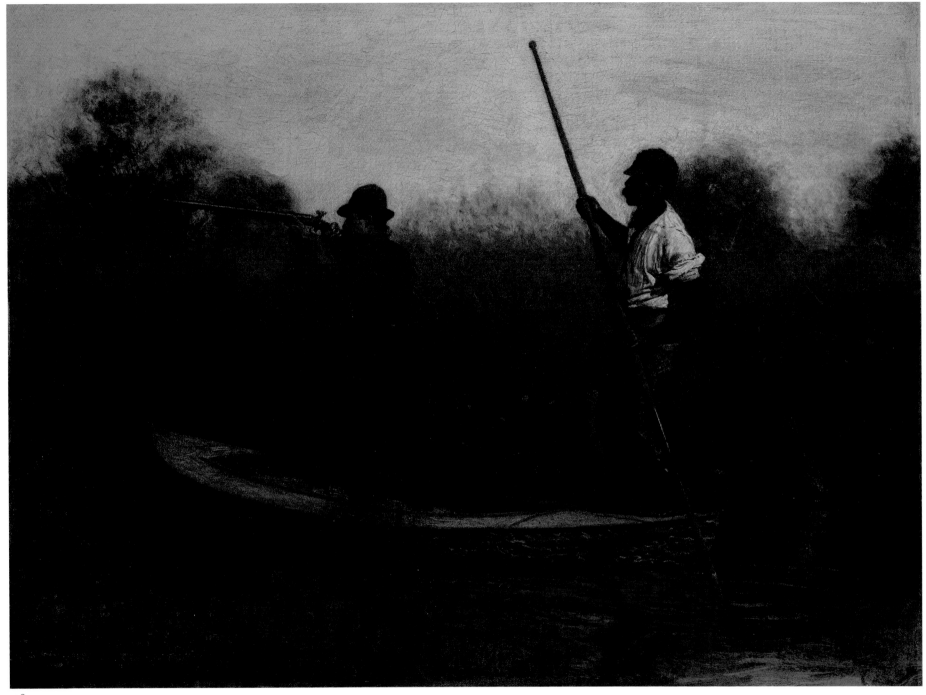

208

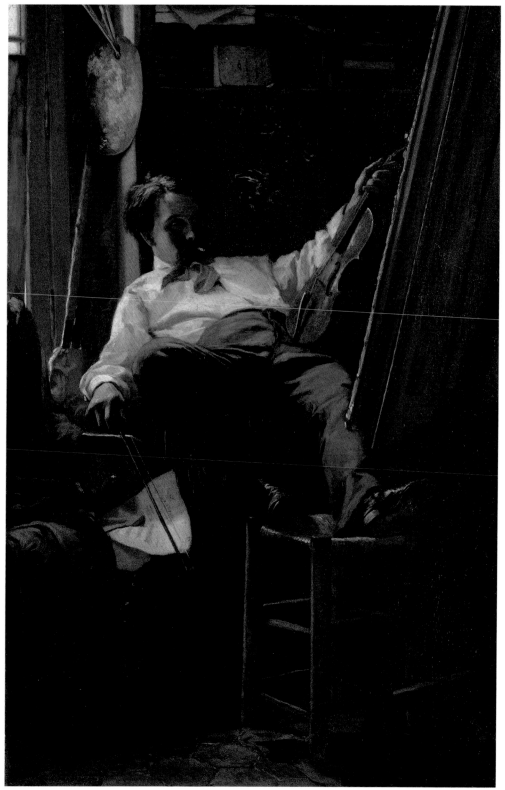

209

Thomas Hovenden (b. Ireland, 1840–1895)
Self-Portrait of the Artist in His Studio, 1875
Oil on canvas, 26 5/8 x 17 5/8 in. (67.6 x 44.8 cm)
Mabel Brady Garvan and John H. Niemeyer,
M.A. (HON.) 1874, Funds, 1969.28

In 1874, funded by two Baltimore business-men, Thomas Hovenden departed for France to hone his craft. Nearly thirty-five years old, he had already had a range of artistic experience, from frame-making and gilding to coloring photographs and illustrating. He studied with Alexandre Cabanel at the École des Beaux-Arts in Paris and then worked for five years in Pont-Aven. There Hovenden found his painterly voice. Drawn to romantic and historical subjects, he perfected the painstaking realism that would make him a favorite among international audiences in the years to come.

Prominently inscribed "Hovenden/Paris 1875," *Self-Portrait of the Artist in His Studio* dramatizes Hovenden's surrender to the artistic culture of Paris and his evolving sense of self. Two years earlier, in the United States, the artist had portrayed himself in reserved, respectable terms, with his hair neatly combed and his tie cinched tightly at the neck.[1] In Paris, he assumed the guise of the bohemian visionary, with mussed hair, flowing tie, and that essential marker of outsider status, the cigarette.[2] Drifting upward in airy blue swirls, the smoke issuing from Hovenden's cigarette mimics the winding contours of his body as an outward manifestation of his inner imaginative spirit. The portrait is a paean to the pleasures of such sensory stimulation; it is less about the art of painting—note that his hands hold violin and bow rather than palette and paintbrush, which are hanging idle on the wall behind the artist—and more about the art of living on the margins of respectable society.[3]

Sliding back on a chest to better view the painting on his easel, his legs splayed, Hovenden flouts bourgeois codes of decorum and creates the sensation that the viewer has been given a privileged glimpse of a private moment of meditation. The viewer focuses on the artist's body, whose potency is intimated by the phallic fingerboard of the violin stretching from his torso to the surface of the painting on his easel. The immodesty of this self-portrayal is tempered, however, by its allusions to that ancient icon of debauchery, the *Barberini Faun* (fig. a).[4] Drawing on this masterpiece of Hellenistic sculpture, the artist infused his presentation of modern bohemianism with an air of ancient legitimacy, asserting his debt to artistic precedent while declaring his position in Paris's artistic vanguard.

Yet this fashionable European vision of artistic identity represents everything that Hovenden was *not*. Upon his return to the United States in 1880, he criticized artists who spent too much time abroad and railed against solipsistic art-making that, as he said, tended "towards self-worship." Instead, Hovenden championed a homespun art for the people, far removed from bohemian experiments.[5] It was a crucial turn of artistic conscience; in the 1890s, American audiences would come to view anything tinged with the European or bohemian as depraved. His bohemian musings behind him, Hovenden achieved tremendous success. When Thomas Eakins was fired from the Pennsylvania Academy of the Fine Arts in 1886, Hovenden was the institution's choice as his replacement, and by 1890, according to one Philadelphia newspaper, he had achieved "immortal" status along with just four other artists, including such canonical masters as Winslow Homer.[6] But it was Hovenden's pivotal experience abroad, so perfectly encapsulated by this atypical self-portrait, that sealed his reputation and perhaps

stimulated his desire to promote the development of art in his adopted homeland. His career was cut short in 1895, when he died in a failed attempt to save a child from an oncoming train. J.A.G.

Notes

1. Private collection. Illustrated in *Americans in Paris, 1860–1900*, exh. cat. (London: National Gallery Company, Ltd., 2006), 57, fig. 4.
2. See Charles de Kay, *The Bohemian: A Tragedy of Modern Life* (New York: Charles Scribner's Sons, 1878), 25–26, for a description of the bohemian artist in these terms. On the cigarette, see Mrs. Jane Aster, ed., *The Ladies' and Gentlemen's Etiquette Book of the Best Society* (New York: G. W. Carleton & Co., 1878), 287; Julian Hawthorne, "A Peaceful Pipe," *The Galaxy* 20 (Nov. 1875), 685; and R. T. Trall, *An Essay on Tobacco-Using* (Battle Creek, Mich.: Office of the Health Reformer, 1872), 47. See also Sarah Burns, *Inventing the Modern Artist: Art and Culture in Gilded Age America* (New Haven and London: Yale University Press, 1996), 37, 335, n. 27; Elizabeth Wilson, *Bohemians: The Glamorous Outcasts* (New Brunswick, N.J.: Rutgers University Press, 2000), 37; and Patricia G. Berman, "Edvard Munch's *Self-Portrait with Cigarette*: Smoking and the Bohemian Persona," *Art Bulletin* 75 (Dec. 1993), 627–46.
3. David B. Cass, *In the Studio*, exh. cat. (Williamstown, Mass.: Sterling and Francine Clark Art Institute, 1981), 42, suggests that the painting may be an allegory of the senses. I thank Dennis Carr for suggesting this relationship between palette and violin, brush and bow.
4. Hovenden might have known the sculpture as early as the late 1850s, when he was studying plaster casts at the Cork School of Design.
5. For Hovenden's views on art's purpose, see "What Is the Purpose of Art?" *Norristown Daily Herald* (Pa.), 9 Feb. 1895, Frame 293, Reel P13, Thomas Hovenden Scrapbook, Archives of American Art, Washington, D.C.
6. "America's Immortals," *Philadelphia Inquirer*, 11 Oct. 1890, Frame 65, Reel P13, Thomas Hovenden Scrapbook, Archives of American Art, Washington, D.C.

fig. a *Barberini Faun*, ca. 220 B.C. Marble, h. 84 5/8 in. (215 cm). Glyptothek, Staatliche Antikensammlung, Munich, Germany

Thomas Eakins (1844–1916)

210

Kathrin, 1872
Oil on canvas, 65 x 52 ½ in. (165.1 x 133 cm)
Bequest of Stephen Carlton Clark, B.A. 1903,
1961.18.17

211

Maud Cook (Mrs. Robert C. Reid), 1895
Oil on canvas, 24 ½ x 20 ¹/₁₆ in. (62.2 x 51 cm)
Bequest of Stephen Carlton Clark, B.A. 1903,
1961.18.18

After he returned from study abroad in 1870, Eakins explored the theme of introspection in a series of paintings of women in domestic interiors, including this full-length portrait of his sister-in-law Kathrin Crowell (1851–1879) (cat. no. 210).[1] Eakins posed her in his family home, where darkness seems to entrap her. Her slight frame is dwarfed by the massive cupboard and bookcase behind her and the high back of the Renaissance Revival armchair—a throne-like chair of masculine proportions, suggestive of paternal authority, which appears repeatedly in Eakins's portraits of women.[2] While society portraitists of the period frequently depicted lovely ladies seated in armless chairs, with their dresses gracefully cascading unencumbered, Eakins highlights the muslin fabric of Kathrin's dress bunching awkwardly around the arm of a chair better suited to a man's clothing and larger body. In one bony hand, she holds an open fan; the other pauses in midair above a kitten on her lap. Fans and cats were often attributes of female sexuality in the paintings that lined the walls of the Salon exhibitions Eakins had recently seen in Paris. In contrast to the seductiveness promised by the direct gazes and engaging gestures in more conventional paintings of women in interiors, Kathrin turns her plain face into the shadows and withdraws into herself. Her concealed expression gives no hint of how she feels about the other person in this dimly lit room, the intently watching artist to whom she would become engaged in less than two years. Their engagement lasted five years, until Kathrin's death from meningitis at age 28.

At the same time that Eakins presented women in private moments of reverie, defining them by their emotional vulnerability, he also was depicting men taking action in the public arena, characterizing them by their intellectual or physical achievements (cat. nos. 206–8). His examination of polarities reflects cultural assumptions about gender roles and how they help determine individual character.

Eakins broached the theme of introspection again in his late portraits, which are frank explorations of individuals—both men and women—caught in the act of thinking (cat. no. 95).[3] More than two decades after painting *Kathrin,* Eakins depicted a young woman willing to have light flood her face, willing to allow him to reveal her sensuality (cat. no. 211). Years after sitting for her portrait, Maud Cook (1869–1956) recalled, "As I was just a young girl, my hair is done low in the neck & tied with a ribbon. . . . Mr. Eakins never gave . . . [the painting] a name but said to himself it was like 'a big rose bud.'"[4] His depiction makes vivid his simile, for the rippling layers of pink fabric covering the twenty-four-year-old Maud's bosom promise to be as delicate to the touch as unfolding petals—and just as suggestive of female anatomy. She remains a fresh bud in the process of opening, evoking not only a nascent eroticism but also the brevity of youth. Eakins's pictorial analogy between feminine and floral beauty avoids cliché, for his sitter is neither conventionally pretty nor easily accessible. By isolating her against a dark background

211

and tilting her head toward the light, he caught the dishevelment of her hair yet hides most of it in shadow; revealed the contours of her glowing neck and full lips yet bathed her expression with pensive melancholy. She looks away, but her eyes bear the emotional burden of the painting.

In comparison to *Kathrin, Maud Cook* conveys the somewhat greater autonomy of the new woman. Eakins positions Maud close to the picture plane and uses direct paint application to bring her forward, impressing the viewer with her magnetic appeal. Nonetheless, both portraits emphasize the sitters' vulnerability. The artist's perceptions were shaped by personal tragedy: his mother and his niece were both mentally ill—at a time when his friend the

neurologist and novelist Dr. S. Weir Mitchell linked such illness to women's inferiority—and both his fiancée, Kathrin, and his sister, Margaret, died early from physical maladies.[5] Eakins's portraits of female family and friends vacillate between his respect for his sitters as individuals—here he allowed Maud Cook to remain lost in her own thoughts—and his projection of his own consciousness onto theirs, making such portraits a record of a deeply conflicted dialogue between artist and sitter.

In *Maud Cook,* Eakins's brush carried the message of youthful promise, of life about to be discovered, within and without, painted by someone closely acquainted with disappointment. His own ambitions were dimmed after he was forced to resign in 1886 from his prestigious position at the Pennsylvania Academy of the Fine Arts for removing a loincloth from a male model in a class that included women; in 1895, the Drexel Institute dismissed him following a similar controversy. The uncompromising Eakins, who rarely received commissions, depicted those in his circle. Offering his "rose bud" as a gift, Eakins inscribed it to Maud on the reverse, and the portrait long remained in her possession. She posed in neoclassical draperies in Eakins's studio and participated in musical retreats at his sister's Avondale farm. There, among family and friends, the artist found refuge from public humiliation. Shortly before he painted this portrait, Eakins proclaimed, "My honors are misunderstanding, persecution, and neglect, enhanced because unsought."[6] Believing fervently in artistic mastery of the naked body—not the idealized nude—and refusing to conform to behavioral mores, he persistently asked sitters to pose without clothing; Maud was one of the few women who accepted.[7] That response suffuses his vision of her with sensuality and empathy. He conveyed a paradoxical mix of sexual

longing and psychological innocence, physical proximity and emotional withdrawal. While the candor of Eakins's late portraits remains exceptional for their time, his probing of the human soul—his own and his sitters'—tapped into a prevalent concern about how the anxieties of modern American life scarred the human psyche. R.J.F.

Notes

1. For a thoughtful reading of this portrait, see Jules D. Prown, "Kathrin," in *Thomas Eakins (1844–1916) and the Heart of American Life,* ed. John Wilmerding (London: National Portrait Gallery, 1993), 66–67. On the "gentle but condescending" tone of Eakins's letters to the younger Kathrin, see Kathleen A. Foster and Cheryl Leibold, *Writing about Eakins: Manuscripts in Charles Bregler's Thomas Eakins Collection* (Philadelphia: University of Pennsylvania Press, 1989), 64–66, 131, 154.

2. On the chair, see Kathleen A. Foster, *Thomas Eakins Rediscovered: Charles Bregler's Thomas Eakins Collection at the Pennsylvania Academy of the Fine Arts* (Philadelphia: Pennsylvania Academy of the Fine Arts; New Haven and London: Yale University Press, 1997), 10–12.

3. Eakins's portraiture after 1886 has been frequently studied; see John Wilmerding, "Thomas Eakins's Late Portraits," *Arts Magazine* 53 (May 1979), 108–12; Lloyd Goodrich, *Thomas Eakins,* 2 vols. (Cambridge, Mass.: Harvard University Press for the National Gallery of Art, 1982), 2:52–98; Elizabeth Johns, *Thomas Eakins: The Heroism of Modern Life* (Princeton: Princeton University Press, 1983); William J. Clark, "Iconography of Gender in Thomas Eakins's Portraiture," *American Studies* 32 (fall 1991), 5–28; Wilmerding, 1993; and Darrel Sewell et al., *Thomas Eakins,* exh. cat. (Philadelphia: Philadelphia Museum of Art, 2001), 257–351.

4. Mrs. Robert C. Reid (Maud Cook) to Lloyd Goodrich, 6 Sept. 1930, Lloyd Goodrich and Edith Havens Goodrich, Whitney Museum of Art, Record of Works by Thomas Eakins, Philadelphia Museum of Art, quoted in Goodrich, 1982, 2:69. The source of the sitter's given name, which is now known to be Matilda Ivins Cook, and life dates is a

letter dated 28 Apr. 1982 from Elizabeth K. Cramer, whose husband was Maud Cook's grandson (YUAG Object Files). For a sensitive reading of this portrait, see the entry by Elizabeth Johns in Wilmerding, 1993, 122–25.

5. On Eakins and Mitchell, see Norma Lifton, "Thomas Eakins and S. Weir Mitchell: Images and Cures in the Late Nineteenth Century," in *Psychoanalytic Perspectives on Art,* ed. Mary Mathews Gedo, 3 vols. (Hillsdale, N.J.: Analytic Press, 1985–88), 2:247–74; Kathleen Spies, "Figuring the Neurasthenic: Thomas Eakins, Nervous Illness, and Gender in Victorian America," *Nineteenth Century Studies* 12 (1998), 85–109.

6. Thomas Eakins, autobiographical statement, 23 Apr. 1894, Archives, Pennsylvania Academy of the Fine Arts, Philadelphia.

7. Weda Cook (Addicks), interview with Lloyd Goodrich, 30 May 1931, Lloyd Goodrich and Edith Havens Goodrich, Record of Works; cited by William Innes Homer, *Thomas Eakins: His Life and Art* (New York: Abbeville Press, 1992), 177.

212

212

Alexander Roux (b. France, 1813–1886)
Cabinet
New York City, 1860–75

Rosewood veneer, marquetry, plywood, soft
maple, American black cherry, chestnut, eastern
white pine, yellow poplar, curly maple veneer,
ormolu mounts, and porcelain plaques,
$50^{7}\!/_{8}$ x $69^{1}\!/_{2}$ x $16^{3}\!/_{16}$ in. (129.2 x 176.6 x 41.1 cm)
Mabel Brady Garvan Collection, 1970.55

This ornate Renaissance Revival cabinet by
Alexander Roux exemplifies the taste for the
eclectic in post–Civil War society. Although
there are shelves inside the piece, its main
function is display, not storage. The pedestal
on top of the cabinet is designed to hold a
clock, statue, or other valued possession.
Furthermore, with its elaborate decoration,
the cabinet not only displayed a family's art
objects but also served as an art object itself.
An exuberant blend of carving, veneer, inlay,
marquetry, and gilding with porcelain and
ormolu accents, the cabinet's design incorpo-
rates elements of Renaissance, neoclassical,
and rococo styles. The architectural elements
of the piece—its columns, pediment, and
pedestal—are typical of Renaissance Revival
furniture. The porcelain plaques on the doors,
probably imported from Europe, depict
courting couples and are directly derived
from Louis XVI designs. Intricate inlay rem-
iniscent of the classical designs popular in
the late eighteenth century surrounds each
plaque. The curved sides of the cabinet fea-
ture marquetry in a naturalistic floral design.
A gilded-bronze plaque depicting a classi-
cally garbed female figure is set in the cabi-
net's central column, while an ormolu cary-
atid figure decorates each of the front side
columns. The cabinet's cast-bronze mounts
could have been imported from Europe
along with the plaques or acquired from a
New York manufacturer such as P. E. Guerin

(cat. no. 213). Other cabinets similar to this one in design and decoration exist, some with only one door, others with marquetry in place of the porcelain plaques.[1]

The keys to the cabinet doors are stamped with the name "Roux." Alexander Roux was born in France in 1813 and by 1836 had immigrated to the United States and established a furniture business in New York City. In his advertisements, he referred to his French heritage and training, which would have appealed to American consumers eager to infuse their homes with a touch of European sophistication. As a furniture designer, importer, and interior designer, Roux worked in all of the many styles popular in mid-nineteenth-century America. In *The Architecture of Country Houses* (1850), influential author and arbiter of taste Andrew Jackson Downing recommended that consumers look to Roux for "the most tasteful designs of Louis Quatorze, Renaissance, Gothic, etc., to be found in the country."[2] E.E.

Notes
1. Gerald W. R. Ward, *American Case Furniture in the Mabel Brady Garvan and Other Collections at Yale University* (New Haven: Yale University Art Gallery, 1988), 12; Anne G. Perry, introduction to *Renaissance Revival Victorian Furniture*, exh. cat. (Grand Rapids, Mich.: Grand Rapids Art Museum, 1976). For other examples, see Perry, 1976, no. 2, and Anna Tobin D'Ambrosio, ed., *Masterpieces of American Furniture from the Munson-Williams-Proctor Institute*, exh. cat. (Syracuse, N.Y.: Syracuse University Press and Munson-Williams-Proctor Institute, 1999), 106, no. 36.
2. Dianne D. Hausermann, "Alexander Roux and His 'Plain and Artistic Furniture,'" *Antiques* 93 (Feb. 1968), 210; Catherine Hoover Voorsanger, "'Gorgeous Articles of Furniture': Cabinetmaking in the Empire City," in *Art and the Empire City: New York, 1825–1861*, ed. Catherine Hoover Voorsanger and John K. Howat, exh. cat. (New York: Metropolitan Museum of Art, and New Haven and London: Yale University Press, 2000), 308, 318; Andrew Jackson Downing, *The Architecture of Country Houses* (New York: D. Appleton and Co., 1850; repr. New York: Da Capo, 1968), 432.

213

Unidentified cabinetmaker
P. E. Guerin (1864–present),
manufacturer of bronze mounts
Sofa
New York City, 1865–75

Rosewood, ash, gilded bronze, and silk upholstery, 34 1/2 x 72 x 35 in. (87.6 x 182.9 x 88.9 cm)
Gift of Archer M. Huntington, M.A. (HON.) 1897, in memory of his mother, Arabella D. Huntington, by exchange, 1997.62.1

Although the classical and rococo revivals are perhaps the most famous of the many revival styles that influenced American decorative arts in the nineteenth century, artists and craftsmen also looked to other times and places for designs, including ancient Egypt, which inspired this sofa. Napoleon's expeditions to Egypt in the late 1790s and the beginning of the serious study of Egyptology brought this culture to the West's attention, particularly in architecture, but it was not until after the Civil War that elements of Egyptian design began appearing in American decorative arts in significant numbers. The 1869 opening of the Suez Canal, the 1873 American premiere of Giuseppe Verdi's opera *Aïda*, and the Egyptian pavilions at the 1876 Centennial Exhibition all helped stimulate America's interest in ancient Egypt.

Unlike other revival styles that manifested themselves as overall design schemes for rooms or even homes, the Egyptian Revival style was most often seen in specific ornaments in a room. This sofa, part of a larger parlor suite, has several "Egyptianizing" features, including its Nile-green silk upholstery. The sofa's paw feet are similar to the feline feet seen on surviving Egyptian furniture. The most Egyptian features of the sofa are the gilt-bronze mounts on each armrest. Manufactured by the New York City firm of P. E. Guerin, the mounts depict female busts wearing an Egyptian-style collar and a *nemes*, the traditional striped headdress of Egyptian royalty also seen on the famous Sphinx. While eighteenth-century cabinetmakers often used mounts to protect vulnerable areas on furniture, in the nineteenth century mounts were largely decorative. They were a popular expression of the Egyptian movement and were often used on chair arms.[1]

Founded in 1864 and still operating today, the P. E. Guerin company specializes in metal mounts and hardware. In the nineteenth century, under the direction of founder Pierre Emmanuel Guerin, its wares decorated the products of New York City's finest cabinetmakers, including Kimbel and Cabus, Léon Marcotte, Pottier and Stymus, and Alexander Roux. The wide variety of decorative mounts offered by P. E. Guerin and its competitors allowed furniture manufacturers to create pieces in any revival style by applying a range of mounts to a relatively generic base. As the interchangeable nature of the base furniture and gilt decorations makes clear, late-nineteenth-century revival styles had less to do with achieving historical realism than with creating an exotic and exciting domestic atmosphere.[2] E.E.

Notes
1. Both a sofa and a matching chair owned by the Brooklyn Museum retain elements of the original green-silk upholstery. The Yale sofa has been conserved with a reproduction fabric whose color and pattern evoke the original. Bernadette M. Sigler, "The Egyptian Movement in American Decorative Arts, 1865–1935," in *The Sphinx and the Lotus: The Egyptian Movement in American Decorative Arts, 1865–1935*, ed. Bernadette M. Sigler, exh. cat. (Yonkers, N.Y.: Hudson River Museum, 1990), 16–18; Barbara Laux, "The Furniture Mounts of P. E. Guerin," *Antiques* 161 (May 2002), 143.
2. Laux, 2002, 145; Kevin Stayton, "Revivalism and the Egyptian Movement," in Sigler, 1990, 7.

213

214

214

Thomas Jerome Wheatley (1853–1917)
T. J. Wheatley & Company (1880–82)
Vase
Cincinnati, Ohio, 1880–82
Buff earthenware, colored slip, and polychrome
and colorless glaze, h. 13¼, diam. 9¼ in.
(33.7 x 23.5 cm)
Mabel Brady Garvan Collection, by exchange,
1993.28.14

The crayfish, shells, and seaweed on this
vase, modeled from local clay and partly cast
from life, reflect an aesthetic derived from
the Japanese interpretations of nature that
engrossed many American artists and artisans
in the years following the Centennial Exhi-
bition of 1876 (fig. a). Japan's display in
Philadelphia's Fairmount Park gave many
Americans their first glimpse of the astonish-
ingly realistic depictions of a variety of
organisms, from spiders to crabs, adorning
precious objects in silver, mixed metals,

ivory, and bone, as well as clay and other
materials. Such curious and skillfully exe-
cuted products had captivated Western
Europeans for more than a decade.

One exhibitor at the Centennial Exhibi-
tion that had successfully adapted the Japa-
nese taste was Haviland & Co., a ceramics
manufacturer started by two American broth-
ers and their father in Limoges, France. The
firm's display of hand-painted earthenware
employing the barbotine technique—paint-
ing colored slip directly on unfired ware prior
to glazing—awed a group of amateur decora-
tors visiting from Cincinnati and inspired
their leader, Mary Louise McLaughlin, to
mimic the process.[1] When native Cincinnat-
ian Thomas Wheatley took up pottery deco-
ration in about 1879, the young sculptor
and painter was introduced to the barbotine
technique used in the background of
this vase, although he would later claim
he discovered it on his own, and even pat-
ented it.[2] This method was of tremendous

fig. a Hara Yōyūsai, *Shell Matching Tebako Box,* late 18th to mid-19th century. Lacquer decorated with silver, *kirikane* (cut gold), and gold dust, 3 x 6¾ x 9⅜ in. (7.7 x 17.3 x 23.7 cm). Scholten Japanese Art, New York

importance to Wheatley and other Ohio art potters, especially those at the Rookwood Pottery, which soon eclipsed the other early makers of "Cincinnati Faience." Wheatley, however, preferred painting most of his distinctive sculpted decoration with the glossy glazes used on contemporary majolica.[3]

The results met with instant approval, inspiring one critic to write, "Mr. Wheatley models his own vases, builds them up in bas relief . . . paints them on the wet clay and glazes them as well as the best Haviland ware"; his creations sold alongside those of Haviland and McLaughlin at Tiffany & Co. in New York City.[4] After opening his eponymous pottery in 1880 at 23 Hunt Street, Wheatley exhibited some two hundred examples that year at the Eighth Cincinnati Exposition.[5] This productive start ended abruptly when a fire destroyed the pottery and much of its inventory, making this large sculpted example, marked in script as model "No. 73" by "TJW Co.," a rare survivor of Gilded Age artistry in the Japanese taste. C.M.H.

Notes
1. Edwin Atlee Barber, *Pottery and Porcelain of the United States: An Historical Overview of American Ceramic Art with a New Introduction and Bibliography* (1893; repr. Watkins Glen, N.Y.: Century House Americana, 1971), 276, 279, 300.
2. For the most recent biographical information on Wheatley, see *Artists in Ohio, 1787–1900: A Biographical Dictionary* (London, England, and Kent, Ohio: Kent State University Press, 2002), 929.
3. In this respect, Wheatley's vase relates to the sculpted majolica made by the Renaissance potter Bernard Pallissey and his nineteenth-century followers, as Ellen Paul Denker pointed out in Wendy Kaplan et al., *"The Art That Is Life": The Arts and Crafts Movement in America*, exh. cat. (Boston: Museum of Fine Arts and Little, Brown, 1987), nos. 67–68.
4. "American Faience," *Crockery and Glass Journal* 12 (4 Sept. 1879), 12.
5. "The Cincinnati Exposition," *Crockery and Glass Journal* 12 (16 Sept. 1880), 10.

215

Chelsea Keramic Art Works (1872–89)
Teapot
Chelsea, Massachusetts, 1877–78

Earthenware with glazed interior,
7 3/8 x 9 7/8 x 3 3/8 in. (18.7 x 25.1 x 8.6 cm)
Yale University Art Gallery, 2000.77.3

The design of this Chelsea Keramic Art Works teapot is emblematic of the Japanese aesthetic as filtered through the English ceramic industry. The form of the vessel is taken from a Japanese fan, and the handle is fashioned after a stalk of bamboo. The motif of bamboo and birds adorning the sides appears in Japanese metalwork and textiles, as well as in graphic art. A teapot of this design was made by the Copeland Company of Staffordshire, England, in about 1874 (fig. a). A few years later, the Chelsea Keramic Art Works produced a redware example. One of the firm's owners, Hugh Cornwall Robertson, had attended the 1876 Centennial Exhibition and was profoundly influenced by the Asian ceramics on display. In duplicating the English model, the firm was confident it would sell well.[1]

The Robertsons also made an astute choice in using a local red clay. Terra-cotta was not only cost-effective but was already being championed by adherents of the Aesthetic movement in England and was catching on in Boston and New York. It also recalls the aesthetic of YiXing teapots, which were central to Japanese tea ceremonies and had been envied in Europe since the eighteenth century. Though larger than these, the makers of the Chelsea teapot achieved a comparable thinness by casting a slurry of clay into plaster molds and then assembling the parts. A thin, clear, lead glaze coating the interior sealed the porous earthenware clay, making it possible to use the pot for tea. The Chelsea Keramic Art Works produced the teapot in glazed majolica as well as this unglazed version.[2] C.M.H.

215

Notes
1. For an account of the Chelsea Keramic Art Works, see Doreen Bolger Burke et al., *In Pursuit of Beauty: Americans and the Aesthetic Movement*, exh. cat. (New York: Metropolitan Museum of Art and Rizzoli, 1986), 407–8.
2. Collection of the Smithsonian Institution, National Museum of American History, inv. no. 65.1, Gift of Dr. Lloyd E. Hawes.

fig. a W. T. Copeland, *Teapot*. Stoke-on-Trent, Staffordshire, England, ca. 1874. Parian and pewter, 5 3/4 x 8 1/2 in. (14.6 x 21.6 cm). Collection of Ralph and Terry Kovel

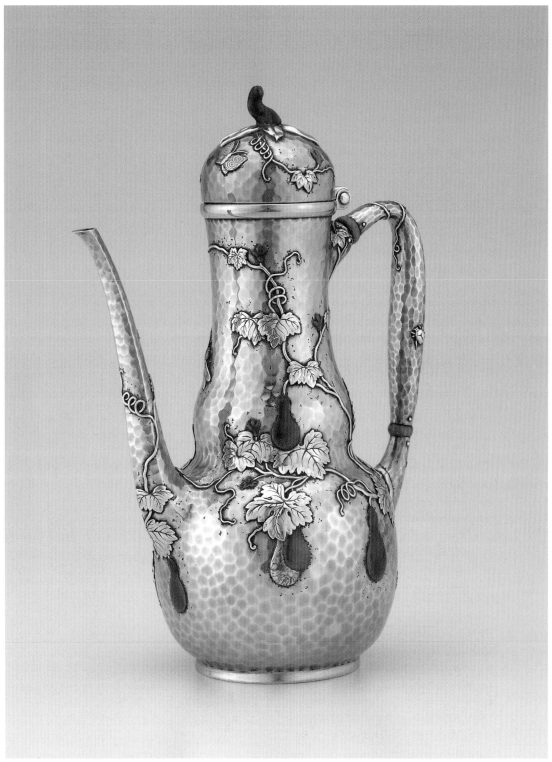

216

Tiffany & Co. (founded 1837)
Coffeepot
New York City, 1877–78

Sterling silver, ivory, and silver, copper,
and brass alloys, h. 10¾, w. 8, diam. 5¾ in.
(27.3 x 20.3 x 14.6 cm), wt. 31 oz., 3 dwt.
(970 gm)
Mrs. Alfred E. Bissell, Mr. and Mrs. Samuel
Schwartz, Mr. and Mrs. E. Martin Wunsch, and
the American Arts Purchase Funds, 1981.98

After centuries of isolation, Japan in 1854 had
been forced to open its doors to the West.
Soon thereafter, the influence of Japanese
culture was seen in "everything from music
and theatre to advertising and home fur-
nishing."[1] Tiffany & Co., realizing the mar-
keting potential of the new interest in all
things Japanese, sent the British designer
Christopher Dresser to Japan on a buying trip
in 1876. Dresser returned with nearly two
thousand objects, from carved jade and pot-
tery to textiles and lacquer, which, in 1877,
Tiffany exhibited and then auctioned at the
Clinton Hall salesrooms in New York.
Though this initial sale was not very success-
ful, Tiffany's design director, Edward C.
Moore, used the objects as the basis for a
multitude of designs in the "Japanese" style,
including Yale's coffeepot.[2]

Both the form of the object—a bulbous
double gourd with curving, vinelike handle
and spout and stemlike lid and finial—and
its decoration of applied dragonfly, butterfly,
beetle, and gourds were seen as particularly
"Japanese" by Westerners and were used by
Tiffany on many of its pieces in various com-
binations. Furthermore, to render these
applied forms, Tiffany's workmen used a
Japanese metalworking technique called
mokume, in which layers of different metals
are repeatedly hammered and folded until
the metals mix, creating a marbled effect, as
visible on the pair of overlapping gourds at

the center of the lower part of the pot.
These pieces in the Japanese aesthetic dom-
inated the metalwork category of the Paris
Exposition of 1878, earning Tiffany & Co. a
Grand Prix, Edward C. Moore a gold
medal, and Charles L. Tiffany the title of
"Chevalier of the Legion of Honor in
France" (fig. a).[3]

Tiffany's Japanesque pieces were also mar-
ketable at home. The vine and gourd design
became a particular favorite of the American
public after its 1877 issue, which is evident
in both the wear of the design pattern sketch
and the numerous order numbers recorded
for it in the Tiffany & Co. pattern ledger.
By owning a piece of Japanesque Tiffany
silver, Americans could not only show that
they were wealthy enough to purchase
such a lavish and expensive object, but also
express their awareness and embrace of con-
temporary fashion. K.W.

Notes
1. Tiffany & Co. Archives. In addition, this coffee-
pot was illustrated in the November 1879 "National
Repository," as shown in Christie's, New York
(*Important American Furniture, Silver, and Folk
Art Featuring the Lafayette Washington Pistols
and English Pottery from the Collection of the Late
Robert J. Kahn*, 18 Jan. 2002, 112).
2. This design is No. 138, "Hammering Design for
Coffee of Tea Set No. 4872." Both the design sketch
and the pattern ledger are in the Tiffany & Co.
Archives in Parsippany, N.J.
3. A coffeepot identical to this one appears in many
photographs taken at the Paris Exposition, in the
Tiffany & Co. Archives.

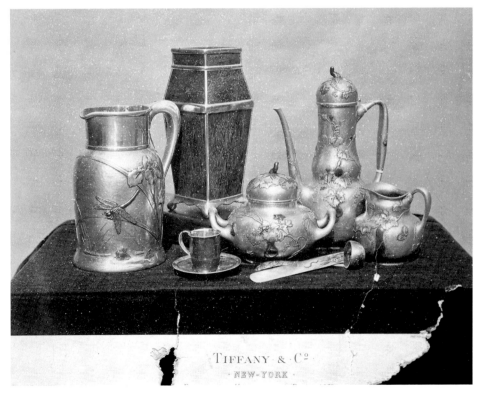

fig. a Tiffany & Co. Silver Hollow ware
shown at the Paris Exposition of 1878,
ca. 1878

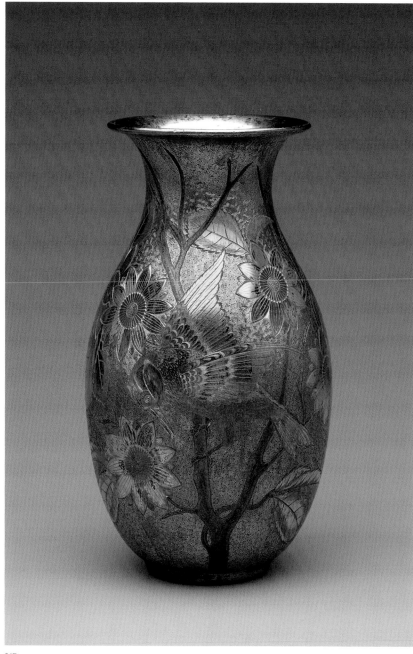

217

217

Meriden Britannia Company
(1852–98)
Vase
Meriden, Connecticut, 1882–83

Copper, brass, silver, and gold plate on white
metal, h. 11½, max. diam. 5¼ in. (29.2 x 13.3 cm)
Yale University Art Gallery, 2000.77.2

A product of the "Japan craze," which seized
America in the late nineteenth century,
this vase reflects America's fascination with
that country's art and culture. The United
States not only imported Japanese goods in
large numbers but also produced Japanese-
influenced designs of its own.

While Tiffany and Gorham, America's
leaders in silver design and manufacture,
sold Japanese-style silver designs to an elite
upper-class clientele, silver-plating companies
aimed their products at the growing middle
class. Although silver-plated objects were by
no means cheap, they were less expensive
than similar solid silver goods. Furthermore,
since less of the cost of silver-plated objects
was determined by their materials, they were
often much more elaborately and ostenta-
tiously decorated than sterling silver objects.[1]

The silver-plating industry was highly
competitive in this period. The Meriden
Britannia Company was battling for market
share with at least a dozen other companies
in Connecticut and Massachusetts. Seizing
the chance to increase sales, it quickly inte-
grated Japanese-inspired designs into its
product line. In 1882, the company com-
pletely redesigned its marketing materials
along a Japanese theme. This vase, model
number 397, appears as a late addition to the
company's 1882–83 catalogue. It was avail-
able in three finishes: silver or gold "Russian
inlay," at $41, and "India chasing," at $42.50.
This particular vase is the most expensive
version: the "India chased gold inlaid"

model. Knowing that the general public did
not completely grasp the complexities of
metalsmithing, silver-plating companies
tossed around terms such as "inlaid" and
"chased" to give their pieces a more exclusive
cachet. The "India chased" background on
this example is not actually chased but rather
acid-etched. Similarly, the "inlaid" gold on
this piece is not inlaid but made by selective
electroplating. By electroplating gold, silver,
and copper on a britannia metal base, the
company could re-create the look of mixed-
metal Japanese goods. The varied colors of
the metals highlight the engraved bird and
flowers that embellish the vase.[2]

In their attempts to draw on the Japanese
aesthetic, American silver-plate designers
placed a major emphasis on surface texture.
American silversmiths had traditionally
sought a smooth surface with occasional
applied, chased, or engraved decoration, but
Japanese metalwork featured such a wide
variety of textures that smooth surfaces
became a rarity.[3] This concern with texture
can be seen in the vase's zigzag background
pattern, which resembles the representations
of cracked ice and lightning that often appear
on Japanese artwork. E.E.

Notes
1. William N. Hosley, Jr., *The Japan Idea: Art and
Life in Victorian America*, exh. cat. (Hartford,
Conn.: Wadsworth Atheneum, 1990), 126.
2. Ibid., 130–33; Meriden Britannia Company,
*Appendix to Meriden Britannia Co.'s Illustrated
Catalogue and Price List . . .* (Meriden, Conn.:
Meriden Britannia Co., 1882–83), pl. 5, Meriden
Historical Society.
3. Hosley, 1990, 130, fig. 114b.

218

Meriden Britannia Company (1852–98)
Ice Urn, Goblets, and Slop Bowl
Meriden, Connecticut, ca. 1884

Silver electroplated white metal and porcelain,
25 9/16 x 12 13/16 x 16 3/4 in. (65 x 32.5 x 42.6 cm)
Yale University Art Gallery, 1995.35.1.1–.4

The mechanical procedures used to fabricate
and decorate this ice-urn set demonstrate the
shift from the small-scale shop to the large-
scale factory that took place in the decades
after the Civil War. The hollow-ware forms—
like the urn, its goblets, and its cover—were
spun. Elements of the decorative ornament,
including the geometric surface of the two
goblets and the stippled finish on the base,
were produced by die rolling and acid etch-
ing. The surface of the set's five individual
pieces—the urn, the slop bowl and base, and
the two goblets—was also produced by a
mechanical process, in which silver and gold
were transferred from a solution onto the
base metal by means of an electric current.[1]

By increasing supply and lowering prices,
the industrialization of the silver industry
made large and intricate pieces of silver
affordable to the middle class. The engraved
inscription on the lid of the urn, "LB / From
the Field and Staff / 1st Reg[T] / CNG," indi-
cates that the set was purchased by one of the
institutions of this class, the Connecticut
National Guard, which awarded it to Lucius
A. Barbour, a colonel who retired from its
ranks in 1884. As a banker and investor in
the new industries that blossomed in Hart-
ford, Connecticut, during the years after the
Civil War,[2] Barbour would have appreci-
ated the technological innovation that cre-
ated the ice-urn set. Yet the objects make no
explicit visual reference to the advanced
methods of their production, nor do they
include any images that testify to Barbour's
military career.

Instead, the urn's decoration—flower
arrangements and Japanese-inspired birds,
butterflies, and insects hovering over placid
lakes with wooded shores—defiantly evokes
the antithesis of this militaristic and indus-
trial era. On one level, this peaceful world
was a fitting emblem for the beverage—ice
water—that this set was made to dispense.
Ice water was first celebrated in the late
nineteenth century for its salutary benefits.
Encouraged by a trend toward more diverse
meals and refined dining, the ideas of a bur-
geoning temperance movement, and a grow-
ing spirit of health consciousness, a group
of wealthy taste-makers defined water as a
purifier of and antidote to the evils inherent
in the rapid industrialization of post–Civil
War America. As one *Harper's New Monthly
Magazine* writer noted, "Half the passions,
crimes and miseries of humanity would be
calmed down under the influence of water."[3]
But the organic motifs of the ice-urn set
seem at odds with the industrial processes
by which it was made. Though men like
Barbour celebrated and profited from tech-
nological advancement, it appears that
references to this progress—like Barbour's
military service—were not acceptable in
the middle-class parlor. In this space, the
world of work was concealed beneath
the purifying aura of a beverage and the
serene imagery of nature. E.L.

Notes

1. Stephen Victor, "From the Shop to the Manufac-
tory: Silver and Industry, 1800–1970," in *Silver in
American Life: Selections from the Mabel Brady
Garvan and Other Collections at Yale University*,
ed. Barbara McLean Ward and Gerald W. R.
Ward, exh. cat. (New Haven: Yale University Art
Gallery, and New York, American Federation of
Arts, 1979), 23–31.
2. Donald Barber, *Connecticut Barbours* (Utica,
Ky.: McDowell Press, 2001), 348.
3. Quoted in Charles Venable, "The Silver-Plated
Ice Water Pitcher: An Image of Changing America,
1850–1900," *Material Culture* 19 (spring 1987), 43.

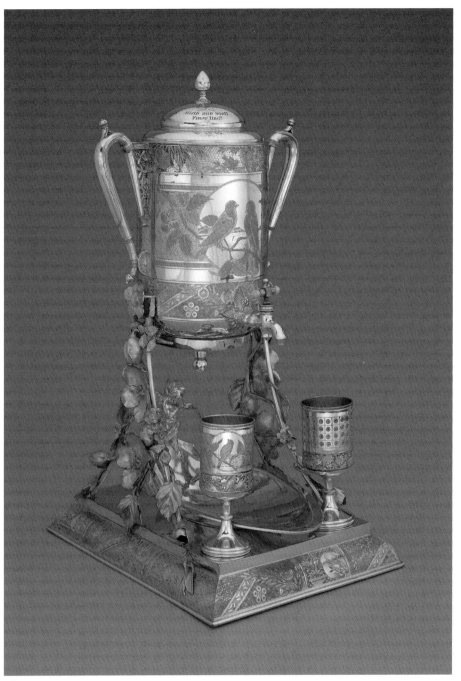

218

219

Kimbel & Cabus (active 1863–82)
Parlor Cabinet
New York City, 1876–82

Ebonized cherry with painted panels and printed-paper appliqués, gilding, brass, velvet, and mirrored and transparent glass, 78 x 52 15/16 x 16 1/8 in. (198.1 x 134.5 x 41 cm)
Gift of Thomas D. Cabot, Jr., and Charles Seymour, B.A. 1908, and bequest of Olive Louise Dann, by exchange, 1997.2.1

During the late nineteenth century, prosperous Americans demonstrated their refinement by collecting "artistic" objects and exhibiting them in display cabinets. Every detail of the decoration on this cabinet was intended to convey the owner's cultivated taste. The cabinet doors with their gold ground evoke thirteenth- and fourteenth-century Italian panel paintings, while the striking ebonized surface reflects the fascination with Japanese aesthetics that followed the opening of Japan to the West in 1854. Conceived in the Reform Gothic style, the cabinet's rectilinearity was inspired by a reverence for medieval models of the preindustrial past, as espoused in the writings of taste-makers Charles Locke Eastlake and others.[1] The principal influence was the English designer Bruce J. Talbert, who rejected the florid lines and naturalistic ornament of the Rococo Revival and emphasized simplicity of structure, two-dimensional ornament, and stylized, abstract patterns—all features he identified with medieval furniture. Talbert's designs were published in 1867 and 1868 in *Gothic Forms Applied to Furniture* and in *American Architect and Building News* following his untimely death. His design for a "bric-a-brac cabinet" has the "setback" profile, figural panels, and unusual glazed, hinged doors seen on Yale's cabinet.[2]

Kimbel & Cabus became closely identified with this style after the New York firm displayed a drawing room at the 1876 Philadelphia Centennial Exhibition to great acclaim.[3]

It produced a range of similarly styled geometric Gothic cabinets, wall shelves, tables, and other forms that appealed to a sophisticated middle- to upper-middle-class clientele. Other Kimbel & Cabus furniture incorporates some of the same decorative flourishes used on this cabinet.[4] Unlike elite firms like Herter Brothers, which used costly materials, elaborate upholstery, and labor-intensive ornamental techniques, Kimbel & Cabus produced furniture that was available in a range of prices, from relatively inexpensive objects made of oak with nickel hardware to pricier models like this one with its carved, ebonized surface and incised, gilded hardware. A distinctive feature was the firm's use of printed-paper appliqués. The tilelike panels of musicians directly above the painted doors, the circular panels, the narrow, horizontal bands of patterns used in four different places, and the back-to-back birds, which derive directly from Christopher Dresser's *Studies in Design* of 1876, are all paper.[5] This method created the appearance of marquetry and inlay without the expense. C.M.H.

Notes
1. Marilynn Johnson, "The Artful Interior," in Doreen Bolger Burke et al., *In Pursuit of Beauty: Americans and the Aesthetic Movement*, exh. cat. (New York: Metropolitan Museum of Art and Rizzoli, 1986), 110–41.
2. Sally MacDonald, "Gothic Forms Applied to Furniture: The Early Work of Bruce James Talbert," *Furniture History: Journal of the Furniture History Society* 23 (1987), 54.
3. For more on the firm founded by Anthony Kimbel and Joseph Cabus, see Catherine Hoover Voorsanger's entry in Burke et al., 1986, 446–47.
4. Kimbel & Cabus [Furniture designed and sold by the New York firm of Kimbel & Cabus], four albums of photographic and negative prints (ca. 1875), Cooper-Hewitt, National Design Museum Library, New York.
5. Christopher Dresser, *Studies in Design* (London: Cassell, Peter, and Galpin, 1876; repr. London: Studio Editions, 1988), pl. 6.

220

Reverse

220

Samuel Kirk and Son (partnership of 1868–96)
Covered Ewer and Stand
Baltimore, 1881–90

Sterling silver, ewer 10 13/16 x 8 15/16 x 5 1/8 in. (27.4 x 22.7 x 13 cm); stand h. 1 1/8, diam. 9 7/16 in. (2.9 x 24 cm), wt. 64 oz., 18 dwt. (2019 gm)
Mabel Brady Garvan Collection, by exchange, 1994.44.1.1–.2

The eclecticism of American design in the last quarter of the nineteenth century is exemplified by this object, which synthesizes a variety of historical and contemporary sources. Silver ewers with similar bell-shaped bodies and angular handles were made in Spain during the later sixteenth century. The bands of chased foliate ornament derive from ancient and Renaissance prototypes. The finial of a youth emptying a flask into his mouth is reminiscent of pastoral figures in eighteenth-century French *fêtes-galantes* paintings. These diverse historical models reflect the late Victorian belief that contemporary Western culture represented the apogee of centuries of civilization and was therefore entitled to appropriate freely from this broad heritage. As one critic observed of American silver exhibited at the 1900 Exposition Universelle, "Every race indigenous to the soil has been made to offer tribute in the form of models or decorative schemes."[1]

The manufacturer of this ewer and stand, Samuel Kirk and Son of Baltimore, was renowned for its lavish use of chased ornament. Two classical scenes centered on embracing couples were chased on the ewer's lowest register. Most of the figures were copied from two drawings published in 1881 by the British architect and designer John Moyr Smith. The lower register pictured on the left condenses the composition of Moyr Smith's *Epithalamios*, which portrays

fig. a John Moyr Smith, *Epithalamios*, 1881 after a drawing of 1873, from *Decoration* 2 (Aug. 1881)

fig. b John Moyr Smith, *Terpander Singing in Lesbos*, 1881, from *Decoration* 2 (July 1881)

an ancient Greek wedding procession, by flanking the central group with seated figures from the far left and right of the original drawing (fig. a). On the reverse, various subsidiary figures from *Epithalamios* and another composition, *Terpander Singing in Lesbos*, were grouped around a man and woman taken from an unidentified source (fig. b). Known today as a follower of Christopher Dresser, Moyr Smith enjoyed considerable fame for his designs of the late 1870s and early 1880s, most notably for Minton tiles. The use of these two designs indicates that Moyr Smith's periodical *Decoration* was available in Baltimore, just as Dresser's designs were used on furniture made in New York by Kimbel & Cabus (cat. no. 219).[2]

These scenes featuring couples, one of them in a wedding procession, suggest that the ewer was a special commission in celebration of a marriage or anniversary. The finial figure, moreover, is seated on a basket overflowing with grapes, perhaps indicating that the ewer was intended for wine. Undoubtedly a custom order intended to make a sumptuous statement, the set unfortunately bears no owner's monogram or initials, and the model number "306" stamped on the ewer cannot now be connected to a specific client in Samuel Kirk and Son's fragmentary records. D.L.B.

Notes

1. For Spanish ewers, see Charles Oman, *The Golden Age of Hispanic Silver, 1400–1665* (London: Her Majesty's Stationery Office, 1968), figs. 190, 195, 224. For the review of the Exposition Universelle quote, see Janet Zapata, "The Rediscovery of Paulding Farnham, Tiffany's Designer *extraordinaire*, Part II: Silver," *Antiques* 139 (Apr. 1991), 722–24.

2. For Moyr Smith, see Annamarie Stapleton, *John Moyr Smith, 1839–1912: A Victorian Designer* (Shepton Beauchamp, England: Richard Dennis, 2002). *Terpander* was published in *Decoration* 2 (July 1881), and *Epithalamios* in *Decoration* 2 (Aug. 1881), both as unpaginated lithographic plates.

Detail

221

Thomas Nast (b. Germany, 1841–1906)

221

The Capital $ Ceiling Scandal, 1889

Pen and ink, 25 ⅝ x 17 ½ in. (65.1 x 44.5 cm)
Gift of Edward K. Mills, Jr., LL.B. 1931,
1962.60.10

222

To the Victors Belong the Spoils, 1889

Pen and ink, 19 ⅝ x 15 ⅝ in. (49.8 x 39.7 cm)
Gift of Cyril Nast and Mrs. Mabel Nast
Crawford, 1954.62.3

223

English Syndicate (British Gold), 1889

Pen and ink, 17 ⅝ x 25 ⅝ in. (44.7 x 65.1 cm)
Gift of Edward K. Mills, Jr., LL.B. 1931,
1962.60.12

224

"It Leads **U S** *To* **A** *Challenge." "It was
indeed a 'Wild and Reckless' Sacrifice of
Blood and Money To Save One's Country To
Be Ruled Over by One So Ungrateful!"*
—*A Union Veteran (Sharpshooter)*, 1893

Pen and ink, 22 x 15 ⅞ in. (55.9 x 40.3 cm)
Gift of Cyril Nast and Mrs. Mabel Nast
Crawford, 1954.62.4

Bavarian-born Thomas Nast was one of the
most influential artist-satirists in United
States history. His scathing illustrations of
well-known public figures subtly insinuated
their character traits and personal weak-
nesses into a potent combination of truth and
exaggeration, which he reinforced with satir-
ical titles. Nast's Tammany Tiger (fig. a),
introduced in 1871, soon became graphically
synonymous with "Boss" William Marcy
Tweed and his powerful Tammany Hall syn-
dicate, a gang of corrupt politicians who
controlled the government of New York and
defrauded the city of some $200 million

dollars, ultimately leading to Tweed's convic-
tion and lifetime imprisonment. Nast created
the familiar personification of Santa Claus
and the stock figure of Uncle Sam that is still
recognized today (cat. no. 223).[1] Nast also
introduced the Republican elephant, the
Democratic donkey,[2] and the dollar sign as
a symbol of greed or fiscal dishonesty. In
the post–Civil War decades, a period that
came to be known as the Gilded Age, his
sharp wit and biting images in *Harper's
Weekly* were devastating expressions of a
country struggling to regain social order in
the face of rampant political corruption,
burgeoning immigration, labor-union unrest,
and economic instability.

"The Capital $ Ceiling Scandal," inscribed
on a ceiling crossbeam (cat. no. 221),
addresses the construction history of one of
the nation's most elaborate and expensive
state-capitol buildings. In 1868, the New York
State Constitutional Convention, sitting in
the Old Capitol building, voted in favor of
the construction of a new building, the cost
not to exceed four million dollars. Finally
completed in 1899 for over twenty million
dollars, it was the most expensive government
building of its time.[3] The dollar signs in the
drawing underscore this profligacy with
public funds.

In Nast's exposé, Democrat David
Bennett Hill, a governor (1885–92) and
U.S. senator (1885–97), is shown walking
upside down on the Chamber ceiling of the
infamous Albany building. Hill's reputation
was besmirched by scandal as he deftly
manipulated powerful alliances to win local
and state offices. Supported by the organiza-
tions named on his magnetized footwear,
he is suspended from the elegant Chamber
ceiling—a "high" place, labeled "A Loose
Plank / Hill's Platform." Tammany Hall
(its name appears on one of the magnets)
retained its influence on New York politics
despite Tweed's conviction. The inscription

"ALCO/Hall" on the other magnet is a play on the name "Hall" of New York City mayor Abraham Oakley Hall (note the "A/O" of "Hall" inside the magnet). Known as "Elegant Hall" for his flashy, stylish clothing, he was a strong ally of Boss Tweed and was twice indicted for his part in Tweed Ring scandals.[4]

Tucked under Hill's arm is a blackboard inscribed "White House 1892" with a balloon, "D—/B—/Hill" attached, anticipating his presidential ambitions. Were Hill to be nominated, party alliances would be crucial in swinging the powerful bloc of New York State electoral votes to his side. Votes for a syndicate-supported candidate such as Hill were "bagged" through promises of political favor or outright bribery. For encouraging voters to get to the polls, party workers received "favors" from local and national sources.[5] Money to support these

political organizations was often raised by "taxing" wealthy individuals eager for office, while illegal protection from liquor and other taxes was available for a price paid to organized politics—hence, "Whiskey" and "Water" on Hill's epaulettes.

To the Victors Belong the Spoils (cat. no. 222) revisited one of Nash's favorite targets: granting political favors to win office. As the Democratic presidential candidate in 1872, Horace Greeley was obliged to sell his daily newspaper, the *New York Tribune*, and to relinquish his position as editor. In this drawing, Nast accuses Greeley of seeking the endorsement of the popular daily that was once his. The organ grinder is Whitelaw Reid, the paper's new owner and editor, who declared that the *Tribune* was not a "party organ," despite its obvious support for Greeley over the incumbent Republican Ulysses S. Grant.[6] In this image, the bag of money drawn on

the front of the organ box makes clear Nast's message about the spoils.[7] Reid resigned as the paper's editor in 1889, the date of this drawing. By then, Reid had adapted his politics to suit the times: he was appointed minister to France by Republican president Benjamin Harrison. Nast noted Reid's shifting allegiance by including an Eiffel Tower and the female personification of France, seated under a tattered tricolor at the left, wearing the Phrygian cap of Liberté. A small dog caricatured as Reid appears puzzled by a reference to his former self, the organ grinder. Reid returned to the United States in 1892 to run for vice president under Benjamin Harrison, but they lost this election to Democrat Grover Cleveland.

After the Civil War, Nast viewed with chagrin the growing abuse of power by European countries in their dealings with the United States. In *English Syndicate (British Gold)* (cat. no. 223), Nast specifically condemned rapacious British investors, personified here as John Bull, who were buying up American industries with hard money—goldbacked British pounds—and dumping them into "English Syndicate" ownership. Nast feared meddlesome European countries and was wary of potential foreign control of U.S. business interests. He believed that only investment with gold-backed currency was sound; many of his cartoons about financial problems of the post–Civil War era frequently blame inflation and deficit spending on promoters of soft money—greenback currency that was not backed by gold bullion, then in short supply, and was therefore unredeemable.

By the late 1870s and early 1880s, Nast's shaken idealism and nostalgia for postbellum euphoria appeared more consistently in his artistic commentary. Organized labor, industrial unrest, and widespread labor-union strikes threatened law and order. *"It Leads* **U S** *To* **A** *Challenge"* (cat. no. 224) looks back

to the politics of Republican James Gillespie Blaine, who had twice sought the party presidential nomination, both times unsuccessfully. He had advocated a protective tariff and coaxed the fragmented Radical Republican Party away from its ideological and euphoric Civil War mindset.[8] In this drawing, the portly Blaine cowers in front of a frame inscribed "Gen. U.S. Grant," defensively protesting the accusing finger pointed at him by a legless Civil War Union veteran positioned in front of the "A. Lincoln" frame on the wall.

Praised by Grant for cartoons that helped "preserve the Union and bring the war to an end,"[9] Nast supported Grant and the Radical Republican Party's postwar stance favoring the Union and political and social justice for the freedmen. However, in the election of 1884, for the first time, Nast supported a Democrat, Grover Cleveland, for president rather than the scandal-tainted Blaine. Known for excessively protesting his innocence, Blaine lost the presidency to Cleveland because of his role in an Arkansas railroad scandal, among other irregularities. This image somehow crystallizes Nast's shaken social beliefs—he was neither a supporter of hard money and low taxes and wages, nor did he have particular ties to the big capitalists or gentle reformers among the liberal Republicans. Nast had idealized General Grant, and he could not now reconcile his hero's image with Grant's lack of commitment to racial equality, especially in the North, or with the proliferating riots, strikes, Wall Street fraud, and widespread political corruption—disturbances that ushered in a new era.[10]

E.K.K.

fig. a Thomas Nast, *The Tammany Tiger Loose.—"What Are You Going To Do About It?,"* from *Harper's Weekly* 15 (11 Nov. 1871), 1056–57

Notes

1. Albert Boime, "Nast and French Art," *American Art Journal* 4 (spring 1972), 43.
2. Both political animals were first shown together in Dec. 1879. See Thomas Nast St. Hill, *Thomas*

Nast: Cartoons and Illustrations (New York: Dover Publications, 1974), pl. 89.

3. *Harper's Weekly* 75 (July 1887), 309; I thank Graham C. Boettcher for this reference.

4. Kenneth T. Jackson, ed., *The Encyclopedia of New York City* (New Haven and London: Yale University Press, and New York: New-York Historical Society, 1995), s.v. "Hall, Abraham Oakley." See also Edwin G. Burrows and Mike Wallace, *Gotham: A History of New York City* (New York: Oxford University Press, 1999), 571.

5. J. Herbert Bass, *"I Am a Democrat": The Political Career of David Bennett Hill* (Syracuse, N.Y.: Syracuse University Press, 1961), 113–15, 121–25. Grover Cleveland lost the presidential election to Benjamin Harrison due to Hill's manipulations in 1888; see Milton M. Klein, ed., *The Empire State: A History of New York* (Ithaca, N.Y., and London: Cornell University Press, and Cooperstown, N.Y.: New York State Historical Association, 2001), 484–91.

6. *Encyclopedia of New York City*, s.v. "New York Tribune."

7. The *New York Times* supported Grant; see Albert Bigelow Paine, *Thomas Nast: His Period and His Pictures* (1904; repr. New York: Dover, 1978), 246–47.

8. Sean Dennis Cashman, *America in the Gilded Age*, 2nd ed. (New York and London: New York University Press, 1988), 198–200.

9. Paine, 1978, 69, 106. Grant could also have attributed his presidential victory to "the pencil of Thomas Nast," ibid., 129; also cited in Wendy Wick Reaves, "Thomas Nast and the President," *American Art Journal* 19 (1987), 60.

10. Morton Keller, *The Art and Politics of Thomas Nast* (New York: Oxford University Press, 1968), 243–47.

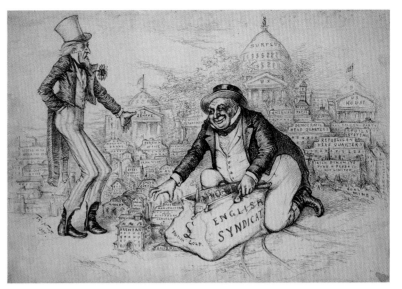

223

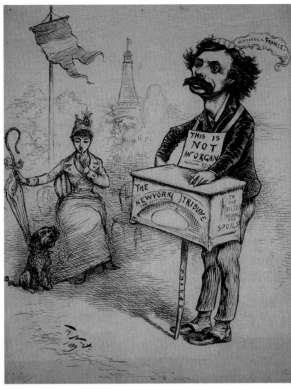

222

224

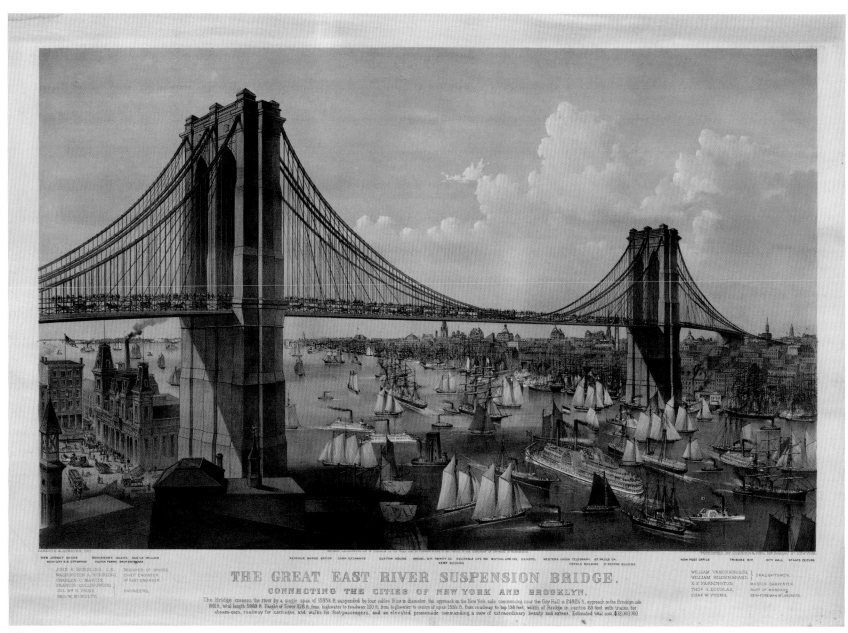

THE GREAT EAST RIVER SUSPENSION BRIDGE.
CONNECTING THE CITIES OF NEW YORK AND BROOKLYN.

225

Charles R. Parsons (1821–1910) and
Lyman W. Atwater (1835–1891), artists
and lithographers
Published by **Currier & Ives** (active
1857–1907)
*The Great East River Suspension Bridge.
Connecting the Cities of New York and
Brooklyn*, 1874
Color lithograph, 26 3/16 x 35 13/16 in.
(66.5 x 91 cm)
Mabel Brady Garvan Collection, 1946.9.2108

*It so happens that the work which is likely to
be our most durable monument, and which is
likely to convey some knowledge of us to the
most remote posterity, is a work of bare util-
ity; not a shrine, not a fortress, not a palace,
but a bridge.*

— Montgomery Schuyler,
"The Bridge as Monument"

When it came to producing and marketing
a potentially popular subject, the litho-
graphic publishing firm of Currier & Ives was
never one to let itself be beaten to the press
by its competitors. Certainly this was not to
happen in 1874—a full nine years before the
completion of the Brooklyn Bridge—when
the firm issued this extraordinary print,
showing the bridge already finished and in
use. Drawn by two of Currier & Ives's most
skilled artists, Charles Parsons and Lyman
Atwater, it was likely the earliest large-folio
image of the Brooklyn Bridge to be offered
for sale to the American public. Thus it is
important not only as a cultural object but
also as a prophetic symbol of the iconic role
that the bridge would come to play in
American culture.

That Currier & Ives published twenty
lithographs of the Brooklyn Bridge in the
twenty years between 1872 and 1892 is
evidence of the enormous excitement
generated by this marvel of fin-de-siècle
American engineering—the perfect marriage
of technical ingenuity and architectural
beauty. As with earlier major public
works projects, the Erie Canal and the
Croton Aqueduct, the realization of the
bridge depended on a timely convergence
of practical need, public sponsorship,
artistic vision, and scientific capability.[1]
The Brooklyn Bridge was the brainchild
of Prussian-born civil engineer John A.
Roebling, who had designed other suspen-
sion bridges, including those at Cincinnati
and Niagara Falls, but never one so ambi-
tious in length, height, and grandeur as this
one. Roebling contracted tetanus in July
1869 and did not live to see the realization of
his greatest work. His son Washington took
his father's place as chief engineer and saw his
design through to completion. The construc-
tion of the Brooklyn Bridge, which began
in early January 1870 and continued for
thirteen years, coincided with an extraordi-
narily rich period in American entrepreneur-
ship that witnessed the invention of the tele-
phone, the phonograph, and the lightbulb.

In this print, both the roadway and the
pedestrian walkway of the bridge are in full
use. The East River below is also heavily
trafficked with vessels of all types, most of
which traverse the river north to south rather
than east to west—a subtle reminder that
the bridge, once completed, would alleviate
the need for such lateral river traffic. Con-
struction of the bridge was a feat of immense
proportion—and one accomplished without
the use of hydraulic machinery. The bridge
was 1595.5 feet long, and its two stone
masonry towers were 276.5 feet above the
high-water level—an altitude exceeded, in
1883, only by the spire of New York's Trinity
Church. The towers anchored a complex but
elegant system of twisted-wire cables. Though
the initial projected cost of the bridge was
not to exceed $8 million, this estimate had
risen to $12 million by 1874 (as indicated in
the legend of this print), and the final sum
would exceed $15 million. The bridge spoke
of its time, combining solidity of purpose
with modernity of construction: its grand
neo-Gothic towers provided a noble entrance
to the Empire City, and its seemingly ethe-
real cables created a look that hailed a
new century.

The New York and Brooklyn Bridge, as
it was officially named,[2] was dedicated on
24 May 1883 before a crowd of fifty thousand,
including honorary guest President Chester
Arthur. In his inaugural remarks, industrial-
ist Abram S. Hewitt, soon to be mayor of
New York, remarked of the bridge: "It looks
like a motionless mass of masonry and metal;
but, as a matter of fact, it is instinct with
motion. There is not a particle of matter in it
which is at rest even for the minutest por-
tion of time. It is an aggregation of unstable
elements, changing with every change in the
temperature, and every movement of the
heavenly bodies."[3] In these remarks, Hewitt
prophetically touched on the very qualities
that would inspire successive generations of
artists, architects, novelists, poets, song-
writers, and filmmakers, who would immor-
talize the bridge and make it one of the most
frequently referenced of America's land-
marks. Along with the Statue of Liberty
(dedicated just three and a half years later, on
18 October 1886), the Brooklyn Bridge
remains among the most enduring symbols
of American promise and vitality. E.H.

Notes

The epigraph to this text is drawn from Montgomery
Schuyler, "The Bridge as Monument," *Harper's
Weekly* (26 May 1883), 326.
1. For comprehensive accounts of the making of
the Brooklyn Bridge and its symbolic legacy, see
David McCullough, *The Great Bridge: The Epic
Story of the Building of the Brooklyn Bridge* (1972;
repr. New York: Simon & Schuster, 2001); Alan
Trachtenberg, *Brooklyn Bridge, Fact and Symbol*
(New York: Oxford University Press, 1965); and
Brooklyn Bridge, a film by Ken Burns (produced by
Florentine Films in association with the Department
of Records and Information Services of the City of
New York and WNET/THIRTEEN, a PBS station),
directed by Ken Burns, written by Amy Stechler.
2. Known initially as the Great East River Bridge,
this expanse of stone and steel had several alterna-
tive names: the East River Bridge, Empire Bridge,
Great Bridge, and Roebling Bridge. It would be
officially named the New York and Brooklyn Bridge
(5 June 1874). Later, it would simply come to be
called the Brooklyn Bridge.
3. Abram S. Hewitt, *Address Delivered by Abram
S. Hewitt, on the Occasion of the Opening of the
New York and Brooklyn Bridge, May 24th, 1883*
(New York: printed by John Polhemus, 1883), 23.

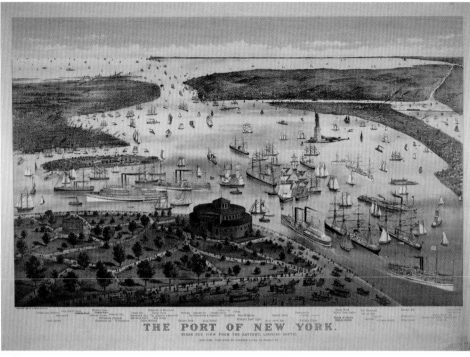

226

226

Unknown lithographer
Published by **Currier & Ives**
(active 1857–1907)
The Port of New York. Bird's Eye View from the Battery, Looking South, 1892

Color lithograph, 25½ x 35¾ in. (64.8 x 90.8 cm)
Mabel Brady Garvan Collection, 1946.9.2111

By the end of the Civil War, the perspective in nearly all printed views of American communities had shifted from a slightly elevated vista executed at a remove from the city to the vantage point of an imagined observer high in the sky.[1] Manipulating the angle of perception in this way made it possible to illustrate every aspect of the scene with equal clarity, and the result is an all-inclusive, bird's-eye view.

Always in touch with popular taste, Currier & Ives published many such prints of cities seemingly drawn from an aerial position. The majority of those executed as color lithographs appeared after 1880,[2] but three of the port of New York are dated 1872, 1878, and 1892. In the first, Castle Garden, which was built as a fort but used from 1855 to 1890 as an immigration depot,[3] appears at the right, and the legend identifies forty-eight landmarks. Castle Garden is placed near the center of the second, which lists fifty-six landmarks.

This print is the third version. In it, Castle Garden is even more centrally located than before, although it had not been used for immigrants since 1890, and there were no longer any outbuildings. The gazebo at left, prefiguring the recreational use of Castle Garden as an aquarium from 1896 to 1941, is another change in this iteration.

Between 1890 and 1892, a temporary facility was used to serve immigrants, and since Currier & Ives commonly issued prints to illustrate events, it may be that this depiction of the harbor was intended to mark the opening of Ellis Island in 1892. The new, larger port of call for ships carrying immigrants would serve twenty-two million newcomers (nearly three times as many as disembarked at Castle Garden) before the numbers began declining in 1924. Still another change in this version is the appearance of that other famous immigrant beacon, the Statue of Liberty (celebrated by Currier & Ives with a print in 1885).

Many ships of all types, both sail and steam, stretch from the Battery to the ocean. However, unlike the very earliest views of New York, which look inward from the sea, the lively traffic on land is as fully documented in all three prints as the water traffic. On crowded walkways, elegantly dressed ladies and gentlemen at leisure alternate with workers and street tradesmen, while horse-drawn trolleys, carriages, and freight wagons fill the roadways. All are emblems of civic prosperity and pride in a great city, the immigrant gateway to America, and it can be argued that nearly two hundred years after cartographers recorded the geographic facts to the contrary, New Yorkers still preferred to see themselves as the center of the universe. S.L.C.

Notes
1. John W. Reps, *Views and Viewmakers of Urban America: 1825–1925* (Columbia: University of Missouri Press, 1984), viii.
2. Peter C. Marzio, *The Democratic Art: Chromolithography 1840–1900* (Boston: David R. Godine, 1979), 63.
3. The Southwest Battery, completed in 1811, was renamed Castle Clinton after the War of 1812 in honor of Governor De Witt Clinton, but in 1824 it became Castle Garden, a theater for public entertainments. Today it is again Castle Clinton, a National Park Service visitor center.

227

Unknown lithographer
Published by **Currier & Ives**
(active 1857–1907)
The City of Chicago, 1892

Color lithograph, 18 x 24 in. (45.7 x 61 cm)
Mabel Brady Garvan Collection, 1946.9.1554

Always quick to react to current events, in 1892 Currier & Ives published two bird's-eye views of Chicago, host city of the World's Columbian Exposition, the largest world's fair held up to that time. New York had argued that it could best represent the nation's achievements during the four hundred years since Columbus discovered America, but Chicago energetically pursued the prize. The younger city, which had doubled in size since its disastrous fire in 1871, also claimed to typify the national character and declared that it was long past time to recognize the wealth and power of the emerging West. When civic leaders willingly agreed to match New York's pledge of money and a fitting location for the fair, Congress awarded the honor to Chicago.[1]

Congressional legislation had specified that the dedication of the exposition buildings was to be in October 1892, and the Hall of Manufactures and Liberal Arts (the large elliptical building at the edge of the water directly above the words "Exposition Buildings" in this print) was ready for the occasion. Probably because no other structures were completed until the fair opened in May 1893, the grand scheme of palatial white buildings around a great lagoon is not pictured. Nonetheless, the view does offer a visual catalogue of Chicago's many resources: its vast size, its favorable situation as a lake port, the canal linking Lake Michigan to the Chicago River and serving interior industrial sites, and, especially, the railroads, which made Chicago a national center of commerce.

Bird's-eye views printed by Currier & Ives typically portrayed large metropolitan areas such as Chicago. Initially the artist might have made sketches of individual buildings. Next, often using a town map, he or she constructed a scaled perspective grid of the city's streets and proceeded to draw in buildings. The artist frequently incorporated true linear perspective, so that only structures in the foreground are seen in clear detail, while "progressively stylized rectangles to represent receding structures" disappear into the distance.[2] Currier & Ives sold these prints at their own retail stores in New York and through an office in London. Prints were also distributed by sales agents and by peddlers or "traveling agents" throughout the country.[3]

The relatively low cost of lithography meant that ordinary citizens everywhere could afford large-folio aerial views in which their own properties could clearly be seen—an enticement to some artists to travel from town to town selling subscriptions before turning drawings into finished prints. City and business promoters used prints to encourage investment in their communities and sometimes paid artists to insert small portraits of specific buildings around the image's borders. By the end of the century, almost every American settlement of any size was pictured in print.[4] S.L.C.

Notes
1. See R. Reid Badger, *The Great American Fair* (Chicago: Nelson Hall, 1979).
2. John W. Reps, *Views and Viewmakers of Urban America: 1825–1925* (Columbia: University of Missouri Press, 1984), 21.
3. Harry T. Peters, *Currier & Ives, Printmakers to the American People* (Garden City, N.Y.: Doubleday, Doran, 1942), 12.
4. David Ruell, "The Bird's Eye Views of New Hampshire: 1875–1899," *Historical New Hampshire* 38 (spring 1983), 1–85.

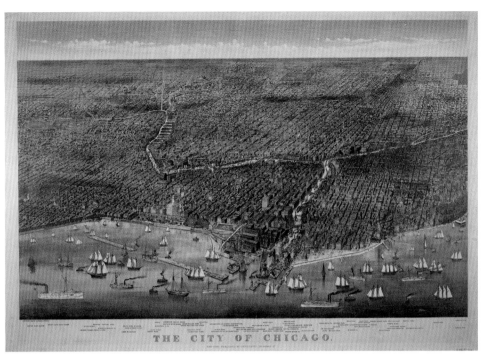

227

228

Thomas Wilmer Dewing (1851–1938)
Summer, 1890

Oil on canvas, 20½ x 36 in. (52.1 x 91.4 cm), in original gilded plaster and pine frame designed by Stanford White (1853–1906)
Gift from the estate of Miss Frances L. Howland, 1947.83

As the first of the landscapes with figures that Thomas Wilmer Dewing painted at his Cornish, New Hampshire, retreat, *Summer* marks a transformative moment in the artist's vision.[1] The dissolving contours of his figures give way to atmosphere, while the space remains articulated through the separation between the foreground screen of female bodies and the background row of sapling birch trees. This alternation of two rhythmic lines spread horizontally across the canvas, with the slim trees punctuating the space between the figures, evokes the disposition of musical notes across a page.[2] Richard Watson Gilder, poet and editor-in-chief of *Century* magazine, recognized the arrangement's relationship to music in the poem he penned to accompany the picture:

> Behold these maidens in a row
> Against the birches' freshening green;
> Their lines like music sway and flow;
> They move before the emerald screen
> Like broidered figures dimly seen
> On woven cloths, in moony glow—
> Gracious, and graceful, and serene.
> They hear the harp; its lovely tones
> Each maiden in each motion owns,
> As if she were a living note
> Which from the curved harp doth
> float.[3]

With arms that curve outward from attenuated bodies, Dewing's figures echo the shape of the harp that inspires their dance, seeming, as Gilder wrote, to emanate from it, each one like a note plucked from its strings. Communing trancelike without words through music and touch, the women of *Summer* demonstrate why some critics found Dewing's pictures to be tinged with mysticism.[4] These are not the pantaloon-wearing, cigarette-smoking, bicycle-riding "New Women" of the day; Dewing's women are "spirits" on a more sophisticated plane.[5] Their features are soft; their old-fashioned gowns give off mists of iridescent color at the hemline as they float, ungrounded, in a sea of green: these modern incarnations of Botticelli's Graces induce one to meditation.[6]

In the face of the "convulsive" and far more popular Coney Island style of summer recreation, *Summer* is a paean to the "lost . . . old sweet calm" of summer leisure.[7] It visualizes the kind of perfect balance that was lacking in the often chaotic urban industrial experience, from which Dewing sought refuge in Cornish: the golden tonality of the frame—a "u-decoration" type produced for the painting by the architect Stanford White—is picked up in the harp and in the leftmost figure's gown, its foliage design echoed by the overlapping leaf pattern in the painting's upper third. An aesthetically and hermetically contained object, the Dewing/White work seals womankind off from modern tribulations, denying the realities of her changing social position and reinforcing the time-honored connection between nature and femininity.[8] It is a socially conservative statement bred of the artist's desire to preserve the elite status of his social caste and its way of life within a changing social landscape.[9] Yet, in anticipating the aims of younger twentieth-century artists—to enrapture the senses through abstract patterns of glowing color—*Summer* is, aesthetically, exceedingly modern. J.A.G.

Notes

1. I thank Susan Hobbs for sharing her file on *Summer* with me. On Dewing's Cornish period, see Hobbs, "Thomas Dewing in Cornish, 1885–1905," *American Art Journal* 17 (spring 1985), 2–32.

2. Sarah Burns made this connection to musical notation in her dissertation, "The Poetic Mode in American Painting: George Fuller and Thomas Dewing" (PH.D. diss., University of Illinois at Urbana-Champaign, 1979).

3. Richard Watson Gilder, "The Dancers, on a Picture Entitled Summer by T. W. Dewing," in *The Poems of Richard Watson Gilder* (Boston and New York: Houghton Mifflin, 1908), 156.

4. Catherine Beach Ely, "Thomas W. Dewing," *Art in America* 10 (Aug. 1922), 226; Charles H. Caffin, "Some American Portrait Painters," *Critic* 44 (Jan. 1904), 36. For the female mystic in literature, see Henry James, *The Bostonians* (1886; repr. London: Penguin, 1984).

5. Dewing wrote to his patron Charles Lang Freer that he pictured a place where only "a few choice spirits live." Thomas Wilmer Dewing to Charles Lang Freer, 16 Feb. 1901, Letter 110, Freer Gallery of Art, Washington, D.C.; cited in Susan Hobbs, "Thomas Wilmer Dewing: The Early Years, 1851–1885," *American Art Journal* 13 (spring 1981), 5.

6. See Sarah Burns, "Painting as Rest Cure," in her *Inventing the Modern Artist: Art and Culture in Gilded Age America* (New Haven and London: Yale University Press, 1996), 120–58. Charles H. Caffin, in "The Art of Thomas W. Dewing," *Harper's New Monthly Magazine* 116 (Apr. 1908), 723, likened Dewing's women to those of Botticelli. See also Susan A. Hobbs and Barbara Dayer Gallati, *The Art of Thomas Wilmer Dewing: Beauty Reconfigured*, exh. cat. (Brooklyn, N.Y.: Brooklyn Museum, and Washington, D.C., and London: Smithsonian Institution Press, 1996), 127–28.

7. The editors of *Appleton's Journal* 11 (Aug. 1881), 185, lamented the shift toward a thrill-seeking brand of summer recreation, citing Coney Island as their primary example: "It is impossible not to feel that summer pleasuring . . . has lost the old sweet calm that characterized it, and become a thing of convulsion and turbulence."

8. On woman's function as decorative object and the link between woman and nature, see Leila Bailey Van Hook, "Decorative Images of American Women: The Aristocratic Aesthetic of the Late Nineteenth Century," *Smithsonian Studies in American Art* 4 (winter 1990), 45–69, and her broader study, *Angels of Art: Women and Art in American Society, 1876–1914* (University Park: Pennsylvania State University Press, 1996).

9. See Kathleen Pyne, "Evolutionary Typology and the American Woman in the Work of Thomas Dewing," *American Art* 7 (winter 1993), 13–29, and Pyne, *Art and the Higher Life: Painting and Evolutionary Thought in Late Nineteenth-Century America* (Austin: University of Texas Press, 1996), esp. 135–219.

228

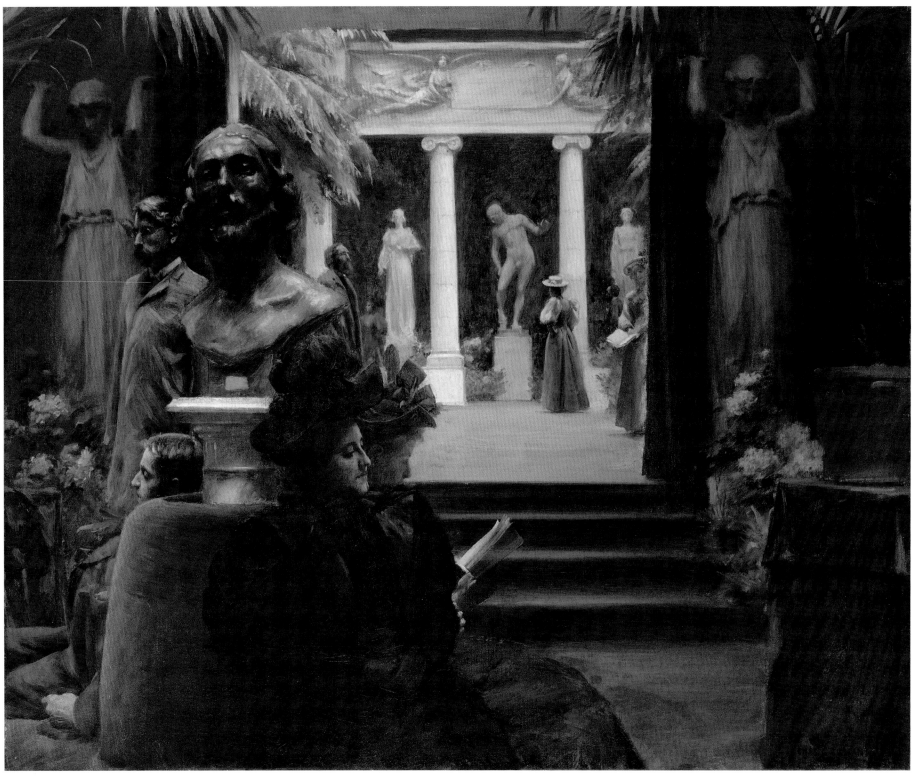

229

Charles Courtney Curran (1861–1942)
At the Sculpture Exhibition, 1895

Oil on canvas, 18 x 22 in. (45.7 x 55.9 cm)
Stephen Carlton Clark, B.A. 1903, Fund, 1973.103

In 1895, the National Sculpture Society held its second exhibition in New York City and changed the way Americans experienced sculpture. "Never in this country has plastic art had so fair a chance," the *New York Times* declared, "and not before have our sculptors been seen under such favorable conditions." Instead of pitting sculpture against painting in keeping with standard display practice, the society accented the pieces on view with a lush array of plants and flowers, creating a tranquil haven just "one step from the noise of the New-York streets."[1]

Curran, better known today for his impressionist and fantasy pictures of women with flowers, recorded this landmark show with the eye of a documentarian. He realistically depicted the galleries of the American Fine Arts Society Building in New York and portrayed all the works in the exhibition. With the exception of the Frenchman Auguste Rodin's *Head of St. John the Baptist,* the sculptures are by Americans, and classical motifs abound. In the rear gallery, Herbert Adams's model for a relief in Judson Memorial Church is mounted on the Ionic columns; Charles Henry Niehaus's Greek athlete *The Scraper,* between the columns, is flanked by Philip Martiny's and J. Massey Rhind's allegorical, draped figures for a new building on Broadway, while Olin Warner's *Caryatid* stand on either side of the doorway between the galleries.[2] While some critics praised the implied connection with classical Greece ("We, like the Greeks, are free men. . . . We are the heirs, more than any other

people . . . of the past history of the world"), others decried the reliance on foreign influences in art: "Culture . . . must come from within; it cannot be imported."[3]

The National Sculpture Society was founded in 1893 to encourage the appreciation and sale of work by American sculptors. Critics had often compared the United States unfavorably to France, where sculpture, as a highly regarded art form, enjoyed significant government patronage. Exhibitions such as the one Curran so vividly brings to life were concerned with the development, definition, and display of an emergent American school. "We need a national school," wrote one critic; "the time has come when the nation, settling down to a consciousness of stability and sure of a grand and prosperous future, . . . shall be moved by great thoughts and aspire to utter them in the language of art, but in a dialect of its own, racy with the flavor of the Western world."[4]

In his intimate portrait of the exhibition's verdant rooms, Curran provided a telling view of the art-going public and his own ambitions as a painter. Among the visitors, he includes himself, standing to the left of the *Head of St. John.* Rigidly, even sculpturally posed, similarly bearded and gazing soberly at an unseen object, the artist assumes a measure of the colossal head's masculine dignity. He stands in striking contrast to the man slumped indecorously on the pouf, who may be the critic and Rodin admirer Kenyon Cox. Although they are situated in a public art gallery, the two men appear lost in private moments, as do the fashionable ladies—one of whom, seated in the foreground, is the artist's wife, Grace Wickham Curran. Curran's figures demonstrate precisely the kind of "idleness full of thought," the leisurely breathing in of a refined environment, that was commonly prescribed in the Gilded Age as an antidote

to the stress of the modern urban experience.[5] Amid such noble statuary, visitors might forget the bustling metropolis outside.

John Adams might have envisioned a scene not so far removed from *At the Sculpture Exhibition* when, over 100 years earlier, he expressed the hope that instead of studying only "politics and war," future generations might have the freedom to study "painting, poetry, music, architecture, statuary, tapestry and porcelain."[6] H.A.C.

Notes

1. "The Sculpture Society," *New York Times,* 7 May 1895, 5.
2. Kenneth Silver, *"At the Sculpture Exhibition by Charles Curran," Yale University Art Gallery Bulletin* 35 (summer 1974), 21–23.
3. William Ordway Partridge, *Art for America* (Boston: Roberts Brothers, 1894), 58, quoted in Silver, 1974, 25.
4. "Tendencies in American Art," *American Art Review* (1880), 107.
5. Agnes Repplier, "Leisure," *Scribner's* 14 (July-Dec. 1893), 65. See also "Editor's Drawer," *Harper's New Monthly Magazine* 83 (Aug. 1891), 480–81, and George M. Beard, *American Nervousness: Its Causes and Consequences* (New York: G. P. Putnam's Sons, 1881; repr., New York: Arno Press, 1972), esp. vi, 106, 108.
6. John Adams to Abigail ("Nabby") Adams, [post 12 May 1780], in Lyman Henry Butterfield, ed., *Adams Family Correspondence,* vol. 3 (Cambridge, Mass.: Belknap Press of Harvard University Press, 1963), 342.

Index

Page references in *italic* refer to illustrations.

Photograph Credits

First published in 2008 by the
Yale University Art Gallery
P.O. Box 208271
New Haven, Conn. 06520-8271
www.artgallery.yale.edu

in association with
Yale University Press
P.O. Box 209040
New Haven, Conn. 06520-9040
www.yalebooks.com

Published in conjunction with the exhibition *Life, Liberty,
and the Pursuit of Happiness: American Art from the Yale University
Art Gallery,* organized by the Yale University Art Gallery

Speed Art Museum, Louisville, Ky., 7 September 2008–4 January 2009;
Seattle Art Museum, Wash., 26 February–24 May 2009; Birmingham Museum
of Art, Ala., 4 October 2009–10 January 2010

This exhibition and publication received crucial and generous funding from
Happy and Bob Doran, B.A. 1955, Carolyn and Gerald Grinstein, B.A. 1954,
Mrs. William S. Kilroy, Sr., Mrs. Frederick R. Mayer, Nancy and Clive
Runnells, B.A. 1948, in celebration of his 60th class reunion and in memory of
their son Pierce and in honor of their daughter Helen for her leadership on
the Yale University Art Gallery's Governing Board, Ellen and Stephen D.
Susman, B.A. 1962, for their special support of the audio tour, the Eugénie
Prendergast Fund for American Art, given by Jan and Warren Adelson, and
the Friends of American Arts at Yale.

EDITOR Tiffany Sprague
CONTENT EDITOR Diana Murphy
COPYEDITOR Janet Wilson
DESIGNER Jenny Chan/Jack Design
Set in Baskerville 10 and John Sans type by Amy Storm.
Printed in Singapore by CS Graphics.

LIBRARY OF CONGRESS CATALOGING-IN-PUBLICATION DATA
Life, liberty, and the pursuit of happiness : American art from the Yale University
Art Gallery / introduction by David McCullough ; essays by Jon Butler ;
catalogue organized by Helen A. Cooper . . . [et al.].
p. cm.
Published in conjunction with an exhibition at the Yale University Art Gallery
and other venues.
Includes bibliographical references and index.
ISBN 978-0-300-12289-3 (hardcover : alk. paper)—ISBN 978-0-89467-966-7
(pbk. : alk. paper)
1. Art, American—Exhibitions. 2. History in art—Exhibitions. 3. United States—
In art—Exhibitions. 4. United States—History—Exhibitions.
I. McCullough, David G. II. Butler, Jon, 1940- III. Cooper, Helen A.
IV. Yale University. Art Gallery.

N6505.L54 2007
709.73'0747468—dc22
2007008833

10 9 8 7 6 5 4 3 2 1

COVER ILLUSTRATIONS *(front)* Albert Bierstadt, *Yosemite Valley, Glacier Point Trail,*
 ca. 1873 (detail of cat. no. 201); *(back, clockwise from top left)* Jonathan
 Budington, *Portrait of George Eliot and Family,* probably 1798 (cat. no. 124);
 John Coney, *Monteith,* Boston, ca. 1705 (cat. no. 98); Thomas Eakins, *John Biglin
 in a Single Scull,* 1874 (cat. no. 206); *Side Chair,* New York City, 1750–70 (cat. no.
 101); George Frederic Barker, *The Moon,* 1864 (cat. no. 131)
PAGES II–III Edward Hicks, *The Peaceable Kingdom,* 1829–30
 (detail of cat. no. 9)
PAGES IV–V John Trumbull, *The Battle of Bunker's Hill, June 17, 1775,* 1786
 (detail of cat. no. 31)
PAGE V Possibly by Samuel Henszey, *High Chest of Drawers,* Pennsylvania, 1765–70
 (detail of cat. no. 12)
PAGE VI Martin Johnson Heade, *Lynn Meadows,* 1863 (detail of cat. no. 138)
PAGE XV Unknown lithographer, published by Currier & Ives,
 The Port of New York. Bird's Eye View from the Battery, Looking South, 1892
 (detail of cat. no. 226)
PAGE 14 Johann Christoph Heyne, *Flagon,* Lancaster, Pennsylvania, 1771
 (detail of cat. no. 7)
PAGE 60 John Sartain, lithographer, after a painting by George Caleb Bingham,
 The County Election, 1854 (detail of cat. no. 78)
PAGE 160 Charles Willson Peale, *Mrs. Walter Stewart (Deborah McClenachan),*
 1782 (detail of cat. no. 110)